John and Joy Kasson

The Sociology of Art

Arnold Hauser
The Sociology of Art

Translated by Kenneth J. Northcott

The University of Chicago Press
Chicago and London

Arnold Hauser is the author of *The Social History of Art, Philosophy of Art History,* and *Mannerism.*

Kenneth J. Northcott is professor of German literature and comparative studies at the University of Chicago. He has written, edited, and translated numerous works. His translation of Gotthold Ephraim Lessing's *Minna von Barnhelm* is published by the University of Chicago Press.

Originally published as *Soziologie der Kunst,*
©C. H. Beck'sche Verlagsbuchhandlung (Oscar Beck), München 1974. The section in chapter 6 entitled "*L'art pour l'art* Problem" (pp. 313–28) appeared in translation in *Critical Inquiry* (vol. 5, no. 3 [1979], pp. 425–40), © 1979 The University of Chicago.

The University of Chicago Press, Chicago 60637
The University of Chicago Press, Ltd., London

Library of Congress Cataloging in Publication Data

Hauser, Arnold, 1892–1978.
 The sociology of art.

 Translation of: Soziologie der Kunst.
 Includes bibliografical references.
 1. Arts and society. I. Title.
NX180.S6H3413 700'.1'03 81-13098
ISBN 0-226-31949-0 AACR2

Contents

Foreword

The translation of *The Sociology of Art* has been a long and arduous task. The density of thought behind the work, the sense that this was the *summa* of Arnold Hauser's scholarly contribution—a sense heightened by his death in 1977—all added to the usual burdens of the translator's task. I have spoken elsewhere of the opacity of language which is part of the German scholarly heritage, at least from Hegel onward. The present work was no exception. I have tried—not always successfully—to reduce the length of sentences, to present the work as far as is possible in good and idiomatic English.

Arnold Hauser's death prevented me from having the discussions which I had hoped would be possible when I began the work. Thus, there must be many passages where my translation represents my interpretation of what I think he was saying; that others will have different interpretations is more than probable. In any case part of the fun of reading translations is pointing out the errors which the translator has made, and I am sure that the present work will, like all translations, present innumerable opportunities for the playing of this game. For all of that I take full responsibility. I hope, on the other hand, that the positive merits of this stimulating, testing, and densely argued work will outweigh the cosmetic flaws which are the lot of every translation.

I have tried to identify bibliographical references to the best of my ability, but the bibliography in the original was at times incorrect, and generally scanty—in the manner of German bibliographies, where there is no standardized method of citation. Again, although I was prevented by Hauser's death from inquiring as to the editions he used,

I hope that the bibliography will nonetheless prove of use and service to the reader.

There are many to whom thanks are due. I know that my friends will heave a sigh of relief when they know that "Hauser" is actually finished. To Michael Gillespie I owe special thanks for his help and counsel with the Hegelian vocabulary. Others, like Bernhard and Hildegard Büchner, Pat Anderson, and all those who lent me space and typewriters, will know that they are assured of my gratitude. I must single out my wife, Zarina, for her support—in spite of her remorseless schedule at the Orthogenic School—during the summer months of 1980 when I was engaged upon the final revision. She found the time, but more astonishingly the energy and good humor, to lend me the support I needed for that final "push."

Kenneth J. Northcott

Preface

I am publishing the present work in the hope of having undertaken the first comprehensive discussion of the subject—"comprehensive" in the sense of a systematically related, unified representation of the sociology of art which gives a total picture of the essential questions which arise in it today. It is not, however, "exhaustive," for such a treatment would demand a totality of view which could only be achieved from an artistically imaginative point of view. Since art, to use a citation from my own work, is always at its goal while science is merely on the way to an unattainable one, the statement that the discussion which is carried on here is the first of its kind does not mean that the sociological problems of art have been neglected in discussions up to this time or that they have been dismissed without considerable results having been obtained. There are innumerable treatments, both monographs and parts of larger works, which are in part so informative, even indispensable, that a work like the present could not have been completed without them; indeed, it could not even have been undertaken. They go back to the works of Diderot, Lessing, Mme de Staël, Marx, and Hegel and are continued by critics and sociologists like Sartre, Edmund Wilson, Walter Benjamin, Georg Lukács, and Adorno up to the present day—the process has been interrupted from time to time, but never completely broken off.

Just like the efforts which have been made up to now, this one, too, does not offer a final, incontestable, invariable solution to the problem. Indeed, it does so all the less because every attempt at a solution is of necessity undertaken from a particular, historically and socially conditioned point of view, and all the points of view which arise in this

way form a spiral and circle around the object which is being viewed, instead of making a beeline for it. Just as objectively the present enterprise had a long, tortuous prehistory which reached its conclusion in several more or less independent phases of development, so subjectively the problems and points of view of the investigation were gradually discovered, formulated, and clarified. All my earlier works represent studies, preparation, and introductions to the answer to the primary question. This, however, arose in connection with my services to a film corporation, and under the influence of an event for which history—since the beginning of Greek drama—can show no parallel. It was the birth of a new art which, because I had to publicize films, I could observe under, so to speak, laboratory conditions. The task of judging the relationship between the productions and their reception placed the results (from the beginning) in the area of sociology. These results at first combined with that basis of experiences and perceptions which always lies dormant for a long time and which is only dug up and used after many years. At first I was concerned only with *art* and scarcely with its relationship to society: my interest in it was purely formalistic, in the sense of Wölfflin's principles, and for a long time my aesthetic point of view remained, in accordance with his doctrine oriented toward the inner logic of art history.

It was only slowly and hesitatingly that I recognized the limited significance of formalism and the less-limited validity of realism in art, something for which Chekhov found—in one of his works—the wonderfully telling *mot* that we help people just by showing them—no matter what comes out in the process—what their nature is. It was only in the course of work on my book which was to become *The Social History of Art* and which occupied me between 1940 and 1950 that I became aware of the full implications of the sociological facts of the development of art history. But the conception, choice of material, and organization of this book were by no means simple and certainly not consistent in view of the goals. The undertaking started with a commission which was certainly not in accordance with the result. In some way, more came out than could have been expected from the original intention. At first it was a question of nothing more than an extensive introduction to an anthology which was to be put together from writings about the social function of art and the work was, if possible, to reflect the continuous development of the problem. Meanwhile, it transpired that, aside from shorter and fragmentary treatments which varied in value, there was no more extensive work on the subject and that it could be said of almost everything which offered itself as such what was said of J-M. Guyau's *L'art au point de vue sociologique*—the first book of this sort—namely, that the author

had no more to say about the subject under discussion than there was in the title. Further it also transpired that a continuous history of the theory of the sociology of art was not something which simply came into being: it had first to be constructed. The components for it had to be taken from the whole of the development of art and culture, and from these fragments a connection had to be made which was for the most part merely conjectural. It is in this way—from the supposed introduction to an anthology—that a work in two volumes each of five hundred pages emerged and presented such a store of sociohistorical information that I was able to rely on it for my further work. There was simply no room for an introduction which would have explained the methodological principles on which this already very large "introduction" was based. This had to be left for a further discussion and, after more perspicacious historico-philosophical considerations, was published originally under the title *The Philosophy of Art History* (1958) and rechristened in a later edition *Methoden moderner Kunstanschauung* [*Modern Methods of Viewing Art*]. Here for the first time I defined unequivocally and globally the fundamental concepts around which, from then on, thinking on the sociology of art revolved: the concept of the goals and limits of a sociology of art, of the ideological foundation, of the aims, of movement in taste and style, of artistic points of view, of the contradiction of sociological and psychological points of view from which aesthetic judgments could be made, of the fiction of a "history of art without names," and of a completely immanent and endogenous development of art, finally of the origin and development of conventions, which remained fundamental to the intellectual construction of *The Sociology of Art* which I now present.

In order to proceed to a more extensive discussion of the sociological problems of art, I thought that I should first busy myself more thoroughly with a particular art historical problem. The thing that I was concerned with was the first explanation of the stylistic concept of the criteria and complications of the change of style at the time of one of the most serious crises of art, the breach that is called *mannerism* in the development between Renaissance and baroque, which, like the current crisis in art, seemed to threaten many with the collapse of art. Since the book I wrote about this, entitled *Der Ursprung der modernen Kunst und Literatur: Die Entwicklung des Manierismus seit der Krise der Renaissance* (1964) [*The Origin of Modern Art and Literature: The Developement of Mannerism since the Crisis of the Renaissance*], was concerned with the concept of style, fine arts were central to the discussion, since stylistic genesis and change is most obvious in their history. However, they did not enjoy pride of place or a privileged position in this book any more than in my others. In the present

Sociology of Art one could even say (because of a more frequent appeal to ideology than to form) that we could speak of the predominance of literature: this would be as unfounded as the assumption of a prejudiced verdict in favor of the fine arts.

In connection with the precise definition of the interest which guided me in my work, I must further confess that sociology was for me always an excuse to look at art from one point of view, in the process of which new or insufficiently considered characteristics would appear. In the sense, now, that from a point of view like this everything which stands in a sensible relationship to the object of discussion can be included, we can call the work—according to its form—an essay, unless we object to that from the beginning because of the size of the work.

The Sociology of Art as it is now presented is based, in one or another connection, on my previously published works. The conceptual apparatus developed in the *Methoden moderner Kunstanschauung* certainly forms the most suitable basis for this new, extensive examination, the most advanced possible within the existing circumstances. Some of the fundamental concepts which have essentially been preserved were, however, in the course of their examination, subject to changes of meaning and reevaluations which certainly reveal that the final point of view could not have been attained without such a modification. Among these modifications is, above all, the distinction between theoretical and political Marxism, in antithesis to the orthodox unity of principles and practice in the sense in which Marx proclaimed the dogma. Among the fundamentals of the perception which is developed here is the apparently heretical principle that we may agree with Marxism as a philosophy of history and society without being a Marxist in the politically activist sense, indeed, without being a socialist in the narrower sense. Another fundamental is that the "theoretical" interpretation of the view even has the advantage of freeing Marxist thought from the metaphysical ballast which is tied to the prognosis of the "classless society."

The fundamental principles of Marxism underwent a further reinterpretation with respect to the theory of historical materialism. The thesis that every ideology and every intellectual attitude which is ideologically conditioned is materially—that is, socially and economically—established was naturally retained; however, more emphasis was placed on the point of view which has previously been mentioned: that the "infrastructure" upon which the "superstructure" rests consists not entirely of material and interpersonal constituents, but also of intellectual, conscious, and individual ones. The orthodox doctrine of historical materialism explains the connection between the material conditions of existence and their ideological aspects by the assumption of *mediations,* namely, of the different distance of attitudes

and actions from their material basis—and this varies from case to case—and the gradual overcoming of the distance by the movement which is allegedly simultaneously objective and subjective, gradual and abrupt: that is, with essentially a continuous character in spite of its fragmentary nature. The present representation of the process differs from the old one in that it declares the concept of the mediations, which are being talked of, to be a fiction and interprets every step of this sort, no matter how short and tentative, as a *leap* which leads to something novel without denying the function of what is already present as a springboard. The apparent gradualness of the transition between successive phases of development in the earlier theory emerged from the great distance from which the process was viewed. The change of one form of consciousness to another does not vary significantly according to the complexity of intellectual attitudes. The distance between habits or customs of two successive periods of history is scarcely less than that between the moral or legal norms. Development is in any case never completely continuous or discontinuous.

The concept of *dialectic* also reveals some new—if not decisively changed—characteristics in this work. The thought process and method of work remain completely dialectical in the orthodox sense: the relevance of dialectic was, however, sometimes expanded, sometimes reduced. We have to understand sociology from the beginning as a dialectical doctrine pure and simple, since the thought which corresponds to historical development and which underlies its norms is essentially more or less dialectically oriented. Historically conditioned attitudes are at most more unmistakably involved in dialectical antinomies, their conflict and their reconciliation, than thinking, which is related to practice and critically established action in general. Not all happening, however, is historical and dialectical; much of it moves simply in a continuous, discursive direction which merely differentiates the earlier point of view. Dialectic, too, does not even extend to the whole area of what is historical. There are stages of development which are not dialectical in nature and which lead to constellations in which the possibilities which open up do not contradict one another, but ramify and permit us to make a choice between more than two alternatives. Nevertheless, dialectic remains a fundamental form of the historical process. It may not always express the possibilities which are to be chosen from as antinomies, but a development of decisive significance takes place only when such antinomies force us to take a position and move forward.

<div style="text-align: center">

Arnold Hauser
March 1974

</div>

Part One Fundamentals

1

The Totality of Life
and the Totality of Art

What is here understood by the totality of life is that immediate relation of sense and being in which, with all his inclinations and tendencies, his interests and endeavors, man is involved. Such a totality is encountered twice in the whole field of human activity, once in the motley, turbid, irresoluble complex of ordinary everyday existence and once in the single homogeneous forms of art, all of which are reduced to one common denominator. In the other relationships—social, moral, and scientific forms of organization and objectivization—life loses the character of totality, its context of continuity, and its concrete, sensually immediate nature which is qualitatively unmistakable in all its manifestations. Compared with the uninterrupted continuity of everyday, undifferentiated, and unregulated life or with the concrete sensuousness and the self-sufficing immanence of art, such forms always produce the effect of being more or less incomplete and abstract, removed from the living being and his personal experiences.

Even for the simplest everyday tasks, normal practice borrows numerous concepts of order and measures of value from the abstract systems by which reality is organized scientifically, socially, and morally, and, in the course of time, these borrowings tend to multiply. The concrete, heterogeneous, and atomized stuff of the experience of normal practice shows on every side traces of abstraction, generalization, and typification of forms of thought; in spite, however, of the intrusion of these principles which are foreign to life, it manages to preserve the heterogeneous and rhapsodic singularity of its original form and opposes regulation and systematization. It represents a many-sided complex in which concrete and spontaneous elements always predominate, but from which the abstract and reflective are never

3

entirely absent. Of all the forms of consciousness, art is the only one that from the very outset opposes every desensitizing abstraction. Art rejects everything that is mere thought, mere system and generalization, pure ideal or intellect and strives to be the object of immediate vision, unmitigated sensual impressions, and concrete experiences.

Art forms the substratum of normative aesthetic behavior just as long as it remains related to the totality of concrete, practical, and undivided life, as long as it is the vehicle of expression and the medium of empathy for the "whole person," and as long as it can embrace the sum of experience, which results from existential practice and remains capable of including all these in the homogeneous forms of its statements. The true aesthetic phenomenon is the whole human experience of the totality of life—the dynamic process in which the creative or the receptive subject is at one with the world, with the real life which is actually lived. It is not the objective, objectivized work of art which divorces itself from the subject. The latter can be observed, interpreted, and evaluated for itself, whereas the former only acquires significance and value in conjunction with the totality of life. Only such an experience, linked to his being and involved in the whole of his existence, can be of true emotional value to the individual and have a life-shaping, life-enhancing quality. The work of art in itself—the artistic product as a closed formal system—atually represents a break in the living aesthetic process, and this is unavoidable the moment the objective basis of experience is torn from the context of sense and value and is removed from the function which has been determined as its role in the life of the individual. In this self-sufficiency and isolation the work of art becomes a useless toy, no matter how charming it may be, and is bound to lose its humanistic meaning, no matter how appealing.

Art reflects reality most fully in the liveliest manner and most penetratingly when it sticks to its most manifest characteristics. To the extent that it rejects these, its representations lose their immediate evocative power. Its exhaustive microcosmic quality is achieved only by immediate penetration and not by the unending plenitude of its characteristics. The concept of "intensive totality" is the most telling designation of the saturated sensuality and the absolute entirety with which art, thanks to its "limitation to the actual," can penetrate to the heart of the matter rather than staying on the surface. The totality of art is not the sum of its parts; it is inherent in every part. The individual forces of a work of art are of the same nature as its totality and unity; each of them is saturated with the life with which the structure as a whole is filled. Thus, while science nowhere and at no time exhausts the "extensive totality" which it pursues, art everywhere achieves its goal. Its totality is conditioned neither by the number nor by the

variety of the characteristics of reality it reflects. Thus, it is not true of the work of art that nothing can be taken away from or added to its component parts but, rather, that, whatever changes or truncation may be made, the work is able to retain its total vitality and its inner unity and remain complete and self-contained after its own fashion.

The most important insight into art from the point of view of the sociology of art is one based on the fact that all our thoughts, feelings, and will are directed toward one and the same reality—that, basically, we are always faced with the same facts, questions, and difficulties and are striving with all our power and ability to solve the problems of a unified and undivided existence. Whatever we undertake and in whatever form we do it, we are always trying to understand better a reality which is, to all intents and purposes, chaotic, enigmatic, and often threatening, to judge it more accurately and cope with it more successfully. All our efforts revolve around this goal, and our success in life is dependent, in the first place, on the accuracy of our judgment of the conditions of existence and our evaluation of the problems it poses. We try in art, as we do in normal practice and in the individual sciences, to discover the nature of the world with which we have to deal and how we may best survive in it. Works of art are deposits of experiences and are directed, like all cultural achievements, toward practical ends. It is only when special efforts are made and in special sociohistorical conditions that art can be torn from the existential relationship in which it is rooted. Only in special circumstances can it be separated from the general practice and noesis with which it has coalesced. Then it may be judged and carried on as an independent activity having its own laws and values. It is by no means so radically separated from practical experience and theoretical understanding as we are prone to assume. Both art and science are concerned with the solution of problems which arise from the tasks, the sorrows, and the necessities of life and which revolve around the struggle for existence; thus, they form a firm and, in the last resort, indissoluble element.

Art is a source of knowledge not only because it immediately continues the work of the sciences and completes their discoveries, especially in psychology, but also because it points out the limits of scientific competence and takes over at the point at which further knowledge can be acquired only along paths which cannot be trodden outside of art. Through art we come to understandings which expand our knowledge even though they are not of an abstract-scientific nature. Although, for example, the elucidation of spatial relationships or of stereometric forms by painting is not always valid, as far as the nature of the visual is concerned it does contain information that far transcends the significance of the theory of central perspective or of

the three-dimensional structure of objects. The findings of art about phenomena which, because of the lack of means, science can so far only investigate are particularly important. Artistic intuition has insights which can serve as signposts for scientific investigation. This was no doubt what Marx had in mind when he declared that he had learned more about the history of modern France from the works of Balzac than he had from all the history books of his time. Of course, it was not historical facts that he was thinking about but the analysis of the postrevolutionary social process and the interpretation of the modern class struggle which contemporary historical and social science did not properly understand—and for which it had no suitable conceptual apparatus. Balzac on the other hand recognized in historical facts forces and laws of motion which were only later to be formulated and explained scientifically. Thus it was that the beginnings of the modern novel and the foundation of sociology in the modern sense coincided and art and science spoke the same language, a proof that the wildest imaginings of a real artist can never be too audacious and always contain at least a grain of truth.

Nothing is more evident than that art, as art, begins at the point where it deviates from the pure truth of science. It does not begin as science and does not end as it, either. Rather, it is born in the beginnings of knowledge and speculation and out of the needs of life and finds itself side by side with science on the same endless path interpreting and guiding human existence, but while the work of art, as a form, always reaches its goal, art as doctrine and knowledge never does.

Art and science are most closely connected in that both of them, of all intellectual structures, are *mimesis*, the imitation of reality. The others transform phenomena more or less consciously and as a matter of principle, and subject them to alien forms, principles of ordering, and measures of value. Of course, art, too, transforms, stylizes, and idealizes reality, just as even the most exact science imposes upon reality its own spontaneous creative categories. Both of them, however, stay tied to objective realities, the authoritative facts of normal vital practice. In this sense, art is just as realistic as science. Naturally this does not mean that there is an absence of any sort of tension between artistic vision and empirical reality or that the distance between the creative subject and objective facts is denied. It merely means that it is a law that—however stylized, fantastic, or absurd the structure may be as a whole—the elements from which a work of art is put together derive from the world of experience and not from a supersensual, supernatural world of ideas. It is a well-known fact that Balzac himself, who as the first classical writer of naturalist novels and the true authority on artistic realism in the sense in which Marx and Engels meant

it, often depicts sheer fictions to replace observation and invents characters, physiognomies, landscapes, and interiors he claims to have observed in real life. Nevertheless his method serves Engels as a paradigm for the "triumph of Realism" and as a typical example of the "cunning" with the help of which truth penetrates art by the back door, when every other entry is barred to it.

The different forms of objectivity create individual reflections of reality which are irreducible and incomparable the one with the other. It would be wrong to perceive in the one—say, in the scientific reflection of reality a more faithful representation of facts than in the others, which would then be explained as more or less capricious deviation from objective reality. The scientific conception of the world is not closer to reality than the artistic one, and art itself, as a matter of principle, sets itself no farther apart from reality than science. If, however, we overlook the constitutive role of the discerning subject categories in scientific knowledge, we tend to overestimate the creative and underestimate the mimetic element in art. Consciousness in all its objectivizations faces an independent reality of which, however, it remains completely independent. Yet there is no form of consciousness in which reality remains free of "categories." Even where it is possible to speak of a relatively extensive freedom in one form as compared to another, we are speaking of morality and law rather than art. In spite of all the fantasy and extravagance which it allows, art is just as indissolubly bound to reality as is science, although in a different way; its structures are always built of the bricks of reality, even if their plan is removed from reality. As Brecht says (in *Ueber Lyrik*), "Nothing prevents Cervantes and Swift, realists that they are, from seeing knights joust with windmills and horses found states." In every effort to free the subject from the routine of everyday life and permit his self-realization in a world of unfettered utopianism, art has an insatiable need for naked facts, immediate experience, and pure vital expression.

Nothing is more significant for the role realism has played in art than that turning point in the genesis of Proust's *A la recherche du temps perdu* which the author believes responsible for the whole work. It happened when, after years of helpless meandering and searching, he discovered what he calls the "reality of literature" and suddenly grew conscious of his ability to seize and hold fast to this reality. Basically it is a question of the discovery and recording of very simple, but extremely vital, impressions which are disturbing because of their sensual importunacy and their conceptual incomprehensibility. They were impressions which he had encountered as a very young man and which had always evoked in him the feeling, at once disturbing and gratifying, that he had experienced something indescribable. He had

a sense of having participated in something precious, which was to be preserved at all costs, an experience for which he would have to account and in the appreciation and depiction of which he saw the whole meaning and goal of his existence. He wanted to write, for he knew that he was good for nothing else and he felt that essentially what was involved was to describe and discover things like the line of trees, which he had once seen at Hudimésnil near Balbic, the line of church spires of Martinville, whose perspective he had observed on a carriage trip and—as the most remarkable of all the experiences—the taste of a madeleine dunked in a cup of tea. It was a question, too, of finding out where the endless sense of well-being came from which was connected with this taste and with what discarded memories, with what hidden reality, it must be pregnant so as to seem so promising and significant. Years of darkness followed upon the period in which he had these lightning flashes of "unwished-for memory," years of forgetting, of the "suspension of feeling," of questing and asking without receiving an answer, years of muted, senseless, and aimless suffering. Then suddenly a door, on which he had previously knocked a thousand times in vain, opened as if of its own accord. He was suddenly flooded with the fullness of being, overpowered by the reality of things. He was overcome by the shock that the unequal heights of two paving stones could conjure up a memory of Venice, the pavement in the baptistery of Saint Mark's, of how the sound of a spoon falling on a plate recalled the sound of a wheel-tapper's hammer on the railway and with it memories of distant stations through which he had traveled long years before. The touch of a napkin reminds him of stiffness of the weave of a hand towel he had used years before in a seaside hotel, a memory filled with such penetrating reality that it opens up a view of the same sparkling greenish blue sea which had lain before him at that time. Now he is what he had vainly tried to be in the past, an artist who has been given the indescribable good fortune of being able to possess reality and preserve it.

What more could be said of this favorable reality than that it is so real, so "actual"? Goethe's word expresses the qualitatively irreducible and stylistically indifferent nature of the "realism" which is aimed at this reality most tersely and impressively. The most important works of all the great masters, epochs, and people—Homer and Dante, Shakespeare and Cervantes, Rubens and Rembrandt, Stendhal and Balzac, Dostoevski and Tolstoy, Cézanne and van Gogh—are all "realistic" in the same sense: they are thirsty for and drunk with reality. When Cézanne[1] and Proust[2] use the same word *réaliser* to describe the aims and the methods of art, they are both thinking of realism, that act of realization we are talking about here. They never manage to say

anything more precise about it. It is true that Proust probably tends to attribute a Platonic substantiality and ideal to the reality he is seeking, but his obscure Platonism bears no relation to his actual artistic goals or to the true character of his art. The reality he tries to wrest from the "lost time" has nothing to do with a more substantial existence, with higher truths or purer ideas. It forms the content of completely concrete, individual experiences which are placed into a unique perspective. The endless difficulty of lifting the veil which these experiences have in the course of time put on tempts him to imagine that he is engaged in working out a deeper, more essential being. It was in fact a question, as it is in every work of art, of freeing comprehensible, sensually immediate phenomena, which have been experienced in their qualitative peculiarity, from all that is abstract, universal, and ideal, from all timelessness and worldlessness. Artistic creation is not the fight for the display of "ideas" but a struggle against the concealment of things by ideas, essences, and universals. Plato knew very well why he banned poets from his republic.

As one master of language tried to explain to a young writer, art is concerned first and foremost with the clear, harsh, unabridged sensual impression. The writer, in his view, should write so that the reader can hear the coin which has been tossed to the hurdy-gurdy man from the window land upon the sidewalk. Proust, for all his latent Platonism, certainly knew this. Does not his Bergotte say of Vermeer's *View of Delft,* "Yes, that's the way to write, just as the master painted, just as this wall lit by the afternoon sun is painted"? Every great realist has thought in the same sober and objective way and has observed things with the same impartiality and incorruptibility, from Homer, whose Telemachus speaks of his father, Odysseus, who is believed to be dead, as a stranger whose "White skeleton is decaying in the rain somewhere on the dark strand," and Balzac, who says no more of the dead Lucien de Rubempré than that he dangled, like a coat which has been thrown over a hook, from the bars of the window on which he has hanged himself. The naturalism of which we are here talking should not be understood as the art of the *petits faits vrais,* but as that art with which Balzac, for example, expresses the fact that even Eugénie Grandet is also a "Grandet." The description of her mode of life after her father's death is one of the greatest triumphs of this great tragic art, and it remains so in spite of all the other "petty traits." The old miser destroyed the happiness of his daughter by preventing her from marrying a poor cousin whom she loved passionately. His tyranny, which is expressed in regulations such as forbidding the heating of the house between the middle of March and the end of October, is scarcely worth considering beside such cruelty. It merely serves to bring more vividly

to the reader's consciousness the frosty, stifling atmosphere which surrounds him. The relationship between him and his daughter, for all its apparently unquestioning authority and humility, is an undeclared, but ceaseless, life-and-death struggle. Not only is the inhuman creature ready to sacrifice at any moment his only child, his daughter, for an ounce of gold, but even the patient and subjugated Eugénie is at one point close to murdering the old man. This is at the moment when, apparently mad, he wishes for the sake of its small gold frame to snatch from her the portrait of her beloved which she has secretly kept. After all this, when she is left unhappy and bewildered, as always, with an inheritance of a million francs, she still does not heat the house between the middle of March and the end of October, however cold the weather. It is not because she wants to save money, but simply because the blood of Grandet is stronger than Eugénie the individual.

Orthodox Marxist criticism of art ascribes an excessive significance to the differentiation of realism and naturalism. It is, in fact, at best a question of difference of degree. What is generally understood by naturalism (as opposed to realism) is simply bad, scientific, and thus artistically inadequate realism. In the history of art the boundaries between realism and naturalism are fluid, if not actually misleading, and it is pointless to distinguish between the two. They both represent for the most part a movement which is opposed to what is classical, formalistic, and strictly stylized and which is unified, freer, and more closely related to the reality of experience. It is certainly more expedient to define the whole realist-naturalist trend as *naturalism*, as the history of fine art does, and keep the term *realism* to designate a common view of the world which is opposed to the irrationalism and idealism of the romantics. In this way naturalism remains a term for a purely artistic style and an unequivocally aesthetic category. Realism, which if seen as a style only complicates the conceptual formations of the history of style and presents the criticism of art with a pseudoproblem, is the attribute of a philosophical outlook.

The earliest known artistic creations, the cave paintings of the Paleolithic period, are the original and prototypical images of all artistic activity. They represent the means of a practicality which was concerned with the support of life, and they stem from primitive hunters who lived in a world governed by purely practical interests adapting themselves to conditions in which all their energies were put into the acquisition of food. Their artistic productions were the instruments of a sober, goal-oriented technique, and portrayed a trap into which the game to be hunted and killed had to fall if the magic ideal were sufficiently true to nature. Their creations do not rely upon a symbolic, religious, or aesthetic act, nor upon one which is either frivolous

imitation or depicts a sacrifice, but on a simple undisguised practical activity in which there could be virtually no question of anything like decorative effect or pure functionless beauty. The latter is at best a by-product of the magic practice which was aimed solely at the utilitarian. No matter how close the Paleolithic animal drawings were to the early and no longer identifiable forms of art, they can scarcely have been identical with them. Be that as it may, they represent the prototypes of the artistic reflection of reality, which, even in the case of the most extreme detachment, is never without point or function.

The specific structure of mental attitudes, their autonomy and their inherent qualities, the peculiar categorical structure of scientific knowledge, of moral evaluation, or of artistic creation are both historically and psychologically of secondary significance. What is of primary importance in a practical sense is their juxtaposition, their common participation in the human endeavor to come to terms with reality and survive in the struggle for existence. Art, especially, however playful and unconcerned, fantastic, and extravagant it may be, serves not only indirectly, by honing the sense of reality, but also directly as an instrument of magic, ritual, and propaganda, in the creation of weapons for the struggle for existence. Far from using art as a respite from the struggle, people set the most dangerous traps for their enemies and competitors under the guise of peaceful intentions. They are contriving most deadly instruments of warfare just when they seem to be resting most peacefully. Peace and harmony may be by-products of art, but they are seldom among its sources. Deceit and infatuation, surprise and subjugation, are the weapons art takes up more often than friendly persuasion and peaceful conversion. It frequently achieves only an armistice between two campaigns, a breathing space in which to recoup its powers, and it acts only as a narcotic, an opiate, to tranquilize the spirits and to disperse all suspicion.

Art is always concerned with altering life. Without the feeling that the world is, as van Gogh said, "an unfinished sketch" there would be little art at all. Art is by no means the product of a purely contemplative attitude which simply accepts things as they are or passively submits to them. It is rather a means of taking possession of the world by force or cunning, of achieving hegemony over people by love or hatred, and of seizing the victims who have been overpowered either directly or indirectly. Paleolithic man depicted animals in order to hunt, capture, and kill them. In the same way children's drawings do not present a "disinterested" view of reality; they, too, pursue a sort of magic purpose, express love and hatred, and serve as a way of gaining power over the person depicted. We may, then, use art as a means of subsistence, as a weapon in the struggle, as a vehicle for the

dissipation of aggressive drives or as a sedative which will allay destructive and mutilating desires. We may use it to correct the incomplete nature of things and demonstrate against its gloomy and lackluster character and against its senselessness and aimlessness. No matter what the reason, art remains realistic and activist, and it is only in exceptional cases that it expresses a disinterested or neutral attitude toward questions of practice.

The outlook of a sociohistorically homogeneous group is indivisible. The attempt to separate the different areas of the group's culture from one another, however seductive and rewarding this may be from the point of view of a structural analysis or a theory of cognition, is certainly not unobjectionable from a sociological viewpoint. Economy, law, morality, science, and art are only different forces or aspects of an essentially unified attitude toward reality. It is not essentially a question either of determining scientific truths or of creating works of art, indeed not even of evolving and formulating rules for the moral life, but simply of shaping an outlook which has as its function the acquisition of directives which can be relied upon in practice. People undertake in the form of culture the struggle against the bewildering disorder and the crippling anarchy of existence, not when they have acquired their livelihood but usually in order to assure it. The mastery of the chaos which threatens on all sides, by dominion, religion, morals, knowledge, and art, is one of the presuppositions for a sense of security and thus for success in the struggle for existence.

Science may be more universal, more objective, and more autonomous than art, and it may be more independent of the interests of society, which alter according to the given historical situation; nevertheless, it, too, originates in social needs and its limits and guiding principles are set by class interests. Objectivity, impartiality, and lack of assumptions are part of its ideal, no matter how far it succeeds in realizing them. Neutrality and lack of prejudice are on the other hand not even the ideal aims of art, however slight the practical intent may be with which they are pursued, nor are they, in principle, the presuppositions of artistic success. Partiality and prejudice best characterize the reaction of the artist to the impressions and challenges he experiences. The scientifically oriented cognitive subject must reject the chance, individually variable characteristics of the ordinary man involved in everyday life. Only in this way can he perform the objective, normative, and exemplary act of cognition, freed from ephemeral psychological impulses and contingent individual motives. On the other hand these unique circumstances, which vary according to time and place, are one source of the originality and individuality of the creative artist's mode of expression. It is to them, too, that he owes

the increase in knowledge which the world of ideas and images gains through his work. The personal partiality and the prejudice which arises from the assumption of a certain standpoint, the perspective which is constantly changing, whether psychologically or ideologically, are for the artist the source of ever new and unexpected experiences, of individual, incommensurable, and indispensable perceptions. In this way his personality does not first need to be desubjectivized and de-natured in order to achieve significance for others: on the contrary, the more subjective and peculiar its characteristics, the more artistically significant it is.

Because of their mimetic nature, art and science are the closest of all structures of meaning. They are most sharply distinguished from one another by the fact that art reveals the most characteristics which are anthropomorphically, physiologically, and psychologically linked with human nature, whereas science shows the fewest of these char-acteristics. Science presupposes as a subject an abstract, colorless, so to speak transparent consciousness; art, in contrast, is linked to man *qua* man, to the individual as a peculiar being who is incomparable because of his unrepeatable combination of dispositions and tendencies.

Since the Renaissance and in line with the progressive division of labor and specialization, the philosophical interpretation of attitudes and achievements has been more and more exclusively dominated by the idea of autonomy and immanence. Toward the end of the last century, when analyzing attitudes toward reality, people thought, es-pecially in the case of art and science, that they should proceed from their individuality and isolation and believed that they could discover in each a sort of valid truth or binding value, a fundamental type of independent and not mutually interchangeable form and norm. The higher the rank ascribed to the individual categories, the more uncon-ditional appeared the autonomy of their constitutive principles and of the values which determined them. Of all systems the most complete sovereignty had been claimed for the aesthetic, at least since the days of romanticism. Art was supposed, according to what was taught and believed, to have nothing to do with good and evil, truth or falsity, or what was politically desirable or reprehensible. Even as realistic and allegedly rationalistic a doctrine as psychoanalysis, true to its romantic heritage, played a part in the separation of art from the rest of reality, from the totality of normal life.

Freud saw in art, as in neurosis, a failure to fit in with reality. The artist alienates himself from the world, he maintained, in consequence of an inability to control his asocial urges. He creates for himself, in the unreal sphere of art, a compensation for the place which he lacks

in society. The artist leads an existence which is just as alienated from reality as that of the neurotic in his separate realm of sickness. Freud spoke in both cases of a "loss of reality," with the difference that the neurotic, in his view, does not deny reality but merely forgets it; the artist on the other hand denies it and replaces it by a fiction—he is thus closer to psychosis than neurosis. Freud did, however, grant that the artist, in contrast to the neurotic and the psychotic, could always start "back to nature." In other words he was not the victim of an obstinate illusionism but preserved, in spite of his alienation from reality, a certain flexibility of spirit which allowed him to alter his distance from facts, to loosen or tighten his relationship to them, and once more to assume immediate contact with them.

This flexibility is one of the more characteristic signs of the artistic attitude. It reveals itself as a continuing change in the erection and dismantlement of simulation and self-deception and brings in its train a constant fluctuation in the relationship of illusion and reality, of poetry and truth, and of the acceptance or rejection of facts. However, Freud emphasized the interrupted relationship of the artist to reality too strongly in order to do justice to his original harnomy with it. The exaggerated significance he ascribed to anomaly was above all the result of the ahistorical nature of his doctrine. The alienation of the artist, which he stressed in spite of his assumption of a possible "return to reality," was at one with the particular historical situation in which he and his generation found themselves, and had nothing to do with a universal biological law as he assumed. His concept of alienation was itself historically conditioned, and without the romantics, with whom his doctrine was most closely associated, it would certainly have taken a different form.

The longest periods of history knew only artistic activities which were concerned with practicality and which aimed at instant success: it would be senseless to talk of them in terms of alienation and loss of reality. The concept of art as a substitute satisfaction and as a compensation for something more real, valuable, but more inaccessible was unknown before the romantics. Art may have represented wish-fulfillment and fantasies which went beyond the everyday world; it was not a substitute which would have been accepted in exchange for real life. As a form of "flight to sickness" the idea of a flight from reality into a fictive world was completely alien to the preromantic view of art. It is only the romantics who make the transcending of normal reality into a presupposition of artistic creation and its rejection into a condition for artistic success, which they then start to contrast with external success. From then on art is not merely a compensation for what has been missed in life; it only has value and meaning for those

who have missed the chance to possess and enjoy life. It has become the legend of a life from which people feel themselves exiled. It is merely a symbol and no longer a likeness. The poet talks only of what he is *not* and what he lacks. Love, faith and heroism, said Flaubert, can be depicted only if you are not a lover, a saint, or a hero. Anyone who is one of these three has little interest in talking about his nature, his love, and his passion. Only someone who is a failure in life is anxious to do this, someone who cannot be what he would like to be and has to make the best of portraying people whose life he cannot lead.

The consciousness most recent generations have of their own social status and its implications has given rise to the artistic crisis which has emerged sinced romanticism and the promulgation of the doctrine of *l'art pour l'art*. It is a crisis in which art has removed itself further and further from practical interests, moral considerations, and scientific points of view and is merely a sociohistorical phenomenon, a symptom of the progressive specialization and atomization of the vital tasks. As a result, it has been seen that the assumption of the isolated existence of art is untenable within a unified life, which is for all practical purposes indivisible and which allows no break in its view of the world. The idea that art and science concern themselves with two different types of experience is nevertheless obstinately persistent. However, the belief that in art we can take a final farewell from normal life, its interests, and its cares finds less and less resonance. With the understanding that man lives an essentially social existence, sociology has moved into the center of scientific thought; it has become a central science and has taken over within the cultural system the integrating function which previously belonged to philosophy and religion. Art has this new orientation to thank for the growing consciousness that it enjoys a unity with the rest of the cultural structures.

The sociological reflection upon the unified origin and the mutual dependence of intellectual attitudes, and the attendant breakup of the autonomy of artistic criteria of taste, scientific concepts of truth, and moral measures of value represents a late stage of development in the history of culture. Yet it was not originally debilitation and denial but the discovery of and emphasis upon autonomy of values that were the result of a lengthy development, and the close of a long historical period, an era in which people apparently did not consider at all the possibility of a number of different attitudes toward reality and the inner laws of the conceptual forms, modes of thought, and evaluation which corresponded to them. If, however, we wish to follow precisely the process which resulted in the modern state of consciousness which at first rigidly separated the attitudes and then reunited them, we must

go still further back into the prehistory of sociological self-consideration. The gradual differentiation of individual attitudes from one another and from the complex of the undifferentiated practice of life must have demanded an immeasurable length of time and must have occurred long before the idea of their independence was formulated. The separation of productive labor from magic, of science from religion, of law from morals, of artistic invention from mere invocation for the sake of magic, animistic, or ritualistic purposes was doubtless a process which spread over most of the early history of culture. The development presumably groped forward hesitatingly, taking a few progressive and many regressive steps. Even the progressive stages of development were probably not immediately recognizable as such, and a stage which had been newly reached was certainly not distinguishable at a single glance from the preceding one. It must have been part of the nature of the artistic activity which arose from the needs of practical everyday existence—and this is the case with every function that slowly separates and makes itself independent of the unified practice of life— that it at first appeared more or less blurred, inarticulate, and undefined and that its products only slowly differentiated themselves from other creations. The earliest artistic products must not have seemed "artistic" to the people of the time. We ourselves, if we were to see them, would scarcely recognize them as works of art. They would certainly be so similar to other products made for other practical purposes that we would not be in a position to draw a clear line between what was "not yet" and what was "already" artistic.

The lack of differentiation of these primitive relationships has little in common with the integration of attitudes and achievements which could only come about after the differentiation and specialization had been completed. The sociological self-consideration, which makes us conscious of the unified origin and the common aim of the various attitudes and functions, naturally implies no simple return to the primitive unity of interests and the undeveloped means of satisfying them. Sociology only "puts into brackets" the individuality and the inner laws which govern different human attitudes. It ignores them when it recognizes in the autonomy of the individual areas of consciousness, of practice and theory, of law and morals, of science and art, merely a working hypothesis for the theory of cognition, of structural analysis, and of specialized cultural activity. However, sociology does not suspend the actual difference of the cultural functions by putting the overvalued autonomies into brackets or disregarding them entirely, nor does it deny the possibility and the productivity of concentrating consciousness on particular goals. To ignore the fact that people are basically struggling with the solution of identical and closely related

tasks leads to a completely false concept of the nature of their needs and the means which serve to satisfy them. But the neglect of the circumstance that their formerly so simple and unified life has given place to a system of products which is infinitely complicated and which can function only within this complexity of relationships has just as misleading an effect and can render nugatory every successful work of culture. To ignore the role which the unity and totality of society plays in all human endeavor makes life and culture senseless. At the same time the underestimation of the degree to which tasks have become specialized and the renunciation of the ramifications and the refinement of working methods would also be a regression, one from which no direct progress would be possible.

Spontaneity and Convention

The claim of the sociology of art to be a true science revolves around the concept of spontaneity. Its competence depends upon the role we ascribe to the subjective impulse in artistic creativity. The question is whether we understand the creative process as an attitude which rests upon drive, talent, and inclination, and which cannot essentially be reduced to external inspiration, or as a process which is for the most part independent but conditioned by interpersonal relationships. If we consider the artistic process to be essentially spontaneous, autonomous, and autogenous, then it is clearly absurd to ascribe a special meaning to the circumstances attendant upon its accomplishment. Idealists and romantics, for whom the work of art is something which simply pours out the soul and which remains in the final analysis concerned only with itself, see in the sociology of art nothing but a series of pseudoproblems and false conclusions, and this is perfectly right from their point of view. Their sharpest objection to the sociological point of view stems from a belief in the spontaneous and divinely inspired nature of artistic creation and from a feeling that the miracle of the creative act would be damaged in every case in which there was mediation between the genius and his work. Anything which intervenes, they feel, and which interrupts their secret and immediate contact would change the mystery of what they regard as an "immaculate conception" into a complicated process placing demands upon the most widely diverse profane forces.

It is not always a prejudice against sociology which lies at the base of reservations of this sort. Every attempt to derive the work of art from a heterogeneous principle which lies beyond the spheres will probably meet the same resistance from an idealism which insists upon

the immanence of the spirit and the autonomy of its order of values. Even the pursuit of the psychological origin of the artistic impulse and the progress of the spiritual processes which play their part in the process of creation can be regarded as misleading and confusing. For we shall, if we operate within the limits of psychology, overstep the bounds of aesthetics in the strict sense and destroy the myth that something can be created from nothing, which is what the concept of spontaneity amounts to.

The idea of "inspiration," too, rests upon a similar mythic idea; here the alleged irrationality and the lack of social relevance of artistic creativity are more strongly emphasized and the origin of the idea of unselfish spontaneity which derives from Bacchic and Platonic *enthusiasm* is more apparent. The terms *spontaneity* and *inspiration,* however, often embrace concepts which both agree and disagree with each other. Inspiration is sometimes described as the secret origin of an idea for which there appears to be no external cause, sometimes as the effect of a purely external and coincidental happening, or of an experience which is of no consequence in itself but to which the artist relates the genesis of his work in a causal, though hidden, way.

The actual connection between the inner impulse and the opportunity afforded for its actualization and objectivization is for the most part obscure and even puzzling to the artist himself. He will often idealize and dramatize the happening to which he is able to attribute the genesis of his work, and will ascribe a greater importance to the occurrence than is its due. He will also invent for a work a cause which seems sufficiently suitable and impressive. It is well known that Beethoven makes a connection between the *Eroica* and the fate of Napoleon and that Mendelssohn connects the *Hebrides* Overture with a memorable experience of nature. Liszt, too, connects the genesis of many of his compositions with similar reminiscences. The young composer in Richard Strauss's *Ariadne* maintains that the theme of Bacchus's great aria occurred to him in the course of the excitement which surrounded the preparations for his opera when he was annoyed with an impudent lackey and the tenor had just boxed the barber's ears. What makes this little episode so charming is the manner in which the incompatibility of cause and event, which in most accounts of the genesis of works of art is veiled or embellished, is here so impudently stated. Franz Lachner's story of a visit to Schubert is similar. Schubert, we are told, had at the moment no desire to work and was happy to be distracted.

"Come on, let's have a cup of coffee," Schubert suggested, and got out his old coffee-mill. Suddenly he exclaimed, "I've got it! I've got it! you rusty old machine," and threw the coffee-mill into a corner.

"What have you got, Franz?" asked Lachner. "A coffee-mill like that's really magnificent. The melodies and the themes simply come flying in. Don't you see? This ra-ra-ra inspires me and transports us into the wonderful realm of the imagination." "Oh, so it's your coffee-mill that composes and not your head?" "Quite right, Franz," cried Schubert, "my head will go on looking for a motif for days on end but that little machine comes up with it in a second. Listen!" They were the themes for the String Quartet in D Minor.[3]

It is obvious that nothing will come of nothing and that everything which exists goes back to prior existence, that the explanation of artistic creativity as an act which is spontaneously based upon itself actually explains nothing and makes of the genesis of a work of art a mystery similar to the biblical version of the genesis of the world. On the other hand there can also be no doubt that artistic creativity remains in part underivable and preserves spontaneous elements which can only be described as autogenous, since "underivable" and "spontaneous" are in this connection interchangeable concepts for discursive thought. Although extraartistic stimuli are of decisive importance for it, a work of art can still as a whole only be explained as a product of antithetical facts, both extraartistic—deriving from objective, material, and social reality—and innerartistic—formal, spontaneous, and completely creative acts of consciousness. The role of artistic spontaneity cannot be minimized no matter how far-reaching the influence of externally derived motifs. The contrast between spontaneity and causality which cannot be brought into harmony, the dualism of a subjective and an objective or of an active and an inert principle, is the basic formula for artistic creativity, as it is of every conscious attitude toward reality. Even if neither complete sovereignty nor totally passive, purely mechanical causality is decisive in the process of mirroring reality, there are different degrees of freedom, and in art the spontaneous element comes more to the front, even if it is perhaps no more valid here than elsewhere.

Just as we cannot conceive of a consciousness as such, but only a consciousness of something, a consciousness of a being, so it is impossible to imagine a free-floating, self-propelled, self-igniting artistic spontaneity. We can only think of one which is affected, conditioned, and limited by a material reality foreign to it. We only arrive at the concept of spontaneity as an open, unfettered, unprejudiced preparedness by way of speculation and abstraction. We never come across it directly, immediately, and untrammeled: we can only reach a conclusion about what it may be through conceptual analysis. As an independent faculty, it is a pure fiction: in reality we become aware of it only as an act of functioning as it struggles against an alien, inert

principle. It has to find a foundation in order to assume an objective and, in one way or another, tangible and definable form so that it can stand out and be actualized. The opposition it meets in asserting itself is a double one. It consists in part of the facts of experience, which are the material of artistic representation, in part of the conventions of communication, which serve as the vehicle of representation.

Every new experience, every new impulse to communicate meets with obstacles in the process of expression, and at least a part of its originality, its immediacy, and its liveliness is sacrificed to these obstacles. The imparting of something which is utterly ineffable, which is the expression of spontaneity, is achieved only at the price of accepting a more or less colorless cliché. It would be absurd to expect the traditional and conventional forms which the artist has at his disposal—and to which, for the sake of indirectness, he has to fit every new experience and every new impulse—to remain unchanged. In the same way it would be absurd to expect every new spiritual content to create spontaneously, of its own accord and using its own means, a form of expression which would suit whatever the experience of the moment might be. It is true that expression always moves on well-worn tracks, but the tracks multiply and bifurcate as they are being traveled. The means and modes of expression which obstruct a person's power to communicate at the same time loosen his tongue: the experience which at a given moment has to fit the available forms shatters them at the same time.

The process is dialectical. Spontaneity and resistance, invention and convention: dynamic impulses born of experience break down or expand forms, and fixed, inert, stable forms condition, obstruct, and enhance each other. It is the riddle of Kant's pigeon—the atmospheric pressure which seems to hinder its flight is what makes it possible. Artistic expression comes about not in spite of, but thanks to, the resistance which convention offers to it. The artist must possess a formal language which is not too flexible so that others will understand him and so that he can understand himself. He must stick to a relatively simple grammar and a standardized dictionary, not only to avoid unusual and complicated ideas, but to conceive of them at all. Indeed, in communicating with himself he uses a language full of conventional forms. To be sure, it is part of the dialectical nature of the process that the artist while appropriating and using the given language simultaneously prevents it from growing rigid and attenuated. This is a striking example of Hegel's *Aufhebung:* a simultaneous erection and destruction of valid conventions, symbols, schemata without which no understanding is possible, but which in their hypertrophy reach a sort

of standstill where nothing is left but a game with empty syntactic forms.

Robert Musil gives an excellent description of the creative act, of its noninspirational nature, of the bewildered feelings with which the author confronts his own work as something foreign to him and of the impersonal but not superpersonal forces which play their part in the making of the work.

"There is unfortunately nothing so difficult to represent in literature," he says, "as a thinking person. A great inventor when asked how he arranged to have so many new things occur to him once answered, 'I was constantly in the process of thinking about them.' In fact, one may well say that unexpected ideas present themselves simply because they are expected. They are in no small degree a result of character, of steadfast disposition, enduring ambition, and constant activity. How boring such persistence must be! From another point of view the solution of an intellectual problem comes about in no very different manner from that of a dog who is carrying a stick in its mouth and wants to pass through a narrow doorway. He turns his head left and right long enough for the stick to slip through, and we do something very similar, with the one difference that we do not go at it indiscriminately, but know more or less by experience how it is to be done. Even so a clever person, with, of course, far greater skill and experience in making the turns back and forth than a stupid one, will still be surprised when the stick slips through. It is suddenly there, and we can perceive quite clearly in ourselves a slightly bewildered feeling that the thoughts generated themselves without waiting for their originator. Nowadays many people call this feeling of bewilderment *intuition*, when they had previously called it *inspiration*, and believe that they have to regard it as superpersonal. It is in fact only impersonal, that is to say, the affinity and the congruity of the things themselves meet in one person's head.

"The better the head, the less obvious it will be in the process. For this reason, thought, as long as it is incomplete, is actually a miserable state, like a colic of all the cerebral grooves. When it is complete, it is no longer as thought that we experience it, but as what has been thought, and that is, alas, an impersonal form, for the thought has been turned outward and is directed at communicating with the whole world. When someone is thinking, we cannot, so to speak, grasp the interaction between the personal and the impersonal. What is it then? The world going in and out . . ."[4]

As Hegel said, the work belongs and does not belong to its originator. The artistic drive, if that is what we want to call a still unarticulated and indefinable artistic spontaneity, always asserts itself

according to the criteria of social needs and expresses itself in forms which correspond to these. No spontaneity ever leads to the production of works of art without some relationship to society, to the interpersonal medium; without a mandate; or without the expectation of some effect. By the same token, no external stimulus, opportunity, or need produces works of art, stylistic forms, or trends in taste without an artistic impulse and a creative talent. We are always dealing with the reciprocal dependence of two principles which are equally constitutive. We cannot separate the subjective impulse toward artistic creativity, the will to expression, and the talent for expression from social conditions, nor can we derive the subjective impulse from these conditions. Spontaneity and causality are not in this connection radical alternatives: they occur only in conjunction with each other.

Thus, no matter how close the connection is between the social essence and artistic phenomena, they are in no way the immediate products or the results of social circumstance. Plecahanow noted that an artistic form—for example, a minuet—simply cannot be explained by contemporary social conditions. If what he wanted to say was that the art form was not contained in the social essence and did not result from it, then his statement is unobjectionable. Sociology knows of no tricks by which it can produce a work of art from society as though from a conjurer's hat. It can merely show that the work is not a purely formal optical or acoustic structure, but is at the same time the expression of a view of the world which is socially qualified; as Paul Valéry says, "Toute oeuvre est l'oeuvre de bien d'autres choses qu'un 'auteur.'"[5] The minuet does not in any way "follow" from a social structure in the sense, for example, that such a structure would reveal certain elements of musical form. The society for which the minuet was intended with its refined taste, its sense of the playful and the terpsichorean, its preference for the pretty, the tender, and the elegant simply provided a fertile soil for its creation by developing a cultural need and an understanding of art which corresponded to the charm of the minuet. The society itself did not dispose of the means and talents by which works of art and art forms were created. It is true that many of the most characteristic traits of this society are discernible in the minuet, but the minuet is not present in that society in even the most embryonic form. An artistic creation cannot be derived from the conditions of its utility. If we know nothing more about an audience than its social composition, we cannot imagine one single feature of a work which would correspond to this audience. To do so would presuppose the theoretical constructibility of creative talents and the determination of individual inclinations and goals which are neither predictable nor calculable beforehand. Thus, in all research in the sociology of art

there remains an unknown element, which makes speculations of every sort about the nature of works yet to be created—indeed, even satisfactory causal explanations about the form of extant works—illusory. It does, however, seem more promising to orient remarks about the relationship between artistic and social phenomena toward the concept of correspondence rather than toward causality in the sense of a compelling and sufficient cause. There is an unmistakable correlation between the forms of art and society, in which a change in one corresponds to a change in the other. The changes, however, are by no means always connected and are never entirely related as cause and effect. They are, incidentally, often completely out of keeping with one another as to their significance, and even a recurrence of virtually identical social circumstances does not permit us to assume that an artistic phenomenon will be repeated.

A social situation is an opportunity but not a compelling reason for the appearance of an artistic happening. "Opportunity" and "happening" are nevertheless related in a significant and regular manner. The mention of significant coincidence, whose criteria point to simultaneous social and artistic phenomena, is not an empty and pointless substitute for the lack of a causal relation. The law relating to this coincidence can be formulated with the utmost universal validity as follows: everything is not possible in every sociohistorical situation and under all possible social conditions, although we can never say ahead of time what may prove to be possible in the given circumstances. It is true that the same historical circumstances, which are, incidentally, never the same, often sanction different sorts of art, but those which arise gain a new, separate, and universal meaning by dint of their relationship to contemporary social conditions. For if all that we know is that every social constellation permits a given number of artistic forms and excludes others, we already possess an important conceptual key, although in this way we cast more light on the incompatibility than on the compatibility of phenomena.

If, however, we see social causality only as a form of a *conditio sine qua non*, according to which a social order excludes certain artistic solutions without necessarily introducing others, we are still not changing in any way the connection between art and society into a relationship which is purely negatively determined. This would not mean, for example, that in certain social conditions certain art forms would never appear and that all others could—in other words, that an incalculable number of artistic equivalents might be connected to every social situation. It is true that it often happens that the differentiation of art forms is more diverse than that of the social ones and that a social situation leaves the choice open among often quite numerous

artistic trends. However, it happens almost as often that we come across similar artistic phenomena in very different social systems. In eighteenth-century France there still exists, side by side with the exclusive society painting of a more or less private character, the bourgeois portrait and the intimate landscape, a narrative and representational painting in the grand style, and this courtly monumental art is in many cases intended for the same patrons as the minor erotic art of the period. On the other hand the essentially homogeneous form of the heroic tragedy is accepted by audiences as different as those of classical Athens, Elizabethan England, the court of Louis XIV, and the educated middle class of the Enlightenment in France and Germany. Still, the connection between sociohistorical circumstances and artistic movements is not a chance and superficial one. The currency of different art forms and stylistic trends at one and the same time corresponds for the most part to a stratification of society into several classes of wealth and culture, or else it is the harbinger of a coming split between the leading social class and the cultural elite. The continued existence or the rebirth of the same forms can again be ascribed in part to the change in form and function to which these forms are often subjected and in part to the inertia with which forms that have developed into patterns oppose change.

However, different stylistic forms correspond in large part to different social forms, although the changes in the different areas do not always occur equally or unambiguously. We cannot speak of a strictly logical correlation in their relationship because social changes are always accompanied, even if only more or less immediately, by artistic changes. On the other hand, artistic changes often have no visible or significant social results. The connection is based on something like a "common denominator," which apparently is not formally expressed in the particular phenomena, but which nevertheless binds them tightly together. There is a unity of outlook between the Homeric epic and the feudalism of the archaic princedoms, the monumental art of Byzantium and caesaropapism, the poetry of the troubadours and the chivalric aristocracy, Versailles baroque and French absolutism, romanticism and the postrevolutionary intelligentsia, the naturalist novel and the modern bourgeoisie. In all of these there is a unity of vital feeling, an agreement on emotional and intellectual values which would not appear in any other combination of social and artistic factors. Certainly we should not take "common denominator" as meaning something like the spirit of a people or an age *(Volks-oder Zeitgeist)* as a common cause, thus smuggling the principle of causality in by the back door. The concept of correspondence which replaces causality in this connection merely means that the simultaneity of the phenom-

ena, which are brought into relation to one another, is significant and informative, and that their encounter can certainly not be called necessary—that is, inevitable—nor can it be called coincidental—that is, it did not come about by the combination of any random processes.

Cognitive perception is generally represented as an essentially passive attitude which tries to portray reality as faithfully as possible; artistic creation, on the other hand, is seen as something completely original which changes the picture of reality capriciously. Both ideas call for correction, and even if Kant did point to the role of the spontaneous elements of cognition as coming out of the observing consciousness itself, the corresponding problem in relation to art had still to be solved. In contrast, the subjectivization of knowledge would insist that artistic spontaneity be kept within its proper bounds. This spontaneity encounters rigid barriers not only in the conventions of expression to which it has to adjust but also in objective reality, and, again, not only in an external reality but also in an inner one which has to be accepted and reproduced, so that subjective self-expression revolves around a hard core of inevitable reality. This reality places limits upon the capriciousness of the creative impulse, the blind urge to communicate oneself, and the unbridled outpouring of subjectivity, and gives it direction. In the face of pure striving for expression and the drive to communicate, even the most intimate feelings and the most fleeting emotions assert themselves as an objectivity which is to be occupied and preserved in its own quality. The artist must perceive his own identity, his most personal experiences and innermost feelings as something apart from himself, something foreign to him, and something which opposes his will to form so that he can express them in concrete terms.

An empirically based theory of art which is rationally developed and historically and sociologically oriented proceeds not from the spontaneous but from the pragmatic elements of artistic creation which derive from practice and experience. In order to do justice to its object it will have to take account of two facts: one, that artistic structure originates in these pragmatic elements; and two, its own peculiar, purely aesthetic structure. In the analysis of aesthetic objectivization, it must distinguish between "begin with" and "spring from" in the Kantian sense. Just as Kant presented all knowledge as beginning with sensual perception though not springing from it in its entirety, so artistic creation proceeds from practical objectives and social institutions, but the tasks associated with these institutions and interests do not represent its entirety. It is part of the essence of art that its creations, deeply rooted as they may be in practical interests, assume the character of aimlessness, immediacy, and spontaneity. An experience which is

commensurate with its essence comes into being only when the work of art gives the impression of being a free expression which flows involuntarily and irresistibly from its creator.

Art also shows this strange combination of spontaneous and un-spontaneous forces in relation to the sincerity of the feelings it expresses. The contradiction—which Diderot observed and which he dubbed the "paradox of the actor"—between what the artist appears to feel and what he actually feels revolves entirely around the presuppositions of the artistic illusion. The true meaning of Diderot's thought does not actually consist in the discovery that the false and insincere can produce a quite spontaneous and natural effect in art but in the recognition that this effect is produced only because it is more or less false and unspontaneous, carefully thought out and exactly calculated. Diderot recognized that the successful representation of emotional states presupposes a certain emotional distance rather than too strong an emotional link, and he does not hesitate to declare that the artistic expression is often that much weaker, the stronger and more genuine feelings are which have to be expressed. The dilettante generally has more feeling and is more honest than the artist. Furthermore, even if the truth value of a poem does not necessarily stand in an inverse proportion to the truthfulness of the poet, a work of literature with fictive emotions is on firmer ground than one with genuine ones. The mouth twitching with emotion and the eyes wet with tears are that much more expressionless, the more uncontrolled the passion which grips the heart. The artist is concerned not with feelings but with the presentation, the *imago,* of feelings. He has no more to experience the emotional content of his work than he has to be a murderer or a lunatic in order to portray a murderer or a madman. Imaginary feelings can be completely convincing if the tone which is set at the beginning is maintained: true feelings on the other hand have no effect if the tiniest false note is struck in their depiction.

Is a feeling less genuine because it is conscious? Or because it is displayed? And even if, in its exhibition, it should sacrifice something in immediacy and warmth, is not every artistic expression which aims at effect and which rests upon "conscious self-deception" linked from the outset with a mediation and weakening of feeling? Is it not unavoidable, once expression is geared toward effect, that both the power of the spontaneous impulse and the freshness of the immediate impression should be reduced? Whatever the answer may be, we can scarcely doubt that spontaneity and emotivity are moral and not aesthetic values.

According to the idealistic doctrine of artistic creativity, the decisive prerequisites for his work are to be found within the author himself.

In principle, he can do everything at any moment and his talents know only inner bounds. He makes himself independent of both the material conditions of his time and the spiritual heritage of the past. According to this view, every artistic product, if subjected to a suitable and in-depth analysis, can be traced back to an individual act of creation.[6] If there is a "corresponding push forward" in the other direction, then we reach with equal certainty impersonal, superindividual, interpersonal sources of creation. The retreat from the individual to the social is just as legitimate as the pursuit of the opposite course. The mutual regression from one aspect to another is an endless process; in either direction there remains a residuum which is irreducible and, from the opposite point of view, inaccessible. The quality of novelty and individuality, which belongs to the essence of the artistic, is inseparable from the spontaneity of the individual. But since the individual himself is to some extent the product of the social soil in which he is rooted, the social element is not merely a supplement to the individual creative factor but a component part of the factor itself.

The individual and the group are, like spontaneity and convention, originality and tradition, heredity and environment, inseparable from each other and irreducible to one another. To quote a famous example: if a plant has a certain amount of rain and sunshine it may bear a certain fruit; in different climatic circumstances the fruit will be different, but another genus of plants will never bear this sort of fruit, no matter what the combination of rain and sunshine. The fruit is, in nature as in art, the product of two different factors: an inner proclivity and a series of external stimuli. The biological nature of the plant in itself is just as little explanation of the characteristics of the fruit as is the environment which ripens it. It is the same thing with the quality of a work of art: neither the individual talent, the inherited gifts, the personal inclinations of the artist, nor the impersonal nature, the institutions, and traditions of the social environment can completely account for it. Everything is not possible at every moment, nor can everyone realize the potential of the moment; to produce a work of art, we need the right talent in the right place at the right moment.

Opinions as to whether pride of place in the historical and social process should be accorded to individual freedom or to superindividual necessity are divided in modern philosophical thought and are constantly changing. In contrast to the theory of validity, in which the individual represents the principle of relativity and the origin of constant deception, pragmatism, and existentialism tend toward an over-estimation of personal characteristics and spontaneity. Modern individualism was originally a product of the Enlightenment and of revolution, and evolved as an expression of protest against the neglect

of the individual and the deprivation of his rights, as such, in favor of birth and class. The matter became more complicated after socialism, in accord with its collective principle, had prepared the way for an antiindividualistic philosophy of history. In spite of the predominantly individualistic feeling of the whole romantic and postromantic epoch, it became apparent toward the end of last century, independently of socialism and liberalism, that there was an increasing coolness toward the zeal for individual freedom and disengagement, and in its place we find a preference for the often hazy notions of anonymity, timeless norms, and the force of destiny. It is true that this antiindividualistic movement implied in itself no deeper understanding of the social form of historical processes; Wölflin's doctrine of "art history without names" is an example, but it does imply recognition of the fact that in history other tendencies and inclinations are at work beside individual ones. A telling symptom of the tendency to transcend the idea of individuality was Benedetto Croce's differentiation of the "aesthetic" and "biographical" personality. He states that the job of the art historian and critic is concerned entirely with the aesthetically responsible but biographically indifferent subject. Indeed, Croce even felt that he could talk of cases where "one and the same artistic personality divides into several biographical individuals" and where "two or more different artistic *personae* succeed each other in the same individual and are interchangeable."[7] Croce's "aesthetic personality" is clearly a mere abstraction and refers to an individual who is constructed according to the pattern of the logical subject, an idea as contrary to the sociological concept of the artist as the psycho-biographical one is. It can be decked out with a superindividual norm and necessity, but not with any superindividual reality.

Art is no more the unforgettable and irreplaceable "mother tongue of humanity" than is any other mode of expression; it, too, is merely an "idiom" which has a limited validity. Art cannot be seen as a protolanguage preceded by no other or as a universal language comprehensible to everyone at all times. It is nonetheless a "language," a dialect which is spoken and understood by many people; that is to say, it is a vehicle of expression, the usefulness of which rests upon the validity of conventional, tacitly accepted means of understanding.

Since there are always more things, ideas, and sentiments than symbols and since even the most eloquent and skillful art does not possess separate terms for every concept and every emotion, art is forced to use a "dictionary" in which there is often only one term for several ideas. That art is capable of creating illusion in spite of these symbolic schemes can be ascribed to the conventionality of its mode of expression, and to the receptivity of the reader or the audience to the "rules"

which govern the presentation. There would be no art, in our sense, if there were no conventions of the sort which permit the characters in a play to "think aloud" or to talk aloud without being heard by other people on the stage (if that is what the rules happen to call for at that moment) or which permit a painting to be two-dimensional and sculpture monotone.

A communication which becomes comprehensible only when it submits to schematization and conventionalization and which moves from the sphere of private and personal meaning into that of interpersonal relationships always has to pay the price of the content which is to be communicated losing a part of its original sense. The whole history of art can be seen as the spectacle of a continuing battle against this diminution of content. Almost every change of style begins with a struggle against certain conventions which are suddenly felt to be intolerable because they cannot be expressed. The new "immediacy" which is temporarily achieved is by no means always a path to easier understanding; it frequently means, as Nietzsche remarked, rather the desire not to be understood.[8] Thus, mannerism and romanticism oppose the conventions of the previous generation not because they are difficult or unclear but, on the contrary, because they appear too simple, unequivocal, and insipid. There was a desire not for a simpler, clearer mode of expression but, rather, for a more complicated and unusual one, which as it grew more artificial and arcane became that much more interesting and attractive.

Yet we should not imagine the process of conventionalization as, for example, a process in which stereotypical forms bracket the spontaneous core of motifs or complement them afterward but, rather, one in which every work, every form, and even the minutest attempt at expression using significant symbols are always the result of a conflict between spontaneity and convention, originality and tradition, immediacy and fixed formulas. The process is not one in which spontaneous personal experiences become communicable and accessible only through conventional forms, but one in which the experiences to be depicted move from the outset along conventionally regulated lines. Completely subjective and spontaneous experience free from each and every conventional and stereotypical element is a borderline concept, an abstract idea which bears no relation to reality.

Every artist expresses himself in the language of his predecessors, his models, and his teachers; for just as he does not invent the slang he uses, he does not create his own artistic language and does not make provision for his own formal needs. It takes a long time for him to start talking with his own individual intonation and to discover the entrée to the sources of his own personal mode of expression. Even

young titans and rebels express themselves in the idiom of the older generation, and even the fiercest opposition uses the means of expression of the movement which it is attacking, not only so that it can be understood but because of the wish to proceed from the "dark urge" of expression to a stage of articulateness. Yet even when an artist has already succeeded in gaining independence from his predecessors—when an art movement has developed to the point where it can separate itself from the movements that have gone before—the most that takes place is a renewal of language, not a creation of it. Even then every newly created work owes more to other works than to the invention and experience of its creator.

However, what is most significant is not the fact that every expression uses conventional forms from the very beginning but the fact that conventional forms of expression themselves create in part the content of what is being expressed. It is reasonably easy to explain that thought processes develop fixed linguistic forms—certain word-meanings, stereotypical turns of language, fixed images—in order to gain more convenient, if not always more exact, means of representing thoughts. What is much harder to grasp is how the means of expression which are available do not merely serve to reproduce cut-and-dried thoughts but change the thoughts to be expressed, and, by becoming the "beaten tracks" of thought, move the thinker to develop his ideas along these lines rather than along those of his original intention. It is part of the dialectical nature of the processes of consciousness that forms not only serve to express ideas, notions, and emotions, but are, in part, the source of their creation. It is not only language, forms, and conventions that have to be changed, bent, and stretched in order to become vehicles which express changing thought; the thoughts themselves must "be cut according to their cloth" if they are to be expressed. In the final analysis we only want to express what can be expressed.

The romantics complained from the beginning that language was inflexible and mechanical, and they maintained that the mutual dependence of language and thought, form and content, individual experience and schematic expression fatally impoverished and debased the spiritual impulse. On one hand they raised the inner sovereign existence of the personality to the level of a myth; on the other they exaggerated the danger associated with the routinization and immobilization of forms. They might have learned better from Kant and have persuaded themselves that aesthetics like philosophy are not in the least concerned with the comprehension of "das Ding an sich" and that those categories which serve to represent inwardness are both the limits and condition of their comprehension. However much conventional means of expression may confine and obstruct the opening up

of the inner life, they are the initial means of access to it and there is thus little point in bewailing their insufficiency.

In every art form elements which are true to nature are mixed with those that are contrary to nature. The way in which the degree of truth to nature is measured is never completely uniform and unambiguous. To what extent we can tolerate unnatural characteristics side by side with naturalistic ones, and accept or overlook the inconsistency, generally depends on unconscious criteria and tacit conventions. The most obvious sign of the conventional nature of an artistic view consists precisely in the readiness to accept contradictions of this sort without more ado.

A convention of artistic representation can usually be traced to a technical difficulty which cannot be solved or which could not at one time be solved; but no convention is entirely explained by this. The frontality of Egyptian art, the stock example of all conventions of this sort, apparently originated in the difficulty of the proper representing foreshortened views. The fact, however, that frontality persisted long after art had developed to the point where the problem had been solved shows that the principle of frontality had, in the course of time, acquired its own significance and had changed from a technical expedient to a symbolic form, an improvization into an institution. We are face to face with a convention only when a constantly recurring deviation from reality is no longer the result of an inadequacy, when a virtue is made of necessity, and when what was formerly a "must" becomes a "should."

The theater is considered the art form which embraces the greatest number of conventions and which clings most obstinately to them. The improbabilities it accepts are that much more strange, since they are in the sharpest contrast to the reality of the given medium—the living performer, the three-dimensional stage, and tangible properties. Fine arts, however, make use of almost as many and just as arbitrary though more flexible conventions. The flatness and lack of shadow in East Asian painting, the frontality of ancient Oriental art, the canonical proportions of classical Greece, the spacelessness of the early Middle Ages, the linear perspective of the Renaissance, baroque chiaroscuro, impressionist resolution of contours and colors are merely conventional distortions of nature. They can be traced to such differing causes as lack of technical skill, the homogenization of the medium toward pure visibility, the renunciation of the visual in favor of a conceptual image, the tenacious existence of antiquated forms and reluctance to replace old-fashioned methods with new ones.

The number of conventions and the strength with which they assert themselves correspond generally to the nature of the particular social

system, whether it is authoritarian or liberal, conservative or progressive, rigid or flexible in its ruling principles. In Paleolithic times, conventional elements in the representation of reality are relatively minor and unimportant; at the beginning of the Neolithic period, with the rise of more rigid forms in the development of economy and society, possessions and dominion, and worship and state, artistic representations become more uniform and rigid. Side by side with the tendency toward rigidity, which is entirely part of cultural development, the process of conventionalization is particularly stimulated by the ritual function and the symbolical meaning which are now attached to the work of art. Apart from products which served a purely decorative function and which multiplied as permanent dwellings were established, art elsewhere also merely needed to point to the object being depicted and, whether voluntarily because of its symbolic meaning or perforce because of its sacral character, it could renounce any immediate fidelity to nature. The work of art changed from a reproduction into a suggestion of reality: the outward signs of the suggestion submitted, however, from the outset much more to the rules of correspondence than the means of fundamental true-life representation.

Depiction and suggestion, image and symbol, fidelity to nature and decorative form now develop into independent stylistic phenomena, which can no longer be divorced from one another. The whole subsequent history of art is concerned only with hybrid forms of these developmental trends which limit, qualify, and supersede one another. The formalism of the Egyptians, the geometrism of the Greeks, and the conventionalism of Byzantium are trends which tend essentially to the symbolic and the stylized. Almost from the beginning they had to assert themselves against a developing form of naturalism, and they finally had to compromise as to how true to life they would be. The golden background of Byzantine and early medieval painting is a sign of a deficiency which can perhaps be traced back to an inability to depict space, but it then develops into a convention and replaces spatial depth. At the same time, however, it symbolizes a sphere of existence in which natural concepts of space do not hold good. As long as Western art was purely devotional it could cling to such conventions and symbols, but as soon as it had to fulfill a mainly secular function they were felt to be bonds and were gradually cast off.

No stylistic period possessed a greater number or a more intricately developed system of conventional means of expression than the Christian Middle Ages. Almost every artistic representation signified something more than the natural object which was being depicted, and this additional meaning was indicated by purely conventional means. As long as the Church was in undisputed control no one thought of

questioning the validity of these means with their sacrifice of all regard for experience. Such questioning only started with the beginning of the Renaissance when the Church began to lose its authority because of the gradual decline in feudal rule, the collapse of traditional thought, and the rise of the idea of competition in economic and intellectual life. The Renaissance, which abrogated the special conventions of the Middle Ages, does not signify the end of conventionalism altogether. Linear perspective creates spatial relations just as fictive as the medieval discontinuity of parts of space. Its continuity rests on just as arbitrary a convention as the discontinuity of discrete space. It simply represents a fiction of a time that rationalized, systematized, and subordinated space to a particular viewpoint, just as it did all structures of consciousness. The perspective depictions of space by painters of the quattrocento are in no way "more correct" than, for example, the urban vistas of Ambrogio Lorenzetti; they merely correspond to other, more scientific conventions. The Renaissance perceived space scientifically and so it treated all the other visual elements—proportion, the treatment of light and color, the anatomy of the human body, and the fashioning of landscapes. Objectivity, harmonious order, and regular beauty are the most significant traits of the rationalism and realism of the new artistic enterprise and are those which contrast most markedly with medieval supranaturalism. They are, too, precisely the principles of style which mannerism most sharply criticizes in Renaissance classicism and which it attacks most harshly as being the most conventional. In contrast to the earlier conventions of harmony, beauty, and naturalness, mannerism, extolling ambiguity, paradox, and ambivalence of expression—the antithesis of the sensual-spiritual, divine-demonic, and tragicomic—creates new conventions and in fact more numerous and more artificial ones than the Renaissance ever did.

Baroque begins, like mannerism, with a protest against the conventionalism of the previous period and ends, again like mannerism, by developing many of the most conventional and rigid formulas for artistic representation. The progress from spontaneity to convention, from anarchy to dogmatism, from rebellion to academism repeats itself from then on in every change of style. Rococo is essentially a rejection of the conventional theatricality and rhetoric of the courtly baroque but is at the same time an artistic exercise which is only based upon another form of conventionalism— a social game with laxer rules. The most significant example of the process of repetition is furnished by neoclassicism, which was originally a movement for freedom directed against the rococo and in line with the spirit of the French Revolution, but which finally developed into the most intolerant and long-lived academism that history has ever known.

Romanticism with its intransigence represents the embodiment of all movements directed against conventionalism. It combats everything which is stereotypical, regular, or normative with the same intense passion, and it labels every exemplary form a questionable commonplace, a cheap cliché, a mechanically manipulable formula. Indeed, it is only since the romantic crusade against classicism that conventions have been viewed in a deprecatory light and conventionalism has been seen as one of the most serious symptoms of the present cultural crisis. Romanticism, however, only presents the struggle in a particularly intense, though by no means new, form. The revolt against convention is now, as always, a force in the dialectic which exists between freedom and the norm and which takes place in changes in style and taste. It is the expression of a contradiction, which generally appears first in the economy, society, and politics. Mme de Staël recognized this connection and maintained that the validity of the conventions of the classical theater was based upon the rule of the aristocracy, just as, incidentally, Lessing explained the formal principles of *tragédie classique* in terms of contemporary social and political aspirations. Unfortunately they both failed to recognize that the phenomenon of conventionalization is by no means confined to aristocratic societies and absolutist states, but extends to every ephemeral culture. Romanticism, the bourgeois trend in art par excellence, produced the most crippling of all conventions—the pursuit of originality at any price. It placed the art of the past, with the whole irresistible power of its classical examples, on the conscience of every modern artist. Anyone who wanted to rescue his threatened self and preserve his self-respect had to avoid anything which had existed previously. Romanticism, however, was not satisfied with this convention of unconventionality and this fiction of the creative gift as a tabula rasa; it wrote its own dictionary of valid and current forms of expression, which was soon to be more out-of-date than any previous reference work.

Modern naturalism, too, only replaced antiquated conventions with new ones and turned equally frequently to a vocabulary of means of expression which were counted as "natural" as though they were turning to Nature itself. Impressionism, the most highly developed form of naturalistic art, also used a system of conventions which was just as rich and complicated as the most rigid of the earlier styles. Most of its artifices—exaggerated light and color, the dissolution of massive corporeality and of solid forms into thin flecks and fleeting flashes of color, the softening of outlines and the elimination of spatial depth, the calculated neglect of closed form and the assault upon the picture frame, the ostentatiously improvizational brushwork, the radical separation of the visual from the rest of the experience, and the

renunciation of anything conceptual and noetic in the representation of reality—were selected according to a plan, artificially developed and imposed upon and not derived from Nature. Even with the aid of these conventions, impressionism did not create a more faithful way of depicting Nature—merely a new and fictive equivalent to fidelity to Nature.

The tension between spontaneous feelings and traditional forms, on one hand, and original forms and conventional feelings, on the other, is one of the most effective forces in artistic development. The antithesis between these forces is the motor which the dialectic of the history of art most frequently and most persistently sets in motion. If the change in sentiments, inclinations, and dispositions were always to go hand in hand with formal renovation, and if it were not the case as it more generally is that sometimes forms outlive the vitality which underlies them and that sometimes new spiritual dispositions and attitudes proclaim themselves before proper modes of expression are available to them, the historical development of art would be as unproblematical, but just as "incomprehensible," as the growth of a plant. Before an old form devoid of content is given up and a new dim awareness finds its proper expression, a number of things have to be overcome: the multiplicity of development, the continued existence of certain forms and the anticipation of others, the different rate at which the individual factors of artistic creation are conventionalized, and the diversity of the opposition. It is this that gives the process of the history of art its special imprint, its character of crisis, conflict, and mediation. The process is structurally an ongoing shift of the center of gravity between spontaneity and conventionalism. There is no form of expression which is so lively or so personal as to preserve its spontaneous nature beyond a certain length of time, and there is no form so rigid as to have begun its development as an impersonal, mechanical convention. Even the sonnet and the eclogue were the inventions of single, individual poets and grew into conventional forms only after an ever-increasing number of other poets had taken them over and used them in a way which was either suited or unsuited to their original sense. There are clearly dangers inherent in the process. An art form does not necessarily forfeit its value when it becomes a convention: it may indeed in the course of time take on qualities by virtue of which it becomes suited to fulfill new artistic functions. For instance, the monologue, as a dramatic device, was originally an extraordinarily clumsy and unattractive solution of the problem presented by the need to impart information about things which, for one reason or another, could not be included in the dialogue. Yet it developed into a convention which was artistically unassailable and even

fruitful, partly because people had grown used to the cumbersome expedient and were no longer disturbed by its unnaturalness, and partly because they saw in it the source of possible new dramatic effects. There are opponents of the monologue as early as the seventeenth century, and their numbers constantly grew until the close of the naturalist period. In the meantime, however, not only were there defenders as well as attackers but the monologue gradually gained a new artistic significance and its own dramatic value. Even a naturalist like Strindberg finds pretexts for retaining it. Alfred Kerr, too, one of the most radical pioneers of naturalism in drama, more or less justifies the monologue: "When I have nine improbabilities," he writes, "then I'll make allowance for a tenth."[9] Even melodies, which are regarded as the most spontaneous and personal elements in music, are in part conventional, even in the hands of the most outstanding composers. They cling to prototypes, particular types of *ductus*, fixed forms, and phrases. A considerable number of Mozart's melodies belong to the common property of his century. If we wished to explain this by saying that it was, after all, the conventional eighteenth century, then we would do well to remember that even many of the greatest romantic or postromantic composers at least stick to conventions which they themselves have invented, and that even in Beethoven's compositions a few simple melodic types and phrases constantly recur. In all these cases, conventionalism is a force of the dialectic of artistic creation: it not only limits spontaneity but also gives it wings. Just as the power of musical invention is nowhere more apparent than in the variation, where it is tied to a fixed theme, so the repeated musical formula, the *Wanderthema* or the *leitmotiv*, is often the most fruitful source of invention.

Every statement, every form of communication and discourse must dissect what in experience is an undivided and undifferentiated unity, reduce it to its elements, and provide them all with a predicate. Art is different from other mental structures only because it preserves the unity and coherence of experience in the face of all analysis. The essence of art is expressed in this tension between unity and differentiation, immediacy and mediation, experience and alienation; it is here that its spiritual and sensual, rational and irrational, spontaneous and conventional duality of character is most apparent. Yet nothing would be more absurd than to assume that the spiritual and emotional factors in a work of art are less removed from the experience being conveyed than the sensory, technical, and formal ones are. The removal from pure inwardness does proceed from the use of acoustic, optical, or tactile means of expression, of tools and soulless materials, of mechanical methods of work which have to be performed, learned, and

transmitted as though they were a craft. It already begins when the unified, and not yet distinct, experience is divided into content and a cloak of meaning, with the first elementary attempt to change a dim, opaque, immediate experience into something which is articulated and can be felt. Yet art derives no more from the sheer wish for sensual distance which arises from the articulation of inwardness than it does from an inner lack of distance from experience. Art seeks both—the immediate, spontaneous experience as well as the statement, the communication, the articulation, and the organization of experience. It seeks, too, both the soul which builds itself a body in order to become visible and accessible, and the body which is visible, tangible, and sensually animating and which remains for the mind incommensurable, impenetrable, and inexhaustible. The problem of artistic form derives from this divided purpose.

Since, in principle, everything is knowable and everything which is knowable can be expressed scientifically, science does not have the same problem of the limits of form that artistic expression does. There is also no problem of conventionalism, in the sense of the borderline between what can be communicated directly and what indirectly, or of the distance between spontaneous and stereotypical expression. Science can always talk about what it knows; the artist in contrast cannot always say what he experiences and what he knows after his own fashion; indeed, he can almost never do so in its entirety. He can only make himself understood indirectly, and always in more or less inadequate forms with the help of hieroglyphs, cryptic means, which are fundamentally alien to the experiences he wishes to relate. The romantics correctly recognized the alienation of the means of expression from its content; but at the same time they completely failed to recognize the irrelevance of this distance or even its possible fruitfulness for the quality of expression. Caught in the delusion that one soul could contact another, they believed that there was no alternative but to remain conventional as long as conventional methods were being used, and that the artist should use no conventions and make no compromise with available means if a work of art were to be produced.

Routine and improvization have rightly been called the two greatest dangers for art. They are nonetheless innocuous if they remain in balance. Both have a part to play in artistic success as long as they are in a state of equilibrium. An art dependent upon pure routine, one which was completely conventional and consisted purely of elements which were tried and contained no breath of risk, would be just as unattractive and insipid as one which depended only upon original, improvised, and unqualified means would be incomprehensible and unpalatable. The artist's individuality is never more markedly apparent

than when he accepts the same conventions as other artists. It is not only the timelessness and the sense of community, but also the originality and the unmistakability of a Dante, a Raphael, or a Mozart, which is most apparent when they are compared with their contemporaries, by whom they are most influenced.

If the romantics are right and every convention contains within itself the harbingers of death and rigidity, if every convention has to cease making an impression or a statement, then the nonromantic point of view is also justified: completely novel forms devoid of every conventional element are unsuited from the beginning to communicate thoughts and feelings. For if it is their originality which makes them worth communicating, then it is conventions which make them capable of communicating. The search for originality widens the limits of inherited traditions and conventions, but also shatters them from time to time. This is the formula to which artistic development can be reduced for all its unpredictable turns and its changes which are not susceptible of schematization. Every new trend means a break in the straight-line continuity of conventionality in an artistic style. Every spontaneous, improvised idea can interrupt the progress of history and mark the beginning of a new stage of development. But where everything is improvised, there is no "history": this only starts when improvisations change into institutions and spontaneity functions within the limits of conventions. The first convention is the first institution, the first assured possession of mankind, and the foundation of its future history.

3 Sociology and Psychology

The individual and society are historically and systemically indivisible. Society consists of individuals and they are its only representatives, just as individuals exist only within a society. Individual and social existence are themselves manifest simultaneously, develop at the same rate, and change interdependently. It is only on the basis of this mutuality that we can say anything about what they are. Nothing would be more absurd than to believe that human beings come into existence first as independent subjects and only afterward as members of a society. It is wrong to believe that they take on the characteristics of social existence as though they were a corrective or a complement to their original asocial nature or that they change from independent individualists without obligations into members of a social community under the pressure of sorrow and need, or as a result of habit and experience. They are in fact born social beings similar to one another long before they are distinguished from one another. They develop individual traits only in relationship to one another, by alliance and opposition, imitation and individualization, cooperation and competition, authority and subordination, right and duty.

An individual free from every interpersonal bond and every social influence is a fiction of alienated thought, which makes an abstraction of reality. Or else such an existence is an example of the abnormal, more or less pathological case of a *déraciné* whose very isolation represents a social phenomenon, in that it is an existence which is alienated from society and not one which is untouched by it. If we reject the use of sociological categories for individual phenomena, we fail to recognize not only that the individual develops only within the context of society but also that isolation makes sense only if it is related to a

40

social existence. Simply being alone is both trivial and pointless: we are alone and feel neglected only when we are conscious of a social reality from which we are excluded. The fundamental separation of the individual from society leads to a pseudoproblem, not only because the individual has, from the very outset, a social character and can only be thought of in terms of a functional connection with the social conditions of existence but also because he is governed by social forces and determined by social achievements every time he rebels against society. This is true even if he believes that he owes everything he finds to be positive and valuable in himself and his achievements to a revolt against social institutions which he sees as nothing but a source of inhibitions, obstacles, and dangers. Opposition, uprising, and alienation are eminently social attitudes, which are motivated ideologically.

The actual relationship of the artist to society is in this respect antithetical to the doctrines of the idealistic—whether classical or romantic—theory of art. Artists like their fellow human beings are social beings, products and producers of society, neither fully independent and tyrannical, nor from the first *déraciné* and alienated. They are no more the victims exiled from a society which is inhumanly manipulated and inflexibly organized which they cannot come to terms with, and from which they seek refuge in art, than they are the speaking tubes of an eternal and unified humanity. However superior they may feel toward their fellow men or however alienated from them, they speak the same language, speak *to* them and speak *for* them.

We draw too fine a line between the individual and the social element in human attitudes and achievements if we assume that the individual and society lead their own existence according to their own laws and could manage to exist without one another. In fact they not only need each other but form two aspects of one and the same phenomenon. Not only is society the only form in which something like individual existence can be conceived, but at the same time the individual is the only agent of society, its one active representative, the one explicit expression of the drives and forces contained in it. For as ineradicable as the social element is from every human activity, it is nevertheless always the individual that thinks, feels, acts, recognizes truth, and creates work of art, even if he does it only as part of a cooperative effort.

The individual and society interact in artistic creation in such a manifold and complicated manner that their mutual relationship cannot be expressed just in terms of a simple dualism. To ask to what degree individual factors participate in the artistic process, which is the most important, and what changes in their relationships take place misses the real point. The idea of a cut-and-dried, authoritative, sociohistor-

ical situation which can be accepted without question, of an objective period style or an exemplary trend in taste, and of an individual personality independent of this situation spontaneously and arbitrarily approaching the tasks of the moment is the source of far-reaching errors. There is less independence of social and asocial factors here than in other areas of human activity. For it is the case not simply that where there is no society there can also be no individuals but also that even that personality which seems to act completely spontaneously only embodies a reaction, accepts a challenge, and answers a pending question. An artist becomes what he is in the course of wrestling with the historically and socially conditioned task he is trying to interpret and to solve in his own manner. He has no artistic individuality before the task is solved and can be distinguished and defined only in relation to the concrete situation created by the task at hand. Without Renaissance society, the soil of Italy, and the national past; without Florence and Rome, the Florentine quattrocento with its achievements, and the Roman curia with its aspirations and means of power; without Perugino as his teacher and Michelangelo as his rival, there would have been no Raphael. But without Raphael the Renaissance would not have been the Renaissance and Rome would not have been Rome. It was not decisive for the process that Raphael became the representative of the development for which the quattrocento paved the way both artistically and socially because of its better organized artists' workshops, its more favorable conditions on the art market, and its intellectual and material support of the market in the centers of culture. Neither was it decisive that Raphael himself created the classical style. What was decisive was that the Renaissance and Raphael's own artistic personality developed simultaneously and at the same rate without ever being separated from each other. Not only is it the intended solution—in this case the work of the Renaissance artists—that is the result of concrete problems, but the problems themselves are posed only when the possibilities of solution exist. They are then firmly delineated and definitively formulated and identified in the course of their solution.

The problem which in the course of his development every artist has to pose to himself and solve in one way or another is not how he can best adapt himself to society and its conventions, but on the contrary how he can most successfully free himself from them. For just as a child at first only uses the language of his immediate environment, so the artist begins by imitating others, by copying and modifying his prototypes. He develops usually from using a more general to a more individual formal language, follows, that is, a direction which is opposed to the widespread and romantic notion of the evolution of an artist: he departs from the general idiom and approaches a personal

form of expression instead of taking the opposite course. As he gradually frees himself from conventional formulas and stereotypical solutions, it is clear that it is harder for him to forget than to preserve what he has learned from others. As time passes he may, or he may not, become more original, but at the beginning he is at his least original. True, there are some gifted people who mature early and have from their earliest youth a sensibility, nonconformist ideas, and their own unmistakable tone, but there have scarcely been any artists who spoke a new formal language from the beginning. Actual artistic revolutions, those that go beyond mere programs and proclamations, seldom emanate from young people. Titian, Michelangelo, Rembrandt, Shakespeare, Beethoven, and Goethe were all more progressive and innovative in their maturity than in their youth. They began with the conventional forms of their time and adapted to them without qualms and only gave them up later, so that they could finally break with conventions, for whose genesis they themselves had the greatest responsibility.

The relationship between individual and society does not always, and never exactly, correspond to the antithesis between spontaneity and convention; this antithesis represents only one of the different aspects of that relationship. The individual is a dynamic complex who bears within himself the antinomy of the inherent and the alien, originality and norm, permanence and change, and he becomes himself the scene of their struggles with each other. The task of sociology would be relatively simple if the individual and society were nothing more or less than adversaries: the gap between what is social and what is asocial does not stay within the limits of the individual but goes beyond them. For just as society consists not only *of* but also *in* the individuals, so the individual not only is conditioned by society from without but finds the social principle, whether through stimulus or resistance, in his own being and in everything he does. Without dividing the individual into two selves—a subjective and an objective, a particular and a general, a private and a social—we shall never be able to bridge the gulf between the social and the asocial principle, between subject and object, between the individual and the world, just as we can never reach consciousness from the thing, or the thing from consciousness.

The analogy between art and language is one of the most revealing parallelisms in the whole of aesthetics, at least as far as the relationship of spontaneous to conventional means of expression is concerned. It clarifies not only the manner in which the beginner takes up his artistic work but also how he gradually becomes his interlocutor's teacher and how there develops between them a dialogue and a mutual dependency. The artist not only uses other people's language until he has found his

own but later expresses himself in a dialect of the common language. In this process, not only does his own language change but the language of the group is also subject to change and becomes the product of a development, the stages of which are marked by individual contributions. Art like language is the result of the amalgamation of a traditional collective idiom with constant innovations by individuals. Vital art, like the vital living language, forms a variously tangled web of relationships in which many participants are involved. The tangled threads of the web lead from one participant to another until, finally, it is almost impossible to discern how give-and-take, property and loan, initiative and routine are divided and united. Just as a social being develops from the stammering child repeating mechanically what its parents say, so the poet reveals himself as a linguistic innovator, though like every speaker of a language he never ceases to be receptive to others. Yet by what ways and means and to what extent their influence makes itself felt can never be entirely determined. The artist, however sure he is of his own method of creation, is scarcely able to give himself an account of where and when he found a particular motif, took possession of an event he did not immediately experience, or picked up a glance, an image, or a word which became the seed of so unhoped for a fruit. He hardly ever has an idea of what he owes to his public, his opponents, or his followers, or what part is played in his task by the understanding he finds or hopes to find there, the criticisms for which he is prepared and over which he silently triumphs, the applause which intoxicates him ahead of time, the goal of pleasing, of communicating himself, and of forming an imaginary family with all those who agree with him.

The function of the individual changes incessantly in the course of history, and individualism undergoes such fundamental changes that we even think we can distinguish clearly between individualistic and antiindividualistic periods in culture. In reality, however, there is no stage in the development of culture in which the phenomenon of individuality is unknown and no phase of individualism in which the individual did not have an adversary. Just as the most unified and homogeneous community consists of different individuals, so the most primitive and most differentiated form of individualism bears the stamp of society within itself. It is not its structure as the expression of a dialectic full of tension, but its function as a creative power, which changes in the course of history. Its role may be considerable or quite minor. Since the Renaissance its role has been growing constantly, and since the romantics it has dominated the scene of Western cultural life. The individuality of creative subjects may participate essentially in the individual achievements even when the personal note is almost un-

noticeable, so that even periods which did not know the concept of individualism were not unfamiliar with the phenomenon of individuality.

Individuals who in the sense of single beings can more or less be distinguished from one another have existed ever since there has been a history, a process of socialization, social union, and antithesis, ever since there have been rulers and ruled, organizers and organized—in short, ever since more clearly delineated personalities have clearly stood out from groups still in a state of flux. The beginnings of differentiation obviously go back to the prehistoric state of nature and can be found among animals. The mere phenomenon of the individual as a leader who is still completely one with the group he is leading and guiding is not problematic, divisive, or atomizing in spite of the authority which is exercised. But an individual of this sort, even a particularly active or capable person, is one thing; a man who is aware of his talent and his ability to act, admits to special abilities, and tries to promote them is another. The change from the mere fact of individuality to individualism takes place only when this self-knowledge is present.

Even the mere consciousness of being different from others insofar as it is linked to a claim to prestige and privilege creates a tension between the individual and the rest of the community and leads to a loosening of the unity of the group. In the Egypt of the New Kingdom and more strikingly in the Hellenistic Empire, this situation already shows signs which remind us of the present-day atomization of culture. But it is not until the Renaissance that there is an actual cultural crisis, as the obverse of intellectual competition. This comes at a time when individualism appears fully developed and a *reflexive* individual consciousness replaces the earlier still more or less *mechanical* reaction to impressions. The development of individual initiative is accompanied by the collapse of the authoritarian medieval view of the world, the decline of the idea of universal Christian culture, the dissolution of the unity of faith and knowledge, laws and morality, art and craft. As a result of this, the tension between individual and society develops into a true antithesis and a cleft develops which threatens the individual with the loss of his assured place in society. This precarious situation does not, it is true, alter the fact that the artist is affiliated to society or that his work is sociologically conditioned. The careful observer will see that the dependence of the alienated individual upon social reality is even more unmistakable than that of a person who is in complete accord with the established order and is in complete agreement with its values, and who thinks from the beginning in accordance with its conventions—who is, in a word, never tempted to leave it.

Individual spontaneity is the great Renaissance experience, the concept of genius and the idea of the work of art as the expression of a genius's personality its great discovery. The Middle Ages, which did not know the concept of competition and was thus completely untouched by the idea of intellectual or economic competition, did not see any advantage in originality or any shortcoming in stereotypicality. Yet anonymity of achievement was not a goal which might have been striven for, and the idea of the artist who knowingly and voluntarily hid himself in his cell or his guild workshop has long been shown to be a romantic fiction. Nevertheless the most obvious mark of the arrival of the Renaissance is the turning point in the history of individualism. It is marked not only by the fact that the creative individual becomes totally aware of his specialness and demands his special rights, but also by the fact that the attention of the public undergoes a corresponding change in orientation and turns from the work to the artist. This is the beginning of the crisis of individualism—the increasing tension between artist and public and the mutual suspicion which finally makes rebels and reactionaries out of both. The cult of genius which marks the peak of individualism in the Renaissance and from which the artist derives the right to rebel against tradition, doctrine, and rules not only introduces a reconsideration of values, as a result of which the artist tends to be placed above his works, but also prepares the arena for the conflict which threatens from the very beginning to upset the precarious equilibrium existing between the pretensions of the individual and the demands of society. The shift of accent from achievement to the ability to achieve, from success and completion to artistic idea and intention—in short, the one-sided judgment that genius is the authoritative principle—leads to the destruction of that harmony between work and personality which dangled as a goal before the Renaissance but which it unavoidably robbed of any meaning as soon as it saw the individual no longer as the mere messenger but as the embodiment of the message itself. Michelangelo enjoyed a rank beside which every earlier idea of intellectual freedom appears paltry and limited. He was the first to achieve the complete emancipation of the individual from rules, and he took the final step in his climb. The artist becomes an idol, the embodiment of an ideal which unites the highest values in itself. He no longer has to identify himself as what he is. Michelangelo remains, even after his flight into the "arms of Christ," the "divine" master that he was. No artist has ever been surrounded by the aura which surrounded him; no other one could have laid aside his tools to serve God other than by the works of his hands and at the same time preserved his reputation as an artist.

The mannerist artists lost their hold on the institutions of a unified social order and a world view which was for the most part still a closed one. The protection the guilds had afforded their predecessors, the unambiguous relationship to their patrons, the Church, and the secular rulers, the sure trust in ecclesiastical dogma and artistic tradition were gone or shattered. The principle of individualism, which now ruled unfettered, opened up undreamed of possibilities for them and transported them into a vacuum of freedom. The spiritual breakup meant that they could neither entrust themselves entirely to an external rule nor rely upon their inner urges. Tossed hither and thither between subordination and helpless anarchy, they stood unarmed in the face of a chaos which threatened to engulf them and from which even the greatest often only managed to escape by a *tour de force*. They were the first modern artists in the sense that their extreme individualism turned into a split feeling for life and ended in an attitude in which historical ties and rebellion against history joined forces with a romantic striving for freedom, a flirting with order and discipline, uninhibited exhibitionism, and a coquettish modesty which always seemed to promise something captious. This represented the final stage in the history of individualism and of the relationship of the individual to himself—a stage of development in which not only the value of individualism became problematic and the individual did not know what to make of himself, but also in which both were stripped of their meaning. This crisis of self-confidence expressed itself sometimes in an exaggerated, sometimes in a suppressed subjectivism. It was the failure of the idea the Renaissance had inspired, the prevention of freedom of movement between past and present, tradition and invention, rules and arbitrariness, classical norm and spontaneous fancy, and this became the heritage which weighed on the whole of modern art. Sometimes this resisted any ties at all and at others it bound itself in the tightest chains.

Just as we cannot postulate a collective entity as the representative of cultural processes—whether it be a medium of feeling, volition, or the production of artifacts—or postulate the function of thought or action as anywhere but with the individual, so we cannot anticipate that the individual will think, will, or act entirely through self-motivation. It is obvious not only that it is the subjective, psychological mechanisms which determine an individual's behavior and that not everything he does or which happens because of him happens on his account, but also that he is always speaking and acting on behalf of others, even if he merely seems to behave according to his own private interests and objectives. The only question is how much of his behavior which appears purely psychological is in actuality sociological. That

interpersonal functions are always carried out through the medium of the individual psyche does not mean that they originate there.

There is an apparent alternative, which is to derive social structures, relationships, and conditions from the individual psychological subjects or fictive agents of a collective consciousness, from a popular- or group-psyche, or from the spirit of a race, a nation, or a historical period. There is also a third, more obvious explanation for their objective existence and their regulatory nature: individuals, as social subjects, submit to a particular context of meaning, which originates from the rationale, the inner order, and the consistency of the social process. It is a conjunction of modes of behavior, which condition and cause each other, and which exclude others, relating to concrete empirical subjects, without their having been arbitrarily caused by them or without their being able to be invalidated and changed by them. They form a unity of relationships, which are not psychologically localized, whose origin cannot be unequivocally determined, but which gain power over the thoughts and volition of the individual as soon as he enters the social sphere. Thus, even if society never thinks for the individual, as soon as the individual finds himself in a social situation and involved in interpersonal relationships, he does think according to the "logic" of the situation, which is not identical and congruent with his mode of thought as a psychological individual but which is governed by its own purposive, coherent laws.

The identification and differentiation of phenomena occur in the fields of sociology and psychology according to completely different criteria. Generally speaking, the psychological variability of the same social structure is greater than the social mutability of the same psychological type. This is obvious, since there are more psychological types than there are social structures. When Balzac, for example, remarks that greed changes from a vice into a virtue as soon as it has a specific objective, the change he has in mind is a moral and psychological one: the socioeconomic category of greed as an attitude of mind concerned with the accumulation of property remains the same. Balzac, however, had no intention of assigning pride of place to psychology rather than sociology. This was what Freud did when he maintained that different individuals act differently even under the same economic conditions, overlooking the fact that under the same economic conditions they often, indeed more frequently, act in the same way and develop identical group characteristics such as class consciousness, class ideologies, norms of behavior suited to their class, fundamentals of good taste, and the like. It was precisely in connection with the discrepancy pointed out by Balzac that Max Weber showed not only how great the difference is between psychological and sociological moti-

vation, but also how remarkable the psychological variability of a phenomenon like "acquisitiveness" can be within the same socioeconomic category. The same striving for profitability can often be connected with quite different traits of character in two successive owners of the same business and can be the result of quite different psychological motivations. The social behavior appropriate to acquisitiveness derives from a rationality which is beyond psychology, and this is the same for two owners who represent the same economic systems but whose characters are differently motivated.

The relationship between psychology and sociology corresponds in many ways to that between heredity and environment. Just as every vital phenomenon is the result of a series of constitutional stimuli and of a number of environmental circumstances, so, too, the cultural process consists of the development of instinctual tendencies in particular economic and social conditions. The psychological apparatus of the representatives of culture plays just as large a role as the social mechanism which directs mental functions in certain directions. Every cultural structure is the work of an individual endowed with mental abilities, but the individual is always in a situation conditioned by time and place. His achievements are just as much the product of his disposition and inclinations as they are of the situations in which he finds himself.

As an example of the unpsychological nature of socioeconomic processes, Georg Simmel quotes the phenomenon observed by Marx: "The explanation of the replacement of slave-economy by feudal economy and of feudal economy by wage-labor is not to be sought in the consciousness of the subjects, but in the logical consequences, so to speak, of economic technique. . . . Here consciousness is completely eliminated."[10] When despite this, he goes on to say in another work that "no circumstance is realized through its own logic but by social and mental forces,"[11] he is merely trying to account for the dual motivation of historical processes and to point out the difficulty, which Engels had already emphasized, that in the course of these processes motives which are extrapsychological and alien to consciousness have to "pass through people's heads" (Ludwig Feuerbach) in order to be activated. The matter is by no means always as simple as in Simmel's first example, where the objective, nonconscious force is fully concretized in the "economic technique" before taking on conscious forms, and it is even more complicated than in the second example, because it is conditioned dialectically and not just causally.

The mutual dependence of sociology and psychology works in such a way that only what can be experienced psychologically can appear socially and historically effective psychological impulses are from the

outset interpersonal. Just as everything which "sets men in motion has to go through the head," everything which goes through the head also has to refer to other people. The social mechanism of capitalistic accumulation is not, it is true, identical with individual acquisitiveness, but without such a psychological spur the profit motive would not be effective. Sociological and psychological motivations of this and similar sorts usually appear simultaneously, develop concurrently, and achieve the same success. The reciprocity of motives, however, is not always clearly expressed either in the course or in the explanation of historical processes. At one time the overemphasis on the psychological form of phenomena overlays the sociological meaning of a circumstance; another time the all too obvious social manifestation or the exaggerated social explanation of forms of behavior blurs the psychological characteristics. In the one case, psychology is merely a veiled, unexplained, or improperly thought-out sociology; in the other, sociology is nothing more than a disguised invisible psychology which is foisting a collective tendency upon individual psychological impulses.

The purely psychological explanation of the eroticism of the troubadour love lyric is a striking example of sociological methods which have not been "properly thought through." Nothing expresses the inner antitheses of chivalric life more vividly and nothing is more significant for the transition from the ecclesiastical culture of the Middle Ages to the secular culture of the Renaissance than the ambivalent attitude of the knight toward a love in which the highest spirituality is combined with the most downright sensuality. This ambivalence can be understood only if we consider the sociohistorical background of these contradictory relationships. Only then does it become clear that chivalry's strange candor in matters of love is the result of the weakening of social prejudices and the relaxation of the boundaries between classes, and that the new tone in love poetry presupposed the rise of a new and emancipated educated class.[12] An equally remarkable example of the blending of sociological and psychological categories and of the attempt to explain psychologically phenomena which are really only susceptible of a sociological explanation is narcissism, from which psychology likes to derive the concept of alienation. This concept, however, can be clarified and made scientifically sensible only by explaining it as a crisis in interpersonal relationships and as a threat to the individual's roots in the society. On the psychological level it remains afflicted with the obscure and ambiguous notion of personal *malaise*. As such the turbid, pathological state Freud understood as narcissism does in fact correspond to alienation. Yet all that the two phenomena have in common is that alienation is a disease of society and narcissism one of the individual psyche, As historical phenomena

it is possible that they are the expression of the same spiritual crisis, of the same feeling of abandonment, defenselessness, and helplessness, but what is decisive is that, when they do coincide, it is the psychological state which is prepared and caused by the social, and not vice versa. Irrespective of how much the psychological analysis of narcissism can contribute to our understanding of alienation, narcissism is not one of the presuppositions for an alienated society or for the alienation of the individual from himself and society. It is the case rather that narcissism becomes a serious pathological phenomenon only in an alienated society. The psychological state of crisis does presuppose sociohistorical difficulties— alienation can exist without narcissism—but there can be no narcissism, at least no pathological narcissism, without alienation.[13]

The role which has generally been accorded romanticism in the history of the past century is uncommonly revealing on the subject of the obfuscation of sociology by an overemphasis on psychology. Its most characteristic and essential trait consists of a protest against the social order as a whole and an accusation against society as such. Previously people had only protested against certain institutions, certain governmental measures, or the abuse of certain privileges by one social class or another. Now people discovered that society can only function if it abuses power and deprives the majority of their rights. Part of this discovery issued from the knowledge that the hopes which the Enlightenment and the French Revolution had encouraged in intellectuals and their spokesmen were not to be realized. The poets and philosophers, who had lost their prestige and their political influence in the postrevolutionary era, felt that they were superfluous, and this sense of uselessness led to all sorts of attempted escapes. The past and utopia, childhood and nature, sickness and illusion, the secret and the uncanny, the unconscious and the irrational simply became refuges, hiding places in which they could pursue irresponsibility and acknowledge defeat. But whatever they were enthusiastic about or gave themselves out to be, they were rebels, in spite of their flirtation with ideas of medieval order and fixed institutions, and they became the pioneers of a new revolution which has since then become permanent. The psychological explanation of the romantic view of art and of the world as a new mode of mood and feeling is obviously inadequate. The disillusionment of the romantics was the reflection of their lack of social success. The intellectuals of the preromantic period were able to allow themselves to be ruled by others because they believed that life could be governed and they believed government was advantageous. The romantics fought against every tie because they had lost their trust in conventional norms and values and had, from the begin-

ning, denied the right of society to harness the individual. People who feel relatively secure and expect to be successful are more prone to conform to social demands and more readily renounce aberrant urges than those who are dissatisfied and suspect in every demand made of them injustice and an encroachment upon their rights. It is manifest that the psychology underlying this need for emancipation is dependent upon social circumstances. The whole romantic attitude, which was both alienated from reality and hostile to it, merely accords with the position, the role, the prospects, and the chances of success society offered to an intelligentsia disappointed by the failure of the revolution. For this reason people were in revolt against morals and order, not because they had suddenly discovered that the Alps were so high and so pure, or that the brook in the valley burbled so lightheartedly and so peacefully, or because they would rather say "soldier" than "warrior," but because people thought about and felt everything differently from the way they had previously, and because they had nothing but antipathy toward the views and conventions of the society with which they were involved.

The misunderstanding of the role played by differing motivations is nowhere more apparent than in the primacy which psychoanalysis accords to psychological as against social processes. Institutions, moral principles, and legal norms are not the result of inhibitions—which is what the psychoanalysts maintain—but, on the contrary, inhibition is a result of the recognition of moral values and social institutions which are suited to maintaining a recognition of the set values. The rule which expresses the particular social interests comes first, and then comes the prohibition which, disguised as inhibition, protects these interests. Where there is no institution and no rule, there are also no prohibitions or inhibitions. Only what threatens the perpetuation of a fixed order is prohibited. Laws—moral as well as juridical—rest upon authority, not upon an abstract feeling for justice. Dependence is the precursor of every attachment and loyalty, as well as of every uprising and aggression.

No less suspect than the masking of sociology by psychology is the opposite process, as a result of which sociology becomes a form of unclarified, misunderstood, or disguised psychology. Even if this takes place more rarely, it is all the better known, especially because of the practice of imputing all unpleasant phenomena to capitalism or to "bourgeois decadence." The greed pilloried by the socialists, just like the hypocrisy and vanity the French moralists criticize, is all too human and permanent for it to be charged to the account of a particular economic system or class of society. Spiritual dispositions of this sort are, if not exactly timeless, nonetheless more conservative, rigid, and

longer-lived than the cultural structures in which they clothe themselves, although the institutions, the stimuli, which underlie them often survive. For all that, if we consider the immeasurable variety and variability of conventions and institutions, we cannot without further ado agree with the widespread and apparently unassailable view that the social in contrast to the psychological is a purely mechanistic province.[14] In this connection, too, there is a division of the roles played by psychology and sociology. For even if society can never dispense with the psychological individual as an agent, the individual acts as an agent of society in such a way that the origin of his actions exists partly outside himself. Seen from this aspect, the roles are not simply divided but exchanged; psychological actions may in some circumstances appear more mechanistic than social stimuli, and the psychological constitution may oppose certain changes rather than promote them. Ferdinand de Saussure, the founder of linguistic structuralism, calls the conventional forms of language "arbitrary" (arbitraire) in antithesis to the spontaneity of the speaker, which, when looked at from another point of view, seems that much more willful.

The recognition that social processes always go into action by psychological means and never express themselves directly, that "they have to go through people's heads," is certainly not the same as saying, as one famous art historian did, that since the scholarly study of art originates in the mind, it can only be done as psychology.[15] One does not have to be a Hegelian or a Husserlian to perceive that everything which happens in the human mind is not of a "psychological" nature, nor does it have to be explained by psychological means and methods. Not everything which appears in the form of psychological processes comes from a psychological mechanism. The identification of psychology with the knowledge of the mind is no less naive than the assumption that everything which happens on the earth is an object of geographical study.

The actual relation of sociological and psychological motivation is based on total reciprocity, and essentially consists of the fact that a social modification of psychological invariables on one hand corresponds to a psychological differentiation of social constants on the other. Such a relationship excludes the possibility of the continuation or the abolition of one order by the other. For this reason, Talcott Parsons, who, it is true, concedes their particularity and relative autonomy, takes a wrong view of their relationship to each other when he looks upon their unification and integration as a question of the methodology and organization of scholarly work.[16] The two aspects cannot be brought into "agreement" or represented as the continuation of each other, no matter how careful the research and how far-reaching

the clarification of the concepts. It is true they do refer to a unified, undivided entity, but even here, as in the case of the different views the forester, the botanist, and the painter will take of the same tree, we are concerned with different objectivations which neither correct nor enhance each other. Unlike the different ideas of the tree, the different aspects from which sociology and psychology perceive the entity are interdependent, so that one cannot be thought of without the other, yet neither can be reduced to or resolved in the other. The two structures are not related to each other like the successive phases of a direct development but like different factors in a functional interrelationship, whose connection consists rather in the polarity than in the final synthesis of opposing forces. Society is a context which implies the existence of the individual psychological being, without producing it from itself, and of the individual's vital processes, which presuppose a social entity—from which, however, it is quite impossible to derive society.

Side by side with the sociological and psychological context of meaning we can determine in art, as in logic and ethics, a third order of meaningfully interrelated structures, which is based on the specificity of the respective form of objectivity. In this way we are concerned with three more or less independent regularities in each of these areas. As soon as the process of creation is completed and the formal structure exists, or the work is experienced and thought of as a formal structure, the work of art emancipates itself from the personality of its creator and from the social soil from which it springs by virtue of its immanent aesthetic meaning. Its independence is so stringent that the mere idea of the role it has played in the life of the artist or can play in the life of society may be felt to be disruptive—even destructive—of its formal aesthetic entity. Aesthetic character and artistic quality have no immediate connection with the fact that a work may have served its creator as a solution to some personal problem or that it is suited to serve as a political weapon for a society. The most formally diverse means of expression and communication can serve creator and audience in the same way. Even those elements of a work of art in which the author expresses his deepest emotions or solves the most difficult problems and which seem to him most important because of the role they play in his moral and intellectual development, or those elements which are of the greatest use to society, are by no means always the same as the ones that are artistically most valuable and significant. Aesthetical value has neither a psychological nor a sociological equivalent. The same social interests and political aims can be expressed in both the most successful and most unsuccessful works. In the same way the same mental states, the same experiences, sentiments, and inclinations,

even the same artistic ideas and efforts underlie products of the most disparate quality. Mental states and social circumstances belong to the presuppositions of works but not to the material from which the works are created. Libidinous, aggressive, or submissive inclinations, social opportunism or obstruction of the existing order may inspire the artist to work and energize the mechanism which moves him, but they do not provide him with the means of creating his work. These means are neither psychological nor sociological.

Yet it is not only formal elements but also emotional motives which have to thank the context of the work in which they appear— not the concatenation of experiences from which they derive—for their artistic significance. They have their existence, in the words of T. S. Eliot, "in the poem and not in the history of the poet."[17] All the components of an artistic creation can appear empty and trivial if they are torn from the context of the work and put back into the process of its development, into the "history of the poet." They owe their life not to conception but to delivery from the mother's womb which conceived them. The closer we get to the origin of a work, the further we may be from its artistic meaning. If there is an interdependence between the work and the biography of an artist, it is a mutual and dialectic one. The biography of an author is determined as much by the nature of his works as these are by the nature of his personality. The artist sums up his life in his work and predicts the outlines of his work in what he experiences. He anticipates the material and the significance of his art in his biography, but the content of his life consists only of what he can fashion as an artist. He discards whatever he finds artistically indifferent.

Sociology and psychology are equally alien to the work of art as an aesthetic structure. The work of art as a formal structure is an independent system, complete in itself and in no need of external motivation. It is a whole, the individual parts of which appear fully explained by and founded on their inner relationships and they make no reference to their psychological origin or their sociological function. From the aesthetic point of view, the sociology and the psychology of art function within the limits drawn by artistic form and in the direction to which it points. Looked at psychologically or sociologically, on the other hand, all the effective forces in a work of art appear to be translated to levels in other spheres which are different from the formal artistic context. As a psychological document the work of art stands in need neither of a formal-aesthetic judgment nor of a practical-sociological one, and as a social phenomenon it does not become more meaningful or significant because of its formal value or its psychological motivation. From each of these aspects the object of aesthetic expe-

rience appears in a one-sided, broken perspective which distorts the true relationships. All three modes of thought appropriate to these one-sided points of view—aestheticism as well as psychology and sociology—overemphasize one level of meaning of the artistic facts and so destroy its totality and unity. Aestheticism makes a fetish of the means, the medium, and the vehicle of the function just as much as psychology does of the origin and sociology of the ultimate purpose. For the last two it is essentially content and expression, for the first form and decoration. When they complement each other they recall that art must certainly always consist of content and expression, but that it can never be these alone and that if it is never entirely determined from within, neither is it only conditioned externally.

The relevance of sociological inquiry depends on the concept of one particular representative of the social processes. We can talk of sociology as an independent discipline only if we can attribute an objective existence to the substratum of interpersonal relationships, contexts, and functions. Such an objectivity must be free of individual empirical subjects and their psychological motives. A sociology which is not just an appendage to psychology ascribes a special objective reality, its own significant order, and a more or less autonomous rationale to social structures. However, sociology will take on a scientific character freed of all false metaphysics and vacuous mystification only when the reality and rationale of its basis is neither a hypostasis of "higher" principles—that is, essences like Platonic ideas or scholastic universals, Hegel's *Weltgeist* or the romantic *Volksseele*—nor the presentation of psychological processes as substances.

The peculiar fact that collective bodies take on a special form of existence which is different from that of the individual entities comprising these bodies is expressed in the simplest collective nouns like *alliance, army, or herd.* These simply represent the collection of individual persons or animals, and as such lack the vividness of concrete, individual phenomena. Yet they are not mere abstractions like *Volksseele* or "national spirit" whose unreality is obvious as soon as we try to imagine them as actively thinking or willing subjects. Compared with these abstractions, the peculiar reality of a collective social body, a social class, generation, or cultural group, is unmistakably the basis if not the subject of an activity. *Volksseele* and *Volksgeist* are nothing else but constructs with a conceptual reality rather like *beauty* or *art* in relation to individual arts or works of art—or, even more obviously, *artistry* as related to artists as a group. The crucial ontological difference can perhaps be made most clear if we look at them in the context of the concept of style. The *Renaissance* is clearly less obvious as a concept than are the objects associated with it—namely, the works of the Re-

naissance masters—and yet it is, for example, more real than art, as a whole, in relation to concrete works of art or the concept of the triangle in relation to individual triangles. For no matter how different the degree of reality of an artistic style may be from that of a palpable object, it represents an objective sociohistorical structure and not a mere abstraction.

Sociological contexts, orders, and structures are syntheses integrations, and totalities consisting of elements which are not themselves sociological in nature but only take on that character when they are related to one another. If we are led to the tacit or explicit conclusion that sociology is essentially psychology and that social processes have their origin in psychological attitudes by the fact that society, like every single social group, consists of individuals and that social relationships operate by way of psychological inclinations, energies, and mechanisms, we are in fact admitting that the combination of psychological elements is nothing more than the sum of its components. In reality, however, a social collective not only is more than the sum of its components but also differs from them in quality. It not only contains a new element but adds an index to its components by means of which every element is modified in relationship to the whole. It is sufficient to recollect that every chemical compound creates a new quality which was not present in its individual elements, that the life of the biological cell is not present in any of its chemical constituents, and that the quality of a secondary color cannot be recognized at all in any one of its components. As soon as we have green, yellow and blue disappear. The elements make the whole possible but do not contain it. Just as the nature of the components disappears when they combine, so the quality of the whole ceases to exist when it is once resolved into its component parts. Even in those cases, however, where the properties of the elements do not entirely disappear—for example, those of copper and tin in bronze—a new property may appear, namely hardness, which is completely new, is completely unpredictable, and could not, in theory, be produced. Sociological units are part of this sort of integration. Individuals with their particular natures, interests, and aims are not eradicated in social structures, but take on a whole set of characteristics they do not possess individually. Every structure of this sort unites factors which do not of themselves allow us to draw a conclusion about the whole and which when synthesized produce something new while at the same time retaining their original properties.

Individuals are, accordingly, only the representatives of social agencies, not their creators or sources. For, if the forces in the social process always have to transform themselves into psychological impulses to

be effective and discernible, their structure, specific forms, and combinations, their mechanisms and functions, are quite distinct from the orders and laws which exist in the individual's mentality. No one individual can entirely represent the meaning of a social structure or totality, of a means of production, of the status of a class and its ideology, of the rationality of phenomena such as capitalist acquisitiveness or competition, of aristocratic traditionalism or bourgeois conformism. Yet these social forms are always represented by individual subjects and find their expression in empirical psychological processes.

Marx recognized quite early on that social existence had a reality of its own and that its "individual moments . . . emanate from the conscious will and the special purposes of individuals," but they "lie neither in their consciousness nor are they subsumed under it as a whole." The "clash (of the individual moments) produces an alien social force which stands above them: their mutual interaction a force and process which is independent of them."[18] What Marx discovers here, and he constantly harks back to this later on, is the strange phenomenon that when an individual enters into the interplay of social forces, his behavior brings motivations into effect which clearly proceed from him but which do not acquire their meaning or direction from his personal intentions, interests, and objectives. The correlations which arise in this way constitute a reality which is different from the individual's but which has no supernatural substantiality. In their final form they are not in themselves present inside or outside the individual, but arise and have their existence in interpersonal relationships, and as long as they persist, they embody an objective order of law to which their agents themselves are subject.

When Emile Durkheim (obviously inspired by Marx) emphasized the presence of a "social reality *sui generis,*"[19] he wanted primarily to explain that the "social" was a final irreducible principle which can be derived only from interpersonal relationships. Social reality constitutes itself in particular circumstances but is not contained in any of them. One way in which Durkheim illustrates the thesis is by his statements about the phenomenon of suicides, the increase in which is based, as he shows, entirely upon social reality.[20] Suicide can be motivated by neither the psychological nor the physiological constitution of the people involved, by neither their race nor their nationality, by neither their occupation nor their level of education, but is the result of their incapacity to adapt to the social order in certain unusual situations. They commit suicide under the pressure of different, even antithetical, motives which coincide with one another to the extent that they throw the individual off his normal track.

Durkheim maintains that a sudden change of fortune leads to suicide, and he makes a social type out of the private individual who is the master of his fate. Thanks to the same social reality, Paul Lacombe makes an "institution" out of one single happening (événement), a permanent structure out of a chance discovery, an aesthetic rule out of a spontaneous idea, a form which can be repeated over and over again out of a chance, lucky solution, and an exemplary method out of a successful trick.[21] Meters like hexameters, genres like the sonnet, schemas for composition like the "dramatic unities" are institutions of the sort which change one individual case into a sociological genre— a norm with its own laws, which can be continued and developed.

The special rationale of the social process, which Marx regards as a force inherent in social reality, appears in every interpersonal, conventional, and constitutional form. Nothing expresses this more clearly than the law of the market, to which everyone, as consumer and producer, is subject at every turn. Every new buyer raises prices and is the victim of a rationale which opposes his own actual goal. As a result of its immanent logic and its "inner antitheses," whether this be the "pauperization of the proletariat" or the power of its coalition, capitalism creates conditions which are completely at odds with the intention of the individual capitalist and which actually endanger his ultimate success and the continuity of the system. People involve themselves daily, even hourly, in situations in which they do not act according to their own inclinations as social subjects. Instead they are governed by motives of enthusiasm, fear, or force which accord with the state of mind of the group in which they find themselves. The rationale of the group is in this connection often not only more irresistible but also more unified and unambiguous than that of the individual.

Social reality, which we are talking about here, is not an essence but a state, not a thing but a relationship, not something set and fixed but a process: it comes into being and activates itself when the individual comes into contact with other individuals and creates independent relationships. Society *is* not, it *becomes;* it is never complete but remains a system of relations which are always in the process of being realized. It corresponds to a concept of function not of substance. Individuals form a social reality when they conform to what they expect from others and when they adapt or oppose other people's supposed behavior. They follow, preserve, develop, or overcome attitudes which they expect from others according to circumstances.

The thesis that an appropriate description of collective patterns of behavior such as historical materialism or class-oriented ideologies is not psychological is based on the observation that social forces, in-

teractions, and achievements cannot be explained by a causality present in the active mental life of the individual. In the context of the decisive factors of these manifestations it is not even quite inappropriate to talk of "interests" in the psychological sense. As social beings, people do not necessarily act to further their own personal ends. They act and think generally according to those principles which ensure the continued existence and welfare of their own class, but which are often unclear to them and only mediately related to their own interests. They are not always conscious of class in their thinking, even when they are acting in accord with the interests of their class.

Class consciousness is the most striking example of a social rationale which is expedient but free from choice. It reflects a consistency of thought and will which does not spring from a group's intentional or planned organization, agreed politics or tactics. It is merely the concurrence of spontaneous, individual attitudes which seem as though the same feelings of mutual solidarity and distance from other classes are awakened in all their representatives, all of whom seem intent on nothing but the success of their own class.

Class consciousness bears only an apparent relationship to the concepts of *Volksgeist* and group mentality *(Gruppenseele),* for even if it cannot be regarded as the actual agent—the active and spontaneous representative of actions and achievements—it is more than a mere hypostasis. Categories like *Volksgeist* or *Gruppenseele* are constructed a posteriori; they add nothing to the attitudes which form their content and do not influence the character of their components. Social realities and rationales like class consciousness not only develop a resistance to certain individual velleities but also represent essential constituents of given attitudes and actions. A form of social unity like class consciousness can be reconciled with the coexistence of very different individuals who do not merge in relation one to another, even though they are not independent of one another. It simply forms a "common denominator" which is constructed afterward. For all that, when we define class consciousness, we must emphasize the collective and not the conscious force, for, in the strict sense of the word, only the single concrete individual is possessed of a consciousness. The use of the term to refer to social entities is justified only to the extent that the behavior of individuals of the same class shows a consistency and apparent purposefulness similar to that of the individual consciousness.

As Georg Lukács remarked, class consciousness is a "class determined unconsciousness,"[22] more precisely, a "possibility of becoming conscious"[23] rather than a "having become conscious." In other words, it is a potentiality rather than an actuality and exists only inasmuch as individuals behave according to the tenets of their class. What is

decisive, however, is that individuals, though moved by impulses which move them as members of a class, do not have to be aware of them. "It is not a question," said Marx in the *Holy Family*, "of what this or that member of the proletariat or, for that matter, the whole proletariat, sees as its goal. It is a question of *what it is* and what historically it will be forced to do according to this *entity*." People behave well or badly toward one another according to their socioeconomic situation. "They do not know this, but they do it."[24]

To call the rationale which prompts social subjects to think and act according to their class situation and their class interests *class consciousness*, and to relate it in any way to *consciousness* is inappropriate and misleading. The assumption that this rationale is *conscious* is just as unfounded and irrelevant as to assume that it is *unconscious:* it has nothing to do with consciousness in the positive or the negative sense. While from an activist political point of view it may be most important to establish whether class consciousness is empirically and psychologically conscious or not, from the point of view of social phenomenology it makes no essential difference. The psychological alternative, conscious or unconscious, is on a different plane from the difference between those social motives individuals consciously pursue or those which make them into instruments of class warfare by excluding their consciousness. Unconsciousness may be one of the most striking features of sociological attitudes, but it is by no means the characteristic which distinguishes them most sharply and most often from psychological attitudes. Psychological being and consciousness are no more the same than are sociological being and consciousness. The unconscious, too, is psychologically real and actual. Just as unconsciousness is often a frequent but not a necessary symptom of social processes, the criterion of what is psychological is personal motivation, not consciousness. The unconscious, too, is *psychological*, but not what has no personal motivation. On the other hand, social attitudes have their motivations, but they are not necessarily personal ones, and what makes them real and provides their rationale is that component of the group interests which transcends personal interests.

Class consciousness and ideology may be repressed in the psychoanalytical sense and kept from the light of psychological consciousness. The difference between the individual's consciousness of himself and the collective class consciousness, however, is not the same as the difference between the conscious and unconscious in psychoanalysis, however much this analogy may be suggested by the impulses class consciousness brings into play for which the subject takes no responsibility. Psychologically, the unconscious makes sense only when related to the individual, and Jung's "collective unconscious" is more

unreal than collective consciousness, whether in the romantic or the psychoanalytical sense. The analogy between the two forms of unconsciousness rests purely and simply upon the circumstance that in both cases a mechanism is in effect which prevents "underground" impulses from entering the consciousness of the individual. But while, in the mind, the repressions which stem from the unconscious cease to be effective the moment their origin is discovered, the inhibitions which derive from class consciousness often remain in effect even after they have been revealed as such. The ideological motives for social attitudes may, it is true, be unconscious and unknown to the individuals who hold them; nevertheless the struggle against their concealment, if one ever takes place, is fought out in the light of consciousness and reason, in contrast to the defensive maneuvers of neurotics, which take place in the dark of the unconscious. Consequently the class struggle, in spite of the impersonal and partially opaque nature of class consciousness, has incomparably less to do with depth psychology than those defensive operations against the revelation of repressed, rationalized, or sublimated urges known to psychoanalysis. The course of these operations is just as nebulous and obscure as the origin of the repressions, rationalizations, and sublimations themselves.

Ideology as the quintessence of a world view, of a feeling for life and for the values and norms of a social class, is a concept related to class consciousness. This is true insofar as they both originate in a rationale which sets a standard for the members of a group and they both express a context of meaning in which the discursively logical and psychological operations of the individual are not manifest. They differ from each other above all in that the influence of ideology on the effective thought and will of individual subjects is more obvious and more concrete than the influence of class consciousness. The latter has less sharply defined principles. A further distinction is that ideology is merely a means to class struggle and class consciousness. Consequently, ideology is closer to the psychoanalytical concept of rationalization and class consciousness to the concept of the unconscious which has to be rationalized.

The analogy between the formation of ideologies and psychological rationalization has been repeatedly pointed out. Ideology as "false consciousness" with which the members of a social class defend, conceal, or gloss over the actual motives for their actions is like the "rationalization" with which, according to psychoanalysis, people attempt to conceal or justify offensive thoughts and tendencies. To the extent that an ideology is mendacious and its true motives are not the same as the ideas, sentiments, and standards expressed in it, sociology is faced with a task of exposing and disclosing similar to that of psy-

choanalysis. The difference is that ideology does not collapse after the completion of the task as we expect rationalization to do after successful psychoanalytical treatment, but often only changes into a form of propaganda which is both explicit and unambiguous.

Of course, the consciousness of the members of a social class may be so "false" and deceitful that it is beyond the power of the individual to sustain an ideology in it. It may cause inner conflicts just as difficult and moral wounds just as harmful as the repression of motives rationalized by the neurotic. In this case the representative of the ideology has no other course but to adopt a cynical conformism—if his conscience is strong enough—or—if he is more frail—to take to a quixotic flight from reality. The possible cure, which is, to be sure, more dubious than in the case of neurosis, would be to discover the origin of the conflicts and for those afflicted to admit to the existence of the crisis and undertake its resolution. The artist, who plays such an important part in the formulation, justification, or exposure of ideologies, must be sufficiently prejudiced or uninhibited to justify the ideological travestying of truth in the face of all odds, or he must have the courage to declare war upon the fictions and lies associated with it. Otherwise he has to lie unconsciously, contradict himself, conceal the picture of reality which he paints and so forfeit his credibility.

"Men make their history," says Marx in his *Deutsche Ideologie*, "but they do not know they are making it." This process, which remains for the most part unperceived, is history which is ideologically directed or conditioned. The people who make this history do not know what they are doing, because it is not the conscious aims and interests or principles and values they endorse which are responsible for what happens, but those motives which are often concealed or which deserve to be palliated. These motives are manifest in the inner contradictions of social orders, in the irresoluble antinomies of economic systems, in underground class antagonism, and in the partially sublimated forms of class conflicts. Generally speaking, the real forces of history prevail in this concealed form so that people have no idea how far they are its source or its instrument.

The neglect of the individual and his spontaneity, whether it is prompted by idealism or materialism, leads to a conception of the nature of the cultural process which is just as false as the contrary misunderstanding. According to this misunderstanding, everything which goes beyond the individual and his peculiar psychological motives, everything beyond the concrete, specific case with its empirical conditions—especially the ideological structure of attitudes as a thing apart from the psychological processes of the moment—appears to be nothing but arbitrary and artificial abstraction, something without

substance or relevance. However, if the theory that the individual with his inclinations is only ideologically determined goes too far in the sociological direction, its converse—the assumption that ideologies are the products of men and are nothing but a patchwork—simplifies the actual facts of the matter in a much more serious way and makes do with a bland positivism so as to avoid what is an apparent abstraction. It is clear that people do not create ideologies arbitrarily and without some postulates, and it is precisely in the making of ideologies that it becomes most apparent that they think in a context of form and function which is alien to them as individuals. They reveal aims which they had not immediately foreseen and values which they had not consciously developed. People do not create ideologies according to their fancy and just as they please: they submit in the process to an objectivity, though not necessarily that of impartial truth. They are "master and servant" of their ideologies. The irreducibility of both functions expresses a characteristic feature of human consciousness, its duality, its subjective and objective, individual and social nature. In spite of all the testing, criticism, and correction to which it subjects ideologies, thought is still ideologically conditioned, just as, in spite of its dependence upon society, it is caught up in a permanent tension with and a repeated opposition to it.

Class consciousness is not a norm which is fixed a priori, is universally valid for all members of a group and followed unconditionally by them; it is not a cut-and-dried model for thought or a general rule according to which the individual has to behave. It is an eminently historical phenomenon which is always reconstituting itself according to the degree and the way in which individuals assert their class situation; it is always in a state of flux and change and in its collective spiritual and subjective-objective essence points to the concept of style in art and cultural history. Bourgeois class consciousness is just as firmly tied to a particular epoch as is naturalism, and like the latter, although it is collective in nature, it is represented in different ways by various individuals of the period. The one phenomenon is no more a creation of single individuals than the other. An artistic style, as Ernst Gall says, referring especially to Gothic art, is not "invented"; in other words, it is not produced spontaneously as a personal accomplishment or according to a particular plan by a particular artist. Yet somehow, at some point in time, it must have issued from an individual, personal, creative idea, even if this idea cannot be traced to a particular brain wave, a vision which could only originate with one single individual. Like other social structures, it is nothing more than the result of purely conscious and premeditated individual achievements, but

does not occur consciously and intentionally and does not limit itself to the consciousness of the individuals whose works represent it.

From every other point of view, a sociological category like class consciousness, ideology, or the mode of economic production is essentially different from the concept of a style like Renaissance or naturalism. In reality there are only more or less close approximations to such a style, not complete embodiments of it. A style is constantly developing; it is never complete and can never be realized as a definite totality. Class consciousness on the other hand may be more or less distinctly and exhaustively expressed by single individuals. The meaning of aristocratic, bourgeois, or proletarian class consciousness is absolutely unambiguous. It can, it is true, be defended, misunderstood, deformed, or sacrificed with differing degrees of intensity, but it is only susceptible of one adequate interpretation. To talk of a single adequate realization or definition of the Renaissance would be absurd; like every style there are innumerable examples of it which differ as to formal structure or artistic merit, but they are all equally relevant in the history of art.

In this connection it is worth mentioning the difference between the two meanings a concept like capitalism can have: these differ according to whether we are thinking of a historical style of economic activity, or a class-determined attitude or state of mind. The concept certainly remains a historical, collective one, uniquely objective, but while in practice capitalist economy does not have a unified measure of values and is constantly changing criteria, the capitalist state of mind as class consciousness is determined by a particular ideal, by the idea of a suitable attitude, although it does not offer *ab ovo* a finished pattern, just an objective rationale for class orientation. The "ideal" of correct class consciousness is only a sort of political imperative, and only in this connection does it have the character of a demand. At the same time it does involve a criterion of value which is foreign to the concept of historical style. It is therefore just as senseless to talk of a "stylistic ideal" of capitalist economy as it is to speak of an ideal realization of the Renaissance. Of course, some methods of capitalist economics are more successful than others, but there is no unified measure by which they can be judged. Every method, like every work of art, must be judged according to the way in which it solves the task at hand.

The idea that an artistic style is embodied with equal power in the output of an entire era, in the large work as in the small, in the monumental work and in the tiniest ornament is both unrealistic and untenable. Just as the same artist does not always express himself with the same intensity and concentration, so the characteristics of a style do not appear in all its diverse manifestations with the same clarity

and cogency. Every style is a borderline concept which is never entirely present in any single work or individual case. The concept has a number of characteristics in common with what Max Weber understands by the "ideal type," especially those which differentiate it from a metaphysical idea, a permanent value, or an unconditionally valid norm. The ideal types of capitalism, of craft, or of the medieval city are not, for Weber, the "essence" of the individual phenomena which form these categories but merely their exaggerated, utopian form, an abstraction which, without being in any way better or more complete, never occurs in reality. Their "ideality" does not rest in their "exemplary" nature, but solely in the fact that, purged of alien or inessential characteristics and freed from disfiguring accessories they show the characteristic properties of their type, in, as it were, "pure culture."

Even a style, like an ideal type, is a sort of "utopia" inasmuch as it is fully and finally represented by a single work. No reality at all, but only a heuristic function, can be ascribed to an ideal type, since it is in fact nothing more than a "methodological constructional aid" and serves to compare, subsume, and classify concrete things. A historical style, however, represents a "reality" of a type which is not exhausted by its individual representatives, and contains an objectivity and independence similar to social structures. For even if a style has less concrete characteristics than the individual work of art, it is a historical fact the reality of which is manifest in the tension between the peculiar effort of the artist and the direction of the collective trend, and this in no way resembles the relationship between the individual case and the ideal type. The style of a period is, for artist and audience, something entirely objective and accepted on its own terms, a movement which can be independently expounded and which has its own set of rules. The subject can be carried along by the movement, can accept it or oppose it, but in any case it is more than a collective concept, a thought construct, or an idea without substance. "The" medieval city never existed in this sense: there were only medieval "cities" to which the ideal type of the medieval city stands in the same relationship as the concept—totally unrelated to reality—of "style," stands to the different individual styles of, say the Renaissance or naturalism, which are not mere abstractions even if they can never be perceived. Just as there is in reality no such thing as "art," there is also no "style"—only styles. In the same way there are only different languages, or, strictly speaking, dialects, and no such thing as "language." In both cases we are dealing with concrete modifications of a basic form which does *not* exist. Art, too, speaks in dialects. The exercise of art without a particular style is as unthinkable as a universal language which, if it were to continue to be used effectively, would

remain unchanged and "unspoiled." "Style" is an abstraction just as Esperanto is a lifeless artifact. The different modern languages—German, French, English—with their historically and geographically conditioned rules, stereotypical word formations, and idiomatic turns of phrase correspond to styles. The concept of "the" style as a universal theoretical category of art, particular historical art styles, and the individual works of art represent three stages of being which extend from a completely unreal concept of genre to a reality *hic et nunc* of unique, empirical, concrete things. An individual artistic style like the Renaissance or naturalism stands in the middle of the scale. It is neither as immediate nor as tangible as a painting or a sculpture, but becomes, unlike an ideal type, the substratum of an attitude in which taste and emotion are stressed.

Ideal types can be constructed for the most diverse phenomena, objects of sensual experience and abstract thought, individual and collective, historical and timeless facts. The ideal type itself is, however, an ahistorical structural concept, whereas a style is essentially and exclusively a historical phenomenon. The unreality of the one is expressed in its alienation from history, the reality of the other in its historical character. In this sense a style, unlike an ideal type, shows a tendency toward development and implies the concept of a direction, the idea of the gradual realization of an intention, a creative urge, even if this is not a continuous and always progressive process. It implies a conception of form which, however, has nothing to do with an increase in artistic value. The representatives of a stylistic movement behave in any case as though they were driven by a particular impulse to reach a certain goal. This stimulus, although it cannot be thought of in any sense as a real anonymous power, has things in common with other subjects, of course, but it changes with every creative subject into its own inner, personal dynamic and conforms only because it is influenced by traditions, conventions, and institutions. It is true that Hegel's doctrine of the "cunning of reason" does mystify the super-individual purposefulness of development by making an actual driving force out of a concept which was only constituted for speculative purposes. However, phenomena like ideologies or historical styles can only be described by stating that their representatives are conditioned by a rationality which does not issue from their own consciousness, which they do not have to be aware of, and which, so to speak, manifests itself over their heads.

The difficulty surrounding the formation of a concept of style is by and large the same as that surrounding the conceptual definition of social structures. We also have to understand a style as something general, a pattern which is separable from individuals and their works,

without at the same time thinking of it as something like a transcen-
dental prototype which is presented to individuals, an example they
consciously follow, a standard of value or a binding norm. It is not
a basic concept which is fixed for all time and which subsumes phe-
nomena of a less general nature. Nor is it a supreme, logical concept
from which other subordinate concepts can be derived. It is a dynamic,
dialectical, relational category which is constantly changing according
to its content, scope, and sphere of validity, and this is modified by
every important work. On no account should we think of it as an
entelechy associated with Hegel's "world spirit" *(Weltgeist)*. Styles
have nothing to do either with the purpose of a universal plan, as the
philosophers of history would have it, or with the supernatural aptness
of some intuitive idea. A style is nothing but the result at a given
moment of purely individual products, a result which assumes different
forms from time to time. The products themselves are always directed
toward an immediate, concrete task; individually, they have an aim in
view, but they are completely unaware of the final goal. A style never
materializes in the consciousness of its originator more than a step at
a time; in other words, it does not enter the consciousness of the
individuals from whose products it arises.

The collective attitude which is expressed in an artistic style realizes
something which no one has "willed" and realizes *more* than any one
individual could will. What is willed at a given moment is the single,
particular work of art—Leonardo's *Last Supper* or Raphael's *Sistine
Madonna*, not the "High Renaissance." Style is nonetheless an entity
of which we can talk without any conceptual realism and without
substantiating an abstraction. The common stylistic characteristic
which unites the products of a period does not have to be present in
any individual consciousness in order to manifest itself as a perceptible
reality. Collective intellectual tendencies take on a mystical, meta-
physical character only when we see in them the expression of hidden
goals and consider them as having been placed in the service of a
Weltgeist, an ultimate goal of history, an autonomous logic of the
economic and social process or of an abstract, impersonal artistic vo-
lition.

A style is neither a single, concrete thing nor a collective concept;
it cannot be derived from characteristics of its exponents either by
addition or abstractions. It is always more, but at the same time less,
than what is expressed in the works which make it up. It is neither
contained in the works nor are the works contained in it. The most
suitable way of describing it is in terms of a musical theme of which
only variations are extant. The theme which has to be re-created will
be neither the sum of the variations nor a selection of their character-

istics nor an abstract compilation of characteristics common to the variations. A sum never contains more, an abstraction always less, and neither anything further than the elements of which they are made. Theme and variations go beyond one another, although they are strictly bound to each other. In certain circumstances the theme will not show a single concrete feature of the variations but will instead clarify the musical thought which is at the base of all the variations but which does not clearly emerge from any of them. The possibility that more than one theme could be reconstructed from a series of variations does not alter the fact that every series has a special structure which can be formulated with more or less luck and skill. Not only the variations but also the different possible formulations of the theme—which, with respect to the problem we are here discussing, correspond to the different definitions of a given style—merely revolve around an ideal structure without always grasping it satisfactorily.

The observations of *Gestalt* psychology on the phenomenon of unchanging structures which possess different attributes are also valid for the concept of style, which is obviously a *Gestalt* concept. *Gestalt* psychology emphasizes the fact that we recognize a melody even when it is played in a different key from the one in which we first heard it. The structure, the coherence, the sequence of intervals are expressed through, but not in, the notes. It is this which makes them recognizable, although everything audible, all the actual sounds, has changed. This structure is no less real than the notes played separately even though it is not perceptible to our senses. In any case we experience it directly and do not establish its presence by deliberation and speculation. We are faced with a similar phenomenon in the case of an artistic style. Just like a musical structure there is also a Renaissance style which is a collective, objective structure not contained in any work of Leonardo or Raphael but having the same unambiguous reality.

In order to form a correct idea of symbols of this sort we must bear in mind, on one hand, that they lack empirical and metaphysical substance, that their reality is neither sensible nor transcendental, and, on the other, that they have their own peculiar purport and objectivity. We must not forget that in them we are dealing with *structures* which can neither be called things nor mere constructs. The uncritical positivist fails to recognize in every sphere of culture, in every valid objectivation and verifiable interpretation of existence, the workings of its own coherent and consistent sense—of a "rationale." Idealism alienated from experience also fails to recognize that the principles inherent in cultural structures are not autonomous forces which move history but, rather, objective relationships which change from one case

to another. Their authoritative influence rests on the fact that they form quasi-institutional receptacles in which the subjects which have been formed by tradition and convention and which are linked by interplay can operate.

In the sense of Ranke's dictum, "Imagine aristocracy in all its aspects, you will never imagine Sparta,"[25] we can never guess the individuality of a particular artist from the characteristics of a style. No matter how exact our knowledge of the Renaissance, we cannot have an idea of the possibilities inherent in a single representative of the style. A similar relationship exists in cultural history between every collective and its components. The normative totality artistic styles have in common with social structures prevents us in both cases from drawing definitive conclusions about the components. Totalities of this sort inevitably sacrifice their peculiar nature as soon as they are cut up into single acts, attitudes, and products. Just as a social totality comes about not through the summation of individual attitudes but by the functions individuals perform only after they have come into contact with one another, so the unity and totality of works of art do not arise merely as the sum of words, notes, lines, and colors. They are the dialectical result of the tension which is renewed, heightened, and sharpened from word to word, note to note, and brush-stroke to brush-stroke, whereby the structure of the whole arises *pari passu* with the differentiation of the details.

4 Art and Historicity

Idealists and romantics are of the opinion that the more loosely works of art are connected with the period in which they are created, the more important they are. Michelangelo, Shakespeare, and Bach are heroes of the mind, who have taken up cudgels on behalf of all mankind and spoken to the whole world not only about things which are equally important to all races, classes, and generations, but also in a language which everyone understands. What they had in common with their times and their contemporaries was neither particularly noteworthy nor especially lasting. Upon closer inspection, however, we see that the greater the artist, the more numerous and significant the points of contact between artistic creation and historical circumstances. Shakespeare came to terms with the theatrical conditions of his day, the prevailing stage conventions, and public taste—questionable though it was in many of its aspects—more readily than most of the ambitious dramatists of later centuries who moved in the rarefied atmosphere of an ideal stage. Bach's formal language was as much a part of his time and his fidelity to tradition was so unshakable that even the next generation, which included, of course, his sons, looked upon him as a dangerously conservative artist. Cézanne, too, not only remained true to the achievements of his impressionist predecessors when he was already producing the new masterpieces of an epoch-making art but also actually believed that his progressive artistic ideas could find a point of contact with Poussin, the founder of French classical taste.

There are innumerable convincing examples of the congruence of greatness and convention, progress and tradition, immortality and contemporaneity in art, and principles of taste which are historically conditioned and appropriate to the demands of the day can be shown to

71

be completely reconcilable with the highest artistic standards. In spite of this, the idealist and the romantic will unfailingly start talking about the "eternal" and "universally human" as soon as he begins to philosophize about art. In reality nothing changes more strikingly and radically than art, and nothing changes its forms so frequently and obviously as artistic expression. There is also no area of thought and sentiment in which men are more widely separated than in this. Every nation, every social and educational class is inclined to develop its own formal language and to express itself in a manner which generally seems to all the others to be pointless and unattractive. Nowhere do we meet universal human statements less often than in art. The artist always addresses his contemporaries, but usually only relatively few of them. Only the very smallest number of authentic works of art are understood adequately by a large number of people; most have to be explained first and then seriously recommended to, or even forced upon, the public. The art of the past which, thanks to its inculcated reputation, does not need such a recommendation is as a rule misunderstood because of changed conditions, new forms of thought, feeling, and living. A work of art is created and exerts its influence in the medium of historical time; its success, or lack of it, depends just as much on the external circumstances of the moment as upon its inner aesthetic quality. It is saved from transitoriness not because of its supposed timelessness but as a result of its repeated involvement in the course of history, and it survives the day of its birth and rebirth as it moves out of the darkness of oblivion and misunderstanding into the light of a more or less short-lived memory. Bach, whose works have come to be recognized as possessing a more abiding and unquestionable merit than those of anybody else, was actually one of the masters who remained most completely unrecognized for the longest time after their death. Shakespeare fared little better; between Dr. Johnson's day and the romantics little thought was given to him. The French seem to manage just as well without Shakespeare as the English do without Racine.

Art is in no sense the "mother tongue of humanity," either in the sense of a primitive, original ability which the romantics thought of as natural and instinctual, or in the sense of an eternal, universal means of expression which preserves its essence and its value, as the doctrine of the "validity" of higher values would have it. The language of art emerges slowly and with difficulty; neither does it fall into people's laps from heaven, nor does it come to them naturally. There is nothing natural, necessary, or organic about it; everything is artificial, a cultural product, the result of experiments, changes, and corrections.

The most generally valid characteristic of art—about which, other-
wise, so many contradictory statements can be made, such as that it
is at once formal and material, spontaneous and conventional, pur-
posive and purposeless, personal and superpersonal—is its novelty,
uniqueness, and unrepeatable character, in short, the dependence its
products have upon time. The objection that in spite of this they retain
their attractiveness and influence, sometimes for centuries or millennia,
is sustained only to the extent that many artistic creations are redis-
covered reinterpreted and put back into circulation a long time after
they have become antiquated. That this happens only in very special
and particular circumstances shows that art cannot escape historical
contingency, even with its renaissances. Its works are never immortal,
however tough an existence they may lead in a period of education,
academism, or historicism.

All attitudes of consciousness and all cultural achievements occur
in forms which are historically conditioned and which have a validity
limited by time. However the aims and achievements, rules and values
of learning and morals rise above the subjectivity of their represen-
tatives, the aesthetic attitude in both its creative and receptive form
remains linked to the given unique, concrete, and contingent individ-
ual. As a result, artistic experiences have a more expressly and more
exclusively historical character than other forms which are guided by
objective values. Even a scientific discovery is temporally, spatially,
and socially conditioned—if not in its entirety, at least as far as its
practical function is concerned. Yet even in science not everything is
possible at every moment. This is not only because every discovery
and statement is historically preconditioned and represents a particular
stage of development in thought and research, but also because the
establishment of truth originates in a particular sociohistorical situation
and in the tasks and interests proper to it, not in an abstract urge for
knowledge or an ardor for the facts. In the area of theory it is the
search for truth, the process of finding out the truth, the succession
of questions, perceptions, and errors rather than the scientific truth
itself, the content and the validity of perception, which has a "history."
This is unlike art, where, in addition to the application and recogni-
tion of values, the circumstances of production and consumption, the
ways and means, and the organization of labor and of product evalua-
tion, values, criteria of taste, and measures of quality are historically
conditioned.

Art is historical in character not only because of its means of expres-
sion, which are more deeply rooted in cultural development than most
media of communication, not only because the artist is more eager
than others to exert influence, but also because of the substratum, the

material, the objects, and the motives of its representations. All this is a product of historical development as the artist finds it and not as he fashions it. In pointing to this double historicity, Georg Lukács in his *Aesthetics* says that the raw material of music and architecture, in contrast to natural objects, which "exist of themselves," only emerges in the course of history.[26] The historical nature of the material, which is the stuff of art, reveals itself not only where, as in music, architecture or ornamentation, it creates its own substratum but also in forms in which it uses independent, finished, natural objects. However much the artist seems to be above ephemeral reality and however much he tries to embrace what is eternally human, it is always people, milieus, and situations in one brief historical moment that he depicts. Also, not only is it characters, psychological problems, and moral conflicts which he portrays differently from time to time and from case to case, but even objects of extrahuman reality reveal divergent features according to the extent to which they are related to human existence in the hands of a particular artist. Landscape painting of the nineteenth century differs from that of the seventeenth in more than simply style and motifs. A different *historical* world from the forest clearings, marshes, and meadows of the School of Barbizon or the fields, gardens, and roads of the impressionists—a different source of sensibility—opens up in the cloudscapes, the dunes, and the canals of the Dutch masters. Town and country, companionship and solitude, a sense of unease in the civilized world, and the return to the soil from which we have been alienated mean something different in every case. An artistic creation always owes vitality and truth to the certainty and the limitation of its object and its aspect. The features of a real work of art are never discernible from a timeless distance. Its genesis, effect, and renaissance are all linked to time in one and the same way.

The historical nature of art derives mainly from the fact that the true, high-quality, complete aesthetic object consists of the active subject-object relationship. It is not the artwork itself, but the actual artistic experience that has become effective. This not only means that receptive subjects in their particular historical situation always experience and evaluate different works or experience and evaluate the same works differently, but also that the works in themselves seem to change as they appear in changing historical contexts. It is not only that new works are created under the influence of old ones but that these too change according to the particular art which they are unavoidably related to at the moment. We distinguish historically between artistic creations mainly as to whether we experience them as topical, relevant to their own time, existence, and practice, or whether we regard them as pure fiction, imagination, and a fierce incursion into a strange,

distant, antiquated, and vanished world. The borderline between the two areas is in a constant state of flux. Every new movement, every new artist, every new work can change the kaleidoscopic picture which results from products and works already well known. Proust describes the process remarkably vividly: "Les plus vieux (des gens) auraient pu se dire qu'au cours de leur vie ils avaient vu au fur et à mesure que les années les en éloignaient, la distance infranchissable entre ce qu'ils jugeaient un chef d'oeuvre d'Ingres et ce qu'ils croyaient devoir rester à jamais une erreur (par exemple, l'*Olympia* de Manet) diminuer jusqu'à-ce que les deux toiles eussent l'air jumelles."[27] To the extent that works are created which are felt to be new, contemporary, vital, attractive, or repellent, so the number of classical works and the criteria for classical quality change. New works are always entering the class of authentic, exemplary products, while others no longer count as classics. Every shift of this sort results in a reevaluation of all known works and a new inventory of the whole stock of standard artistic creations. The moment we recognize Manet's Olympia as a master-piece, our concept not only of modern art but of classical art as well changes.

Artistic creations never appear to a later generation in their original, relatively simple, and unambiguous form, but always laden with an accretion, enriched and partially concealed by sediments with which later works cover them. Just as Greek sculpture acquired new, more dynamic and dramatic features because of Michelangelo, so Michel-angelo's art was put into a new light by the work of Rodin and brought closer to impressionism. The baroque art of Rubens was intensified by Delacroix; the pictorial improvisation of Frans Hals and Velazquez revealed new qualities to the eye schooled in the art of Manet and Renoir. Piero della Francesca has become a master since Cézanne, Seurat, and the cubists redeveloped the clear articulation of the per-spective plane and the sense for tectonics which had for the time being been lost. We may recollect in this context of meaning the following passage in *Modeste Mignon:* "Au bas de Montmartre un océan d'ardoises montre ses lames bleues figées; à Ingouville on voit comme des toits mobiles agités par les vents" and Paul Valéry's "toit tranquille où marchent des colombes," and we would rightly observe that the "meaning of the *Comédie Humaine* has been enriched by its relation-ship to a magic of which Balzac himself probably did not have even an inkling.[28]

The story of the production of works of art is by no means complete when their authors hand them over. They continue the process of metamorphosis which constitutes their existence and táke on not only unexpected new features but also a new meaning which would have

been incomprehensible and probably often surprising to an earlier generation. Talking historically, they are never complete and just as they do not come into existence full-blown, they never disappear once and for all from human sight. The museum or the textbook is frequently all too confining for them: they move constantly between birth, apparent death, and renaissance.

There is no stage of development from which the next stage of history can be deduced; none permits a prophesy to be made, but each one bears the marks of Friedrich Schlegel's "backward-looking prophesy" in itself. Just as every work of art, thanks to its traditional elements, appears to be the result and summary of the past, so, thanks to its original and topical features, it becomes at any given time the source of a new image of the past and of a new historical orientation and periodization. The productivity and the originality of a given present are responsible not only for the new discoveries and reevaluations made by the history of art with its constantly expanding field of vision but also for the shifts in perspective which from time to time redirect and reorganize the whole development of art. Since every image of the past is oriented toward a consciousness of the present and we only see as much of the art of the past as is visible from the present, the retrogressive force of the actual developmental tendency is no less powerful than the impulse which drives it forward. The history of art so regarded is dialectical. The new arises from the old, but the old is always changing in the light of the new and takes on features which were not visible at any former stage.

It is part of the paradoxical nature of the work of art that it is always transitory and that as a historical phenomenon it fits into a chronological series; on the other hand it has to renounce this transitory character and the relationship to other artistic phenomena and stand as a completely isolated individual case, unprecedented and individual. Only in this way can it become the object of an immediate, evocative, microcosmic experience related to the totality of life. Works of art are historically unique; they are linked to a particular point in time without being lost in the historical process. They cannot be explained adequately by their genesis or be surpassed in the course of development or rejected once and for all. They remain incommensurable and cannot be repeated, and, unlike the periodicity of natural phenomena, this uniqueness expresses their historicity.

Every human achievement which is unmistakably individual reveals unique features, but a work of art is unique in a much stricter sense of the word than any other human structure. We mask or falsify its aesthetic character if we ignore its incomparability whether in the historical or the systematic sense. Every type of conceptual structure

which goes beyond the individual work of art—the philosophy of art, which regards "art" and "beauty" as realities; the theory of art, which regards "arts" and "genres" as objects of immediate experience; and the history of art, which sees its actual material in "styles," "movements," and "schools"—leaves the realm of real artistic phenomena and enters an area which is in part ultraartistic. The various works, styles, genres, and arts do not form a "system" in the sense in which the relationship between scientific concepts and categories do. There is no unified art from which the different arts derive, and there are no unified arts and genres from which single works can be derived, but there are also no collective styles from which we could derive special personal aims. The individual work of art and the individual desire to create a single work of art are the only things that are "real" in the sense of an object which is immediately accessible and capable of being experienced. In relation to art, everything else is a mere abstraction and has at best a theoretical, logical, psychological, or sociological meaning, not an intrinsic aesthetic one.

The idea of universal human aesthetic values which are conditioned superhistorically and have an eternal validity only emerges when we give "art" pride of place over individual artistic efforts and achievements. In contrast to this, the concept of an art always identified with itself or of an artistic urge inherent in nature and innate to man is completely fictitious. Originally we only have different reflections of reality through our senses and the forms of consciousness latent in these reflections. The conceptions and representations of real objects are constructed from these and among them the original individual artistic depictions which are connected to one another only in their relationship to common practice. The conceptual integration of these isolated forms into genres, into types of art, and finally into the unity of art must be the result of a complicated process of abstraction, no matter how vague and logically inexplicable. It must be the result of a long development of thought which has no immediate connection with the production of individual objects.

One thing is certain: every work of art shows clear traces of its own time, and contains the unique, unrepeatable, and unmistakable character of a historical constellation. It represents a stage in the development of style which is precisely definable, in technical accomplishments and in sensual-intellectual sensibility. It depicts people and relationships in situations which arise once and only once and addresses itself to individuals who judge the depictions from a specific historical standpoint and a particular social position. Whether reality in and of itself is "by nature historical,"[29] as the extreme historicists have it, must remain undecided, for an observation of this sort contains a consid-

erable dose of metaphysics. The thesis that nature is a historical con-dition and can be talked about only in a metaphorical sense represents, in contrast to the doctrine that art is a product of history and culture, just as bold a construct as, for example, the theory of a dialectic of nature and belongs to the same complex of ideas. If we were even to consider the question of whether nature is historically or dialectically activated, we would have to deal with spans of time as immeasurable as that needed for biological change in organs, and this would be incompatible from the outset with the concept of history as a cultural development. In any case, even if we did widen our boundaries to this extent, we could only talk of a "history" of nature in the sense of an essentially automatic and continual development which is interrupted only by external mechanical or internal pathological disturbances. In the history of cultural structures on the other hand we can talk neither of a continuity nor of a straight-line development in this sense, and the concept of "interruption" can never be applied to other phenomena unless it is used to explain every change.

No matter how often the rule of development has been corroborated, it cannot raise history above the incalculability of determinant motives and the unpredictability of personal initiative. Wölfflin's thesis that "everything is not possible at every moment" nevertheless remains valid.[30] For the individual always only has a choice of limited options. Wölfflin, however, did fail to recognize the significance of historical dialectic. Although he was certainly aware of the limitation of what is historically possible at any moment, he did overlook the fact, as Dilthey correctly remarked, that there are always several ways open to the individual.[31] In Wölfflin's doctrine of "art history without names," the freedom of the individual falls victim to a one-sided un-dialectical logic of history where the means of expression not only are given primacy but also have an autonomy ascribed to them which places them above the individual will to expression and above indi-vidual meaning. No account is taken of the fact that both factors possess the same dynamic nature, and that the historical development of art is kept in motion by the tension between the will to expression and its means.

The doctrine of periodicity, of the regular articulation and circularity of historical development, recurring types, and morphological stages, and even the tripartite scheme of the dialectical process are, like the idea of historical destiny, of constant progress, or of inevitable decline, merely a variant of that historico-philosophical mysticism which be-lieves that historical processes can be constructed and schematized. History operates within the boundaries of the individual's personal creative initiative, however limited this may be. Everything which lies

on either side of his relative freedom is beyond the sphere of history. The principle of periodicity Wölfflin advances in his "art history without names" is just as ahistorical as the autonomy he ascribes to the development of the visual as the medium of fine arts. The real history of art goes as far beyond such physiological and psychological categories as it stops short of that universal historical logic which according to Hegel asserts itself over the head of, and independent of, the will of the creative subjects. It is governed by a principle of freedom—of a freedom which is in a state of permanent tension with physiology, psychology, and sociology.

Constraint and freedom, law and coincidence can scarcely be separated in history. The degree of their involvement can best be illustrated by the familiar example of two balls which have been set in motion and which then collide. Each of the two balls runs its own course as a result of a causal necessity which conforms with the impact it suffers from the other. That one ball is struck by the other has nothing to do with the causality of their motion and is coincidental to their inclination to move. The chance collision results, like the coincidental nature of every historical phenomenon, from the fact that events are always the result of several intersecting lines of causality. Every artistic style, every creative personality, and every individual work of art come into being through the "chance" collision of different, autonomous lines of causality. The means of production available at a given time, the social orders, the organization of artistic work, the economic state of the art market, the influence of traditions, the state of artistic technology, the biological and psychological state of individual talents all have their own raisons d'être and assert themselves according to a causal necessity. Their fusion in the creation of a particular style or work depends upon an incalculable number of coincidences. But it is not only the combination of different lines of causality which is coincidental: coincidences are also involved in the more or less precisely prescribed development of every factor—every one of them contains incalculable, spontaneous elements.

An event or an achievement may appear necessary as the known result of known causative conditions, but the end-result is still not predictable, no matter how many known factors there may be. An event which has taken place can be more or less satisfactorily explained; its development cannot be observed. Engels's view was that we always see only the individual factors of a happening, "the components of a parallelogram of forces"; we never see the process by which the resulting force arises, and so we can easily gain the impression that there is a higher, supernatural force at work. The only thing beyond doubt is that in a gathering of men, when one person tries to prevent another

from doing something, something emerges which no one has willed or foreseen.[32]

The complete causal foundation of the historical process appears to be unattainable in the face of the innumerable number of determinants. That there is a non–causally determined residue which plays a coincidental part in all history does not mean that this residue is without a causal context. The coincidental nature of historical events often means merely that the reasons for the events are not yet known. Much that seems coincidental today may appear to be causally conditioned tomorrow. Yet even if the history of mankind were one day to present the picture of an unbroken chain of causes, it would still be far from presenting the picture of a logical necessity. In spite of all its causal necessity, logically it would remain coincidental. For though we would know why one event follows another, we would have no evidence that this was the only possible continuation of the preceding happening.

Every work of art is a milestone on a road which follows, it is true, a certain direction, but which as a whole has no particular or constant end in view and, though it may lead to certain achievements, never reveals a definitive purpose which guides all the efforts involved.

The unique and unrepeatable quality of artistic creations expresses not only the historical peculiarity of art but also an ahistorical something, the microcosmic exclusivity, the unsurpassable quality, and the final nature of works of art. While works of art are most intimately linked with the circumstances surrounding their genesis, they are only superficially connected to one another. The artistic products of different stylistic periods, generations, and artists not only have no common aim, unless it be a technical one, but cannot even be judged by the same criteria. They do not continue or supplement one another; their relationship is a more or less arbitrary construction of art history. In reality each follows its own path and starts afresh. No matter how often they make reference to other works, they never represent a step by step ascent. Later works are not necessarily more valuable than earlier ones; indeed, they cannot even be compared with one another. As Walter Benjamin says, "Perfection keeps works of art apart from each other" *(One-Way Street)*. The absence of value judgments in the concept of development in art means not that there is no technical progress, nor that we can talk of individual products only in terms of "good" and "reprehensible," "success" or "failure," nor that the transition from one extreme to another did not matter. It simply means that a stage which is historically more developed does not—as it does in technology—of itself ensure a better result.

It is not only progress in technical execution, but also the enrichment and differentiation of motifs and forms of the depiction of reality and

feelings which may be of no artistic concern; for even the heightened sense of reality and refined sensibility merely represent component parts of a complex, which can be judged artistically only in its entirety. That the history of art can dispense with the concept of development and progress no more than can the history of science is of no great importance in this connection. What is important is merely that a higher stage of stylistic development does not of itself mean a higher quality. A heterogeneity of values of this sort is unknown in the scientific domain. The difference is apparently linked to the fact that artistic quality is determined by a complexity and by an inner relationship of its components, which science taking a total abstract view of life abandons from the outset.

The unique, incomparable, and final character of artistic creations also explains why the nature of evidence in art is so different from what it is in science and that the representation of reality in one work of art can never be contradicted by another. For this reason the experiences and perceptions gained by art are never vitiated by their ideological prejudices. It is not in the least disturbing that many observations made by art often quickly lose their validity and never actually achieve universal recognition. They contain statements which are neither objectively binding nor susceptible of proof and which indeed do not permit discussion of their factual content, even though they do represent insights into the meaning of life which are otherwise essential, invaluable, and apparently irreplaceable. Artistic representations of reality aim to be, and should be, relevant, revealing, and inspiring, but their relevance does not depend on their being correct or indisputable and has nothing in common with the role of validity in science.

The doctrine of validity is based on the view that the truth of a statement has nothing to do with its genesis, its discovery, and its formulation, with the completeness or incompleteness of its assertions, with whether it is accepted or rejected, indeed, with whether anyone is even aware of it. The concept of validity owes its origin to the antithesis between the logical structure of truth and the psychological conditions by which something is found to be true. Its origin is to be found, in other words, in the discrepancy between the normative sense of truth and the individually varying ideas we have of it in a particular set of circumstances—ideas which do not, however, interfere with the intended sense. The view of the objective nature of truth in science which is in opposition to subjective acts of perception is of fundamental importance, however we answer the question of whether it can ever be grasped. It is also independent of the circumstances which make its discovery topical, which determine its form at a given moment, and

which make it able to enter human consciousness. On the other hand, it is doubtful whether we can talk at all of validity in art, where the difference between truth and the discovery of truth finds no analogy to science, and the psychologically empirical subject only plays a significant role in research and not in the network of thoughts which are explored.

Essentially, the doctrine of validity consists in the assumption of the complete objectivity and timelessness of meaning-contents—in the notion, that is, that the value of a statement was present and in force before it was observed and perceived and that it would retain its meaning and force even if it were never perceived. Now if such an "essential form" were at all conceivable, even though not acceptable with respect to theoretical or moral values, it would have no basis in reality as far as aesthetic values are concerned. These not only make their initial appearance in individual concrete works of art but only acquire substance by means of them. There is no artistic value separate from a work of art which could have any validity or which could become the object of a "phenomenology." The same truth can appear in the most varied contexts and be subject to the most diverse modifications and yet assert its validity; but for a creative work of art there is only one single valid form—that which is discovered by the unique and individual psychological subject.

We must ask ourselves in what sense we can talk of an aesthetic validity as well as a logical one. There is a certain degree of objectivity attached to the meaning of a work of art as well as to a scientific thesis or a moral norm. As aesthetically receptive subjects, we are also aware that we confront objective structures which point out a direction for our reactions and which contain the criteria for their correct interpretation. We are sensitive to the work of art as something unambiguous, something to be interpreted in a particular sense—however differently it may be experienced and judged from case to case. Its meaning poses a task which may be susceptible of several solutions, but it refers to an objective content similar to that which obtains in the perception of a scientific thesis or theory. The receptive subject is here, just as he is there, in a state of tension as regards objectivity with the reception and understanding of which he is charged. Judgments of works of art are formed in accordance with this objectivity in accordance with the belief that, though they may not be binding upon everyone, they are of normative significance to the person making the judgment. They are reminiscent of the challenging character of the validity of logical judgments and correspond to a presumed necessity for recognition. They are not simply determinative judgments merely registering content, but qualitative value judgments, often in the double sense of the

word. The genuine work of art is called successful when compared with similar but less worthy products (and this may or may not be so): it stays true to its own aims and is, and stays, suited to its idea and the means of its execution. The other value concept which is generally involved in aesthetic judgments is much more problematical. According to this, the creative activity of the artist is related to superpersonal and supertemporal rules and norms and the artist's merit is made dependent upon whether and to what extent he adheres to these abstract criteria. The observation of such measures of value is based on a misunderstanding of the nature of art and involves the mechanical transmission of logical validity to aesthetics.

If we can talk about validity in art at all, we can do so only in the sense that values which have already been realized are objective and can claim recognition. We can never talk of absolute values, constant from the outset, which have their own existence and can claim of their own right to be realized by the artist. If we sense some obligation to these principles of value, we are simply expressing a self-imposed duty, one that merely objectivizes an inner subjective impulse. The receptive subject, on the other hand, is guided by a real objectivity in his reception of a work of art. The presupposition of objective, impersonal aesthetic values which are to be recognized unconditionally by the artist but which nevertheless remain independent of his proclivities and inclinations is based on the totally arbitrary construct of an abstract normativeness of formal artistic principles which correspond to the validity of theoretical truth. We cannot talk in art, as we do in science, of an alienation between the idea and its execution, of value and its realization, of valid norm and historical form. In art the two forms of the concept are an indivisible unity. The work of art is the aesthetic value itself, which is not present, in any form, outside the work of art and cannot reasonably be generalized. It is completely pointless to want to distinguish between a value which is to be realized—say, an abstract beauty or a general aesthetic form—and values which have been realized artistically, unless we do it for the sake of formal logic. For although the artist may have the feeling that he has not completely realized the vision which appeared to him as an object, he will nonetheless be able to describe the vision only in the forms of the supposedly insufficient work and realize it for himself in this way. A vision can never be determined in abstract form—only in the form of a concrete work.

It is altogether questionable whether, side by side with values which have been realized and recognized as normative and exemplary, we can speak of values still to be realized which lay claim to a superhuman and supernatural spiritual origin. Values exist only where there are

needs. Human beings create themselves and their history, in the Marxist sense, by ascribing the character of a value to the products which satisfy their needs. The aesthetic values which correspond to this presupposition no longer have any autonomous idealistic necessity; they are needs which have been satisfied; they are no longer postulates.[33]

Artistic values only appear as historical realities; they only exist from the moment they are given body. The artist does not discover them; he creates them. They are not cut-and-dried, preexistent, ideal images simply waiting to be taken hold of. For this reason there is nothing in the domain of art which could correspond to the approximation of the idea of truth in science. If the artist appears to be remote from his idea, this means that there is a lack of clarity and precision in the idea itself; it does not mean, for instance, that the idea was present somewhere, and somehow, in a more complete form than in the artist's imagination.

Only in the relationship of the receptive subject to the work of art do we have anything like the tension which exists between content and comprehension in the realm of theoretical thought. The receptive aesthetic attitude is an attempt to reproduce experientially the meaning of an artistic work and the feeling behind it as they are objectified in the work. This is the value which has to be grasped. The grasp of it by the receptive subject always, though actually never totally, corresponds to the value represented by the work of art as opposed to the creative act, for here we cannot speak of a value which is independent of the act. The receptive aesthetic experience, however, represents a fundamentally different attitude from the effort to seek truth, although there is a similar tension between subject and object. In the field of art the receptive subject plays a part which is conditioned by all the circumstances of existence. To develop the appropriate, normative, imperative, receptive experience, the subject must retain that complete empirical diversity which corresponds to the totality of life. It is just as important that there be directed as adequately as possible toward the work a context of meaning which is objective and independent of the subject.

It is the relationship between historicity and timelessness in which aesthetics differs most sharply from theory, as far as both the productive and the receptive acts are concerned. Scientific research has for long (though not limitless) periods of history directed its attention toward constant goals and has sought to acquire and expand homogeneous knowledge. This is a process which, taken all in all, is rectilinear and progressive. It is conditioned more frequently from within, that is, by results already achieved, the completion of solutions already to hand, and the filling in of disturbing gaps between problems already

solved rather than by contemporary historical circumstances and needs. In this sense we can maintain that the sciences, especially the formal ones like logic or mathematics, have no actual "history" and that as far as they are concerned it is more proper to speak of a history of errors and misunderstandings than of one with positive results. It is true that even here the results of research are always expressed in formulas which are historically conditioned, but this is in no sense identical with the development of truth.

In the domain of art, where the history of formulations and of values cannot be distinguished, the historical problem consists in the apparently puzzling fact that works whose character is indissolubly linked with their historical motivation also have a value for periods which have nothing in common with the circumstances prevailing when these links were created—and can become the object of direct empathy. Marx defined the problem in the introduction to his *Critique of Political Economy:*

"Is Achilles possible in a time of gunpowder and lead, or the *Iliad* at all in the age of the printing press or printing machines? Doesn't the printer's devil, of necessity, signify an end to singing and the muse; don't the necessary conditions for epic poetry disappear?

"The difficulty is not in understanding that Greek art and epic were linked to certain forms of social development. The difficulty is that they still give us artistic pleasure and in a certain sense act as a norm and an unattainable example."

We are faced with the riddle of reconciling historical origin and the timeless and continuing effect of artistic stimuli. How is it possible that something which is so thoroughly historically formed as a work of art should gain superhistorical validity? The paradox contains a difficult antithesis, though one not as troublesome as it would be in logic. For the determining role of historically real social and psychological factors raises basic difficulties in theory which are unknown to aesthetics. The assumption that the actual, accidental, and variable conditions of the thought process have a decisive influence upon the result of that thought calls the validity of scientific observations into question; it makes us admit that our own thought is relative and questionable, and requires us to ask whether we can make any assertion about the value of thought. On the other hand, if we assume such historically variable, realistic conditions for the effect of art, we are less involved in a contradiction, since it is the very essence of art not only to permit different attitudes to the same object, problem, and value concept but actually to favor them. The paradox of the compatibility of objective aesthetic values with subjective evaluations also means that the relativism of the evaluation of artistic achievements is

not necessarily linked to the lack of commitment found in aesthetic judgments. Just as works of art do not contradict one another, so different judgments of taste are not mutually exclusive, for they differ from one another as relevant or irrelevant, or as more or less informative, rather than as true or false.

An apparent misunderstanding of the difference between logical and aesthetic validity led Wölfflin to develop his thesis of "art history without names." He doubtless thought that just as a subject perceiving the truth of a logical proposition arrives at the perception formulated in that proposition, so for a work of art it is irrelevant who produced it or in what circumstances. He believed that artistic form is not created freely and spontaneously, but neither is it conditioned by economic or social externals. It is prescribed by the logic of history and accords with a possibility the artist and his generation can and must realize. Wölfflin saw in stylistic forms rather what Husserl did in the forms of logical thought—ideal structures separable from the individual personality and its experiential reality. He regarded the individual with all the particularity of his needs, talents, and propensities as the mere substratum of superindividual tendencies toward development. These tendencies had to prevail and were for all practical purposes inevitable.

This view was based on the indisputable fact that development proceeds in a more or less objective direction, thanks to the quasi-institutional nature of the bases, traditions, and conventions of artistic production, and is also stimulated in part by endogenous forces. He did not, however, take into account that the apparently undisturbed immanence of the process is interrupted and divided at every stage of development by a branching out of possible consequences. As this multiplicity of trends starts to develop, the external circumstances, the social and individual motives which affect the choice between the alternatives available at any given time, come into their own and become decisive factors in the play of forces involved in the historical process. If neither society nor the individual determines the actual course of development, they always make choices between possible courses. They become the representatives of a dynamic which does not permit abstract logic to prevail in the domain of history, which penetrates the autonomy and immanence of the individual cultural areas and secures their indivisibility within a given sociohistorical period.

Part Two The Interaction between
 Art and Society

Introduction

Interaction and Dialectic

When we talk about the sociology of art, we are thinking more of an influence which starts with art and is directed toward society than of one which emanates from society and finds its expression in art. This is in spite of the fact that art both influences and is influenced by social changes, that it initiates social changes while itself changing with them. Art and society are not monolithically related; each of them can be object as well as subject. The influence of art on society is not even the more dominant or significant force in this mutual relationship. The influence that starts in society and is directed toward art determines the nature of the relationship more than the reverse, where a form of art—already characterized by interpersonal relationships—reacts upon society. When society determines art (and this is particularly characteristic of primitive cultures), it is scarcely, if at all, influenced by art. In more advanced stages of history, it is not only that art reveals social traits from the outset, but society, too, from the very beginning bears traces of an artistic or magical-artistic development, so that we always have to talk of a contemporaneity and a mutuality of social and artistic effects.

Which of the two takes the first step in the process of interaction between art and society cannot be determined. Even if it is the social body to whose needs art reacts with its expressive, imitative, and evocative forms, the artistic stimuli still flow back into the riverbed in which they had their origin and create their product from the womb to which they owe their existence. This by no means represents the total influence of society upon art; it asserts itself within the framework of a mutual independence, of a reciprocal functionalism. The question of the *primum mobile* is irrelevant; the only thing that matters is that

89

every effect within the relationship reacts upon and constantly changes the cause from which it emerged. To be sure, the predominance of social being is expressed in the fact that the interchange goes on only as long as the social order in which the social and artistic interests are combined continues to exist. Its continuity may be reconcilable with the most radical stylistic changes; its dissolution leads unavoidably to a new artistic start.

The problem of the relationship in question would be relatively simple if it were merely a question of the reaction of an art which is socially determined and defined to a society which is to be influenced by art. In fact, as far as we can tell from human history, we are concerned not with the influence a socially complete art has on a society as yet unaffected by art, but with a correspondence, a crossing and mutual enhancement or impairment of influences. In other words, it is a question of the limitation of art by a society which can already point to artistic components and of the changing of society by artistic products which are themselves social products. The particular nature of the relationship, however, consists not only in the reciprocity but also in the simultaneity of influences. The one factor changes under the influence of its own effect upon the other.

What is most significant about this whole state of affairs is the duality of motivation which contrasts with the one-sided causality displayed in other connections. We are talking here of the lack of independence, whether of variable or invariable components, on one hand, and of the mutual dependence of one variable in each case, on the other. In the name of dialectic there has recently been a tendency to do away with the principle of causality altogether and to speak only of a reciprocal dependence and a functional relationship. No matter how problematical the concept of causality may be in itself, there is no doubt that the process in which two phenomena are connected with each other is in innumerable cases determined and revealed from one side only. The sun, for example, when melting the snow, does not itself undergo any change. In the social process, on the other hand, where, as Georg Simmel has emphasized, everything depends on reciprocity, we never come across a one-sided causality of this sort. A human being as a biological, physiological, and psychological being is determined and similarly, in his turn, determines, one-sidedly. A work of art, simply as a thing—a piece of marble or canvas, a structure of pure lines and tones—represents only the origin or the product of such a causality. In the normative aesthetic experience the spontaneous and conventional factors, subject and object, producer and consumer, are reciprocally linked.

In the case of historico-social processes that reveal a parallelism and a reciprocal functionalism of heterogeneous phenomena, there is even less point in trying to seek a causal nexus. For here the processes cannot be repeated, and we cannot experiment by eliminating individual forces. No one factor can be artibrarily excluded from a historical constellation without changing the whole state of affairs. The individual artifact—for example, a Greek sculpture—can retain its artistic value no matter how damaged or truncated. Yet if we ignore but one of the historical circumstances surrounding its creation, we may place it in a context in which its uniqueness either remains inexplicable or is misinterpreted. The most serious shortcoming of a sociological interpretation which rejects a causal explanation is in the blurred nature of the correspondence between social and artistic phenomena, which lacks the stringency of causal connections and often leads to conclusions that cannot be substantiated. It permits the same artistic phenomena to be derived from different social circumstances and the same social conditions to become the origin of different artistic developments. However, we have to admit that the connection between similar social conditions even when these have different artistic manifestations can be entirely meaningful and does not have to be in the least coincidental. On one hand certain conditions are not compatible with each and every consequence, and on the other the results at a given point are not consistent with each and every formative cause. Modern bourgeois society is neither the sufficient nor the sole cause for the rise of the naturalist novel: yet this is not to say that the coincidence of the modern bourgeoisie and the naturalist novel is meaningless or happenstance. Both are also involved in many other socioartistic complexes, without one combination destroying the relevance of the other.

If such connections were constructed according to whim and were thus irrelevant, the sociology of art would really have to confine itself to examining the influence a work of art exercises upon people leading a social existence and it would be little more than a branch of social psychology and moral philosophy. Only the motives and goals which assert themselves in the course of the genesis, modification, and differentiation of artistic forms and contents reveal specifically sociological laws of structure. Society can be influenced in the same sense by different means, and art, as one of these means, exhibits little of its own social nature. This is not to aver that the relationship between art and society, when viewed from the other side—from the social origin of artistic creativity—reveals a completely meaningful picture which exhausts the real aesthetic process. We arrive at, a complete picture only when both aspects are combined. Even a work which its author never published is still socially determined, not only because

it draws from social sources—traditions and conventions, common forms of speech and technical advances that have been collectively achieved—but also because it addresses itself, even though unconsciously, to others. In any case it becomes an authentic social phenomenon only when it is the substratum of a concrete artistic experience in which the interaction between individual and interpersonal motives has been made manifest.

When stimuli intersect, the one or the other may predominate. At one time the influence of society upon works of art and at another the participation of works of art in the metamorphosis of society may predominate. Homeric epics, the *Divine Comedy,* Elizabethan drama, and the naturalist novel more clearly express their time and their society, while Athenian tragedy, the *tragédie classique,* and the literary works of the Enlightenment are more emphatically propagandistic, didactic, or agitatorial. What remains beyond all doubt is that we can imagine a society without art but not art without society. The artist is under the influence of social agencies even while he is trying to influence them. In this way the reciprocity between being and consciousness, thing and perception, objective sensory impression and subjective categorical apparatus is repeated. What is determined reacts upon what is to be determined, and the result can only be understood as the product of both factors, of material entity and categorical function. What is decisive for the determination of the socioartistic process, whose origin remains unknown, is not the sequence, but the juxtaposition, of factors.

Art and society are in a state of continuous mutual dependence which propagates itself like a chain reaction. This means not only that they influence each other, that society is modified by the art whose product it is, and that art in a given society confronts a structure which presupposes many of its characteristics, but also that every change in one sphere is linked to change in the other and calls forth a further change in the system in which the change originates. Every step sets the clockwork in motion; to express it visually, the pictures on both sides reflect each other in endless refractions, as in a hall of mirrors. In this way there is a constant multiplication and intensification of stimuli, a relentless rush and jockeying for position in the race of competing social and artistic forces without which the interchange would take on a dialectical character. It is simply the question of an interdependence between the individual phases of two developmental series. There is no actual struggle between the opposing positions but an inner contradiction which drives them on, keeps them in motion, and spurs them toward a settlement.

Dialectic proceeds from a unity in which a split—a division of impulses, interests, and endeavors—takes place, thus giving rise to an

unbearable contradiction, an intolerable conflict of motives which urges the elimination of the contradiction. Interaction on the other hand presupposes from the outset a duality of the moving principles which move each other, at each step, in opposite directions but are neither in conflict nor in harmony. Within unified economic orders or artistic movements, contradictory tendencies arise which lead to conflict and, in the next phase of development, to a reconciliation and a settlement of antitheses. In contrast to this, body and soul, for example, represent from the beginning two principles which interact with each other but can never be united. They are neither contradictory forces nor the components of a synthesis, in spite of the fact that they cannot be derived from each other and are mutually irreducible. Their duality is as irreconcilable as their correspondence is unbroken. The relationship between society and art is in some ways like the relationship between body and soul: neither are they contradictory, nor can they ever be in harmony. The dialectical development of art, whether it be in the genesis of individual works, in the act of reception, or in the course of the history of style, does not proceed from an antagonism between social and artistic interests, but is the result of conflicting artistic intentions, problems, possibilities of solution, and means of representation. It is, in short, the result of an individual differentiation, of a change in taste and style which social development only provides the spur to but which does not proceed from a contradiction between art and society. An antithetical attitude is not an antagonism, and an interaction is not a dialectical dispute. There are antagonisms within society and within art, but there is none between society and art.

The fact on one hand that society influences art, and on the other that art influences society does not mean that a change in one corresponds to a change in the other. Art and society exist as two discrete, though not necessarily isolated, realities side by side with each other. They neither correspond to nor contradict each other; they neither divide nor unite each other, however deep the traces the one leaves upon the structure of the other. They are, like body and soul, indivisible, but they have no common aim or meaning. Thus, their reciprocal relationship is quite different from the relationship in art between spontaneity and convention, between the will to expression and its means, between form and content. There we have antitheses which constantly deny one another, antitheses leading to new states of equilibrium and to syntheses in which none of the premises remains unchanged but in which none of them is completely lost. Art arises, however, neither as the "negation" of society nor as the "negation of this negation," and in society art is not "superseded" (aufgehoben) but merely accommodated to the other components of the totality of society.

5 Art as a Product of Society

The Elements of Artistic Creation

The production of works of art depends as a sociohistorical process on a number of diverse factors. It is determined by nature and culture, geography and race, time and place, biology and psychology, and economic and social class. None of these asserts itself consistently in the same sense; each acquires its particular meaning according to the context in which it appears with the other factors of development. Just as ethnographic types differentiate themselves according to social stratification, so ideologies acquire different characteristics according to the dispositions and inclinations of the individuals who represent them. The factors involved in the creative or the receptive artistic act acquire their concrete character only by the way they limit one another—when measured by the totality of the artistic experience they are mere abstractions. No matter how great a part they play in the formation of an aesthetic concept, none of them shows, in itself, that special quality which makes a structure into a work of art.

The components of an artistic whole, whether it be an objective product or a subjective experience, belong in part to the class of natural, constant (or relatively constant) phenomena and in part to the class of cultural, social, and historically changeable phenomena. Side by side with spontaneity, variability, and flexibility of effort, the static constitution of external natural data and of the inner, organic properties of objects plays the same part in the artistic act as it plays in every cultural process. To ascribe to rigid, hereditary predispositions and to conservative, imperceptibly changing drives a more important role would lead to just as unscientific and metaphysically prejudiced a point of view as the attempt to make the creative consciousness independent of material reality or of invariable or inflexible natural conditions. If

we give primacy to natural forces in the cultural process, we change the genesis of the cultural structure into a "mysterious natural process." If we give primacy to consciousness, we create from this substratum a monstrosity with no content. To the creative consciousness, passive and blind nature is just as mysterious as spontaneous consciousness is from the point of view of nature. The idealist gives up in the face of the irresistible power of the laws of nature, just as the realist lays down his arms when he allows the mind to rule untrammeled and unconditionally.

At first sight, artistic creation seems to consist of the interaction of partly variable and partly invariable factors, in a process involving forces which are both dependent upon and independent of each other. The task of the sociology of art would essentially be solved if we could discover an "independent variable" of development which could be modified of its own accord and could be made to depend upon changes in other factors. In fact, artistic creation depends neither on independent variables nor on invariables of any sort. It is entirely the result of the interaction of mutually dependent variables. All the natural and cultural elements of an artistic act—those factors which are more or less constant and those which are by and large susceptible to modification—assert themselves in an indivisible interdependence. They function only in relation to one another and accomplish only what their coordinates permit, although every factor, from the perspective of the others, is negative rather than positive and is the limit rather than the goal of what can at a given time be realized, thought, felt, and communicated. The psychologist sees society as a hindrance to the individual's freedom of movement; to the sociologist the psyche often reluctantly fulfills social functions.

Every historically concrete subject who thinks and acts finds himself in a real, temporal, and locally determined situation, an objectively given milieu. His inner potentiality is always linked to a set of static external conditions. Yet this does not signify that the dynamic and static factors of the historical process are merely complementary or that they preserve their own nature while influencing one another. In the process, their character undergoes a fundamental change. The apparently constant factors become dynamic and take on characteristics corresponding to the state of development at the moment, while those components which are essentially changeable become to some extent immobile and objectified, and form autonomous structures which emancipate themselves from their original roots and conditions of existence. The static elements of reality become factors in historical development only in a form which accords with the functional possibility of the moment. The vehicles human beings create for social groupings

and the formation of culture, conventions, and institutions, norms and values, rules of behavior and laws governing thought, stylistic trends and forms of expression, change into firm principles which oppose pure spontaneity and individual freedom.

The gravest shortcoming of that uncritical, methodologically obscure sociology of art, the prototype of which is Taine's theory of milieu, lies in the lack of a principle by which to discriminate between natural and cultural, static and dynamic, essentially unchangeable and completely variable factors of development. For Taine the concept of "milieu" serves as a crude and mechanical subsumption of natural—especially geographic-climatic—cultural, and interpersonal conditions; it ignores the interaction between the diverse factors present in the processes concerned. Wherever there is an effect, Taine immediately talks of causality in the scientific sense. The inadequacy of his theory is most sharply revealed in the assumption that there is a unilateral dependence between physical data and intellectual attitudes and that they form a nexus.

Because of this lack of methodological clarity, the whole pretentious classification of the factors of artistic development into *race, milieu,* and *moment* is as good as worthless. What Taine understands by "race" is, it is true, fairly clear, but the role he assigns to this factor was from the beginning problematical and in the course of the development of art history has lost more and more of its meaning. The concept of a racial factor may be unambiguous, but it is precisely in this lack of conceptual ambiguity and in its immutability that it is unreal and imaginary. In Taine's sense, there are no constant races. The flexibility of his two other principles proceeds not from the understanding that what is given in nature becomes dynamic as culture develops and that its meaning and influence change, but from the lack of clarity with which they are defined. Taine understands by "milieu," apart from racial characteristics, the totality of external conditions on which the particularity of a literary work may depend—that is, both the social relationships and the natural circumstances. We may ask ourselves why he distinguishes between *three* factors in development. Least clear of all is what his *moment* signifies in this connection. If we are to understand by this the point in time when a work or stylistic trend appears, then the category must be placed in a quite different order of concepts from the other two. *Moment* does not then mean a "factor" in the structure which is to be analyzed, but the medium in which the other two categories function. If on the other hand we are to understand by the term merely a point in time or a period, then it is only a variant of *milieu,* in which case, to set it up as a basic category of artistic construction is superfluous and meaningless. In short, all that

can be retained of the whole of Taine's theory is the fact that literature is conditioned by the location of its author in time and space. But even that was not new for his day: Mme de Staël was already on the right track.

Nevertheless, the analysis of Taine's theory does lead indirectly to an insight of the greatest significance. Nothing reveals more clearly the inadequacy of the unilateral genetic explanation of artistic creations. Every attempt to explain them in this way is based on the evolutionary conception according to which the origin of a developmental process is decisive for the nature of the final product. Yet those who argue in this way fail to recognize that, in the case of an intellectual act of creation, especially an artistic one, the artist is stimulated, faces prob lems, and solves them at different points in time and at different turning points along the road which he is traveling—often, indeed, at points on the side of that road—and which would lead directly from the original idea to the final solution. The idea that the first phase of a process—indeed, the very act of conception—is most decisive in determining the final form of the product is a fallacy derived from scientific thought and the formation of biological concepts. In fact, the result of every historical development is often the multifariously mediated by-product of forces at work in the process. It depends far more immediately and decisively on factors which only crop up later in the process. Every genetic theory of the formation of culture which proceeds from natural conditions, whether these be geographic, ethnographic, or psychophysiological, tends to underestimate the deviations the development makes from its original tendency. Only a method oriented, in principle, toward interaction and with a cultural construct that is the gradually evolving result of factors which create ever fresh complications and for which every step in the process may lead to the discovery of an element which will create and constitute the final result can correct the false, unilaterally genetic picture.

Natural Factors

The bare natural circumstances are among the indispensable preconditions of the cultural process. We can talk of history and society only on the assumption that there are extrahistorical conditions of existence, no matter how decisively everything which affects men as men takes place in the historical sphere. The existence of nature which is ahistorical and asocial not only is the precondition under which we can conceive of history and society but also is essential for the material foundations upon which culture as a superstructure rests. Where there is no "nature" to serve as a substratum of happening, there can be no

history as the function of existence. It is true that "man" becomes man only through history and within the medium of history. It is also true that he finds the material with which he "makes his history" partly in extrahuman nature. He bears it in part himself, in his own nature, as an unrealized potentiality, as an unfulfilled possibility, as a raw physiological and psychological disposition.

What is purely natural, however, does not appear on the plane of history. It loses its static character, begins to move and grow functional as it becomes a factor in historical development. Not only does the biological constitution of the human being, his instincts and dispositions, inclinations and abilities, "character and corporeal structure" change, not only do his racial and ethnic characteristics develop and change, but also the geographic and climatic conditions—or at least their significance for and effect upon the life of man—are subject to a slow but constant change. The change and historicization of life's natural conditions consist not in their effective transformation, which as such belongs to "natural history," but in their changing effect upon the life of the people they touch. Topographical conditions which are objectively the same, the same racial character, and the same biological constitution do not produce the same developmental factors in the historical process at different developmental stages: they vary according to the functions they perform.

The meaning of the interaction between nature and culture, disposition and function, ahistorical infrastructure and historical superstructure consists precisely in the fact that the natural, existential, apparently invariable givens are always what men make of them, how they react to them as vital conditions, and how and for what purpose they use them. This relationism does not alter the fact that culture is based on a number of natural existential conditions which simply have to be accepted, but it does mean that the foundations are modified as the building takes shape. First and foremost, this is an expression of the peculiarity of history which says that all the elements of development in contact with one another change according to a principle which may not always be clear or unambiguously definable. The difficulty in defining it comes chiefly from the circumstance that the natural givens certainly condition the cultural structure but in no way produce it. They are neither its source nor its causes nor its constitutive elements; they simply belong to the apparatus without which no cultural process can be accomplished. The apparatus is only the presupposition, however; it is not a sufficient cause for the process.

Natural conditions carry no constant index of value and have no autonomous function in history. They become determining factors in development only when they fuse with the variable conditions of ex-

istence. For this reason we cannot, for example, speak of the historical role of inertia or of the oxygen content of the air. And for the same reason not even a landscape could perform a historical function but would have to persist in a historically meaningless state, a state without influence, if its picture were not to change in man's consciousness. The interaction upon which the cultural process rests is activated only when the inert elements of existence start to function in the context of life. Theoretically this process will be halted not only when the natural conditions of existence can be judged to be unchangeable factors but also when we come to think that the course of history is governed by principles expressing a sort of natural history or a logic, fixed from the outset. This happens when, for example, Ferdinand Brunetière tries to explain the formation, modification, and splitting up of literary genres by Darwin's theory of natural selection.[1] He dehistoricizes and mechanizes the process by seeing a correspondence between the law of development and selection by which the genres change and the cycle of youth, maturity, and old age. According to him, epic, lyric, and drama, like natural genera, lead an organic, plantlike existence, and this existence is independent of social conventions and spontaneity of spirit. With his "art history without names," Wölfflin propounds a Hegelian logic of history which starts out from quite different premises but follows essentially the same method, subordinating development to the ahistorical principle of anonymity and finally changing it from a dynamic to a static process.

No natural condition is of itself a factor in the historical and cultural process. Each condition asserts itself as a coefficient of history only at a given stage of development, through special circumstances, and in unique relation to the rest of culture. None of them is so alien to intellect, so lacking in meaning and value, so needing the mediation of functions which have already been performed in order to gain historical significance as geographic-climatic conditions are. As completely stationary and inflexible phenomena, they are historically not only indifferent but also not even, so to speak, present. Merely that a country is situated on an island, by the sea, among mountains or rivers means relatively little unless we consider the part its situation played at a given point of time in the historical life of its inhabitants. Geography and climate increase and change in significance according to what a people can at different times make for themselves out of a particular geographical situation and a particular climate, or what different people can make out of them at the same time.

The geophysical nature of an area, its articulation by mountains and waters, its raw or mild climate belong to conditions of life which are objectively the most constant. They are, however, subjectively change-

able, for although, in fact, they remain the same, people always react differently to them and so change their cast and meaning. Nevertheless, they form the (relatively) most constant factors in cultural development and are in any case less plastic than human needs and endeavors at a given time. Water is generally an element of linkage and traffic, of expansion and the distribution of cultural achievements, but at the same time it may hinder people's movements and separate them from one another. Mountains may protect and shelter, but for the most part they, too, restrict and separate. But however land and soil, birthplace and home, permanent dwelling or temporary settlement may be fashioned, their effects are subject to historical modification. Thus, the sea acts as a divider as long as it is difficult to cross, but with the development of navigation it becomes one of the most important means of communication, of cultural exchange, and of progress.[2] The influence of geographical conditions does not, however, change consistently and progressively in one direction: circumstances arise again and again which arrest or even reverse the current direction. With advances in communication, the insular situation of England led to the foundation of the British Empire and made of the English a nation of cosmopolitans and globe-trotters, but this insularity became at the same time one of the reasons for the cultural separation of the country from the continent and for the consolidation of its traditionalism. But the simple equation of its geographical isolation with its cultural insularity rests upon an equivocation. The alienation from foreign countries does not take place until after a long period of cosmopolitanism—in the reign of Elizabeth I—and is largely the result of economic causes.

Geographical data sometimes make themselves felt as the framework and the borders of cultural units, sometimes as the bridges and links between them. Every unit has its natural borders and its original center; but the boundaries are always more or less fluid, and the center changes according to economic and political interests, technological development, and the available means of communication. Cultural forms and artistic movements spread mostly in conformity with national and political spheres of influence; nevertheless, there is no necessary coincidence between the political and cultural domains. Cultural forms and artistic trends sometimes tend toward local centralization, sometimes toward spatial diffusion, and are from the outset topographically more broadly or more narrowly delimited. In no case, however, is the distinction, the homogeneity, or the longevity of a style dependent upon its geographical concentration and isolation. Incomparably more extensive territories than those of other European countries form the framework of a homogeneous culture in Russia. The heterogeneity or homogeneity of a cultural sphere makes constant presuppositions about

nature—among them topographical ones. However, whether a people or a society tends to be receptive to foreign stimuli or is intent upon preserving its own traditions, native practices, customs, language, and art forms depends, apart from natural conditions, upon numerous factors having nothing to do with geographical and ecological ones. Western development, in contrast to Oriental, shows a general tendency to weaken local traditions and to enhance centralized and standardized cultural activity, and this tendency is as independent of natural conditions as it is of the particular character of the regional cultures. The rapid development of technology and communication, people's increasing mobility, their frequent separation from their place of birth and work, their alienation from their homeland and the environment with which they are familiar, reduce the significance of geographical conditions of existence and change the spatial coefficients of the cultural process into temporal ones. This temporalization of milieu has a connection not only with the development of such an art form as film but also with the view, like that expressed by Proust, that a place we remember also means a point of time in our life and that it has no true reality outside of time.

The movement, combination, or separation of the bearers of culture brings with it a continuing reevaluation of geographical conditions. Technological and civilizing progress generally has the effect of reducing the distance between the different cultural areas and educational strata. In an externally integrated cultural area the inner tension and friction among the different social groups, which corresponds to the overall historical situation, may sometimes be greater, sometimes less. The cultural differences from region to region may have a retardant and rigidifying effect, but one which is also healthily conservative and protective of achievements, in that it acts as a brake upon the tendency toward thoughtless centralization and standardization. The cultural process shows itself in this connection, too, as one which is reciprocally conditioned by opposing forces. The centripetal and centrifugal tendencies, the drive toward integration, and the striving toward individuation are antithetical impulses which now hinder and now promote one another, but whose interaction is an essential presupposition for profitable developments in art and culture. As the history of many local schools of artists shows, endogenous development leads very easily to the exhaustion of the formal language, while the infusion of alien blood rejuvenates, when the indigenous stem is no longer sufficiently lively to produce progeny.

As often as, and in no matter how many directions, development may diverge from the natural ways of culture, there is nevertheless a firm map of cultural areas and their spheres of influence which is

oriented toward firm reference points, just as there is a map of political and ethnographic groupings. In this sense, we can, in spite of all changes and fluctuations, maintain that river valleys, estuaries, abundantly articulated seashores, upland landscapes watered richly by rivers and lakes with temperate climatic conditions serve to promote culture. They lead to union and to communication, to the exchange of cultural goods, and to the mutual stimulation of the groups which come into contact with one another. But as often as the cultural development brings in its train the gradual emancipation from geographical conditions, cultures, especially in early history, are bound to the geophysical structure of their birthplace. The epochs whose economy is still dominated by primary production develop in the framework of irrigation cultures—the "great river cultures," as they are called when referring to Mesopotamia and ancient Egypt.

The centers from which Western art and culture flowed were river landscapes and littoral areas like Asia Minor and Egypt, lands with long-fissured seacoasts like Greece and Italy, areas abounding in lakes and rivers like the area around Lake Constance, the banks of the Tiber, the Po, and the Arno, the Seine and the Loire, the Rhine Valley and the area between the Elbe and the Danube. The most favorable geographical and climatic conditions doubtless contributed to the rich artistic and cultural harvest in these territories. However, there must have been innumerable mediating components which contributed to the process and helped it progress from a simple natural phenomenon to a cultural structure. The romantic view, shared by Richard Wagner, that "historical man" did not receive his art and his culture from nature but developed them in a bitter struggle with her,[3] is just as uncritical as is Comte's determinism, which presupposes an infantile dependence of man upon nature. In reality, creative man is neither the spoiled nor the abused child of nature: sometimes in the creation of his works he is opposed by nature, sometimes pushed on by her.

To see how small the direct dependence of cultural products is upon natural geographical conditions, we have only to ask how many representatives of a style were born and grew up in the town where they developed their art. It soon transpires that the social conditions which determine the forms of patronage, trade, artistic education, professional union, organization of work, and so on, bear far more on the character of works of art than the topographical conditions in which they are created. We arrive at the same conclusion when we examine the relationship between the extent of a country or a territory's sphere of influence and the significance of its art. Territorial size and the extent of sovereignty are certainly not unimportant in relation to art, but the value and influence of artistic products do not stand in any determin-

able relationship to the territorial extent or the political power of the commonwealth in whose framework they are created. Artistic styles, like cultural structures in general, spread as they age, increase their circle of influence, and become more and more independent of the geographical and climatic conditions of their origins. This is one of the few hard and fast rules of the relationship between external spatial conditions and internal cultural developments. This tendency is indissolubly linked to the tendency to radiation and cleavage present in every culture. The phenomenon that cultural structures are more firmly rooted in their native soil at the beginning than they are later on is tied not only to the natural but to the social factors of their history. The separation of worth from the circumstances of genesis and the progressive movement toward autonomy, formalization, and petrifaction of cultural forms corresponds to a fundamental law of cultural development. The uprooting of cultural forms from their native soil by no means implies that topographical circumstances play a lesser part in their formation than other ones.

The influence of geographical conditions is expressed most sharply and immediately in the effect of the climate on people's frame of mind, temperament, and emotions. The paralyzing effect of excessive temperatures and the increased capacity for work in climatically temperate zones are well-known phenomena. The most significant creations of Western culture were produced in easily bearable climatic conditions. Yet people do not react to climatic conditions in the same way throughout different periods of their history. Habit deadens sensitivity to disagreeable living conditions, while technological progress and protection from cold and heat tend to spoil and enervate. The significance of the difference of climatic conditions between Nothern and Southern Europe, its effect upon the mood, the outlook, and the taste of the people, the tendency toward monumental forms and exhibition among the Latin peoples, and the preference for intimate effects among the Germanic nations are a commonplace of art history. This difference, too, lessened in the course of development and as people were more effectively protected against the weather. Climatic influences upon origin are scarcely to be found in present-day art unless it be innervated impulses whose origin dates back hundreds and thousands of years. As far as the distant past is concerned, there is no more striking example of the influence of natural conditions on stylistic change in art and culture than the change which took place in the climatic conditions of the then inhabited zones at the end of the Ice Age. We are talking here of the change in the way of life from the Paleolithic age to that of the New Stone Age caused by milder climatic conditions. The parasitical gathering and hunting society gives way to productive

agriculture and cattle raising, nomadic hordes give way to communities, and in place of magical naturalism we have an animistic formalism. Never again in the whole course of history do we meet so unmistakable an example of the external conditioning of a new *Weltanschauung,* a new social and economic system, and a new formal artistic language, nor of the ability of a natural factor, like climate, to play so important a part in the whole feeling for life.

Geographic circumstances like the isolation or the union of different cultural areas, the segregation of the bearers of culture or their intercourse with one another, the inbreeding of forms and motifs or their migration and transplanting represent decisive factors of artistic development and are the object of important questions in art theory. The solution of the problem, of whether different races' and nations' popular poetry with its many common traits and motifs stems from a prenational popular poetry, depends on the evaluation of geographical conditions. Was there an original unity of *Volksgeister,* or did the poetry derive from the literature of higher cultural classes and proceed downward or from the center to the periphery? The different aspects of the problem are best known from the controversy which arose in connection with research into the fairy tale. This deals mainly with the question of whether the same fairy tale motifs sprang up spontaneously in different regions or whether they were spread by way of migration and borrowing. The exponents of the migration theory assumed a unified Oriental origin for the best-known fairy tale motifs and explained their dissemination by cultural migrations and military campaigns—especially by the Crusades. The representatives of the later anthropological school on the other hand taught that the similarity was to be derived from the same human dispositions and inclinations and that the same or similar fairy tale subject matter is to be found in quite different geographical zones completely isolated from one another. For all their disparity, the theories of the diffusionists and the evolutionists are equally irrational and romantic. The anthropological doctrine stems from the notion of the permanence and identity of human nature, while the migration theory views individuals and individual peoples as the essentially neutral agents of impersonal tendencies, influences, and impulses which always fulfill the same functions. These are merely two variants of the same ahistorical and unsociological view of man and of his supposedly "unattached" interests, abilities, and artistic claims. In both cases an abstract principle and a general law triumph over the concrete case, its ephemeral representatives, and its special situation. In the one as in the other, there is a lack of understanding for the fact that similar cultural structures can arise independently of and without any contact with one another

and do not have to presume an identity of human nature. Their similarity may rest upon the identity of social conditions in which anthropologically different and geographically separated people live and function. As far as that goes, a one-sided point of view is found to be unproductive for dealing with the invention and the borrowing of artistic motifs, just as it is in so many other sociological and sociohistorical connections. Some artistic structures migrate, are borrowed, or are subject to variation, while others arise in different places and at different times in the same or in similar form. Most of them represent hybrids in which borrowing and spontaneous, independent inventions are indissolubly linked.

However little may be gained in the science of history by sustaining the principle of the constancy of human nature, cultural processes are conceivable only if we assume that there are everywhere similar subjects who sustain culture. This is true whether we believe in a homogeneity of spontaneous invention in differing external conditions or that different people and individuals adopt and repeat the same patterns. A certain constancy, if not an express identity of human nature, must be assumed simply to understand its changeability. Substratum and function, being and becoming, time and timelessness make sense only in relation to each other. Apart from this correlation, that which is "universally human" has no place in history. Without its mobility, questions such as why certain forms of culture recur, are adopted, and are preserved while others change, develop, and are modified cannot be answered. Neither is what is universally human so "universal" nor is the individual so spontaneous as they appear to be. The antithetical and interdependent, and the universal anthropological and specifically regional factors are caught up in just as irreducible an interaction as all other social and natural conditions.

The development of art is connected with ethnic-national conditions in the same way as it is with geographic-climatic ones. The difference is that race and nationality retain their identity even less than ecological circumstances do. The racial and national determinants of artistic creation represent a static principle in contrast to the essentially historical factors. Yet they are incomparably more flexible and are much more strongly affected by the general tendency of development than are the natural conditions that appear in landscape or climate. For as little as we can dispute on the one hand that there is a nonreducible popular and national character which determines the thought, feeling, and artistic creation of groups linked by ties of blood or region, there is on the other hand no doubt that races and nations in spite of their natural predispositions are historical structures and are in a constant state of change. If we imagine the gap between nature and culture as a road

which begins in the natural milieu of a community, then with race and nation we move a step farther away from what we can regard as mere permanent nature. Yet in this way we remain close to nature and far from society as the sustainer of culture. For we find in the scrutiny of local factors of artistic and cultural development that there are much closer relationships among the different groups of a society than among groups which correspond to geographical and political borders. We also find that the solidarity of the members of a station, a property class, or a cultural stratum is more important in the formation of cultural structures than proximity or trade, and we find that common ethnic origin and national community are sociologically and culturally comparatively irrelevant.

Races form homogeneous units only at the primitive stages of development. Later on, as a result of a mixing which can often only be forcibly prevented, they lose not only their purity but also the communal character that arose in consequence of the irresistible differentiation of the groups. In the present state of development we can scarcely speak any more of races in the real sense of the word or of racial characteristics and clearly distinguishable cultural factors. For although not only social groups but to a certain extent races and nations often acquire sharper definition only as they develop and distinguish themselves more decisively from one another, they lose most of their individuality and give up their differentiating influence as a result of the multiplication of the means of communication and the shrinking of the world.

Racial characteristics are biological: they rest on heredity and inbreeding. Characteristics which we could label the common intellectual features of a race cannot be determined, however—at least as far back as we can go in history. The earliest history of mankind already shows traces of the mixing and joining of different races. Finally, there is nothing left of the biological relationship except the unity of linguistic families, so that "Semites" and "Aryans" are today neither regional, cultural, nor ethnological entities, but mere linguistic groups. The same race may divide up into different social, political, and cultural units, and the same social structure or the same cultural group may unite different races within themselves.

In the course of the formation of racial character, the acceptance or rejection of alien influences, their absorption or rejection play the same part as in the development of all bearers of culture. This happens side by side with disposition and heredity, blood and family, drive and inclination. Even the constitution of a race's character may go through a phase of integration before entering the stage of differentiation and disintegration. This, too, is a unified totality and not a complete entity

from the outset; it is a functional totality continuously renewing itself and not a simple, indivisible entity. At a certain very early stage, as we have said, its unified character disintegrates, although the components, inclinations, dispositions, and abilities which underlie it continue to play their part as cultural factors in the course of further development.

In the course of the gradual rendering of the constant or quasi-constant factors of national history dynamic and the partial metamorphosis of unchangeable facts into changeable elements, which is tied up with the disintegration of the homogeneous racial character, it is the impulse to imitation—something always so important in social life—which plays the leading part. Civilizations lose their individuality and change their supposedly peculiar developmental tendency when they come into contact with other civilizations, social orders, and forms of life and try to adapt to them. Imitation is one of the most effective means of revivifying stagnating energies, although it itself leads to stagnation if the patterns being imitated do not change. The imitation of changing patterns is, however, the actual motive force which keeps cultural development in motion and prevents elements of sloth, like an unchangeable ambience and unbroken endogamy, from gaining the upper hand over the principles of innovation.

The most confusing thing about judging these conditions is the fact that we are generally comparing different historical and social structures with one another when we think we are confronting different races and racial cultures. Thus, it is by no means ethnological disposition or nationally conditioned criteria of taste which appear side by side in the Dutch and Flemish painting of the seventeenth century. The different dispositions are only activated and actualized by the different social conditions which arise in the two parts of the Netherlands as a result of the Spanish Wars; they do not arise spontaneously. It is the same in the case of the different styles of Italian and Dutch art in the fifteenth century: these differences are not, as we often assume, to be explained by constant racial or national inclinations but mainly by historical changes. It is not a matter of the antithesis of Southern Romanic and Northern Germanic racial and national character, but of the more progressive economic and social conditions prevailing in Italy than in the North, which was more closely linked to the Middle Ages. Stylistic differences of this sort are the precipitate of historical developments and the reflection of social constellations; they are not the expression of static local or ethnic particularities. Nothing shows this more clearly than the greater resemblance in many respects of Sienese painting of the quattrocento to the contemporary art of the Netherlands than to Florentine art, despite the fact that Siena not only is an

Italian city but is close to Florence. In the meantime it forms the home of a society which in accordance with its bourgeois and religious ideology has more numerous points of contact with the North than it does with the progressive city of Florence, dominated as it is by a rational and unprejudiced cultural elite. In cases of this sort the supposedly constant factors of development are nothing more than an insufficient substitute for unresearched historical facts, which are completely susceptible of being uncovered if we take factors like racial or national characteristics into consideration instead of rejecting as far as possible an explanation based on changeable and flexible circumstances.

In spite of this, there is no doubt that in the diversity of many cultural structures, existing side by side with purely historical conditions, we see the remains of racially conditioned inclinations which have become fixed national characteristics. Thus, Max Weber's "Western rationalism," unlike Oriental irrationalism and traditionalism, is a historical structure—in which the racial moment plays a decisive part. The racial character of the Mediterranean peoples, notwithstanding all the progressive confusion of ethnic borders, is certainly not without its influence on the continuing existence of the contrast between North and South.

Race is essentially a biological phenomenon which can be related to culture only indirectly. The confusion of concepts responsible for its being placed in immediate proximity to culture comes from the assumption that there is a collective "racial soul." Modeled on the romantic "folk-spirit" *(Volksgeist),* the conception of this collective animus was connected with the inability to distinguish between the substratum of a collective attitude, which may be natural, and a collectively psychological, culturally productive subject, which is a mere construct and does not appear in reality.

When Taine talks of "race," it is usually in reference to national peculiarities. From time to time, however—as, for example, in his comments on the art of the Netherlands—he makes a fundamental distinction between race and nation, calling the racial characteristics invariable, and national character a phenomenon which changes with "milieu and development."[4] His introduction of the concept of variability into an area where, since the romantics, the principle of constancy had completely dominated is of great significance. This is true despite his failure to recognize that in this connection there is only a graduated distinction between race and nation and that both are only quasi-natural and pseudostatic phenomena. They probably rest upon natural data and are part of the presuppositions for cultural processes, but as such they appear on the cultural level, for here the natural state is "neutralized"—that is, antiquated—although it is part of it.

The validity of the racial principle is by no means linked to the consciousness of a racial community: it often has a greater influence, the more unconscious it remains. The emphasis upon racial unity may indeed be a symptom of its opacity. On the other hand we can speak of a nation only where there is a consciousness of the unity of the language, of origin and homeland, of morals and customs, of traditions and institutions. This conformity need not, however, correspond to geographical and political borders. On one hand several nationalities can be joined within the borders of a country as in Switzerland; on the other a linguistically unified national community can spread out over many lands like the English or the Italian. Races exist, insofar as they do exist, like social classes, without people's having to be aware of them; there is no such thing as a nation without a national consciousness. A race is a concrete biological entity which cannot be represented or replaced by any consciousness. In contrast to this a class is a purely sociological context, of which we do not have to be conscious in order to be one of its members and to behave according to its structural laws. Finally, a nation consists of real, biologically conditioned individuals, who, however, become a collective entity only by means of the consciousness of a special sense of kinship.

Every artistic means of expression contains national characteristics. Not one uses a universal, nationally indifferent language, but not one of them is from the beginning confined within the borders of one nation. Every art, not just literature, expresses itself in a national idiom. Italian, German, and French music differ as unmistakably from one another as do Italian, German, and French literature. That art moves in such a differentiated medium is perhaps not the most essential thing about it, but it is part of its essence. The language of art is the product of a dialectic which starts with a national idiom and preserves the national quality in spite of the supranationality to which it aspires. Shakespeare and Racine created their works in the spirit of their mother tongue; yet we can enjoy and value them without being French or English, but only if we have an ear for the French or English cadence of their diction. Without feeling the individuality of their language, we cannot adequately understand them.

The nineteenth century stayed true to its romantic heritage insofar as it not only saw national factors in culture but also highly overrated them. In line with romantic conservatism, it exploited the apparently immutable, constant, and eternal principles of cultural development against progressive, reformist, and revolutionary political tendencies. Everything which seemed indigenous—from racial loyalty and national feeling to peculiarity of dialect—and which seemed to accord with the nature of the native land, everything which was apparently arbitrarily

created and which could not be changed overnight was felt to be useful, wholesome, and fruitful. On the other hand everything produced without taking account of the supposedly universal and eternal laws of the human spirit was seen as "decadent," unhealthy, and consuming of the vital forces of the race and the nation. Marx, as is well known, called the glorification of nature and the fetishistic approach to it a "stupid peasant idyll." As the most conceivably naive version of this idyll, Pareto's sociology, which was based on the same romantic conservatism, shows how small the gap is between the conversion of folk art into a fetish and the exploitation of the popular by fascism. For Pareto scientific systems, theories, and ideas are nothing but "derivations"—that is, mere functions of psychological constants, the so-called residues he regards as the decisive factors of all culture. For him they form the quintessence of ubiquitous drives, passions, and inclinations, of firmly rooted and ineradicable traditions, of the eternal, immutable, and unalterable foundation of constructions which are always more or less arbitrary, rational, and therefore questionable. Since they are constructed with the material of "derivations," they are unreliable indicators of "feeling"; they are unnatural and merely clever games.

In a certain sense we can, of course, talk of nations in antiquity and the Middle Ages. Before the beginning of the modern era, however, the limits between them are so blurred and their connections with one another are so diffuse because of the extensive trade routes and the supranational empires of integrated feudalism and the universal Church—even if, in everyday practice, they can only be reconstructed with difficulty—that an actual national consciousness can scarcely have been developed. Such a consciousness comes about only after the dissolution of the unified Christian culture of the Middle Ages. The Renaissance, in spite of its universal significance, already had national roots. Mannerism, baroque, and rococo are certainly more nationally oriented. After the French Revolution and the Napoleonic Wars, which bring the opposing national interests more into our consciousness and create conditions which find their expression on one hand in the atomization of competitive capitalist economy and on the other in romantic individualism, national endeavors find a new impetus. Capitalist freedom of competition is part of the ideological foundation of modern individualism. It is only remarkable that romanticism, which saw in the individual the principle of freedom, pure and simple, interprets nationalism in the sense of an obligation. Romanticism understands by phenomena such as national past and national characteristics, native customs and traditions, national language and folk art forms of a higher irrevocable obligation which cannot be relaxed. It is as though, with

its capitulation to the idea of immutable nature and the indestructible nation, it is seeking protection against the anarchy of freedom, which it had prescribed for itself. The romantic overestimation of the timeless and the enduring, of the immutable and the fatal is the counterbalance to sudden rationalization, to the all too rapid devaluation and rejection of traditions, then just beginning. It has been said that nationalism is collective narcissism. This is all the more apposite in that it expresses the idea that a nation embraces not only a union but also an isolation. The strange untamed, arbitrary, irresistible genius becomes for the romantic a refuge from the dangers of misunderstood and misused freedom in which he senses the origin of an unconditional subordination—subjection to irrational drives—instead of a principle of reason which can be bent and to which he can adjust. Instinct and intuition, feeling and passion, imagination and ecstasy become his idols, not in spite of the fact but because they impose themselves upon him so irresistibly and refuse to be controlled. For this reason history which "man makes" is no longer "his" history—for this he would have to be its master, not its slave—it is fate which overwhelms him and has to be humbly accepted by him.

In more than one way it transpires that constancy of national character is only apparent. The character of a nation changes with time and is part of an immanent development, independent of the changing role it plays in relation to other nations. It has its own inner history, progresses while always mastering the same problem more and more successfully, and is hampered in its development when it encounters unexpected difficulties. It changes its natural qualities and extends or narrows the limits of its functions according to the position it is permitted to take in the world. It can see itself required to adjust or isolate itself, to develop its individuality or suppress it. To what extent national character and national consciousness are historical and social structures and not merely biologically conditioned phenomena can be seen most clearly in the way the English, as islanders, developed. Up to the time of the Hundred Years War they felt completely at one with the remainder of the West and particularly closely linked culturally to the French. It was only during the long campaign against France and during the period of danger which threatened them from the Continent that there arose the pressure for isolation and the tendency to develop conventions, forms of life, and norms different from those of the Continent. Without this change, the abuses of puritanism and that encapsulation which fundamentally changed the English national character might never have come about. The consciousness of insularity, of detachment and exclusion from abroad was certainly not the mere result of feelings, sympathies, and antipathies, or moral principles and

taste. Economic, social, political, and religious changes were chiefly responsible for it. The sea, which had long been a lively trade route, becomes with England's rise to maritime power simply another means of separation and defense.

The thesis of the allegedly permanent conservatism and conventionalism of Egyptian art is one of the commonplaces of history. That its stylistic character corresponds to no racial or national disposition, however, but is conditioned sociohistorically and changes as the culture develops becomes most obvious when we consider that in its earlier periods it is less stylized and schematized than in the later ones. In works like the *Scribe* in the Louvre or the *Village Magistrate* in Cairo we see the effects of the dynamic forms of life of the new urban culture, the differentiated social conditions, the professional specialization, and the antitraditional spirit of a trade and money economy. We see how this leads to an individualism and rationalism more consistently than in the art of the later period, in which the influence of these conditions was weakened or rendered void by the conservatives' struggle for the perpetuation of their power. The inflexible conventions and rigid formulas which in general seem to be characteristic of the Egyptians only develop in the Middle Kingdom, apparently in connection with interests which have to be defended by, and the strong class consciousness of, the new feudal aristocracy. This is the beginning of that courtly hieratic view of art which is much more narrow-minded than the as yet unendangered priestly royal one and which refuses to permit any spontaneous personal expression.

Despite such changes Egyptian art remains Egyptian, just as the English remained English before and after the Hundred Years War, their rise to world power, the Reformation, and puritanism. Yet common nationality is not one of the strongest human bonds. A German and a French knight had far more in common with each other in feudal times than either had with the nonknightly class of his own land. This sort of solidarity characterizes not only medieval conditions, in which nationality did not play a significant part in a people's feeling for life, but also modern conditions, in which the consciousness of tribal community gives way to class association. In the differentiation of classes, it is true, the difference of nations competing with one another economically bears more weight than ever, yet not only the members of the same moneyed class but also those of the same cultural stratum are closer than inhabitants of the same nation. Thus, we see the development of the idea of the cultural irrelevance of nationality and that cosmopolitan spirit which counterbalances earlier capitalist particularism and romantic nationalism. This new postromantic point of view

is expressed in statements like Hebbel's "Shakespeare was not a Britain just as Jesus was not a Jew."

The progressive cultural process generally demands the leveling of nationalism. The tendency toward uniformity is by no means constant, however, but subject to frequent and sensitive oscillations. At the end of the Middle Ages Italy and Flanders develop a national culture at the same time, in conjunction with an awakening national consciousness, as the bonds of the universal Church, of international chivalry, and of Western feudalism begin to loosen. France on the other hand preserves the remnants of the medieval cultural tradition not in spite of but precisely because of its intellectual leadership in the Middle Ages. Yet the progress from integration to differentiation in modern culture is by no means a constant one, as the former process of leveling was. Mannerism already denotes a new cultural union after the national division which was accomplished in the Renaissance. With the change to mannerism the Italian Renaissance, the form in which it was accepted by the West, loses its national stamp and takes on the character of a universal European style reminiscent of the Gothic. Yet this is only a temporary regression to universalism. Side by side with its international traits, the baroque, in accord with the national churches of the counter-Reformation and absolutist mercantilism, reveals nationally shaded variants. Later capitalism and socialism with their ideology of class solidarity and the class struggle overcome the particularism of early capitalism and render the concept of nation outmoded, without completely eliminating the function of nationality in the cultural process. The dialectic of national and supranational factors becomes more complicated and opaque, but it is by no means done away with.

Not all the natural factors of the cultural process are impersonal like the geographic-climatic and ethnographic-national ones. The biological conditions of cultural products, physiological and psychological dispositions, which people bring with them as their inborn heredity, are natural, but also individually differentiated, data. These, too, preserve a certain rigidity which opposes individual spontaneity and so only dispose of a limited plasticity. While physical dispositions and aptitudes remain largely invariable and inflexible, spiritual forces and tendencies are from the beginning more or less mutable. The artist's decisive hereditary aptitudes, sensitivity, and differentiation of the organs of sense are caught in the middle of the two biological mechanisms. In contrast to Lessing's concept of the artistic genius, we can imagine neither a Raphael "without hands" nor a Raphael with the hands and dexterity of the master but without the corresponding visual talent. The elementary aptitudes belong to man's natural equipment whether they are physically or spiritually, sensually or automatically associative,

and they develop along fixed, determined lines. On the other hand the relationships between hereditary dispositions and objective reality are completely mutable and in part spontaneous. The functional totalities in which they complement each other are dependent upon dispositions and their objective substrata to the same degree.

A person's good ear or graphic skill can permit us to make only a rough estimate of his artistic ability. Gifts and tendencies of this sort touch the personality only externally. Their relevance depends upon what the person can do with them, just as it does with all the rest of his natural gifts. Hereditary dispositions, a person's psychosomatic tendencies and abilities remain dormant potentialities in the depths of his being: they first have to be roused, functionalized, and historicized if they are to become the source of artistic creations. They merely represent possibilities, and they are so far from counting as accomplishments that an all too playful, organic ability, unbridled and untrammeled, is often more of a danger to than a guarantee of artistic success. Skills and abilities which are separate from the totality of a person—his interests and efforts—have as little to do with authentic artistic creations expressive of a personality as, for example, the gait or tone of voice of the same person. The way, however, that the creative individual utilizes his talent and harmonizes it with his acquired skills, his gradually developed needs, and his criteria of taste, which grow constantly more exigent, shows most clearly how the reciprocal complementation of natural and cultural components of the achievements proceeds and how the work of art comes into being as a total sense structure. Everything individual and particular in the phenomena of life remains nature and pure potentiality. The humanity of man, his existence as a historical being, and his participation in culture begin with the dissolution of the rigidity of his natural gifts and the change of his particular activities into parts of a unified totality.

In contrast to humanity's cultural possessions is the whole psychophysical equipment which serves for their acquisition—something objective and external, an empty vehicle or an instrument which is first silent and has to be made to sound, like, for example, a violin or a singer's throat. It belongs to the person but is a foreign body, a tool, a machine with its own mechanical, spiritually alien conditions of functioning. As historically indeterminate and socially indifferent data, not only a person's physical but also his psychic constitution is an apparatus which is idling, which leads to the production of meaningful and culturally valuable products only by the introduction of concrete temporally, spatially, and socially determined experiential material. Thus, the artist may find his talent, strictly limited and sharply delineated as it is, not only a help but a hindrance and an inhibition which

he has to master and which he has to disregard. This is not only because of the inflexibility of the direction that is more or less part of every talent and often increases with the magnitude of the talent, but also because of the singularity with which it opposes, as a mere instrument, the artist's intention, intervenes between his self and his work, and alienates the former from him.

The question to what extent and in what sense we can talk of innate talent seems at first sight to be the most important one in connection with the biological factors of artistic creation. However, if we consider that hereditary dispositions produce intellectual achievements only in conjunction with cultural—that is, acquired—skills, it becomes apparent that this is merely an apparent problem and that the actual creative talent is no more innate to the artist than it is acquired. The legend of genius, whether by the grace of God or nature, is an invention of artists, poets, and thinkers who wish to assert their claim to the privileges of an aristocracy of the spirit based on birth and blood. It usually serves to push them up the social ladder and corresponds to circumstances in which the creative intelligentsia can hope to disguise their origin by means of their achievements.

Only when we compare it with the spontaneity and flexibility of completely individual tendencies does what we understand by "talent" reveal characteristics of a constant and purely natural quality. In essence the naturalness of the biological presuppositions for artistic creativity is far less rigid and constant than that of its other geographical and ethnographical conditions of existence. All natural factors in the cultural process, it is true, change according to their role in the life and activity of people; but they are essentially different in this respect, too, and always change very slowly, but nevertheless now more and now less distinctly. None of these natural factors is more changeable and more subject to historical perspective than the spiritual and physical constitution and disposition of individuals. There is no human function, no attitude—strictly speaking, no instinct—that would not change its character in the course of its development. Every spiritual statement is tied to a particular point in time and a particular situation, as regards not only its object but also its form and structure, its biological motive force, and its psychic mechanism. Organs and impulses change incomparably more slowly than the content of experience, feelings, and expressions of will. Yet even to assume that they remain static while their functions change would place the evident interaction between mental forms and content in question and presuppose a causality with variable moments on one side and invariable ones on the other.

The changes landscape and climate, race and nation reveal are for the most part accomplished merely in the subjective bearers of the cultural processes and consist mainly in their changing views of objectively unchanged conditions of existence. In contrast to geophysical ones, climatic conditions sometimes undergo incisive changes of an objective nature and create, under certain circumstances—as, for example, at the end of the Paleolithic age—completely new conditions of life, which lead to new economic and social organizations. Even cultural change in races conditioned by interacting spiritual relationships has incomparably more far-reaching results than physiological degeneration and miscegenation, which only lessen the gap between them and make their identity problematic. An essential difference between the changes in natural factors precipitated by historical relations and their autonomous physical changes becomes apparent only with the change in man's physiological and psychological constitution. This exists and develops independently of the movement of the historical system, of which it is part of the equipment. We can speak of the actual "life" of the landscape and climatic milieu only in a scientific sense, just as we can speak of the "life" of a race or a nation only in a metaphorical one. The actual creative, not purely vegetative, life begins with men's psychophysical functions.

As indubitable as it is that every artistic act, whether productive or receptive, rests upon a natural datum, a particular talent, a particular skill or ability, so the concept of the specific talent proves in relation to the variability of purely individual modes of behavior to be a narrow and rigid category, however elastic we may conceive it to be. Its range grows less with every positive characteristic we add to it. Art as the expression of an innate talent thus becomes a principle of obligation and loses more and more its quality of freedom. Particularly limited, however, is the validity and practically barren is the concept of the psychic insufficiencies, inhibitions, and slips, the feelings of alienation and the desire for isolation which are regarded as the constant idiosyncrasies of the artist. But the meaning of these always depends on special historical and social circumstances, and they have essentially no claim to universality. Even if what we understand by artistic character and temperament is a daring abstraction and generalization, a product of the separation and isolation of the human abilities, the concept of the "sick" artist is based entirely upon an idea which had its origin in particular historical conditions, namely, those of romanticism. As a result of postrevolutionary disillusionment the artist, alienated from bourgeois society, took refuge in "abnormal" attitudes. Extravagance as a fashionable illness appeared, certainly not for the first time, but for the first time as an epidemic. It made itself apparent

in a more or less challenging way when the artist felt grounds for dissatisfaction and protested against what he saw as a supposed injustice by isolating himself from society and when a public was available to show interest in this curious display. The symptoms of alienation were the same in all periods of aestheticism late antiquity, the High Renaissance, mannerism, and the period of the movement of *l'art pour l'art*. The phenomenon of the alienation of the artist has been present in all periods of history, however.

Romanticism also bears responsibility for that exaggerated idea of the abnormality of the artist which gained currency as "genius and madness." In fact, none of the really great masters like Dante, Shakespeare, Michelangelo, Rembrandt, Bach, Beethoven, Goethe, Balzac, or Tolstoy was mentally deranged, and the works of the great talents who did go mad, like Torquato Tasso, Orlando di Lasso, Annibale Carracci, Schumann, Hölderlin, or van Gogh, seem to reveal signs of derangement. Whatever the case may be, facts like madness, neurosis, and similar irregularities belong to the natural data which influence artistic achievements in the most diverse and often contradictory ways. Neither sickness nor health, however, plays an immediate part in the quality of an artwork, its aesthetic value or lack of it. The relationship of these circumstances to the significance of the work is, in any case, uncommonly mediate, opaque, and ambiguous. A psychic or physical lack can as easily become a hindrance as it can, thanks to overcompensation, the origin of increased productivity. What we are accustomed to view as eccentricity, pathological sensitivity, neurasthenic irritability, even mental derangement, not only paralyzes but collects and channels the mental powers. Mental impulses, like the Oedipus complex or narcissism, aggression and regression, sadism and masochism, rationalization or sublimation, not only correspond to particular sociohistorical situations and exert their influence during these more or less limited periods, but achieve results during these periods which vary from case to case. Sometimes they calm excessive impulses by forms of direct wish fulfillment; sometimes they will bring forth products which substitute for such forms. Sadomasochistic impulses operate differently in the works of Cervantes and Swift from the way they do in, for example, the works of Baudelaire or Dostoevski. And what we understand by narcissism in the Freudian sense acquires the nature of alienation recently ascribed to it only through the Marxist conception of mechanized, depersonalized production dependent on the division of labor.

Every attempt to define the character of the artist which does not take into account the artist's particular historical situation and social circumstances is doomed to failure. Artistic talent has without doubt

more or less general constitutional presuppositions, but these vary from time to time, from society to society, and from individual to individual so extensively that to talk of an "artistic type" is illusory. The aim of isolating the artist from the rest of society always has the same romantic origin and is, even if we see the *differentia specifica* of the genus in pathological or other socially questionable attributes, aimed at acquiring special rights for him. There is still something of this romantic view in the rejection of the artist by writers like Thomas Mann, who play off the somewhat faded virtues of the decent bourgeois against the not entirely unattractive vices of their nonbourgeois artist figures and flirt with both ideologies.

Artists may tend toward depressive states and neuroses because of their sensibility and the supplanted motives of their extravagant striving after success. But just as we seldom meet psychotics among them, so very few end up committing suicide. From Durkheim, we know that the frequency of suicide is not psychologically but sociologically determined, that most cases are related not to class and profession, education and religion, mental crises and dramatic conflicts in the life of the victims, for example, but to a sudden unexpected change which throws the individual off the track of his former existence and customary conditions, no matter whether his fate takes a turn for the better or the worse. The artist is exposed to this danger like everyone else in whose existence success, happiness, fortune, and chance play a part, but he is no more threatened by it than any other gambler.

Human psychological mechanisms, their tendency, particular impulses, desires, and appetites, their emotionality and moods change fundamentally with time. However, the psychophysical apparatus at their disposal also changes, namely, their sensitivity, their mental grasp, and the predominance of their individual organs of sense. Historical epochs differ psychologically from one another not only according to whether their representatives are sentimental or rational, ascetic or hedonistic, heroic or passively conformistic, but also according to whether their perceptibility is essentially visual or acoustic, plastic or motor, homogeneous or heterogeneous. The criterion for the prevalence of the one form or the other is usually seen by whether this or that predominates in a particular epoch. In this sense we talk of periods of painterly visuality, of musical ear, or of literary feeling for language. However, because the most progressive, fruitful, and attractive medium of communication at any given time moves from one art form to another, simply to talk of visual or acoustic periods is an all too bold simplification of the facts. The predominance of one form of sensuality and the art form corresponding to it—which is, incidentally, never unconditional—depends upon many circumstances so that we

can never speak of the primacy of a particular organ of sense and its predominance in the whole area of art in a particular period. What can really be ascertained is confined to the modification of the sensitivity of the organs of sense and their changing role in the reflection of reality. What remains decisive is that their function is always linked to natural—that is, more or less permanent—data and the precedence of one or the other is always the result of an interchange between what we want and what we are able to do.

This is sufficient for us to insist that, apart from general, purely formal determinations, the only psychology is a historical one, in which the ahistorical element probably plays a larger part than, for instance, in sociology, which is nevertheless concerned with man as a historically mutable being and to which he appears, in every concrete way, as historically modified and broken. Not even as objective and purely quantitatively expressible a moment as the different ages of man has a meaning fixed forever. Youth and age assume from time to time a different meaning vis-à-vis each other. As far as definitive insights and achievements go, age is for classically and conservatively conditioned periods, youth for romantically and progressive periods—the more valuable, productive, and richer phase of human life. In the Goethean idea of age's tolerance and the romantic concept of the right of youth to be intolerant, in the different views of evolution and revolution, initiative and maturity it is clear that the biological categories acquire an anthropological meaning only in their historical aspects. The prestige of age is reduced, as Max Weber remarked,[5] in periods of economic crisis, in wars and revolutions, when traditions weaken and disintegrate. The psychological data are, like all natural factors, mere opportunities, whose meaning and value for sociology depend upon their historicization—their connection with the history of mankind as a whole.

The Generation Factor

The community of generation forms, according to its structure, the transition between the natural and the cultural factors of the historical process. It has variable and invariable characteristics. The constant ones come from the identity of age of the members of a generation, the mutable ones from the diverse roles members of a generation play in the culture of their time. The biological fact of the date of birth cannot be changed and is uninfluenced by the conditions of a given moment. Sociohistorical circumstances may have a decisive influence upon the life span of man, but his birth is a natural and not a historical phenomenon. Just as birth and age cannot be changed, so youthful

experiences are to some extent irreplaceable and inalienable. They are happenings from which many try in vain to free themselves. The remaining constitutive elements of a community of generation are on the other hand inconstant, and they change not only as individuals develop, grow up, and become old, but also inasmuch as the relationship of the different generations to one another and to social groups of all sorts is subject to constant change. The same generation not only has a different character as a group of twenty-year-olds from that of thirty-, fifty-, or seventy-year-olds, but also changes its character according to its relationship to different generations at one and the same time. The interaction within a generation goes so far that its representatives seem to stay young for a longer or shorter time, to leave the life of society earlier or later, according to the function they fulfill in the total culture of a period.

The different factors of the historical and social process have either predominantly natural or essentially cultural characteristics, although in their function in historical life the natural data also assume certain characteristics of the cultural components and undergo modifications according to the historical role they play at a particular time. On the other hand a generation never appears at any stage of development as pure nature, without ever actually losing all its natural characteristics. It is tied to a fixed date of birth, but apart from this everything is dynamic, mutable, and fluid within it. Simply as an age-group, a generation has no particular historical meaning. It acquires such a meaning only in relation to the totality of the given situation and to the complex of the different social classes and generations with which it is symbiotically linked. A relationship of this sort involves not merely the reciprocal complementation of products but also the continual interplay of forces and the constant adjustment of tasks. Even the mere transfer of cultural goods, the process of learning and teaching, of stimulus and response, in which the context of generations is expressed, would in a deeper sense scarcely be possible without, on the one hand, the pupils' taking over the experiences of the teachers and, on the other hand the teachers' acquiring new points of view from the questions of their pupils and successors.[6]

Thus, however, decisive birthdates may be for qualifying a social group as a generation, the same birthdate in no way ensures a feeling of solidarity within a generational community. To this feeling belong common historically and socially conditioned interests, problems, and aims. A concept of generation including all people of the same age would have no sociological relevance no matter how constituted. The symbiosis of contemporaries would remain—apart from their distinc-

tion from one another—culturally amorphous and unarticulated, from a sociohistorical point of view. In the same way, the purely sociological categories, void of natural conditions of being in whose element they assert themselves, would remain abstract, empty, and unworldly. Even in this context we face the already known fact that goes to designate the whole cultural process—namely, that natural phenomena belong to the indispensable preconditions of the sociohistorical processes, but not to the causes from which they could be derived or to the entities in which they were contained in embryo. Identity of age is a necessary foundation of the community of a generation, but there are both purely culturally and socially more definitive solidarities than community of age. In fact, we come across just as many and just as diverse outlooks in one and the same age group as we do agreement between members of different age-groups. No matter how indubitably contemporaneity may lay the foundations of similar dispositions, this foundation begins just as unavoidably to shake when the feeling of community of age is pushed in different directions by different class ideologies, professional interests, cultural traditions, and cultural ideals.

It is a well-known phenomenon that different stylistic movements are represented in the same period by different generations, and it is very easy to bring difference in immediate style into causal relationship with the situation of a generation. Palestrina was still creatively active when Monteverdi began to compose. The date of the forward-looking *Princesse de Clèves* (1678) is also the date of the classicistic *Fables* of La Fontaine. The conservative Fra Bartolommeo and the progressive Pontormo were contemporaries, but they were no more members of the same generation than were Mme de Lafayette and La Fontaine, or Palestrina and Monteverdi. Difference in style can in these cases really be explained or made more comprehensible by the difference in generation. The situation grows more complicated, however, when we meet similar great stylistic differences in the same generation. The worldly, realistic Donatello was born in 1386, Fra Angelico, bound to the church and the Middle Ages, in 1387. Bach, the introvert, and Handel, the worldly, both belong to the generation of 1685, one which contained an extraordinary number of rich talents. Benjamin Constant and Chateaubriand, whose works are miles apart, were born in successive years (1767 and 1768). Goethe and Schiller represent, in spite of the difference in their ages, the same generation, but they express within this the same prototypical antithesis between traditionalism and antitraditionalism which is immanent in a generation and which exists between Voltaire and Rousseau where there is more and between Tolstoy and Dostoevski where there is less time and difference. The difference in style and character is in these cases mainly to be explained

by sociological factors which intersect with natural conditions—differences in class and the particular socioethical measures of value.

One of the most revealing examples of the organization of artistic development by generations is offered by Dutch painting of the seventeenth century. The three greatest representatives of the period, Frans Hals, Rembrandt, and Vermeer, each belong to successive generations and represent at the same time three clearly distinguishable variants of style in the same artistic movement. Frans Hals's effervescent affirmation of life and his love of reality, Rembrandt's spiritualization and inwardness, and Vermeer's cool and bold elegance correspond to three sharply defined phases in the rise of the Dutch bourgeoisie. The first generation is filled with a striving for success; the second experiences the rise of a new propertied class with much free time at its disposal; the third grows accustomed to well-being and security, is saturated, and already tends toward conservatism. None of the three masters had contemporaries of equal rank, and none of them could count on an extensive and really artistically sensitive circle. However, in the community of a generation it is more a matter of the unity of feeling for life and the similarity of interests conditioned by a particular view of life than of the number and equality of rank of the creative and critical personalities or of complete agreement on standards of value for artist and public. In spite of the close relationship between Rembrandt and the intelligentsia of his time, even his friends and patrons probably did not do complete justice to the significance of his works. Of course, artists were not exemplary "citizens" as defined by their time and society and they were by no means the most definitive representatives of their contemporary compatriots. The association of a generation is the same as the natural conditions of common living space, the same ethnic or national origin, or the same biological disposition. In the context of this association we may also ask what someone can do with the natural gifts he has been given and whether and to what extent he is able and ready to make use of the chances offered him as the member of a particular generation. The situation of a generation is nothing but an empty space which is to be filled with positive content consisting of certain social and cultural links. The same birthdate, simultaneous youth and maturity belong to the mere framework of the picture which is put together from social connections, class, interest and cultural solidarities, common ideologies, and political objectives. An individual who is historically *déraciné* and disoriented, socially unattached and disinterested, cannot profit or make real sense of the situation of his generation.

Thus, if a generation owes its homogeneous character first and foremost to birthdate, it is not entirely the case—as, for example, Ortega

y Gasset suggests—that a generation forms a "human variety" whose representatives "are born with certain typical characteristics."[7] People of the same age may, it is true, express the same tendencies and needs within the same period of time, and the homogeneity of their reaction to given stimuli may in part be explained by their age. They only become a "human variety" in a not purely biological sense under the influence of those stimuli, not as a result of their common birthdate. The character of a generation arises from the simultaneity and the succession of people of the same age—people who have, however, only the potential, not the ways and means, to behave in the same way. For this reason birthdates of themselves say very little, and thus we know as good as nothing, if we know only that Beethoven, Hegel, Hölderlin, Novalis, Wordsworth, Coleridge, Rousseau, Chateaubriand, Mme de Staël, and John Constable were born in or around 1770. We are far from knowing what they have in common with one another. For not only were the differences between their interests, attitudes, and products greater than the compass and depth of the problems they shared, but also these problems themselves were so diverse and disparate that they could not condition a community of views among their representatives.

Yet even if we were to disregard the differentiation which the different personalities, problems, and media bring in their train and the concept of generation were to be oriented toward dates and ages, we should not be able to transcend the primitiveness of the psychology that simply represents youth as progressive and old age as conservative. The identity of a generation may certainly be determined by birthdates; its character, however, is not determined once and for all. The members of a generation do not represent the same character types at twenty-five, fifty, and seventy-five. The answer to the question, especially, as to what age finds them most suited to fulfilling the task of their generation, may differ from time to time. There are epochs in which young people and some in which older people play a more important part and are more closely linked. A cultural elite which is conservative and idealistic and which holds fast to classical principles of art will accord special advantages to the older generation—mainly to protect itself against the "irresponsibility" of young rebels. A progressive, liberal intelligentsia which thinks nominalistically and follows romantic or naturalist principles of style will on the other hand have a tendency from the beginning to regard youth as intellectually more productive and as more definitive from the point of view of historical development. The legend of the unique historical mission of youth is entirely an invention of the romantic-naturalist periods of art and was unknown before them. To judge a generation on the basis of its youth movements

is justified only to the extent that it is mainly the youthful period of a generation which bears the responsibility for eliminating the old measures of value and choosing new norms and models, even if its most important representatives do not produce their most progressive and epoch-making works in their youth. In any case the solidarity of a generation usually asserts itself most strongly as a "community of youth,"[8] and in this sense we can talk, at least since the romantics, of an "alliance of youth" against age. The age of a person as a creative individual cannot, however, be measured in terms of years. One person will be exhausted at thirty, whereas another may gather his powers only when he is well advanced in years. Many experience a second youth in old age, a new creative period of life, and represent two generations in one and the same person. Aged artists may often be a residue of earlier times; but alongside limping antiquity, we also find premature maturity. And although no one can rush ahead of his time, there are, side by side with the older generations which keep pace with their time, younger ones which grasp ideas that are in the air so quickly that they seem to invent them.

The phenomenon of generation does not as a result of its constant characteristics become a definitive factor in the historical process as geographical, ethnic, or biological data do. If the significance of a birthdate were not of itself more variable than that of a place of birth or a physical type, and if the different structures of generations were not involved in a more inner and constant interaction than the natural conditions of creative activity, then there would be no reason to lay claim to a special place for the generation as a factor. In fact, the actual life and influence of generations consist not of genesis and development but of competition and cooperation on the part of the bearers of culture. In this process not only are generations which work side by side or compete, but also those which succeed one another and relate to one another involved in a mutual dependence. In the relationship of successive generations not only is the present generation influenced by the former, but the past which has been superseded now appears in the light and perspective of the particular present. Threadbare traditions, devaluated models, and debilitated rules are actualized by the new views of the generation involved in the operation. In no process is the reevaluation of the past—the rediscovery of an outdated, neglected, or misunderstood artistic style—so clearly reflected as in the appearance of a new age-group that no longer feels bound by an older generation's criteria of value. The biological fact of birth may not be the decisive motif for the change; nevertheless, it represents one circumstance which belongs to the presuppositions for the change. The change and interaction of generations are factors in the cultural process

which are both biologically and sociologically conditioned. The system of coordinates in which the articulation of generations is effected comes from crossing the two processes in historical time in the one direction and in social space in the other.

Apart from the common birth date of their representatives, generations are marked as biological and anthropological entities by the periodic intervals between the appearance of different creative age-groups with authoritative personalities at their disposal. To some extent what we call the rhythm of the succession of generations is also part of this concept. Of course, we can only speak of a purely mechanical or an irregular rhythm—which is not an actual rhythm—as long as we do not wish to get involved in metaphysical speculation or in making a forcible construction. Either we divide every century into the life of about three generations and arrive at a purely natural historical classification which is culturally as good as useless, or else we talk of a "new" generation only when a culturally creative age-group emerges and so give up the concept of rhythm linked to some sort of regularity. A biological generation probably has a life of thirty years, but the assumption that a decisive or significant change takes place every thirty years in the culture of a nation or a society would lead to an artificial periodization, which, like the doctrine of cultural cycles in general, has absolutely no foundation.

The principle that a stage of life represents nothing but an open-ended possibility, the realization of which depends on historical, social, and cultural conditions—not on natural or biological ones—is confirmed in the so-called rhythm of the succession of generations. Since natural potentiality always needs a certain activating force to be historically effective, it does not seem guaranteed that at the end of a generation there will always be a change in life-style. The change of generation styles, sensitivities, and views of art by no means always corresponds to the biological change of generation, no matter how we average things out. There are centuries, like the sixteenth in Italy, with four different stylistic movements differentiated according to age-groups, and others, like the seventeenth in France, with only two definitive and distinguishable styles, an academic, rationalistic one and a less formally rigid, more emotional one. The general rule is, however, that the epoch-making change of generation accelerates as development progresses. In the Ancient East there was no question of a generation's being a measure of stylistic development, and this is still pretty much true of the Middle Ages. Since the Renaissance, however, the representatives of different generations have become more and more unmistakable and seem to be further and further away from each other.

Today a generation embraces several styles, which replace each other more and more rapidly.

In modern times there have been many relatively short periods particularly rich in creative talents, and although talents always appear as single numbers, it often happens that they appear either in groups or not at all. These groups are, however, never "chances of nature," as Wilhelm Pinder calls them,[9] but the expression of culturally favorable circumstances in which dispositions and abilities become productive, which may otherwise be present but lie fallow because the necessary conditions of development are lacking. Instead of Pinder's "regular grouping of decisive births," we can at best talk of the possibility that a society capable of producing a certain number of talents would also provide them greater latitude. Thus, the grouping of talents corresponds not to a natural rhythm of births, but to a completely "unnatural" massing of intellectual production under certain conditions.

In any case, the alternation of continuity and discontinuity which characterizes the history of generations introduces something of the principle of rhythm, in a nonactual sense and with unequal intervals, into the essentially arhythmic flow of history. The articulation of development according to mere phases adds a further dimension to the linear historical process. With the introduction of the concept of generation into history we have also the aspect of an interrupted development. Those generations which support traditions represent at the same time a principle which is contradictory to them. With both of their functions they are part of the indispensable presuppositions of every productive culture that shows itself capable of development. We can talk of such a culture only where spiritual values are transmitted, but these are from time to time suspended by change in their supporters—they are renewed and filled with fresh life. Generation and tradition are connected in a double sense. On one hand, they are antithetical, since every generation implies, more or less, a break with tradition; on the other, they seem inseparable, for a tradition is a tradition only if it is appropriated not merely by single individuals, all too narrow communities of interest and cultural strata, but by a generation, which for all its social differentiation represents a sort of cross section of the society of a period.

The change in the social standing of individuals, their rise from one class to another, the change in their relationship to individual cultural strata, their withdrawal of loyalty to a group with which they formerly felt a solidarity introduce changes in the world view similar to that brought about by a change in generation. The historian Henri Pirenne went so far as to place purely socioeconomic changes into immediate

relationship with change of generation. He believed that he had found the constant rhythm of the social history of capitalism in the elimination of the saturated strata of society from active economic life and in the rise of classes which had not till then participated in the profit of the economy, and in the development of the poor into wealthy classes and of the wealthy classes into the aristocracy and the ruling class.[10] As the bearer of culture, the generation which was still progressive while it was immediately tied to the economy begins to think and feel conservatively after retiring from economic activity. It hands over the leadership to the next generation, which is stimulated by a dynamic feeling for life but which in about another generation will begin to retard development in order to make room for another stratum. Pirenne's succession of representative social classes is, it is true, divided up more irregularly and conditioned by more rational factors than Pinder's succession of generations, simply because it is based not on biological and natural data, but on historically variable conditions that can be influenced intentionally. However, he also makes use of the concept of a somewhat mechanical rhythm and neglects the fact that phases of development which alternate are completely irregular and that their alternation cannot be explained by a theory of fatigue, as we can see most clearly when we analyze changes of style in art.[11] Every sociohistorical change presupposes a nonmechanical, incalculable, and unschematic movement, peculiar to every case and conditioned by different, often contradictory forces. Such a movement yields to the rules of no constant rhythm no matter what form it may take.

The sociological structure of a generation has nothing in common with the inner structure of a coalition that has been carefully planned, consciously developed, or agreed upon. Its coherence is effective, like class structure, often without the consciousness or will of its members. It is not a community of interests like an economic class or a profession; it is not an alliance or a coalition that can be joined or left at will. A community of a generation represents an order of relationships which becomes, and remains, valid without its members having to account for their homogeneity. Their community is capable of consciousness like that of members of the same class. It can become conscious at any moment, but it functions without the consciousness of its bearers. Pinder himself already emphasized that consciousness of community is not among the conditions of belonging to a generation, that consciousness is independent of the knowledge and desire of its exponents, and that in many decisive cases such a consciousness never develops at all. He also pointed to the remarkable phenomenon that a consciousness of community develops more readily in relatively narrowly defined groups like the Sturm und Drang, the Parnassians, the Barbizon

school, and the impressionists, than it does in the Renaissance, the baroque period, or the romantic age. The more limited a group is, the more programmatically its goals can be expressed and the more strongly its unity can enter the consciousness of its participants.

It is clear that an objectively identical point of time always means something different to different individuals according to their age, the particular stage of life in which they find themselves, and the extent of their experiences. The world does not present the same picture to a young, a mature, and an old man even at the same time, nor does it have the same meaning or present the same problems. It is the nature of the perspective of the picture of the world at a given time, and the changing aspect from which they view things, that distinguishes most clearly not only different generations from one another, but also different ages in the same generation. Thus, different ages within the same community of a generation represent another criterion for the differentiation of views of the world and modes of behavior. They offer a clue, which is by no means negligible, to the classification of the different experiences that are related to historical reality. Certainly a biological category, like that of a generation, loses much of its unambiguity when it is related to social or cultural facts. The concept of age assumes a meaning in its translation of biology to history that is partly relativistic and partly metaphorical. How "old" one is depends, from the cultural point of view, not only on the years of a man's life, but also on many other circumstances; thus, it is possible to grow old, decrepit, and outdated more or less independently of age.

It is well known that simultaneous artistic phenomena are not always at the same stage of stylistic development—not only in the different arts, depending on which one is playing the leading role at the moment, but also within the same form of art or the same genre. This depends on the cultural strata for which the works are intended and whether they are in contact with movements which are more or less progressive. Since the decisive differentiation of the public for art in the eighteenth century, it is clear that literature, painting, and music do not move on the same plane. Not only was music, as a whole, more backward than literature or painting, but within musical production itself there were simultaneously more progressive and more backward products. The developmental and aesthetic significance of these sometimes stood in an inverse proportion to each other, as in the case of Bach and his sons. Many of the contemporary works were so far apart from each other—not only because of the difference in generation between their authors, but also because of the difference in interests and culture of the patrons and recipients—that it seemed as if the people in question, even when they were actually neighbors, did not live in the same

world. Thus, it was the same Venice in which the old Titian and Tintoretto, younger by a generation, made their home, but it was not the same Venice in which they "lived." In the last century, too, it was not the same Europe in which the July Revolution was for Heine a world-shattering happening and for Goethe a bagatelle.

Pinder distinguishes between community of generation and a common stage of development. Bach, Handel, Domenico Scarlatti, and Rameau, who were born in 1685 or just before, have all reached the same stage in the development of Western music. They are, however, no more closely linked to one another in a community of generation than they are to the almost contemporary Watteau or Piazzetta. It is enough to compare Bach and Watteau to become aware of the fact that in no sense at all do these two contemporaries represent the same style. What is therefore the meaning of Pinder's "common stage of development"? Certainly not much, if we overlook, as he did, the fact that a point of time merely represents a possibility, a possibility which does not permit us to draw definite conclusions—as to its effect upon the nature of the particular phenomena—from the purely chronological coincidence. It is also true that particular forces essentially different from the natural, biological ones must also cooperate in order for a concrete, personal happening with real historical significance to develop from the naked fact of a point of time or from an objective value in a developmental process.

Pinder's most valuable contribution to the doctrine of generations is not in his consideration of the stages of life when he is analyzing inclinations or movements, whose role in the cultural process was known long before him, but in the insight that the assumption of the "one-dimensionality" of culture is untenable. Behind the historical constellations and cultural relationships, artistic movements, and drifts in taste, there are no "ageless norms," as he says, but representatives of different age-groups all acting at the same time. In this way every culture is composed of contributions made by groups of different ages. All he neglects to mention is that the influence of age on the formation of a cultural consciousness can go so far that the individual cultural structures, intellectual trends, and points of view, even for the same person, always mean something different according to the actual point of time that person has reached in his life. He recognizes, however, that there are no simple one-dimensional presents which people replace with their birth dates in the "anonymous" view of history.[12] Every historical moment is experienced by individuals of different ages, is interpreted and used as an opportunity for action; and every set of historical facts is accordingly multidimensional.

A culture which consisted of one stratum of generation is unthinkable at a late stage of development, even in cases where definitive products are produced in a single generation. If a stylistic period, for example, the High Renaissance, seems to be dominated by a generation, this is, as far as the facts go, a distorted historical simplification. It leaves out of account the fact that noteworthy stragglers of the quattrocento were active at the same time as the classicists of the Renaissance, the young mannerists, and the representatives of the protobaroque and that they all played a not inconsiderable part in the production of art in this epoch. The unanimous authority of a generation without competition or contradiction would presuppose a strict community of circumstances which would correspond to Pirenne's possibilities of advancement. In these circumstances the older generations would have to retire as soon as the younger ones were ready to start their activity, and the old would all grow tired of their activity at the same time, while the young would become ready for action. This sort of straight-line continuity never takes place in this way in real life. Not only do teachers, masters, and immediate successors all work side by side, but there are even people who are still active after seeing two younger generations grow up.

The phenomenon which Pinder, somewhat overstating the case, calls the "lack of simultaneity in the simultaneous" but which should more correctly be called the simultaneity of dissimilar age does undoubtedly represent a significant discovery, but its implications must be thought through and interpreted more clearly. Its essence is that the culture of no historical period is monopolized by a single generation and that its apparent unity is always only the sum of the contributions of different age-groups working side by side. Pinder assumes a "three-part harmony" for different periods in general. He admits, however, that this scheme is an exaggerated simplification of the facts, since in reality a new generation is born every minute.[13] If that is the case, however, what does a "generation" mean in the cultural context? How do we reconcile this to the fact that in every cultural epoch we come across only a limited number of generations—three or four in a century? Historically, we can apparently speak of a distinctive generation only when a unified age-group asserts itself with particular, unmistakable characteristics and original representatives who are authentic in the eyes of their contemporaries. In this connection it is just as meaningless to assume either a number which is determined beforehand or an unlimited number of generations. In the last century we can only speak of a romantic, naturalist, or impressionist generation. The assertion that a new generation is born every minute can only mean that the condition of a common birth date is not to be taken literally and that

even with the aggregation of individuals into generations the dialectic remains operative to the extent that the collectivist tendency toward the formation of groups meets resistance from the individualist tendency to isolation. Generations finally strike a balance between biological and historical possibilities, natural stimuli, and cultural reactions.

A philosophy of culture founded on the concept of generation would remain a dangerous simplification no matter how many voices were singing in the choir. The parting of the ways never happens on one level or in a straight line, but on different levels and in different directions, so that the polyphony of the generation is only one moment in so complex a set of facts. Pinder, it is true, touches on the thought that in a historical situation, there is to be seen besides this polyphony a phenomenon he calls the "infection" of one generation by the other. However, instead of pursuing its beginning and end and investigating the part played by sociohistorical factors like coalition, imitation, opposition, competition, tradition, conformism, and alienation in the complex of relationships, he holds fast to his biological ontology and asks whether the principles which are set above generation, insofar as they exist for us, do not finally turn out to be a "meeting of individual entelechies of generations."[14] Thus, he finds no way out of the cul-de-sac of his unsociological philosophy of history and remains trapped in his naturalistic determinism and caught up in his nondialectical, unresisting, and dominating principle of generation.

Only when we become aware of the fact not only that every culture is the work of several generations linked together, but also that the individual age-groups cooperate and compete at the same time in the process can we grasp the dialectical nature of the process which is taking place. The structure of relationships can best be understood in the form of a score with a polyphonic structure in which the individual voices correspond to one another but at the same time contradict one another, or in the notes of a tune in which each stage supersedes the preceding one and at the same time preserves it, so that the context of the notes represents not only vertically—that is, harmonically—but also horizontally—that is, as a proceeding "argumentation"—argument, development, and solution. The dialectic of the generation is represented in the sense of such a score both in its thematic successions and in its contrapuntal juxtaposition.

The inadequacy of Pinder's theory consists mainly in the fact that according to it the "entelechy" of a generation is determined by "fate" and allows of no choice or change. The nature of socialization, the forms of union and opposition, communities of interest, and competitive struggles are on the other hand of more or less no concern for the structure of generations. Pinder's entelechy of the generations re-

minds us to some extent of Riegl's "artistic intention," but whereas the latter is merely a matter of a concept of style, the former contains the whole culture of a generation. Even if Riegl's principle of style did bear the character of necessity and did not actually permit intention or choice, for Pinder the community of generation becomes a fate whose inevitable nature is only strengthened by its biological origin. Even for Riegl there are different contemporaneous artistic intentions, which contrast with each other more or less sharply according to the concepts of form and criteria of taste, local schools and traditions, national types and individual inclinations at a given time. "Artistic intention" as a temporal style, as he wanted the concept to be mainly understood, embraced for the most part, however, all the remaining stylistic tendencies. In contrast to this, Pinder's theory of generation rejects the supposed unity of an epoch, as taught by the doctrines of *Zeitgeist* and the style of a period, and replaces them by a variety of mentalities within generations. For Pinder the concepts of individuation and the fatality of the cultural process are indivisible. He emphasizes on one hand the concerted nature of generations as against the anonymity and abstraction of constructs like the romantic *Zeitgeist* and Riegl's artistic intention, and on the other the idea of fate in connection with every human activity as against the materialism and the mechanism of the "nonspiritual" scientific and voluntaristic world view of the period. In so doing he overlooks the more or less mechanical nature of every force that determines intention and action from the beginning, whereas the truly humanistic attitude involves the assumption of a challenge on the part of objective reality and its conquest by the consciousness.

To explain historical development on the basis of generations is particularly fruitful in such complex artistic and cultural movements as romanticism. For it is only when we distinguish the different romantic generations from one another that we begin to comprehend the contradictions in attitudes to art in the different Western nations. A one-sided concern for the principle of generation that does not take into account other constitutive factors of development proves, however, even in this case to be inadequate. The historical viewpoint oriented toward generation becomes really revealing only if we recognize that the whole sociohistorical situation and corresponding ideology, the interpretation of the feeling of community at a given time, and the consciousness of solidarity bear more weight than the birth dates and ages of the participants. As a result of this, the units of generations which correspond chronologically to one another often play very different roles in individual national cultures.

The first generation of German romantics felt itself very close to the revolution; it thought absolutely progressively and only later turned to reaction. The first romantics in France, however, were conservative-minded, and only the second generation moved toward political radicalism and the doctrine of artistic anarchy. The most illuminating explanation of the discrepancy seems to be that nonconformist philosophy and literature appear to the youth of the German romantic period as a sort of compensation for the revolution which did not take place. In France, on the other hand, where the best part of literary production both during and immediately after the revolution is émigré literature written by members of the old aristocracy, romanticism reveals only a counterrevolutionary character, and it only gradually becomes more progressive as the émigrés fall silent or die off. The state of affairs becomes more complicated, meanwhile, because the second phase of development in Germany is in the hands not of a new generation, but of the same generation grown older—the mature Friedrich Schlegel, Hegel, Novalis, and Schelling.

Apart from age-groups, the stratification of communities of generation is determined not only by national cultures and the dominating cultural strata at a given time but also by common intellectual interests and goals. The three groups of writers (1) Chénier (b. 1762), Mme de Staël (1766), and Chateaubriand (1782); (2) Wordsworth (1770), Walter Scott (1771), and Coleridge (1772); (3) Hölderlin, Hegel (both 1770), Friedrich Schlegel, Novalis (both 1772), and Schelling (1775) belong chronologically to virtually the same generation. However, as a result of their different nationalities and cultural traditions, they form completely characteristic and noninterchangeable generation units. The most important groups in the second romantic generation are more sharply differentiated according to their specific areas of activity, views of the world, and ways of life: (1) Lamartine (1790), Vigny (1797), and Hugo (1802); (2) Géricault (1792), Delaroche (1797), and Delacroix (1799); (3) Carl Maria von Weber (1786) and Schubert (1797); (4) Byron (1788) and Carlyle (1795); (5) Leopardi (1798) and Pushkin (1799). Cases like Delacroix and Ingres (1800), like Handel and Bach before them, show that the chronological generation unit, even when there is a common cultural tradition and a similar activity, is not always enough to create a true community of generation.

If we describe the romantic movement according to generations and point out that its individual national variants are not unified and unequivocal but present a changing picture structured according to generations, we come closer to the facts than earlier explanations did. These traced contradictions within the movement back to individual or national peculiarities, and yet an explanation which clings to the

idea of conservatism in one generation and progress in the other is also unsatisfactory. Both could in fact achieve their answers by following an inadequate, unrealistic, and undialectic path which avoids the contradictory yet mutually interacting forces of history. Friedrich Schlegel's simultaneous enthusiasm for "the French Revolution, Fichte's *Wissenschaftslehre* and Goethe's *Wilhelm Meister*" was just as naive, unworldly, and unaware of the problems at hand as his later intervention in the cause of the Holy Alliance—indeed, the whole romantic enthusiasm for Church and crown, feudalism and chivalry, monastery and guild.

Irrationalism, like emotionalism, is the experience of a generation and can be encountered in every form of romanticism, whether conservative or progressive. It is simply that irrationalism is different and has different consequences according to the political point of view of its representatives. That of the liberal class is based on the principle of unfettered freedom and spontaneity, deriving from the idea of individuality. It is unexceptionable and remains harmless; the rationalistic heritage of the Enlightenment limits arbitrariness. On the other hand, the irrationalism of the conservative classes is disquieting, governed as it is by their principles of being and tenacity, like origin, race, and nation, the idea of a perpetually youthful folk-spirit and a naive folk-art which is indestructible; it serves as an ideology for that romantic trend which opposes the Enlightenment. Both directions are grounded in the principle of generations; however, not only are they dependent upon factors much more complex than the character of generations, but they are generally represented in the different countries by different generations according to the political role these are playing at a given time.

The Cultural Factors

On one hand cultural structures grow out of natural (physical and psychic) data, on the other out of social needs. They are linked to an objective, natural existence, presuppose a ready-made, natural world, but assert themselves for the first time only on a level to which access has to be opened, acquired by effort, and worked for. The natural factors of history are either inherited or already present; they are either patrinomy or plunder. The cultural elements, in contrast, have to be achieved, developed, carefully formed, and protected—their production, use and conversion form the content of history.

The stage of nature which is purely material, ahistoric, and alien to sense—of the geographical, ethnic, and biological conditions of existence—is not transcended by the fully articulated forms of socializa-

tion; by totally organized coalescence and strictly regulated cooperation; by the more or less rigidly organized conditions of government and property, and the division of the body social into federations and leagues, institutions and associations. The most primitive conditions of production and the rudiments of economy already show traces of rational expediency and indicate that certain principles of order and organization have been adopted, no matter how elementary these may be. They owe their meaningfulness and purposiveness to the flexibility of the conditions of production, the ability of people to take into account and to adapt to conditions of existence at a given time—in short, to the fact that cultural factors can be modified and natural data cannot; this is essentially the basis of historical existence. The constitutive role of natural phenomena in the historical process is unquestioned; positivism only makes the mistake of trying to derive history immediately and entirely from them. They probably do change their function according to the historical situation, but the purely mutable and flexible elements of the cultural process are not the natural but the social factors of development. As Saint-Simon says, society finds itself constantly *en acte*, changes constantly, and is always dominated by a dynamic principle. In comparison with society, the substratum of the most lively individual attitudes—biological nature and the psychological disposition of the most active people—is essentially static. It represents both a principle of limitation and one of potentiality. Even the psychophysiological substratum of historical processes may change, but this change remains a natural phenomenon. It takes place not only independently of human knowledge and will, not only so slowly that man's biological constitution seems in every practical sense to be stationary, but also according to laws completely different from those governing the historical and social process. In the course of natural development there unfold more or less constant dispositions, forces, and tendencies that are more or less permanent; the course of history on the other hand involves innumerable factors which are unforeseeably varied.

Social and cultural factors participate in the historical process not only as a mere substratum of expressions of consciousness and will, like the natural factors, but also as the principles of dynamism and mobility themselves, and in more than one connection. As structures conditioned upon their situation, as classes, professions, communities of interest, cultural strata, social circles, and the like, they are involved in constant differentiation, development, or integration. None of these structures remains unchanged for long, no matter how stable the external conditions. The individual subject, however, moves from one social category to another even if the external conditions remain

unchanged, and he is constantly moving up or down within the same category. It is finally part of the dynamic of social existence that the different forms of interpersonal relationships, like coalition and opposition, cooperation and competition, solidarity and alienation, become actual and effective only as they succeed one another. Thus, the changing picture presented by an individual in different periods and situations in his life is only a reflex of the social role he plays, a point Proust believed he had determined and explained with his perspective psychology.

The natural data remain essentially stable in spite of their changing function and the different use made of them; they do not appear as purely natural phenomena on the historical level. On the other hand, the cultural factors in the historical process are essentially dynamic, lively, and mobile. Yet, though the natural conditions remain the same but without always meaning the same thing—that is, they more or less historicize themselves—a reversal in the opposite sense takes place in the cultural factors. They immobilize themselves to some extent and change, from completely mutable and apparently freely chosen means of solving different practical problems, into fixed forms that are autonomous and quasi-logical and that claim to be timeless. This immobilization of forms corresponds essentially to the well-known tendency, mentioned by Georg Simmel, of culture to harden and mechanize the functions that were originally spontaneous and differentiated according to the purpose of the moment. This is a development from which consciousness and will are more and more eliminated. However unmistakably the finished forms of culture oppose any admixture and assume the characteristics of objective, self-sufficient, and autonomous entities, there is no doubt that they are produced by free, more or less spontaneous subjects who preserve a mobility of intellect within the limits of material reality.

The proper idea of the work of art as a cultural structure rests fundamentally on the comprehension that it is partly a living, partly a coagulated form, that it is thus only partially the creation and property of the individual who created it. "It belongs to him and does not belong to him." It belongs to him psychologically because he willed it. Yet it does not belong to him because it is not an arbitrary and purely subjective product and owes neither its origin to the whole nor its completion—in the sense of its total exploitation of hidden forces—to him alone. Side by side with its subjective presuppositions, it is the result of innumerable objective determinants. The work is determined by techniques and traditions, partly of unfathomable origin, by conventions and institutions of a superindividual nature, by principles of form and criteria of taste, which are determined not by will and ability

but by material and medium, by the goal which is beyond the work, and by the extraartistic image, the social standing, and the author's particular public.

The social position of the artist, which is the most important objective condition for determining the form and content of the work of art, is most clearly expressed in his relation to the interests, aspirations, chances, means of power, and privileges of the group to which he belongs or believes he belongs. We must here distinguish all the more strictly between the actual and the presumed community, since the work of art always evidences the ambivalence which stems from the often divided loyalty of its creator. On one hand it is conditioned by the tasks the artist is assigned by his client, patron, and buyer, on the other by his own class consciousness and the ideology corresponding to it, which, even if masked, may be the very opposite of his employer's. A further complication arises from the artist's flirtation with political ideas that are neither those of his origin and class nor those of his public. He may adopt them for the most varied reasons, may subscribe irresponsibly or thoughtlessly to them because of a fleeting ambition or a playful desire for experimentation. He may support them merely for the sake of fun or appearances. But no matter how far he departs from his own actual social class and for whatever reason, he never completely severs his link with it, although he is in a position to emancipate himself from his class and station more completely than are other members of society. For although he by no means "hovers freely between the classes" as the whole intelligentsia pretends to do, the concept of class does not exactly cover the social category into which he can be ordered.

We can never foretell in a conflict of different solidarities—namely, that between the ideology of the class from which the artist stems and that which he undertakes to serve and whose interests, goals, and norms he undertakes to justify and defend—to what extent and with what success the artist will succeed in satisfying the one or the other. It is even doubtful whether two different creative personalities—even of the same rank—would be able to realize Engels's "triumph of realism" in the manner in which Balzac did. The medieval *ministeriales* may have invented chivalric love, the Rouen advocate Corneille may have invented the aristocratic concept of honor which informed the court of Versailles, and the Antwerp master Van Dyck may have invented, as has been suggested, the face of the English aristocracy; it is nonetheless questionable whether they were faced with the same dilemma as Balzac. It is unclear, too, whether the artistic triumph which was theirs signified a victory over their own convictions in the Balzacian sense or whether perhaps their most brilliant triumph was

when they subjected themselves to the norms of an ideology that was less progressive, just, and human than their own.

An ideology inherited and acquired since childhood is far too deeply rooted to be given up without a fight. This is especially true of an artist for whom the earliest effective, and therefore most influential, means of social discipline are often those of the formation of taste. His social and artistic education have common origins in "primary groups," the family circle, his playmates, the neighborhood, the kindergarten, and the elementary school. Preparation for the artistic profession, the awakening of sensual sensitivity, and the earliest stimuli to the development of more or less definite aesthetic pretensions do not begin with the systematic training of the art school or the academy, the workshop or studio—not even with elementary or intermediate drawing lessons. A child learns to draw in the same way that it learns to speak: unconsciously, groping, without a particular plan. Everything it hears from its parents, siblings, or playmates is language training; everything it sees around it is a part of its artistic education. Before making the first attempt to draw an object, it has acquired a series of mechanical formulas, conventional signs, and ready-made clichés. At every stage of an individual's artistic development, contact with society, as an anonymous teacher, anticipates the influence of the official teacher and competes with it. Fellow pupils and colleagues, co-workers and rivals, the unknown painters of placards, and the unmentioned composers of hits, whose products make their impression willy-nilly, belong to the faculty of the "school without walls" in which an artist grows up and matures. The most effective instruction may be just what neither the teachers nor the pupil takes into account. The mass media gain their importance through the anonymity, the ubiquity, and the irresistibility of the impressions emanating from them. If their influence were to be restricted to those effects of which we are conscious and to which we willingly expose ourselves, not only the public taste but also the education of the artist would present a quite different picture from what it does today.

The transmission of traditional forms of expression and communication from one generation to another within the framework of the family is the most elementary phase of the cultural process in the individual's life. Within the family, however, biological continuity is by no means always reflected in such a closed, complete, and uncontradicted historical continuity. The disagreement, which manifests itself in the succession of cultural models of two generations, represents the prototype of the social conflicts which accompany the history of culture. Cultures differ first of all in that at one time it is cultural traditions and at another their supporters which prove the stronger, and also in

that cultural forms are sometimes more long-lived and sometimes more ephemeral than the generations which shape and make them their own. All cultural factors possess a certain dynamic in contrast to the natural data, but they are not all equally dynamic. Institutions and groups like the family, station at birth, religious community, or village community present a high degree of stability and tenacity. Other forms of social-ization, like property classes, professional groups, and cultural strata, which are more closely connected with city life and modern trade, show a tendency to a more intense dynamic. The family is the most natural of all established and primarily changeable forms of cultural life and accordingly has the most static characteristics. It recalls, in contrast to other variable cultural factors, the community of a gen-eration. Thus, above all it is the biological homogeneity of the members that defines the family even more than it does the coherence of a generation. The family, however, represents a biological unit whose completeness and continued existence rests, in contrast to the com-munity of a generation, on institutional determinations and social sanc-tions. It represents society at a stage where nature and culture, instinct and order are still in equilibrium, though it may be a precarious one.

It is one of the commonplaces of sociology that the family comprises society in a nutshell and that, as a microcosm of society, it reveals all the fundamental social relationships. This thesis can, however, only be maintained within certain limitations. The family does contain forms of authority and subordination, adaptation and opposition, coopera-tion and rivalry, solidarity and self-assertion. On the other hand, the family lacks all those characteristics which society reveals as a result of its stratification and division into classes, which are expressed in different ideologies, means, and methods of the class struggle—in a word, the modes of behavior that Marxism sees as fundamental forms of the social process.

Whatever our attitude toward Marxist doctrine may be in other cases, we probably have to agree that the social value of an individual is determined first and foremost by his class situation and that this is mainly determined by his wealth and his means. This is the most decisive expression of the criterion of social differentiation. The artist, like the intellectual in general, may be more strongly determined in his thought and feeling by other social solidarities, but his station in the economic system and his role in the corresponding communities of interest are also decisive for him when they conflict with other ties. Apparently autonomous, economically indifferent attitudes are in his case also conditioned, at least to some extent, by unmistakable, even if unconscious and unadmitted, class interests. Although we can always only talk of a "free-floating" social situation in a very limited sense,

when we talk of the artist we have to talk of a class affinity rather than a class commitment. This is because he has ramified social roots, divided sympathies, and changing interests. It is significant that he is generally not faced with the alternatives of the Marxist two-class system and so does not feel pressured to choose, with an "either-or," between capitalists and proletarians, but rather lays claim to a *tertium datur*. For preference he likes to play referee in a struggle which can in reality only be fought out, not settled by blowing a whistle. The belief that some uncommitted individual can settle the issue belongs to the peculiar, self-satisfied ideology of the intelligentsia.

However, that the artist is not capable of hiding his class affinity does not by any means suggest that his class situation can simply be read from his style. For instance, Theodor W. Adorno has shown how rarely similar conditions of wealth result in a similar formal language in composers' works and how often the character of their artistic style contradicts these conditions.[15] Luigi Barzini arrives at the same conclusion—though he is less pretentious—when he compares the style and life of his compatriots Gabriele D'Annunzio and Alberto Moravia with their origin and wealth. D'Annunzio led the life of a Renaissance prince surrounded by greyhounds, brocades, duchesses, and famous theatrical stars. He wrote an exquisite prose and a carefully chiseled verse; politically, he was far to the right. In reality he was a poor wretch, an inflated provincial celebrity, the son of a Pescaran greengrocer. Moravia on the other hand, who went about in a sweater and shabby clothes and appeared in the company of girls of doubtful reputation, who often used highly improper turns of phrase in his works and was politically on the far left, could have lived comfortably on the income from the estate his father left him. Both of them represent to Barzini a class and a mode of life which are not their own; but both play their *rôles* so well that we cannot at once recognize the gap between reality and fiction.[16] It would, however, be just as mistaken to assume on the basis of such facts that an artist's origin and his social situation do not affect his choice of stylistic media. In the same way it would be naive to expect that the character of a person's class can be immediately revealed by his means of expression. Often an apparently autonomous stylistic character, even one which contrasts with the social situation of the artist, is sociologically just as revealing as an apparently class-linked one which corresponds absolutely to actual social conditions. D'Annunzio overcompensates for his petit bourgeois origin and lack of means, while the wealthy Moravia is indifferent to everything which the parvenu and the snob rate too highly. Neither of them lives practically or thinks in a manner which corresponds to his means and circumstances, yet both depend upon the same bourgeois

ideology. It is just that the parvenu, with his inferiority complex, tends to exaggerate the values which the one favored by the system tends to take for granted or treat as bagatelles. The sense of economic determination tends to be impaired, even somewhat distorted, if we overlook the fact that those who are rich and those who try with all their might to be or appear rich have the same common denominator. Even if their actions as artists are not always determined by this denominator, we shall if we look more closely always be able to detect common characteristics in their thinking and efforts, even without their bank balances' being immediately expressed in their style.

To arrive at the correct assessment of a person's or group's class situation, we must first and foremost have an understanding for the principle of mobility in the formation of their social *rôle*. Even the most inflexible, idle, and stationary social structures are in a state of constant change and development. Their movement is not a uniform and constant one, but one which moves from one side to the other or up and down. A society only lives by changing, but it does not aim at a particular (predetermined) goal. The question of social mobility is raised, as far as the artist is concerned, mainly in connection with the phenomenon that on the one hand members of classes who regard artistic activity as beneath their dignity suddenly take up this activity and join a social stratum which was till then unknown to them. On the other hand, in certain families people begin to cling to the artistic profession, and so the practice of this profession begins to be part of the acknowledged status of these families. Loyalty to the artistic profession for several generations, particularly at an early stage of development, is a sign that the activity has become respectable. If the son takes up the same profession as the father, this can also mean that society has forced him to renounce social mobility and that he has had to adapt to conditions of existence which are simply unchangeable and incorrigible. The history of the artist in the Hellenistic period, the Renaissance, the Enlightenment, and afterward contains telling examples of the growing respectability of the profession, even if there are not as many examples of this as there are of the prevention of the artist-craftsman from participating in social ascent to the same extent as did the poet and man of letters. The classical example of a mobility expressed in the literary activity of a new stratum which had played, up till then, as good as no part in intellectual life and of the new moral orientation arising from this is shown by the change in function between the aristocracy and the new, enlightened bourgeoisie in the production and consumption of cultural wares. However the later bourgeoisie, strengthened in its ascendancy, may have viewed the artist

and writer, the creative intelligentsia now becomes a force which can be opposed but not neglected.

Families committed to the artistic profession either in music or one of the fine arts were always numerous, at least more numerous than those who were committed to a literary activity, which does not require such an early introduction and practice as the other arts. The poet-writer is, and remains, in comparison with the competent painter or musician, an amateur and enjoys—simply as a result of his distance from the philistine—from earliest times a more or less privileged position. The comparatively inaccurate sociological definition of literary activity derives apparently from the fact that entry into this profession never involved any presuppositions, never needed any particular preparation. The author, already as a child, uses means of communication which will serve him as an artistic form of expression. The fact that he develops so slowly as a creative personality and that there are no prodigies in literature only becomes comprehensible when we realize that content plays a much more important part than form and that every significant product must be the result of long experience and the work of a mature person.

The social situation of the artist sometimes changes more rapidly, sometimes more slowly than that of society as a whole. The artistic profession can move from one social stratum to another, the prestige of the artist can suddenly be subjected to reevaluations, while other social changes proceed much more slowly. Nevertheless, social mobility in the sphere of art corresponds to the entire course of history. According to the general liberalization process, the artist has, since the end of the Middle Ages, enjoyed an almost unbroken social improvement. This has meant not only better conditions of life but also a more certain, more sharply articulated consciousness of station and more autonomous artistic objects corrresponding to this new consciousness. Up to the time of the Renaissance the question of the artist's own social status is of almost no consequence. He has to adapt to the interests and aims of his client and cannot seek these out for himself. In the Middle Ages—with the artist mainly in the service of the Church and guided by the higher clergy, or in the courts, where though there were probably enough poets of lower rank, side by side with the aristocratic dilettantes, these, too, only spoke for the nobility and the chivalric classes—almost all artistic activity is directed to the tastes and norms of the ruling class. It is only in the late Middle Ages that we can talk of the assertion of bourgeois principles of taste, after the production of works of fine art passes almost completely into the hands of bourgeois masters and when the bourgeoisie gains an important influence on the nature of commissions, even if not as private persons,

at least within the framework of urban communities and guilds. The production of art still stands, even in progressive Italy, in the service of the Church, the princes, the higher guilds, and the city communities ruled over by the higher bourgeoisie and the remnants of the nobility. As the quattrocento progressed and the cinquecento began, bourgeois principles of art, as limited as their influence was, gave way once again to the pressures of those of the higher strata of society.

The profession of artist, as such, is probably not as old as artistic activity in general, and its history is apparently less continuous than that of craft in general. Even if the makers of Paleolithic cave paintings already formed an independent professional class, the practice of art in the course of its further development was subjected, particularly in literature, to constant new orientations, and it oscillated between amateurism and professionalism, hobby and livelihood, pure pastime and philistinism. Artistic professionalism prevails very early in the fine arts, but in literature the process is much slower and there are frequent regressions. No matter how early the plastic artist separated himself from other occupations and became a member of an independent profession, his social separation from the craftsman took place only slowly. The prejudice against manual labor and the despised concept of philistinism, as they are expressed in antiquity but which certainly date from an earlier period, remain widespread during the Middle Ages, and it is only the popularity of the monks and the life of toil in the monasteries which brings about a relaxation of this point of view. We can still see in the bourgeois work ethic of the later Middle Ages, with its organization into guilds, an effective relaxation of the monastic rules. The organization of crafts in the guilds gave the masters an enhanced respectability in the princely courts—certainly vis-à-vis journeymen and workers. From the beginning of the Renaissance artists shared the status of craftsmen, but they did not regard it as such an honorable one. They begin to join together in new and special sorts of association and gradually transfer the functions of the guilds to the academies which are beginning to develop. The transition between the two institutions is made by the Renaissance courts, which while serving as a framework for artistic work grant an ever-increasing measure of freedom to the individual artist.

The fact that the disdain for manual labor and the abuse of philistine forms of life become less severe with the beginning of the Renaissance, and that the links between art and craft are loosened while those between the artist and the humanist are strengthened, opens up an entrée into the artistic profession for the higher levels of the middle class. Nonetheless, the artists of the early Renaissance are for the most part little people. For a long time they are regarded as superior crafts-

men and are hardly to be distinguished from the masters and jour-
neymen of the guilds. Andrea del Castagno is the son of a peasant,
Filippo Lippi the son of a butcher; the Pollaiuolos bear the name of
the father's trade—poulterer. In the artists' biographies of the period
humbleness of origin is often exaggerated as a stereotypical part of the
legend of the artist. It is, however, a sign of changed circumstances
that the prestige of a famous man is in no way diminished by this
humbleness. The social rise of the artist still proceeds only very slowly,
in spite of the apparent lack of prejudice and the incomparable rep-
utation of a Michelangelo or the princely standard of living enjoyed
by a Raphael or a Titian. Most artists still lead a humble existence even
in the sixteenth century, even if we can no longer talk of artistic penury
as we could centuries before. What is significant for the social con-
ditions is that Michelangelo's family, as Condivi tells us, regards entry
into the artistic profession as humiliating. The majority of artists ac-
tually do come from the lower classes until the eighteenth century. It
is only since the Enlightenment that the sons of the upper middle class
and even the nobility have been active in large numbers as professional
writers, though this is still the exception in music and painting. The
plastic artist's chances of success and his possibility of earning a living
have improved greatly in Italy, France, and Flanders since the sev-
enteenth century. Celebrities like Bernini, Rubens, Rigaud, and Le
Brun were paid very well and had distinctions piled upon them. True,
none of them was called "divine" like Michelangelo, spoiled by popes
like Raphael, or wooed by kings like Titian. The improved situation
of the artist, however, has firmer moral and material bases than ever
before because of the increasing need of art felt by the curia and the
absolute monarchs, and in spite of th precarious position of the Dutch
painters and the almost total dependence of French art upon the court.
In the next century the position continues to improve, insofar as not
only the reading public but also the clientele for works of fine art—
and this is separate from the general love of collecting—are constantly
growing because of the rise of a bourgeoisie mindful of art.

The vicissitudes in the history of the artist as a professional man
depend mainly upon the laws of supply and demand. The phenomena
of gain and loss of prestige are connected with this. What is more
difficult to ascertain is how far and in what sense these changes influ-
ence the feeling of solidarity and the collective consciousness of the
group. In a profession like that of artist the bonds of solidarity and
sympathy are stronger on one hand and weaker on the other than in
more extensive groups—for example, station in life, property classes,
political parties, or religious communities. They are stronger because
the group is smaller and the contact of the members of the group with

one another is that much more immediate. They are weaker because the unity is more diverse as a result of different material situations, personal interests, and chances of success. The community of profession—which, incidentally, does not have to be a community of culture—may prove to be that much weaker in comparison with other social links because the rivalry among the members of no other social group is as bitter as it is in this one. Durkheim thought that he had found in professional groups in general the closest possible communities.[17] He thought that here single individuals make contact more constantly, closely, and uninterruptedly than in any other category. He tended to this view as a result of his conviction that institutions are the basic forms of socialization and that grouping according to profession is an exemplary form of organization. Yet the thesis that a common profession forms the basis of the closest social community can be maintained only for workers of equal rank in the framework of the same method of production; that is where the common profession corresponds to a similar situation with regard to property, the same way of life, and an identical education. This can scarcely be held to be true of artists in general. To what extent would a great seigneur like Raphael or Titian have felt solidarity with his poor, neglected, badly educated, even if not incapable, professional comrades? We need not even mention modern conditions.

The sense of belonging, among artists, was strengthened by nothing as much as by their coalescing in the course of the Renaissance into a more unified cultural stratum, although the difference in chances of success, honors, and rewards as obstacles to a real feeling of community remained. The decisive step toward the formation of the artist's consciousness of social status was taken with the deepening and extension of artistic education. Its emancipation from the purely practical course of instruction in the workshops of the masters, its theoretical supplementation and academic regulation in evening courses and in the newly formed academies, the development of aesthetic theories, and the writing of treatises on painting which aimed at being not merely recipes but answers to the question of what actually happens in the creation of a work of art, proceeded step by step. The interest in the exploration of the distinction between art and craft and the emphasis on the difference between them mark the beginning not only of the autonomy but also of the crisis of modern art. This is inseparable from the problematic of their practical function and the appearance of *l'art pour l'art* principle.

The artists' *botteghi* of the quattrocento have been called the art schools of the century, and they actually did constitute the transition from the guild workshop with its craftsman's training to the differ-

entiated education of the later academies, even if these were no more personal. The training of young people in these artists' workshops was still in many ways medieval; it lasted from eight to ten years and progressed through the traditional stages of apprentice, journeyman, and master. Yet just because of the fact that the connection with practice, craft, and tradition was not yet broken, the work of education could in many ways be more successful than in the academies of the following period. In the great mannerist workshops of the Vasari or the Zuccari the contradiction between the principles of work and education increased, and the works which came from them owed some of their high quality to the tension between freedom and obligation so characteristic of the whole of mannerism. To the extent, however, that the tendency to compulsion and conformism gains the upper hand, as it does in mannerism, artistic education strives ever more decisively for a canon of instruction, which is first realized in French classicism but which originates here. For this reason it is not chance that Vasari, the first mannerist to be totally aware of his stylistic individuality, was also the first person to found an academy of art. The period lasting from the Reformation and the Catholic reform movement to the Council of Trent and the Counter-Reformation, from early experimental capitalism to modern industrial and financial capitalism, from Copernicus to Kepler, from Machiavelli to Mazarin developed the spirit of academism which accorded to its innermost nature. In all these phenomena we see the expression of the spirit of authority.

Academism also went through repeated crises during its three centuries of domination and suffered many severe reverses. Its classicist principles were not even free from attack or unbroken during the lifetime of Louis XIV. Even the struggle between the Poussinists and the Rubenists was a symptom of crisis, and the victory of the *coloristes* over the representatives of classical linear movement was an omen of the change in taste which led to the rococo and to a far-reaching liberalization of the school discipline, so that even completely autonomous artists like Watteau, Fragonard, and Chardin were accepted by the academies without demur. Of course, the concessions were not made entirely voluntarily and openhandedly. Even the first mitigation of the rules sanctioned by Le Brun can be explained in part by the fact that grants to artists diminished at the end of the reign of Louis XIV and the academy had to turn to the wider public in order to make up the deficit. In the rococo period they could keep their heads above water only by making the most far-reaching concessions.

The revolution meant the end of the dictatorship the academy had exercised in France. This domination was practically the equivalent of the monopolization of artistic production and the market by the court,

the aristocracy, and (later on) high finance. During the revolution the academy was first stripped of its monopoly on exhibitions; its training functions were not affected. It was looked upon as *the* art school of the nation, though there were already a number of private schools and evening courses which gave instruction in art. It maintained its peculiar situation in the eyes of the official authorities and of the higher bourgeoisie. With the predominance of high finance in society and the conquest of the most influential government posts by the higher bourgeoisie, the academy actually reached a new zenith in its influence and reputation.

The rebirth of academism in the Second Empire can be ascribed in part to the growing role of tradition in the life of a bourgeoisie which always felt itself threatened. The bourgeois tried to base the privileges they enjoyed on the inviolability of what existed and what was traditional, though these privileges were not as ancient or indisputable as they would have liked to believe. The idea of the academy and of a cultural tradition was an obvious aid to their point of view. They were all the more ready to support the confusion, as it appeared to defend spiritual values while actually being more concerned with material goods. It interpreted the idea of tradition—which had played an ambivalent and constantly changing role in the history of Western art and culture ever since the mannerist period—in an all too unambiguous sense, but this accorded with their class interests and attributed a culturally completely beneficial function to them. It blurred over everything by which it might become the substratum of a historical dialectic, which could exercise simultaneously a progressive and restraining, innovative and conservative effect upon society. Such a dialectic often has a destructive effect in that it tries too slavishly to preserve traditional values, or else it leads to innovation and renaissance, while clinging so long to the old until it awakens to new life in the light of which the present and progressive tendencies gain increased power and clarity through their link with the past.

Tradition represents the quintessence of the cultural factors of development. It is the form in which the continuity, perpetuation, and ability of cultural achievements to last are most clearly expressed. As a substratum of technical and stylistic development and as the source of conscious and unconscious stimuli, it fulfills an incomparable function in the history of art. Antiquity could play such a decisive role in the development of the Renaissance only because receptivity of the Greco-Roman heritage had never completely died out in the Middle Ages in spite of the Christian cultural crisis. Of course, tradition alone cannot explain the course of development. Since its effect is always merely a symptom of a general social and attitudinal orientation, its

actualization and its effectiveness as the sign of a new orientation have themselves to be explained. The special, often essentially contradictory significance traditional values may acquire in the developmental process at a given time arises out of the connection between tradition and sociocultural totality. For it is part of their essence that they often appear not as a stimulus to, but as a brake upon, development. Just as traditionalism, in Max Weber's sense, as opposed to what he understands by "rationalism," becomes a deadweight on society and culture and can prevent all progress, so artistic tradition which has congealed into academism and orthodoxy has an "antitraditionalistic" effect. It becomes a principle which protects and preserves the old merely because it is old and delays progress which finds its joy in the actual and the present.

In art, however, it is only in the most infrequent cases a question of an alternative between progress and retrogression. The development of art usually takes place as a contest between continuity and discontinuity. A dialectical movement of this sort, which asserts the principle of progress and of perseverance, can be seen in every cultural process, but the tension between the two forces plays a greater part in art than elsewhere. The reason for this is, essentially, that art in the stricter sense is "language," remains more strongly attached to its particular form of expression, and makes more generous use of its collected store of means of communication than other forms of culture. Conservatism and conventionalism are essential characteristics of all "linguistic" communication and thus of tradition in art. While the principle of continuity comes into play more here than elsewhere because of the significance of the medium, its influence diminishes because, in the sphere of art, continuous progress in the sense of scientific or technological development is hardly the question. Artistic techniques, as the application of craft, do show a more constant progress and more persistent traditions than the other factors of artistic production. Yet the technical processes which are gradually developed, as well as the formal achievements—like linear perspective or the "unities"—are restricted to certain stylistic periods.

The view that every true art has its firmest foundation in its faithfulness to tradition is just as untenable as the opposite viewpoint, which holds that a living art must free itself from all binding, allegedly immobilizing traditions. The principles of progress and perseverance work independently inside every tradition, but so in general do tradition and lack of tradition. Not only do they owe to each other their being and their meaning, but each owes its strength and effectiveness to the resistance it meets in the other. In art, a tradition has value and weight only if it is conjoined with the will to innovate, and in the same

way this will acquires force and becomes productive only in the tension between existing traditions and clarifying conventions. Even in periods dominated most strongly by the spirit of traditionalism, not everything hangs together traditionally; side by side with unbroken traditions there are gaps in the tradition. If everything were to have its origin in tradition, there would be just as little historical development as if nothing were determined by tradition. History probably means essentially continuity, but a completely unbroken consistency of development would exclude all initiative and would change history into a mechanical process. Again, a total discontinuity, that is, the breaking of all ties of tradition, would be synonymous with the end of culture and would totally atomize history and irrevocably abolish its context. In reality only certain traditions are given up, while others remain more or less unchanged. Even the birth of Christianity does not introduce a total breach into the development of culture, and the Renaissance ties in not only with antiquities that have been preserved but with strands which were spun after the collapse of the Roman Empire and which spin on into the Christian tradition. Yet history preserves only certain components of uninterrupted traditions. At times there is a continuity of form and a discontinuity of content and vice versa. "People do not always change their form of expression when they change their habits," says the historian Marc Bloch very appositely.[18] They also do not always change their habits when they change their method of expression. The continuity of a tradition is not always expressed in the persistence of forms, although these are generally more tenacious than content. The indolence of traditions may in any case be expressed in the time which one or the other of these components lasts.

Social structures, like economic systems, orders of authority, professional organizations, unions, and associations, represent in Emile Durkheim's sense institutions which protect society from the danger of individual caprice.[19] Paul Lacombe varies this idea in talking of cultural structures, namely, literary forms.[20] If an invention or an innovation of any sort ceases, as he says, to be an "event," if it loses its singularity and can be repeated, imitated, and continued, then a model or a rule, a collective possession or a common directive—in one word, an "institution"—comes into being. This institution both frees and binds; it represents a scheme by which the individual and the singular become communicable and available, exemplary, and capable of being adapted to. The metamorphosis of nonrecurring *trouvailles* into lasting prototypes is nowhere more unmistakable and full of consequence than in the formation of collective traditions from personal initiatives. The peculiar existence of social structures is nowhere more clearly expressed

than in suprapersonal traditions, independent of individual motivation, surviving the conditions of their birth, yet persisting in historical time. Not only is a society which they have founded part of their existence and function, but also it is one which adopts, sustains, and extends them. They can justifiably be seen as the fundamental forms of social being, change, and development.

The acquisition and continuation of traditions takes place under different conditions and circumstances. While cultural structures become the content of traditions, they not only emancipate themselves from the reasons for their genesis, but also undergo a far-reaching reinterpretation of their original meaning. A tradition sometimes contains more, sometimes less, but generally something different from what was first instilled into it. Frequently the origin of a tradition is older than the need which motivates it, and the significance attached to it is, not infrequently, nothing more than the subsequent rationalization of an attitude or mode of behavior whose meaning has been lost. For this reason the motives for the genesis of a tradition can be completely irrelevant to its function. The tradition of ritual ceremonies is generally older than the creeds connected with them. A symbol often precedes the meaning ascribed to it. Custom is almost always older than morality. In this way artistic forms also frequently survive the actuality of the needs to which they owe their genesis and become elements of a tradition whose role has changed and is still changing.

Tradition is in no sense an unambiguous and invariable phenomenon. There are more and less traditionally oriented societies and generations, more and less traditionally oriented historical and stylistic periods. The different arts, genres, and forms are distinguishable according to their inclination or disinclination to stick to a traditional form of expression. The further we go back in history—that is, the more undifferentiated the art is and the more undeveloped the means of communication which correspond to it are—the more tied to tradition the products of art are. In the Ancient East, the history of style is divided according to millennia, in the Middle Ages according to centuries, in the nineteenth century according to generations, and nowadays largely according to decades. Religious music was always more strongly tied to tradition than secular; Roman Catholic church music was almost always more inhibited than Protestant because of the liturgy. The tradition of the church service explains the conservatism of many of the great masters of this art; it explains both Monteverdi's hesitation to follow the principles of the baroque and Bach's refusal to give them up.

It has been asserted that a work of literature is more closely linked to literary tradition than to the social circumstances of its time. No

matter how closely an artistic product is related to earlier products of its kind, the tradition linking them is itself a product of historical and social circumstances. It is renewed, sustained, and continued by them. Modes of thought, feeling, and expression develop into traditions only when they are approved of by a particular, historically defined society, taken over by it, and transmitted to the next generation. Tradition is not a natural growth which corresponds to the romantic notion of an organism (*Volks* or *Zeitgeist*) or which leads its own existence independent of individuals and social groups. If we represent tradition as a medium in which the history of art moves according to certain laws, then we must guard against ascribing to it a mystical force which is self-sustaining and self-motivating. It is never ready-made and complete, but always appears as the changing result of experiences, achievements, and inventions, which are used at different times, by different societies, for different purposes, in a different way, and with a different sense.

The role tradition plays in the life of the individual is, with its changing perspective, also part of the erratic, flexible, variable essence of tradition. Apart from the fact that every young artist first attaches himself to a tradition and only later achieves independence and develops his own idiosyncrasies when he becomes a mature artist, nevertheless the movement of which he thinks he is a part at any given moment can be opposed to that in which he is working—even if unconsciously. Thus, the beginner just as often appears to be a revolutionary innovator as the mature artist appears to grow ever more conscious of his historical origin and thinks himself more conciliatory in his attitude to his environment when he is actually insisting upon his idiosyncrasies and making fewer and fewer concessions. Whether and to what extent an artist is linked to the tradition of his craft depends upon neither his consciousness nor the progressive or backward style of his works. A completely new and revolutionary art movement may be just as deeply rooted in tradition as an old-fashioned and conservative one. The actual relationship to tradition is seldom expressed in reflected forms of consciousness. Yet even if traditions do not necessarily function on the level of consciousness, consciousness of what happens in artistic creativity by no means excludes tradition. Traditional attitudes are generally an obstacle to critical thought and rationally purposive action, yet traditions can nevertheless be consciously and intentionally pursued.

In discussing the relationship between tradition and the artist we do not, however, have to ask only how the artistic creations of the individual are influenced by the works and values he takes over from the past, but also to what extent and in what sense this stock of

traditional goods is changed by his contribution. T. S. Eliot points to an essential of tradition when he says that tradition changes completely with every new and important work and thus creates a new order in all existing works.[21] In other words, tradition is not a permanent stock-in-trade, but a mélange of goods available and usable at a given time, which changes fundamentally with each new addition. The inadequacy of this idea is expressed by his all too naive approach to Bergson's theory, which states that the past is nothing but the product of the present, and which changes the perspective that is part of the conditioning of our view of the past into a mere relativism.

Origin, education, and tradition are forms of social union in the dimension of time: they represent nonsimultaneous, interpersonal relationships which occur in the succession of historical periods, generations, and ages. Linked to these are forms of socialization, which divide people's lives and activities in space. Artists living and working at the same time belong to different groups, associations, and movements, which cross and complicate their historical relationships. The forms in which the organization of artistic work takes place belong to the most singular of these categories. They differ first of all according to whether artistic production takes place individually or collectively. Yet no matter what forms the production may take, they are always judged in the light of the relationship between the final unity of the work of art and the division of functions in the creative process. It is always a question of whether an apparently indivisible totality, like that of an art product, is possible when the individual contributions are isolated and whether in view of this atomization we can speak of the indivisibility of the creative artistic act at all.

These questions will be answered in a different manner, apart from different historical periods, according to the particular forms of art. In the plastic arts collective forms of production were for long periods of history the normal and the generally customary ones. In the theater, and especially the film, they are the only possible ones. We frequently come across them in literature, as long as poems were sung or recited to the accompaniment of musical instruments. The Homeric epics are collective works, though they are not "folk-art" in the romantic sense, and clearly show the traces of a single poetic hand. Whether this hand can still be identified or not, whether it is merely discernible in the final redaction or visible in earlier versions of the work, whether its intervention is of major or minor importance, changes nothing in the indisputable fact that the individual products, irrespective of everything else, can only be executed by single individuals. There is no such thing as a collective that writes, composes, paints, builds, or makes an ar-

chitectural design in the same way that a committee comes together and takes a decision.

The organization of artistic work in collective forms may go far back into history: we can only make assumptions about its origin. In Egypt, at all events, the conditions were already so far developed that, as far as the use of different workers, the specification of tasks, and the harmonization of different activities are concerned, we are reminded of the working methods of the medieval masons' lodges. As a result of the stylistic nature of ancient Oriental art, the aim of development was to standardize production, and the collective method—with its division of labor—was eminently suited to this. In order to satisfy rapidly increasing demand people soon saw the necessity for working according to fixed models and unitary patterns and of following a largely mechanical and stereotyped method of production. With the help of this method the desired objets d'art could be assembled from single, ready-made, and unchangeable parts. Besides Egypt we know of group work in art and of craft collectives among the Greeks and the Romans, where they took the form of the "building corporations" which were formed for larger projects. These associations were certainly not of the same character as the later masons' lodges, which were closed corporations, autonomously and centrally governed in the way they developed in connection with the building of the great Gothic churches. A corporation of this sort would not have accorded with the spirit of antiquity with its contempt for labor. Even in the early Middle Ages if there was something like a masons' lodge it consisted merely of a coalition of the workshops involved in the building of a monastery. The essential feature of later cooperatives of this sort—the mobility of the whole thing and of its parts—was completely lacking.

Arts and crafts in the early Middle Ages were carried on almost exclusively in the monasteries. The illustration and copying of manuscripts were from the earliest times their most important cultural activity. The monks in any case engaged in work which was physically less strenuous—especially in minor handicraft—and left the greatest part of the manual labor to the lay brothers and outside workers. Even the copying of manuscripts occupied less of their time than was formerly assumed. They busied themselves with the organization of their concerns rather than with carrying out programs and plans. The control of artistic production was almost entirely in the hands of the clergy— actually the monks—but it never played the role in the construction of the great ecclesiastical buildings which the romantics ascribed to it and which is apparently merely another part of the legend of the Middle Ages. It was romanticized just as the heroic legends were mysticized, by being translated into the principles of that organic, plantlike growth

people thought they had observed in folk-poetry or in the phenomenon they called by that name. Even in this domain they called into question anything done according to a plan and every idea which might have come from an individual, was coherent, and was fundamental to the activity. They denied the existence of an architect who could finally be credited with the work in the same way that they denied, in the "folk-epics," the existence of an individual independent poet. In other words, the decisive role in the erection of a building was given not to the artist keeping an eye on the whole, consciously and carefully carrying out the work, but to the naive craftsman driven by instinct and guided by tradition and agreement. The anonymity of the artist, the blurred picture of the unknown monk who, hidden in his cell, created his works simply and solely for the glory of God, belonged to the same romantic legend. In a very unromantic way it turned out that, in most cases, where we do have artists' names from the Middle Ages these were monks who were favored by those clergy whose decision it was whether the name of an artist should or should not appear on a monument of church art. Compared with antiquity or the Renaissance there can be no doubt about the impersonality of the work of art and the unobtrusiveness of its creator. On the other hand, we cannot talk of a total anonymity of medieval art. From every phase of medieval history we know thousands of names, even if these are the names of patrons and donors, bishops and abbots, the chairman and members of a building commission rather than of artists.

No matter what role the clergy played in the building of a church and no matter how the artistic work may have been divided between the director and directed, there must somewhere have been a limit to the division of functions. Cathedral chapters and building commissions may have decided about the plans, the artistic problems may have been solved by a collective, but the individual steps in the creative process can only have been taken by single, individual, goal-oriented artists who accounted for every stage of their work. Such a complicated structure as a medieval church could not come into being as spontaneously as a folk-song. Yet a folk-song—whether as a whole or in parts and in different versions—always derives from particular, if unknown, individuals. However—in contrast to a complex building—it may come into being without a plan and grow by accretion like a crystal. It is not the assumption that a work of art is the common creation of a number of people that is romantic and scientifically untenable, for the work of a single individual is composed of several heterogeneous elements. What is naive and romantic is the idea that a work of art represents right down to its final elements the indivisible product of a group which cannot be differentiated or divided into

integral parts and, moreover, that its origin presupposes no unified and premeditated plan, however obscure and changeable.

The masons' lodges, it is true, remained for generations in the same place if the building of a church took a long time, but when the work was completed they went on to accept new orders. Their freedom proclaimed itself, however, not merely in their moving from place to place as a collective but also in the coming and going of the individual artists and craftsmen in their move from one lodge to another. And although there had earlier been wandering craftsmen who went from monastery to monastery and from one estate to another, the stability of labor and the steadiness and slowness of the development of art in the Middle Ages actually ceased only when production moved from the monastery to the masons' lodge. From that point on, stimuli were received from afar and became widespread. When freedom became a universal principle and laymen gained the upper hand in the building trade, when the cities were reborn and a money economy developed, the masons' lodge had to replace the discipline of the monastery workshop with a new form of organization. It solved the problem by a completely novel ordering of the relationship between the authoritarian and subordinate functionaries, one which was fundamentally different from the traditional method. There were precise regulations about the hiring, pay, and dismissal of workers, the rights and duties of the masters and the journeymen, the limits of individual intellectual freedom, and the division of common tasks. The goal could be reached only if there were a truly collective outlook and a complete integration of labor. It was only the voluntary subordination of personal aspirations to the wishes of the master builder that ensured the necessary harmony of talents without lowering the general level of achievement.

The question of how, and with what success, a division of labor like the masons' lodge can be carried out in so complex a spiritual process as the production of a work of art calls forth contradictory responses. The different suggestions only have the same romantic presuppositions in common. On the one hand, people are inclined to see in the collectivity of artistic creation—namely, its origin in a spiritual community—a condition of actual success. On the other hand, people believe that the division of duties and the limitation of individual. freedom which is tied to collective work put the emergence of genuine works of art at least into question. It is well known that the positive attitude to the problem was expressed by the romantics themselves with respect to medieval art, the heroic epic, and folk-poetry, while the negative was expressed by representatives of neo-romantic art criticism, mainly as regards film. Both points of view have, in spite of the difference in the results to which they lead, the same idea of the essential

nature of artistic creativity, since they see in the work of art the product of a unified, indivisible, completely spontaneous, quasi-divine, and arbitrary act. Nineteenth-century romanticism personified the collective essence of the masons' lodge as the entity of a folk or group soul—that is, they individualized and psychologized something fundamentally nonindividual and unpsychological and derived works, which were the products of individual persons attuned to each other, from this fictitious, unified, and individually conceived group soul. Again, romantically minded film critics certainly do not conceal the atomized nature of the products and emphasize the impersonal or, as they like to call it, "mechanical" nature of the processes whose end result is the film. However, they question the artistic quality of the product precisely because of its impersonality and its inorganically connected structure. What we forget or neglect in this form of argumentation, above all, is that the working method of the artist proceeding individually and independently is by no means as unified and organic as the romantics pretend. Every intellectual process, even if it is only *somewhat* complex—and artistic creativity is one of the most complex—consists of an immense number of more or less independent, conscious and unconscious, rational and irrational functions, whose result, if it is to be comprehended and evaluated by others, has to be examined and edited by a critical authority within the creative subject itself. The individual products of the leader of a masons' lodge or any other community of labor have to be tested, corrected, and harmonized. The excessively unified and naturally organic view of the faculties and functions of the human spirit is just as untenable, unrealistic, and nondialectic a fiction as the assumption of a folk and group soul acting as an independent subject outside single individuals. Individual souls represent, if you like, parts and fractions of a collective consciousness. Yet this consciousness only presents itself, practically, in its components and parts. Thus, the individual soul only expresses itself at first in a series of largely separate functions, whose unity and totality are not the gift of inspiration but have on each occasion to be taken by storm.

The rationalistic and individualistic tendencies which assert themselves with the dissolution of feudalism and the development of capitalism also assert themselves in the changing organization of artistic work and lead from the masons' lodge to the guild workshop and the artist's *botteghe* as the framework of production. The masons' lodge, as a way of organizing labor, met the demands of a time in which the Church and the municipalities were almost the only clients for buildings and the only people interested in larger and more ambitious works of fine art. It was not only the circle of clients which was limited; the

existing demand itself was only felt at widely different times and in widely different places. The masons' lodge with its elasticity and mobility, on one hand, and its discipline and authoritarian organization, on the other, took these conditions fully into account. As soon as the purchasing power of the new urban citizenry had grown to the point where the city dwellers, as private people, formed a more or less regular market for artistic products, too, artists gradually left the masons' lodge and settled in the cities as independent masters. The competition which developed among them made collective measures necessary and led at first to guild regulation, a form of self-government which had been in existence for most craftsmen for a long time and which in the course of the fourteenth century now began to gain a foothold among artists.

The fundamental difference between the masons' lodge and the guild consists in the fact that one is an authoritarian organization of labor—with established periods of notice—for mobile workers, the other a local, originally egalitarian association of independent entrepreneurs. From the artistic point of view, no one was free in the masons' lodge, for even the master builder and the manager had to comply with a fixed program set down by the ecclesiastical authority. On the other hand, in the urban workshops that constituted the guild, every craftsman was his own master not only in the way he used his assistants but also in his choice of artistic materials. Yet, in another way the guild regulations restrict artistic freedom so much that the organization of labor remains for the most part a medieval one. The decisive change in the structure of artists' collectives comes with the transition from the guild workshop to the Renaissance studio. It is a slow and halting progress, and the development is at first only perceptible in that the master has to take immediate responsibility for the quality of the work of a particular atelier and not do this via a guild; thus, he alone is responsible to the client. The result of this, however, is that everyone begins to associate himself with his product and thus sets out on the path to our modern view of the artist. In spite of this, the early Renaissance studio, as far as the training of a succeeding generation, the authority of the master, and the attunement of the individual to a group are concerned, was still dominated by the spirit of the Middle Ages. Just as the work of art is still not necessarily the expression of an individual personality stressing its own idiosyncrasy, so artistic work can still be accomplished in collective forms. In order to come to terms with the often significant and diverse commissions, people founded large industrial concerns with a large labor force. There were also owners of ateliers who were entrepreneurs rather than artists, that is, they accepted orders in order to fill them with the help of people

who were suitable for the purpose but who otherwise meant nothing to them. Michelangelo was the first to express the decisive wish to carry out a work single-handedly, from beginning to end, and he was reluctant to work with students or helpers. He is thus in this sense the first modern artist whose social peculiarity contains nonconformism and alienation as constant determinants.

The next phase of development is by no means unambiguous. It tends on one hand toward collective production as this was carried on in the *botteghi* of the quattrocento, reaching a highpoint in Raphael's workshop, which was staffed by pupils and helpers, and on the other toward the modern method of work par excellence of the great individualists like Michelangelo. Mannerism with its ambivalent tendencies and inner contradictions produces examples of both types. The introverted Pontormo, who cut himself off from the world, is a prime example of the one; his studio could be reached only by a ladder which was generally not in place. Vasari with his *savoir vivre* is a characteristic representative of the other; he ran a large-scale enterprise which often produced wares better than the works of his own hand. A contrast of this sort is completely comprehensible in mannerism. What is notable, however, is that, in a period of individualism like the baroque, artists' collectives like the Rubens workshop not only should exist but should develop the idea of the division of labor. Rubens could cope with the orders he received only by transferring contemporary methods of production to the organization of artistic work. He employed highly specialized workers and used their abilities in the most rational way possible. The contemporary Dutch and even most of the contemporary Italian ateliers appear old-fashioned in comparison with the productivity of his undertaking, in spite of the fact that they employed the same principles of the division of labor.

It has been remarked that Rubens's method of production is based on the classical concept of artistic creation. The rational organization of artistic work, as it was first developed in Raphael's atelier, was predicated on the notion that the conception of an artistic idea is fundamentally distinct from its realization. It was considered that the essence and value of a work of art were already present in the design and that the transferral of the vision of a picture from a sketch, or a cartoon, to the final pictorial form was only of secondary significance. This idealistic, essentially Platonic view of the relation of the idea to its concrete realization still held good for the courtly and monumental baroque, though not always to the same extent. In the art of bourgeois, Protestant Holland it soon lost its validity. Here the modern concept of authentic execution, coming directly from the hand of the master, of the original signature, and of the artist's unmistakable brush-stroke

acquired such an overwhelming significance that the aim of preserving it imposed from the beginning strict limits upon the division of labor. It is significant that Rubens adopted the method of production which corresponded to the classical conception just when he was busiest, when he had to work with the largest organization, and when he had to leave the execution of the works that had been commissioned almost exclusively to assistants. He only adopted this method after he had painted *The Raising of the Cross* and only abandoned it in his final period in works which were too dear to him personally to be entrusted to a stranger. The question of whether this estimation of the artist's "signature" is merely an aesthetic fetishism or the recognition of a real, irreplaceable, and unrepeatable value can only be answered on the basis of the individual case. The fact, however, that since impressionism and postimpressionism less and less value has been ascribed to it, points to its validity's being historically conditioned. It is not individualism as such to which the work of art owes its "aura,"[22] but that exaggerated individualism whose time has passed.

The industrial organization of artistic production seems to have met less resistance in a system like the absolute monarchy and the French courtly culture of the seventeenth century than it did in Rubens's later period. Colbert made the king the only important person in the country concerned with art when he ousted even the aristocracy and the very wealthy. Just as he made the academy the center of art education, so he developed the system of the manufacture of tapestries—which he acquired from the Gobelin family—into the framework of artistic production for the whole country. Painters and sculptors, tapestry makers and cabinetmakers, bronze founders and potters, silk and cloth makers all unite in common production. In spite of this diversity, everything produced in the royal workshops is of faultless taste and technically perfect. There may be no individually unique masterpieces, but the general level of quality is all the more even. Of course, this was only achieved at the price of having works of painting and sculpture with a craftsmanlike character, of artists producing sets rather than individual pieces and seeking to repeat or vary fixed types, and giving as much attention to the frame as to the work of art itself. The standardization of production certainly does not produce merely negative results. The new mechanized method makes it possible to create a source of its own attractiveness out of the technical smoothness of the objects created in groups and of the skillful, considered handling of materials. The fact, however, that this movement toward craft cannot keep pace with technical development and that later periods go back to an appreciation of the unique and individual in the works of the masters shows that the impersonal nature of art in the period of Colbert and

Le Brun was not just the result of technology but that other factors played a role. These factors corresponded to the spirit of mercantilism and of its trade policies, which furthered the export of objets d'art. Incidentally, the impersonal practice of art not only ceases in the midst of the mechanization of industrial production, but also only begins a long while after the introduction of manufacturing in nonartistic industries. It is precisely during the Industrial Revolution that art again moves away from being indifferent to "personal handwriting."

The mechanization of artistic work and the division of tasks among different specialized workers were only recently resumed and further developed. It was the production of films which first gave rise to the formation of new artists' collectives and the taking of a path which lay in the familiar direction already taken by the old masons' lodge with its rationalization of functions, but which led substantially further than had ever before seemed possible. The present state of affairs differs from every previous one not only because of the stricter division of labor resulting from the progress in mechanization but also because of the stronger resistance to the cooperation of the participants as a result of intensified individualism. It is mainly the authors of scripts, or rather of the works upon which the scripts are based, who most violently oppose giving a collective the responsibility for the creation of "works of art." They also find it particularly humiliating that decisions are made dictatorially or at best on the basis of a majority decision, the motives for which even the most consciously creative artist is scarcely able to account. The individually isolated artistic endeavors of the postromantic era opposed to any external interference meet for the first time in the film with a principle of cooperation and the integration of creative forces. This tendency only corresponds, it is true, to the planning and regulation which is sought in the total economic, political, and cultural life of the present day. The tabulation of principles of order, however, which cannot in other areas be achieved without more ado, meets with even greater difficulties in the sphere of art, where every breach of spontaneity, every one-sided exertion of influence on the historical dialectical process is subject to particular dangers. The fact, however, that gifted directors often work with untalented authors or that good novels or plays are made a mess of by bad scriptwriters actually means that two nonsimultaneous and dissimilar phenomena stand face to face with one another—the isolated poet completely on his own, and the problems of the film which have to be solved collectively. The common labor apparatus of filmmaking presupposes a social technique most people are not up to, just as the newly discovered film camera, in its day, involved an artistic technique people did not know how to handle properly. It is still an open question

whether the film represents the beginning of a new development in art, along with the other collectively produced and collectively consumed mass media, or whether it is a passing disturbance, a mere anomaly which will not escape the fate of being superseded by progressive individualism.

The detachment of the artist, his wish to go his own way and his resistance to cooperating with others in his work, means—and this is especially true since the romantic period—that he lays claim to special rights. His antipathy toward participating in the collective forms of production has its origin largely in the fear that by giving up his ostentatious independence he will suffer a loss of prestige. A profession whose well-being depends to such a large extent upon the reputation it enjoys cannot afford to renounce ostentation. The interests involved in the artist's well-being, fortune, and reputation are of course uncommonly complicated. There is no point at which they seem to be assured by the validity of one single principle. Their preservation is guaranteed by neither a progressive and liberal nor an authoritarian and conservative social order. The one may assure the artist security, the other freedom; but in neither will he find both. In the service of the medieval church or the court of Versailles he had no need to suffer privation, and in seventeenth-century Holland he had no need to fear external interference or restraint—yet security without freedom in the one case and freedom without security in the other may seen equally valueless to him. The conflict of interests was not over for him even then, for the enthusiastic estimation of works of art was by no means always commensurate with the prestige of their creators. In times of the greatest flowering of art and of the most complete recognition of the products, as, for example, in antiquity, artists themselves often received the least adulation. They were counted as part of the mob and were often regarded as skillful workers or ingenious parasites. An ambivalent attitude of this sort is expressed in the period of Roman aestheticism in Seneca's famous dictum, which seems to express the view of the whole cultural elite: we worship idols but despise the sculptors who made them. We know how immediately the unfavorable economic conditions under which the artists of antiquity had to work are linked to this disregard. It is not always clear even in the Renaissance whether, in the struggle for the artist's emancipation against the guilds, we are dealing with considerations of prestige or material interests. We do not know whether the two forces are even separable— that is, whether we are dealing in the case of a gain in prestige with better economic prospects or whether a better economic situation is not a question of increased reputation and greater influence.

The prestige of the artist depended until the most recent past mainly on his utility or on conventions like the estimation in which labor was held and only to a lesser or a very small degree on purely aesthetic considerations. The artist of the prehistoric (magic) period may or may not have had the same reputation as a magician, wizard, miracle worker, or the like, but he would have participated in certain privileges of the rank. In earlier periods of history— particularly the Greek— the poet, unlike the philistine artist, was honored as a sort of seer, prophet, priest, or soothsayer and, later, as the guardian of a higher truth and the teacher of his people. However, with progressive rationalization, artists like poets had to surrender their special rank and become the propagandists and odd-job men for rulers in the development of their pomp and circumstance. The plastic artist never enjoyed a high reputation until the Renaissance, but from the end of the heroic period the poet, too, was only accorded special esteem from time to time and as an exception. In the later Middle Ages people began to identify him with the *vagantes,* and from this time on there has always been an aura of the déclassé about him. Movements like humanism and the Enlightenment may have contributed to whitewashing the stigma, but in the eyes of the solid bourgeois the ink-slinger retained the blemish which his past as a minstrel, his friendship with jugglers and prostitutes had placed upon him.

Social ascent and the improvement of the artist's economic situation during the Renaissance took place at the same time and apparently as a result of interaction. The artists of the early Renaissance are in general the equals of the petit bourgeois craftsmen. Their situation is not brilliant, but it is not risky; there are no magnificent livings to be gained, but there is no artistic proletariat. In Italy they were better off from the start than in the North, because the Italian princes and despots could make better use of their talents than could rulers in other lands. Furthermore, as they often thought it valuable to acquire distant masters for their court, they were set upon relaxing the guild regulations which favored local artists. The emancipation of artists from the guilds was therefore not so much a result of their increased self-confidence and their claim to be considered the equal of the poet or humanist, as of the fact that their services were needed, thus causing them to be accorded a certain freedom of movement. Their pride and ambition are nothing more than the ideological expression of their increasing market value. Thus, it was not, for example, the benevolence of the humanists to which artists owed their independence. They sought the friendship of the humanists not in order to break the resistance of the guilds but in order to justify in the eyes of the upper class with its humanist leanings the economic position they had already achieved.

The humanists were for the artists the guarantee of their own value; the humanists, for their part, saw in the artists' work the best propaganda for the ideas upon which they based their intellectual domination. It was from this community of interests that, in part at least, there arose that unified concept of art which was as good as unknown up to the time of the Renaissance. Not only does Plato talk about plastic art in a completely different sense from that in which he talks about poetry—even in later antiquity and right into the Middle Ages no one thinks of assuming a closer relationship between the two than, for example, between science and literature, or philosophy and art in general.

The Renaissance view of art and the artist's newly won prestige which corresponds to it revolve around the discovery of the concept of genius; that is, the conception that the work of art is the creation of a high-handed personality above tradition and rules—even above the work itself—and that its laws derive only from this personality. The development of the concept of genius begins with the idea of intellectual property. In the Middle Ages there is a lack not only of this idea but also of any appreciation or desire for originality—they are completely interdependent. Talent can be compatible with dependence upon tradition and imitation, the spirit of authority, and the readiness to cooperate; genius cannot. The beginning of the claim to intellectual property and the beginning of modern capitalism are coeval, but the equation of the two would rest upon the mere equivocation of two different concepts inserted into the category of "property." Intellectual productivity and the property rights based on it may be indissolubly connected with the new forces of production, and new conditions of property and historical change may be reflected equally well in the rise of a money, trade, and competitive economy as in the atomization and the individualization of a formerly unified Christian culture; the two processes do not represent one and the same thing. If we once stop regarding individual structures as different forms of the same truth content—which happens with the dissolution of medieval universalism—nothing further apparently stands in the way of making its individuality and originality into the standard of its value. This originality then becomes simultaneously a weapon in the competitive fight for possessions, influence, and prestige. In this process the economic and social forces, however, take over a medium which they have not themselves created; they merely adapt it to their own ends and increase its effectiveness. A concept like that of originality grows neither in the soil of pure economy nor in the sphere of mere ideas. It was the product of a development in which the traditional feudal conditions of production were shattered and the new antifeudal

economic and social order as well as the antitraditional idea of the individual power of creativity could come into being, but it was first inspired by the ideas of competition and personal initiative which are the presuppositions of the concept of genius.

The raising of the creative personality above the value of the work itself, in which the cult of genius and the prestige of the artist reach their zenith, means the precedence of ability to produce over the product itself—the ascendancy of the urge and intention over achievement and success. It includes, however, at the same time the idea that it is not possible for everyone to be a genius. It is only a step from the idea of genius that can never completely communicate itself to the idea of the misunderstood artist with his appeal to posterity. It is, however, a step which the Renaissance had not yet taken and one with which the struggle of the modern artist with his public begins. Nevertheless, artists had already developed an aggressive attitude, which was directed, on one hand, against the philistines and, on the other, against the botchers and daubers. It hid itself from the one behind a mask of extravagance, while it asserted against the other the birthright of the select and the favored. In both connections it was a case of the formation of an intellectual aristocracy which was ready to exchange personal merit for divine inspiration as long as it succeeded in separating itself fron the unprivileged.

With its cult of genius, and with the brilliant position and unheard of authority it assures to a Michelangelo, a Raphael, or a Titian, the Italian Renaissance is an episode which by no means proves to be typical of the further process of development. What is much more significant is the change taking place in the economic and social position of the artist in seventeenth-century Holland, where artists are probably more independent than ever and yet are living in worse circumstances than when they were most oppressed. Since the public is not capable of accepting merely domestic production, there arises a serious crisis in art which numbers among its victims some of the greatest talents. After the dissolution of the guilds and the abolition of the regulation of production and consumption by forces like the court and the government, the boom on the art market changes into a wild competitive struggle and for the first time in the history of the plastic arts—which had formerly assured their executants a reasonable if sparse income—we have a class that can be called an artistic proletariat. The victims are, however, for all their misery not actually proletarians but bourgeois, even if frequently petit bourgeois who have come down in life. However, there was no previous example in their profession of the misery with which they now had to contend. The cares and privations among which Rembrandt, Frans Hals, and others among the greatest

artists of their day eked out their existence were some of the phenomena that accompanied that freedom to which the Dutch owed their prosperity and influence but that led in the field of art to the anarchy which to this day has not been overcome. In particular, the situation in which Rembrandt found himself—his changing circumstances, his unstable relationship to the various strata of the bourgeoisie, his multifaceted relationship to the intellectuals and his completely unstable existence on the fringe of many different classes—was typical not only of the social position of the artist of his time but also of the modern artist in general. It is the first insistent example of the problematic economic and social conditions that arose for artists after they had freed themselves from external conditions which may have hampered their artistic freedom but with which they lost the last remnant of the security they enjoyed, thanks to their servility.

Yet the circumstances in Holland are a more or less isolated phenomenon which has no immediate sequel even if they do presuppose the ensuing development in a much more meaningful sociohistorical sense than do the reputation and well-being of the masters of the Italian Renaissance. In both cases we are concerned, however, with conditions determined by time and place. Before the eighteenth century we never find artists living in a uniform situation. Nowhere are the individual artist's chances of success the same, nowhere do the same conditions of patronage obtain for people with the same talents—nor do they necessarily enjoy equal reputations. Their good fortune, well-being, and fame depend upon the means and influence of their patrons. It is only when the public for art is potentially that of the entire bourgeoisie and when the bourgeoisie develops into the ruling class which supports culture, when art becomes a universal need and the whole of the upper middle class becomes a class of people interested in art, that private patronage and the inequality of artists' earnings cease. The role of patron and protector is taken over by the political parties, sometimes by the government, but generally by periodicals, publishers, art dealers, and concert agencies with their own, impersonal, generally agitatory or purely commercial criteria of artistic value. The difference between the writers of best-sellers and the literary hacks, the well-paid, fashionable painters and the makers of likenesses, the celebrated virtuosos and the starving composers exists as it always did, but the possibilities of social improvement are now the same for all, even if the fortune of the individual and his skill in seizing his fortune may differ greatly from case to case.

The artist finds himself and his intellectual products thrown onto the open, insecure, incalculable market and has to see how best he can manage. The final metamorphosis of the work of art into goods does

not always occur without humiliation or bitterness, but it must not be judged too irrationally and undialectically. The artist in the capitalist era would never have become the representative of a middle-class, respectable, independent, and regularly practiced profession without a change in his social function from a form of personal service, of salutation, of panegyric, and of personal propaganda into that of more universally applicable, objectively determinable values. It is precisely as a result of the objectivization of relationships between producers and consumers that artistic activity gained its solid, even though not invariably reliable foundation and the artist as such achieved his reputation, which is, in principle, uncontested but which is frequently accorded to him only with reluctance. The difference between the earlier conditions and those we are talking about here is most clearly expressed by the fact that, when we buy a book of which thousands of copies have been printed, we do not obviously do the author a favor; on the other hand, the reward which previously came from a patron when he was handed a manuscript always smacked a little of alms. While an artist's reputation depended, in the period of courtly and aristocratic society, upon the rank of his protector, in the period of capitalism and liberalism he now enjoys a reputation which is the greater the more independent he is of personal expressions of favor and the better he asserts himself in impersonal contact with the public—relying on objective products. The reputation of the literary and the plastic artist, in the eyes of the public, generally increases as relations become objective. The famous masters of the Renaissance may have been as celebrated and spoiled as we like; most authors and the majority of artists were regarded as mere writers or useful craftsmen. Now all are bathed to some extent in the light which the period of individual genius sheds upon the intelligentsia. The concept of genius, to which everyone who now lifts a pen lays claim, is, from the point of view of historical materialism, only a form of self-advertisement and a weapon in the competitive struggle which takes place in a market that is flooded with books. The subjectivism of genius is partially economically conditioned. In the same way the early romantic movement—with its emphasis upon emotions—as bourgeois opposition to the aristocracy's classical artistic and world view, which is based upon reticence, reason, and order, can be understood properly only as an ideological phenomenon.

The genius's behavior, which seemed at the time of the Enlightenment and preromanticism to justify the special position of the artist, loses the strident, blatant, challenging character of self-advertisement as the bourgeoisie gains in self-confidence and security and becomes conscious of its moral superiority vis-à-vis the aristocracy. What is

especially symptomatic of this change is the attitude of Goethe, who, in spite of his inclination toward the aristocratic forms of life, begins to defend the idea of the bourgeois work ethic against the inspired artist and poet. In his later years he underlines ever more strongly the craftsmanlike nature of literary creativity, and demands of the artist, above all, solidity and reliability. In the Renaissance when art was still often practiced as craft, the artist had to be stimulated to raise himself above his fellow guild members who were merely engaged in trade. Now, however, when the unrestrained subjectivism of original genius begins to take effect as an outgrowth of bourgeois emancipation and as a means of tasteless competition, it seems to be time to remind poet and artist of the bourgeois seriousness of their profession. The lofty rank of the artist no longer needs to be emphasized; what is necessary, however, is to prevent his lapsing into dilettantism and charlatanry. Ostentatious genius was the artists' weapon at the time when their emancipation began: by now this is completed. To be allowed to be a "genius" was a sign of a freedom which had scarcely been achieved; no longer wishing or having to be a genius is the sign of a condition in which artistic freedom is taken for granted. With his aversion to everything unstable and unsound, anarchic and chaotic, Goethe anticipates the point of view of the bourgeoisie of the following generation. He also proclaims the problem around which, in the works of Thomas Mann, for example, the psychology of the artist's way of life will revolve: how is a type of person, to whose nature with all its sensibility belong the pathological, the unreliable, even to some extent the criminal, to be integrated into bourgeois society and bourgeois forms of life?

In order to achieve the sharpness of focus the problem received in the works of Thomas Mann and, before him, in the works of writers like Henry James or Flaubert it was necessary that there be a *Bohème*, Gautier's "red vest," Courbet's beer cellar, and a solidarity of the artistic proletariat with the prostitute—the indifferent manipulator of feelings—for the artist to lose the rest of his reputation in the eyes of the bourgeoisie. Thomas Mann and morally concerned writers of his sort already regarded as tragic what Diderot had judged completely unpathetically. Diderot depicted it in the sense that the artist was of necessity forced to lead an extrahuman existence, to some extent an *inhuman* one; the ordinary paths of bourgeois existence could not be trodden by him and spontaneous, warm, human feelings were of no use to him in his undertaking. It is true that Diderot let his paradigmatic actor express emotions convincingly without any real feeling and had him create a genuine effect simply because there was a lack of feeling. It would never have occurred to him as it does to Mann to regard as

the artist's spiritual relatives all the problematic, ambiguous, and disreputable existences, all the weaklings, the sick and degenerate, the adventurers, confidence men, and criminals.

As similar as the preromanticism of the eighteenth century and later romanticism seem to be if we look only at their ostentatious cult of genius and their insistence upon the special rights of the artist, the gap between them appears just as deep when we reflect that the earlier movement was linked to an immeasurable increase in prestige while the later—with all its aestheticization of world outlook in this whole period—saw a sensible loss of prestige. The optimism of the Enlightenment was based on a belief in the inseparability of freedom and equality, intellect and practice; the knowledge that they had become irreconcilable was the source of the disillusion and pessimism of the postrevolutionary generation and the reason their intellectual spokesmen were discredited. The defeat of the revolution censured the Enlightenment with its belief in the unlimited dominion of reason; no one listened any more to its poets and thinkers, and they comforted themselves for their uselessness with all sorts of surrogates. Besides the past and utopia, the unconscious and nature, these were blind instinct, dream, and sickness. The whole thing was a question of saving the artist's prestige. In the face of the intellectual alienation of the postrevolutionary bourgeoisie and the antiintellectualism of the philistines, with the suspicion the "responsible elements" nurtured against the artist's extravagances and lack of influence on political practice, they created a sphere in which they could lead their lives unmolested and in which life was judged according to the criteria of art. Once again we are dealing with the creation of something like a priestly class with a priestly concept that was all the more sublime the less it corresponded to the standards of value of the uninitiated.

Certainly the feelings of the artists who developed this concept of prestige were fundamentally just as ambivalent as those of the bourgeoisie who—with the partial reception of the outlooks of the aesthetic world view and the acceptance of their representatives—became an enemy in its own camp. Aestheticism became problematical for the artist himself in that it forced him to withdraw further and further from the life which was the medium of his existence and at the same time the material of his art. Ibsen finally arrives at a clear insight into the paradox which Balzac had hinted at in his *Chef d'oeuvre inconnu* and which, after him, Flaubert, Mallarmé, and Rimbaud found ever more tormenting. Rubek, the hero of his last drama and the executor of his literary testament, finally denies his work in the consciousness that life has passed him by because of his art. This was expressed more or less clearly by every artist since the romantics, and

the growing fear about it went hand in hand with the history of aestheticism throughout the nineteenth century. The artist's prestige could only be rescued at the end by giving up the aesthetic world view which had been thought to be its foundation.

The relationship of the artist to the intelligentsia had been the central issue around which the artist's prestige revolved ever since the distinction was made in ancient Egypt between the learned scribe and the artist, who was considered an ordinary worker. For a long time artists were obviously acquiescent in being placed among the simple tradesmen, and even when they had already begun to lay claim to be counted among the intelligentsia it is more a question of economic and social gain than one of an increase in prestige. The division of the two goals from each other on principle still runs into difficulties in the Renaissance and even later.

The intelligentsia is a social structure which is hard to define. It does not represent a class—like, for example, the bourgeoisie or the industrial laboring class—although it is by no means indifferent to class. It does not constitute a uniform professional station since it embraces such disparate branches of activity as the artist, the writer, the academic and independent professions, and the higher civil service. Even if we were to apply the concept of intelligentsia only to artists and writers, we would first have to distinguish between creative and merely receptive intellectuals—between those who were active in art, literature, and the academy and those who merely read books, those who merely enjoyed works of art, and the cultured members of society who reacted vivaciously to intellectual stimuli. The further difficulty in the definition of the intelligentsia consists in the fact that they reveal the traits neither of an institutional structure, that is to say, of a corporation, an association, a party, or a church, whose bylaws and rules are more or less voluntarily accepted; nor of a community like that of a generation, which is mainly based upon natural conditions; nor of the family, in whose structure natural and institutional elements are mixed. We belong to the intelligentsia without joining it: however, we are not born into it, but develop into members of it as a result of an interaction of personal and superpersonal motives. If we once belong to it, then we behave according to particular principles which are peculiar to the group as a social reality, but which are completely or partially independent of the psychology of its individual members.

The problematical relationship between the creative intelligentsia in general and the artist in particular points to a fundamental lack of clarity in the concept of intelligentsia. Unless he is a writer, an artist cannot immediately count as an intellectual and certainly not without reservation: the criterion as to whether he can be considered one has,

in any case, nothing to do with his ability as a painter, sculptor, or composer. Not only would we object to recognizing the mason of the masons' lodge or every painter in the painters' *botteghe* of the Renaissance as an intellectual, but we might even have reservations about using the qualification in the case of a master like Bruckner. This will certainly be unjustified if we are not from the outset to restrict the concept to writers, thinkers, and scholars—which would obviously be absurd. Of course, we can be "intelligent" in many different ways. No matter how incomparable the intelligence of a profound poet, a mathematician who thinks in abstract forms, an inventive merchant, or a circumspect chess player who carefully weighs complex, though unworldly, problems, is with that of a "great child" like Bruckner, they all have a right to the title. Bruckner—like Schubert, for example—may have been a simple soul in many regards, but as a composer he was inspired and obsessed with his undertaking. He could also think in extraordinarily complex forms, could approach his work consciously and with a high degree of self-criticism, could examine his ideas according to highly developed and widely tested criteria of taste, and was completely at home in the world of the intellect. He was precisely what we understand by "intellectual" in the best sense.

The greatest difficulty in defining the concept of intelligentsia, however, comes from its undetermined and unclear class situation. Its class allegiance is generally a loose one, and the frequently unrestrained changes in its loyalty from one political camp to another led to its well-known definition as a "socially floating" class whose raison d'être consists in formulating, propagating, and defending, or of debating, criticizing, and rejecting the ideology of classes with which its members are more or less or even not at all, identified. In short, they are a group of professional spokesmen who criticize society and manipulate public opinion. If we see the function of the intelligentsia as fulfilling tasks such as these, it is more than questionable whether artists in toto can be considered a part of it. Most painters and composers are simply incapable of formulating their views and efforts in an agitatory fashion. If Bruckner were to use a linguistic, rational, immediately communicable medium, he would appear like Baudelaire's stranded swan, dragging his wings in the dust behind him.

The assertion that the intelligentsia approaches every social organization critically is, it is true, just as daring a generalization as the theory that it is a social stratum called upon to exercise social criticism, empowered to do so, and capable of it is a complacent myth; yet its tendency toward criticism is not in doubt. It is part of the explanation of this disposition that, apart from the political and professional heterogeneity of the group, it has its origins in the bourgeoisie, whose

self-critical attitude—as one of its most significant characteristics—was first noted and emphasized by Brunetière. On the other hand it is quite untenable to take the view that the intelligentsia is the voice of liberal, leftist, essentially anticapitalistic social criticism. It may have been mainly progressive, even revolutionary-minded, in the Enlightenment and in 1848, but after the revolutionary period, during the second half of the nineteenth century and particularly at the turn of the century when the fascist movement was beginning, the conservative and reactionary tendency was just as strong, even if not stronger, than the progressive.

If we understand the "socially floating" situation of the intelligentsia to mean that they are onlookers who are not bound to a particular class, who are inwardly aloof and not *engagé*, then we shall not get very far. The position of the intelligentsia "between classes," insofar as there is something of this sort, does not imply a lack of social commitment or an indifference but simply a particularly complex, many-sided, and consequently contradictory dependence on class interests and ideologies. The mobility in world view and ideology which Alfred Weber and Karl Mannheim ascribe to the intelligentsia does not in any way mean the same thing as lack of social roots. The intelligentsia is, as Mannheim himself admits, only relatively "floating," but it is in no way unaffected by class bonds. It may, as a result of its professional thinking and its practice of taking stock of itself, perceive the partiality of ideologies—and to some extent of its own ideology—more clearly and objectively than other strata of society. No thinker who is really worthy of the name moves completely "freely" in judging social reality, not one "floats" in the air, but each is, rather, ontologically bound and has his roots in the social soil, however loosely these may sit and however easily they can be transplanted. Mannheim emphasizes, and probably correctly, that a sociology that was oriented *only* toward the concept of classes could not do a concept like the intelligentsia justice.[23] For no matter how unmistakably it may be rooted in the wealthy bourgeoisie, which can afford the luxury of education, we obtain a completely false concept of it if we leave out of account the social ties which cross its community of class with the bourgeoisie and if we fail to take into account that it represents a stratum of culture whose limits are in many ways more narrow and in others broader than those of the bourgeoisie. In the sense that he has a number of ties, not just ones of class, the intellectual does not even distinguish himself in that way from other social subjects. For in a complex culture and a society conditioned by a variety of interests each person is very often engaged in different and often contradictory directions. The mere statement that we are dealing here with a plurality

of particular motives leaves open the question of what has priority. If we are from the beginning to stress culture as a meaningful phenomenon, the motives connected with community of class seem to take a subordinate place. In reality, however, culture is a phenomenon which is not beyond class, even if it is a special one which transcends the limits of class. Rather, it receives its content, its direction, and its norms from the ideology of the class with which it identifies or to which it subscribes. As long as the intelligentsia remains linked to a class ideology, whether its own or one alien, even antagonistic, to it, its bias is unmistakable. It seems to assume an autonomous character beyond class only when its relationship to the class in whose name and interest it speaks becomes problematical and the feelings by which it is moved—at best ambivalent—are dominated by the consciousness of the contradiction between wealth and education, power and intellect, ideology and the idea of truth.

What part does the intelligentsia play in the formation of ideologies involving class interests that do not correspond to its members' own social goals? Is it really, as has been asserted, the originator of the systems of thought and orders of value in which the efforts of the ruling classes find their justification and expression? Or does it merely perform the scribal services which have always been its lot? To the extent that it starts to be involved in the power of the leading strata and to speak for itself, naturally its influence upon the content and tone of ideological declarations grows, but where its own interests are not at stake, it is never the actual source of ideologies. It does not think them out and invent them; it merely makes cosmetic adjustments. The members of a class follow, consciously or unconsciously, the principles upon which their ideology rests, even if they are not always capable of formulating and propagating them. The origin of these principles is always the economic and social practice in which they are involved, and the intelligentsia is at most the mouthpiece they use.

The modern creative intelligentsia finds its immediate predecessors in the literary figures of the Enlightenment. These represent the first intellectual leaders to be for the most part economically independent, the first creators of cultural estates who are no longer in the direct service of an authority or a ruling class and are no longer protected by individual private patrons. They enjoy the privilege of public criticism in political matters, morals and taste, and thus develop into the living conscience of the time. They exercise the function of public prosecutor, without the dignity of the office, without express authority, without maintaining firm and secure ties to any one class, and become—as soon as their short-lived glory is over—the prototypes of the modern intelligentsia. The prehistory of this cultural stratum as

a social phenomenon is certainly much older. After a period lasting millennia in which literary activity—apart from that of the independent poets, who appear sporadically—was restricted to the priesthood or the court, there appears in Greece in the fourth century B.C. among the Sophists and their disciples a uniform professional class among poets. As an autonomous intelligentsia this class has no predecessors but has an all the more significant group of successors. However, up to the time of the Enlightenment this class asserts itself decisively only once—in humanism. The humanistic movement itself is, it is true, by and large episodic in character and is in the hands of a relatively small group; it is, however, of great symptomatic importance, and its effect as a stimulating example lasts for a long time. The modern literary intelligentsia is meanwhile not linked to the Sophists or the humanists by an unbroken historical continuity or a common social structure. The exception would be if it were a question every time of a professional class which was formally independent, although more or less firmly linked ideologically and economically dependent on itself, and which reckoned on a mixed, amorphous public, and this class offered itself—asked or unasked—for duty as teachers and referees.

The Sophists uprooted the whole aristocratic culture which up to that time had, with few interruptions, dominated Greek culture. The educational ideal they represented contrasted the idea of an irrational elite education based upon heritage, family, and social status with an education of rationally thinking, articulate citizens capable of making their own judgments. It corresponds to the ideology of a social class that—deeply as it might be linked to the nobility—was more concerned with the education of a youth aimed toward political activity than with the training of warriors and freebooters. The history of Western social and cultural criticism begins with this new idea of education. The examination of dogmas, myths, prejudices, and outmoded conventions derives from it. The Sophists are the first thinkers to realize that religious creeds, scientific truths, and moral values are historically conditioned, and to recognize the relativity of good and evil, justice and injustice, truth and falsehood. They thus become the founders of all Western enlightenment movements and the forerunners of all the humanistically inclined, nonconformist literary movements. Under the tyrants, we already encounter poets who write professionally and offer their intellectual products frankly and freely to purchasers. The Sophists, with their sober realism, are the successors of these uninhibited experts, except that they are no longer parasites and lackeys, they are not exposed to the favor or disfavor of a small number of interested people but are already standing face to face with a wider, more impersonal, and more liberal circle of consumers. Nevertheless, they lead

an economically and socially ambiguous existence. They are in principle independent, are friends of the people and rebels; but they have to earn their living by teaching the children of the wealthy, since the poorer children can neither afford nor appreciate their pedagogic services. This contradiction may have been the first example of that tension between wealth and culture, material and spiritual means of power, which dominates the psychology of the intelligentsia.

The ambivalent feelings toward the economic and social elite actually only develop properly in the period of humanism. The humanists with their antithesis between the fiction of independence and their actual duties, and as a result of their *ressentiment* against their employers, become a new social phenomenon: they become "paid enemies." Yet how was it possible for people who were in possession of the truth, of knowledge, and of all the means of cultivated social intercourse not to feel envy and jealousy toward the class which was in total possession of political and economic power? In the Middle Ages, the clergy, who monopolized truth and knowledge, also controlled political and economic power. Thanks to this coincidence, the pathological phenomena which were later the result of the division of spheres of power and which produced *ressentiment* on one hand and unquenchable suspicion on the other were not yet to be seen. The predecessors of the humanists in this sense are therefore neither the Sophists, the clergy, nor even the medieval *vagantes,* but at best the so-called *ménestrels,* who functioned from the end of the thirteenth century as firmly appointed court poets. They contrasted emphatically and consciously with the wandering minstrels, were burdened with all the vanity and pride of the humanists, and began to develop into an arrogant group of literati who had already started to play the role of teachers and confidants for their patrons.

The practical presupposition for the genesis of a group of literati, who were in principle free, was the presence of a broader propertied class which was suited to the forming of a literary public and which strove to do so. The literature of both antiquity and the Middle Ages was still intended for a relatively narrowly defined group of people, most of whom were known to the writers. The advantages of a free literary market, which the humanists enjoyed, are owed to the fact that they are no longer dependent upon a particular patron or upon a restricted group of patrons but find so many potential purchasers for their intellectual products that they no longer have to get along with everyone. Yet it is still a fairly thin cultural stratum upon which they can count as a public, and thus they generally remain dependent on the favor of the princes or the generosity of the wealthy and ambitious bourgeoisie, for whom they often perform the services of sec-

retary or majordomo. Instead of being the court fool or court singers, panegyrists and chroniclers, they now consider themselves humanists who do the same tasks as their predecessors. It was expected that they would identify with their employers' ideology, and the haute bourgeoisie hoped to link itself with the nobility through its patronage of them, just as it had previously joined the aristocracy by marrying into it.

The deeper the humanists penetrated into the fiction of their intellectual freedom, the more humiliating they found their dependence on the ruling class and the deeper the inner conflicts associated with the adoption of the alien ideology. The age-old institution of patronage, whose value had till then been unopposed, seemed to have lost its apparently harmless quality. Since coming into closer contact with the upper classes, the literati and artists had changed their views and demands together with their life-style. While it never occurred to the Sophists or the clergy active in literature or the stray, wandering minstrels to enter into rivalry with the ruling class and the wealthy, the humanists, as the first intellectuals, lay claim to wealth and influence. The class antagonism between the two camps is most drastically expressed by the fact that the humanists, who are for the most part of plebeian origin, are finally suppressed by the upper classes after having first been encouraged to climb socially. The ideological contrast could not remain concealed forever; the mutual mistrust which existed between the sober, industrious, power-hungry, intellectually alienated political and economic ruling class and the proud, unreliable cultural stratum opposed to any ties at all, had to lead to conflicts. Just as the ruling class in Plato's time were aware of the danger that threatened them from the Sophists, they now nurture a suspicion of the humanists which can never be completely concealed. The humanists become an explosive element which threatens the unstable social balance because of their insolent ambition and their quiet resentment.

The modern intelligentsia derived for the most part from the new bureaucracy which was employed in the princely courts and the Renaissance chanceries. The civil service included a considerable number of aristocrats who had forfeited their military role and had to look for a new means of livelihood. For the most part, however, it consisted of lower class people for whom the career of bureaucrat represented a social improvement. The prestige of the literati was founded partially upon a personal union with the civil servants. This opened to them the shortest route to "society." It was possible to belong to the ruling class without being cultured, but it was scarcely possible to belong to the cultured stratum without being linked to the ruling class and recognized and accepted by it. It is only since the Renaissance that talent and works have been sufficient to ensure entrée into society and to

justify claims to office and influence. The general availability of posts did, however, result in a partial lowering of their social prestige. The humanists were rewarded and spoiled by their masters, praised and often feared, but not always respected. Thus, humanism may mean a step forward in social emancipation and scientific independence, but not a general improvement in the relationships between employers and those who sing their praises. We could rather maintain that a conflict arises where there previously did not seem to be one.

With their frequently complicated relationship to the intelligentsia the princely courts and the great houses of the Renaissance form the origin of the later royal households, the most complete example of which is Versailles. On the other hand they are the origin of the literary salon, which played so important a part in seventeenth- and eighteenth-century French culture. Although the Italian courts and the great houses of the Renaissance already admitted poets and literati from the most diverse social circles if their abilities and attitudes corresponded to expectations, it is only in the salon that a real mixing of aristocratic and bourgeois elements takes place: the salon remains for the most part independent of the court and develops into a forum suited to the literati. In the salon, too, not only are people all judged according to the same set of standards but gradually bourgeois values prevail. In this way there arises an intelligentsia which emancipates itself completely from social origin and develops into a new stratum which makes the bourgeois the real supporter of culture.

Private patronage begins to cease in the seventeenth century. In England at first, after the beginning of the Enlightenment, there is an increase in the number of writers who live by their pen and of people who buy and read books. Patronage is replaced by the publisher as a source of subsistence. Subscriptions to periodicals form the transition between the two. Patronage was still an exclusively aristocratic form of the relationship between writer and public: the subscription loosens the tie without erasing all personal traits. The publication of books for interested people whose circle had fluid boundaries and who had no personal contact with the author already corresponds in bourgeois capitalist society to trade economy, which is also anonymous. As a result of the almost total transition of both productive and receptive interest in literature from the aristocracy to the middle class—which is partly the result and partly the origin of their mixing—what is till then an unprecedented rapprochement takes place between the producer and the consumer. The result of this is that the area of friction between the supporters and the heralds of ideological points of view disappears almost completely. Neither before nor since had they come so close together as at this time, when the intellectually most valuable

and the politically most progressive elements of the aristocracy and the haute bourgeoisie clearly recognized the omens of the final dissolution of the feudal social order, and the literati, no matter what class they belonged to, were persuaded to speak for the whole society. Strictly speaking, this was never actually the case, for even in the most unanimous phase of the Enlightenment—and even in the case of writers as closely linked by language, literary tradition, and political outlook as were Voltaire and Rousseau—the ruling intellectual values and criteria of taste proved irreconcilable. They split into so many directions that the sharpest intellectual conflicts in the following century seemed to arise from the conflict between them. The conflict between Rousseau's subjectivism and emotionalism, naturalism and cultural nihilism, and what Voltaire regarded as civilized forms of life—human dignity and decency, good taste, and common sense—naturally had class origins. From the social point of view, however, it is all the harder to define and explain it, since the usual division of ideological attitudes into a rational and progressive and an irrational and conservative stance contributes little to the explanation of the conditions. Voltaire, the classicist and antiromantic, the protagonist of the old aristocratic and haute bourgeois way of thought and taste, is really the liberal and progressive thinker, while Rousseau, the *déraciné* plebeian and the disrespectful anarchist, the sentimental romantic and the irrational dreamer, creates the basis of the world view and the feeling for life of reactionaries like Chateaubriand, Bonald, and de Maistre. If we want to talk at all about a "socially hovering" intelligentsia, we can at most do it in cases like this, where the ideologies in question are conditioned not by class situation and conditions of wealth but by very different and often contradictory motives. Voltaire and Rousseau are on the side of different classes in very different relationships, and even if the ideologies they represent are by no means free from class ties, we can scarcely explain it on the basis of these.

After becoming almost totally bourgeois during the Enlightenment and the revolution, Western literature once more falls into the hands of the aristocracy during the romantic period, particularly the period between Chateaubriand and Lamartine. It is only in the work of Victor Hugo, Théophile Gautier, and Alexandre Dumas that it becomes fully bourgeois and progressive again. Moreover, romanticism in the whole of the West brings such a confusion of guidelines and such an incongruence of political and artistic values in its train—no matter how different the political views may be which are linked to it and no matter how different, in each case, the process may be by which the contradictory loyalties take one another's place—that the literati of the nineteenth century never really find their way back into a realistic

relationship with society. If they seem to hover between classes, this does not mean that they are ideologically unprejudiced and free from every class tie, but only that they are unable to identify, without reservation, with any class or stratum of society. Their apparent *dégagement* is not to be explained as a flexibility of views but in most cases as merely the incapability of taking a point of view in a time of problematical and contradictory values and in a historical situation in which the artistically definitive strata were separated from one another socially by an abyss. The literati of the Enlightenment were in the fortunate and almost unique situation of associating themselves in a far-reaching inner agreement with the social and cultural elite of their time. Previously culture had been for the most part restricted to the ruling class, at least in the sense that the receptive intelligentsia belonged almost entirely to this stratum and the creative intelligentsia, apart from exceptions like the Sophists and the humanists, had never been capable of expressing a nonconformist ideology of its own. Now, in the nineteenth century, for the first time the social and economic upper class in part tolerates an art and literature—even encourages it— which opposes its ideology, and the artists, particularly in the late stage of the development, defend an ideology opposed to their class situation without being forced to do so as they had previously. It is no wonder that the relationship between productive and receptive intelligentsia, art and public, writer and reader is full of misunderstandings, deceptions, and traps.

There is now only a bourgeois reading public, inadequate as it may be. The authors, however, behave—as far as their programmatic declarations go—as enemies of the bourgeoisie, opposed to bourgeois institutions and to the principles of democracy; this does not mean, however, that they are not in every way rooted in the ideology of the bourgeoisie. They remain in fact inseparably devoted to it, not only because they now have only bourgeois readers but also because—while wishing to revolt and protest against it—they can see the world only through the eyes of the bourgeoisie, which came of age in the Enlightenment, which feeds upon the ideas of the Enlightenment, and which came to power through democracy, and they find through this a secure existence as rentiers. Their loyalty, divided as it is between the public for which they write—the single real, actually reading public—and an imaginary superbourgeois readership which remains utopian (even if it is addressed sometimes concretely in the form of the proletariat—which does not read at all and which, even if it did wish to read, would be incapable of reading the best of what is written), creates a skewed relationship between production and consumption unparalleled in the earlier history of literature. The writers can do

nothing but curse their readers, which they do the more embitteredly, the more—like, for instance, Flaubert—they struggle against their own prejudices while raging against the bourgeoisie. If we want to understand the complicated relationship between the antibourgeois intelligentsia and the bourgeoisie which suffers their attacks, we must be on guard against every one-sided judgment of the antagonists. We must avoid falling, on one hand, into a messianic interpretation of the aggressive criticism or an overestimation of patience, on the other. If the bourgeoisie were to oppose the right of the intelligentsia to criticize, it would place its own right to existence in question. A social class that bases its right to rule not on blood and birth but on the principles of reason and law cannot deny the validity of these principles in any way without undermining the system on which its privileges and means of power rest. The rule of the bourgeoisie and the criticism of this domination by the intelligentsia are based on the validity of the same rights.

The complete alienation of the creative intelligentsia from bourgeois society was accomplished after the 1848 revolution, as a reaction to a period of great intellectual ferment at the end of a revolutionary development which had been in progress since 1789 and 1830. In the case of the ruling class it was no longer a question of indifference to intellectual values when its social privileges were at stake but of a flattening out of thought and a brutalization of taste as a result of its enmity toward the intelligentsia. The bourgeoisie of the Second Empire not only plotted against the revolution, not only denounced the class struggle as treason to the nation, not only suppressed the freedom of the press, not only made of the bureaucracy a blind tool of their class domination but at the same time set up the police state as the highest authority in all questions of morals and taste. Up to this time the intelligentsia had not been in the least politically unanimous; rather, they had been divided into a progressive Left and a conservative Right, whereby the conservatives from time to time, particularly in the romantic period, had played a decisive role. After 1848 there arose within the intelligentsia a division between rebellion and cant that was essentially different from the earlier party differences. Whoever howled with the wolves did not always do so out of conviction, and whoever played the rebel often merely wished to attract attention. Apart from that not inconsiderable part of the intelligentsia which was not quite settled as to its own interests and aims and which constantly wavered as a result of its disorientation, artists divided themselves into two propertied classes, the contrast between which since the Renaissance especially (but even earlier) was unmistakable. They formed two camps. There were the rentiers like Flaubert, Maupassant, and the

Goncourts on one hand, and the *Bohème* on the other, and there was no earlier example of such a sharp division. There were probably a few wealthy artists but no compact stratum of artists which might have been imbued with the later-nineteenth-century upper middle-class consciousness of the literary rentiers, and there were enough poverty-stricken and neglected artists. However, in spite of the paltry existence of many representatives of the early quattrocento and of the poverty of the Dutch seventeenth-century painters there was no artistic proletariat with nothing to gain or lose.

Up to 1848, in spite of existing contrasts and conflicts, the intelligentsia remained for the most part the avant-garde of the bourgeoisie. Afterward it became—even though frequently unconsciously and without wishing to, but generally completely successfully—the rear guard of the obstinate bourgeoisie or the all too conscious though less successful vanguard of the working class. The *Bohème* feels a certain community of fate—in spite of its insecure existence—with the proletariat and indulges in the illusion that it can make the social struggle into a cultural struggle. It seems to know nothing of the uncommonly complex nature of the relationship between social reality and artistically expressed ideology. The skirmishes of the *Bohème* with the bourgeoisie, its manifestos of protest against the bourgeois rule of life and bourgeois prejudices, bear the same unreal and ineffective character as its attempts to join immediately with the lower classes. The influence of art on society has itself social presuppositions; a mere decision is not enough, although this decision is already socially conditioned. The *Bohème*'s optimism vis-à-vis the possibility of influencing the uneducated is just as naive as the idea that a change in the class struggle could change the relationship between artist and public at one blow.

The change proceeds uncommonly slowly. Before the nineteenth century there is probably no decided artistic proletariat, but we come across proletarian phenomena among artists ever since the Middle Ages. They are always the product of the same social conditions, of the anarchy of supply and demand, of the shrinking of the labor market, and of lessened security. A certain lack of security was probably connected with the change in the Sophists' life-style, but we can talk of the beginnings of that alienation and rootlessness which belong to the concept of the *Bohème* only since the rise of the *vagantes*, the clergy and scholars who roamed as minstrels. It is a concomitant of the dissolution of the feudal system, of the late medieval economic and social change of system, and it is connected with the move of large strata of the population from the country to the town and their change from strictly closed groups into looser social structures which had more freedom but less protection. With the revitalization of the towns

and the overcrowding of the universities there emerged a learned pro-
letariat composed of the young people who were no longer able to be
accommodated by the Church and who could not even finish their
studies. This proletariat leads the mendicant life of the wandering actor
which the *vagantes* led and only differs from the ordinary minstrels
in their sense of being déclassé.

Just as we find only isolated signs of poverty among artists until the
middle nineteenth century but no real proletariat in the actual sense,
so there are only preforms of the *Bohème* but no actual *Bohème*, Even
the romantics only play with the role of outcast. Since they are for the
most part the sons of wealthy people, their demonstration against the
bourgeois way of life is nothing more than youthful exuberance and
the spirit of contradiction. Théophile Gautier, Arsène Houssaye, and
Nestor Roqueplan make their excursions into the world of the despised
with the consciousness that they can tread the path of return to bour-
geois respectability at any time. Moreover, they only represent a small
minority within the romantic movement. Definitive representatives of
the movement such as Delacroix was, for example, nourish a deep
antipathy toward the bad manners of the *Bohème* in spite of their
contempt for the stupid bourgeoisie.

The next, naturalist generation was both artistically and politically
militant, the first true representatives of the *Bohème;* this produces the
first true artistic proletariat and consists largely of people whose ex-
istence is completely insecure. They exist outside the limits of bour-
geois society, and their struggle against the bourgeoisie is no longer
a mere masquerade. Courbet, the artist who sets the tone for the
movement, not only is of the people but remains throughout his life
an outsider who finally, with his socialism, turns his back on the
bourgeois public. The identification of truth in art with politics which
he, Proudhon, and Champfleury formulate as their motto forms the
beginning of a tradition which stretches to Zola and Tolstoy and—as
the fundamental thesis of the doctrine of the indivisibility of what is
artistically valuable and what is socially worth striving for—still be-
longs to the basis of the Left's radical art criticism. The period of later
naturalism and impressionism which produced a wilder and more des-
perate form of *Bohème* than had ever been known and which, with
Rimbaud, Verlaine, Tristan Corbière, Lautréamont, and van Gogh,
produces a generation of artists that spends its life in brothels, cafes,
hospitals, and lunatic asylums proves simultaneously that poverty and
despair, plebeianism and dissoluteness are not among the absolutely
essential criteria for anger against society. Dostoevski, who was both
conservative and in many ways reactionary, who was a prototype of
the artistic proletarian, and Tolstoy—with his socialist views—who

gave up his estates to the peasants for nothing yet remained as he had been born, a count for his whole life, were equally alienated and rootless.

Dandyism in literature, just like the feeling of "discomfort in culture" with which the epoch began, goes back to Baudelaire and represents more openly, and often more ostentatiously, a movement which has nothing to do with the proletariat or with socialism. It also wants nothing to do with the bourgeoisie because of its plebeian essence. It found its most extreme form in England, where Oscar Wilde remained a successful writer as long as he amused people but who was mercilessly liquidated as soon as he began to annoy society. Here the harmless dandy took the place of the *Bohème*, whose protagonists or substitutes were, incidentally, also to be found in France in the person of Baudelaire or Barbey d'Aurevillys. He is, so to speak, the intellectual who has been déclassé in an upward direction just as the *bohème* is the artist who has sunk down into the proletariat. The studied elegance of his clothes and the extravagance of his recherché manners fulfill the same social function of setting him apart as do the neglect and the dissoluteness of the *bohème*. The same protest against the banality of bourgeois existence is expressed in the one as in the other form. From this point of view it makes perfect sense for Baudelaire to place the dandy, with his nonchalance and the lack of practical goals in his life, above the artist who still maintains his enthusiasms and still works, and is thus to some extent the "philistine" which the Greeks labeled him. The artist's prestige has described a remarkable circle to get back to this zero point. It is true that today no one thinks any more of a philistine, a *bohème*, or even a dandy when talking about the artist; but we think all the more often of the questionable nature of the value of art in the whole of human culture, and so the loss of the aura which surrounded the work of art in the past is all the more obvious.

As a result of its special interests and personal goals, of its different situations with regard to wealth and origin, of its changing social situation and reputation, of its special talent and educational level, the community of artists represents an extremely loose structure, and one which is scarcely ever able to be exactly repeated. However, it always possesses that essential sociological character, that reality sui generis as a result of which it has validity as a structure which develops its own dynamic and is not absorbed in its own psychology. Nothing is apparently more suited to the illustration of the comparative independence of a social group from the behavior and character of its members than the structure of the community of artists *(Künstlerschaft)*. If we compare this category with that of the artistic gift *(Künstlertum)*, its concrete and autonomous nature becomes unmistakable as a sociolog-

ical reality. *Künstlertum* is the result of an abstraction: to ascribe to this collective idea an existence which was independent of the contemplative subject's world of ideas would be sheer conceptual realism. It merely represents an agglomeration of natures, tendencies, abilities, and readinesses; it does not form a concrete objective entity, unlike the *Künstlerschaft*, which asserts itself vis-è-vis separate individuals as a mechanism with its own motive force, with particular possibilities and limits which correspond to its extra- and superindividual nature, and which affects social subjects now in a helpful, now in an obstructive manner. The *Künstlerschaft* is a collective "subject," the substratum of attitudes, actions, and products which, it is true, can only be accomplished by individual psychological subjects. The artists' collective, however, represents a real context which is not only present in "the head" of the concrete individuals, but which also causes them, from outside, to accomplish functions, although the process of motivation and the change of motives into functions "must go through the head" in order for the actions and products to be accomplished.

The characteristics of a category, whose limits are set as wide as those of the *Künstlerschaft*, cannot be all too numerous. Even such vague marks of distinction as intelligence are not suited without some limitation to the *Künstlerschaft*. As we have already suggested, either we have to admit several forms of the concept or we cannot call all artists intellectuals. Most of the groups in which artists are united to one another, such as those that correspond to origin, class situation, way of life, stage of education, are not freely chosen and consciously organized forms of socialization. Their scope is different from case to case, and their influence on artistic behavior is not dependent on the significance individual subjects ascribe or concede to them. These, too, are certainly, like the whole historical world, "made" by men, but they are based on extrahuman ontological data and represent objective structures which influence individual people just as strongly as they are influenced by the individuals. Associations are different; they represent institutions in the narrower sense, structures which are organized according to a plan, are arbitrarily modified, and are retained or sacrificed according to will. Corporations like the guild or the masons' lodge move on the border between institutions, in the narrower, statutory sense, and the forms of social union as a whole. Even the academies, as the successors of the guilds, present numerous characteristics which reject the idea of planning and correspond in large measure to the nature of the given productive forces and the inertia of existing social technique. This is true in spite of their carefully organized form as professional associations and teaching institutions.

As is well known, there were organizations for the preservation of common interests, for the pursuit of similar economic and social goals, for the organization of labor collectives and workers' coalitions among artists and craftsmen from ancient times on. The rhapsodists, especially the Homeridae, formed a closed, guildlike group of this sort, except that here the union was allegedly based on origin and community of blood, in accordance with the ideology which was oriented toward the concept of family. The building corporations, guild workshops, artists' *botteghe,* academies, painters' studios, and craft manufactories of the succeeding centuries were institutions in which at one time the tasks of professional organization and collective work and at another artistic education and tradition were in the foreground. In none of them was it a question of an essentially aesthetic-programmatic form of union which anticipated practice either sociophilosophically or according to the theory of art. It was only the period of the alienation of the intelligentsia from the rest of society, of the partial impoverishment of the artist, and of the rise of the *Bohème* which is at one and the same time the genesis of artists' colonies and poetic coteries, of the romantic *cénacles* and circles of friends, of the schools of artists and poets which mainly represent stylistic movements and which are represented by reformers and avant-garde artists. They are associations whose rules and regulations are imposed by the different groups of artists themselves not so much for the purpose of expansion and climbing, the extension of their rights and their elevation above other strata, as for their entrenchment and separation in accord with the general disillusion and resignation which dominated the century.

The romantic *cénacles* are the successors of the eighteenth century literary salons in which poets, artists, and critics regularly met with the representatives of the upper classes and where they were all more or less on the same footing. However, they maintained their "social" character and let high society continue to set the tone in many ways. Their influence was not immediately creative, however great the stimulus they gave. They constituted a forum to whose judgment people submitted, a school of good taste, and an authority whose competence in questions of literature no one doubted. They were not, however, a workshop team in which one or the other group of writers would have been decisively supported in its work. In the romantic coteries on the other hand the "social" moment receded sharply, first as a result of the fact that they are artistic circles of friends—which have from the beginning a much more closed character than even the most liberal salons—and then again because they do not adopt the principles of taste of a particular social class, however readily accessible. They follow instead the artistic program of a single poet or of a relatively small

group of poets. In this way they differ both from the habitués of the French salons and from the members and regular guests of the English clubs and coffeehouses, which are not grouped around a stable personal center and whose influence as a school is of minor importance.

Neither the seventeenth nor the eighteenth century knew the institution of literary schools with their express, logically thought out, and precisely formulated programs, although they would have been more suited to the normative character of classical literature than to romanticism with its anarchistic inclinations. In the period of classicism the whole of Western literature, and particularly French literature, formed one large school in which a uniform, exemplary taste dominated, The dissidents constituted such a small number in comparison with the orthodox and they were so fragmented that they could not unite within the framework of a common opposition. Now, in the romantic period, on the other hand, when French literature becomes the battleground of two large, almost equally powerful parties and only has to follow the example of political practice to formulate party programs and the artistic aims of the new movement are so vague and contradictory that they have to be expressly formulated and summarized, the time when schools are founded has arrived.

The stylistic periods of naturalism and impressionism, which are at the same time the youth and heroic age of modern socialism, supports—unlike the romantic coteries—the formation of artists' associations in the form of colonies and settlements on a cooperative rather than an aesthetic, doctrinaire basis. The Barbizon school, which the structurally similar impressionist artists' colonies imitate, is the prototype of the new artists' associations. Its members are loosely linked, the striving after stylistic unity recedes, and there is a dominating consciousness of the moral obligations of community, a simple, unpretentious devotion to craft, and a refusal to proclaim theses and theories. These associations make up for the impression of philistinism by awakening the feeling that successful work is essentially a moral act and the expression of true solidarity. Artists' associations of this sort no longer exist; people theorize again and make proclamations, but they do not believe in common goals or in a universal profession of art.

Historical Materialism

The doctrine of historical materialism revolves around the socioeconomic conditions of existence as the fundamental, even if not exclusive, presuppositions of higher cultural and thus also of artistic structures. Its classical formulations, which stem from Marx and Engels, form the

basis of a realistic, not merely speculative, theory of art, although they are far from providing the principle of a comprehensive and definitive doctrine for the solution of all decisive aesthetic problems. Fundamentally they say little more than that art is a part of the spiritual superstructure, which in the last resort rests upon the material basis of a given movement—or, as Marx prefers to say, on the vital process, which is both productive and reproductive. It also expresses, in the form of an ideology, the more or less veiled complex of interests of the social class which controls the conditions of production with which the supporters of artistic movements are linked by origin, class, or outlook. The most important implication of the doctrine is that artistic creations and stylistic movements are not determined by subjective impulses, supertemporal values, or preconceived ideas and cannot be explained as the result of processes inherent in a sphere or form and which are accomplished by quasi-logical processes.

The scientific value of historical materialism as the explanation of ideological structures consists, when compared with other methods of research, in its realistic basis, its empirical verifiability, and the rationalistic evidence for its formation of concepts. The dangers of the theory reveal themselves on one hand in a one-sided economic determinism, to which its representatives permit themselves to be seduced, and on the other in the historical determinism to which it leads if we see in it an instrument of prognosis and try to construct future development instead of explaining the development which has already taken place. Yet neither economic monism nor historical determinism belongs to the essence of the theory. Marx and Engels got off on the wrong track because they were moved by political, propagandistic motives, in that they were in part trying to combat Hegel's idealism and in part trying to substantiate their socialistic prophecy. For essentially it is precisely their dialectic which provides the most suitable means for correcting the economic and deterministic exaggeration of historical materialism.

With his basic formula ("It is not man's consciousness which conditions his being, but the reverse: his social being which determines his consciousness") Marx seems to ascribe ideal changes simply to change in material conditions of existence. Yet when expressly called to account, neither he nor Engels clings to one-sided economic causality or to the unconditional priority of material existence. Apparently they were first and foremost concerned with the explanation that without a being, without an objective reality which transcends consciousness and is alienated from sense, no consciousness, no thought, no thought structures are possible and that the social being can have its origin in no idea which is superimposed on the historical process.

Essentially what the Marxist theory says is that being would remain a "being" even without a consciousness to perceive it and think. A consciousness on the other hand which had no reference to an existence as the substratum of perception and thought would be an absurdity. Consciousness can only be the consciousness of something—without reference to something beyond consciousness it remains a concept without content. Thought without thought content, without a reality to be absorbed by thought, alien to thought, and independent of the thought process would annul itself. We do not know what the development of our intellectual world—the construction of thought-out and perceived reality—begins with, but we must assume something beyond consciousness in order to think of consciousness itself. Only if there is also something not perceived, not thought-out, not conscious is the concept of perception, thought, and consciousness conceivable.

The maxim of the ontological precedence of the object of perception over the perceiving subject goes back to the empirical principle already enunciated by Locke, according to which nothing is contained in the consciousness which does not come from sensual perception. The correction of the thesis made by Kant consisted mainly in pointing out that a "Ding an sich" presented to the perception is nothing but a peripheral concept without content or character and that it only becomes an "object" of perception in relation to a subject and through the categories of reason. The path of classical German philosophy led from Kant's critique of perception on the one hand to Hegel's self-realization of the spirit and on the other hand to Marx's self-movement of economy. Both Hegel and Marx were, however, conscious that world and spirit, being and sense, subject and object, are dialectically inseparable, and their philosophy bears everywhere within it traces of the contradiction which exists between their spiritual, or as the case may be, materialist axiom and their dialectical method.

The fact that no "objective world," no reality which can be called such in any way, is possible without a consciousness to perceive it, does not assure the consciousness which is probably indispensable but never autonomous any pride of place in the theory of perception. The act of consciousness rather presupposes an *existing* consciousness, that is, a being with consciousness itself. The *being* subject belongs just as much to the presuppositions of the acts of consciousness as the being object. The assumption of a transcendental subject as a pure categorical apparatus is an untenable metaphysical construction just as the assumption of its counterpart the "Ding an sich" as an object to be perceived and capable of perception is. The primacy of the being, which is Marx's starting point, has merely an ontological but no epistemological significance. It rejects "naive realism" as a point of view

of perception theory just as decisively as it rejects naive idealism. Only dialectic, which does not admit the validity of either of the two factors of perception "in themselves" but only each one in a historical inter-action, does justice to his view of truth.

Historical materialism is, all in all, not a strictly materialistic theory. To correspond to such a theory the material forces of production—as the only substantial factors of being and the only independent variables of development—would have to produce everything spiritual and ideal from within themselves. Marx on the other hand clings to the dualism of the factors of being and consciousness in the historical and the social process. He may emphasize the factual priority of material being, but he is always on guard against the appearance of having renovated Hegel's false metaphysics with reversed signs and of having replaced the spiritualism of his philosophical predecessor with a one-sided ma-terialism. The most essential thing about his view of history is by no means the materialist principle, in the sense of some sort of monism, which reduces everything to obvious elements, but the realism which emanates from the objectively given being, and in which it is at first undecided what the being is like, apart from its objectivity which is beyond the subject. This realistic Weltanschauung is, as Marx expressly declared, irreconcilable with both idealism and materialism.

Phenomenologically the gap between being and consciousness, ma-terial and idea, natural forces alien to sense and sensible cultural struc-tures is unbridgeable. In a practical, historical, and social relationship, however, their split from one another is the result of a violent, unreal abstraction—in reality, we always experience them and their influence in conjunction with one another. From the phenomenological point of view of the immanence of the sphere, which divides the modes of behavior of the being according to their "sense," their metamorphosis into one another may appear as unthinkable as possible; in practice material data change into spiritual structures immediately, even if in a theoretically inexplicable manner, and spiritual creations are expe-rienced immediately as though they belong to concrete material reality. The question of primacy is undialectical, meaningless, and pointless as far as they are concerned, since it is in principle insoluble. It is an *arché* which is being sought, where there is no "first" for dialectical thought and where there cannot be one, and the most important insight consists in the fact that such a first has no scientific meaning either as a perceptible object or as a subject capable of thought and consciousness which is presented to the perception. Truth is nowhere more validly and essentially expressed than in the principle that subject and object can only be conceived and defined in conjunction with one another, namely, in the functional context by which they reciprocally determine

each other. If this agreement and disagreement were dissolved, not only would the whole historical and cultural process, but all thought, every relationship between man and the world, every connection between sense structures which can be conceived at all, and the substratum of structure which is alien to sense would cease. Marx certainly maintains that it is the being which determines consciousness and not vice versa; yet he certainly does not pretend that he can make any sort of definite statement about this being, which is alien to consciousness. As a dialectician he does not concern himself with the question of primacy any further and, insofar as it is mentioned by him, it has to be rejected as being finally one which cannot be admitted. The primacy of being is only assumed in order to prevent the rise of primacy of the consciousness in the struggle against the fetishist spirit and the timeless spiritual values of conservatism.

Once the irresolvable contrast between being and consciousness, subject and object, thought content and thought categories has been determined we have reached the limit of perception. We come up against it in all the constant, recurring problems of philosophy which can never be finally solved, in the alternative of idea or experience, nominalism or universalism, historicism or timelessness, subjective spontaneity or objective validity. The attempt to derive the one principle from the other, to change being into consciousness or consciousness into being, to achieve the object from the subject or the material world from the spirit leads either to metaphysical imaginings or at best to one of those subtle formulas which like the "cunning of reason" or the "self-movement of economic development" smuggle the unauthenticated irrational solution—which is unacceptable to the intellect—in by the back door. Both Hegel's "reason" and Marx's "economy" assert themselves, it is true, over the heads of their individual supporters; however, none appears impersonally and anonymously upon the scene and asserts itself at the same time as a supernatural power.

In spite of all the dependence of spiritual structures upon material conditions of existence, there exists between the two orders a difference in quality, the irresoluble nature of which is most strikingly, and at the same time most incontestably, formulated by Ernst Bloch: "There can be nothing in the superstructure which is not in the economic infrastructure—except the superstructure itself." In other words, all the presuppositions for the superstructure may be present in the infrastructure with the exception of that quality which makes the superstructure into the superstructure. This quality does not arise from economic conditions which are alien to the superstructure even if it could not arise without them.

The positive economic determinations of historical materialism were gradually so extensively limited, nodified, and mitigated by Marx and Engels that the material basis for the cultural process is finally only decisive "in the last resort." Engels, from whom most of the express concessions emanate, is always referring to Marx's agreement; the Soviet Russian Marxists, however, emphasize their unconditional orthodoxy in spite of the dynamic-dialectical extension of the doctrine, which they oppose with their "mechanistic" materialist interpretation. Among the objections which they make to the all too rigid division of superstructure and infrastructure, they first point to the fact that there are often common traits in the superstructure of different societies, that is, in ideologies which rest upon different economic bases, so that these apparently cannot always or exclusively be explained on the basis of economic determinants. They further admit that there may be contradictions in the superstructure which do not correspond to contradictions in the infrastructure. In this way they affirm that relative independence of sense structures which Marx and Engels had already pointed out. Finally, they observe that changes in the ideal superstructure do not generally follow immediately or by any means automatically upon corresponding changes in the economic infrastructure.[24] All these addenda to and modifications of the orthodox formulations of historical materialism, however, merely mean a loosening of and certainly not a breach between material conditions of existence and cultural structures. There is no suggestion of an abandonment of the fundamental principle of the material conception of history, at best of a correction of its one-sidedly causal interpretation.

The revision which is of the greatest consequence, to which the intransigent interpretation of the doctrine is subjected, comes from Marx and Engels themselves. It consists in the admission that the ideal superstructure is not simply a function of being, but that while it "reacts" upon the infrastructure and modifies it, it also takes part in the formation of this being. In this way the rigid one-sidedness and the mechanical causality of the theory are corrected and its principles adjusted to the idea of dialectic. All definitive presentations of the material view of history since then aim at the mediation of the all too immediately and straightforwardly conceived connection between economic conditions and ideal forms. Concepts like that of the non-mechanical "reflection" of reality, of the interaction between individual factors of the historical process, of the different "distance" and the manifold "adjustments" between the material infrastructure and the cultural superstructure are merely aids to bridging the gap which divides them from one another and to changing their crass opposition into a correspondence and interdependence. The interaction means not

only a more developed form of the reaction of ideal structures upon the material basis, but also the actual, original form in which every contact between conditions of existence and activities of the consciousness—every effect of the forces involved in the historical process—takes place. The thesis not only that it is the infrastructure which determines the superstructure, but also that this takes part in the formation of the infrastructure, is thus not to be viewed in the light that a completed superstructure affects a completed infrastructure by way of modification or extension but rather that both develop and change hand in hand. Ideal forms change while the economic form changes, and this, too, changes to some extent according to the change in spiritual structures. Thus, we can understand when the *Deutsche Ideologie* already states that the form of cooperation of . . . several individuals is "itself a productive force," apparently referring to a form of superstructure.[25]

The greater importance of the economic infrastructure is maintained in any case—as Engels explains—when unequal forces are involved in the interaction between economy and ideology,[26] or, as the newer official explanation of the thesis runs, it is a question not of "two independent stable factors" but of a context in which the superstructure, which reacts on the basis, is already a reflection of the infrastructure:[27]. In this way we arrive at a situation where we no longer know whether it began with the chicken or the egg and from which the only way out is a dialectic without beginning or end, a dialectic we have to sacrifice if we want to let materialism stand unconditionally. Marxism is unable to circumvent the contradiction between an uncompromising materialism and a consistent dialectic. Engels, particularly, remained irretrievably entangled in this contradiction. On one hand he declares that economy is in no way the only motive force in historical development and refuses to regard all its other factors as principles of passivity;[28] on the other he assumes the extreme materialist and mechanistic point of view and sees in consciousness a mere epiphenomenon and in reason nothing more than the ideology of the triumphant bourgeoisie. "Eternal reason," he writes, "is in reality nothing but . . . the idealized intellect of . . . the middle class developed further into the bourgeoisie."[29]

Already in the assumption that the superstructure merely reacts to the economic basis, the fact that the socioeconomic process cannot be explained by the causality which emanates exclusively from conditions of being must have played an important role. When we use the concept of interaction and follow the principle of linking action and reaction inseparably to one another, presumably we have to avoid the decisive motive that causality should be brought in to explain the social process.

For if in the process which has to be explained the action which is called forth reacts upon its cause in such a way that while asserting itself it changes itself, the concept of causality apparently loses its actual sense and assumes the meaning of a functional connection in which there is no longer a hierarchy of motives.

An interaction between economic practice and prevailing ideas can be established in the analysis of every concrete historical situation. Thus, for example, the principle of liberty of value *(Wertfreiheit)* which Machiavelli claims for political practice in the sense of the emancipation of thought and action from moral standards of value asserts itself in the most diverse aspects of the economy of the time. The rise of an impersonal money and trade economy, the lifting of the prohibition on interest, the giving up of the concept of a "just price," the approval of free competition, the change in industrial labor from a craft skill into mechanical manipulation with tools and machines and of every act of labor from a service into a ware are mere symptoms of the same practice—based upon freedom of values—which leads in modern capitalism to that autonomy of the economic principle which corresponds to Machiavellianism in politics. The Machiavellian doctrine with its unconditional concept of the value of achievement and of success is in part a product of the same circumstances which brought about modern capitalism. However, it doubtless contributed a great deal to the circumstances which served to consolidate the capitalist economic system. The functional connection we have to deal with in socio-historical reality does not therefore mean that one phenomenon which precedes another is the cause of the latter, but merely that the two depend reciprocally upon each other—that the one is always accompanied by the other and that every change in the one complex of phenomena corresponds to a change in the other which takes place according to an objective regularity. No process represents a development which is purely motivated from within and which develops immanently. The whole historical process consists rather in the fluctuation of indivisible variables which are completely dependent upon one another. With the change of causality into a reciprocal functionality of this sort, historical phenomena, which when explained causally always have a more or less particular character, acquire a closed structure and reveal the outlines of a totality which otherwise never appears. The scientific value of historical materialism consists in the acquisition of this total perception, in the understanding of the historical situation which is under discussion at any given time, as a strictly coherent, real unity, in the change of the juxtaposition of a single causal series into a significant coincidence and correspondence of processes.

The so-called mechanistic conception of historical materialism with its principle of one-sided causality emerges from the economic basis as the "independent variables" of development. The recognition of the reaction on the part of the superstructure and the interaction between material and ideal factors as decisive motives in the historical process changes the infrastructure into a variable which is to some extent dependent upon the superstructure. The materialistic conception of history gains in the process a form which is more adequate to the real spirit of Marxism, for the inherent dialectic of this doctrine cannot be reconciled with any *cause universelle et permanente*. It admits not only no "independent variable" but no unambiguous and permanent fact of sociohistorical development at all. The functional connection into which the one-sided and particular causal nexus changes means moreover merely the independence of one process from another. In some circumstances when this happens, nothing is known beyond the fact that in the course of the change of one phenomenon—in the present case the economic basis—another one also changes—in this case the ideal structure. It is thus, for example, not assumed that the change of the one force represents sufficient cause for the change of the other. It may be that in the process, apart from the known conditions, any number of unknown presuppositions also play a part.

When we replace the causal nexus by the functional connection and use it as an explanation of the contact between the different moments of a social process, the category of "take place with" asserts itself in place of the category of "derive from." The phenomena that are connected in an interaction do not arise out of each other; they merely presuppose each other. The interaction of effects does not involve any sort of establishment of the origin, the cause, and the course of events. Even the doctrine of historical materialism merely says that certain economic and material facts have to be present for certain ideal structures to arise. And just as "begin with" and "derive from" are two completely different processes, a presupposition in this connection, too, is by no means the same as a cause, nor is a *conditio sine qua non* the same as a "sufficient cause." Certain economic circumstances make possible certain cultural forms, but they do not guarantee or preform them. They do not let us for a moment conclude what sort of spiritual structures whose prerequisites they are part of may arise in the course of development. History is an incalculable series of largely unknown and unforeseeable premises. Even if all the components of development were to be known, which is of itself unimaginable, we could still not draw any conclusions about the result. For not only do new and unexpected historical factors always appear, but every already known factor changes its meaning and function according to the changes which

are taking place in the other factors. Every one develops in a direction which is not determined beforehand and which is imposed upon it by the others. Yet in relation to the other, every one is mere condition; none is sufficient cause.

Marx and Engels—in spite of their conviction that the economic basis is the same for all cultural structures in a period, and that all manifestations of a society are global in character because of the interaction between their factors—already admitted the relative independence of the different cultural areas and ideal structures and ascribed this relative autonomy mainly to the fact that every cultural sector has its own traditions which set the standard and that the development in each is linked to certain technical means and achievements. They were fully aware that in every area of human activity there is a continuity deriving from historical development, which by no means eliminates the socioeconomic conditions of the processes but crosses and modifies them. History moves according to this conception in a sort of system of coordinates whose axes on one hand are formed by general economic factors and on the other by specific, traditional forms which vary from sphere to sphere. In any case Engels must have had a system of this sort in mind when he developed his doctrine of the "parallelogram of forces" according to the scheme of which the bearers of different functions influence each other and the forms of thought, modes of feeling, and acts of will acquire their final direction. While men, in his opinion, follow their particular goals, they encounter resistance from the others who, like them, also have their own interests and intentions and behave accordingly. The effective historical process comes about as the result of the conflict of many different individual efforts, which form a parallelogram of forces which cross one another. Everyone wants something that is thwarted by others, and what finally emerges in the process is something that no one wanted.[30] The thesis expresses the view not only that the historical process takes place in the form of interactions and that the course of history is not determined entirely by those directly involved in it, but at the same time that cultural structures belong according to their structure to two different orders— one which can be called traditional and one which can be called revolutionary. It is unmistakable that Engels is here, just as he and Marx were in the face of similar phenomena elsewhere, under the influence of Hegel's idea of the "cunning of reason." However much the two of them must have been conscious of the mystifying formulation and the rationally unsatisfying nature of the idea, nevertheless they must have felt that its meaning lay more in the question it posed than in the answer it received. It became in any case the origin of one of the most fertile aspects of Marxist social and historical philosophy, since it led

to the insight that as soon as the thinking, feeling, and acting subject enters into certain objective relationships, it is subject to certain laws which it follows for good or ill, although its part in their formation is uncertain and remains in part unknown. What is unquestionable is that such laws exist and that their validity is relatively independent of the individual wills which submit to them.

The principle of reaction and interaction is already to some extent expressed in the Marxist concept of "reflection," a function in which the material and the medium of reproduction are equally involved and in which the categories of object formation play just as constitutive a role as the things which are to be reflected. This conception of the theory of perception differs from that of Kant mainly because there is a far greater emphasis upon the realism of the process and because the objective picture which evolves from it is a mirror image, even if not a mechanical reproduction. The difference in principle which has the most consequences between the two epistemological points of view consists, however, in the fact that in Marxism the forms with which thought approaches objective reality are not universally human, historically and socially indifferent, and invariable categories of reason as they are for Kant. They are constantly changing criteria of judgment which are conditioned by the social point of view and the class interests of the subjects.

Reflection is probably a concept which is highly suited to the designation of the Marxist Weltanschauung, for it takes into account on one hand the realism of the objective picture and on the other its possible deformation and displacement by the perspective of the spectator. However, the concept brings us no closer to our understanding of how the complex picture of the world arises from economy and ideology, infrastructure and superstructure, productive forces and means of production. The process by which ideal cultural structures emerge from material conditions of existence or how the reflected being emerges from the being to be reflected is just as impossible to construct as the metamorphosis of sensual perceptions into the Kantian "object." What is clear, however, is that in attempting such a reconstruction we can no more start out with the concept of a "mirror" than we can with the concept of consciousness or reason. For if a mirror is just as indispensable to the reflection of reality as the reality to be reflected is, it is equally true that things are conceivable without a mirror but not a mirror without things. It would simply not be a mirror if there were nothing else.

Yet the actual problem is not that of the dualism of infrastructure and superstructure in itself, not the mere fact that a particular consciousness corresponds to a being, and a particular ideology, and

particular objectives and attitudes which are conditioned by particular interests, to a particular economic situation. The actual difficulty begins with the question of how this correspondence comes about, how the natural material conditions of existence which form the basis of economy change into ideal forms of cultural structures, into social institutions, political aims, moral standards, and artistic criteria of taste—how, in one word, the *transition* from one order to another takes place. And this question of transition, of conversion from material data into spiritual structures, remains the most difficult, the simply insoluble question of orthodox historical materialism and of the one-sidedly materialist sociology of art which is derived from it.

The correspondence between economic circumstances and spiritual forms is obvious; however, the road which leads from conditions of existence to structures of consciousness is just as impossible to follow as the reverse road, which would lead from the principle of consciousness, the spirit, or the idea to material reality. Historical materialism has thus almost from the beginning renounced the immediate derivation of ideal structures from economic conditions and has represented the path from the material infrastructure to the ideal superstructure as a very, very long one, complicated, often interrupted, and ramified. In short, it has assumed, instead of a direct transition or a single leap, the existence of gradual "intermediaries." The distance between material and spirit, economy and ideology, infrastructure and superstructure seemed perhaps to grow smaller by this means, but in reality the abyss between the opposite poles remained just as deep, the transition from one extreme to the other just as erratic and dangerous as ever. The alternative between a direct leap and a gradual transition proves in this context to be inessential. The agreement between economy and ideology arises not from the metamorphosis of the one principle into the other—for a "metamorphosis" of this sort does not take place—but as a result of the fact that society realizes itself with the same intensity, immediacy, and significance in the one as in the other. They do not depend on each other, but they both depend on the fact of socialization as a common origin. The problem does not consist in the task—which is from the beginning insoluble—of creating a continuity, a smooth, uninterrupted transition, since it is only possible to move from one position to another by an abrupt, unmediated change in quality. A truly uninterrupted continuity, which is here lacking, is only to be met with in the sphere of the purely psychic. The spiritual existence is the only domain of an uninterrupted continuum, of a continuous flowing and surging, of a constant changing and becoming, of an unlimited metamorphosis and modification. Here causality signifies the rise of one form out of another—not a problem—for succes-

sion is on this plane of being always a separation as well; in the medium of inwardness everything can grow out of everything else.

In the ontological as well as the phenomenological regard—that is to say, both in what concerns the form of reality and in the sense content of phenomena the gap between being and consciousness, material and spirit, productive forces and the conditions of production cannot be bridged. Psychologically on the other hand there is no fundamental difference between the contents of consciousness no matter what their provenance. The relationship between the material and ideal factors of existence becomes a problem—which has to be solved from case to case—only in social and historical practice, where the causal nexus between the two orders, the transition from the one to the other, and their harmonization with one another are indeed possible, but are always problematical and endangered, never unambiguously determined, and scarcely ever conceivable outside a reciprocal functionality. Here the processes neither remain purely subjective and reflexive, nor become completely objective and autonomous, but they are at one and the same time subjective and objective, spontaneous and conventional, individual and social, materially based and spiritually coordinated. Here the transition from being to consciousness, the conversion of the material into the ideal, and the formation of reality by ideality form a real problem—a question which cannot be answered without further ado, even though in principle it is not unanswerable.

However, it would be foolish to assume that such leaps between the processes and such breaches in the chain of causal connections are met only in the course of the transition from the material to the ideal. Even the change of one ideal form into another, a change in style or taste, the influence of one artist on the formal language of another, often even successive phases in the development of the same artist cannot be followed more exactly, and are no less erratic than the transitions between economic circumstances and ideal structures. Every change appears, when viewed from the outside, abrupt, disjointed, and fundamentally incomprehensible. The unbroken continuity of inner mental processes, the consistency of the subject's psychic development cannot be reconstructed objectively. The objectivizations of experiences can theoretically only be analyzed and split into more or less significant components. The qualitative peculiarity of experiences itself, however, consists not in their elements, which may be the same in the most diverse cases, but rather in the different connection between their own continuity and totality, which differs from case to case and in which they appear to be involved, and which are preserved concretely only in the heterogeneous continuum of everyday practice, in the normal reality of experience, and in works of art. Everywhere else

where the gradualness and fluidity of transitions are replaced by leaps, everywhere except in direct pretheoretical practice and in art which is concerned with the immediate sensuality of forms, we are dealing with abstractions, simplification, and impoverishment, the particularity and isolation of phenomena.

However deeply, too, the gap may be in principle between productive forces and conditions of production, conditions of life and forms of life, practically speaking the border between the two cannot readily be determined. Not everything we are accustomed to look upon as material being, as a natural condition of life which is beyond consciousness, is purely "material," completely free of spiritual formation, of social organization, of planned solicitude and provision. Even the most elementary economy is to some extent ordered and regulated, and it, too, represents a stage at which the material data, the raw, more or less ready-made productive forces, are in some way channeled and used appropriately. The instinct for food and its immediate parasitic satisfaction is purely natural, completely alien to sense, and completely spontaneous. Naked greed and its satiation are at bottom only stimuli and inducements to practice an economy, but they are not yet an economy itself. For this to happen the impulse has to be made conscious, has to be mastered and satisfied prudently and carefully. Only thus will it move out of the sphere of mere nature and biology into that of history and culture. But when even the most rudimentary economy is to some extent a planned economy, and the leap from being to consciousness, from nature to culture, from impoverishment to institution takes place already in the economic area, it seems impossible to separate and isolate the components of history radically—at least as far back as we can go in the past. The distance between the completely unmastered natural condition, threatened by sheer accidents and dangers, and the form of an ordered economy no matter how undeveloped, is in any case greater than that between this primitive economy and the highest, most differentiated, and most sublimated forms of culture. However, the history of mankind remains determined by such contradictory factors and leads to such incalculable results that it retains something of the fortuitousness and erraticism of its first steps at each succeeding stage no matter how elevated.

The doctrine of "mediations" which join the economic infrastructure to the ideological superstructure and which are supposed to represent the gradual transition from material conditions of being to ideal cultural structures is a more or less arbitrary construction in order to avoid the assumption of a rationally incomprehensible "leap" between the two orders. Even in the best case it represents an only partially successful attempt to replace the sudden change which is, as such, unable to be

pursued a route that can be traversed, and to mediate the unbridgeable gap between economic conditions alien to sense and sensible cultural structures by the insertion of intermediate stages. However, the solution of the problem which then presents itself is in this way only postponed and in no way accomplished. We arrive, in spite of all the real and alleged mediations, from the material basis to the spiritual superstructure by a sudden change which can never be completely mastered theoretically, can only be carried out practically, and consists of mere leaps no matter how many intermediate stages there may be.

The thought that cultural structures stand on different spiritual levels and are therefore at different distances from their economic base goes back to an axiom of historical materialism itself. Engels states in a frequently quoted passage from his paper on Feuerbach that in the forms which he calls the higher ideologies, "the connection of ideas with their material conditions of being becomes ever more complicated, ever more obscured by the connecting links." Both of the concepts which are linked here, the different distance and the series of mediations between economic conditions and ideologies—a series of differing length—are, however, merely to be understood metaphorically. They merely say that the agreement of the two orders seems to demand different efforts from case to case and that the demands grow with the complexity and sublimity of the ideological forms. Religion, philosophy, and art should, as the most spiritualized forms of culture, have a more richly differentiated content and a less socioeconomic basis than the natural sciences—which are apparently pursuing more practical ends—and the determinations of law and state which assert themselves more unambiguously. However, despite the fact that we often come into contact with artistic structures, moral judgments, and religious ideas which cause the economic and social interests and aspirations forming their base to emerge more clearly than the political and legal ideologies which are directly created to hide them, the cases, too, in which, for example, works of art cause their economic basis to be readily recognized in no way prove that they are more independent of this basis than law, state, political practice, and daily custom. Art—as a result of its involvement in the totality of life—refers even more frequently and diversely to the socioeconomic, historically unique reality than law with its summary decrees or the state with its impersonal schemata, no matter how successfully it may conceal the existent practical interests. When Engels talks of religion, philosophy, and art as "higher" ideologies more remote from the material basis of culture,[31] this is yet another remnant of the old idealistic conception of the hierarchy of values, and we are not in this case to take expressions like "sublimated" and "mediated" literally. In the case of art especially,

it is neither historically nor psychologically true that it is always connected with the economic circumstances of its time through the mediation of "less high" forms such as law, politics, and custom. It is sufficient to recall the Paleolithic cave paintings in order to see that the path from economics to art can be an absolutely direct one.

However, there is an express difference in the relationship of the individual cultural areas to economics, even if it is not exactly in Engels's sense of levels. It is above all unmistakable that social, political, and legal institutions change more fundamentally and immediately with economic conditions than methods of research and criteria of truth in the theoretical disciplines, especially in the exact sciences. Marx himself thought that the natural sciences developed essentially independently of the economy and saw their doctrines as essentially free from ideology, namely, as formulations of truth whose validity is emancipated from social reality. We must, he writes, "always distinguish between the material revolution in the economic conditions of production, which can be verified scientifically, and the legal, political, religious, artistic, and philosophical, in short, ideological forms in which people become aware of these conflicts and where they fight them out."[32] Strangely enough, the force of increasing achievements and progress expresses itself much more decisively and resolutely in the forms of the exact sciences than in the structures for which Marx reserves the designation "ideological forms," in spite of the fact that these forms are in more immediate contact with external universal socioeconomic reality. If, however, these forms of religion, philosophy, and art which are less dominated by the principle of progress do not in the course of their historical development necessarily perfect themselves, this by no means implies that they are in some way timeless, beyond history, and independent of the historical circumstances of their birth. They are historically tied to their position without being tied to progress. While the exact sciences, apart from relatively short, "disturbing" interruptions, find themselves in a constant state of advancement, we can ascribe to human culture in general an unconditional and consistently progressive developmental tendency only from a metaphysical, politically and socially biased point of view. In the history of art we can only talk of "progress" at best in a technical sense and within periods which are stylistically limited. The aesthetic standards of value change so radically with every real change in style and taste that not only does an advance in development seem to be called into question, but the continuity of objectives acquires a completely different meaning from what it has in technological practice and scientific research.

Yet no matter what the case is with the question of "mediations," the road from the economic conditions of production to individual, ideal structures seems sometimes to be a long and tortuous one, sometimes a shorter and more direct one, and causes us to think of a sort of hierarchy of ideological forms, only it is difficult to find a principle according to which an unambiguous and firm order of precedence of the various intellectual activities, attitudes, and products could be determined in relation to their economic basis. Historical, psychological, and ideal progress bear no relationship at all to one another in this context. The different stages of ideal or psychological significance, of differentiation, complication, and depth are not expressed in correspondingly long and complicated historical processes. At most what seems to be unquestionable is that in the early periods of history the leap from economy to religion and art was shorter than in later periods. In the Paleolithic age transitional forms between provision of vital necessities, art, and magic were apparently completely lacking and the parasitical predatory economy of the hunters and gatherers must have found immediate expression in the naturalism of the period—difficult as it may be to follow this sudden leap in theory. Only in relatively progressive periods in the history of culture will a form of economy have to change into a social order which corresponds to it, into a legal system which ensures its continuation, into certain mores, conventions, and institutions, before it can express itself in forms of philosophy, science, and art.

The objections and limitations which people feel obliged to try to establish in relation to the doctrine of "mediations" do not, however, mean that we are to see the immediate reflection of socioeconomic reality in ideal structures and especially in works of art. The most simple criticism of historical materialism is still within its rights when it rejects the validity of simplifying equations like feudalism and rigor of form, mercantilism and classicism, capitalism and naturalism. Economic and artistic movements of this sort may develop side by side as parallel tendencies, but we have all the less right to assume a causal relationship between them, since they certainly do not always appear joined to each other and never with the regularity of cause and effect. The difficulty of finding a definition of the relationship is, however, only apparently removed by the assumption of intermediate stages, which are supposed to form a transition from socioeconomic conditions of existence to artistic movements. For even a mediated causality which takes place by stages is still a causality, and beyond this the alleged explanation of the transition from one order of phenomena to another as a gradual dematerialization, spiritualization, and sublimation is only a metaphor to which nothing definite corresponds in reality.

We have to accept the "leap" without dissolving it into a glide but also without believing that by this means we have created an essentially instructive relationship between simultaneous phenomena.

It is apparent that the dissolution of feudalism and the beginnings of modern money economy are linked with the genesis of late medieval and early Renaissance naturalism by a gradual development and the artistic effect and stylistic expression of the social and economic changes presuppose a series of transitional phenomena, mediating intermediary stages, and gradual appoximations. The new productive powers may at first have led from outmoded legal norms to more timely legal principles, from traditional moral rigorism to a more flexible moral view, and finally from rigid philosophical universalism to nominalist-individualist concepts. Thomas Aquinas declared in this same spirit that God enjoyed all things, since every one accorded with His being and had its own irreplaceable value. From this point on, the realistic world view and the naturalistic direction of style of the transitional period between the Middle Ages and the modern period were no longer far away. As soon as the individual thing no longer had meaning and value as a metaphor for an ultramundane being but had become remarkable simply because it really existed, it also became of itself artistically interesting. The series of intermediate links which led from the end of feudalism to the beginning of naturalism may have been longer or shorter, the succession of stages may have been displaced, even reversed, and the one or the other cultural structure may have been able to be reached from the economic basis without intermediate stages. Yet since every phase, every transitional form, every link of the chain, which was formed of more or less individual pieces, was connected with a "leap"—a change of quality which could not be followed intellectually—the reconstruction of the transition from infrastructure to superstructure often appears to be all the more difficult the more transitional stages we assume.

Nevertheless, however problematical the concept of mediations is in and of itself, economic conditions do change, even if erratically—but not without emotional and ideal attendant circumstances—into cultural structures. Gordon Childe points to such circumstances when he remarks that the rule of the pharaohs functioned so long and so smoothly and was able to penetrate the forms of Egyptian culture so completely not because their subjects were aware that the kings supported their economy, created corresponding institutions, and protected them from the enemies of the country, but because they believed unflinchingly, even if not spontaneously, in the divinity of their rulers and were loyally devoted to them. The conditions of production had to be furthered by feelings, linked to ideas and ideals in order to

produce valid norms and binding standards of behavior. Gordon Childe certainly emphasizes that no faith, no devotion, no ideology proves effective unless it is in harmony with the productive forces of the given moment and with the interests of the classes in control of them.[33]

However complex, multifarious, and complicated the way may be in which we get from the socioeconomic state of affairs to an artistic structure—however tortuous, for example, the way is which leads from the absolutism and mercantilism of the *grand siècle* to French classicism, or from seventeenth-century bourgeois capitalism to the naturalism of Dutch painting—we finally have to decide for or against the relevance of these relationships. We can certainly put off the decision and conceal the principled point of view, we can incline to the assumption of a leap or a mediation, a causality or an interaction between material and ideal factors, but sooner or later we have to declare ourselves for good or ill, expressly or mutely, to be realists or idealists, representatives or opponents of the materialist view of history.

The fact that social existence with its form of economy, class stratification, system of laws, moral conventions, etc., is able to transform itself without any difficulty into art is just as evident as the fact that the two phenomena are not the same in essence and that art is something quite different from a repetition or a simple continuation of customary reality. The problem which has to be solved, even if it can hardly ever be solved satisfactorily, consists in answering the question as to how it is that everything connected with art is invested from the outset with a sociological significance and assumes a particular place not only in the art historical process but also in the sociohistorical one. The difficulty is caused not by the sheer dualism of human existence, not by its bifurcation into being and consciousness, not by the idea that the consciousness appears to be limited and conditioned by something which is not consciousness but only by the concept of a metamorphosis of the one force into the other. The metamorphosis of an existence— which asserts itself in productive forces, modes of economy, and conditions of property—into ideal forms, a faith, a norm, a doctrine, a scientific theory, or an artistic creation remains, in spite of all limitations of immediate causality, all mediations, reactions, and reciprocal effects, an unfathomable process which cannot be analyzed rationally. If, as has been asserted, there is a remnant of mysticism in Marxism,[34] then it consists in the unexplained connection between the two fundamental facts of human existence, its ontological and conscious, material and ideal, nonsensual and sensual factors.

Whether the economic presuppositions of cultural structures are causal or functional in nature, whether they involve a one-sided

conditioning or a reciprocity between the different elements of the cultural process, makes little difference to the dependence of ideal formations on the conditions of existence to which historical materialism clings in all circumstances. More difficult and finally more decisive is the question involved with the alternative—whether socioeconomic conditions play a *constitutive* or merely a selective role in the genesis and the predominance of ideal forms. Does the form of economy at a given moment create new forms of consciousness? Does it merely modify what is already present? Does it itself produce the possibilities from which a choice can be made, or does it merely limit the number and the type of those available?

If we limit the role of economic reality in the history of ideas to a mere selection among possibilities which are already present and ready-made, and which arose according to certain principles immanent in their sphere, then essentially we deny historical materialism. Of course, it is conceded that material circumustances can hinder the assertion of certain ideal forms, but by no means that they are in a position to bring about the genesis of such forms or to determine their particular nature and the change of their structure. The theory of selection presupposes in their qualitative peculiarity different ways of thinking and feeling, the artistic aims and movements in taste of a given moment. Whether it is subjects determined by their economic and social situation or their individual talent which make the choice, the ideal forms are ready to be chosen just as they have developed according to their own immanent laws. The essence of the materialist conception of history consists, on the other hand, in the perception that such an immanent development of ideal forms which is alien to society takes place, at best, in the exact sciences—and there only to a certain extent—but that historical changes like a change in taste or style presuppose complicated driving forces, outside the sphere, which are interpersonal and sociohistorical. Of course it is true that, as Plechnow asserts, we can never arrive at a particular artistic form like the minuet if we start out from the economy and society of a period; it is, however, no less true that a compositional form like that of the minuet does not arise merely out of the formal possibilities of music or of old dance forms. It demands the coexistence and correspondence of both factors, of the one immanent in the form and the one that transcends form.

None of the material or ideal factors, whether inherent in the sphere or beyond it, represents a completely active or a completely passive component of stylistic development. Both assert themselves as dialectical moments in the developmental process, as forces which participate in the historical argument, now questioning and challenging, now agencies which respond and parry. The socioeconomic conditions of

existence do not represent a dead, objective system which is ready-made once and for all, but a connection of open possibilities of action which have been realized or are to be realized by human beings and which only make sense in human life. They represent a series of changes, an order of versatile modes of behavior, which not only form objective conditions, pose concrete tasks, and challenge us to react in a certain manner, but also—in keeping with the resistance with which they meet in human affairs—change themselves and reply to problems—which have been solved—with new ones, and to antitheses—which have been resolved—with new contradictions and complications. None of the factors involved in the historical process offers a final solution; none creates possibilities from which a choice can be made independently or chooses freely between possibilities of equal value. The "possibilities" among which a choice is made according to the theory of selection are already "chosen." The immanent possibilities of form do not fall from the sky: they, too, are the work of human beings and the product of society. The possibilities which open up are themselves determined by historical materialism.

The assumption that art historical development is limited entirely to the mere choice between forms already to hand and which have developed from within the sphere signifies nothing more than Wölfflin's well-known thesis that "not everything is possible at all times." The reduction of the formation of objects to such a selective function excludes, in the area of art as in that of culture in general, every real creative work, whether it be personally or socially conditioned. The inner regularity of the system, the quasi-logical development of the formal principles, just like the "cunning" of the history of style, which has to prevail independently of society and the individual and in some circumstances in opposition to them, becomes in this mysterious way the spontaneous motive force of development. It leaves open the decisive question in which—even if everything is not possible at all times—we have to see the origin of what is actually made possible and realized. Since the answer to all that had to be taken into account in this connection can be neither that human beings—as economic and social subjects—determine unambiguously and autocratically the forms of consciousness, nor that they choose by themselves from forms which are already to hand or which are possible, while accepting one and rejecting another, it must take the form of saying that the forms available for choice develop and differentiate themselves *pari passu* with the process of selection.

Already in his manuscript of 1844, Marx discusses the principle according to which human beings create themselves by making their own history. When he states, at the same time, that he develops his

abilities by using them and only becomes a human being by dint of his work, he anticipates a thought expressed later by Konrad Fiedler. For just as the latter declares that the hand by no means always does what was already present in the mind, so Marx says that "it is only music which rouses the human being's musical sense" and that it is "only through the objectively developed wealth of man's being . . . that a musical ear, an eye for beauty of form, in short . . . *senses* capable of human pleasures . . . are in part developed and in part created."[35] Later, in *Das Kapital*, however, when he tries to distinguish conceptually between the products of human beings and those of animal labor, he gets involved in a contradiction with his earlier views about human gifts and their activity. "What distinguishes the worst builder," he writes, "from the best bee is that he built the cell in his head before he built it in wax. At the end of the work process there emerges a result which was already in the mind of the worker at the beginning, that is, it was already ideally there."[36] There are apparently manifold differences between human and animal work, but it is impossible to assume that a product of labor, particularly a work of art, is ready-made ideally in a person's head from the outset, thus anticipating the whole craft process with its gradual inspirations. A spontaneous stimulus, which differs from an animal impulse, is doubtless always at play in the creative process; but this spontaneity never leads to the work of art on its own. The work of art is generated only as a result of a step by step accommodation between impulse, vision, and intention on one hand and material, tools, and technique on the other.

Marx remains fully aware, in spite of occasional contradictions, of the dialectical nature of development and emphasizes it particularly in the passage which contains the fundamental of his philosophy of history. "Men make their history, but they do not make it out of their own free will, not in circumstances of their choosing, but in ones which they find immediately to hand, which are given and handed down."[37] The bearers of history are not passive marionettes but exert a decisive influence on the course of things: they are, as Marx himself says, "pressured" but not forced to act in a certain manner. However, no matter how large their part in the formation of events may be, the "circumstances" in which they make their history form the inescapable element in which they move, namely, the medium whose motive force and resistance belong to the constituents of their products. The thought that the spontaneity with which people make their history and their cultural structures is only valid under objectively given, ready-made circumstances in the framework of spatial, temporal, and socially determined limits that these limits are, however, flexible and in the course of development contrast and expand—forms the quintessence of the

materialistic view of history and of the sociology of art and culture which corresponds to it. There is no theory of history to which this view is more sharply opposed than Wölfflin's with its principle of development which is immanent within its sphere and corresponds to the inner logic of specific forms. No matter how far we may go in agreeing with historical materialism in this sense, and however convinced we may be that the logic of the development of form is not of itself capable of explaining any change in style or taste, we will still have to admit that the history of art not only represents the history of social tasks and orders or of individual attempts at and possibilities of expression and does not consist only in the construction of relationships between artists and patrons, supply and demand, workshop and art market, but is at the same time "history of form" and—side by side with individual spontaneity and social convention—corresponds to a regularity of formal development. This regularity, while admitting one formal solution and rejecting another, permits a third factor in the historical process to emerge. True, not everything that is formally possible is realized: but what is realized must have become formally possible. In other words, if the forms which are present never produce the wider ones of their own accord, they prevent an unlimited number of formal possibilities from ever being realized.

There is no socioeconomic situation or individual attempt at expression which would establish itself in art outside the limits of certain genres and stylistic movements. We cannot think of the modern naturalist novel, it is true, without the advancing and, finally, successful bourgeoisie; of romantic literature without postrevolutionary social conditions; of the rationalism of the Renaissance without a foundering feudalism and universalism, the beginnings of the industrial division of labor, and economic competition. These socioeconomic facts did not delineate themselves on a blank sheet of paper while becoming valid in art. They asserted themselves in the face of living traditions, existing movements of taste, normal technical processes—in a word, within the limits of dominating formal conditions. "The tradition of all dead generations lies like a nightmare on the mind of the living," wrote Marx in the *18th Brumaire*. As a dialectician he knew exactly not only that tradition, however unpleasant its effects may be from time to time, represents just as important a factor of development as the will to innovation, but also that an innovation, indeed a historical movement in general, only ever takes place where there is a tradition, that development and progress only acquire meaning and significance in connection with a continuity of traditions.

Both Marx and Engels emphasized that the history of a society and a culture is a global process in which all the moments of development

are linked in a correlation with one another. Yet they were also aware of the fact that within the total process every cultural area, every order of values, every system of forms preserves its own legitimacy more or less autonomously. And they took into account not only the particular dynamic and the reactionary force of the "formally instituted" forms of the superstructure, but also their nature, which strives for "possible independence" and "self-motivation."[38] They repeatedly pointed to the tendency toward persistence and stiffening in cultural structures, particularly the forms of science and art, and eliminated the fact of their emancipation from both their psychological and their sociological origin. Engels thought that he could establish this tendency for all ideological forms and ascribed it mainly to the conservative force of tradition, which makes itself altogether independent of its origin in the class struggle and the economic basis, although it can again be changed by alterations in class relationships.[39] Even Marx paid the greatest attention to the question of the freeing of values from their ideological origin, but he still owed us a satisfactory explanation of this strange phenomenon, which is so puzzling to historical materialism. The passage in the *Critique of Political Economy* in which he appeals to the superhistorical validity of the Homeric epics has often been quoted: "The difficulty does not lie in understanding that Greek art and epic were tied to particular social forms of development. The difficulty is that they still give us an artistic pleasure and in a certain way act as a norm and a paragon which is unattainable."[40]

The Marxist posing of the problem with its opposition of historicity and timelessness is significant and fruitful; the alleged solution with its indication of the imperishable charm of "the childhood of man" is, however, more naive than the object of discussion.

The insoluble dependence of the formation of social forms of organization—like the feudal households, the medieval guilds, and the mercantile state economies or the Roman manorial and middle-class jurisdiction—on the historical circumstances of their genesis, is just as evident as it is, on the other hand, unmistakable that the validity of the doctrines of the exact sciences remains by comparison independent of the change of history. Works of art stand midway between both sorts of phenomena. They do not absolutely lose their value and their validity as the time which produced them passes, but they cannot be actualized, newly discovered, and sufficiently appreciated by each and every period. Their repeated actualization may be brought about by the development of socioeconomic, artistic, and politico-cultural data, which are structurally like those that were in force at the time of their genesis. But they may also be produced by the continuation of the tradition of certain technical and artistic methods or the renewal

of aesthetic standards of value on the basis of historical research and education. Georg Lukács already pointed out that works of art, even if they do not perish once and for all with the conditions of existence of the time of their genesis, cannot be actualized whenever we like.[41] In this case, what is decisive is the fact into which he does not go, namely, that the recognition by posterity of works of art of the past depends just as much upon certain historically particular presuppositions as does their genesis. It is always the case that they are only rediscovered and received by a present which is struggling with ideological, social, and artistic problems similar to those with which their originators were engaged.

If, as the official representatives of Marxism have recently done, we try to distinguish rigidly between "historical" and "dialectical" materialism, we are only justified if in this way—in comparison with the simplification of economic monism—we do more justice to the interaction of infrastructure and superstructure. The terminological distinction, however, loses its relevance when we, as in the present investigation, start out from the principle that there is actually only "historical" dialectic and that the historical process is essentially "dialectical." Historical materialism by no means confines itself to ascertaining whether the institutions, forms of thought, and standards of value of a society reflect the structure of its economy but extends to the establishment of the dynamic nature of social essence which is determined by the dialectic of its inner conflicts. The form of economy at a given moment, which is expressed most clearly in the special relationships of property and class stratifications, leads to tensions and conflicts and to attempts to fight them out and reconcile them. The social classes see themselves involved in a constant battle over the ownership of the means of production, since the frightful inequality of their distribution belongs to the essence of every class society. The most favored strata attempt to preserve their privileged situation, while the disadvantaged try first of all to attack, with the ideological means at their disposal, the order upon which the permanence of the conditions of property ownership rest. The struggle for the means of production and the influence which their possession ensures is the fundamental fact of historical life, while the ideologies—as the most important means of the struggle between the antagonistic classes—form the actual object around which historical materialism revolves.

It is possible to recognize the materialist view of history and the doctrine of the class struggle as a permanent characteristic of history even without any political bias and partiality. Scientific Marxism exists even without political Marxism. The philosophy of history which connects cultural structures with an economic basis corresponding to them

and recognizes in both the function of the same motive forces does not presuppose any particular party-political point of view. We can assume a materialist reason for ideal behavior even if we regret its material motives and lament the materialistic criteria of the prevailing values. Even the most narrow-minded political conservatism is in principle reconcilable with historical materialism and the ideological interpretation of the values in force at a given time. We encounter this combination so seldom only because idealism, with its timeless standards and universal human norms, suits the interests of the strata who are concerned with the uninterrupted continuation of their privileges, right from the beginning, better than the doctrine which emanates from the historically changeable nature of the conditions of ownership, laws, and values. The effectively decisive significance, even if not the moral justification, of the class struggle may dawn upon an idealist— if he is capable of thinking in historical categories—just as easily as upon a materialist. It is absolutely unnecessary to believe in the rise of the "classless society" in order to interpret "the history of all society up to the present" as "the history of class struggles." Without this belief Marxism merely loses its messianic character but nothing of its scientific value.

In this connection it would be necessary—with reference to art—to mention another important aspect of historical materialism. Just as the economic limitation of ideal modes of behavior cannot be completely explained by the immediate interests of their representatives, so, too, the historico-materialistic doctrine of art does not just mean that the precondition for a fruitful artistic development is to be seen in well-being and surplus. Art would simply have to be a product of leisure and a means of passing the time, mere embellishment of life, ornamentation, and decoration in order for this to be a presupposition. Its production would then really require above all a surplus of time and the means of subsistence. Since, however, it serves not merely as a pastime and a sensual pleasure but also as a weapon in the struggle for life, and the reception which suits its essence often poses an exacting problem which we solve with all the more success the deeper we are involved in the problems and pressures of existence, the most desperate times of crisis can be just as artistically fruitful as the periods of history which are economically the most flourishing. The materialistic presuppositions for artistic production and reception consist not in the possession of economic goods, but in the way in which they are acquired and the influence of the principles which prevail in their preservation and security. Marx was completely aware that the periods when art flourishes, as he emphasizes especially with regard to the Greeks, are not always the most comfortable phases of economic his-

tory.[42] It is only that the examples of the divergence of successful periods in different spheres of human activity are more numerous than he perhaps thought. Venetian painting reached the zenith of its development only after the center of gravity of world trade had moved to the seafaring nations of England and Holland—thanks to the discovery of new sea routes and as a result of the interruption of trade between Italy and the Orient. The high point of Spanish painting also comes at a time when the zenith of the nation's political influence and economic superiority had passed. The most important works of French naturalism and impressionism come about, it is true, at the height of the prosperity of the Second Empire, but they do not owe anything to it—indeed, they express a protest against the system and the ideology of *enrichissez-vous*. The most fruitful epochs especially of literature seldom coincide with periods of well-being and of official prosperity.

A similar discrepancy to that between economic and artistic heydays often exists between social and aesthetic values in general. Historical materialism signifies that it is by no means a particular aesthetic level of quality that is linked to a particular form of economy, but a way of feeling, a movement in taste, and a conception of form that corresponds to it. The social value involves no artistic value of an equal level: the occasional discrepancy between them is just as characteristic for the sociology of art as their frequent correspondence. The thesis of orthodox Marxism that the connection between the social conditions of existence and artistic products asserts itself not merely in a uniform ideology but also in the uniformity of qualitative standards of value and in the agreement of what is socially useful with what is artistically valuable, belongs to the myths of the creed. Essentially the norms of aesthetics and the principles of socialism agree with one another no more than do the presuppositions of scientific and political Marxism. In spite of the alleged unity of theory and practice, we can agree with the doctrine without binding ourselves politically in the orthodox sense.

If all art, as we are taught by historical materialism, is specially conditioned, nevertheless, not everything in art can be socially defined—least of all the criteria of aesthetic quality and of complete success. Artistic value has no sociological equivalent and cannot simply be translated into a category of social attitude. The same social circumstances can serve to produce highly valuable and completely inconsequential products; that is, they can produce works which have nothing but a common social and political background, which is to the art critic more or less a matter of indifference. The ideological components can be the same even if the artistic *niveau* is as different as can be, just as the artistic value can be equally high or equally low

when seen from the most contradictory ideological, political, and moral viewpoints. Sociology is able at best to relate the individual elements—partly formal, partly related to subject matter—of a work of art to their ideological origin, the social position of its creator and its public. Artistic value, however, depends not on the nature and origin of these elements but on their relationship to one another, their inner connection, their place and function in the totality of the works, on criteria which are not reducible to social circumstances.

The doctrine of historical materialism is a genetic theory: it contains statements about the origin of sociocultural structures but says just as little about their qualitative value as does psychology about the immanent value of intellectual products. The objective aesthetic value of a work of art depends no more on its function as political propaganda and social message than on the genuineness and the immediate experience of the emotions and passions its creator depicts. And while the materialistic philosophy of history attempts to ascertain not only the social origin of works but also the standards according to which they are judged at different times, it is just as unsuccessful in establishing fundamental and definitive connections between the value and relevance of judgments on one hand and the advantages and disadvantages of the society of the moment, or the political services and the wrongs of its art critics on the other. The assumption that a social order of which we should approve (for example, the democratic distribution of political rights, the chances of success for everyone in the acquisition of material goods and in the development and exercise of abilities) guarantees the genesis of true art—in other words, that a good society guarantees good art and that significant artistic products are based upon undoubted social values, progressive political principles, and deep human feelings of solidarity—is illusory and untenable. This view is just as illusory and untenable, indeed, as the view that a corrupt society, despotic forms of government, and exploitative conditions of production cannot be reconciled with the creation of art of high value. The most superficial examination of art historical development shows that we cannot infer in any way from values in one area that there are similar ones in the other. They may influence, enhance, or prejudice one another, but the presence of the one sort does not condition the existence of the other. An inadequate piece of bungling does not become better because the social and political attitude of its maker is praiseworthy, although the artistic effect of an otherwise authentic work can suffer irreparable damage because of the triviality or meanness of his attitude. In no way are the works of a conservatively thinking artist inferior per se or those of a progressively minded one of more value per se than those of a less progressive thinker. The

independence of aesthetic value from political and social attitudes does not mean that artistic quality is independent of social links and is neutral with regard to political aims or even that artistic values and human interests have nothing to do with each other; it means merely that this quality cannot be formulated in the sense of political progressiveness and social benevolence. The fact that socialism is humanly preferable to a reactionary obscurantism does not per se make a socialist into a better artist unless his political credo is precisely his link with concrete reality.

The Marxist doctrine of common social origin, the same social standard, and the same criterion of value for all cultural values is not free of all myth and mysticism. The view that social fairness and artistic success somehow correspond to one another—in other words, that we can draw apodictic conclusions from the social conditions under which works of art come into being—not only as to their nature but also as to their value is a survival and echo of the idea of the unity of the good and the beautiful, the ancient $\kappa\alpha\lambda o\kappa\dot\alpha\gamma\alpha\theta\dot\iota\alpha$. The alliance between political progress and true art, liberal attitude and artistic judgment, general human interests and universally valid rules of art, of which mid-nineteenth-century democracy had some vague notion, was pure illusion and mere utopianism. Even that identification of truth in art with truth and justice in politics, that identification of realism with socialism which Courbet and his disciples defended and which belonged from the beginning to the axioms of Marxist theory, is questionable.

Social and artistic values do not correspond to each other, do not presuppose one another, and cannot be derived from one another; they are simply incommensurable. Yet there must exist, as George Orwell said, "some connection" between them.[43] The unavoidable paradox of art consists in part in the fact that this "connection" of values is just as conclusive for aesthetics as is their incommensurability. In no way have social utility and artistic significance no more to do with one another than, for example, the nutritiousness and the taste of a dish, nor can they be so simply distinguished as sensual pleasure and abstinence. Ruskin and William Morris, who started out from the principle that good art could only be produced by a "healthy" society, entertained—besides the right idea that the feeling of social responsibility creates an artistically favorable climate—a whole series of romantic misunderstandings. These misunderstandings sprang from their inability to do justice to the degree to which the problem to be solved was differentiated at the given stage of development. Above all, they failed to recognize that the so-called health of society is an uncommonly complex concept and that in the machine age it is subject to

different assumptions from what it was in the period of medieval craft, which they regarded as exemplary.

The utopian character of the doctrine of the agreement between social and artistic values expresses itself most strikingly in the desire for injustice and oppression to be punished with intellectual barrenness, an expectation which was never fulfilled at all in the days of these social reformers. The politically and socially unsatisfying years of the Victorian period and the Second Empire produced superior and inferior products, and the valuable ones only came in small part from artists who had socialist ideas. They were, too, only in the rarest cases designed for the broad strata of society who, moreover, would have been least able to appreciate them. And the further we go back in history, the harder it is to relate the cultural values of the various spheres to one another. We cannot appeal to the great art of the Ancient East or of early antiquity in this connection, if only because human rights, concepts of freedom, and ideas of progress still meant something completely different from what they did later, particularly after the Enlightenment. Yet even in a past which is as comparatively recent as the time immediately after the French Revolution, the borderline between what was still politically tolerable and what already seemed intolerable has been moved so far that even the progressiveness of, say, a Goethe can scarcely be judged properly any longer.

It is making things altogether too easy if we appeal to the works of art of the Ancient Eastern despotisms, the classical aristocracies, the intolerant churches, the absolute monarchies to prove that there is a discrepancy between social and aesthetic values and to judge them according to today's concepts of law and fairness. Concepts of this sort are constantly in a state of change, and if we make them into the criteria of artistic value, the artistic value itself becomes relative. In the age of slavery, of bondage, of the ancien régime, of postrevolutionary capitalism, and of modern socialism not only different standards of what is socially acceptable and spiritually tolerable but different concepts of what is humane itself apply. Thus, forms like the Homeric epics, the chivalric novel, the *tragédie classique,* and the modern naturalist novel must, from this point of view, be judged differently from the outset. The political views which are hard to forgive in T. S. Eliot or Ezra Pound and for which we still feel obliged to forgive Balzac do not have to be specially justified in the work of Racine and Corneille. Racine's loyalty to the Church, the crown, and the nobility may still have been in harmony with the deepest humanism; Balzac's legitimism already demanded Engels's "triumph of realism" as an explanation; today's reactionaryism, whatever fruits it may produce, would have to find a much more sophisticated excuse in order to be

acceptable. We make the solution of the problem of the incongruence of values easier for ourselves if we expect from an artist of the past only that he respond adequately to the decisive social questions, the conventions, of his own day. Yet many of the greatest poets and artists do not even fulfill this expectation, so that we can assert that Euripides was the only representative of the whole of classical literature who was progressively minded.

The great revolutionary periods of history do not even fulfill the expectation that, in accordance with their love of progress and their ability to change, they contribute immediately to the production of works of art which condition a change in style and taste. Neither the French Revolution nor the disorders, insurrections, and religious wars connected with the Reformation, neither the class struggles of the fourteenth century in Italy, nor of revolutionary seventeenth-century England nor of prerevolutionary eighteenth-century France proved to be very fruitful artistically. The yield of the Russian revolution in the field of art, as far as we can judge the results, seems to be relatively small. In spite of this, it would be shortsighted to conclude that the epochs which have been most fruitful for artistic creation are those of peace, order, and stability, when artists, undisturbed by social disorders and political agitation, could devote themselves to their harmless fancy. It would above all be narrow-minded to measure the artistic fertility of a socially tense and politically revolutionary time by the amount of what was effectively completed. Its return for art consists almost never so much in what it brings to fruition as in what it promises and prepares. The class struggles of the fourteenth century only had an effect in the naturalism of the quattrocento, the spirit of the struggles of the Reformation bore fruit only in mannerism and the baroque, the English revolution only received adequate artistic expression in the Enlightenment of the following century, and romanticism, the most profound artistic upheaval the modern West has undergone, would be unthinkable without the French Revolution, although it developed only after the conclusion, even the partial failure, of its political prelude.

The Role of the Artist in the Life of Society
Propaganda and Ideology

Just as man becomes what he is while fulfilling social tasks, so the artist only becomes an artist when he enters into interpersonal relationships. It happens only exceptionally, in special, rare combinations of circumstances, that the urge toward artistic creation asserts itself

and leads to the genesis of works of art without the presence of corresponding social needs and demands. Thus, the history of artistic activity can be represented, by and large, as the history of tasks which fall to the artist. It is often more difficult to explain it as a series of products for which a use is sought than as a series of obligations which have to be met.

Every art sets itself the goal of acting evocatively and awakening in the spectator, the listener, or the reader emotions and stimulations to action or opposition. The evocation of will, however, demands more than the mere expression of feeling, fascinating mimesis, and alluring word, sound, or line structures. It assumes forces which are beyond feeling and form, which assert themselves simultaneously and in agreement with the emotional, mimetic, and formal artistic media but which are fundamentally different from them. The artist develops them in the service of a ruler, despot, or monarch, a community, a rank, or a propertied class, a state or a church, a federation or a party, as the representative or the spokesman of a system of government, an order of conventions and norms—in short, of a more or less strictly governed and extensive organization.

He can meet the tasks which fall to him in such a manner in two ways. He may assert ideas, values, and standards which he stands for either in the form of explicit utterances—as an open confession, a manifest program, a plainly declared tendency—or in the form of mere implications—as mute, veiled, in some cases unconscious ideological presuppositions of an activity which seems from a practical point of view to be indifferent. His works may bear the character of blatant propaganda or of a veiled, hidden, dislocated ideology. The border line between the two forms of propaganda may in practice be fluid; in principle it is unmistakable. The purpose and sense of an outspoken confession or of a message which is ordered, or communicated as if ordered, are always known to the speaker and the transmitter, and the appeal is either consciously accepted or rejected by the addressee. The impulse which is exercised by a work of art may, however, also remain unconscious and, indeed, not only may be expressed in an unconscious manner but also may have an unconscious effect; that is, it influences the ideas, the feelings, and the actions of the recipient without his taking it into account. In any case it is a significant fact that the social and political effect of a work is that much stronger the less obviously the intention is expressed and the less it seeks agreement. Naked, crude, direct tendentiousness alienates, arouses suspicion, and provokes a defense, whereas latent, hidden ideology, the opiate which is sneaked in and the hidden poison, act unexpectedly and do not put us on our guard.

Art is concerned with propaganda, thesis, and tendentiousness when the author expresses his political attitude in such a way that it remains distinguishable and separable from the aesthetic elements of the work in the narrower sense. In the case of ideological content, on the other hand, the ideological and political motifs are inseparably bound up with the other components of the work. That mundane will which is called ideology is inserted completely into the aesthetic structure and entirely dissolved in the totality of the artistic structure. The works of Virgil, Dante, Rousseau, Voltaire, and Dickens, and Dostoevski, Goya, David, and Daumier generally belong in the first, those of Shakespeare, Cervantes, Goethe, and Balzac, and Flaubert, Courbet, Millet, and van Gogh in the second category. The expression of a class situation, a class consciousness which is ideologically attached to a work, and of the interests, ideas, judgments, and efforts which correspond more or less to a social station at a given moment may be more or less successful, may be embodied more or less "organically" in the work, but it is, wherever possible, concealed and sublimated. An agitatory tendency on the other hand seems to be an external addition to the presentation and remains an unintegrated foreign body in the work. However, the point of view of the artist is equally biased in the one and in the other case and looks out for interests, irrespective of whether these are expressed in the form of a tendency or of an ideology: the difference is only in the tactics—the direct or indirect form of attack—not in the aesthetic rank or the artistic admissibility and suitability of the means. Designations like "organic" and "external addition" sound like general aesthetic judgments; in reality their validity is restricted to the realm of classical art. The creations of many of the great masters, like the works of Shakespeare, *Don Quixote*, the most perfect naturalist novels, and the most successful works of the mannerist painters, no matter what sort of stimulation they may use, neither grow organically nor are so uniformly composed that nothing could be added to them and nothing taken away. No tendency can be more direct, more heavily imposed, and more external than that which is expressed in Dante's angry political outbursts, yet it does not damage his poetry in the least. For whether a tendency is tolerable depends not on its force and severity but on the capacity, the artistic force, and the elasticity of the work, which if it is authentic permits the most outrageous excesses.

Diderot, Dumas fils, and Shaw write plays with an undisguised message; the tendency which they represent is not only to be found "between the lines"—as it is, for example, in Sophocles, Shakespeare, or Racine—is not wrapped in some unobtrusive ideology, but also only convinces those who approach the works with almost complete

conviction. The ideological, indirect, veiled mode of expression is not only technically the more difficult, but also practically the more successful and stylistically the more relevant, for the agitatory and especially the style-forming influence of an opinionated intention is the greater the more mediate, the less insistent, and the more roundabout it appears. The direct, artless expression of a thesis is linked immediately with the most different artistic forms, since it is simply explained directly; the merely latent ideology has to be brought into a form which corresponds to it, transferred into a style which points indirectly to it in order for it to have an artistic effect.

A ruling and social order which is not endangered fills its demand for artistic means of influencing public opinion with forms of propaganda, panegyrics, publicity, and the display of pomp and circumstance. It is only a form of government and society which has to defend and justify itself which has to deceive and blind, and uses cunning ideologies rather than open propaganda to manipulate its underlings. Propaganda announces, determines, presents; ideologies argue, prove, dicker for recognition, while propaganda simply refuses to go into the questionability of the values and merits which have been proclaimed. The despotisms of Oriental antiquity do not develop ideologies which thirst for conquest; their art simply glorifies the king—it is panegyric not apologetic. It is only the feudalism of the heroic age of Greece and of the Aegean princedoms which brings into play a moral doctrine for the glorification of the desire for battle and booty—a doctrine which serves as a veil—and creates a literature which is ideologically disguised in the praise of the battle lords, instead of—like the Babylonians and the Egyptians—being satisfied with mere homage and flattery.

The question of the admissibility of tendentiousness in art has caused problems for sociology and aesthetics from time immemorial. Not even the point of view taken by Marx and Engels was completely unambiguous and logical. If it was a question of inferior products, they talked slightingly about any form of tendentiousness, but in the case of authors like Goethe and Balzac who were their particular favorites they found excuses to justify and excuse even tendentiousness which was directed toward the Right. "I am in no way," declared Engels, "an opponent of tendentious poetry as such. The father of tragedy, Aeschylus, and the father of comedy, Aristophanes, were both strongly tendentious poets, no less than Dante and Cervantes, and the best thing about Schiller's *Kabale und Liebe* is that it is the first German political and tendentious drama. . . . But," he hastened to add, "I believe that the tendentiousness has to emerge from the situation and the action themselves without its being expressly pointed out."[44]

Although the tendency being talked of here can be immediately accepted in the one case and rejected in the other, Engels neglects to observe that tendentious art of itself needs no justification, of the sort which he believed he had found in the unity of the structure of the work. It was indeed Marxism which saw through the unavoidable bias of art and led to the recognition of the fact that even its apparent indifference and passivity express a point of view with regard to reality—namely, the artist's tacit understanding of existing conditions. The bias of art comes from its completely social nature. It is always talking for someone to someone, and reflects reality seen from a social station and in order that it can be seen from such a social station. The artistic inadequacy of the works Engels rejects because of their unassimilated tendentiousness consists not in the heterogeneity of social doctrine and aesthetic reflection but in the imperfection of the reflection itself. It is not only the political view to which the artist confesses in the abstract that is aesthetically indifferent in terms of the doctrine of the "triumph of realism" but also whether this view "emerges (as a tendency) from the situation and the action themselves" or is imposed upon them. The artistic quality depends entirely upon whether the reflection of reality is strong, broad, and flexible enough to bear a weight of this sort.

The legitimacy of tendentiousness in art is based not only on the constant involvement of artistic creativity in practice; it rests upon the fact that art never wants just to represent but always wants to persuade at the same time. It is never entirely expression, but always address as well. Rhetoric is one of its essential elements. The most simple and objective enunciation of art is already evocation, provocation, subjugation, and often violence. The mere naming of an object, which moves the listener to listen, look, and think, is magic, the magic of words and of drawing, the conjuring up of the thing and the bewitching of the person. In this way there was always only an activist art and from the end of the prehistoric period to *l'art pour l'art* one which was only conditioned panegyrically, apologetically, and ideologically. Tendentiousness as a thesis to be defended appears much earlier in literature than we usually assume. For it is by no means the bourgeois drama of the eighteenth and nineteenth centuries which produced the play with a message. It was not Lillo, Diderot, Beaumarchais, and Mercier who were the first to use the stage as a lay preacher's pulpit and as a political tribune; not only Augier, Sardou, and Dumas write their plays in the style and spirit of the publicists of their day. The *tragédie classique,* too, the works of Corneille and Racine, were publicity media in the service of the politics of the day, vehicles for the glorification and the enhancement of the idea of the absolute monarchy.

Indeed, noble Greek tragedy already revolved around contemporary political and social questions and treated them from the point of view of the authorities of the day. The Athenian festival theater belonged to the most important propaganda media of the polis. It would be almost unthinkable that they would have surrendered it, in the prevailing circumstances, to the mood or the mercy of the poets. The tragedians were pensioners of the state; the polis rewarded them for the plays which were produced and which corresponded to their policies and to the interests of the strata which supported the state. The tragedies, as "plays with a message," took a stand directly or indirectly on the most burning problem of their time, the conflict between oligarchy and democracy. Nothing was further from the view of art at that time than the ideal of a theater which was free from every connection with practical life and contemporary politics. Not even Bertolt Brecht's or Erwin Piscator's theater is "political theater" in a stricter sense than the Greek dramatists' theater was. However, even if the bourgeois drama of the eighteenth century cannot be counted as the first example of the treatment of social conflicts on the stage, nevertheless in this theater such conflicts did form for the first time the actual object of a dramatic exposition and the class struggle was here for the first time the central point in the stage action. In Greek tragedy the struggle between the nobility and the forerunners of democracy, in Elizabethan drama that between the feudal barons and the new middle class, is never mentioned by name; now on the other hand it is expressly stated that the honest burgher can never come to terms with a society of an outdated world governed by parasites.

It is one of the paradoxes of dramatic form that as a result of its pointedly dialectical nature it provokes polemics; its objectivity completely prevents the author from appearing personally and taking the part of one or the other of his characters. In the epic or the lyric the poet not only may talk in the first person, but also can involve himself in the process of events as commentator, critic, or umpire. This is not immediately possible on the stage, and if it does happen—as in the bourgeois drama—by the introduction of the *raisonneur* or the "sage," whose presence, as Maeterlinck declares, "prevents tragedy," his involvement in the mechanism of the drama changes the whole structure of the genre. There are few examples in the history of art which are more suited to demonstrate that changes in ideological elements—as the new social interests and political aims of the beginning bourgeois period were—are capable of introducing the most far-reaching formal changes. It is sufficient to recall the change in the peripeteia, which had counted from time immemorial as the essential element of tragic drama. The reversal of fate had always had an all the more shocking

effect the higher the station from which the hero fell. He had to be a prince, a general, or a similarly highly placed person for his fall to have a tragic effect. The mere fact that the new drama chose ordinary bourgeois people for its protagonists and made them the representatives of high moral ideas marks a revolutionary change in both form and motif. Not only does it condition a new conception of peripeteia, but it leads to a rejection of it and pushes toward a reconciliation rather than to a tragic end. Lessing's *Nathan* marks the beginning of a new dramatic form which has been called the fundamentally nontragic "play of the wise man" and which marks the close of the history of tragedy in the old sense. We begin to be conscious of the fact that the hero's high rank lessens the interest of the public in his fate—in contrast to the earlier view, which was dependent on the aristocracy—and that true sympathy develops only among people of the same social rank.[45] The genesis of the bourgeois drama marks, simultaneously, the hour of birth of modern naturalism and liberalism in literature. While Diderot emphasized the class nature of the *tragédie classique*, which Lessing had also mentioned, and recognized in the unnaturalness of its tirades and the mendacity of its moral doctrine one and the same principle, he discovered the value of artistic truth as a weapon in the social struggle and reached the conviction that the true depiction of facts leads of itself to the dissolution of social prejudice, that consequently artistic truth and social justice essentially agree.

Ideology is sophisticated, sublimated, but at the same time unadmitted, dishonest propaganda. The classes and groups which dispose of power and property must, if they cannot make a direct claim to their privileges, disguise, adorn, and idealize their interests, and aims, norms, and principles. Art also preserves its propagandistic character as an ideology, for although it ceases to be direct propaganda, express glorification of the rulers and patrons, it does remain a sort of legitimation of their rights to "conspicuous waste" and "conspicuous leisure," which belong to the artists's conditions of existence and to the possession and enjoyment of works of art[46]—the enjoyment of products, that is, which are destined for a privileged part of society, an elite which also has the means to acquire and enjoy these works. Often a special and decisive premium is set upon the use of means for this end. Art furthers the interests of the stratum which, so to speak, enjoys a monopoly on it, simply by the reflection of its ideology and the tacit recognition of its social standards of value and criteria of taste. The artist whose existence and progress depends upon the charity and benevolence of this stratum and is delivered up to it with all his hopes and prospects becomes unwillingly and unwittingly its mouthpiece in

the pursuit of its goals and the support of the system which ensures its dominance.

The value of art as a means of propaganda was early recognized, and considerable use was made of it as such from the beginning. It was, however, a long time before people became conscious of the latent propagandistic power, the ideological meaning and effect of artistic creations, and began to take into account the fact that for good or ill they pursued practical goals. The perception that they often betray more than they state was one of the most decisive steps in the history of critical thought. The mechanism of ideology was mainly connected with the insight into relativity, the difference and the mutability of ideal standards of value, and was already recognized by the philosophers of the French, even the Greek, Enlightenment. Since then, doubts about the objectivity and ideality of human judgments have been expressed more and more and ever more audibly. Machiavelli's principle of a "double morality";[47] Montaigne's distinction between truths "on this and on that side of the mountain"; the psychology of hypocrisy, self-deception, and vanity in the works of the French moralists La Bruyère, La Rochefoucauld, and Chamfort; the discovery of "rationalization" of motives, of attitudes, and of actions which psychoanalysis first mentioned by name but which was known long before are mere precursors of the doctrine and critique of ideology. Marx was in any case the first to give voice to the epoch-making thought that intellectual judgments, their formulation, and their proclamation are political weapons in the class struggle. He first maintained that every conscious structure, every reflection of reality and every idea and concept which we construct about it, has its origin in an aspect of reality which is conditioned by interests, is perspectively one-sided and distorted, and that as long as society remains divided into classes, as long as different privileged groups can assert their interests and aspirations against one another, only such a one-sided, twisted, insane, and misleading view of reality is possible.

The analogy between the Marxist concept of ideology which is linked to the idea of "false consciousness" and the distortion of truth and "rationalization" in the psychoanalytical sense was often stressed. In both cases it is a matter of giving an appearance that is unexceptionable from the point of view of social conventions to certain attitudes that are offensive and unacceptable for moral and social reasons. Both concepts also have this in common: the psychological subject involved in the process remains unconscious of the substitution of the actual motives for ideologically counterfeit or psychoanalytically rationalized attitudes by merely alleged or ostensible ones. If the people involved in the processes were conscious of what they were actually doing and

what motivated them, then, as Engels says, "the whole of ideology would be finished,"[48] for we would be dealing with lies and swindles rather than ideology and rationalization. Propaganda distinguishes itself most decisively from the ideological representation and interpretation of facts by the fact that it is a conscious falsification, an intentional manipulation of truth. Ideology on the other hand is mere deception, essentially self-deception, never simply lie and deceit. The concealment of truth is aimed not so much at leading others astray as at the preservation and enhancement of the self-confidence of the supporters and beneficiaries of ideological deceit.

In spite of this, if Marx and Engels when referring to ideology still speak of deceit—namely, of "false consciousness"—they are thinking of the false picture which arises when reality is viewed from the stance of a particular social class. With the corresponding elimination of every trace of lie from the concept of ideology, it was rightly stressed that the liar does not think falsely; rather, he thinks properly—he only wants to deceive the others.[49] Recently it has been more and more frequently pointed out that ideology is determined not by purely economic motives but by the class situation in general; that is, it is determined not only by possession and usurpation of the forces of production, but also by claim to and prospect of distinction, by striving for influence and regard, in short, by the most diverse benefits for which a class may struggle. In spite of the justification of these reservations, ideology, like class consciousness, is still in the last resort determined by the economic basis. If, however, Marxism still speaks in one case of "false" and in the other of "correct" consciousness, then the differentiation rests on the fact that ideology pretends to be determined by ideal motives while class consciousness admits the relevance of the actual material motives.

No matter how the ideologically determining motives may be composed, we can scarcely talk of an ideologically unprejudiced consciousness in a society which is structured according to class. All thought is ideological even if ideological thinking is not unconditionally erroneous, and correct thinking does not merely mean freedom from ideology. The analogy between the doctrine of ideology and psychoanalysis leads further than to the establishment of the mutual bending of truth, where the admission of the true state of affairs could prove to be dangerous or harmful. It stretches particularly to the fact that, just as the individual does not have to rationalize everything that he feels or desires, because much of this is a matter of indifference to others or seems harmless to them, the interested motives, too, of social groups do not always need to be thrust aside, ideologically disguised, and glossed over, for they are of themselves often harmless and socially

indifferent, even if they are by no means uninfluenced by society. Many of the representations and interpretations of reality can remain "objective" since they are neither in concert with nor in contradiction to the interests of one particular group. Mathematical theses and scientific theories are in this sense generally objective and follow principles which correspond to the criteria of abstract truth. The province of such theories is, however, relatively narrow, and although the solution of the problems, to which they aspire, may lay claim to a certain universal validity, the development into topicality of these problems is historically and socially conditioned.

Orthodox Marxism infers the extreme relativism of thought from "ideologicality," and if Engels already saw in knowledge the mere epiphenomenon of being, Stalin maintains that "the superstructure was created by the basis just for the purpose of serving it."[50] The "ideologicality" of a statement, however, has nothing to do in principle with its truth content. It merely means that the thesis represents the function of a social station, a class situation, and an aspect suited to it. In spite of its "social functionality,"[51] in spite of its social purposiveness, a scientific doctrine may be true and prove true in different sociohistorical contexts. What is essential, however, is that a structure of consciousness becomes in part the ideology of one group because it promises to be useful to it, but is rejected by another because it seems to threaten its existence. Since, however, an ideology does not purely consist of elements which arise from a group's economic infrastructure and complex of interests—although all are connected with it[52]—its concept is not completely absorbed in the doctrine of historical materialism. Scientific theories and artistic creations are more than purely ideological structures; they may be ideologically charged, linked to ideologies, and founded in them, but they contain representations and interpretations, discoveries and illuminations which lie beyond the sphere of material interests.

The critique of ideology is based on the ability to be aware of the one-sidedness and the bias of thought which is linked to class and status, although this awareness in no sense means that it is possible to eliminate the source of error completely. We are faced with an insoluble problem if we wish to become independent of the soil in which we have our roots. What we have to aim for consists at best in the knowledge of how deeply and where we are rooted. We misunderstand Engels if we interpret his idea of the "triumph of realism" as his expectation, for example, that Balzac would pull himself out of the morass by his own efforts. He merely thought that, as a real artist, he would have been capable of moving from an ideology which was unsuited to him to one which corresponded better with his actual social

situation and the actual conditions of his time. What prevents if not from the outset every correction of the ideological deformation of truth—at least, it limits it—is the fact that the correction itself still moves within the limits of thought which is dependent upon station. The fact that ideology is not a rigid formula but a fluid, flexible form which suits many conditions—a form which arises as a result of the tension and difference between economically and socially linked forces which are in the process of emancipating themselves from economy and society—loosens the dependence of ideal structures on social conditions of existence. The fact, however, that in spite of this there are limits to the freedom and objectivity of thought signifies the final and decisive justification of the ideological and sociological interpretation of culture. They bar the last exit which would permit thought to escape from social obligation.

The study of ideology involves the application of the principles of the doctrine of ideology to its own assumptions. If we weigh the implications of the concept of ideology, we come to perceive that the critics of ideologies think ideologically themselves. The critique of ideology is only truly a critique when it becomes conscious of the limitation of its own aspect as well. This, too, suffers, like every aspect linked to station, from the fundamental erroneousness of thinking, which for all its particularity and perspectivism lays claim to totality. The cognitive theoretical significance of the particularity of thought structures was recognized by Marx and Engels. Every ideology they stressed makes its appearance with the claim of being valid for the whole society while judging ideal values according to the interests of a class.[53] A mode of thought is ideological because it is confined to a particular view. Its relativity follows from its particularity, its limited validity from its link with a station. In art these concepts have from the outset a different meaning from what they have in the other spheres of culture. The problem of ideology takes a different form here from what it does particularly in the sciences, because the concept of truth is a different one. A work of art is not "right" or "wrong" in the same sense as a scientific theory, and strictly speaking it cannot be designated as true or untrue. Even artistic representations can, it is true, be "mendacious," can distort facts and do without evidence, but never as a result of the relativity and perspectivism of their point of view. The concept of universal validity cannot be applied to art either in the superhistorical or in the superpersonal sense. To talk about a "false" consciousness in relation to art is as nonsensical as it is to talk of a "right" one. A representation of reality which would have to be looked upon as false in an objective scientific sense can be completely true artistically, can be convincing and of greater relevance, than the sci-

entifically most unexceptionable one. Where scientific veracity is not intended, we cannot talk of its jurisdiction, and no sanctions can be imposed because it is avoided. Art's perspectival view does not call for correction and suffers none, for "perspectivist" and "false" here have nothing to do with one another. The truth of art cannot be proved; the harmful effects of its deviation from truth cannot be demonstrated. It is true not in spite of, but thanks to, its ideological nature, its insoluble involvement in practice, and it is untrue not because it pursues one politico-ideological direction and neglects to follow another, but because it represents the ideology upon which it depends lukewarmly and indecisively, or because it pretends to an unbroken and balanced view of the world when it is paralyzed by a crumbling and contradictory one.

Just as historical materialism is not a psychological theory, so the concept of ideology which depends upon it is derived not from the personal, empirically psychological motives which people follow in their behavior, but from the sociohistorical forces which assert themselves in their thinking, feeling, and action as a result of their belonging to a group—often without their will or knowledge. A consciousness is "false" in the Marxist sense if it confuses psychological motives with those which determine the historical and social process.[54] Ideology bears the stamp of social conditions of existence even among those who represent the opposition to the dominant social system. The thinker or artist represents the society in which he is rooted; he is its product whether he follows its direction or opposes and fights it. The ideological formation of cultural structures does not take place under any circumstances as the completion or correction of what are originally attitudes and products free from ideology and unbound by society. We fail to understand the nature of ideological attitudes if we overlook the fact that they are from the first connected with class stratification and the differentiation of interests, and that they do not adapt to them subsequently—après la lettre, so to speak. As Marx says, just as we do not have to be a small shopkeeper or be linked by class to small shopkeepers to represent the ideology of the petit bourgeois, so we certainly do not have to be one of the members of a class to share its ideology. History shows innumerable examples of artists who assumed the ideology of their employers, masters, and patrons not because of a feeling of duty or convention, but out of conviction and devotion. Up to the time of their emancipation as a professional class this was almost the rule. Since then and especially since the Enlightenment, not only have they become more and more class conscious but we find among them more and more advocates of the lower classes. Many of the most outstanding exponents of the literature of the En-

lightenment are descendants of the aristocracy, and the thinkers, poets, and artists who in the last century formulated the ideology of the industrial workers, developed it programmatically, and proclaimed it most enthusiastically came almost without exception from the ranks of the bourgeoisie. Yet, however deep and ineradicable the traces which origin, wealth, education, social position of parents, and the family's form of life leave on the individual, to expect that a poet who is descended from the nobility will have to remain true to the ideology of the nobility in spite of every social change or to be surprised that it was sons of the bourgeoisie like Marx and Engels who "discovered" the ideology of the proletariat would be a sign of an all too simple notion of the ideological structure of thought.

In connection with the social attribution of ideology the most significant thing is not the fact that artists, poets, and thinkers proclaim sometimes with and sometimes without conviction the ideology of their patrons, employers, and customers, but rather the fact that they do it unconsciously and without taking into consideration whether they are sincere in their acceptance or denial of it. The actual sense of ideologies consists precisely in the fact that the individual's thinking, feeling, and willing—whether he accounts to himself for it or not— follow the logic, morals, and movement of taste which correspond to the concepts of value of the leading and determinant order of society— feudalism, absolutism, or capitalism. From the beginning the so-called turncoats played the greatest possible role in the formulation and dissemination of ideologies, and, in fact, not only the proselytes from below but also those from above. This did not happen, either, after the nobility of the Enlightenment had made the cause of the bourgeoisie its own or after the bourgeoisie had put the idea of "proletarian class consciousness" and the "class struggle" into circulation but ever since the Roman patricians allied themselves with the plebeians and the members of the ruling class in Rome proclaimed the message of Christ. The fact that representatives of the upper classes take up the cause of the lower often has more realistic causes than would appear to be the case at first sight. They participate in the slaves', the serfs', or the proletariat's struggle for freedom more often out of fear of a general collapse and in expectation of a new order than because they are moved by sympathy and humanity.

The attribution of ideologies only became a real problem in the modern period after the question could be posed whether concepts like "class struggle" or "class-linked ideology" are not perhaps the invention of those turncoats who are called "free-floating" intellectuals and who could make manipulation of these concepts into a source of income. The fact that proletarian class consciousness and socialist ide-

ology find fewer express prophets among the workers than among the intellectuals and that they would never have become the object of a theory and a program without the educated turncoats is not of itself surprising. Even Lenin admitted that the workers were not capable of developing a real socialist consciousness, and were at best capable of thinking at the level of the trade union movement, so that their liberation would never have been possible without the help of comrades from the wealthy and educated classes. In reality, however, the philosophical, historical, and economic theories of the turncoats would never have come into being without the new conditions of production, the existence of a new industrial work force, and the crises, conflicts, and struggles which are connected with them. The function of the turncoats was to translate the antitheses which were effective in historical development into concepts of dialectical thought. A class consciousness and a class struggle do not only come about after they have been clearly and unambiguously defined theoretically. They are, rather, virtually given with the classes in question and are capable of being carried out conceptually by each class member who is capable of thinking according to his class situation. The turncoats, intellectuals, propagandists, and authors of ideological manifestos find the definitive class stratifications, attitudes, and capabilities of consciousness more or less ready-made, and the most they do is bring them to the light of day. Whether an ideology is within the consciousness of a majority or a minority of subjects is not decisively significant in the process.

Engels's thesis of the "triumph of realism" is based on the independence of the sociological state of artistic creations from the psychological motives upon which they are based. The ideological principles an artist acknowledges, which govern his consciousness on the psychological level and which he thinks and hopes he is furthering, certainly do not have to be the same as those which determine the character of his artistic creation. Engels is of the opinion that the illusions which correspond to an artist's hopes and wishes conceal reality for him, but if he is a real artist, they cannot prevent his depicting conditions as they really are. What is decisive, however, is not the assumption that in his work the genuine artist cannot avoid taking the socially correct—in Engels's sense, progressive—point of view, a point which of itself must remain moot, but the fact that, apart from the psychological level upon which he behaves somewhat irresponsibly, he also moves in a sphere which is governed by an objective rationality and in which he is guided by an ideology that suits him, his real class situation, and his true social interests. It is not essential that Balzac, as Engels believed, observed and thought as an artist more correctly than Balzac the philosophizing and politicizing "screwball" did, and

that, in spite of his naive prejudices, he felt himself prevailed upon to recognize the extraordinary abilities and merits of the bourgeoisie, for in fact in his works he praised the aristocratic virtues just as often, if not more often. What is decisive is that he deliberately defended the nobility, the legitimists, and the Church with agitatory fervor, in a completely biased manner, yet, on the other hand, he did justice to the bourgeoisie lovelessly and against his will. He was enthusiastic about the aristocracy, romantically enamored of them, and blinded by them, whereas as a nonengaged realist he depicted the bourgeoisie but with all the more understanding and all the more conviction because he was not an aristocrat but—for all his thoughtlessness and extravagance—a rationally thinking, sober bourgeois. The essence of the doctrine, however, which can be extrapolated from the theory of the "triumph of realism" and with which we can get closest to the ideological nature of art, consists of the perception that, for the artist's conception of the world, what is decisive is not whose part he takes and with whom he declares his solidarity in principle, but with whose eyes he views the world.

Engels's "triumph of realism" means at bottom a triumph of historicism. What Balzac discovered and the perception in which Engels sees his greatness is the fact that the aristocratic has become dated. However picturesque they may appear to him, however theatrical and impressive and romantically exciting the picture may be which is before him, the incorruptible, observant artist cannot conceal from himself that the aristocracy often produces a tragicomic effect in the modern bourgeois world. No matter with how much nostalgia for the mysticized past, how tenderly and melancholically he presents his aristocrats, they remain puppets in his *cabinet des antiques,* a cupboard full of wax dolls.

According to its origin, an artist's ideological attitude is usually uncommonly complex; motives of station and attitude, class and education, profession and biography may be decisive for it. In some circumstances the attitude is sometimes different in different periods of an artist's development and in different works and weighs differently with his creations at different times. The main thing is that we cannot always determine whether an artist has a basic or single decisive ideology. Yet, even so, we are still able to talk of an ideology or a complex of ideological orientations and are still capable of finding the definitive attitude, even where there are contradictory motives. For even such an unstable, unexplained, and undecided attitude is from the social point of view instructive. The thesis of the "triumph of realism" has not been extensively enough developed to accommodate this complexity of circumstances. It consists of little more than a fortunate

aperçu, the striking formulation of an observation which is right for but far removed from serving as a basis for an even halfway comprehensive doctrine of the sociology of art. Actually, it says scarcely more than that the artist moves in a social medium sui generis in which laws are decisive that have nothing to do structurally with the psychological motives governing him but that can be decisive for the meaning of his art. What is remarkable is that with this thesis, like that of the "parallelogram of forces"—that is with two of his characteristic ideas—Engels follows Hegelian principles, especially the principle of the "cunning of reason." Both have in common with Hegel's doctrine the thought that is characteristic both of Hegelianism and of the school which embraces Marxism: that the empirical psychological subject takes part in the realization of a historical product, of which he has to know nothing as a goal and of which he can know nothing on the prephilosophical level of consciousness.

The simultaneity of the investigation of the ideological nature of thought and of depth psychology discoveries about the perspectivist nature of perception and the relativity of cultural values points to their common historical and social origin. Without the dominant role which the decisive motives of economy—which were up till then concealed—achieved in the consciousness of the modern bourgeoisie, these doctrines would have scarcely acquired the significance they subsequently maintained in scientific thought. The cheerless experiences and the lost illusions of the revolutionary epoch belong to the genesis of the concepts of ideology and rationalization, the mendacity of life *(Lebenslüge)* and *ressentiment,* artistic derivations and deceptive perspectives. The decisive historical experience of the period, which was so contradictorily determined by the results of the revolution but which was for all the participants equally problematical, revolved around the dialectic of all happening, the antitheses of thought, and the ambivalence of feelings and judgments. The new way of thought was based on the suspicion that hidden behind everything manifest there was something latent, that behind everything conscious there was something unconscious, and that behind everything which seemed unequivocal there was something conflicting, ambiguous, and doubtful. The idea of a thought which would reveal, of the examination and revelation of every statement with regard to the underlying intention, was part of the public property of the period. Marx, Nietzsche, Freud, and Pareto meet on this ground as true contemporaries even if they meet in other cases as ever such irreconcilable antipodes. In any case they agree with one another that the manifest, conscious, psychic life—with all that people imagine they know about the motives for their views, feelings, and actions—is often merely the cover or distortion, the purely con-

structed or derived form of the actual motives for their behavior. All of them follow fundamentally—however they may think otherwise at the moment when they develop their own doctrines—the technique of the analysis of consciousness and the interpretation of ideas which finds an application in historical materialism and in the doctrine of ideology. All of them operate with the concept of "false consciousness," no matter what they may call it.

The perception of the real connection between sociology and psychology, the fact that the objective meaning of social contexts, structures, and laws does not have to correspond to the intentions which are subjectively linked to them, that the means of production, social institutions, class divisions, and class struggles follow their own laws and logic and "think," so to speak, for themselves, is the quintessence of the Marxist doctrine of ideology. What is being said is that the single individual who is in a particular socioeconomic situation is not "free" in completely decisive relationships, but in accordance with his situation thinks, feels, and acts in a biased and unobjective manner. In Hegel's terminology we could here speak of a "cunning" of class reason, which asserts itself over the heads of its representatives. The capitalist striving for success as a superpersonal rationality is not identical with private striving toward gain and the individual passion for profit, and, as a collective impulse, it is driven by a quite different mechanism from the psychology of greed. According to Marx, it is also of no concern sociologically "what a person believes and says about himself"; what counts is "what he really is and does."[55] So, too, the ideological significance of modes of behavior is also completely different from their psychological sense. People constantly confuse the subjective with the social role of the products of their labor and their structures of consciousness. The Marxist dictum "they don't know that, but they do it"[56] could be the motto of the whole doctrine of ideology.

The psychic motives which prompt a person to volunteer for military duty can be purely idealistic: he may believe that he wants to fight for justice and freedom, and in spite of this not only may the causes of the war be objectively essentially economic in nature, but there may be unconscious, veiled, and sublimated material motives behind the apparently idealistic motives of the volunteer. His concept of freedom and justice generally has its roots from the outset in the ideology of those strata which determine the politics of the country for whom he has gone to war. History is an unbroken series of examples of quid pro quos of this sort. People believe that they are fighting feudalism because they wish for freedom of movement; they attempt to topple the ecclesiastical hierarchy in the interests of freedom of belief; and

they oppose absolutism with the ideal of equality and fraternity in their heart. These ideas also reflect in part the real motives of their struggles, wars, and revolutions. Psychologically, we can confidently take this as a starting point and let things be, for people scarcely know about any other motives in their aims and undertakings. It is only the ideological interpretation of their attitudes which reveals the real background of the processes.

What sort of a "consciousness" is it, however, of which people know nothing? Sociologically, the classes' latent ability to be conscious functions just as effectively and surely as the obvious class situation which has become conscious and is ostentatiously expressed. As a manifest, immediately effective class consciousness, this ability is actualized only when people think according to their class situation, which they certainly do not always do, even if they behave according to it. In this sense Georg Lukács asserts that class consciousness first "stepped into the phase of *bewusst werden können* (the ability to become conscious) when the class structure was done away with and a purely economically stratified society was erected." He ascribes the change to the fact that people have only in this way reached the stage at which "the social struggle is reflected in an ideological struggle for consciousness, for the veiling or revelation of the class character of society."[57]

In no case is class consciousness identical with ideology. Ideology is actualized in all the statements of a social subject, while class consciousness is not always present for him. However, it by no means follows from the fact that ideologies belong to the constant instruments of human activity that men create ideologies, although there is just as little ground for considering that they are produced by them. The reversal of the Marxist thesis, the assertion which was made that ideologies are the product of people and not people the product of ideologies,[58] in any case simplifies the state of affairs. It is probably people who create ideologies, but they do not create them without prior conditions. It is precisely in the assumptions implicit in them that the superindividual and interpersonal, the social objectivity and autonomy of ideologies are most purely expressed. People in no way create ideologies in the way they would like; otherwise, ideologies would be not ideologies but mere inventions, speculative constructions, or poetic fantasies. The contradiction between man as a psychological subject creating ideologies and a sociological one created by ideologies is, however, not irreconcilable, even if it is one which constantly recurs. In this contradiction there is expressed the double essence, the individual and at the same time the social nature of man, and in it is the basis of the dialectic which dominates his existence. The criticism to which he subjects his ideology no more neutralizes the ideological

limitation of his thought than the social basis of his thought prevents his opposing the social unit to which he belongs and his remaining in a state of tension with it.

One of the earliest and clearest examples of the formation of ideologies—and the social history of art can be represented as a result of it—is the development of the strict style which corresponded to the code of honor of the Greek nobility in the Archaic period. The artistic production of the sixth and seventh centuries B.C. served the nobility, which was still wealthy and still governed the state, but which was already threatened in its economic and political influence. Its eviction from the leading position in the economy by the urban middle class and the devaluation of its natural income by the great profits made by strata interested in money economy are in progress. In this critical situation the nobles begin—as threatened classes often do in similar circumstances—to recall their particularity. In any case they begin to emphasize their excellence, and on the one hand they start to justify claims to their privileges and on the other to compensate for their defeat in the struggle against the economically more vigorous social groups by other alleged merits. Family and class characteristics of which they had until then seemed scarcely conscious are asserted as virtues and titles of glory, and now, in the moment of danger, the rules for a mode of life are first formulated and determined—rules which earlier, in the days of the politically still unendangered and economically secure existence, were never defined, in fact not properly observed.[59] Now the principles of the ethos of the nobility are developed: the concept of *arête*, with its characteristics derived from birth and race, and the idea of καλοκἀγαθία, of the balance between the physical and mental, military and moral values. The new choral and philosophical poetry has—with its content which refers to topical problems—its origin in the same crisis, and meets with more interest and understanding in the nobility fighting for its power than did the antiquated heroic poetry. The aphoristic and choral poets, particularly Pinder, turn to their noble public with moral advice and warnings instead of with amusing adventures. Their poems are—if not express political agitation—the expression of that completely practical class ideology which sublimates their motives.

The derivation of artistic forms and styles from class situations and ideologies rests upon a purely metaphorical context which is, at bottom, concrete and universally conclusive, but which in the individual case is often arbitrarily constructed. In no process is the sociology of art exposed to more dangerous equivocations. "The elaboration of class-society," writes Christopher Caudwell, "causes the dance to develop into a story, into a *play*. The intricacies of the chorus

loosen sufficiently to permit the emergence of *individual* players. Individuation, produced by the division of labour in a class society, is reflected in the tragedy. A god, a hero, a priest-king, people, great men, detach themselves from the chorus and appear on the stage, giving birth simultaneously to the static act*ing* and the moving act*ion* which were inseparably one in the danced chorus."[60] The birth of tragedy is, as is well known, a long, complicated, and in part still unexplained process, whose beginnings may possibly, but by no means demonstrably, coincide with the transition from the aristocratic state to class society, but are in any case independent of it. Be that as it may, it is a mere equivocation and a rough simplification of the process to bring the emergence of the actor from the chorus into a causal relationship with the dissolution of the kinship community, the differentiation of classes, and the division of labor. It is even questionable whether the great individual whose fate is treated in the tragedy is more closely related in character to the chieftain than to the individual emancipated by the competitive economic struggle.

The social origin and ideological meaning of styles, particularly the connection between rigor of form and conservatism on one hand and naturalism and liberalism on the other, have, however, not only just recently been recognized—for example, because of dependence on Marxist sociology—the Greeks already felt that there was a correspondence, without, it is true, being capable of formulating the phenomenon in principle. Aristophanes was already criticizing the tragedies of Euripides because they violated the old aristocratic ideals of life and the former artistic idealism in the same sense. And, according to Aristotle, Sophocles is already supposed to have said that he showed people as they ought to be, Euripides, on the other hand, as they actually are. If he himself then maintains that the figures of Polygnotus and Homer "are better than we are" (*Poetics* 1448ª11. 5–15), he is only varying the same thought. The idea of classical art as an "idealistic" one, as the representation of a world which should be a more complete world and one of a higher, more noble humanity, belonged, no matter from whom it originated, to the ideological reaction of the nobility to the money economy and the bourgeois development by which the old order was threatened.

A counterpart to this change in ideology arises with the appearance of the new chivalric class at the turn of the twelfth and thirteenth centuries and with its influence upon the older feudal nobility. The poetic activity of the newly made knight rising up out of vassalage and the change in the courtly lyric and epic which was linked to this represents one of the most profound turning points not only in the history of poetic genres but in ideologies overall. The decisive step

came about with the decree according to which admission to noble rank—to which the upstarts had to thank their elevated position—was once more closed. Nothing is more understandable than that that part of the knighthood which had just been admitted was the one that supported the cutoff most emphatically. It is a well-known phenomenon—which often recurs in social history—that the new members of a privileged stratum represent stronger principles vis-à-vis the criteria appropriate to their station and take greater account of the norms which hold the particular group together and distinguish it from others than the members of the station who grew up with these ideas. The *homo novus* tends to overcompensate for his feelings of inferiority and esteems too highly the moral assumptions for participation in the newly won privileges. Chivalric literature is the ideological expression of class interests and the corresponding class honor of a stratum which has completed its rise from a professional warrior status to a leisured class determined by birth. The remarkable contrast between the social conservatism and the artistic progressiveness of the knights which gave birth to the new love lyric and so to an expression of a new sensibility which served as an example for the whole further development forms a similar problem to that which Engels believed he was able to solve in the case of Balzac with his theory of realism. For no matter how conservatively the new knightly class might behave in a social regard, in its poetry a new ideology was asserted which bore witness of an almost plebeian candor and frankness.

The ideological attribution of cultural structures becomes more clear with the end of the medieval order of status and the genesis of the new, essentially economically stratified class society. The connections became more complicated again in the Reformation and the political, social, and ideal development which accompanied it. They assumed that contradictory character which finds its artistic expression in the stylistic complexity of mannerism. As a religious movement the Reformation had its own assumptions, but at the same time it represents the discharge of an explosive economic situation and the defusing of a social unrest which was widespread. It may be unthinkable without these circumstances, but we shall not be able to derive it simply from social tensions and conflicts, the dissolution of the feudal economy, and the development of modern capitalism. Even if we want to see in it only the religious masking of the social process which was being accomplished, we shall have to ascribe the greatest significance to the fact that the form in which the process makes itself felt is most emphatically a religious one. Whether the Protestant professional ethic, as Max Weber designates it, starts at the beginning as the ideology of the new, capitalistically inclined social classes, who are anxious for

gain and filled with a striving for competition, or whether it only afterward serves as a justification for their economic practice can only be decided on the basis of individual cases according to prevailing historical conditions and local circumstances. In any case, it is remarkable that the cry for religious freedom of conscience agrees with the voice of those who are fighting for economic freedom and against social oppression.

If, however, we have once grasped the meaning of this connection, the praise of profitable activity by Protestant doctrine appears as one of the most revealing examples of the formation of an ideology. The ethical-religious cover which an economic attitude (which has purely profane motives and is at best indifferent to religion if not actually opposed to it) receives in this way, the morality which ennobles and sanctifies earning and represents success in business as a sign of divine grace can only be explained as an ideological superstructure which has to justify and cloak the capitalist striving for success. Protestantism may have furthered the capitalist developmental tendency; it did not bring it about. In the same way economic circumstances may hasten religious renewal and perhaps make it altogether possible, but they could not produce the religious experience from within themselves. Capitalism had material assumptions which were based in the forces of production; without these no intellectual readiness would have been capable of bringing about the profit economy. Without it absolutely no intellectual tendency which moved in the direction of capitalism would have been thinkable. A readiness and a capability to seize the given means and possibilities and to exploit them were needed to develop the system besides the purely material conditions. The structure of consciousness, however, which we are accustomed to understand by the "capitalist spirit" does not belong to the assumptions and causes, but to the consequences, the ideological product, and the expression of capitalism as economic practice.

Nowhere does the dependence of ideologies, particularly of artistic styles, upon socioeconomic conditions of existence appear more clearly than in seventeenth-century Flemish and Dutch painting. Only the doctrine of ideology which rests upon historical materialism is capable of giving a relatively satisfactory explanation of the phenomenon which appears so puzzling at first sight, namely, that Flemish baroque and Dutch naturalism arose almost contemporaneously, in immediate proximity, under almost the same cultural traditions and with a similar historical past only in different political, economic, and social conditions. We can certainly not expect here—any more than we can with other assumptions—an answer to questions of origin, of artistic quality, or of individual talent and personal inflection. These are unique and

incomparable phenomena and cannot be derived from objective and superindividual conditions of any sort. However, what the artists have in common with one another on the one side or the other can be pursued further, and in the attempt to explain the communality of their style, the tendency and the limits of the aims, nothing is more fruitful than the discussion of the social conditions under which they had to work. In Flanders where the restored Church had proved completely successful and the alliance between Church and state left nothing to be desired in cordiality, the Catholic idea joined with the courtly monarchistic conventions and norms just as firmly as Protestantism in Holland did with the republican, bourgeois, and capitalist forms of life. Catholicism derived the sovereignty of the prince from God, according to the principle of the representation of the community by the sacramental priesthood. Protestantism on the other hand, with its doctrine that the believers were children of God, was from the beginning opposed to authority and was democratic. What was decisive in this was not religion; rather, the creed often suited itself to the primary political decision. Immediately after the insurrection the Catholics were almost as numerous in the North as the Protestants: it was only later that they went over to the rulers' camp. Religious antagonism can thus in no way be seen as the reason for the cultural contrast between the two areas. Yet this cannot be derived any more readily from a difference in racial character between the two peoples—on the other hand, however, the economic and social motives are evident. Without wishing to probe into the essentially incommensurable greatness of Rubens and Rembrandt, the fact that the one produced his works in a representative courtly aristocratic society, the other in a bourgeois world which tended to profundity, inwardness, and familiarity is the only genetic—even if it is only genetic and not qualitatively structural—explanation of the uniqueness of their art. In Holland there is no pretentious court, no pompous Church which permitted the development of Rubens's baroque; instead, there is a bourgeois capitalist rule, the principle of laissez-faire, which extends to the practice of art. The devotional picture has no place in the Protestant milieu. Even biblical stories so far as they are treated at all acquire a genre character. The favorite things are representations taken from real, everyday life: the genre picture, landscape, still life, the portrait. The more immediate and tangible a motif is, the more suited it seems for artistic representation. It is an attitude toward the world which lacks distance and is utterly and completely objective which asserts itself, a view to which reality appears as something familiar, something owned and completely possessed. Room and hearth, house and hall, city and field, the house and home of the burgher, the family, the community, the nation are

the foundation of this naturalism, its immediacy, and its self-evidence which distinguishes it not only from the Flemish but from the whole European baroque with its pathos and posing, its ceremonious solemnity and its extravagant sensualism.

The gravest objection to the ideological interpretation of artistic creations is based on the fact that the same stylistic characteristics and formal elements often appear at different times and in different social circumstances, that a style remains alive in one genre longer than in another, and that the less malleable forms seem to limp along behind the more flexible and mobile ones instead of—as their common ideological background would lead us to think—keeping pace with them. Thus, for example, the end of mannerism and the beginning of the baroque come at different times in different arts. In painting, particularly in Italian painting, the change takes place in the sixteenth century; in literature on the other hand it drags on until the middle of the seventeenth century. In the following stylistic period there is an even greater temporal inconsistency to be seen between the different arts. Up till the middle of the eighteenth century, till about the death of Bach, music is dominated by the baroque while, in the fine arts, rococo has reached its full maturity. If, however, the same temporal phenomena do not have the same consequences in all forms of art, if different stylistic forms correspond to the same conditions of existence in the individual arts, then it is clear that we cannot talk in the strict sense either of an ideological limitation or of a sociological set of laws at all. Then the arts develop to a large extent according to their own inner laws, which are independent of social circumstances.

However, before making such a judgment we have to think that the different arts are suited in different measure to social functions, to the development of propaganda, and to the dissemination of ideologies. In this connection we will have to distinguish above all between the literary and the other arts. Music and fine arts may prove to be equally suited, if not more suitable, media for the display of leisure and waste, pomp and circumstance than literary forms; but where we are dealing with more differentiated problems, more abstract ideas, and more complex ideologies, the superiority of literature cannot be mistaken. Nevertheless, the sociological explanation and the ideological interpretation of the difference in style between Bach and Handel, for example, are obvious. The *Eroica* betrays the spirit of the revolutionary epoch even if we know nothing of its relationship to Napoleon. Certainly we could scarcely guess from the musical structure of the *Marseillaise* which social class it served as a war cry. We would at best be able to establish that at the time that is revealed by its form, the aristocracy had no use for music of this sort.

In spite of the divergent tempi of development in the different arts, the connection of styles with the forms of society at a given moment is unmistakable. Even the one or the other form's relative independence of general convention has sociological grounds which can be ascertained. At the time of the change of style from mannerism to baroque, for example, the Church of the Counter-Reformation had a livelier interest in the introduction into church buildings of the splendid, imposing baroque, which would attract the masses, than in the corresponding change of style in literature, the public for which was still relatively limited and from the point of ecclesiastical policy of no consequence. Again, in the eighteenth century the bourgeoisie was able to exert a more decisive influence on the development of literature, to whose public they already belonged in large measure, than on music, for which up to the middle of the century the taste of the courtly circle and the demands of the ecclesiastical ones remained definitive. In Protestant countries the strata themselves on which the Church is based are differently constituted from what they are in Catholic ones, and their influence has from the beginning a different stylistic effect—one which works in an introverted direction. What is most decisive is the fact that the concert business, which relies on a bourgeois public, as the institution which corresponds to the publisher and the exhibitor, was still in its infancy in the eighteenth century. And a stylistic tension of this sort, which is based in the different social organization of the interested parties and of the market, exists between the fine arts and literature almost throughout the history of Western culture. The number of people interested in works of painting or sculpture, to say nothing of the builder, is for obvious economic reasons smaller than that of the reading public. This disproportion among consumers remains even at the time when the bourgeoisie takes over from the upper classes the leading role in culture, and is expressed by the strength with which literature, as opposed to the other arts, places itself in the foreground. Its stylistic progressiveness is more unmistakable than ever, and its central position in the system of arts is more secure than during all the previous centuries, in which the reading of books was the province only of the clergy and of scholars.

Ideologies are first and foremost social—class- and group-conditioned—phenomena, and general historical ones to an incomparably smaller extent. The different role which the individual arts play in the same culture, the different stylistic significance which they acquire from time to time, the shift of interest of the culture-bearing strata from one art form to another, and the lack of simultaneity of stylistic progress in the different forms proclaim most evidently the ideological limitation of the artistic processes. The individual work of

art is more closely linked with the other artistic products of the same social group than with the general idea of art in the history of art as a total process. In comparison with the concrete ideological unity of a social stratum, the homogeneity of art and the continuity of art history are mere constructions. The works of different stylistic periods and artistic generations continue each other only in a very specific and limited sense: every work begins at the beginning, and it is not better and gets no further simply because it was created later. The one at best represents its own ideology, its own perspectivist aspect of the facts, better than the other.

The problem of relativism which we run away from as a result of the inapplicability of the concept of objective truth in the realm of artistic creativity is linked in art history as a science with just as great difficulties as in the other scholarly disciplines. Indeed, these difficulties are the greater since research in art history does not show in its development even that small measure of constant progress which the science of history otherwise presents. One generation's art historical interpretations and evaluations are not only not binding and nondefinitive for the next; they even have to be in part neglected by it in order to find a direct access to the works and take possession of them again. However, no matter how indispensable the change in points of view is for the acquisition of immediate relationships to the artistic creations of the past, different judgments have at some time to be examined as to their validity. We cannot simply accept the notion that the art of past epochs has to be subjected to a continuous reevaluation, that an artist like Raphael is regarded sometimes as *the* exemplary classical master and sometimes as a representative of conventional mediocrity, or that a movement like mannerism which was yesterday decried as a violent confusion of taste is today regarded as one of the most remarkable and stimulating artistic movements. Are, then, such judgments, we have to ask ourselves, right or wrong? Is the one art historical interpretation more correct than the other? Is the later point of view the more correct? Or does the succession of interpretations and judgments have absolutely nothing to do with progress, the gradual establishment of truth, and an objectively valid standard of values? Is there in art history an unavoidable and finally pointless relativism? Or are we here dealing with judgments which have to be distinguished from one another not in any sense as right or wrong but according to completely different criteria? Should we rather ask about the relevance of the contexts and the deepening and enrichment of artistic experiences to which every mature and sensitive interpretation offers a new access? Is it not actually a question of awakening to new life works, styles, and movements in taste which seem to have lost their meaning and

value and which threaten to die out or become lost? Is the main task not to bring these works and stylistic forms into relationship with the living present, to let them take part in our lives and make them a part of that art, which is suitable as an immediate experience for the generation acting as a guide?

In any case there is no doubt that not only the development of art itself but also its history—that is, not only the activity of art but also the explanation of its change and the interpretation of its movement—follow the principles of succession. This succession, in contrast to the continual process of civilization in which achievements are cumulative—something we see in the history of exact sciences and in technology—has to be viewed as an example of the erratic, irregular, not necessarily progressive "cultural movement" in Alfred Weber's sense. The discoveries of art history as a part of this movement can be neither completely objective nor absolutely binding, for they correspond as interpretations and judgments which they essentially are, to no actual perceptions but merely represent ideological vindications and desiderata, wishes and ideals which we should like to realize and which we believe were realized in the past.

We judge, overestimate, or neglect artistic movements and artistic creations of the past according to the aims and standards of value of our own present. We criticize them according to our own artistic goal and view them with renewed interest and fresh understanding only when they lie in the direction of actual goals, some of which have still to be realized. Thus, the rediscovery and reevaluation of the Renaissance was accomplished by the generation of bourgeois liberalism about the middle of the nineteenth century, that of the baroque by the impressionist period, and that of mannerism only as a result of stimuli received from expressionism and surrealism, from the film, and from psychoanalysis. It is clear that all these evaluations and interpretations are conditioned primarily pragmatically and ideologically, not empirically and logically. They correspond far less to progressive scientific research than to an erratically changing practice and do not depend upon timeless and neutral concepts of truth but always on the same conditions of existence as contemporary artistic movements. In order to be aware of the nature of the evaluations it is enough to remember the changes which the evaluation of antiquity has undergone in the course of Western history, how it was judged by the early and High Renaissance, by mannerism and the baroque, by the courtly aristocracy of the seventeenth and eighteenth centuries, by the Enlightenment and the revolution, by bourgeois academism and the nonconformism of the naturalist and impressionist avant-garde, how it seemed to have at one time a progressive and liberalizing, at another a conservative and rig-

orously formalistic character. Certainly the history of art has to cope
with a series of problems in which the principles of factual research
and the criteria of objective truth are definitive, particularly with ques-
tions of the dating and attribution of works, of technological achieve-
ments, and of the relationship between production and consumption,
all of which can be posed and solved at a certain distance from ideology.
Yet even these acquire now a greater, now a lesser significance, are
placed in a more or less sharp light according to the station from which
they are regarded. The evaluation of market conditions and the rela-
tionship of the artists to those who give them commissions, their
patrons and customers, for example, is never completely independent
of the economic interests and the social views of the people who have
to make the judgment.

Yet, instead of always complaining that the interpretation of works
of art and movements in style, and the judgment of their aesthetic
quality and historical role are dependent upon an ideology which is
from the beginning set and tied to a station, we should rather ask
whether a completely objective and neutral point of view would be
worth striving for in this connection. Can and should works of art be
viewed and examined under laboratory conditions of sterility and im-
munity? Do not their aim and value consist precisely in the fulfillment
of ideologically conditioned tasks, in the mastery of problems which
arise from the unity and totality of the vital practice of the given
moment? The philosophy of the history of art, the perception of its
assumptions and its method put us into the position of doing more
justice to the problem of ideology, its role in the whole of culture, and
its stimulating and life-enhancing force. It reminds us that ideological
conditions of consciousness also contain positive elements. Individual
ideologies may be never so false and confusing; the wish for freedom
from ideology is only a variant of the philosophical idea of redemption
which is supposed to open to man access to a world of absolute and
eternal values, a world that is beyond history, is beyond the super-
natural, and is unendangered. It is most clear from the perspective of
art history—the relationship of the interpretation of historical phe-
nomena with the practice of actual aspirations—that there is no access
to such a world for us, that ideology is not only error, disguise, and
deception but at the same time a challenge, a desire, and a will, a view
of the past as a reflex of the present with a view toward the future.

The Position of the Artist in the Changing Course of History

The artist is in large part the product of the role he plays in the life
of society. The role changes according to the sort of master and em-

ployer he serves, the patron or the client he has to satisfy, according to the degree of independence with which he can approach his work and the immediacy of the influence he is able to exercise upon practice. But whether directly or indirectly, as a result of inner or external stimulus, as a bearer of manifest propaganda or latent ideology, he exerts an influence. In his aesthetic behavior whether productive or receptive, the practical goals which are directly connected with everyday existence are from time to time invalidated and remain suspended during decisive phases of artistic experience. This means, however, that they are only temporarily "put into parentheses," neglected, or pushed aside, but not by any means that they lose their constitutive role in the genesis or the influence of the works. Just as no artistic product, whether it be the mere making of a confession or a dialogue with an imaginary partner, comes into being with no concrete goal in mind, so no artistic reception persists which is oblivious to the self and the world in which it would emancipate itself from the reason for the creation of the intended communication and the final aim of its influence.

The *prehistory* of art begins with the inseparable unity of practical and aesthetic interests. Even in the cave paintings of the Paleolithic age, which hardly represent the first steps of all artistic activity, these two aspects cannot be separated from each other without more ado. It cannot be maintained that art merely serves life: it forms an integrating part and an immediate statement of vital practice. As an instrument of magic it fulfills a task which not merely is directed to vital care but also represents, through its daydreams, its ideals, and its magical pictures, a world which is still by no means private and completely different from empirical reality, which is alien to art. The two forms of being are not opposed to each other; the one forms the smooth, unbroken continuation of the other. Pictorial representations do not have a less real or a more significant effect than the objects of immediate experience; they count as their total substitutes, and since they are themselves capable of being formed, they rouse the belief that nature can be controlled. They are nevertheless mere artifacts, and at one time in a not too distant past people did begin, however unwittingly, to choose between more or less satisfying surrogates and more or less suitable means of influencing reality.

The production of effective artistic and magical objects was in the beginning doubtless connected with the concept of charismatic talent, and the artist-magician must have formed a personal union with the priest and the medicine man. With the development of a feeling for the mimetic character of representation—the change of the ideal picture of magic into the image of magical mimetic art—the connection between artistic talent and charismatic authority must have grown looser

without its ever being completely dissolved. The aura surrounding the persona of the artist still retains some of the charismatic quality which surrounded his ancestors. The original belief in the magical power of art does not, however, necessarily mean that artistic achievements can be ascribed only to charismatically graced persons through the whole period of magic. We can easily imagine—indeed, we can scarcely imagine anything else—that magicians and priests used profane help, the more special talent and the longer professional training the production of artistic means of magic called for. The "artist" did not have to have been viewed in any sense as a magician in order to be placed in the service of magic. Side by side with the talent for magic, which was regarded as irrational, there were a whole series of magical practices which served rational ends and which could be learned, practiced, and developed. Among these were artistic mimesis, which did not of itself contain a charismatic legitimation and did not have to be practiced by a supernaturally privileged person. The practice of magic was without doubt—especially as far as the production of magical objects was concerned—a purely pragmatic, completely nonsecret technique which had nothing to do with religion, or a numinous or transcendental being. Pictorial representation was a "trap" for the animal which was to be snared, and it was conceived of and used just as systematically as we would today set a mousetrap or take a sleeping pill.

The answer to the question, at whose behest and on whose authority the creators of artistic products sloughed off their obligation, what social position they occupied, and in what connection their activity may have stood in relation to other activities can only be guessed at, even if we assume that they became the mere jobbers for the actual magicians. A certain exceptional position, which consisted at least in part in freedom from the duties of seeking food, was almost certainly enjoyed by them. The differentiation between the magician with quasi-priestly authority and the producer of the means of magic who merely enjoyed a reputation for manual skill—which corresponded roughly to the medieval relationship between the cleric as the building contractor and the artists and craftsmen who were in the service of the masons' lodge—must have taken place at a fairly early stage of development, as works became technically more accomplished. With the differentiation between skill and mind, no matter at what point in time this took place, there must have taken place for the first time a division between the trivial piece of handiwork which was paid for in one way or another and the authority—ideologically, religiously, or politically secure—which neither looked for nor found any direct payment. The artist becomes a specialist, someone who is employed and who receives commissions.

The most important change in the history of art, and in a certain way its beginning, comes about with the partial independence of artistic form and the development of the feeling for the difference between reality and fiction, example and imitation, thing and decoration. This is a stage which is reached only after Paleolithic naturalism comes to an end and Neolithic stylization and symbolization begin. From this time on, this trait has been recognized as characteristic of almost the whole of Western art. The consciousness of the fictive nature of artistic representations and the self-deception and formal significance which are linked to the aesthetic experience belong to this concept, however closely the individual works may be connected to immediate reality, normal existence, and everyday practice. The notion of the immediate extension of reality in art never in fact completely disappeared. The legend of Pygmalion, who falls in love with the statue he has himself created, originates in a world of emotion which is related to primitive art. The whole of East Asian painting, in which a branch of a tree or a flower simply appears as a shoot or a blossom on the tree of life, without revealing any of the stylization and intensification, recapitulation and exegesis of truth which belong to Western art, confuses the border line between art and nature. Chinese fairy tales also express this spirit; in them fictional characters enter real life through a painted doorway. In all these examples, in those of historical as well as prehistorical times, the border lines between art and reality are eliminated. But whereas in the one case the lack of distance between the two areas is a fiction within a fiction and something in which we do not really believe, the unbroken continuity between original and represented reality in Paleolithic art is an unconditionally accepted fact—the expression of the fact that art is completely rooted in life and is a function of practice.

The two artistic directions, the naturalist-imitative and the geometric-formalistic, which come about in the change from the Paleolithic to the Neolithic age represented the two basic types which are from then on in competition whenever a decisive change in style takes place and around which the whole further history of art revolves. It would be a great achievement both for the theory and for the sociology of art if we were to succeed in placing a finger upon the connection between stylistic change and extraartistic conditions of existence, taking into account still unknown but doubtless uncomplicated conditions determined for the most part by practical considerations.

We cannot overlook the fact that naturalistic representations, which concentrate upon the characteristic details of objects, are replaced by totally conventional signs, almost like hieroglyphs, which are schematic and which hint at, rather than reproduce, the phenomena, that

the concrete totality of life gives way to an idealized formal essence, and that the immediate imitation is replaced by a translated symbol. Both correspond to a social and economic change, and, as a change in style in art, they divide the history of mankind into two sharply defined and clearly differentiated phases. The world of prehistoric man suddenly changes so basically that everything which went before appears merely improvised, instinctive, and almost animalistic; everything that comes afterward appears more or less to have a goal in mind. The decisive step which determined the course of history consists in the fact that man from now on, instead of living off the gifts of nature like a parasite, produces his food for himself, keeps house, and prepares himself for the vicissitudes of existence. The time of planned, organized, vital care, of work and economy in the true sense of the word begins. Man produces a supply of food, is concerned for the future, and develops primitive forms of productive installations. With the rudiments of freely available productive forces, the possession of land which has been cleared, domestic animals, and agricultural implements, society begins to be stratified into those who own property and those who do not, exploiters and exploited. At the same time work begins to be organized, functions are divided up, and trades are separated. Cattle raising and agriculture, primary production and craft, trade and domestic industry, male and female labor, tilling and defense of the land are all differentiated and are carried on separately. The whole rhythm and style of life changes. The unstable, nomadic hordes of hunters and food gatherers change into settled communities of cattle breeders and planters, and we can assume a certain stasis in the way life is carried on and in the feelings people have about it.

The change from mechanical witchcraft and magic to animism as the ideological background for this new way of life takes place simultaneously with this development. Paleolithic man did not connect his fate, his fortune, or his misfortune with any personified power playing the role of Providence. It is the farmer and the cattle breeder who first feel themselves subject in their work to forces which cannot be influenced and which do not react to any simple magic. With the consciousness of his dependence upon weather and storm, plague and drought, richness and infertility of the earth, the abundance or dearth of litters, the farmer begins to conceive of spirits and demons which will bring him wealth or poverty, fortune or curse. The spiritual world is divided into two camps, one benign and one hostile—one of helpers, whose favor lays an obligation for thanks and sacrifice upon the recipient, and one of evil spirits, who have to be placated and won over by gifts and the display of amulets and idols. There arises a need for and a corresponding production of secret means of protection and of

symbols for the prevention of evil—idols, votive gifts, and sacral monumental tombs. There is a need for an art which, it is true, tries to be just as practical and useful as that of the Paleolithic age, but which has nevertheless the hint of an invisible spiritual content and a form essentially different from that of experienced reality. At the same time there is a growing division between sacred and secular art, between art which is religiously significant and profanely decorative, between plastic idols and sepulcher art on one hand and a decorative and functional art on the other—a bifurcation of artistic tasks corresponding to the two-world system that is also developing.

Magic views the world monistically: it conceives reality as a simple, unbroken interaction, an uninterrupted and smooth continuum. Animism is dualistic: it divides the world into a visible reality and an invisible world of the spirit. Magic is entirely sensualistic and remains locked into the concrete and palpable. Animism is spiritualistic and tends toward abstraction. With a change in style from a naturalism derived from experience to a transcendental formalism and a stylized idealism of belief in the soul and in spirits, art also begins to be intellectualized and rationalized. Concrete images and realistic forms are replaced by signs and seals, abstract ideograms and abbreviated signs; the direct, palpable mode of expression is replaced by more and more indirect representations, which alter the natural forms more and more boldly. Artistic creations which are now closer to the border of the aesthetic are no longer express imitations of objects, but thought pictures. They are not so much the distillation of something which has happened and been experienced as they are the expression of something imaginary, a wish or a crazy notion—a form without substance, which is not derived from reality but imposed upon it.

The parallelism between the dualistic view of life, which conditions the Neolithic change in style, and the turn away from the parasitic, wholly consumer-robber economy of the hunters and food gatherers to the productive and constructive economy of the farmers and cattle breeders is apparent. The Neolithic farmer replaced the sensual sentimentality of his ancestors seeking their prey, with the ability to think rationally. This ability for rational thought belongs both to the prerequisites of an economy which plans, shows concern, and takes precautions and to an art which simplifies and stylizes natural forms. Everything points to the contrast between two irreconcilable worlds instead of toward a unified homogeneous being. Art with its new sense of form and order resists the earlier, everyday picture of things based on experience: it opposes nature instead of following it and no longer produces mere reflections and variants of phenomena, but contrasts them with forms of an ideal normative and sensible world.

With the reservation which is always necessary in conjectures of this sort, we may assume that the separation of a sacred and a profane art was connected with the transmission of artistic activity into different hands. The production of gravestones and the sculpture of idols was probably exclusively the task of men, whereas secular art, which confined itself to purely decorative crafts, was probably carried on exclusively by women as a cottage industry.[61] The partial metamorphosis of art into domestic industry and especially into female craftsmanship was from the standpoint of the division of labor and of the differentiation of occupations a retrograde step, for it assumed that artistic activity could be combined with other obligations. In this way, artistic activity must have lost its independence and the occupation of "artist" as an autonomous profession must have come to an end. For the practice of art not only by women but also by men must have become a subsidiary activity. It is probably true that at this stage of development practically all trades were carried on as "sidelines."[62] However, it is worth noting that art, as distinct from mere craft, already had a period of specialization behind it and only then turned into a product of leisure—the leisure of that season of the year which made almost no special demands upon the farmer and his laborers.

In all these speculations the question still remains open whether the retreat of art from independence and specialization was the cause of the geometric simplification and decorative schematization of forms or whether it rather appeared as the result of this formal development. Geometrism with its simple, very conventional patterns and motifs by no means demanded such a specific talent and complicated training as did the forms of naturalistic art which can be repeated and can only be schematized to a limited extent. If, however, the dilettantism which was now gaining the upper hand was possible only after the change in style had taken place, then it must in any case have contributed to a further simplification and coarsening of forms.

After the Neolithic revolution, which divided the history of mankind into two sharply contrasted phases, the so-called urban revolution takes place.[63] This is the next upheaval in world history, and it guides art and culture into new paths. This was probably no sudden and radical change: the town, as the social milieu of the new *Ancient Oriental* culture, has, however, only its origin, not its protoform, in village and settlement. The transition from the late prehistorical period to the early historical periods of the Ancient Orient takes place without a sharp break. In many respects, however, the end of the Neolithic age represents just as fundamental a reorientation of life as its beginning. The first decisive step for the whole future history of mankind was the transition from mere consumption to production, from the

individualism of the primitive hunters to economic cooperation. The second step was the creation of autonomous trade and crafts, of markets and their urban framework, of the combination and stratification of the population which was engaged in trade and craft. As meaningful, however, as this change may have been, Neolithic mores and animistic ideas persisted in most social structures and institutions of the Ancient Oriental world, especially in the authoritarian forms of government, with a partial retention of natural economy, the penetration of life by a religious spirit, and most unmistakably, the strict artistic style. These all existed side by side with the dynamic, antitraditional urban innovations.

The change of the greatest consequence for the new style of life and art apparently came about because the leading (historically most advanced) activity was no longer primary production, but trade and craft. The increase in wealth, the concentration of ever more extensive tracts of arable land and ever greater supplies of food in the hands of a few, created new, more diverse, and more demanding needs and led to an intensification of the division of labor and to the creation of an art which begins to show traces of a luxury character and of a high formal quality, and flawless technical perfection. The former makers of votive offerings and idols, decorated implements, and articles of jewelry move out of the framework of domestic industry and away from the limits of dilettantism and become professionals who practice art as a trade. They are not magicians or aides to magicians, not dexterous members of the household who create objets d'art in their leisure time, but independent craftsmen who chisel sculptures, paint pictures, and make pots, just as other people forge axes or make shoes, and they are for the most part valued no more highly than the blacksmith or the shoemaker.

With the concentration of the different strata of the population, the beginning of economic competition and of economic rationalism, the predominance of money as a means of barter, and the increasing changes in wealth, the town was bound to have a revolutionary effect upon every aspect of culture. In art, too, it was bound to lead to a more dynamic and differentiated style, freer from the traditional types and conventional forms of Neolithic geometrism. The essentially slow rate of development of Ancient Oriental culture merely hindered the mobilizing effect of the town; it did not prevent it. New forces of an until then unknown, even if self-conscious, individualism and a new, ever more expansive, even if it is interrupted from time to time, naturalism develop behind the rigid and repeatedly atrophying forms of tradition. These forces feed upon the urban life and undermine the static forms of Neolithic culture. It is not only the fact that the

schematism of prehistoric peasant art continues to exert an influence, especially in the early phases of the Ancient Oriental period, and produce ever more variants which plays a part in the historical play of forces; it is also the fact that the decisive bearers of culture and those interested in art, the monarch and the priesthood, do their utmost to preserve the status quo at any cost and retain unchanged the valid forms of authority, religion, and art.

The compulsion under which the artist has to work in these conditions is so oppressive that from a present-day point of view we should have to doubt whether any successful artistic activity would be possible at all. In fact, however, in the Ancient Orient even under the most fierce pressure and within the most narrow intellectual confines, we find many of the most magnificent creations of art. The impairment of artistic freedom, the political barriers, and the social taboos with which the artist has to come to terms, the conventional tasks which he is set, and the pedantic rules he has to obey scarcely impinge upon the quality of his work. Every artistic endeavor, just like every other spontaneous act, has to slip through the holes of a tightly drawn net. The inadmissibility of certain motifs or the offensive nature of their treatment, the religious or moral prohibitions which exist at any one time, the insufficient critical acumen of the public or the prejudice of decisive circles against a new and individual mode of expression are just as much permanent and determinant factors in the development of art as the originality and the spontaneity of the goals which are set. Such goals may from the very beginning accommodate themselves to the opposition by which they are threatened and absorb it as a constitutive element, or they may continue an irreconcilable opposition and bring about unconscious and impenetrable compromises. If the artist finds the opposition insurmountable and the conditions of work imposed upon him unacceptable, then he generally turns toward a goal which lies in an as yet unexplored direction, without really knowing that he has made a compromise and created a substitute. Although we generally know nothing of works whose creation has been prevented, outside limitations are apparently seldom an insurmountable barrier to artistic production. By the same token the artist just as seldom has complete and untrammeled freedom of movement vis-à-vis a particular public even in times of the most liberal democracy and the most understanding connoisseurs. The artist never escapes without making certain concessions. If compulsion and convention were of themselves opposed to art, then complete works of art could be produced only in total anarchy. In fact, the assumptions of artistic success lie beyond the alternatives of political freedom or lack of freedom, of authoritarian "compulsory" culture and uninhibi-

ted intellectual competition. Just as pointless and senseless as opting for unconditional freedom and caprice, therefore, is the other extreme, the belief, in fact, that the ties and confines are the test of the master, and that the license accorded the modern artist is to blame for the shortcomings of modern art.

Although the artist occupied positions of different rank in prehistoric society, it is in the Ancient Orient that he seems first to have become what antiquity meant by a philistine, a professional, a craftsman subordinated to society. In Paleolithic times he was partially exempted from the need to provide his own food and he was assured a special position through his connection with magic, however tenuous such a connection may have been. In the Neolithic period, on the other hand, the artist and the craftsman are scarcely separated from those engaged in primary production. The artist's first indubitably identifiable, socially differentiated, and distinguished customers and employers were princes and priests of the Ancient Oriental kingdoms, and the first artists' workshops will have formed part of their temple and palace economies. Here the sculptors and painters worked as freemen or bondsmen, as free craftsmen or lifelong slaves. This, too, must also have been the scene of by far the largest and most important part of artistic production.

Ancient Oriental art confined itself, outside of cottage industry, which was still carried on more or less in the Neolithic way, to the production of dedicatory offerings to the gods and to monuments for kings, requisites for the gods or for the ruler, monuments which were dedicated to the glory of the immortals or the glorious memory of their earthly representatives. In this process, none of the prestige of the person being eulogized filtered down to the person giving that praise. The priests let the kings count as gods in order to include them in their own magic circle, and the kings allowed the building of temples to the gods and priests so that they might profit from the religion which they themselves manipulated. They made the artists into their helpers but not their allies. Under these conditions to talk of the artist as someone who should receive recognition and thanks in addition to payment would be just as impossible as to talk of an autonomous art created from purely aesthetic motives and for purely aesthetic ends. Besides the products made for religious uses of all kinds, the demand for sepulcher art in Egypt was so great that we have to assume that the artistic profession became independent at a very early date. The practical function of works of art was, however, so obvious and their absorption in the task at hand so complete that the person behind their creation paled completely. Painters and sculptors remained anonymous craftsmen, and the few names of artists which we do know cannot be

connected with any identifiable works. The chief masterbuilder and the chief sculptor were court officials and owed their reputation to their post, but probably not always to their talent. At best, we can talk of the intellectual quality of art in the case of the masterbuilder; otherwise, the learned clerks who monopolized the ranks of the intellectual worker spoke with disdain of the triviality of the artist's work. The social discrimination against the fine arts in relation to literature which is so well known from classical antiquity asserts itself unmistakably. The irreconcilability of social esteem with the performance of manual work was probably felt more strongly in Egypt—with its hierarchical divisions—than in Greece and Rome; however, the prestige of the artist does finally grow even in Egypt. In the New Empire not only are many artists members of the higher social classes, but in many families people clung to the profession of artist for many generations as a sign of their elevated consciousness of rank. In any case, however, the role of the artist in the life of the Ancient Orient remains a subordinate one in relation both to the former artist-magician and to the later mentor and preceptor of a nation—especially the Greek poet-prophet and the interpreter of myths.

The literature of the most ancient Greeks was, as is the case with most primitive peoples, presumably to a large extent sacred mass poetry and consisted of magic charms and oracular sayings, blessing and prayer formulas, martial and work songs. The poets scarcely made any attempt to distinguish themselves from each other. The poems were doubtless anonymous and intended for the whole community. In the realm of the visual, primitive idols and fetishes correspond to magic charms and religious songs; they indicate human forms most sparingly and with their undifferentiated stereotyping also suggest a communal art as a social framework. We know nothing of the social position of artists and poets of this time, nor of the esteem which they enjoyed; but they cannot have been honored in the same way as the magicians and the priestly soothsayers of an earlier time, nor treated like the divinely inspired seers and teachers of later generations.

With the beginning of the heroic period the social position of art, and especially of poetry, must have changed fundamentally, and so must the position and rank of the poet. The secular, violently individual attitude of the martial upper class presents the poet with new tasks and imposes new values and norms upon him. Poetry loses its sacred and popular character, and the poet emerges from the darkness of anonymity. The kings, chieftains, and nobles of the Aegean princedoms of the twelfth century B.C., the heroes whose names the period bears, are pirates and robbers; their songs are secular and not pious; their ideology revolves around the commandments of thieves' honor. The

social background to the change is provided by the development of the impersonal, collective-minded— if not unconditionally communist—family organizations of prehistoric times into a sort of feudal kingdom which acknowledges personal loyalty between liege lord and vassals, gang leaders and their cronies, and which acknowledges a social ethic disavowing tribal solidarity. The literature of the heroic age is no longer a popular mass poetry, no longer group and choral poems, but individual songs about individuals and their highly personal successes and adventures. It no longer has the task, which the martial songs may once have had, of encouraging people to fight; now the aim is rather to entertain warriors after the battle is over and to praise them. The heroic epic, which displaces the religious song, had its origin in the warrior nobility's desire for fame. The content of the poems is no longer invocations, prayers, and conjurations, but stories of famous battles and the booty which was captured. The songs lose both the sacred intent and their lyrical character: they become epic and represent the oldest secular literature independent of religion whose trace is to be found in Western culture. Originally they were probably something like war reports and contained the "latest news" of the plundering forays of the tribes. Homer's singers Demodocus and Phemius are, however, no longer mere chroniclers. The battle report has developed into a legendary-historical genre and assumed an essentially ballad character containing epic, dramatic, and lyric elements. The heroic lays, which were the bricks from which the epic was built, must already have had this character.

In the beginning, the poets and the performers of the heroic epic stemmed from the same warrior and ruling stratum as the audience. They were presumably noble, perhaps even princely dilettantes. This dilettantism was, moreover, the single developmental link between the older popular, religious and the new heroic-chivalric poetry. Soon professional poets take the place of the knights who were poets and performers, bards who are certainly still vassals and subordinates of the princes and are treated by the heroes as such. The picture which the Homeric epic paints of the social position of the singer and poet is, however, by no means a unified one. The one is a member of the princely household; the other stands midway between the court singer and the popular singer, who must have made his appearance in the meantime. Apparently, as is often the case with Homer, the conditions of the heroic age are mixed with those which were characteristic of the time of the epic's final redaction rather than of the Homeric period itself. In any case, traveling poets who performed the episodes of the heroic stories for a broad public must have existed relatively early side by side with the courtly bards.

The Doric invasion represents the end of the heroic age, and immediately transformed the story of the warrior exploits of the princes and their vassals into song and legend. The Dorians are a rude peasant people who do not celebrate their victories in song, and the heroic people who were driven out by them undertake no more journeys of adventure from their settlements in Asia Minor. Their military monarchies and their pirate bands are transmogrified into peaceful latifundia and trading aristocracies. The available estates are divided among several owners, and the ostentation of the upper classes is reduced accordingly. Commissions given to painters and sculptors were in the beginning almost certainly petty ones; literary production on the other hand, which was more independent of material resources, took an unexpected upswing. The refugees brought their heroic lays from the Grecian motherland to Ionia, and here, on foreign soil, which they now made into their home, the epic developed during the next three centuries. Little is known about how it developed; we know neither exactly how much it owes artistically to the heroic lay nor how the contributions to its final form may have been divided among the different poets, schools of poetry, traditions, and generations. Above all, we do not know whether the one or the other personality intervened in the collective work, to some extent independently and decisively for the final incomparable success of the genre, or whether the singular and peculiar quality of the poems is rather to be regarded as the result of the long developmental process of transmission which was constantly being taken up again and developed and which by constantly practicing the many aspects harmonized them and became an uncommonly refined, surefire artistic linguistic medium used with great virtuosity.

Literature, which achieved a personal character throughout the heroic age as a result of its separation from every priestly activity that depended upon charismatic authority, while being practiced by singers who emerged as individuals even if they did not have individual characteristics, reveals again and again signs of collectivism. The epic, the form into which this poetic practice finally develops, is no longer the work of single autonomous poets but of whole schools of poets and poetic guilds, no matter how important the contribution of the last conclusive hand may have been for the formal unity of the poems. The Homeric epics are very much the creation, certainly not of the folk—which cannot be thought of as a spontaneous creative subject—but of a working group, that is, a group of individuals who are active singly and of their own accord, but who are closely linked by common traditions, methods of work, and means of expression. This marked the beginning of a form of the organization of labor completely un-

known in earlier literature. It was a method of production which up to that point had only been used, artistically, in the building corporations and which now found an entrée into literature in the division of labor between teachers and pupils, masters and apprentices, older and younger workers.

The change which takes place in this connection in the poet's social position expresses itself most clearly in the distance between the bard and the rhapsodist. The bard of the heroic age sang his songs in the royal halls before a princely and noble audience; the rhapsodist recites from the epic which is already composed not only at the seats of nobles and in country houses, but also at fairs and popular festivals. To the extent that literature became more popular, the performance loses more and more of the stylization and comes closer to everyday speech. The bard was the eulogist of kings and their vassals; the rhapsodist extols the fame of the nation. The former sang of the daring of the dynasts and their followers; the latter reminds us of the past, of the families which are now abdicating, and of future nationhood. The process which is underway can be described as the first phase of the democratization of the profession of poet. What the bard loses in private reputation, the rhapsodist gains in public influence. In other ways, however, the process of differentiation is still in its infancy. The composition and recitation of poems are still not independent, separate obligations; the poet often performs his own poems; the reciter has still not usually composed the works he recites. The Homer of legend stands between Democodus and the Homerides, midway between the bard and the rhapsodist. He is a strange hybrid, hard to conceive of, a priestly seer and a traveling entertainer, an inspired son of the muses and a blind mendicant singer—an eponym, the bearer of a whole literary development from the Aegean heroic lay to the Ionian epic, gradually to become the symbol of national unity.

Homer, whoever it was who bore the name and however much he may have accorded with our conception of him, probably did not at the beginning reveal many of those characteristics which he embodies for later times: preceptor of the nation, divinely inspired seer, and enlightened sage. His apotheosis apparently began with the self-advertisement of the Homerides who organized themselves into some sort of clan or guild and tried to increase their own renown by praising their master. They made him into their ancestor, so that instead of the guild which they apparently formed, they pretended that the association was a family one. The repatriation of the epic and its conclusion in the motherland, its dissemination and its change into tragedy, confirmed the fame of the poet in whose image the ideal characteristics of national genius were finally united. The legend of the heroic epic

grew, the more refined and differentiated Greek culture became, and the place of Homer on Olympus was never more assured than in the period of Alexandrian academism. The archaism of the sixth and seventh centuries B.C., the art of the nobility, already threatened in its position of power, shows a complete reversal in the choice of poetic motifs, in the manner of production and performance of the works, and in the tone and intent with which the poets turn to their audience. The new indigenous choral and philosophical lyric with its moral content which refers directly to the problems of the day arouses more interest among an aristocracy mindful of its individuality than does the imported and by now somewhat antiquated heroic legend. It is for the most part political propaganda, practical philosophy of life, and a moral philosophy, and as such it replaces the old adventure stories and the complacent botched up songs of praise. Pindar's lyric even expresses the tragic feeling for life which accompanied the changed conditions of existence, conditions that had shaken the foundations of the aristocratic system of morals, and which corresponds to the frame of mind from which tragedy proceeds as far as mood if not always motif is concerned. Pindar writes his poems exclusively for his fellow noblemen, and the amateurism he successfully simulates makes it seem at first sight as though professional literary practice, which had long been established, was re-forming. In fact, however, the decisive step toward professional literature is just now being taken. Simonides is already fulfilling commissions just as the Sophists later offered their instruction for sale. He is thus doing precisely what the nobility rejected with the greatest contempt among the Sophists. It is true that among the aristocrats there were real dilettantes who took part in the composition and performance of choruses for pleasure. As a rule, however, both the poets and the performers are professionals who, compared with earlier conditions, represent a progressive differentiation of tasks. The rhapsodist was still mainly poet and performer in one; now the functions are divided: the poet is no longer a singer, and the singer no longer a poet. Professionalism disposes of any appearance of that amateurism in the performer which still clings to the offerings of the poet who is singing out of conviction.

With the development of urban forms of life, of trade, and of the idea of competition, the individualist view of the living world establishes itself. In the Ancient Orient, where the economy, it is true, was also guided into an urban framework and was increasingly extended into trade and industry, the monopolies of the royal and the temple economies and the rooted traditionalism placed strict limits upon liberal development. In Ionia and Greece on the other hand nothing stands in the way of free competition, at least for free citizens. The emergence

of the lyric poet corresponds in literature to the beginning of economic rationalism and individualism. It is a phenomenon of the time which emerges not only with respect to motifs, that is to say, in the personal subjects of the poems, but also in the demand of the poets to be recognized as the creators of their works. It is here that the idea of intellectual property first clearly sees the light of day. The poetry of the rhapsodists was in sum a collective achievement, however individual any given achievement may have been, and was the property of the school, the clan, the guild, or whatever we choose to call the group to which the members belonged. The poets of the archaic aristocracy, and not only the subjective, emotional lyric poets like Alcaeus and Sappho, but also the authors of reflective and choral lyrics, already address the listener in the first person. Poetry changes into the subjective expression of feeling and into a direct address from one person to another.

The first signed works of fine art also derive from the period around the turn of the seventh century B.C.; the first of these is the vase of "Aristonothos." In the sixth century we encounter—fully developed—an artist of a type unknown up to that point, ambitious and emphasizing individuality. In no earlier epoch was there anything like an expressly individual style, private artistic goals, and unconcealed, self-revelatory, individual artistic ambition. Monologues—like, for example, Sappho's poems—the demand to be and remain distinguished from other artists as is expressed in the signing of works, and the attempt to express differently if not exactly better something already said are all new phenomena and presage the development which continues, apart from a few interruptions (for example, the Middle Ages), toward an ever less inhibited individualism. This tendency asserts itself in the face of great opposition in the archaic period in the Dorian cultural area. The aristocracy is essentially antiindividualistic; it substantiates its privileges by characteristics which are common to the whole class, and the Dorian nobility opposes individualistic impulses more decisively than the nobility in general and the Ionian commercial aristocracy in particular. The masters of the heroic age are driven by the urge to fame, the merchants in a trading economy by greed; both are in one sense or another individualists. On the other hand the heroic ideals have lost their attraction for the Dorian landed nobility, without the junkers' being able to see in commercial economy not a danger. but an entrancing opportunity.

The tyranny, which with its inner contradictions became the dominant political system first in Ionia and then in Greece, at the end of the seventh century B.C. leads to the final victory of individualism over family ideology and in this way forms the transition to democracy.

The tyrants are commercial princes who try, like the patrons of the Renaissance, to gloss over the illegitimacy of their rule. Their courts are the most important cultural centers of the time, and collecting points for the whole of artistic production. The customers even for works of sacred art, icons, tombstones, and dedicatory offerings are no longer the priestly corporations, but the tyrants, urban communities, and—for more modest products—wealthy private citizens. Works of this sort have absolutely no magic or healing function to fulfill, and even if they serve divine purposes, they no longer claim to be holy themselves. The process of the emancipation of art from religion has begun.

A new concept of art emerges, probably first in Ionia, with characteristics that distinguish it ever more sharply from the other constructs and tools which serve as weapons and implements in the struggle for existence. Simultaneously with the beginning of "pure" research, of learning merely for the sake of truth and accuracy, there arises an, in part, "pure" art, an aesthetic formal language which exists for its own sake and the sake of pure beauty. Mankind is at the very beginning of the extremely slow and endless process of the separation of "disinterested" art from practice. In any case, however, here are the first signs of visible rupture in the structure of a view of the world which had till then been unified even if sadly lacking in content. Here are the first signs of the disintegration of a coherent whole into different spheres and systems. From this time, art is no longer a part of the totality of life; it becomes the concrete counterpart to the other sectors of the spiritual cosmos which assume abstract forms. Art itself becomes a picture of a totality and serves as compensation for the loss of the world as a unified whole.

This process was at least partially the result of the colonization of Ionia and its effect on the life of the settlers. The alien soil must have aroused in them a consciousness of their own peculiar situation, and by perceiving and affirming their own being, they must have come to discover the idea of spontaneity and the relativity of inclinations and evaluations. This view was sharpened by contact with different peoples, and they gradually became aware of the diversity of those elements which composed the spiritual world of individual peoples, and finally also of their own. However, when we have once observed that individual peoples attribute, for example, the same power over nature to different gods and represent them differently, then we soon start to pay attention to the ways in which they are represented. We try to see things as they do, but without sharing their beliefs, indeed without linking the representations to any sort of emotion connected with faith. In this way we almost arrive at a concept of an autonomous form

independent of any total outlook on the world. The formation of self-consciousness—the concept of the subject who knows himself—is the first decisive step in abstract thought; the emancipation of single intellectual constructs from their function in the totality of life and in a unified view of the world is a further one.

The ability to abstract, which manifests itself in the separation of the forms of consciousness from one another, must, however, have received some important impetus from the conditions of production, the forms of trade, and the modes of thought of the money economy. The introduction of gold as a means of exchange, the reduction of various goods to a common denominator, the division of the barter process into the two acts of sale and purchase are mere forces which accustom us to abstract thought and which involve the idea of the same form with different contents and the same content with different forms. However, once we have learned to distinguish form and content from one another, we are not far from thinking of the two as independent of each other and from recognizing form as an autonomous principle.

Greek democracy is, like its predecessor, the commercial aristocracy of the tyrants, contradictory in more than one respect. First of all, the strata of society are no longer so clearly differentiated in their relationship to each other as the landed nobility and the unpropertied peasantry were. The situation is so complicated that not only are the sympathies of the middle class divided, not only does the urban bourgeoisie often adopt a position which vacillates between the upper and lower strata, participating, on one hand, in the struggle toward a democratic leveling out, on the other, toward the creation of new—plutocratic—privileges, but also as a result of its growing capitalist interests, the nobility loses its old mystical sense of class and comes closer to the rationalistic attitude of the bourgeoisie, which is devoid of tradition. Toward the end of the fifth century B.C., it is true, the participation of the middle class in the direction of public affairs does grow; but the preponderance of the aristocracy continues, and the only progress is that they mask their superiority and have to make at least formal concessions to the bourgeoisie. Inherited nobility is replaced by a moneyed aristocracy and the tribal state by plutocratic rentiers. The creative intelligentsia shows no particular sympathy for the lower classes; it sides with the nobility whether its own origins be noble or bourgeois. With the exception of Euripides and the Sophists, all the poets and thinkers of the fourth and fifth centuries support the interests of the aristocracy and of reaction.

Tragedy is the most complete expression of this so-called democracy: in it there are manifest most clearly the inner conflicts of the system, the contradictory nature of the social groupings and economic interests

of the social strata who are the bearers of culture. Its outer form, the public nature of the offering, is democratic; its content, the heroic legend and the heroic-tragic feeling for life, is on the other hand aristocratic. True, it is intended for a much more numerous and diverse audience than the older heroic lays, which were directed toward an aristocratic courtly society, or even than the epic, which had become more popular. It is directed, however, toward the ethos of the noble, extraordinary, aristocratic man, the embodiment of the uncompromisingly noble ideal of master and hero. The effect of the drama presumably presupposes a strong feeling for community and by its very nature can only come about as a mass experience, but even tragedy turns toward a select audience that consists at best of the totality of free burghers. It is thus no more democratically composed than that stratum of society which carries on the business of the official theater in the name of the polis. The tragedians speak for this stratum, and their task is to interpret legend in such a way as to justify and secure its class hegemony. Literature was never more unmistakably the mouthpiece of class interests, the vehicle of the conservative ideology of the ruling class of the day, and the means of combatting the progressive ideas of a developing class. The politicization of the drama reduces, in the eyes of its audience, neither the artistic nor the moral value of the genre; indeed, it is precisely in this context that the poet is often seen, probably more than at any other time, as the protector of a higher truth and the mentor of his people. After tragedy became the authoritative means of interpreting myth, the tragedian received priestly honors and enjoyed a reputation such as no bard or rhapsodist had enjoyed before him, and one which Homer himself enjoyed only in the eyes of posterity.

With the end of the classical period in the stricter sense, the language and mood of tragedy change; it approaches an everyday conversational tone and assumes lyrical accents, in accord with the general development of style, which favors naturalistic and emotional motifs. It moves in the direction of the characteristic away from the typical, from sparing use of details to an accretion of them, from reticence to exuberance in expression. Characters appear more interesting than action, complex and eccentric natures more gripping than simple and normal ones, problematic relationships poetically more productive than straightforward conflicts. In philosophy, the intellectual revolution of the Sophists which took place in the second half of the fifth century corresponds to this change: it was a revolution which destroyed the bases of a classicism which rested upon the assumptions of an aristocratic culture. Its genesis is immediately linked to the fact that we come into contact here, for the first time, with a creative intelligence

which is no longer a limited professional class like the rhapsodists of the Homeric period, the aphorists of the aristocracy, and even the tragedians of the early pseudodemocracy. It is, rather, in principle, an independent group even if it dispenses entirely with security, and one which is influential enough to give direction to the education of a democratic leadership.

The most important artistic exponent of the movement is Euripides, the only real poet of the Greek enlightenment, who by his discussion of the topical problems of bourgeois life, such as the question of slaves or women, proclaims the end of classical tragedy. This takes place not only in the sense of an unheroic view of life, but also in the sense of an essentially more skeptical interpretation of the idea of fate, which, instead of proceeding from the axiom of "the immanent justice of the world" which was still the basis of Sophocles' view, represents man as the plaything of blind fate.[64] The tragic effect for Euripides consists entirely in dismay at the sudden change of fortune, and his view, which is basically a psychologizing one, corresponds to the relativism of the Sophists. This is also linked to his interest in chance and the wonderful—something of significance for later developments.

Measured against the traditional concept of the poet as derived from his predecessors, Euripides strikes us socially as modern. Like the Sophists in general we are scarcely able to define him unambiguously. He is a professional literary figure and philosopher, a democrat and reformer, classless and socially *déraciné*. There were certainly poets at the time of the tyrants and even before who practiced their profession as a trade, but there were no independent professional groups of literati. Not only was there no suitable means for distributing the intellectual products, but also there was no free market capable of absorbing them. From a social point of view the Sophists are the immediate successors of the poets of the period of the tyranny; they, too, are constantly moving from place to place and lead an unregulated, economically insecure existence. However, they are no longer servants and parasites dependent upon a limited number of masters whose ideological principles they have to absorb, but they are connected to a relatively broad impersonal and heterogeneously constituted group of followers. They form not only what is essentially a fluid stratum, undefined as to class and not belonging to any particular class—a social group for which there was up to that time no analogue, which anticipates in many ways the structure of the later intelligentsia. Euripides' social situation is such that he belongs to this free intelligentsia with its wide ramifications which vacillates between the classes without foothold, even though in its origins and outlook it is by no means classless. Sometimes it sympathizes with the individual classes just as they are; sometimes it

shows distaste but never an unconditional solidarity and unity. Aeschylus still believed in the union of democracy and the aristocratic heroic ideal. Sophocles had reservations about the democratic idea of the state and strong sympathies for the tribal state; Euripides is presumably a democrat through and through, but he has certain reservations in principle about the state as such.

The "modernity" of Euripides also expresses itself in his relatively unsuccessful career in the theater. He was certainly not the first or the only poet, though without a doubt the first important one, whose works, as far as we know, did not strike a particularly harmonious note with their contemporary public. The explanation of this fact is not that there were so many connoisseurs before his time, but that there were so few poets. In Euripides' time, on the other hand, there was over- rather than underproduction, at least in the theater. But the theater audience was by no means composed purely of connoisseurs. This audience's unfailing sense of art belongs to the same sort of romantic fiction as the legend of the democratic nature of the Athenian festivals, which were supposed to embrace the whole folk. The tyrants and their successors in Sicily and Macedonia among whom Euripides, like Aeschylus before him, found that his patrons seem to have provided a better audience than the Athenian "connoisseurs."

The concept of genius in the modern sense, as one who appeals to posterity against the verdict of his contemporaries, is unknown to antiquity. Their poets and artists have nothing of the "genius" about them: rational craftsmanlike skill predominates over the irrational in their works. And although Plato's doctrine of enthusiasm takes full account of the irrationality of poetic inspiration, it does nothing to serve the fame of the poet who ascribes his works to divine inspiration but who stands aside from pure ideas because of the blind force which dominates him. He remains preoccupied mimetically with the imitation of obvious phenomena. The modern concept of genius places the individual above the work of the artist; personality never dissolves in its creation. This is the tragic feature of which antiquity had no inkling.

If we attempt to account for Euripides' lack of success, the explanation lies in the lack among the older nobility of ideological, and among the bourgeois of the cultural, prerequisites which would be needed to find a real pleasure in his dramas. The poets and thinkers who represented the new taste were still, just as in the high-classical time, conservative-minded, although the realism which was developing with the bourgeois forms of life did not correspond to their conservative ideology. The complex intellectual situation, with the divided solidarity of the conservative thinker and the progressive artist in one person, is expressed most clearly in Plato. His idealism is of a political,

old-fashioned kind; the artistic element of his dialogues is, however, progressive and corresponds to the style of the nonconformist, plebeian, and *mimus*. Just as every idealism, in the sense of a radical division between timeless ideas, truths, values, and worths in the world of experience and practice, presupposes a tendency to wish to persist in pure contemplation and to reject changes in reality,[65] so artistic naturalism, as an orientation to changeable reality, has within itself a tendency, if not an actual duty, to be progressive.

Plato's idealist doctrine of art represents the first "iconoclasm" in history; before that there was nothing which could be regarded as inimical to art. It is significant that the first objections to the unpleasant effects of art can be observed at the same time as the aestheticizing view of the world makes its appearance. It is this view which makes it possible for art not only to take its own place in the whole of culture but to overrun it at the cost of other areas of culture. As long as art was essentially a neutral instrument of practice which could be used as need arose and remained a form of culture which was restricted to its own area, there was nothing to fear from it. It was only as the aesthetic aspect began to achieve importance, at which point pleasure in the beautiful form is accompanied by an indifference to content, that we become aware that it can develop into a dangerous opiate. Plato's objections to art are to be explained mainly as a reaction against the aestheticism of the period of the war and postwar economy and the new private economic prosperity with its growing and indiscriminate fondness for art. All this is a symptom of the beginning of the slow change in artistic interest from the public to the private sphere of life.

Hellenism is an international eclecticism in which active commerce between nations corresponds to a leveling out of social strata, though not of the wealthy classes. In any case, an economic commonwealth develops which ensures the citizens of the empire freedom of movement and competition. Rationalism which is expressed in the tendency toward social leveling asserts itself at once in the supranational organization of learning and art and in the union of writers and scholars in one great common cultural undertaking. Just as the Hellenistic state moves its civil servants from one city to another, as capitalism emancipates its economic subjects from their birthplace and their home, so this undertaking uproots artists and scholars and brings them together in international centers of culture, chiefly in Alexandria. The independent life of the Sophists, their freedom to move where they will and independent of the polis, develops into a life-style for which a new form of community sense—a solidarity which embraces the whole educated world—is fundamental. This permits an intellectual

cooperation which up till then would have been unimaginable and an expediency of work which is based so exclusively upon performance that its principles seem to have been derived directly from the organization of capitalist economy. The objectivity of a rationalism based upon productivity and the accompanying "reification" of spiritual life, which we think of as traits of our modern alienated period which makes tasks and areas of labor strictly specialized—or which we at most trace back to the sixteenth century and the beginnings of modern capitalism—are already perceptible in Hellenic days.[66]

Hellenistic eclecticism is a result of the specialization and depersonalization of cultural activity. Artistically, it is most sensitively perceptible in the disunity and in the insecurity of the criteria of taste. The heterogeneity of trends which exist side by side increases with the lack of cohesion among consumers of art and arbiters of taste, and this is a concomitant of social leveling and of a democracy with a money economy. In large part, the capitalistically organized art industry contributes to the increase and the constant change in the number of forms. This is stimulated by aestheticism and the antiquarian interest of the period and produces a demand for art objects which changes according to fashion and which renews itself periodically. Besides the major wholesale business of the ceramic workshops, which in part actually work like factories, masterpieces of sculpture begin to be copied to an unprecedented extent. The routine of the copyists' activity then seduces the creators of original works into merely playing with different stylistic possibilities—into an eclecticism of the most diverse form.

This copyist activity and the major industry which is based upon it reach the height of their productivity in Hellenistic Rome under the influence of international Greek fashion, of Augustan classicism as its Roman variant, and of the striving for ostentatious consumption which the upper classes practice by displaying copies of the famous sculptures of the Greek masters. In the third century B.C. sculpture as the classical art *(katexochen)* had played out its leading role: the copying of sculptures gradually stops, and architectural and monumental sculpture is displaced by painting, the late Roman and Christian art pure and simple. This is also the typical form of Roman popular art, which speaks to all in the language of all. Painting had never been mass-produced in a similar manner before; it had never been used for such trivial purposes and carried on by such indiscriminate means. Anyone who turns to the public and who wishes to influence and change it does it best by a painting, which now becomes a medium of mass communication. It is a news service, an instrument of propaganda, a tool for agitation, an illustration, a film journal, and a film drama all

in one. Victorious generals have pictorial placards carried around; plaintiffs and defendants make use of them before the courts; believers offer up votive pictures which illustrate the danger they have so fortunately escaped. Finally, whatever the outcome, there is no doubt that there is something crude and childish in the desire which this expresses, of experiencing everything directly, of seeing everything with your own eyes, and of having nothing represented indirectly—of receiving nothing in that figurative form in which the essence of every artistic reflection of the truth consists.

The whole "epic" style of the fine arts, the typical pictorial style of Christianity and later Western culture, develops from this popular waxwork and film style, which had to accord with the taste and comprehension of broader and broader classes of society, and from the pleasure in the pictorial representation of more and more bizarre facts, everyday happenings, and anecdotes. The representations of Ancient Oriental and of Greek art are plastic, monumental, devoid of action, or at least with very little action, nondramatic, and nonepic; those of Roman and Western Christian art are illustrative, epic-illusionistic, theatrical, or even filmic. The works of the one consist almost exclusively of single figures, depictions of representation and existence; those of the other are historical paintings, pictorial narratives, and scenic representations. In the one case it is the strict, uncompromising principle of indirect visual depiction which dominates; in the other the concern for the naive, unpracticed eye bound to the immediately heterogeneous impression. The development from the stumbling beginnings to the first perfect examples of the new art corresponds to the social changes which are going on at the same time, as far as both the composition of the public for art and the position and function of the artist are concerned. The new representational art of the established Christian Church develops out of the popular functional painting and the crude provincial art of late Roman times, while at the same time the despised pariahs become a new elite and the daubers of poster and catacomb painting become the masters of an autonomous epic style. The oldest Church Fathers may still have regarded them as makers of idols and even the somewhat later ones as intruders who were merely to be tolerated, to be used, in order to communicate with those who could neither read nor write, but they were soon numbered among the Christian apologists and the pillars of the Church.

In pagan antiquity there is almost no change in the artist's position in society: in comparison to the poet he is thought very little of. The latter often received high honors; the practitioner of the fine arts remains, in contrast, a philistine who is paid for his craft and has no claim to anything else. The propaganda services he performs do not

in the least reduce the prejudice against manual labor. While the poet, even in the times of his complete dependence and servility, still counted as the guest of his patron, there is no attempt to conceal the fact that the artist in the narrower sense works for pay. Antiquity harmonizes the inner contradiction between its lack of respect for work and its respect for art by a strange separation of the artist from his products, a concept entirely foreign to our modern notion of genius; it reveres the works and despises the author. "Fullness of leisure" is and remains the highest good for the ruling classes and the philosophers of classical antiquity, for only the person who has leisure can achieve wisdom and truly enjoy life. The development of this ideal of life as the ideology of a class of rentiers is obvious. It expresses—as does the idea of καλοκἀγαθία—disdain for any sort of one-sidedness, every form of specialization, and expresses the distinction of being without a profession. For it is not only in Plato's eyes, in those of his class, and in those of his followers that every form of specialized knowledge and every limited professional activity is philistine and that philistinism is related to democracy; the ancien régime in France still takes exactly the same point of view and opposes in language, life-style, and mode of thought anything reminiscent of "talking shop."

In the Hellenistic period certain bourgeois forms of life do establish themselves generally and lead in part to a change in the former concepts of prestige; but work is still not in any way valued for its own sake, and there is no question of assigning a didactic value to it which would correspond to the modern work ethic. It is merely excused, and the diligent worker is pardoned. It is not until the ideals of the agon cease to be completely standard—that is, at the end of the polis as a state and social form—that we find the beginnings of a respect for work and with it a new attitude to the fine artist. But there is never a fundamental change of heart in antiquity about this. Even in classical Athens in spite of the unprecedented public significance of art, the artist does not enjoy a higher reputation or economically more favorable treatment than anywhere else in antiquity. The precarious position in which he finds himself can be explained primarily by the unfavorable conditions of work under which he has to eke out his life until the end of Greek independence. Only the polis places more significant artistic orders, and the polis is unchallenged as a patron, for no private person is able to afford the high costs of producing works of art in large format. Mutual undercutting among artists is in no way capable of compensating for the competition among the cities.

The change which takes place in the artist's social and economic situation under Alexander the Great is the result of the new function which falls to his lot because he undertakes more and more propaganda

for the conqueror. The personality cult that is now developing is to his advantage both as eulogist and eulogized. The increasing private need in the courts of the *Diadochoi* increases his value and his reputation. The intrusion of literary and philosophical culture into artistic circles is the most decisive reason for his differentiation and emancipation from the ordinary workers. By signing his works, the painter Parrhasios boasts in a manner which is so complacent as to have enraged everyone a short time before. Zeuxis acquires a fortune that would have been beyond the wildest dreams of any of his predecessors. Apelles, the court painter, becomes at the same time the confidant of Alexander the Great. Contemporary anecdotes about artists reflect in the liveliest manner the change which has taken place, and there are stories of eccentric artists which remind us of the aestheticism of the Renaissance. Finally, under the influence of Plotinus's philosophy we arrive at the "discovery of pictorial genius"[67] and at the concept of the beautiful as an essential trait of divinity, by which means art renews its relationship to enthusiasm for the divine and removes itself from the world of rationality and triviality. The parallel between the artist and worldly demiurge which Dio Chrysostomos develops gains entrée into Neoplatonism and becomes the foundation of the whole romantic-irrational doctrine of the completely creative quality of art.

The Roman Empire and late antiquity reveal a remarkable cleft in the attitude toward the fine artist. At the time of the republic the same attitudes toward manual labor and the artist's profession held sway as had in Greece up till the end of the democracy. It is only after the urbanization and the Hellenization of Roman culture, after the rule of warrior farmers in the third and second centuries B.C., that a certain change came about in the social position, first of the poet, then of the practitioner of the fine arts. In the Augustan age the change becomes clearer and it is manifest on one hand in the concept of the poet as *vates* and on the other in the sudden growth of private patronage alongside the support of art which emanates from the court. The reputation of the fine arts, when compared with literature, is, however, still slight. In the empire, it is true, the love of painting becomes more widespread in the higher social circles; sculpture, however, is still regarded as an unfashionable activity, probably because of the greater physical effort and the more complicated technical apparatus which it demands. Painting, too, only counts as respectable if it is not done for gain. For these reasons those artists who have "arrived"—as, for example, Michelangelo will one day—take no payment for their work.

Seneca still makes the old distinction between the work and the artist's person: "We pray to the images of the gods; we despise the sculptor." Plutarch, too, takes this viewpoint but speaks no more

respectfully of the poet. This equation of the poet with the sculptor is a nonclassical trait and points to the inconsequentiality with which late antiquity evaluated art, an inconsequentiality which corresponds to the social crisis.

The earliest products of medieval Christian art were works of dilettantes and dabblers. The faithful were concerned only with the new spiritual contents, not with the old formal niceties and sensual charms. The new spiritualism was, however, not expressed first in the ugly or formally indifferent expressionist forms of Christian art: it already dominated the late Roman pagan style and must have depended on conditions which belonged to the causes rather than the results of the fall of antiquity. Yet, while the rich and fashionable Romans, even in late antiquity, could still employ real artists, the poor Christian community had to make do with good intentions rather than good quality. This was all the more true since they totally refused the services of good artists, who out of sympathy with the new doctrine would have worked for little or no payment, if these artists continued to make images of heathen gods. This changed as soon as Christianity became the established church and the underground community became the official church of the social and intellectual elite. The guardians of the classical tradition were busy in numerous ways and were well rewarded. Art once more became the servant of the earthly representatives of divine power, and so the spirit of antiquity, its sensualism and monumentalism, entered into ecclesiastical art. In the mosaic in the apse of *S. Pudenziana* Jesus and his apostles are already carrying themselves like imperial dignitaries and aristocratic senators, and the time is not far off when the heavenly company will turn into a princely court.

In Byzantium this process seems to have developed so far that there is no longer any distinction to be perceived between ecclesiastical and courtly art. The personal union of the head of ecclesiastical and secular power in the form of the imperial papacy merely accelerates and confirms the tempo and the tendency of the general development. Byzantine court art simply becomes, for the next few centuries, Christian ecclesiastical art and gains a foothold in the West, because the Church in the West represents just as unconditional and incontestable a power as the *imperium* in the East, and the artistic tasks in the two places are largely the same. They consist in the expression of unlimited authority, superhuman magnitude, and supernatural means of grace. The representation of personalities who command awe and respect is the constantly repeated and ever varied object of art, and strict formalism, especially frontality, is still, as it once was in the Ancient Orient, the most important means of achieving the effect. The effect consists, on

one hand, in making the beholder take up a correspondingly respectful attitude to the imposing frontal stance of the person being represented; on the other, in the impression of deference on the part of the artist to the spectator and admirer of the work, a deference which he always imagines in the person of the emperor, his master and patron, a single being demanding and deserving respect. For the actual sense of frontality is most adequately expressed when a respectful attitude is, paradoxically, also assumed by the person for whom this respect is intended. The psychological mechanism of this identification of the subject and object of respect is the same as when, for example, the king at Versailles is the strictest observer of the rules of etiquette which are developed for him.

By remaining faithful to principles like that of frontality, every figural representation more or less takes on the character of a ceremonial painting, every biblical scene becomes a court ceremony, as in *S. Apollinare nuovo,* and every court festivity becomes a church ritual, as in *S. Vitale.* The formalism of an order of life governed by asceticism and despotism, the representational style of the spiritual and temporal hierarchy, is always the same and demands a strict artistic discipline which corresponds to the culture imposed by the Church and the court. Caesaropapism, which makes the greatest demands upon the loyalty of its subordinates, has to clothe itself in impressive forms and conceal courtly ecclesiastical service behind a mystical ceremonial in order to give the greatest stimulation to the imagination of the faithful and the obedient. In Byzantium, as never before or since, the court becomes the center around which the whole spiritual and social iife of the land revolves. The emperor is the highest protector of the arts and, so to speak, the only customer for more elaborate works of art. It was only in Versailles that art again became so completely a part of the court, without, however, becoming so exclusively royal an art; even there it remained partly an aristocratic art—that is, the expression of an ideology and a trend in taste to which the king, as the "first gentilhomme in the land," submitted in accord with the rules of etiquette to which he submitted, and which he regarded as completely binding. In contrast to this, in Byzantium, art is the instrument of ecclesiastical and courtly devotion, which seems, unlike the ideology of the ancien régime, not to be composed of more or less independent components, but to have its roots in the idea of an indivisible, unified authority.

Nothing reveals the part played by the secular power in the fate of Byzantine ecclesiastical art so clearly as iconoclasm with its primarily political motives. The religious element of the pictorial representations is reduced and suppressed the moment it no longer accords with the

interests of the crown.[68] Such censorship would have been unthinkable in the West, where during and after the migrations *(Völkerwanderungen)* the Church in the midst of the events which presaged and, in part, realized the feudal system showed itself to be the most stable force in the state. The monasteries, which were unable to withstand Byzantine iconoclasm, became almost the exclusive homes of the practice of art in the Germano-Roman world. And even later, when the power of the monarchs was growing, the influence of the crown upon art and culture is shown more outside, or beside, the monasteries than inside. The Carolingians succeed in restoring the power of the kind which had been weakened by their predecessors, but they are not a match for their vassals either inside or outside the Church. The ongoing process of feudalization cannot be halted, and even if the reputation of the king is not yet seriously threatened, he still has to demonstrate more power than he actually has. The court, as the framework of royal representation, becomes once more the setting for a play intended for the public, develops, however, at the same time into a lively cultural center. The individuality and originality of Charlemagne's court consist in the fact that there, for the first time, is a sort of home for the Muses, and as such it becomes the prototype of the European princely court. There is no precedent for it in the courts of Byzantium or Rome; it proceeds from a completely new idea of a great academy of arts and sciences under the leadership of the king. Thus, not only for the first time since Marcus Aurelius do we have a Western prince who is interested in art, science, and literature, but the intellectual activity at the court at Aix-la-Chapelle is the very first example of a European monarch's pursuing an express program of culture—whatever his final aim may have been. The movement brought about in this way not only represents the first example of a renewal of culture which is destined to bear the name of a "renaissance," but also is the first cultural period that anticipates the role of the humanists in the later Renaissance; its didacticism and its elements of publicity are aimed at increasing the reputation of its master.

The development from heroic lay to heroic epic known to us from Greek literature repeats itself in the less representative, less ambitious princely courts and manor houses which are less loyal to the classical heritage. Outside the courts, the heroic verse intended for the princes changes into a form which, because of its more extensive public even if not as a result of its origin, is called "popular" epic. The wandering singer, who disseminates epic narratives like the *Nibelungenlied* among the people, has much in common with the rhapsodist traveling from court to court, and yet he represents a more complex phenomenon than the latter. He has been described as a cross between the early

medieval court singer, who was a bard—a courtly dilettante rather than a rhapsodist, that is, a more highly trained and professionally organized writer—and the ancient mime, a popular actor independent of the official stage, which was reserved for productions of high dramatic worth. He is the first representative of popular art who is better known to us, though certainly not the first there was, and this art must not be confused with "folk-art," which derives from the genius of its audience. In the early Middle Ages the Germanic countries were flooded with *mimi*, the last representatives of the Greek theater. The court singers kept apart from them, but after losing their aristocratic audience, had themselves become something like *mimi* and had to curry favor with the lower social classes because of the selective attitude of the Carolingian Renaissance toward literature and the clerical rigorism of the time immediately following. Singer and actor, poet and entertainer now all function on the same level and are united in the person of the *Spielmann*, or wandering singer, who is at once dramatist and actor, musician and dancer, clown and acrobat, conjurer and bearmaster. The change is one of the most fundamental turning points in the history of the social role and reputation of the artist. The court poet becomes a universal clown; there is no longer any question of distinction and worth. However much recognition and honor the artist may earn in the future, he will never be able to recover fully from the shock, with which his degradation is now linked. He is déclassé, like vagrants and camp followers, charlatans and ne'er-do-wells, runaway monks and students expelled from the university—the ancestors of that problematic society of the modern age, the *Bohème*.

When, after Charlemagne, the monasteries become the intellectual centers of the empire, we have a totally new idea of the artist, and he acquires a new value which distinguishes him from the role he plays at the courts, at fairs, and in inns. Not only do the most important stimuli emanate from the monastic libraries, scriptoria, and workshops, but also the most important works of art, literature, and philosophy. Western Christian culture has the monasteries to thank for its first heyday. Even the mere fact that artistic production was carried out within the framework of regulated, mainly rationally organized concerns with a division of labor and that members of the upper class were also won over to artistic work is a service performed by the monastic orders, which now encompass the whole of the West. In the monasteries, where the nobility are now in a majority, people who had never so much as touched a tool in their lives now come into immediate contact with them. In general, it is true, manual work is still despised and seigniory means a life without labor. However, the fact that, in contrast to antiquity, beside the unbounded leisure of the seigneur,

diligence and labor are now regarded more positively is, in part, a result of the popularity of monastic discipline. True, labor in the monasteries is regarded partially as a work of penance, and there is still no suggestion that life is ennobled by it. The West nevertheless learned from the monks how to work, and whatever reproaches may be made about art as work, no one thought any longer of criticizing it on that account.

The significance of the monasteries for general artistic production also expressed itself in the fact that even the wandering secular artists and the wandering craftsmen came from the monastery workshops, which were rather like the "art schools" of their time. The participation of the monks in ecclesiastical architecture, which, until the development of the masons' lodges, was almost entirely in the hands of the clergy, was apparently very significant, although we must realize that only some of the artists and craftsmen engaged in the building of churches would have been monks. The clergy seem to have commissioned the building rather than to have functioned as masterbuilders themselves, and they seem in the case of larger and more important undertakings to have directed the work rather than to have done it. On one hand, building was never such a constant activity that it could be linked with particular monasteries; on the other, the branches of art which demanded less physical exertion appealed more to the monks than the tasks imposed by monumental art. The participation of the monks in the production of art is not conditioned merely by the type of artifact which has to be produced, but differs from period to period: in general, there is a progressive and continual secularization of labor. The overestimation of the monastic contribution comes from the period of romanticism and belongs to the process by which the Middle Ages were romanticized. Anonymity was its axiom, and the collectivity of artistic creation its principle, even in relation to the period in which the secularization of life already had to a large extent relaxed the communal organization of labor.

Christian art remained a monastic art throughout the Romanesque period and was, as such, homogeneous and stationary. Just as the cities had lost their significance with the collapse of antiquity, it was not simply production and consumption of material goods which was confined to small, dispersed rustic settlements far apart from one another—the whole of culture became rusticized. Its seats, the monasteries, represented in comparison with the towns not only much more restricted but also much more isolated centers of culture. Their self-sufficiency and isolation strengthened the conservative spirit which, in accord with the undynamic economy and the static society of the period, also dominated science, art, and literature and favored in every

way a traditionalism which held fast to recognized values. It was never more obvious that tradition and conservatism, the obstinate preservation of acquired cultural goods and the unconditional clinging to acquired privileges serve the same interests. The Church, which in all spiritual matters was the plenipotentiary of the ruling class and acted as its advocate, suppressed all doubts about the divine aim and immutability of the existing order. It brought every area of life into an immediate relationship with faith and derived—from the primacy of Church doctrine—its right to set the limits and guiding principles of artistic endeavors. It was only in the framework of an "authoritarian and forced culture" of this sort that so homogeneous and unambiguous a formal language as that of early medieval art could have developed and persisted.

There is no question about the mainly sacred character of this art, and contemporaries were scarcely conscious of a gulf between sacred and profane art; yet there can be no talk of a simple unity of the two movements in the romantic sense. The Christian Middle Ages were certainly more deeply religious than antiquity; the connection between social and religious institutions was, however, apparently even closer in Greece and Rome than among the Christians. For the ancients, state, family, and kin were not only social groups but cultural associations and religious communities. In the Middle Ages, in spite of the concern of society with the afterlife, the natural forms of society and the supernatural bonds of faith are separate from one another. The Church doctrine of the unity of the two orders in the idea of the *civitas dei* never went so deep that political groups or an association of kinsmen achieved any religious significance. The sacred character of early medieval and Romanesque art arose not because life at that time was completely conditioned by religion, for that it certainly was not, but rather from the fact that because there was a lack of courtly centers of culture and of state and municipal organs of culture, the Church became almost the only body of any significance which employed artists.

A work like the Bayeux tapestry is one of the best ways of gaining some conception of the secular art of the time. Particularly given the extent of the tasks and the extent of available materials, this would certainly not have been comparable to ecclesiastical art. It was, however, definitely more remarkable than people would be ready to admit on the basis of the relatively few monuments which have been preserved. The small number of known examples is doubtless to be explained by the fact that, in general, people paid less attention to the preservation of secular works of art than of ecclesiastical. But what is really worthy of note is that works like the Bayeux tapestry even

when they are intended as decoration for a church express a completely individual view of art, quite different from the ecclesiastical spirit. The Bayeux tapestry is apparently the product of a workshop which is more or less independent of the Church and is not a product of monastic art. The assertion that it comes from the hands of Queen Mathilde is doubtless based upon a legend: but it does point to the fact that in the early Middle Ages there was already a body of extremely talented professional artists who were independent of the monasteries. These were not only peripatetic artists or craftsmen employed within the framework of medieval domestic economy, but artists who must have been employed in larger independent workshops.

With the collapse of the feudal, economic, and social order which also marks the end of Romanesque art, we have the beginnings of high medieval money and trade economy and the development of a new urban citizenry involved in craft and trade. The move of the center of gravity of cultural activity from the country to the town is decisive for the creation of the conditions of life which lie at the root of the change in artistic style. If, up to this point, production had taken place on the great estates and the monasteries were the places around which people planned their itineraries, now it is the cities where people meet, come into contact with the world, barter, and in part produce their goods. Since the twelfth century there exists alongside the original producer not only an independent body of craftsmen but also regularly employed craftsmen and a specialized body of merchants who form their own professional class. It is the first stage in the alienation of production from immediate need, although the time of the complete abstraction of the production of goods, in which goods have to pass through a number of hands before reaching the consumer, is still far off. This "urban" form of production and consumption also has its effect upon art and results in a distancing of the artist from the contracting party, even though we still cannot talk of an artistic product of an expressly commercial character. The art of the Gothic cathedrals is essentially an urban, bourgeois art, in contrast to Romanesque, which was a monastic and noble one. Gothic, however, is the art of the city and the townspeople not only because laymen play an ever larger part in the building of cathedrals, with a corresponding reduction in the influence of the clergy, but also because the buildings would never have been built without the wealth of the cities. No prince of the Church would have been able to pay for them out of his own pocket.

An extension of the social framework, a liberalization of patronage, and the development of more modest circumstances are reflected in another area—particularly in the genesis of the troubadour lyric, which

is to be found on small estates rather than in the great royal courts and which leads, so to speak, to the satisfaction of the lord's own domestic literary needs. The more intimate circle of the small courts made it possible for the more unrestrained, more individually graded forms of chivalric culture to arise. This is certainly governed by strict conventions, for "courtly" and "conventional" were from the very beginning, and still are, interchangeable concepts. Originality and spontaneity are in essence noncourtly and are unacceptable from the point of view of class norms. To belong to a court circle is the highest distinction; to insist upon one's individuality and to trumpet one's own value abroad mean renouncing this prize. The knights created a cultural form which did not destroy the courtly idea of reserve but which created a true intellectual communion between the lord of the court, the courtiers, and the poets. The poetic courts which thus came into being not only serve to display possessions, power, and prestige, not only wish to impress, to win over, and to bind people, no longer are subsidized places of learning or mere instruments of public patronage, but are communities in which those who invent beautiful forms of life and those who realize and care for them belong to the same group of people. Yet such communities come into being only where the social and intellectual elite is not divided or where access to the upper classes is immediately available to the poet striving to rise up from below. There must also be a broad similarity in life-style among poets and audience which would formerly have been unthinkable, and the difference between courtly and noncourtly is not so much a difference in class as in education, where it is not birth and blood that make a man "courtly" a priori, but education and outlook which make him so. It is easily understandable that such a standard of courtliness could be applied only by a professional nobility still mindful of how it achieved its own privileges, one which is not a hereditary nobility possessing these privileges from time immemorial. The separation of secular from religious education coincides with the new chivalric idea of culture, which identifies literary values with social virtues. The cleric ceases to be *the* representative of culture; his role is taken over, in part, by the poet-knight.

Troubadour lyric poetry is sociohistorically the most progressive and artistically fruitful form of the new chivalric, anticlerical culture. Its conception of love, the intellectualization, romanticization, and mystification of eroticism, the metamorphosis of the joy of love into a cult of suffering and languishing, of dominion over the beloved into a humble service of love, is the most immediate and most fascinating form of that sensibility which becomes the source of the whole of modern emotional poetry. Whether or not the love of which the

troubadours sang was entirely or only partially fiction and convention, it reflects the spirit of vassalage that dominated the social culture of the time. Without the advancement of the *ministeriales* (the service and protective force) into the chivalric class and the concomitant elevated position of the poet in the courts, it would be inexplicable that this love motif should suddenly become the form in which poets were able to clothe their whole emotional life. The mere fact of feudalism is not sufficient to make the new concept of love and the unhindered pouring-out of the new sensibility comprehensible. We have to take into account the special social situation and the revolutionary role of the new, heterogeneously composed chivalric class, which was in part impoverished. Many troubadours and minnesingers were, it is true, of chivalric birth, but most of them—younger sons having no claim to patrimony—remained without estates and entered the service of a feudal lord. A considerable number of them were of lower origin, but they could, if they were talented and supported by a noble patron, be elevated without difficulty into the knightly class. These poor, *déraciné,* or subaltern elements rising up from below were evidently the most progressive representatives of the chivalric poets. Without running the risk of losing prestige, they could risk making innovations which, in the case of a more firmly rooted class, might well have come up against strong internal resistance. The first representatives of the new, open, poetic cult of love and the sudden upsurge of unbridled emotionality were to be found in this relatively unattached class. They became, thanks to their interpretation of love and the loyalty of vassalage and vice versa, the originators both of a new socioethical conception and of a new artistic form.

Even the nonnoble minstrel—who is still encountered and, indeed, in larger numbers than ever—enjoys, in spite of his social disability, unheard of freedom because of his professional connection with the chivalric poets and the new convention of poetic subjectivism. Otherwise, he could never have allowed himself to express his private feelings so frankly and freely, that is, to change from an epic to a lyric poet. Also, only because he shared the prestige of the chivalric poet could he so ostentatiously lay claim to the creation of his own works and name himself in them. Marcabru we know does it frequently and Arnaut Daniel in almost all his poems.

The minstrels, who now form part of even the more modest households, are first and foremost performers who sing and recite. Initially, they, like their predecessors, the *mimi,* who survived from antiquity, probably improvised a great deal and probably still remained both poets and performers until the heyday of the medieval lyric. But at that point there must have been some form of specialization, and the

minstrels probably at least partially restricted themselves to the performance of the work of others. The noble poets were doubtless at first pupils of the minstrels, at least as far as technique goes. The minstrels were often in the service of noble amateurs, but from time to time, especially in the course of later development, there arose a sort of vassal/lord relationship between the dilettante masters and the impoverished chivalric singers. Successful professional poets generally not only performed their own works but also appointed trained minstrels. This form of the division of labor, which corresponded to gradual social differentiation re-forms itself later on, and as a result of the process of leveling-out, there emerges, particularly in northern France, a type of narrative writer similar to what we today regard as a novelist. He is the author of novels of courtly love and adventure; he no longer writes poems for recitation, but books for reading. With the development of the novel designed for reading, a complete change in the history of literature comparable to the rise of the troubadour lyric takes place. The one is concerned with the representation of the intimacy of emotion, the other with the beginnings of the intimacy of the enjoyment of art, as can only happen in the solitude of the reader with his reading-mater.

The further sociohistorical process takes the following form: the development proceeds from the knightly troubadour and the popular minstrel as two completely different types and leads first to a rapprochement of the two and then, probably near the end of the thirteenth century, to their alienation. For then we have the permanent court singer, the minstrel, on one hand, and the wandering jongleur, now the outcast, on the other. The courtly poets develop into true writers in contrast to the unlettered minstrels, and they become the true predecessors of the humanists with all their vanities and arrogance. Beside these writers the picture of the decayed *vagans*, the cleric who ran away and the wandering scholar, stands out with corresponding clarity. As a product of the same economic and social change which with its more dynamic forms of existence produced the urban citizenry out of declining feudalism, the late medieval minstrel already displays some traits of the later *Bohème*. He is totally without respect for the Church or for authority; he is a rebel and a libertine who not only opposes the traditional rules of morality and the traditional norms of behavior, but also is opposed to his actual audience and calumniates and derides his employers. He is the sacrifice of the loss of balance caused by the dynamism of the towns and by the shift of broad groups of the population into structures which are more loosely knit and which afford more freedom but less protection. With the revivification of the towns, the concentration of mobile groups of the population

in a narrower framework, the burgeoning of the universities, and the progress of intellectual competition, a new social phenomenon is called into being—the intellectual proletariat, which had its predecessors in the wandering minstrels. The universities fill up with the sons of poor people; many cannot even complete their studies and lead the lives of mendicant performers like the wandering minstrels. Even a part of the clergy ceases to enjoy its earlier economic security; the Church is no longer in a position to take care of all the products of the episcopal and monastic schools. Nothing is easier to understand than that these victims should avenge themselves upon a society that has treated them so shabbily by turning the venom of their wit upon it.

The change from the monk-poet to the composer of troubadour lyric poetry and the novels of chivalry corresponds more or less to the route of the artist from the monastery workshop to the masons' lodge and the guild. The similarity consists in the relative freedom of movement of those involved, the still existent difference in the fact that fine artists, as members of the masons' lodge, are also active within the framework of a community of labor. The poets apart from the court where poetry is nurtured and where they work side by side but without inner contact, or in the schools of the Meistersingers where they are organized like guilds but without an inner community, neither seek nor find professional contact among themselves. The masons' lodge is still the most significant form in which artistic work was organized in the Middle Ages. The building corporations in Egypt and in antiquity had, as far as we know or can imagine, none of the inner unity of the stonemasons' lodges. The presuppositions for these were the authoritarian culture of the Christian Middle Ages, in relation to which the whole of antiquity appears as a period of despotism and anarchy. In the early Middle Ages, however, every organization of this sort lacked the mobility which became an essential part of the form they later developed. The freedom of movement of those individuals who participate in artistic production is a principle which the Middle Ages, it is true, never realizes, but as feudalisn is increasingly liquidated, it comes closer and closer into sight and it is pursued ever more stubbornly. The mobility of the stonemasons' lodge is expressed, on one hand, by the movement of the whole group from one place to another and, on the other, by the roving life of the individual workers, their comings and goings, their moves from one lodge to another. All this prepares the way most effectively for the emancipation of art from the dictates of the Church. The juncture of the artist with the guilds, just like his later emancipation from them, is only a further dialectical step in a process already begun. The builders of the Romanesque, the abbots, bishops, and landlords of the early Middle Ages, still had to

restrict themselves in their undertakings mainly to the services of their monks, serfs, or subordinates; however, after money became the normal means of exchange, free workers and those from elsewhere could be called upon to a greater extent. In this way a labor market developed which was derived from different places and was in part the origin, and in part the result, of the mobility and dynamism which dominated artistic production from that time onward. Even the guilds preserved, in many respects, the conservative spirit of the ecclesiastical institutions, but they hastened the emancipation from them by the intervention of lay elements and gained greater dynamism by not publicly opposing the dictates of the Church.

At the time of the Renaissance the artist had, for thousands of years, been performing essentially practical tasks; he had helped support life and had helped communicate with good and evil spirits as an intercessor at religious ceremonies and divine services. He had served society as prophet and seer, eulogist and propagandist, teacher and educator, entertainer and master of ceremonies. Now, after formulating and sublimating the scientific, moral, and aesthetic ideals of the ruling classes, the Church, and the elite, he becomes fully conscious of his own subjectivity and, no matter what tasks he may undertake, never loses sight of it again. It is not the consciousness of subjectivity which is new—this was always surfacing from time to time with varying intensity; what is new is the consistent pursuit of it, the intensification of subjectivity as a sense and a value in itself. True, the change is not completed in an instant. Medieval traditionalism, which opposes subjectivity just as obstinately as it does rationalism, endures for a long time and only finally breaks down, in a manner conclusive for the history of style, with the development of mannerism. The Renaissance does, however, mark the beginning of the process, and the special situation, till then unprecedented, in which the artist now finds himself is in no way more significantly expressed than in his loyalty to both the past and the present, tradition and initiative, freely selected forms and imposed forms.

Unlike the art of the contemporary royal courts, the art of the Italian city-states of the trecento was still overwhelmingly ecclesiastical in spirit and mainly devotional in the choice of subject matters it treated. It is not until the quattrocento, when art has to meet private need, playful taste, and the general tendency toward rationalization, that it assumes a more secular character. Not only do new genres evolve independent of the Church, like historical and mythological painting or portraiture, but even religious representations contain more secular motifs. The process of secularization is accelerated by the fact that in the free Italian cities of the fourteenth and fifteenth centuries it is

generally not the clergy who commission more pretentious works of architecture and art, but their bourgeois agents. These are on one hand the communes, the large guilds, and the spiritual brotherhoods; on the other, private donors, and wealthy and influential families. It is only in the middle of the fifteenth century that in addition to making donations to monasteries and churches, the bourgeoisie begins to commission large numbers of works of art of a secular nature. From this time on we find more and more paintings and sculptures in the houses of the rich burgesses as well as in the palaces and castles of the princes and the nobility. The most distinguished and most expert people in art are also not just sporadic purchasers but regular customers and collectors. The development of interest in art from the casual customer and the patron, artistically uninterested but concerned only with the good of his soul or his prestige, to the amateur of art and the collector is reflected most clearly in the history of Medici patronage: Cosimo, the builder of the churches of *S. Croce* and *S. Lorenzo,* is nothing more than a patron, protector, and donor; his son Piero begins to collect, and Lorenzo is nothing but a collector.

The emergence of the connoisseur and the collector signifies one of the most decisive changes in the history of art, a change which brings in its train not only a reform of the art market but a shift in the goals of the artist and of his role in the life of society. The systematic collector and the artist who works independently of a patron and client, taking no account of any one particular customer, are historical correlates. They appear simultaneously, face each other, and remain joined in a mutual relationship. The prehistory of this correlation covers a long period with many gaps, pauses, and setbacks. The patron or client, as a representative of those concerned with art, corresponds to a stage of development in which artistic production is for the most part on the level of craft. The art of the early Renaissance still bears in many ways the character of this craftsmanship. The artist is still bound by the commission he may receive from time to time from the ecclesiastical authority or its plenipotentiaries, or by the desire of a donor, the taste of a patron, if not merely the caprice of a testator. In this way he is in the same position as the artist in the monastery workshop and the masons' lodge or, later, in the guild workshop. His own urge to create, the subjective will to expression, and the spontaneity of creative talent all play a subordinate role in this process. The market for art is conditioned far less by supply than by demand. There is as good as no stock of finished works ready to be bought and seeking a purchaser. Works of art are produced as they are needed, since every artistic product has its precisely determined purpose and bears an immediate relationship to practice. An altarpiece is commissioned for a chapel

well known to the artist, a devotional painting for a particular wall in a particular living room, a portrait for the family gallery. Every sculpture is finished in accordance with the needs of the place for which it is intended; every magnificent piece of furniture is designed with a particular interior in mind. Whatever the artist may have thought about the duty of making his works practical and useful, at the time of the Renaissance artists thought differently about the benevolent effect of compulsion from what we do today, when the artist is free but frequently abuses his freedom. They were concerned with freeing themselves from external bonds as soon as market conditions permitted. Their independence and their self-reliance, their personal responsibility and their ambition grew in proportion to the freedom which they won from those who gave them their commissions and who confined themselves at the time of giving the commission to selecting an artist. What is involved here is an interaction, in the process of which it is hard to say where it begins and where the initial stimulus is to be found. We merely see that as the donor and the client become the buyer, as the user of art becomes the amateur, the connoisseur, and the collector—in short, the modern person interested in art as such, no longer giving commissions but buying what he is offered—the producer of works of art, formerly geared more to craft than art, changes into the artist who works more and more uninhibitedly but is ever more alienated from the public, producing works for stock and for the free market.

The rich selection of works of art of the quattrocento destined for secular use contains not only works of the earlier genres like paintings with a secular content, tapestries, and works of the goldsmith's art, but also new furnishings for the rapidly developing bourgeois domestic interiors. Among such furnishings are richly inlaid panels, painted and carved chests, elaborately decorated tondi christening plates with decorative figural representations, and other sorts of majolica work—mere means of demonstrating conspicuous consumption and revealing wealth. The decorative purpose and the aim of making an impression at all costs balances out the difference between art and skilled craft, just as the lack of differentiation between artist and craftsman did in the Middle Ages. The conception of the similarity between art and the useful arts and the idea of a personal union between the artist and the skilled craftsman, which hold good until the cinquecento, only lose their validity with the discovery of the autonomy of lofty, "pure" art. Then, for the first time, the painter begins to paint his pictures with a different consciousness from that with which he decorates chests and flags, plates and pitchers. For the artist this consciousness is the assumption of a concept of art emancipated from everyday use and of the changeover from working for the individual client to the production

of works of art for the free market, which is not subject to particular ties but which also offers no security. On the part of the consumer, the assumption for this change is to be found in the concept of an art with no particular aim in view, an art whose aim is total form, a view of art which is already very close to the doctrine of *l'art pour l'art*. The institution of the art market in the true sense, the expression of the impersonal relationship between artist and purchaser is conditioned on one hand by the objective production of goods and on the other by formalistically and aesthetically interested collectors. In the quattrocento, where only isolated examples of systematic collection are to be found, trade specifically in art and independent of the producer is virtually unknown. It is only in the next century that we can observe a constant demand for works of the past and for works of contemporary masters, who are nonetheless unknown to the purchaser. At this time agents for foreign collectors, and art dealers who buy pictures from private collections and not only directly from artists are already present in Italy, often with the intention of speculating, since they buy without a direct commission.

Next to Florence, which remains the most important center for art in Italy until the end of the quattrocento, we see the development in the course of the century, of new and significant nurseries of art in royal courts like those of Ferrara, Mantua, and Urbino. The social function of the households was to enlist support for the monarch. It had always been part of their task to impress and dazzle; but now they scarcely consider any other tasks, especially expressly political ones. The Renaissance princes want to impress the nobility and bind them to the court, but they are not dependent upon their services or their company. They can use anyone, no matter what his origin, who contributes to the attraction of the court. The Italian Renaissance courts accordingly differ from their predecessors mainly in their composition: if it is useful, they will accept even upstart traders, badly educated humanists, and plebeian artists into their midst. In contrast to the moral community of the chivalric court, a comparatively free intellectual sociability develops in these courts. This is the origin of the social forms of the salon of the seventeenth and eighteenth century and also of bourgeois social aesthetic culture.

However, no matter how heterogeneous the courtly society of an Italian Renaissance prince may have been in its origin, the Renaissance was not a culture of nouveau riche, half-educated small shopkeepers, nor even of *principi* and *nobili*, who were themselves not always better educated. It was the jealously guarded possession of a presumptuous cultural elite schooled in Latin and far removed from the people, a select group of intellectuals, which the clergy as a whole had never

been. The Christian Middle Ages were no more a period in which there was a standardized cultural community than was the period of antiquity. However, with the exception of some small groups which were formed from time to time, neither of these epochs pursued the goal of creating a cultural elite from which the majority was to be excluded as a matter of principle. This is precisely the change that takes place in the Renaissance and humanistic conception of culture. The language of the Church is Latin since the Church is continuously related to the culture of late Roman times, and Latin is simply the language of writing. The humanists write Latin on the other hand because they do not wish to intensify their relation to the vernacular languages which had developed in the course of the Middle Ages, but wish to create a cultural monopoly for themselves. Artists now make themselves the intellectual wards of the humanists after they have been emancipated from Church and guild. The price which they have to pay for their independence from the old authorities, for their social rise, and for praise and fame is that they have to recognize the humanists as the arbiters of art. They do not do badly by the trade, for if the new protectors are not always the best critics and connoisseurs of art, they do sanction the withdrawal of the artist from his role as craftsman and his rise into the intelligentsia as the class of free, independent intellectual workers. The support of the humanists for the artist is explained by the misunderstanding, shared by the whole Renaissance, which sees in the literary and artistic monuments of antiquity an indivisible unity, and which regards the fine artist of antiquity, whom his contemporaries regarded as nothing more than a philistine, as if he shared the reputation of the heaven-inspired poet. The favor bestowed by the humanists was by no means the ultimate cause of the social rise of the artist; it was itself only a symptom of the development in the course of which the imbalance on the art market between supply and demand which resulted from the increase in seigniories and princedoms began to change in favor of the artist. The latter now began to court the friendship of the humanists not in order to secure economic independence, which he had already won, but in order to justify it. For the artist the humanists represented the guarantors of his intellectual nobility; the humanists for their part recognized in painting and sculpture, which had become the leading art forms, valuable propaganda tools for the ideas upon which they based their intellectual dominion. The unified conception of art which has been current since the Renaissance, but which was previously unknown, grew out of this community of interests. Fine art and craft may still, for all practical purposes, form a very solid unity; art and literature moved in two different spheres. It was not only for Plato that they represented things

which could not be united; it simply did not occur to anyone in late antiquity or the Middle Ages to assume that there was a closer relationship between them than, for example, between philosophy and art.

The significance of Leonardo's, Raphael's, and Michelangelo's masterpieces cannot be derived unequivocally from any of the new tasks which confronted the artist in the Renaissance or from any of the possibilities he enjoyed for attaining fame. Their pretentious, heroic-rhetorical style may be explained by the new economic and social conditions; their particular, highly personal language of form, by their emancipation from the guild, from the patriarchal patron, and in part even from the Church; their virtuosity of technique, by the aestheticism of the time, the cult of beauty, and the victory of the humanists over the clergy—but the actual greatness of works like the *Last Supper,* the *Stanze Frescoes,* and the ceiling of the Sistine Chapel remains sociologically unexplained. There is no rationally determinable relationship to the stimuli which the works have to thank for their existence. In spite of their freedom of spirit they fulfill ecclesiastical commissions and have nothing in common with the independence and the genial élan of the collectors' pieces. They are only loosely connected with current humanistic ideas and the given market conditions, and there would also not have been all that many humanists capable of assessing their true significance. The great liberating trait which is common to them all is the ceremonial earnestness and the deep sense of humanity which permeates them which is hardly to be found in any other manifestations of the Renaissance. Yet these works are inseparable from the Renaissance, which is what it is only because of them. The two postclassical styles, mannerism and baroque, come into being almost simultaneously, arising out of the crisis of the Renaissance, although the manneristic tendency soon displaces the baroque and dominates artistic development from the twenties to the end of the cinquecento until it is finally replaced by high baroque. The mood of crisis, which again and again threatens art in this century, and the opposition to the High Renaissance which asserts itself have their origin in the inadequacy which is felt in comparison to the lofty, supposedly supertemporal and superhuman style of the classical period, and the feeling that this style, with its all too correct, harmonious, and apparently unendangered forms, was in this period of change not only insufficient but actually mendacious. In reality all three styles, Renaissance, mannerism, and baroque, exist side by side in this century, and they all continue—right up to the end of the period of crisis—to produce valuable, even magnificent, works of art. Thus, the development can be called, with a certain amount of justification, a historically stylistic argument be-

tween the synthesis of classical art which had become untenable and the two movements—which were extremely opposed to each other—which resolved it, spiritualistic mannerism and sensual baroque. Actually, we are dealing here with sociological rather than stylistic contrasts. The explanation which derives from the art itself, and the purely formal one, is not sufficiently penetrating. The balance which the early baroque attempts to strike in the early decades of the century between the opposing tendencies on the basis of spontaneous feeling and expressive form does not hold up. Mannerism displaces this precipitately emotional solution as a more adequate expression of the crisis, in which the higher intelligentsia is the only social class capable of taking stock of the situation and making a corresponding use of art. Mannerism is the artistic style of an intellectually aristocratic, essentially international cultural class in contrast to the baroque, which is the means of expression of groups closer to popular thought, more closely attuned to feeling, and more nationally separate. Mature baroque art finally prevails over the intellectual, emotionally ambivalent mannerism—plagued as it is with problems, contradictions, and paradoxes—after this sublimated and exclusive style proves insufficient both for the ecclesiastical propaganda of the Counter-Reformation which attempts to make Catholicism into a popular religion again, and for the political propaganda of absolutist courtly art; it has to give way to an art which expresses itself with a louder voice, in more imposing forms, and with more unmistakable symbols. The outer show of the court as we have it, especially in Versailles, suits the original character of the baroque to its particular purposes by changing its inherent emotionalism into a pompous theatricality. On the other hand, it develops its latent classicism, which had already been furthered by the partial return to Renaissance principles of style after the collapse of mannerism, into a strict rigorism of form and the expression of an unconditional principle of authority which governs the whole of society. It is this rigorous, uncompromising, authoritarian character which is the new element in the baroque, not its courtly character. For mannerism, too, especially in its later form, is essentially a courtly art and in the sixteenth century represents the courtly style par excellence. It was preferred in all the important courts of Europe to any other artistic movement. The court painters are almost all mannerists, especially in Fontainebleau, where there is already a pre-echo of Versailles.

Thus, mannerism recalls the Middle Ages not only because it is the first pan-European artistic movement since Gothic, the first great international style, but because it is the first complete example of a courtly art since chivalric literature. It owes its universal validity to the royal absolutism spreading throughout the West, and also to the

fashions of the intellectually demanding, artistically ambitious royal households. It is true that it is an internationality confined to a cultural elite which is widespread but limited to a rarefied strata of the population which gives mannerism its special stamp. The Renaissance—in the course of which the national forms of languages which were to oust Latin as the written language developed everywhere—in comparison with the clerical culture of the Middle Ages was a popular movement. In the course of its later development it loses more and more of this popular character and finally forfeits it completely in mannerism, the form in which the West adopted the Renaissance.

In these circumstances the artist has a special, and in many respects a new, function to fulfill. Even if he is often a court artist, he is never one in the sense that he has to make political propaganda by developing pomp and circumstance or having to simulate a power which the prince does not yet possess or no longer possesses. A considerable part of artistic production is, at least in the smaller courts, not produced for the purpose of cutting a fine figure, but for the personal pleasure of the prince and his immediate circle. The *Studiolo* artists in Florence, Bartholomes Spranger and Hans von Aachen in Prague, and their professional colleagues in Munich of course paint their erotic pictures not for the great rooms of state, but for more intimate closets and boudoirs. This form of painting is what mannerism to some extent was from the beginning—an art for connoisseurs, the virtuoso products of cultivated and refined artists for the enjoyment of experts and aesthetes capable of making critical judgments. It is the result of that process of artistic aristocratization and intellectualization which had already set its stamp upon the later Renaissance and which finds its final expression in the international style of late mannerism. Before taking the rest of the world by storm, mannerism had already developed in Italy into an elite social art of the ruling classes, an art which asserts itself most impressively in painting in the highly adorned decoration of interiors, in music in the playful social form of the madrigal, and in literature in the intimate secret language of the love lyric, which only a select few can understand.

There are, however, just as many much more decisive progressive traits in mannerism as there are retrograde—if that is what we want to call them; they accompany the birth of modern man and the development of his consciousness at a decisive turning point in the history of society. Luther's doctrine of predestination, Machiavelli's "double morality," the capitalist division of labor, and the growing specialization of functions are merely symptoms of a change in which the role of the artist and the meaning of art for mankind are all undergoing change. At the end of his successful struggle against the limitations

imposed by craft and the guilds, the artist is now his own master, but he loses everything which served to support him in the Middle Ages and on into the Renaissance. He can no longer rely on anything unproblematical, neither upon a secure position in a stable society, upon the protection of a profession organized in a corporate spirit, upon an unambiguous relationship to the Church as an unquestionable authority, nor upon his earlier unshakable faith in the achievements and teachings of the old masters. In the face of the intellectual rupture which is taking place, neither is he in a position to place complete reliance upon their leadership, nor does he dare to follow his own instincts, which have become unreliable. Split within himself, torn by compulsion and freedom, threatened on all sides by the bottomless depths of an abyss, discordant and wildly rebellious, inevitably subjective, and defenseless against anarchy and chaos, perversely exhibitionist, with a furtive reserve which seems to hold back something final and unspeakable, he is now the modern artist. In his work he is not exercising a talent, but wrestling with a problem and engaged in an endless struggle with technical difficulties.

The aestheticism of the enjoyment of art, the whole restriction of the reception of art to forms of collection and dilettantism, corresponds to this sort of artistic creativity. The work of art loses the aura which had formerly surrounded it: instead of that aura, it shines in the light of a cut diamond. The artist is no longer respected as an intellectual hero as he was in earlier times, and he often even forfeits the prestige of the indispensable craftsman in order to participate in the questionable honor of standing on an equal footing with the master for whom he is preparing opiates. The friendly relationships of Rudolf II and Philip II to their artists are of an entirely private nature and are only connected with minor public functions. It is precisely this intimacy, this refusal to penetrate the public domain with religious ideas and doctrines, that the Church criticizes most harshly in mannerism. The breakthrough to the baroque finally occurs—most obviously under the Church's pressure—and produces an art which will correspond to the propaganda of the Counter-Reformation and be religiously impressive. By fulfilling this and a similar political task, that of producing an apologia for, and an idealization of, absolutism, the social function of the artist changes fundamentally. This is the beginning of his immeasurable propagandistic influence, which for all his personal insignificance was unparalleled till this time; without it, the social history of the next two centuries would simply be incomprehensible. Even with the end of the Enlightenment, the revolution, and the beginning of romanticism this influence does not cease: it is more often than not underground and invisible.

Corresponding to the differentiation of style which manifests itself in the baroque in the various countries of the West according to social structure, and ecclesiastical and political organization, the function of the artist also takes on different forms which are at times irreconcilable. Mannerism, it is true, expresses an inner discordant feeling for life, but it was one which dominated the whole of the West. The baroque on the other hand shows a more homogeneous, balanced attitude to the world, but it took on different forms in different cultural areas. Because of its inner contradiction, mannerism was incomparably more complex, yet expressed the same sort of complexity everywhere. The baroque is more simple and unbroken because of its emotional character, but its unified style at any given moment is expressed in a different manner according to a particular time and place. In the royalist Catholic lands the artist has different tasks from what he has, for example, in Protestant-republican Holland. One moment he is serving an ecclesiastical and courtly display of pomp—propaganda against the Reformation and democracy—the next he is the spokesman for bourgeois realism and rationalism, the advocate of immediacy and warmth and of an unpretentious life lived within a modest framework. In both cases, however, his art shows a consistency of line and an unambiguous purpose, in contrast to the shrewd intellectualism and the emotional ambivalence of mannerism. Italian, Spanish, French, and Flemish baroque are in their formal inexhaustibility anything but simple and unified, and they are just as ideologically unambiguous and unmistakable as contemporary Dutch naturalism and just as different from the bizarre, paradoxical, enigmatic art of the mannerists.

Having in mind its goal of establishing a broad base, the Catholic church insists upon a popular, simple, and impressive art, which will convince and overpower but which should never become plebeian. The simple tone of the language of this art, removed from any learned jargon but nonetheless elevated, also corresponds to courtly taste—the levelheadedness of classicism and the objectivity of absolutism. The mixture of classic and baroque which, chiefly in France, dominates the continuing development of the history of art shows how completely the seductive and the aloof, moderation and expanse, rigor and plenitude, rationalism and rhetoric, can be combined within the limits of a style.

The function the artist has to fulfill in the service of the absolute monarch consists of tasks which were always his responsibility at the royal courts. He has to provide effective means of propaganda, vehicles for the display of power, and varied entertainment. Above all, one of his tasks is to increase the glitter and attractiveness of the court and to praise the court circle as the kernel of the nation, and the monarch

as the center of this circle. He is the administrator of public opinion and the chief propagandist, master of ceremonies and *maître de plaisir.* None of these functions are met with for the first time in Versailles. But although the function of the court artist is an institution known from antiquity, it is only in Versailles that the concept of the "court artist" acquires that sense which we connect with it and the meaning which was standard for it in the West throughout the ancien régime. What is new is the intensification of the impersonal nature of court art, the ubiquitous retreat of the private element, and reticence in all communication. Moderation and reserve are simply the courtly virtues. And just as the *honnête homme*, the nobleman as he is now called, does not display his feelings, his sorrow, and his pain, so court art renounces every form of exhibitionism, every play with feelings, all plebeian sentimentality. High courtly art wishes to be representative, not affective, nor overpowering and ravishing. The ideas and the emotions it represents should affect us just as self-evidently, naturally, and reasonably as the princely and courtly institutions, morals, and norms are supposed to. The right which is expressed seems questionable; the passions which are asseverated have no effect; the feelings, which the speaker stutters over, are morbid. The only thing which is true, real, and beautiful is what counts as such at the court in the eye of the narrow community that represents the monarch. Only absolutism, which never permitted any doubt to be expressed about its right and its duration, could maintain a compulsory and authoritarian culture of this sort. It was a culture in which the court could pretend to the power of the Church and the monarch to the infallibility (and sometimes more) of the pope. No social order, no dominion or power has ever been more appropriately named than *le roi soleil.* It was in fact as a sort of solar system with a center which could not be displaced, but which kept everything together and illuminated and transfigured everything, that people tried to imagine cultured society—or at least France as the exemplum of it. The job of the artist now was to represent this system as the only imaginable form of order, of reason, and of natural, divinely ordained, and worthy human existence.

Just as the courtly mores prescribe the subordination of the individual not only to the will of the king, but also to all the rules of etiquette and ceremony of Versailles in which the unspoken wish of the monarch is expressed, so service at the court demands the renunciation of that creative freedom which the artist had gained during the Renaissance and which he now does not know what to do with. Just as artists lose their independence, so from the outset individual works of art lose their autonomy and their sense of microcosmic unity. They become part of the unity of a castle, a palace, an interior; they become

parts of monumental decoration, parts of accessories in which it is more a question of the general *niveau* than of the special quality of the individual contributions. In applied art, the character of which the products of most artists and sculptors of this sort acquire, the retrograde tendency is expressed, in which art retreats to some extent to the position it occupied in the quattrocento, with no differentiation between "pure" and "applied" art. The form in which the artistic personality expresses itself in the most uninhibited way and in which the autonomy of the individual work is most fully asserted is literature, especially drama, a genre which develops under the patronage of the Paris bourgeoisie and the socially heterogeneous literary salons. In the *style précieux* of the salons the contorted manneristic mode of expression is preserved the longest. The bourgeois theater, however, because of its wider audience, exerts a more decisive influence upon the development of the drama than the court and the aristocracy do, in spite of the more or less courtly attitude of most of the dramatists and the nonbourgeois ideology of the classical drama from the very beginning. Yet, if the theater had been there only for the court and the salon, there would probably have been not only no Molière, with his roots in popular theater, but perhaps no Racine, with his tendency toward emotionalism. For they are, in any case, no longer court artists in the strict sense in which Colbert, Le Brun, and their protégés were.

In Flanders the artist has similar tasks to perform to what he has in France. The aristocracy here, as in France, had changed into a docile court nobility, and art for the most part takes on a courtly character, in the process of which it loses more and more of its connection with its popular origins. Here, too, art bears an official stamp, except that in Flanders it is more religious in mood than in France, a fact which can presumably be ascribed to Spanish influence. In contrast to the conditions in France, we cannot talk of the production of art in Flanders as being organized by the state and largely absorbed by the court—on one hand, because the archducal court is not in a position to pay for such an art, on the other, because the Hapsburgs do not rule as oppressively in Flanders as the regimentation of art in these terms would demand. The Church itself, which is the most important consumer of art in the country, gives the artist more freedom than in other countries, which, it is true, does not explain the emergence of a personality like Rubens, but makes it more understandable.

The decisive bifurcation of artistic directions and tasks in the baroque period, however, only becomes comprehensible if we compare French and Flemish conditions with the Dutch. Never before have artists living so close in time and place fulfilled such different social functions. In the royalist Catholic countries they become instruments of state or

ecclesiastical authority; in Holland, by contrast, they remain undisturbed by external influence except for their dependence on bourgeois demand, but the bourgeoisie as a public for art is disoriented and disorganized. The former artists pay for their security with their freedom; the latter, to purchase their freedom, become dependent upon the economy of a moody, unreliable, and incalculable market.

The development of court art comes to a standstill in the eighteenth century and is gradually replaced by the trend to subjectivism, sentimentality, and naturalism, which for the most part still dominate our own view of art. The love of the festive-representative and the rhetorical-theatrical gives way already in the rococo to a tendency toward the delicate and intimate, and by the end of the ancien régime color and nuance are already preferred to the great fixed objective form. The *dix-huitième*, it is true, is in more than one sense the continuation and the completion of the magnificent baroque. The *grand goût* of Versailles already loses its heroically unapproachable character in the regency. In the rococo, which is still an extremely expensive, select, essentially aristocratic art, the element of conventionality probably remains stronger than the voice of warmth and spontaneity, but the particular conventions which are bound to the baroque are already being replaced.

The opposition to the tradition of the whole of courtly baroque and rococo art comes from two sources: the one from the sentimentalism and naturalism represented by Rousseau and Richardson in literature and by Greuze and Hogarth in painting, and the other from the classicism founded and successfully concluded in part by Lessing and Winckelmann and in part by David and Mengs. In both tendencies—in contrast to the courtly passion for show and its arrogance—there is the expression of a puritanically artless mode of life and of an existence dominated by simplicity and earnestness. At the end of the century the only possible art is a noncourtly, bourgeois one. We come across some tendencies which are more progressive and some which are more conservative, but no lively, truly creative art determined by the rules of the aristocratic ideals of life or the courtly principles of taste.

The social role of the artist begins to change even in the heyday of the rococo. With the move from Versailles to Paris, the court, in the old sense of the term, is dissolved. Complete freedom reigns around the regent, and courtly decorum begins to appear old-fashioned. The nobility is scattered in its castles and takes its pleasures in the theaters and salons of Paris. The "city" displaces the "court" as the vehicle of culture and never allows it to assert itself again according to the rules of the *grande manière*. Art becomes more and more human, if not

more approachable; it makes fewer and fewer demands, even though it contains no fewer nuances and is no less complicated. In any case, it is no longer intended to express power and greatness, but rather to be beautiful and pleasant, to stimulate and please. The connoisseurs turn their favor from religious and historical ceremonial painting to the *galant* social picture, and the change in taste which is now taking place is most clearly expressed by the fact that the representative role both stylistically and sociohistorically that was formerly Le Brun's is now Watteau's. The genius painter which the *grand siècle*—with its state commissions, scholarships, and pensions, its academy and *école de Rome*, its royal building and decorative activity—had been unable to produce is produced by the bankrupt, decadent, lascivious regency.

The decisive change in the fate of the artist, his climb up the social ladder, and the assurance of his reputation in the public eye come about with the transference of patronage from the aristocracy to the bourgeoisie. Art was for the nobility still a means of display and ostentation, a signboard and an instrument of propaganda, decoration, and pastime. It was only for the bourgeoisie that it became the quintessence of intellectual goods, the source of the deepest satisfaction and the sweetest solace. Only for them did works of art become an indispensable part of the full life. The history of the change consists of the gradual and finally complete change of public (princely and courtly) support of art into a support dependent upon patrons and collectors. The number of art collectors, which was already in a state of constant growth in the seventeenth century, shows a marked increase in the following period. Already during the regency, even in the final years of the reign of Louis XIV, artists were more and more dependent upon the favor of private art lovers outside the court circles and finally became completely dependent upon them.

Only in England—and there only as far as literature is concerned—is there a form of public support besides private patronage, but this comes not from the court, but in the form of gifts from the government of the day and the political parties. These may have been of vital significance for the recipients; most writers, however, earned their living from the sale of their books to a reading public which was mainly bourgeois. They owed their material independence, and thus their reputation and influence, to the intellectual and social leveling-out which first made possible the education of this public, of a circle which bought and read books regularly. In this way, it is true, literature only moved away from its dependence upon aristocratic patrons into a dependence upon publishers who were anything but fashionable. Literature, however, became an article of consumption for more and more people, and this signified an epoch-making step forward. The old

aristocracy still took care for a time—whether well or badly—of their poets, who were treated as servants but whose services could be dispensed with. The change made itself known, however—long before the end of aristocratic patronage—most unmistakably in the change of interest from edifying literature, which up to the beginning of the century managed to fill nearly completely the demand for books, to worldly, witty literature, which admittedly also only slowly turned away from purely moral to more general themes.

There is no doubt that the journals, which were the most important invention of the period from the point of view of the history of culture, played the largest part in the education of the new bourgeois reading public. Initially, the mode of thought and feeling of these readers was still bound by the criteria of taste and education of an aristocracy schooled in the classics and savoring a clear, pointed, elegant, and witty style. However, they soon find pure wit vain, even laughable, and the political, socioethical, and emotional humanistic content incomparably more interesting and significant than the stylistic form in which it is clothed. The new periodicals become in the main manifestations of criticism and the vehicles of the change which is taking place. Writers, as critics of political, social, and cultural life, become the mouthpieces of public opinion, the "writers" whom the humanists had wanted to be. Before the Enlightenment, however, regular organs of the press and a reliable and constant reading public—indispensable assumptions for the existence of these literati—did not exist. Without these, a world of letters, as an autonomous professional class and a critically normative forum, was unthinkable.

The rise of a world of letters corresponds sociologically to the rise of the world of art, which, having been left in the lurch by every form of patronage—princely, courtly, and official—was responsible for itself and had to achieve its own internal and external independence. Artists achieved what is in principle an unbounded liberty of conscience at the price of total objectivization and of offering their works for sale as goods. Actually, it is only from this time on that we have an art which is *committed* and which is binding on itself. It can become committed only after it can no longer "become committed" by others. The writings of Rousseau, Voltaire, and Diderot, David's *Horatians* and Beethoven's *Fidelio* or *Eroica* as examples of this sort of committed art have no counterpart in earlier history. Certainly, even in earlier periods the artist could from time to time free himself from a service he found repellent, but it generally only remained questionable what he would do with his freedom in a world which was not free. True, even after the Enlightenment, he did not always know what to do with it and he was by no means sure that he would not fall back into the

old vassalage. His basic emancipation from alien ideologies was, however, to whatever extent and in whatever sense he made use of it, one of the most important turning points in the social history of art. He had the mere fact that he could freely commit himself, form bonds, and remain true to himself to thank for the prestige which he enjoyed and which was unparalleled in the history of his advancement, in spite of all earlier adulation and apotheosis.

The freedom of the artist—especially the writer—in England was linked in principle with the transfer of patronage to political parties and democratic institutions, and the emergence of the new periodicals and publishing houses had a practical effect only insofar as people had the right to be for or against a particular political party. In reality, writers had to be guided by the interest of the government which happened to be in power and the material means of the political parties. Literary taste and style were still determined by the ideology of the middle class, but as far as everyday politics was concerned, writers, depending upon the circumstances, represented the interests now of the Whigs, now of the Tories.

It was first in France that his own social situation, his real feelings of solidarity, and his political ideals became a decisive factor in the artist's attitude. All the representative writers of the period are, it is true, guided by the principles of the Enlightenment and of the bourgeois feeling for life. However, it is enough to recall the two most important personalities of the century, Jean Jacques Rousseau and Voltaire, to be conscious of the extent to which the one's plebeian, anarchistic, irrational emotionalism, devoid of historical roots, could assert itself alongside the other's skeptical and objective rationalism, bound to convention and tradition. That stratum of the middle class and that form of revolutionary thought which was expressed in the works of Rousseau was not represented in English literature. For the very first time the creators of artistic or literary works expressed, openly and without further ado, the ideology of the social group they belonged to, by outlook or birth, against the interests of the rulers, the class, or the circle who fed them. Although in England the proponents of the Enlightenment, in spite of their not entirely disinterested connection with governments and political parties, had, because of their revolt against the authorities, already enjoyed a reputation till then unheard of, in France the proponents only really came into their own as the "philosophers" of the *Encyclopédie* and the forerunners of the revolution. Here they change from warriors with "paper cannonballs," as they were known in England, into intellectual leaders of Western humanity. The written and printed word never enjoyed greater

power; never was the belief in the power of thought greater, the trust in the amelioration of the human lot more unbounded.

The struggle for liberalism and democracy was by no means restricted to political, social, and critical writing. The moral bourgeois novel of family life, and especially the bourgeois drama, sought the same goals. They, too, were a part of "political writing"; they were all moved by the same questions; all literature was to some extent propagandistic. Even the problematic which was expressed in opposition to Rousseau's anarchistic emotionalism and Voltaire's disciplined rationalism asserted itself on all sides, and the ethos of the drama, especially, was not left unaffected, least of all in Germany. Yet, no matter how definitely bourgeois in tone the authoritative literature of the Enlightenment may be, its bourgeois spirit is not always unified and unambiguous. The German intelligentsia already started playing its subsequent double game in the Enlightenment, when it sometimes showed enthusiasm for the revolution and sometimes for conservative romanticism and contributed a lot to awakening doubts among the bourgeois about the justice of its demands. It invented the idea of a "suprabourgeois" ideal of and feeling for life and instilled into the bourgeoisie the consciousness that it had overcome itself in order to raise itself up to a higher level of humanity. But on the whole, when people were talking about "suprabourgeois" values, theirs was the determination of a conservative prebourgeois ideology. There was often a highly complex psychology involved. In Schiller's *Kabale und Liebe*, for example, three generations and three different philosophies of life are involved in the process. Besides the prebourgeois courtly circles, which represent the principle of social evil which has to be fought, the two worlds of Louise's bourgeois family and Ferdinand's suprabourgeois world are contrasted.[69] In *Don Carlos*, where Posa with his suprabourgeois ethic not only goes so far as to understand the "unhappy" king but even manages to evoke a certain sympathy for him, the relationships are even more complicated. It becomes ever more difficult to decide whether in this "suprabourgeois" attitude we are beholding a bourgeois victory or a simple betrayal of the revolutionary ideals of the former *citoyen*. In any case, the attacks upon the bourgeoisie and the revolt against bourgeois morality and way of life belong almost from the beginning to the idioms of the bourgeois drama and remain as such until Shaw and Ibsen. They are strengthened to the extent that bourgeois literature as a whole becomes antibourgeois.

The doubts the writers and thinkers of the Enlightenment entertain about the validity of the values which are linked to the concept of the bourgeoisie more or less originated before they had been properly formulated in literature. In this process, however, the role of writers

in the life of society also changed. They ceased to be the spokesmen for their bourgeois public and to determine the principles by which that public had to judge practical problems. They changed from being the lawmakers who determined the criticism the bourgeois public had to make of society to being the critics of the bourgeoisie itself. The honeymoon between the creative intelligentsia and its new masters ended; there followed a stormy marriage, which dragged on and on and refused to dissolve. Goethe still fought the remnants of the cult of genius which stemmed from the Sturm und Drang—a sort of concubinage between the writer and his public—and finally worked through, in *Wilhelm Meister,* the transition from an aesthetic, hedonistic view of life to the ideal of a bourgeois, realistic, active, and useful life. The romantics, however, from the very beginning display the idea of genius and display nonbourgeois traits—this explains Goethe's dislike of them—and Stendhal pronounces his hatred and contempt for everything Goethe may have understood by the "earnest conduct of life."

It has been asserted with a certain justification that the revolution was artistically sterile and that what little art was produced confined itself stylistically to the completion of that classicism whose beginnings went back to the last phase of the rococo. But the actual artistic expression of the revolutionary spirit is not captured by the classicism of David or Chénier, but by the *romanticism* which it first paved the way for. The revolution itself was unable to realize the new style which was suited to it; it expressed itself, rather, often mediately and frequently somewhat awkwardly, in the old forms. The new formal language, which is suited to the events, originated not as a direct expression of the new system but only as the result of the discussion the following generation engaged in with all its problems and puzzles. Art remained, as Marx already noted, behind political development.[70] Poets and artists are not prophets, nor were they prophets at the time of the Enlightenment and the revolution. They were at best good observers who guessed the direction developments would take, or accoucheurs who sped up the process. What is otherwise expected of them is pure mystification. Art often limps along behind the times; it never runs ahead of them.

Romanticism, too, which the revolution paved the way for, rests, it is true, as does the classicism which it terminated, upon an older, related trend. The later romantic movement has, however, less in common with its forerunner, preromanticism, than revolutionary classicism which has its protoforms in the rococo period. Only the irrationalism of preromanticism, certainly not its sentimentality, survives the revolution. What the revolution changes most fundamentally in the area

of aesthetics is the artist's intrapersonal role and the justification of his presumed privileges. Intellectual freedom no longer counts as a privilege of genius, but as the birthright of every talented individual. Every personal statement is unique, incomparable, and irreplaceable; every one carries its own standards and laws within itself. This insight is the most significant achievement of the revolution insofar as art is concerned. The whole of modern art, as a victory over unconditionally and universally valid authorities, conventions, and traditions, is thus the result of the revolution and romanticism. From this time on, the artist, no matter how unconditionally he may espouse movements, schools, or comrades in outlook or arms, is completely on his own from the moment he begins to write, compose, or paint. This feeling becomes the unfailing characteristic of his being. From the romantic period on, art is the language of the lonely man, alienated from the world, seeking and never finding sympathy. He expresses himself in the form of art because—tragically or blessedly—he is not to be confused with his fellow beings.

The special sociohistorical significance of the romantic artist lies in the fact that in the ideological argument with his opponents he speaks for the first time as artist to artist as such. He may earlier, it is true, have expressed his own class consciousness, his economic and social aspirations, but he always allied himself with the interests of a broader and more influential stratum. And if his patrons and masters sometimes even went so far in their aestheticism as to admit that art was its own master, this was always an admission which did not bind them and was never meant literally. The romantic, on the other hand, when thinking of art really thinks only of himself and his fellows. He is the first to create an art for artists, so that the boundaries between the creation and reception of art become blurred and the creative individual can either identify himself completely with the public or separate himself from it irrevocably. In spite of the radical aestheticism which begins with romanticism, the conflict between the two was never so sharp but also at the same time never so veiled as it is now that they have to let the principles of laissez-faire and independence assert themselves reciprocally in order to preserve the basis of their existence. The paradox of their love-hate relationship in the period of liberalism and democracy comes from the fact that they would undermine their own existence if they were to deny the other's right to be free.

The aestheticism of the public is the reverse side of the artist's dislike of the public, a masochistic perversion with which it provides a scapegoat for the other and succumbs to his dislike. If we perhaps see the high point of the artist's advancement in the glorification of Michelangelo, we fail to recognize that there is something unreal about the

cult surrounding him and that the "divine" master, by removing himself from every measure applicable to human beings, assumes the character of being unrelated to practice. In the romantic period, the poet and the artist are certainly far from being respected in this way and they no longer even enjoy authority as the authenticated critic and adviser which they were accorded in the Enlightenment. Yet they do embody an ideal of life that men pursue hypnotically but without affirming it. And the romantic is admired not only as the creator but also as the hero of works of art: in spite of the misfortune which is part of his aura, he is envied. The artist joins the ranks of princes, knights, saints, and amorous heroes, the exemplars of the unusual, interesting, enigmatic person around whom legends, sagas, adventures, and love stories are spun. Almost all the heroes of the novels and dramas of the nineteenth-century authors, from Balzac to Ibsen, are "interesting" characters of this sort, enigmatic neurotics related to the romantic poet, and there are also those who, like Eugène de Rastinac and Frédéric Moreau, have nothing to do with the life of art, or like Wilhelm Meister and Heinrich von Ofterdingen, first proclaim the arrival of the new type. The main figures in Thomas Mann's work shine in the light of romanticism with the problematical, even pathological, nature of their sensibility and the intensity of their suffering. The romantic without help or support is in the forefront of the struggle against mechanical routine and the empty conventions of bourgeois existence: his claim to honor is his vulnerability. The values used to be the other way around: once Philoctetes bore the wound, not Homer; the blindness of the poet stood for the inner light in which the world revealed itself to him.

The century's most significant changes from the point of view of cultural history, romantic disillusionment, the beginnings of *l'art pour l'art* movement, the idea of an art for artists, the justification of life as an artistic experience, and the rise of the artist who bears his unsuitability for life with pride and with a halo are merely reactionary phenomena. They are forms of disappointment which a postrevolutionary generation, seemingly deprived of its rights, feels about the outcome of the revolution. The lack of political influence which had up to this time been the lot of the German intelligentsia now becomes the fate of the whole intelligentsia and fashions out of romanticism, irrespective of its national variants, a universal Western phenomenon. The young people deceived in their expectations, whose state of mind is so touchingly depicted by Stendhal, take shelter from political reality in the past and in utopias, in mirages of longing for insensibility and irresponsibility, in illusions, the opposition to which was among the Enlightenment's highest moral goals.

The crisis of romanticism marks one of the sharpest changes in the variegated history of the social role of the artist, of the constantly changing relationship between the creator of icons and pictures of the gods and the priesthood, the court artist and the prince, the poet and the patron, the autonomous master creating his works of art and the anonymous collector, the professional writer and the reading public with its fluid limits and vacillating expectations. In no previous age had there been such a revolt of the artist against society, so fundamental a refusal to participate in the performance of even the simplest tasks, and such an antipathy to bow to any authority. It probably happened that under cover of a conformist art, the artist concealed a nonconformist attitude. The nonconformity of romantic and postromantic art is, however, without parallel in its unruliness. Its most remarkable characteristic is certainly not its opposition to the bourgeoisie, long after the aristocracy had ceased to play a role as an intellectual force. What is more remarkable is that antibourgeois romanticism is itself essentially a bourgeois movement; indeed, it is *the* bourgeois art movement. It is the movement which finally clears away the conventions of classicism, court art and rhetoric, the elevated style and refined attitudes. Whenever the literature of the Enlightenment had praised and extolled the bourgeois, it had always done so with a barb of polemic against the upper classes: the bourgeois does not become the obvious standard of human behavior until the romantic period. The fact that so many representatives of the movement, certainly at the beginning, are of aristocratic origin makes as little difference to its bourgeois character as does the antiphilistine, anti–middle class attitude of almost all later romantics. The modern West in the whole of its art and literature is romantically bourgeois and antibourgeois in the same complex way that its capitalism, imperialism and bureaucracy, courts of justice and educational system produce on one hand the Enlightenment and the revolution, and on the other Restoration and reaction.

In spite of the contrast in principle between romanticism and naturalism, a contrast that is irresoluble both stylistically and philosophically, nothing significant alters in the social role of art and of the artist in the passage from the one stage of development to the other. The break between the two epochs is so blurred that we can hardly decide in the case of writers like Stendhal or Balzac which movement they actually belong to. The ambiguity of the situation lies in the fact that it is precisely in the works of writers such as this—hard to define and operating at the limits of different areas—that we feel cut off from the past; this is not the case in the works of Chateaubriand, Coleridge, or Hölderlin for example. The stylistic watershed between reflections of reality that have passed into history and those that have remained

current is without doubt romanticism. It is only afterward that art becomes the expression of total alienation, of the irreconcilability of the differences between reason and feeling, practice and contemplation, individual and society. And in spite of this, the modern era does not begin for us with the works of the first romantics, but with novels like *Le rouge et le noir* and *Père Goriot*, that is, on the border line between works which relate to us immediately and older ones, which, however much we may admire them, demand a special approach and effort in order to be understood and adequately evaluated. Modern literature begins with the story of people who are already our contemporaries—even if, from Julien Sorel and Lucien de Rubempré to Charles Swann and *Der Mann ohne Eigenschaften*, little changes in their romantic character, homelessness, and disappointment.

The artist's antipathy to the bourgeoisie also remains unchanged in the passage from romanticism to naturalism, as does his antagonism to the philistine for lack of patience and interest in art, although the relationship of most important writers to the different strata of society remains uncommonly complex, masked, and mediate. What appears most remarkable is that the struggle against the bourgeoisie joins a struggle against romanticism, when the attack upon the bourgeoisie, in the sense in which we here mean it, was launched by the romantics. Antiromanticism lasts from the generation of 1830 till the end of the century; it accompanies the development of romanticism, corresponds to its changes, and reflects its metamorphoses. The contrast which begins with Stendhal's vacillation between *logique* and *espagnolisme* and Balzac's ambivalent attitude to the bourgeoisie with their vacillation between rationalism and irrationalism becomes more and more acute in both directions in the works of Flaubert. He fights against the romantic in himself just as mercilessly as against the bourgeois world around him. Mallarmé and Valéry are still determined by this contrast.

Just as romanticism shook itself free from the sentimentalism of preromanticism but held fast to the primacy of feeling in human things, so Stendhal and Balzac cast off the legend of the Middle Ages and of Spain, and the later naturalists cast off the cult of the past but remained just as full of antipathy to the bourgeoisie as to the romantics. In any case they validated in more than one respect the ideology of the class to which they belonged and which formed their public. They did this not only in the sense of Engels's "triumph of realism" while feeling obliged to recognize the services of the class which they hated, but also by allowing the style and tone of their art to be determined by the ideology against which they thought they were struggling. They had visions of a sociological and psychological naturalism which fol-

lowed the assumptions and rules of the system represented by the bourgeois rentier class.

They have lost the unique position and the unprecedented influence of Enlightenment writers and are no longer their readers' leaders or teachers, but merely their allies always ready for revolution. Once again they have proclaimed a more or less ready-made ideology, just like the writers before the Enlightenment. Now, however, they have to represent the liberalism of the by no means free-thinking bourgeoisie—which develops from the Enlightenment although it travesties many of the Enlightenment's ideas. The only remarkable thing is the extent to which they manage to do this without consciously identifying with their public. Even writers of the Enlightenment could regard only a part of their reading public definitely as disciples and were conscious of facing a partially hostile and by no means harmless world, but they *were* in the same camp as their readers. Even the romantics, too, still felt themselves, in spite of their alienation from bourgeois society and in spite of their homelessness in postrevolutionary Europe, more deeply allied to one or another stratum, and thought that they knew which group or class they were to stand up for. We can scarcely say this any more of a writer like Stendhal. With which part of society would he have felt a solidarity? At best, with his "happy few"—the lonely, *déraciné*, and vanquished, the proud and the cunning. Or do we know more about Balzac's loyalty? Was he on the side of the nobility, the bourgeoisie, or the masses—with the class to whom, in spite of all his sympathies, he leaves his fate, or with the class whose vitality he certainly admires but which repels him, or perhaps with the mob whose immense power terrifies him? Neither of the two has an actual public, neither the successful Balzac nor the unsuccessful Stendhal.

Just as everyday life takes on an ever more obvious political hue and the division of society into parties becomes more and more widespread, so a progressive politicization of literature takes place between the last two bourgeois revolutions, in 1830 and 1848. What is new is not, in fact, politicization itself—for literature had almost always been "political" in the broader sense, and at least since the Enlightenment it had been so in the narrower sense. Rather, what is new is that politics are expressed in literature manifestly rather than latently, that is, in the form of direct propaganda as in the period of absolutisms and despotisms, instead of in the form of an indirect ideology. In this connection, too, the Enlightenment marks a transition, when the political goals pursued by art and literature were hardly disguised any longer. The decisive change, however, only occurs when there are almost no more politically indifferent works and even the avowal of

aestheticism takes on a more and more quietistic character. Nothing expresses the new situation and the writer's new function in the life of society more clearly than the link between political and literary careers. People who choose politics or literature as a career are now for the most part members of the same social stratum. Literary talent is one of the prerequisites for a political career, and political influence is often linked to literary success, just as Balzac depicts in his works. The politicians who are active as writers and the politicizing writers of the July Monarchy—the Guizots, Thiers, Thierrys, and Michelets— are the last heirs of the "philosophers" of the Enlightenment. They mark the end of a long and praiseworthy epoch in the social history of literature. The authors of the next generation have no political ambitions and the politicians no more literary influence. Up until 1848 politics remained the rallying point of the intellectual powers. Journalism is the usual way writers begin and the framework within which they write. Bertin, the editor-in-chief of the *Journal des débats,* is the personification of that triumphant journalism which governed the public life of the July Monarchy. He belongs to the first and the most influential directors of the "industry" into which literature, as Saint-Beuve had already recognized, had now developed.

The writers, especially the novelists, had to provide the newspapers with material for their *feuilletons* or else renounce any regular income. If they did not live from their pensions or did not wish to become literary hacks, they had, like Stendhal, to earn their living by some other form of activity, in the course of which artistic activity, as in seventeenth-century Holland, became a secondary activity. Literature was in danger of becoming either a mechanical product responding to demand as it was even in the case of Balzac, or a quasi-aesthetic amateurism as it was for writers like Flaubert. Up to the middle of the century *l'art pour l'art* movement is still so undeveloped that apart from a small, extremely romantic group no one takes exception to seeing art pressed into the service of politics. The political passivity of early postrevolutionary romanticism is for the most part overcome, and late romantic aestheticism comes to the forefront only after 1848. Up to this point, the thesis of Mme de Staël that literature is the expression of society and the principle that a literary work must be criticized in connection with the political and social problems of the day find general approval. In any case there was never so little abstractly formalistic art criticism carried on as at this time.

The most obvious change in the last century and the one that had the deepest influence upon the development of Western culture is that most works of art and the most important ones were activist in nature up to 1848 and quietistic after that. Stendhal's disillusionment is ag-

gressive and sharply opposed to the ruling social order; Flaubert's resignation is passive, self-destructive, and nihilistic. After the July Revolution the majority of romantics become disaffected on one hand from their earlier clerical and legitimized politics, and on the other from the illusion of "pure art." The leading personalities profess artistic activism and put themselves into the service of a "popular" art. It is not only George Sand and Eugène Sue who maintain that they are socialists, not only Lamartine and Victor Hugo who believe that they are speaking for and in the interests of the people; Scribe, Musset, Mérimée, even Balzac flirt with socialist ideas. But to the extent that the July Monarchy renounces the democratic-revolutionary principles of its original politics and becomes the government of the conservative bourgeoisie, so the romantics become disaffected from socialism. They give up their fiction of a popular art and pave the way for the toning down, the regulation, and the rendering of romantic ideas bourgeois. Under the leadership of Hugo, Vigny, and Musset an academically conservative and modish variety of romanticism develops: it outgrows its wild, aggressive rebelliousness, and the bourgeoisie accepts without reservation the tame, harmless trend which taste now takes. Those strata to whom romanticism still does not seem quite the thing favor the products of a new, sober, insipid classicism—plays and novels of the aesthetic *juste milieu* which represent the victory of Scribe, Ponsard, and Dumas over Hugo, Stendhal, and Balzac, and paintings of the *école de bon sens* which are preferred to the daring of a Delacroix. The saturated, half-educated bourgeois wants no shocks or enlightenment from art, merely entertainment and a way of passing the time. After Ingres there is an endless succession of often correct but mainly tedious academic painters, and after Dumas and Ponsard an equally long file of trained writers for the stage, who keep the state and municipal theaters supplied. People who up to this time had hardly counted as consumers of art now form a considerable part of the reading public, playgoers, and people interested in painting: but they want nothing but their unassuming diversion and their undisturbed recreation. Inasmuch as they set the standards of the demand for art, they represent one of the deepest rifts in the history of artistic taste.

L'art pour l'art movement, which developed out of romanticism and which, as a form of the effort toward emancipation from antiartistic considerations, initially represented nothing but a part of the romantic struggle for freedom, gradually became the manifestation of passive resistance against the prejudices, hypocrisy, brutalization, and obduracy of the bourgeoisie, which had now "arrived." The romantics saw in *l'art pour l'art* doctrine merely a protest against the rule of practical, rational, and moral principles in art. Gautier and his followers fought

under this slogan simply and solely for the freedom of the artist from utilitarian goals. When, however, Flaubert, Baudelaire, and the Goncourts enter the lists in support of the autonomy of art, it is no longer simply a case of merely preserving poets and aesthetes from the impertinence of playing tutor and moralizer but a case essentially of their protest against having anything in common with the bourgeoisie. They now refuse not only to play this or that particular role in the bourgeois world, but to play any role at all. They retreat into the desert, not because they have been excommunicated by the bourgeoisie, but of their own free will.

Stendhal and Balzac were unflinching critics of the society of their time, heirs to the Enlightenment, who still believed in the effectiveness of their message. Flaubert on the other hand no longer believes in trying to come to an understanding with his public; he renounces not only any practical effect but every real intellectual contact with most of his readers. The latter, however, scarcely notice his dislike. The aggressive individualism in which the romantics cloaked their opposition to the postrevolutionary bourgeoisie has fundamentally changed. The pugnacity of the "League of David" has subsided, and the enemies of bourgeois life still emphasize their difference from the society they confront. After 1848, at the end of the period of revolution and its results, the leading writers, both the Parnassians of every stripe and Olympians like Flaubert, refrain from every pronouncement—even one latent in the most peaceable individualism—against the sober and unfeeling bourgeoisie. They veil themselves in a demonstrative lack of sensibility and in impersonality, a disguise which is not the sign of a return to preromantic objectivity but, rather, the most extreme and overweening form of individualism, the expression of a frame of mind in which the subject disdains to unbosom himself.

Nineteenth-century naturalism is, in many respects, nothing other than a form of romanticism using different means and modified conventions. Art remains the expression and effect of the same disappointment which overcame the intelligentsia after the partially unsuccessful revolution and the failure of the bourgeoisie as a liberal class. The only thing new in naturalism—sober as people now were—is the wish to keep "to the facts and nothing but the facts." Within this unified outlook, style is differentiated in two directions according to the difference in social origin, economic situation, and political aspirations of its practitioners: into that of the *Bohème* artists, usually plebeian and without means, like the Barbizon painters and Bourbet and his followers, and into the rentiers, as Flaubert and the Goncourts were called. Both are conditioned by the same political processes, and both take an equally negative attitude toward the circumstances which

confront them; the tasks, however, which their representatives derive from the given facts are—according to the circumstances of their class and property—completely different. In contrast to the despicable passivity of the rentiers, the art of Courbet and Champfleury is filled with a revolutionary pathos and a reformist optimism, which have their origin in the Enlightenment's faith in the future. The protest of the aesthetes is an empty gesture and means, for all its keenness, a resigned acquiescence in things as they are. In the other camp, activism expresses the conviction that naturalism, as Champfleury asserted, is the movement which corresponds to democracy and that naturalism and socialism, artistic and political revolts, as Proudhon and Bourbet asserted, merely represent different forms of the same ideology and conduct of life. Zola still represents this doctrine when he solemnly cries, "La République sera naturaliste ou elle ne sera pas." The realization of naturalism in day to day politics bears witness to the fact that with its rise in the stricter sense, art and the artist begin to assume a new position in the life of society, although their active role, their immediate connection with the politically progressive movements, is restricted to a relatively small circle and an uncommonly short period. Yet a certain liberalism forms part of the whole movement; Flaubert, Baudelaire, Maupassant, Zola, and the Goncourts are, for all the differences in their political opinions, completely one in their nonconformism, their protest against the rigid bourgeois establishment, and their antiregime incorruptibility. None of them will permit himself to be an open partisan of the narrow-minded bourgeoisie. The creative intelligentsia turns as a group and without reserve against the members of its own class.

Although from the point of view of the history of style *impressionism* merely represents the completion of naturalism, it nevertheless represents an unmistakable breach with the fundamentally rationalistic outlook on the world which the naturalists in general and the activists and socialists in particular espoused. Even the political passivity of the aesthetes of an earlier generation became rigidified, although most of them led a proletarian existence and Manet and Degas are in this respect among the exceptions. The bitterness, however, which still pervades Flaubert's generation gives way to a political indifference which had been unknown since the end of the ancien régime. Artists as a group had gotten entirely out of the habit of meddling in practice and of exerting influence on extraartistic matters. The behavior of the impressionists toward the public is, however, even in purely artistic matters, completely devoid of aggressiveness and intransigence. The tendency toward contradiction and the wish to bewilder are further from their thoughts than from those of many naturalists, and if they do put people

off, it is only as a result of the difficulty of the new idiom they are using. A naturalist like Courbet enraged the bourgeois public not only because of his unaccustomed formal language but also because of the triviality of the subjects he chose to represent and the plebeian immediacy with which he presented them. Impressionism is, in contrast to this lack of distance, an "aristocratic style" without any vulgarity; it is tender and elegant, sensitive and nervous, epicurean and sensual, seeks precious nuances and select experiences, suits itself to the taste of connoisseurs and epicureans. It also gradually loses its connection with the empiricism and materialism of the naturalists and, first in literature and then also in painting, expresses a spiritualistic reaction which corresponds, in its completely aestheticizing formalism, to political conservatism, and to which the artists as a group adjust. The impressionists, however, bother less than the artists of the older generation not only about political and social questions, but also about general intellectual and aesthetic ones as well, although one or another of them, Degas especially, is a far more refined and differentiated thinker than Courbet, for example. Generally speaking, they are more one-sided and more simple, more exclusively craftsmen and specialists than their predecessors, they are more complete representatives of the principle of *l'art pour l'art*, of the idea of technical perfection and formal exquisiteness. Paradoxically, the role of the artist since the time of the early Renaissance had never been so totally restricted to the carrying out of his craft and so sharply separated from every other function as in this late phase of intellectual development.

The ideological background to the historical process becomes the more transparent the more *l'art pour l'art* movement identified itself with the derision and condemnation of naturalism—the more people felt they had to fear from its revelations. Naturalism not only is decried as indelicate and indecent, and characterized as a nihilistic movement which sets free the wild, dissolute animal in man and the forces of dissolution and destruction in society, the destruction of religion, nation, and the family, but it is also seen as a trend in taste which feeds people meaningless and empty banalities—a reproach with which people felt they had struck just as sensitive a blow to the painting of Manet as to that of Courbet. Around the middle of the century people still thought they should protect the interests of civilization against naturalism; around 1885 they are protecting the creative life against materialism in art, nothing more or less than the spiritual and divine principle itself. People fantasize about the mysteries of being and the unfathomable depths of the spirit. Everything reasonable is found to be flat, and only what is imperceptible and unnameable is worthy of attention. In literature these tendencies are expressed in the symbolism

of Rimbaud, Mallarmé, and Paul Valéry, which like the art of van Gogh, Gauguin, and the expressionists has its roots in part in impressionism and leads from this, almost imperceptibly, to a completely unnaturalistic art, a neoromantic aestheticism and artistic mysticism. Today's shattering of faith in art is to some extent the result of this incestuous approach to aesthetic culture. The essence of an authentically artistic creation consists in the inseparability of its aesthetic and social functions; when, about the time of the First World War, it ceases to fulfill its social function, we witness the beginning of the crisis of art which is now upon us. Naturally, it is a question of an uncommonly complex process, of which the war is a symptom and not the cause.

The purely contemplative aesthetic attitude which is expressed in impressionism reaches its zenith at the end of the century. The feeling dominates that art is useless and has no function—the fatal romantic renunciation. The renunciation is still more exaggerated not only when life is rejected on account of art, but when it is asserted that in art is to be found the only justification for life. It appears not only as the only compensation for the disappointments we have suffered, but also as the actual realization and completion of an existence which is in itself incomplete and without substance. Not only is the effect of life, in the forms of art, as Proust suggests, more beautiful, significant, and conciliatory than otherwise, but it is only complete and meaningful in recollection, in the artistic vision, and in the aesthetic form. Such a view of art had in mind a public which is composed entirely of actual or potential artists, a public for which reality forms the mere substratum of aesthetic experiences. Works of art are made for artists, and the object of art is now only art itself, the world *sub specie artis*, just as it appears to the artist as artist. Under the burden of such a fiction, art must collapse and the next step can only be its more or less far-reaching rejection.

6

Society as the Product of Art

Art as Social Criticism

The concept of art as seduction and danger must be as old as the idea of the aesthetic education of mankind. At the time of Greek classicism there was in any case still no theory of art as an educational tool which would have been more clear-cut and expressive than the Platonic prohibition and banishment of it from the philosophers' ideal state. Since that time there has been no lack of people opposed to art who have questioned its usefulness and the sense and value of aesthetic education. Is it suited to the increase of knowledge, the cleansing of morals, and the improvement of society? Plato's argumentation with the mendacity of its illusionism and its betrayal of ideas has long since become irrelevant; his thesis of the sensual nature of artistic representation and its suitability for intoxicating the senses and weakening the will has, on the other hand, maintained some of its validity. All iconoclastic movements bear within themselves more or less deep traces of the Platonic doctrine. The antiartistic attitude of the Church Fathers which mainly attacked sensuality reminds us more of the heathen philosophers than of the apostles. Byzantine iconoclasm defends its theory with concepts taken from Plato's doctrine of ideas, and fights against the "idolatry" which is carried on by means of devotional pictures as the sensual depravation of the divine-spiritual being. The hostility of all the sectarians of the Middle Ages toward art and even of those of the Reformation is, in principle, Platonic—that is, irrationalistic and idealistic—at least as far as its resistance to the flesh and the senses goes, however rational and realistic its fight against the Roman church as the seat of idolatry may be. Furthermore, people talked for a long time of the dulling of the senses when they already meant the eclipse of the head, to which art, thanks to its metaphorical mode of expres-

sion, is so suited. Savonarola and the anabaptists express, under the guise of iconoclasm, opposition to existing society and the ruling classes, and do so more clearly than any of their predecessors, who were scarcely aware of the fact that in fighting the spiritual hierarchy and ecclesiastical institutions, they were struggling against outcroppings of feudalism. The ideological background to the struggle becomes more and more clear in the course of historical development and is already unmistakable at the time of the Enlightenment, when the role of Platonism, with its hostility to art, is taken over by Rousseau with his hostility to culture. Since that time the tendency toward self-denial has been one of the permanent features of Western culture, and in politically radical camps there has been a special suspicion of art as a debilitating opiate, although there has been no lack of attempts to make peace with it, as, for example, in the alliance of socialism and naturalism about the middle of the nineteenth century. Meanwhile, the more aestheticist the West became the more the opposition to the domination of life by art grew, and it was not necessary to wait for Dadaism and the antiart movements of our own times in order to find art's sense and purpose being questioned even by artists themselves. Did not Flaubert, who knew of nothing more precious in life than art, ask himself whether it was not the expression of a fearful nihilism, a force hostile to life, a depersonalizing idolatry?

With all this resistance, these objections and doubts, a disapprobation and a summary condemnation of art were expressed, without relating its social or moral role to its individual creations. It seemed from the outset questionable or reprehensible. When talking of the alleged lack of connection between aesthetic value and practical effect, people thought as little about the fact that the poison might be the more frightful the more artistic, intoxicating, and disarming the means were which art used, as about the opposite, namely, the possibility that the intensification of aesthetic values might lessen or prevent their morally depraving effect. It was the Renaissance, that unswervingly aestheticizing period, which first arrived at the idea that the art of the great masters was in itself ennobling and that the educational effect of works of art grew with their artistic worth. In the Middle Ages no moral value was ascribed to artistic quality as such, though there must have been some sensitivity to it and there seemed to be very little differentiation between the two orders of value. The religious visionaries, who rejected art fundamentally, believed that it was reprehensible in every form, and the temporal as well as the spiritual rulers who intended to use it as a means of propaganda did not judge it according to its aesthetic value. Just as the rejection of art was not necessarily

a sign of nonreceptivity to its charm, so the artists' employers and the protectors of the arts were not always connoisseurs.

The antipode of the iconoclasts, who rejected art from the beginning, is not, in the sociological sense, the aesthetes, who judge life according to the yardstick of art and renounce life for the sake of art. Indeed, insofar as they deny or subvert any direct connection between art and society, they are in the same camp as the apostles of divisible values. None of them has confidence in the aesthetic educability of man or the possibility of forming or correcting society through art. Because both the aesthete and the iconoclast separate the two from each other, nothing of this sort can take place. Art reveals itself as socially effective in a positive or negative, constructive or destructive, apologetic or critical sense only when it is aimed at a particular order of power, but not when it finds itself confronted in a social vacuum by humanity, as the aesthetes and the iconoclasts envision it. Art is neither healthful nor harmful per se; but by the same token, there is no specific stylistically or qualitatively unique form in which it could prove noxious or useful for each and every society. Under certain conditions, however, art—which not only reflects social reality but also criticizes society, thus forming it—is suited to the diagnosis and cure of its ills.

The part art plays in the formation of society is not always equally important and apparent. It is not necessarily the greatest artists, the masters of Greek sculpture and of Gothic cathedrals, not Leonardo and Michelangelo, Rubens and Rembrandt, not even the most active manipulators of the artistic influence upon the public, like Le Brun or Vandyke, who change the characteristics of a society most fundamentally and obviously, but social critics like Breughel, Callot, Hogarth, Goya, Millet, and Daumier. In their case, where it is a question of social criticism in the sense of an immediate and clear-cut attack upon a social system as a whole or on individual classes, particular institutions, and conventions, abuses, and misuses, and a matter of revealing and ridiculing certain prejudices and injustices, where accusations are made and verdicts given, the attempt to change society is clearer and more succesful than in works which are first and foremost reflections of finished ideologies or vehicles of propaganda, which thus actually confirm what exists in society or support what is in the process of being developed. In bringing tendencies to light which are already present in society, these works are the products and not the producers of social conditions. As social criticism, art is the producer of these circumstances only insofar as it reacts upon society with the impulse it has received from it and is conditioned by existing contradictions, tensions, and conflicts. As such, every social criticism remains a self-criticism of society. Matthew Arnold is not apparently thinking

of any sort of social criticism in this sense when he calls literature a "criticism of life." He is concerned not with the replacement of some social system with another, not with the correction of inadequacies which could be removed from the world once and for all. He believes rather that literature from the very beginning and without cessation is searching for the ideal, utopian existence and that a circumstance to which it could not reconcile itself lies beyond its scope. According to this undialectically idealistic point of view, the poet and society play an equally passive role in the process. Literature is changed in its essence just as little by life as life is by literature. Life remains the object which needs criticism, literature the self-sufficient organ of art. Oscar Wilde's aphorism that art does not imitate life but vice versa apparently moves on a quite different level from the dictum that literature is the "criticism of life." What it does have in common with Arnold's criticism of life—in contrast, for example, to historical materialism's doctrine of the reaction of the superstructure upon the basis—is the trait of social ineffectiveness. Wilde's aperçu contains nothing about evaluation or challenge; it does not, for example, say that art is better than life. In accord with the aestheticism of the period it contains only as much of the principle of the exemplariness of art as a concept related to Baudelaire's *vie factice,* and in opposition to Rousseauism and its enthusiasm for nature, can express. It says essentially that most people are incapable of perceiving the form and the meaning of things without having them pointed out to them beforehand. Insofar as the artist does it for them, life seems to imitate the work and art seems not to be criticism and correction but rather the example and measure of reality. People notice and actually enjoy the beauty of nature, are conscious of their bodily form, perceive that the life of the city has its own particular charm as does technological progress. They perceive this charm which they find, too, in the speed of life and the traffic, in the extent of their environment and in the shrinking of the world, only after painters and poets have discovered these facts for them, just as they owe their understanding of psychological entanglements, moral conflicts, social tensions, and crises mainly to their writers. The function of art does not, however, consist merely in opening people's eyes, but also in preventing their closing their eyes again to facts, difficult tasks, uncomfortable solutions, and tragic alternatives. Wilde may have thought of everything connected with the revelatory role of art, but he seems to have neglected to think of the responsibility which it places upon the enlightened. He seems to have forgotten the social, humanistic sense of artistic enlightenment.

Meanwhile, art is both normative and exemplary for society not only while it validates humanistic ideals and norms, but also while it

makes new habits, morals, and modes of thought and feeling acceptable and respectable. These forms of life no more originate in the artist's spontaneous creative impulses than do the ideologies which are conditioned by class, but they do owe to them the means by which they are disseminated in order to arouse people's interest and obtain their sympathy. Modes of thought and tendencies of taste, ways of feeling, and standards of value like those which find expression in the languishing of the troubadours, the humanism of the Renaissance, the extravagance of mannerism, the concept of honor of the *tragédie classique*, the rationalism of the Enlightenment, and the philanthropy of the Victorian Age are literary conventions. These conventions may have their roots in the social structure of the time, but people become aware of them only through their literary or artistic forms and in these forms they react upon society. Art becomes a social factor when society makes it one; it revolutionizes after it has itself become a revolutionary force. But while the influence of society on art often remains unrevealed and invisible, the effect of art, however small it may be per se, involuntarily strikes the eye. Thus, it is immaterial whether the final cause of this effect remains hidden in the lap of society or whether it is revealed; its purpose and its direction are clear and unmistakable.

The social effect of art, its role as a factor in the production of society, is most obvious when it becomes the motive force of disturbance, renewal, and revolutionary change and expresses aspirations which deny the existing order and threaten it with destruction. Art, however, evidently also serves to quieten, to stabilize existing conditions, and to smooth out explosive conflicts not only when it tries as an apologia to reconcile broader strata of society with the ideology of more narrowly limited ones but also when it asserts principles of taste which are often a priori more all-embracing than other ideological structures and are more suited to bringing heterogeneous cultural strata into harmony. The scene of the artistic movements of the nineteenth century was a no-man's-land, conditioned in this mannner, in which the antibourgeois intelligentsia and the bourgeoisie, which mistrusted them, lived in a precarious armistice with one another. The audience for art was composed in large part of proselytes of the Left and the Right.

But it would be pure romanticism to overlook the fact that art divides just as often as it unites, simply because it splits people, according to what works they are capable of appreciating, into different camps, in the process of which it is by no means the most important works which have the greatest following. In fact, the opposite seems to be the rule. The aesthetic value and the socially determining function of artistic products stand—in this relationship, too—in an inverse pro-

portion to one another. It is *Werther* and not the *Elective Affinities (Wahlverwandtschaften)*, Richardson and not Jane Austen, Béranger and not Baudelaire or Alfred de Vigny who had greater influence upon the formation of their society. In any case it would be just as wrong to regard the artist's person as a completely positive social factor working as a sort of social putty as it would be to perceive art unconditionally as an element of consolation and fraternization. In many respects it shows itself frankly to be a force hostile to society, a source of quarrels, disintegration, and dissolution. If the artist seems to be concerned with a harmonious society, he is generally only thinking of a unanimous following; his ambition drives him to differ from others and to be unique and incomparable. His struggle for success is just as often determined by envy, jealousy, and *ressentiment* against rivals, critics, and opponents as it is by the desire for sympathy, solidarity, and understanding by all the others. Since the romantic period, he has been—with his subjectivity, his pathological state of being an outsider, his lack of public function, and his fatal alienation—the asocial being pure and simple, the prototype of the allegedly privileged person who has the right in modern society to lead a sort of extraterritorial existence. Nothing is more significant for this unstable social situation and the questionable value of such an existence than the complex sense of the principle of *l'art pour l'art*.

L'art pour l'art Problem

The questions related to the principle of *l'art pour l'art* constitute the most difficult and, in many ways, decisive problem for the sociology of art, for the discipline's claim to scientific validity stands or falls according to what answers are provided. If *l'art pour l'art* position can be maintained and a work of art can be regarded as a closed system whose microcosmic nature is endangered by every form of transcendence, by every transgression of its bounds, no matter how small, then the claim that the meaning and intent of art can be determined sociologically is shown to be illegitimate and unworkable. Are the essence and value of a work of art to be found in its inner structure and the attractiveness of its means of expression—that is, in the reciprocal relations and proportions of its constitutive elements, the vividness and variety of its optical and acoustic forms, its harmonious structure and melodic élan, the magnificence of its colors, and the music of its language—or in its functions—as precept, as appeal and message, as interpretation, as criticism and correction of life? Does art, in other words, play a role in which its sensual forms, speaking only to the senses, are merely a means to an end which lies outside its own bounds

and the aesthetic sphere altogether? The question comes down to whether art is an aim and a purpose in itself or is merely the means of achieving ends which lie beyond it.

From the point of view of historical materialism, the discrepancy between the social and aesthetic functions corresponds to the contradiction which may exist between the artistic, qualitative significance of a work and its suitability to the fulfillment of social and moral obligations. A picture can be faultlessly painted yet otherwise totally indifferent; a novel can be excellently written yet frankly frivolous and socially depraving. The social usefulness, the moral and humanistic value of a work of art have nothing to do with its possible immorality in the usual sense. What gives a work of art social, moral, and human significance does not lie in the motifs, the action, the characters, or the explicit intention which informs it but in the earnestness, the intelligence, and the rigidity, in short, the spiritual maturity, with which it approaches the problems of life. Art which has no meaning or weight is not that which portrays questionable happenings or characters but that which adopts a trivial or mendacious standpoint vis-à-vis the tasks of life and thereby misleads people into a false or wanton estimation of facts and brings them to self-deception and self-degradation. The protest against the doctrine of *l'art pour l'art* is a protest against the romantic principle which advocates fleeing from the real responsibility of life and avoiding the difficulties of existence instead of pitting oneself against them, coming to terms with them, and befriending them.

The tendency of cultural structures to become independent of the circumstances of their genesis, to become ends in themselves, to objectify, formalize, and reify themselves, to change from means of interpersonal understanding and cooperation to something of abstract value, be it a monument or a fetish, is nowhere more apparent than in the metamorphosis of the work of art from an instrument of communication, evocation, and agitation into a complex of forms which has to be interpreted and evaluated as such. The theory of *l'art pour l'art* derives its most serious objection to the utilitarian view precisely from the fact that this metamorphosis can actually be accomplished and that the work of art can be regarded as an independent formal structure, closed and complete within itself, whose moments are all explicable on the basis of their inner cohesion. Therefore, according to the doctrine of *l'art pour l'art*, the psychological genesis and the social and moral purpose of an artistic creation are deemed insignificant, and the genetic or teleological interpretation is condemned because it not only leaves the inner formal structure unexplained but even, supposedly, conceals and falsifies it by drawing attention to how

the artist arrives at the individual components of his work instead of showing how these condition each other and how they are interrelated.

The doctrine which stems from the self-sufficiency of art and clings to the idea that its psychological origins are a matter of indifference and its social effects pointless conforms to the romantic concept of the artist who is simply the creator of his works. In reality such an artist no more exists than does a reader or spectator who is simply the passive receptacle of artistic impressions. Only schoolboys and dilettantes write their poems in this kind of vacuum; they are the purest representatives of the principle of *l'art pour l'art*. Real, mature artists always work in the midst of a social situation, always speak for others while speaking for themselves, and are concerned with the solution of problems of life which do not affect them alone. The difficulty of judging the facts correctly arises from the contradiction that works of art are always produced out of an interpersonal, social need or necessity but must have, as well, their own aesthetic quality, a special irreducible value, in order to be effective. So works of art can be regarded both as gratifications of social needs and as exponents of this special, self-sufficient, nonreducible quality.

The theory of *l'art pour l'art* wants nothing to do with this contradiction and denies not only the moral and social usefulness of art but its every possible practical function as well. "Nobody would write poetry," says Eugenio Montale, "if the problem of literature consisted in making oneself understood." It has also been doubted whether the capacity of making oneself understood, the unambiguous communication of feelings and experiences, even lies within the power of art. What Eduard Hanslick asserts about music in *Von musikalischem Schönen*, namely, that its relation to everything which is nonmusical, everything which has emotional and ideal content, is vague and noncommittal,[71] is to some extent true for all the arts. Just as music expresses something which cannot be translated into any other form, so literature expresses something which is eminently literary, linguistic, something locked into words and syntactic structures. In the same way the untranslatable content of a painting, a pictorial idea, a vision, can only be seized and held onto in optical forms. The composer thinks in tones, the painter in lines and colors, the poet in words, tropes, and rhythms. Indubitable as this is, it is not the whole truth; side by side with the content which can only be expressed adequately in a particular form, there is an intrinsic value which can be translated into any form.

The thesis that each art's medium is singular and homogeneous can be attributed, in part, to the conceptual apparatus of *l'art pour l'art* theory and stands in need of a fundamental correction. This thesis,

too, divides form—a form, moreover, surrounded by abstract incomprehensibility, like that of pure visibility, of pure musical or linguistic expression—too sharply from the rest of the artistic structure and declares form to be irreducible, untranslatable, and irreplaceable. With the transference of heterogeneous reality to the homogeneous medium of the individual arts, the bewildering variety of existence is to some extent brought under control, but it is by no means exhausted. The explanation of artistic creativity as the projection of multidimensional phenomena onto a simple plane is only a partial and metaphorical one. For in the process of creating a sensually unified objectivity out of the chaotic material of empirical experience, the artist does not just see how the kaleidoscope of the material will fit into the homogeneous categories of one sense organ or another. The translation of discontinuous, sensually disparate phenomena to a unified, similar, unbroken plane is only one of the means, even if the most obvious, of conquering the chaos of experience and changing it into a controlled and manageable world: the ideal of art. The homogeneous structure, like microcosmic structure, is an essential factor in a work of art, but not an indispensable one; unity is no more a part of every artistic form than completeness or finality.

According to Max Liebermann's well-known dictum, a well-painted head of cabbage is in itself more valuable than the badly painted head of a Madonna. The head of the Madonna is only more valuable if it is painted better and only becomes an artistic object if it is painted well. However, even this statement, like the reduction of artistic quality to one homogeneous medium, does not contain the whole truth; it must be expanded to indicate that a well-painted head of a Madonna may be elevated to a region which is simply inaccessible to the head of a cabbage. But how does it come about that the subject of the Madonna occupies a higher place when the quality of painting is the unconditional criterion of value? Or vice versa: how is it that the quality of painting is of such great importance when the Madonna— or, for that matter, the human element in general—represents a special value? There is a clear incongruity in standards here: the human and the pictorial belong to two different spheres and represent values which are irreducible to one another—the magnificence of the one may be bound up with the futility of the other.

This inconsistency can be represented by an image: a work of art is something like a window through which we can observe the world without taking into account the nature of the instrument of observation, the form, color, and structure of the pane of glass, but we can also focus attention upon the window without taking heed of the form and meaning of the objects which are visible through it.[72] In this way

art always appears to us under two aspects and we oscillate between them. We regard works at times as self-sufficient fabrications of the senses, detached from reality and from all other objectification, and at others as reflections of reality which are indissolubly related to human existence and help us to perceive, comprehend, and judge it. From the point of view of the pure aesthetic experience, the autonomy and immanence of form seem to be what is essential to the work of art; it can only create a total illusion and become a credible picture of reality when it emancipates itself from everything which stands outside its proper sphere. The illusion, however, by no means makes up the whole content of a work of art and often plays no decisive part in its effect. Art is, and remains, a reflection of reality but maintains an uncommonly flexible relationship to and changing distance from it. Art exists only insofar as it differs from reality, on one hand, and is embroiled in it, on the other. Art not only reflects but abandons and replaces reality; it is part of art's essence to keep the consciousness of reflection, the fact of self-deception, alive by constantly alluding to the reflected truth. There is no authentic work of art in which this reference to reality is lacking, and the most important works are often direct discussions of human existence, of the problems and tasks of real life. The aim of these works is most definitely not to anaesthetize the reader or the spectator or to put him into a condition in which he fails to recognize facts or underestimates their significance. Authentic works of art renounce from the outset the deceptive illusionism of a self-centered artistic microcosm and gesture throughout to a point beyond their own aesthetic range. Beyond any consideration of form and illusion, they are concerned with the answers to contemporary questions about life and with comprehending the situation from which those questions have sprung. How can sense be made out of life? How can we participate in this sense? How can we, just as we are, in a time and society, lead a decent life?

The decision as to whether a work of art is to be understood as a self-sufficient form or as the vehicle of an appeal, a thesis, or a message does not necessarily depend upon the attitude of its author. Every important work more or less fulfills both functions. Even the most politically or morally prejudiced representation of reality can be enjoyed as pure art, as a purely formal structure, if it is aesthetically relevant at all. On the other hand, the most disparate artistic products, even those in which the creator has no practical goal in mind, can function as latent social criticism. Dante's activism no more excludes a purely aesthetic appreciation of the *Divine Comedy* than Flaubert's aestheticism and formalism exclude a sociological interpretation of *Madame Bovary* or *L'éducation sentimentale*. Flaubert regarded him-

self as the representative of *impassibilité* and of the principle of *l'art pour l'art;* he believed that this principle was completely satisfied by the truest possible reproduction of reality according to his tenets, without any embellishment, censorship, or moral preaching. Most of his works, however, in spite of this alleged passivity, express a philosophy of life which is socially and morally barbed. *Madame Bovary,* especially, is clearly a novel with a purpose. The whole novel is a criticism of romanticism as a form of life, a revelation of its false ideals—its self-seeking sentimentality and ecstacy, its self-deception and lies, its falsification of one's own being as well as of reality, from which we should not hide but with which we should come to terms.

The authentic artistic experience presupposes the formal attraction of the means which are used, the technical perfection of execution, and the immediate sensual effect of colors, tones, and words. The precondition for artistic quality and the functions which art has to fulfill is successful form. All art begins with this, even if all art does not end with it. Without satisfying form, art cannot deal with any extra-aesthetic tasks. Artistic effect has an aesthetic threshold, a formal minimum which must be reached in order for the work to enter the sphere of art but which is also far from sufficient for it to penetrate into art's highest and innermost regions. The fact that what is politically, socially, and humanly true and right can only be realized in works which are formally successful is not the axiological primacy but merely the ontological sine qua non of aesthetic quality. Human and social values which do not appear in an aesthetically successful form are artistically nonexistent. The priority of form over content does not here signal a one-sided formalism but, on the contrary, simply means that the form of the transmission of content must be available and at the artist's disposal. Furthermore, the axiological primacy of content does not reduce the importance of form, for we are dealing here with a content which can only be expressed adequately in one particular form and no other and which, in the course of the process, changes just as much as the form which it is using. What makes someone an artist is not the thing which he undertakes to depict, to recommend, and to praise but the way in which he does it; what makes someone a great artist is, however, the thing which he is prepared to stand up for and for which he is willing to use his talent.

Again and again people have constructed a form-content identity as the way out of the dilemma that successful form is the essential prerequisite for artistic effect, and significant content the criterion for powerful form. But the identification of form and content rested at best upon their indivisibility, not on their consubstantiality. How problematical their identification is, even for Marxism, is best expressed

by the fact that their separation from one another was first considered a result of the division of labor. But their divided function in the fulfillment of the artistic achievement has nothing to do with "division of labor" in the Marxist sense for the simple reason that the division did not take place at a given moment but belonged from the beginning to the dialectic of aesthetics. The synthesis of form and content does not eliminate but merely suspends their antagonism. The presumed state of indifference which exists between the two is often taken as a mediation between an intellectually formal principle and a sensual, material, or general human one. This mediation has been called, for example, the symbolic stage by Goethe, the particular by Hegel, and, in the same sense, the typical by Lukács. These are all compromise forms of the concept of identity with which people try to eject from the world the irreconcilable duality of the form-content relationship and by which they hope to rescue the myth of the unity and indivisibility of artistic creativity.

Form and content are two completely different things—the most conceivably different—although they can also only be conceived in relation to one another. Their difference, even their contradictory natures, simply cannot be eliminated from art, which might be defined as a tension which exists between the two. There are no works of art which are either pure form or pure content. Flaubert's wish to write a book without any object, one without content that would have been pure form, remained a daydream; in any case it would have been a mere five-finger exercise like all pure formalism. Content will never be "eradicated by Form," as Schiller assumed.[73] Just as every artistic object only makes an impression through its form, even the most embryonic and simple form owes its effect to the tension between a need to express content and a formal striving for expression.

A form is successful if it corresponds in some way to, indeed if it is to a large extent conditioned by, the content it expresses. Form is never, though, simply a function of the subject matter: while certain forms may be excluded as inappropriate, there is more than one form which will adequately express a particular subject matter. The way in which an artist says something belongs strictly to what he has to say. If a modern artist, for example, expresses himself "incomprehensibly," the incomprehensibility, inarticulateness, and ambiguity of his formal language may be inseparable from his subject matter. His language must, however, make clear that he has something unclear and inexplicable to express. Hamlet's "Oedipus complex" would not be what it is if Shakespeare could have given it a name. We can only make out as much about Prince Myshkin's love for Nastasya Filippovna as Dostoevski lets us know. No one can determine the sphere in which Franz

Kafka's stories are enacted more exactly than the author has. Doubtless it can be held that in a true work of art form and content meet, are congruent, and merge totally, indeed that it can often not be decided whether we are dealing with a formal or a material element. A material element is certainly first revealed by formal means, just as form first appears when it is set off against a material background. The aim of artistic effort is apparently the total immediacy of content and form, the absolute merging of the thoughts and feelings to be communicated in the medium of communication. Nevertheless it remains a mark of what is artistic that form is not content and content is not form. The merging of the one principle with the other is nothing more than a figurative, metaphorical expression for their mutual accommodation.

Form changes unmistakably as content changes. A new concept of morality, duty, or honor may completely change dramatic form. A new outlook on the world may cause the development of the novel from the epic; a new form of sensibility may lead to a new lyrical mode of expression. Yet form still means something which is beyond the material, something which cannot be reduced to the material, and something which is not to be derived from it. Form may contain spontaneous elements, but it is also an impediment, a borderline, even the antithesis of spontaneity. The dialectical process is the fundamental pattern in which the paradoxes—the singular reciprocity of form and content and their indivisibility and resultant lack of identity, the primacy of what is experienced and material and the absolute necessity of the formal element—are encompassed and in which they remain. Form and content are stimulated and furthered by one another in their development. Formal completeness is achieved when some content is rejected and the remainder thereby becomes portrayable. The development of form and content is not a one-sided process aimed in one or the other direction but a series of questions and answers, of ever more entangled problems and ever more far-reaching solutions, ever more differentiated presuppositions and ever more complicated effects. To call this process, consisting as it does of reciprocal steps, the merging of the one into the other not only explains nothing but conceals the fact that though form and content can influence one another they can never turn into one another.

It is perfectly justifiable to ask what the works of the Greek tragedians or Shakespeare, the *Divine Comedy* or *Don Quixote*, the novels of Dostoevski or Tolstoy would shrink into if they were robbed of their moral content. Yet what would they become, we must ask ourselves, if we left them nothing but their moral significance. The stereotypical answer that form and content are inseparable from each other is not entirely satisfactory. There are innumerable examples of

formal success in art where content has no particular significance, but there is no work that owes its artistic value entirely to the significance of its content, no matter how highly we rate the part of content in the enhancement of formal value. An artistically valuable poem consists of excellent verses, but excellent verses do not produce a valuable, let alone a significant, poem. Racine's famous line "La fille de Minos et de Pasaphaé" is charming even from a purely phonetic point of view, but it has no poetic effect in the dramatis personae where it recurs in the same form. It only takes on this quality in the context of the work through the interdependence of elements, consisting of verses, and not just verses.

Paul Valéry's well-known response to a question from Degas—why Valéry could never produce good poetry in spite of all his good ideas—that poetry consists of words and not ideas may be one of the most illuminating things that has been said about the nature of poetry, but it still does not exhaust the essence of the matter. For a poem begins with words but by no means ends with them. We fashion poems from words and read them by letting the words ring out within ourselves, but poems have an origin in the poet and a resonance in the reader beyond language. It is well known that a poem loses in every translation a valuable, often irreplaceable, element of its being, however valuable the new elements may be which the translation itself creates. Nonetheless it remains questionable whether the original version is itself not to be looked upon as a sort of "translation." In other words, the original version may violate the idea just as later translations may violate the form. André Gide's often quoted and adapted dictum that people frequently make the worst literature out of the most beautiful feelings expresses formalism in just as uncompromising a sense as Paul Valéry's; Gide's only appears more acceptable inasmuch as beautiful and ugly, true and fictive feelings are kept at the same distance from artistic quality. In Valéry's saying, "words," as a formal principle opposed to "ideas," represent the aesthetic quality absolutely.

The distinction between artistic means and the meaning of the content, which Valéry formulates so strikingly, has a long history. It apparently goes back to the concept of Greek archaism and corresponds to the idea, at that time certainly not highly developed, that works of art are not only a means to an end, which up to that point they seem exclusively to have been, but that they are aim and purpose in themselves. Previously every form of art had been applied art, a prop of magic and religion, a means of influencing the gods, spirits, and people; at this point in history it becomes in part pure disinterested form—art for its own sake and for the sake of beauty. As soon as the attitudes were separated from one another and the hitherto undifferentiated

knowledge of the world apportioned to individual sectors of culture, the distance between practical reality and the ethical-religious, philosophic scientific, evocative and decorative artistic spheres began to expand. Yet, the emancipation of individual areas of culture, especially that of art, from the totality of practicality was never completely accomplished, and the struggle for the re-creation of the once unified and closed picture of the universe is constantly renewed.

No genuine work of art is experienced in mere contemplation, in passive acceptance, and solely with the "disinterested" enjoyment of aesthetic forms. Even the pure structures of music, which have no conceptual or objective content, are more than mere "forms": they, too, call up in the receptive subject a readiness and inclination to take a revised, more immediate, and more open attitude toward human destiny; they, too, present a humanistic and moral challenge and, like everything which is genuinely artistic, present the picture of an existence which makes sense and which has reached its goal and its end, an existence which has been mastered and controlled. Nevertheless, no work of art persists in remaining close to life. However deeply it may be conditioned by social and ethical motives which lie outside aesthetic form, these must be temporarily suspended so that the work will be able to exercise its effect. Such a suspension of practicality is even unavoidable in the genesis and development of the sciences; they also have to emancipate themselves from the practical tasks and aims to which they are ultimately directed in order to develop methods suited to the discovery of truth. In art the temporary suspension, the placing in parentheses, of practicality, of social interests and goals often seems to be more radical; but, as with the sciences, the connection with practical reality is only postponed, not eradicated. It is only forgotten or concealed; it remains an effective constitutive factor of the reflection of reality.

The nature of the activity which produces form which is of itself gratifying and which has been called, with reference to paintings by monkeys,[74] "self-rewarding" plays a considerable role in genuine artistic creativity. However, where the only motive is satisfaction and the artist loses all interest in his work—just as the ape does in his daubing as soon as it is finished—he is simply discharging excess energies, in the biological sense, or pouring out dreams, fantasies, and high spirits, in the play theory sense; in short, his activity is closely related to *l'art pour l'art* theory. The history of art offers an almost unbroken series of examples of the insufficiency of these "playful" forms. The example best suited to refuting the theories of *l'art pour l'art* and play is the creative activity of David, who is so completely socially and formally representative, in whose work artistic and practical political

values always cohere. The more deeply his art is rooted in social endeavors, the more expressly he places his talents at the service of propaganda, the higher the quality of his work. During the Revolution, when his whole activity revolved around politics and he was painting pictures like the *Oath of the Tennis Court* or the *Death of Marat,* he was at the zenith of his artistic power. Even later, when he had practical tasks to perform in accord with Napoleon's patriotic aims, his art remained lively and creative. During his exile in Brussels, however, when he had no connection with politics and was no more than an artist in *l'art pour l'art* sense, his artistic development was most impeded. Even if David's example does not prove that an artist must be politically engaged and progressively minded in order to paint good pictures, it at least shows, contrary to the proclamations of *l'art pour l'art* theory, that practical interests and immediate political aims by no means hinder or impair the genesis of significant works.

The answers to the problems of life which transcend art—questions about the meaning, value, and aim of human existence—and the path to their solution are not only inseparable from the formal criteria of artistic achievement, they are often presupposed by the form itself. We would look in vain in a Bach fugue or a Cézanne landscape for a direct answer beyond form. In the case of a painter like Greuze or a composer like Tchaikovsky, it is not hard to relate the banality of the ideas to the triviality of the forms; but how are we to describe the universal significance of the art of Bach or Cézanne, where we cannot point to any content of a humanistic nature without involving ourselves in meaningless metaphors and equivocations? The answers to the problems of life which have to be solved, the appeal, and the message to mankind are contained in the formal structure of the work. For the structure does not merely represent the solution of technical problems, of problems connected with the organization of the given material, but also conveys its mastery over opaque and misleading experiences, unarticulated and confused feelings. In an important work of art, existence is rid of its confusion and its provisional nature: its disconnected and dispersed fragments merge into a clearly structured, sensible pattern; if inner contradictions do not always modulate to satisfying harmonies, the contradictions and conflicts which fill the work are not suppressed and silenced but shown for what they are, and the crisis which underlies them comes to a head. This resolution of tensions and crises does not, however, merely mean that the artist has triumphed over agonizing chaos, that he has achieved a formal success which affects him alone; his triumph also affects the listener or the spectator with a purifying power and an imperative which no manipulation of mere forms could produce. Just as the creation of a significant work

of art bears witness to power and the will to withstand the dangers of uprooting and disintegration which threaten life, adequate reception of the work presupposes a similar expenditure of courage and decision on the part of the audience. Whoever approaches the work properly feels inspired to measure up to its demands that he take his life and himself seriously, that he come to an understanding with himself to order the circumstances of his life, to clean up all that is ambiguous and murky both in himself and in his environment, just as the artist has done with worldly things. The artist's "order" is apparently not just a formal aesthetic but a moral achievement. Order cannot be exhausted by a merely sensual experience of form. Every real work of art, as a formal structure, represents a refutation of *l'art pour l'art* theory. The moral appeal and the humanistic message which art conveys do not consist of special recommendations and express prohibitions but of calls to adopt a serious, calm, and reasonable attitude to the world, to life, and to everything which living together with other people implies. Art challenges us to take stock and to reform, but it does not do so in a direct way or through abstract conceptual forms. It makes use of concrete images which can be appreciated by the senses, for example, when Rilke describes the "Archaic Torso of Apollo" as one of the symbols of values and imperatives which are personified by art. We cannot fathom "his untold head" but he still "glows like a candelabra"; the curve of his chest blinds us, and in the "gentle turn of his loins" there is a "smile pointed at the middle where he bore his virility"; the stone is disfigured but it glitters like the "pelts of beasts of prey" and bursts "out of all bounds like a star"—"there is no place that does not look at you." Everything has become visible and seeing, clear and transparent. Everything speaks to you, but it speaks only as form, as curve, as turning, as shimmering pelts and bursting star. What the poet means by all this is the teaching which all genuine art contains—"you must change your life"—and this is to be read everywhere between the lines but is only said directly at the end. The conviction that we cannot go on living as we have done up to the moment, the desire to realize in our own existence the seriousness, the order, and the charm of a work like this torso, is the highest prize of artistic experience.

Every work of art represents an image of an aspiration and an ideal of life. Every one is a wish fullfillment, a sort of legend or utopia, even when it paints the gloomiest possible picture of existence; it opens up a more sensible, more comprehensible world, one which is otherwise unapproachable, a world in which people lead a life suited to their being, their abilities, and their capacities. Even a form like tragedy "improves" life, for in it the principle of consistency and necessity

prevails where otherwise nothing but disorder and chance exist. Tragedy also has an ideal character: it constructs a world in which strict norms, unchangeable, unmistakable, indestructible principles of order, dominate, in which a man is at one with his fate, however cruel it may be, and in which his feelings, decisions, and actions do not depend upon chance moods and caprices. The standards against which the hero of a tragedy is judged and against which he judges himself are unambiguous and indisputable, and what gives his world coherence and his person identity are the firmness of purpose and the permanence of these criteria. He may lose his life, but not himself, not the consciousness of that which he believes he must stand for. In tragedy the untenable nature of *l'art pour l'art* theory and the humanistic and moral relevance of art are most clearly revealed. The idea of catharsis around which tragedy revolves is, in the sense of the admonition "you must change your life," the axis of all artistic purport.

It is nevertheless questionable whether we can go so far in regarding the practical function of art—the human appeal and the social message whose vehicle it is—as to see in its aesthetic quality anything more than an enticement. Beauty as mere bait would correspond to the view of nature according to which flowers are colorful and berries are red so as to entice birds and bees. In this sense Freud simplifies the relationship between the aesthetic and practical effects of art when he interprets artistic enjoyment as a sort of sexual pleasure which places a premium on copulation. Yet when he describes aesthetic pleasure as pre-pleasure *(Vorlust)* which prepares the way for the soul's release from inner tensions—the putative aim of art—he maintains neither that every artistic experience must have such a liberating effect nor that the experience consist merely of a pre-pleasure. He simply explains that aesthetic pleasure can fulfill functions of which neither the creative nor the receptive subject need be aware. Apart from the simplification of the relationship between practical and aesthetic phenomena, the explanation does not differ essentially from that doctrine of the sociology of art which states that the artist is himself not always aware of the practical effect of his art and is not necessarily aiming at one, that art has to serve purposes which lie beyond its aesthetic quality, and that artists are, consciously or unconsciously, directed by motives which lie outside the sphere of art.

Just as historical materialism can be completely reconciled to the discrepancy between social and aesthetic values, so the common ground upon which the artist and his public meet is larger than that of a particular social class or political party. The rejection of *l'art pour l'art* point of view and the common feeling of *hic tua res agitur* does not require that the audience either align themselves with the author's

political views or—as Diderot suggested—feel class solidarity with his characters. It is humanism, humanity, earnestness of purpose, the feeling of responsibility, and the intellectual probity of the author which allow him to take an interest in his subject, his problems, and the fate of his characters, who may be more or less socially alien to him. Community is that much the harder to establish and requires more talent on the part of the author the further the ideological distance between his own point of view and the ideology of the receptive subjects. Aesthetic empathy, solidarity, and understanding on the part of the public form an uncommonly complex phenomenon which often is produced only as a result of many contradictory motives. The reader, auditor, or spectator sometimes has to struggle just as hard to achieve a proper view of the work as he does in practice to arrive at a suitable social attitude or the correct estimation of his own interests and problems. Just as the sociopolitical engagement of the producer hovers between propagandistic activity and ideological obligation, so the sympathy of the receptive subject hovers between unconscious class solidarity and innumerable conscious or half-conscious inclinations, aspirations, and velleities. Both the producer and the consumer of a work are joined together ideologically in a more or less unambiguous manner, and this link is often allowed to assert itself only in the face of strong internal and external resistance.

However, while a particular ideology, even if hidden or repressed, is perceptible behind every artistic creation, we can talk of engagement only when the artist consciously and without inner opposition stands up for a sociopolitical goal. He may without any conviction produce propaganda for diverse interests, some of which are perhaps completely alien to him, and he may even consciously falsify truth or warp justice. He is engaged only when he identifies with the ideology which he asserts in his work. This identification may be the result of an extremely complicated relationship between contradictory factors, however unambiguous the final point of view may be, and the reader's identification with the characters of a drama or a novel depends on a similar complexity and antagonism of motives. The reader's interpretation often moves from one level to another; on each more highly developed level of consciousness a number of different aspects may be expressed. Macbeth may be a repugnant murderer, Othello a stupid egoist, Lear an old fool, Hamlet a dangerous sadist, Antony a strumpet's plaything; they are all, nevertheless, ideal figures, embodiments of the irresistible force of an inflexible will, exemplars of loyalty to a cause, however questionable that cause and however heavily they are themselves burdened. The relationship between producer and consumer grows more complicated when psychologically based sympathies and ideological

solidarity come into conflict. The obdurate bourgeoisie found writers like Stendhal, Flaubert, Baudelaire, Proust, and Kafka repellent; but, for all their differences, each of these writers remained closely tied to the bourgeoisie; none of them succeeded in completely denying his bourgeois ideology.

One of the reasons the fundamental solution of the problem of *l'art pour l'art* is so difficult is the fact that the arts differ in regard to their possible range of ideas, their means of expression, and their social function. Interests, convictions, commitments, and endeavors which are expressed without much ado in literature can be expressed in the fine arts, and especially in music, only indirectly and often in an uncommonly fragmentary fashion. Nevertheless, the difference is only one of degree. For just as literature contains elements which merely have an undecided, evocative, and purely decorative function and elements which are conceptual and immediately communicable, so music contains alongside its formal, conceptually undefinable components others which go beyond formal limitations and which have an unmistakably human meaning. True, there are few instrumental compositions which can be immediately related to a particular subject matter, and these are seldom the best. It is well known that Eduard Hanslick doubted, and not without reason, the emotional unequivocality of opera and maintained that the text of Gluck's famous aria "J'ai perdu mon Eurydice, rien n'égale mon malheur" could also run "J'ai perdu mon Eurydice, rien n'égale mon bonheur." Music, surely, expresses a certain emotivity rather than particular emotions, and we do not have to wait for the development of the libretto to know what the composer was about. In *Fidelio*, for example, the G-major quartet of the first act already reveals the sublimity of the work.

Moreover, for a master like Beethoven, a composition which transcends form does not necessarily have to be an opera. Stravinsky declared that the role of Napoleon in the *Eroica* was purely external and that Beethoven could have been inspired to write a similar work for another motive. Neither absolute monarchy nor the Holy Alliance, with their inadequate concepts of freedom and their questionable ideas of human rights, could have generated a work of this sort. Anyone who is unaware of the background to the composition of the *Eroica* could not arrive at it from the mere structure of the music; however, the Revolution and Napoleon belong not only to the history of the work but also to the prerequisites for its artistic being. Known or not, the political facts are at the base of the mental effort from which the work arose. Once we have realized this, there can be no further doubt that they play a decisive part in linking the musical to the nonmusical elements, even if they were not the only impetus for the genesis of

this unique work. Certainly we often enjoy musical works as sheer form—more often than we do any other art form—but this can scarcely deceive us as to the significance of their not purely formal components. In fact, there is not only, as will be readily admitted, sublime, spiritually refined, and complex music but also spirited, witty, joking, even trivial, simple and downright stupid, and evil music. Otherwise why is it so difficult to live, and why do we feel so guilty living, with Wagner's music, which exercises the most intense sensual charm and makes the deepest of emotional impressions? Nowhere do we feel more strongly that there is no qualitatively exacting and, at the same time, indifferent art—that what does not elate, debases.

Orthodox Marxism generally distinguishes strictly between "realism" and "naturalism," although the two categories do not differ from one another so greatly in the history of style. Marxist art criticism defines realism as the artistic trend which fills the reflection of reality with life, substantiality, social and humanistic significance. Naturalism it defines as the prototype of pseudoart, which remains concerned with the surface of phenomena and sticks to their chance, ephemeral, nonessential characteristics. However superfluous and, on account of its slippery nuances, impractical this delineation of stylistic trends may be—both from the formal aesthetic point of view and from the point of view of art history—the distinction is not entirely meaningless from the sociohumanistic point of view. It is possible to represent reality faithfully without penetrating into its depths to grasp the totality of its context and fill it with humanly meaningful content. Man himself can, so to speak, be treated as part of a still life or a landscape, and a still life and a landscape can be so represented that they, as in the case of the Dutch masters, Claude Lorrain, or Cézanne, acquire a humanistic sense and a meaning which enhances life and deepens existence. A realist in the Marxist sense humanizes the world of things, while a naturalist makes all life into a still life, the whole human world into a landscape, an empty set without actors.

Part Three Dialectic: Light and
 Will-o'-the-Wisp

7 The Concept of Dialectic

Dialectic revolves around one of the main problems of philosophy: the movement from simple perception to differentiated experience, from the object without consciousness to the subject capable of consciousness, from mere nature to culture and history. What happens, it might be dialectically asked, when the state of culture has been reached? How does history march on? What induces those responsible for development to continue along their way? In what forms is the further course of the process accomplished, and what is its aim? The doctrine of dialectic proceeds from the principle that it is antinomies in which attitudes which are becoming questionable and which are in need of change, precarious intrapersonal relationships, and outmoded conventions assert themselves as laws and demands. Every one-sided point of view and aspect, every particular interest and striving for success brings about contradictions and presents the individual with alternatives which force him to make a choice. Every new perspective is linked with a contrary or divergent view which cannot be disregarded. The more numerous the points of view which come to light in this conflict of attitudes, the more favorable the prospect of determining the decisive motives of the finally established attitude from among the antithetical interests. The aim of dialectical thought is to achieve the most far-reaching approach to the totality of the forces in conflict with one another and to attain if possible an exhaustive picture of the sphere from which the constituents of the complex that is under discussion come. In this connection it is always only an approximate completeness that can be achieved. Scientific research as a divided labor extends to more and more numerous and more and more inexhaustible moments, and since dialectical questioning constantly expands with

331

development, the totality of the possible answers becomes more and more illusory. Only artistic representation which is concentrated from the outset upon an intensive totality can do justice to the differentiation and simultaneous integration of the material which is to be formed.

Hegel and Marx do not believe that the character of art is autonomous and immanent, or one which promises or produces totality. From their point of view it is only one factor in the total process of sociohistorical development. As a global unit and collective concept for all possible works, forms, and styles which have and will come about, it becomes merely a stage or phase, a dialectical moment in human history. It dispenses with the substantiality the individual work of art possesses for the concrete experience. The intensive totality of such a work consists essentially in the fact that it can be neither continued nor revised nor corrected. As a general category on the other hand, art, because of its inability to be completed extensively, is open, capable of development, technically able to be intensified even if qualitatively incapable of improvement. Meanwhile, the individual work is qualitatively changeable only during the process of creation: once it is finished it can only be interpreted differently; its substance cannot be changed.

Just as the relationship between the individual and society, invention and convention, the subjective will to expression and the objective means of expression is a fundamentally dialectical one, so is that between the aesthetic factors immanent in a work and the conditions of production which are beyond it. The related forces of artistic creation do not merely influence each other, but constitute one another in reciprocal dependence. If we wish to know their nature, we have to know how they condition one another. Not only society, its institutions, and its media of communication take shape in conformity with different individuals, their needs, and their demands, but the subjects, too, and their striving for expression are in part products of the available forms of expression. Dialectic is a process in which not only is work the product of workers, but the worker is the personification of his product. It is only in the light of this insight that the Marxist statement that man becomes the creator of his own history and of himself acquires a full meaning—the meaning, namely, that he forms his existence, develops his abilities, and enhances his power in the struggle against nature only in the midst of and by means of the media, tools, and structures he has created.

The inner connection between productive forces and means of production, infrastructure and superstructure, economy and ideology can only be explained if at all in the dialectical sense of a mutually constitutive function. The component parts of the complex remain strictly

separate and are irreconcilable with each other if we wish to form an undialectically dogmatic concept in which the meaning of the components of a state of affairs is fixed from the beginning. Then they are like body and soul rather in Hegel's sense, who maintains that "if the two are assumed as abstractly independent of each other they are just as impenetrable to each other as any material is to another."[1] Dialectic, however, does justice to the mutual penetration of antithetical facts and standpoints only if it does not stop at their reciprocal influence and their mutual adaptation to each other. That is to say, it means neither that the one completely melts into the other nor that the one triumphs completely over the other, but merely that they maintain their individuality in spite of their interdependence. The fundamental principle of dialectical thinking rests on the understanding that contradictory determinations and attitudes are not mutually exclusive; on the contrary—just like the individual and society, or form and content—they are indissolubly linked and reveal their nature only through their antagonism.

The whole process of cultural development expresses itself most impressively and significantly in the dialectical process with its perturbation and shaking of the equilibrium between the components of historical constellations, the negation of their positive moments, the changing of their static nature into a dynamic one, the transformation of everything that is at a standstill into movement. The stage of negativity and restlessness in which contradictory conditions, outmoded conditions of production and new productive forces, needs which are subjectively propelled and circumstances which are objectively inhibiting, ideologies which are bound socially more or less firmly are all opposed to one another, urges through the "negation of negation" the discovery of a new equilibrium and a repeated balancing of the opposites. Processes of this sort are present in every historical medium, but most apparently and most radically in the social one. The structures of groups, conditions of property, forms of government, legal norms, institutions, morals, and customs arise and change as a consequence of individuals' encountering material facts and the opposition, suppression, or adaptation which they assert in the face of these. A social structure exists only as long as the dualism of the conditions of existence and the needs of life remains in balance either by dictate or by acceptance. As soon as new productive forces—material or intellectual—disturb the equilibrium of production and consumption, service and reward, striving for recognition and the possibility of success, the process of disturbance and undermining of the system begins.

In order to understand dialectic we must take into consideration the fact that human nature is not uniformly conditioned, that man not

only is there but also is aware of his existence, and not only is aware of it but wants to change it. Marx expresses this dualism in his doctrine of the inseparability of theory and practice. No matter how it is defined and interpreted, the dialectic of history and culture revolves around the unity which has to be created between apparently irreconcilable opposites and consists in the argument between the ideologies of the social consciousness and the idea of pure truth, the spontaneous wish and conditioned ability, the desire to change our existence and the lethargy of existence, in short, our needs, interests, and aims and the material conditions of our existence—a constant oscillation, in which progress and regress, design and assumption, conscious and unconscious motives are indissolubly connected with one another. It is rationally unthinkable that this process could be brought to a standstill; it would mean the end of history, and the announcement of its end would be pure messianism. We may "believe" what we like or what we can: but for rational thought the limits of history are the limits of mankind. We would have to return to our primitive state or look into a utopian world freed from every division and alienation in order to transcend these limits.

Dialectic could be determined, etymologically, to be discussion, argument, or controversy. In any case it has meaning and purpose only when the partners in the discussion—as representatives of contrary opinions, attitudes, and efforts—arrive at perception or knowledge by way of question and answer, challenge and response, attack and defense. In this process neither the one nor the other is absolutely right, but both arrive at a solution which as proper attitude, practically useful thought, or action suited to the circumstances was previously unknown to either of them, or appeared unattainable. Hegel like Marx recognized the dominance of the same dialectical principle in pragmatic thought in sociohistorical development: for them dialectic was the bond between the different spheres of human activity. And what Marx understood by realistic humanism, the quintessence of the demands which man has to accomplish, was (and of this he was completely persuaded) determined—in practical action as in theoretical thought or artistic creativity—by the empirically correct reflection of reality. The "correctness" of this reflection meant for him, however, neither the absolute nor the exclusive operation of external determinism in human behavior. In terms of realistic humanism, all dialectic is determined immanently insofar as the contradictions which appear in it are perhaps actualized by external conditions of existence, yet the dialectical process comes about on the strength of an inner dynamic and by means of the ability to react and the readiness to function of a subjective table of categories. The changes which decisively affect the system at a given moment take

place neither in the productive forces nor in the conditions of production, neither in the infrastructure nor in the superstructure alone, but in both at the same time. The infrastructure is its indispensable substratum, the superstructure its only articulate, communicable, and comprehensible expression. It is only on the level of the superstructure that we become conscious of the existence of contradictions, crises, conflicts and of the inevitability of their settlement. It is only here that thesis and antithesis, negation and the negation of negation achieve their reciprocal sense, although they in no way become a pure product of thought, a mere manipulation or interpretation of reality. No matter how firmly they are founded on a material basis, they take on, as superstructure, a quality which is not present in the infrastructure.

The basic fact to which all thought and will relating to being refer consists in the fact that the subject never finds himself face to face with an object that is complete from the beginning, but that self and world are always caught in a dependence upon each other. Neither of the two factors is only product or only producer. The inevitability and the inconclusiveness of dialectic come from the fact that consciousness which objectifies itself faces at every stage of its development a relatively inert and recalcitrant element, a reality removed from the consciousness and alien to the subject, a reality which arises from the fact of a crude material essence or of a cultural structure which has already become autonomous or which has congealed into objective form. A tension arises between the consciousness and this crude materialism or culturally formed objectivity, and it enters into conflict with one or the other of them and in order to bring about an agreement attempts to bring the dynamic antithesis to a state of equilibrium, until this state, too, is disturbed as a result of a new dynamicizing resistance—is set in motion and is driven to a new equilibrium which resolves greater and more multifaceted tensions.

In this reciprocal process of interlacing progress is expressed one of the most significant traits of dialectic, which is unpredictably tortuous and which cannot be compared with the directness of biological and genetic development. Seen from the dialectical perspective, a historical process is not one which is unequivocally directed and which can be derived directly and without interruption from its origin. It is, rather, the gradual and constantly changing result of complications which keep arising and factors which cause new complications. Every phase of development may represent a creative moment which modifies all previous steps and reevaluates them. Every position from which we may start encounters as it develops the most diverse antitheses and finds itself involved in the most unexpected conflicts, in such a way that

every solution or synthesis which we reach can become the thesis of innumerable new pairs of antitheses.

The social process which bears all these traits is the dialectical process par excellence. There is no other phenomenon which reflects in a more lively manner and more completely the character of historical changes, conditioned and burdened by conflict, and the inherent contradictoriness of their structures. The peculiarity of social formations—groups, alliances, classes, propertied classes, cultural strata—consists in their individually differentiated and collectively integrated unity. This double nature conditions their dialectical changeableness. What is significant for the dialectic of social structures is just this, that the subject becomes what he is only because of them, the personification of a social being's individual freedom and of the collective constraint of an individual.

8 The Principle of Contradiction

Double Truth

The idea of "double truth," which arose first in connection with the debate over universals—like the principle of dualism and relativism—is older than that of dialectic, at least of real dialectic *(Realdialektik)* if not of a dialectic of concepts *(Begriffsdialektik)*. In the Middle Ages a similar double aspect in art corresponded at the same time to double truth in philosophy. Gothic art developed under its sign. However, as soon as it appeared possible to represent things "correctly" without alluding to their supermundane idea, the antithetical nature of the statements became merely a question of circumstances and points of view. The absolute validity of truth was questioned in more and more connections, and from the end of the classical Renaissance apart from short interruptions, the contradictory solution of practical and theoretical problems was a phenomenon which recurred more and more frequently. After Hegel and Marx the principle of noncontradiction lost its claim to incontestability even in pure logic: the validity of an assertion no longer meant that an opposite one was excluded from the beginning.

Hegelian dialectic took as its starting point simply the axiom that A was simultaneously non-A and that everything had a double, even conflicting, meaning. It was based on the simple inevitability of the relation of ideas and norms, which according to formal logic are incompatible and cannot be reduced to one another. The contradiction of priorities became a criterion of truth. Now it was possible to assert not only that complementary concepts like above and below, right and left, positive and negative have meaning and relevance only in relation to one another, but also that categories like self and world, individual and society, even capitalism and socialism condition rather than exclude

one another. The idea of self-contradiction despised by logic became the cornerstone of dialectical theory; judgments which contradicted each other like those that maintain that truths and values are conditioned historically and can simultaneously be considered timeless, that historical developments represent at one and the same time progressive and regressive processes or form continuous and discontinuous series, opened up for them an insight into new relationships which had been, till then, unknown and unsuspected. Their simultaneous validity seemed neither nonsensical nor contrary to experience, but at the most—and this to their advantage—antipositivistic.

The most penetrating justification of dialectical logic is not only that it ignores formal logic's principle of noncontradiction but rather that it goes beyond what are seen as its limits. If we maintain that A is simultaneously non-A, we are not saying that A and non-A are one and the same—merely that we include the concept of non-A when we speak or think of A. A without non-A as a limit is simply unthinkable. If there were no economy but free competition, no ethic but charity, no artistic style but classicism, neither capitalism nor Christianity nor the Renaissance would have a concrete, tangible meaning. All of these concepts achieve a real meaning only in contrast to what they are not. Hegel, however, in saying that everything was at once itself and its opposite, went further. In the sentence $A = $ non-A, "non-A" does not merely form a limit; it is inherent in A and anticipated by it. What A is can and must, under certain circumstances, become non-A. This is the first and decisive step in dialectic. Every equation conceals latent, hidden, suppressed contrasts which have remained unconscious, but which sooner or later become manifest and lead to a conflict with, and a surmounting of, the contradiction which has become apparent. The equation of A and non-A is the motor of the movement. Its meaning was formulated more concretely thus: "It only becomes a problem for the person who can think of society as a different one from the existing one; only through what it is not will it reveal what it is."[2]

Hegel grasped an essential characteristic of dialectic when he ascertained that intellect would remain empty, blind, and not of the world if it did not set itself limits in the objective world and create a resistance, and he recognized at the same time, as a correlate of this characteristic, that the concrete world which resists spontaneous subjectivity is in part a creation of the subject himself. It owes its particular forms, its objectivity which differs from sphere to sphere—to the subject's categories of reason; but the subject, by reifying his structures and giving them an autonomous meaning, transcends them at the same time. This intertwining of immanence and transcendence, and thus the paradox of dialectic itself, reveals itself most breathtakingly and fruitfully in

art, whose creations, in the sense of Hegel's dictum, "belong" and "do not belong" to their creators.

Hegel stuck to his capricious thesis of the completion of history in order to set an abrupt goal for what is in reality an endless process. However, if we characterize his philosophy as purely ideal and speculative, we fundamentally misunderstand it. In fact he was no less concerned about the faithful "reflection" of reality than Marx was about the consideration of the part reason played in the genesis of that reflection. Marx himself by using the word "inversion" of the Hegelian system may have contributed most to the misunderstanding of his relationship to his most important predecessor. In the same way he may have veiled most profoundly the origin of his doctrine of the inseparability of the immanence and transcendence of thought, of the subjective and objective nature of the intellectual processes, of the eternal struggle of reason with material reality. Hegel, like Marx, stands neither on this side nor on the other of the dichotomy we are concerned with here, but he is concerned essentially with the reconciliation of reason with reality and the bridging of the gap between thought and practice. For this reason Lenin—apparently referring to Hegel—said that clever idealism is closer to properly understood dialectic than is stupid materialism. The "clever materialist," in contrast to both the others, ignores the limits of the concepts in the process of thinking them.[3]

For Hegel the dialectical process consists in the transition of antitheses into one another, in their complementary unity in which process "contradiction is what leads forward." Finally, everything boils down to the movement from a more primitive to a more differentiated stage. What was *one* becomes two, and in dividing itself it develops something new from within itself. The creative antithesis contains dialectic in its core, especially the principle according to which the contradiction of formal logic is "suspended" *(aufgehoben)* and a negative changes into a positive. Diversity becomes the origin of a new and more complex unity. The process emanates from a tension between contradictory interests, points of view, and aspects, from a disagreement between changing conditions of existence and needs—a difference which urges us on to a relaxation of the tension and to an accommodation. The harmony that is achieved at a given moment between the forces which are in dispute is, however, only provisional; it is repeatedly disturbed and sooner or later restored again. The theses and attitudes which exclude one another reunite, in the process of which even those that have been rejected are not necessarily destroyed, but are for the most part preserved in the new form. They form moments of the process which remain on a higher historical or intellectual plane,

sum up the development which has already taken place, and anticipate the development which is about to take place. In this sense contradiction and its *Aufhebung*—negation which is fulfilling itself with positive content—is the fundamental principle and the actually creative element of dialectic.

Mere antitheses like ambiguities, polarities, or reciprocities do not of themselves condition tensions and conflicts in the sense of dialectical contradictions. Ambivalences, too, like love and hate, self-aggrandizement or abasement, aggressiveness and servility, sadism and masochism may well be indivisible, may reduce or enhance each other; they do not reveal the decisive moment of dialectic, the constitutive function of the one moment in the genesis of the other. Hatred is not created by love, sadism by masochism, hubris by humiliation, even though the one may be deepened and sharpened by the other. If on the other hand the individual only becomes what he is through society, by wage labor, by exploitation, by alienation caused by the mechanization of work, or if spontaneity only becomes what it is by a series of conventions, both factors achieve an additional, creative, indispensable element through their relationship. Not only is it the case that there would be no poverty, no militant coalition of the workers, and no socialism without the accumulation of wealth, but it is also true that capitalism acquires its full meaning and fulfills its historical role only as a result of these circumstances. With mere complementaries, like light and dark, young and old, *rubato* and *accelerando,* the one moment achieves as much as the other loses: here it is always a question of a sort of compensation. The antithesis of the dialectical process makes no compensation for any loss suffered by the thesis. It signifies rather a newly emerging productive power, new means of wealth, technical achievements, individual talents, or collective preparedness by means of which the existing conditions of production, forms of government, legal procedures, moral concepts, and norms become antiquated; a breach occurs between the outmoded and the new, and a repeated reconciliation of needs with conditions is necessary.

The renewal of productive forces, the change of antitheses of interests and the attempt to smooth them out are permanent characteristics of historical development. Dialectical thinking is determined by the consciousness of this process and derives from its inevitability the principles of a dynamic logic which is opposed to the validity of ahistorical norms. It pursues the constant formation, articulation, and organization of a reality which is unarticulated in its timelessness and still has to be structured. It expresses the view that every statement about the social being comes about provisionally and has to go beyond itself, that every perception is bound to a particular situation and

changes with its assumptions. Structure and history are not mutually exclusive: every structure is itself a product of history—a form which history conditions while it is conditioned by it. With an idea of this sort before him, Engels defines Hegel's principle in the following terms: "The world is not to be grasped as a complex of complete things, but a complex of *processes* in which the apparently stable things, no less than their images in our head, the concepts, experience an uninterrupted change of development and fading away."[4]

The resistance that the satisfaction of needs encounters in the conditions of existence first conditions the full meaning and depth of the effect which emanates from them. Every characteristic of a dialectical process conditions its opposite and is from the outset conditioned by an expected contrary effect. The impulse which moves the subject as the representative of an activity, an attitude, or an intention is opposed by forces which modify or paralyze the original stimulus: they resist either inside or outside subjectivity. With this force of negation as the second step and the overcoming of resistance as the third, the tripartite classical dialectical formula is completed. It is latent in every sort of dialectic, but not so manifest and marked in all of them. The decisive moment, if not the actual impulse, is the resistance without which no intention, no act of will, no effort would surpass itself. Nothing reveals this in a more lively fashion than the experience of Kant's dove, which when it meets with wind resistance starts to think that it could fly better in a vacuum than in space filled with air. It does not occur to it, undialectically, that it is only the pressure of air which makes flight possible.

Opponents of dialectic, for whom the doctrine is a puzzle and thus an annoyance, might learn something from the sports fan who tried to explain to a disappointed spectator at a soccer game that every team plays as well as the opponents allow it to. No dove flies in a vacuum. No soccer team and no group of human beings play against puppets; their achievements are not only limited by their opponents but also sometimes enhanced by them. Not only does the success of team *A* depend upon the way team *B* plays, not only the result of the match, but also the manner of playing takes shape according to the way both teams play. The opposing groups each play against an opponent who is created by themselves. This form of reciprocity is so extensively present in every form of human activity that achievements not only are intensified by the excellence of the opponents but also are harmed by their inadequacy. Two excellent teams usually play better against each other than either of them would against a weaker team. We live, struggle, work, create works of art and artifacts in the interplay of opposing forces and talents, challenges and encounters, possible

dangers and defensive measures which have been anticipated. If we maintain that an orchestra plays as well as the conductor allows it to, we have to add that the conductor, too, is only as good a musician as the orchestra allows him to be. Both statements are correct, but they are correct only in conjunction with each other; their correctness rests upon a dialectical relationship of two functions.

The vague interpretation of the principle of negation comes mostly from the confusion of the concepts of opposition and contradiction. Usually they are looked upon—if not exactly as synonyms—at least as concepts which subsume each other, and we see in the one or the other the stricter, more narrow, more radical form of two categories which are not, it is true, identical but which also do not necessarily exclude each other. Nonetheless, it is essential that contrary phenomena can exist side by side; contradictory points of view and judgments on the other hand are incompatible and untenable in relation to each other. It is not reasonable to maintain that water is simultaneously fluid and solid, that a man is in the same respect both mortal and immortal, that sensual perception is in the same sense both binding and not binding. Different eventualities of this sort can only hold good under different circumstances. On the other hand we often find in the same social and historical conditions a contradiction of a dialectical nature between facts—for example, a bourgeoisie which is on one hand liberal and on the other repressive; a partly spontaneous and partly conventional artistic activity; a public for art in a given period which is in part individually differentiated and in part joined together in classes, professional groups, and cultural strata. A logical contradiction does not demand a resolution and remains incapable of resolution; dialectical contradiction on the other hand can and must be resolved. In formal logic, contradiction is always total and always has to be rejected in every respect; in dialectic, on the other hand, only single aspects, relationships, components, and functions of a contradictory state of affairs are questioned, excluded, or modified, while others remain unchanged.

In the usage of the language of dialectic there is an apparent inconsistency in the use of "antithesis" and "contradiction," especially when it is a question of which of the two should have a real dialectical, ontological meaning ascribed to it and which a merely conceptual dialectical, methodological one. From the purely semantic point of view we would assign the expression "Gegensatz" a "being" rather than a thetic character, but Marx, whose attention was almost exclusively directed to real dialectic, speaks almost always of "antitheses" when he mentions social conflicts. In contrast to the Eleatics, Plato, Augustine, Descartes, or Spinoza, it is for him as for most of the more

modern representatives of dialectic a question of real developments in which the process being discussed consists not in a succession of stasis and movement, being and becoming, state and change, but in the simultaneity of the static and dynamic moments; not in temporary standstill and the change which follows it, but in the contradiction by which the anticipation of the future conditions by the present.

Marxist dialectic is directed above all to the portrayal and explanation of this characteristic. The *Communist Manifesto* lays the greatest emphasis on the change of the class of progressive *citoyens* into that of the conservative bourgeoisie and at the same time of the inherence of the one in the other. The connection of opposites of this sort bears the seed of further simultaneities within itself. The bourgeoisie which is inherent in the progressive citizenry "dissolved its personal dignity in the exchange value . . . and replaced an exploitation veiled in religious and political illusions by open, shameless, direct sterile exploitation." Throughout the age of free trade and competition these historico-dialectical antitheses and changes, the economic crises of the apparently stable bourgeois society, the wage struggles and the chronically explosive mood of the workers allegedly led around by the nose all persist. "The bourgeoisie has not only forged the weapons which will kill them; it has also produced the men who will carry these weapons—modern workers, the proletariat." The way in which dialectic functions in history—movement creating movement, movements becoming constitutive for each other—is no more clearly expressed than by the phenomenon of "alienation," which originally appears in the depersonalization of mechanized labor, but finally also takes hold of the capitalist class and becomes the characteristic of the age.

Dialectic thus by no means consists in the change which a thesis, affirmation, or position undergoes under the influence of an antithesis, negation, or opposition, not even in the mere interaction of antithetical interests, standpoints, and aspects, but mainly in the circumstance that action and reaction are inseparable and conditioned by each other, in a word, are inconceivable without each other. Everyone plays in the great game of life as expertly as his opponents let him, and he plays according to the rules which the others obey. The "game" itself is not the result of but the platform for interaction, and the "rules of the game" do not evolve successively and from themselves, but from the simultaneously and equally relevant principles of a tacit agreement.

The resolution of antagonistic tendencies is, it is true, for both Marx and Hegel, the meaning and purpose of the dialectical process; the identity of antitheses, whether it be of being and nonbeing, of the material and the spiritual, of the forces of productivity and their effect, however, already seems in Hegel to be a mere and often pointless

remnant of the inherited philosophy of identities. For Marx especially, it is as the symbol of the overcoming of the class struggle and of the reconciliation of social efforts only a further illusion of hope, a utopia and prophecy, the simulation of a reward for victory but by no means the "coin" of dialectic which should be "pocketed" at the outset. The contradiction which is expressed in negation is, and remains, the primary characteristic of the process: the so-called identity of antinomies is nothing more than the premium set upon the execution of a successful operation.

Dialectic can no more be founded exclusively either upon materialism or upon idealism than upon their alleged identity. It is based upon the combination of phenomena which remain antithetical, the consistency of their dualism and the ineliminable contradiction of their principles, which can always only be provisionally reconciled. Pure materiality can never subjugate the blind senselessness and purposelessness of mere being; it is only in conjunction with the subject—the human principle—that it becomes an object of thought and a substratum of history. For this reason, Marx always talks of a dialectical materialism, when his doctrinaire disciples and followers speak only of materialism. Mere material no more bears dialectic within itself than does sheer spirit. As soon as it begins to move and develop historically, it is no longer merely materialistic. Already the potentiality for development is more than materialism, which is essentially lethargic. In contrast to Hegel's doctrine, however, the "spirit" is in itself unhistorical and undialectical; it is like raw, unaffected material "abstractly" presented to the principle of history, the division and the conflict between man and nature, subject and object, thing and structure.

The hope of all dialectic is directed at the surmounting of the contradictions between aspects, modes of behavior, and aims which appear simultaneously and which refer to the same phenomena. As a result of the shifts in relationship between producers and those who benefit from production, every sociohistorical constellation sooner or later develops into an untenable complex of opposites. The apparent way out of this situation may mean, from a humanistic and social point of view, a rise or a fall, and the theory of history corresponding to it may be ascending or descending. As long as Hegel sees the inevitable fate of historically conditioned man in alienation, his doctrine of development is a descending one; only when he accepts the thought of taking the alienated objective spirit back into the intimacy of the subject does he change descent into ascent. In the same way Marx actually also saves his essentially unhappy view of history—burdened with the concept of the class struggle—from the hopeless acceptance of the

constant rotation of the master/servant relationship by the idea of the "classless society."

Both ascent and descent are, however, only temporary solutions to the problems posed by the contradiction of historical situations. History does not take a definite point of view in either direction. As a general historical principle dialectic has no direction. As for the precarious position in which society finds itself again and again, it is sometimes hopeful, sometimes hopeless. Man's fate is formed according to antithetical principles whereby progressive and conservative, liberal and repressive, liberating and binding, intellectually spontaneous and materially lethargic moments dissolve. Historical development is, however, on the whole free of value. It is only the individual steps which have more or less value according to the relationship they bear to the needs of the time. History itself is, like life, incommensurable: the value of both is directed toward the way in which we make use of them as possibilities presented to us to achieve something. Their comprehensive interpretation, whether in the sense of a constant or final progress, or of an unavoidable decline, is nothing but an attempt to establish consequentiality and necessity where, without mystification, there is no question of anything of the sort.

The Structure of the Dialectical Process

At first sight dialectic represents a tripartite gradation reminiscent of the syllogism. But whereas the syllogism is an empty methodological formula, dialectic corresponds to a real process with a concrete content which has to be disregarded if we are to achieve a neutral pattern, a mere *modus procedendi*.

The essence of dialectic consists, as it deviates from its classical tripartite structure, in a complex of two contrastive phases and attitudes: on one hand in the negation and surrender of a dominating view or institution, the rejection of demands which are just coming into being as a result of newly arising forces or legal titles; on the other in the settlement of the antagonism which arises by means of a more complex unity, a new synthesis which embraces the antitheses. The contradiction in the points of view is the origin; their reconciliation is the culmination of the dialectical process. Yet neither the tripartite articulation nor the sharply divided bipartite structure is an indispensable force in the dialectical structure: its decisive criterion is antagonism itself.

Dialectic is dialogue, question and answer, challenge and response, tension and release, contest and resolution. Meanwhile the process reaches its conclusion not by the destruction of one or the other of

the contesting forces or principles but by the change of their role and meaning, in the course of which they preserve those forces which are capable of continued existence, which have not become completely out-of-date and are still productive for further development. Hegel was probably the first who saw and emphasized this preservation, or as he called it "storage" *(Aufhebung)*, of the contradictory elements. At the same time he forces the dialectical process most obstinately and uncompromisingly into the tripartite scheme, insisting most strictly upon the rigid formula of thesis, antithesis, and synthesis, a structure which had already proved narrow enough in Fichte's work but whose limitations are only now fully revealed. Hegel's dialectic moves in a mechanical rhythm, a waltz rhythm, as people have not neglected to remark, to which everyone has to dance. The analysis, for example, of the development of love in his *Rechtsphilosophie (Philosophy of Right)* according to which the lonely person feels himself to be inadequate, then finds himself again in another person, and finally unites himself morally with this person shows with what virtuosity he is able to apply the heartbeat of this rhythm to any process at all. Everything falls into three parts, three phases, like three dance figures in whose stereotypical rhythm the artificiality of the choreography only becomes all the more apparent. What cannot be overlooked is that every process of becoming, every development, every change can be traced back to the antithesis of different principles, the lassitude of material reality, of institutions, conventions, and coagulated forms of the existing culture, on one hand, and the dynamic of stimuli in the form of energies newly discovered or used in a new way, of spontaneous inner impulses, or of abilities till then unknown, on the other. The dialectical process, as Lenin already had remarked, does not necessarily have to fall into three phases; it can reveal more or fewer phases of development. In no way is the number of stages its decisive characteristic. What is essential is the mobility of relationships, the transition from one state to another, the indissolubility of the historical complexes, their ability to be taken apart and supplemented in the course of development. Although it does not matter how many parts we are concerned with in the process, the goal of dialectic is the global aspect under which the forces in question form a context. A view in which they appear independent of one another is undialectical.

Dialectic indicates a form of historical development which is often, though by no means necessarily, repeatable, unmistakable, but for the most part independent, to which neither universal validity nor a completely permanent structure can be ascribed. Rather, it represents the principle of a historical typology whose limits are open and fluid. Just as the definitive form of the process of dialectical thought and history

does not consist of the triad but of the opposition and contradiction of the forces involved, so the "synthesis" does not necessarily derive from the conjunction and summation of the theses and antitheses but from the surrender of certain forces which cannot be united and from the preservation of others. For long stretches of the process no synthesis comes about which could be called a solution, but it remains only a precarious, temporarily unresolved antithesis of the factors, and is thus in a situation in which no choice can be made at the fork in the road. Yet no matter how the development finishes, what is decisive is that in spite of the unavoidable negation which has to follow—whether manifest or latent—the position which has been negated is in a more or less unified course of history never totally surrendered, but part of it remains as an achievement which cannot be replaced or lost. The position which has been replaced thus sometimes contains more, sometimes less important elements of the following development and anticipates in their preservation the resolution of the conflict in question. In this way we are dealing only with the metamorphosis of a potentiality into an actuality. The decisive dialectical step thus consists in negation as the origin of a new potentiality, not in the actualization of a possibility which, because of unforeseen obstacles, can be either frustrated or fulfilled.

Negation is the still unfulfilled potentiality which has, however, been promised. Feudalism, which became problematical and which showed itself to be untenable, involves capitalism (the practice of wage and trade economy), which had not yet been realized but which became real with the crisis of feudalism. Yet the old system becomes problematic because the presuppositions for the new economy and the new society are already given in the productive forces which are freely available. Capitalism is just as little the product of an immanent change taking place in the feudal "spirit" as the Renaissance is the simple result of the change of taste and attitude which takes place in Gothic art. Yet the Renaissance is already in the air in the negation of Gothic. The forces, techniques, means of production, labor organizations, individualism, and new discipline which governs the individual—which are necessary for its realization—were all present before the Renaissance appeared as the heir to Gothic art. Indeed, it only makes sense as negated Gothic and is as such inherent in the negation. Only from one such point of view does the Hegelian assertion that A can also simultaneously be non-A become comprehensible. Formally it may be open to any number of questions; as a historical heuristic it is fundamental. Every abrupt change is puzzling; the problem of immanent, apparently automatic change in style and attitude is, however,

completely insoluble. Hegel's paradoxical formulation of contradiction follows from his renunciation of suitable mediations.

For Kant, dialectic was still bipartite, with the consolation of truth and certainty as the first step and faith and simple appearance as the second. He merely saw the division of principles and rejected dialectic as the source of synthetic judgments. His followers, on the contrary, declare that it is the only sure way to discover truth, beginning by turning away from logic's "lack of motion" and leading to the perception that even logical truths are historically conditioned and subject to dialectical modifications.

Nevertheless Kant in more than one way already saw through the antagonistic nature of human affairs and mentioned among other things the "unsocial sociability" of people as an example. "Man wants peace," he says, "but Nature knows better what is good for his nature: it wants struggle." People have rightly pointed out that Tönnies echoes this sentiment when he defines society by saying that people in it are not "essentially unified, but essentially divided."

However, it was left to Fichte to make the great discovery that in its activity the spirit looks at itself and exists not only *"an sich"* (in itself) but also in its ideas and works *"für sich"* (of itself). The spirit in Fichte's dialectic becomes a "non-I," something alien and objective, and its negation consists of this different essence. The work of art, however, becomes not merely expression and self-assertion but, in Hegel's sense, also the "privation" of the artist; it becomes an autonomous and immanent form, something different from what it should have originally become. As soon as he sees and judges his work objectively, something moreover which he does again and again with ever increasing objectivity while working on it, it belongs to him only to a reduced and ever-reducing extent. The umbilical cord between him and his spiritual child is cut. He regains possession of his creation only by the "negation of negation," the taking back of his deprived self. As a recipient he has to reconquer his alienated work.

Dialectic as an ontologically determined process—that is to say, not as a mere methodological operation—becomes apparent only when we perceive the historicity of human culture. Descartes, Leibniz, and Kant think completely unhistorically;[5] it is only the representatives of post-Kantian German philosophy who understand the historical limitation of the conscious processes, and it was only Hegel who developed his philosophy in essentially historical rather than scientific categories. It continued to be indubitable that we cannot speak of phenomena like the individual and society, form and content, spontaneity and convention without thinking of a particular articulation and organization of the material under discussion. Yet at the same time it became obvious

that such structures are not supertemporal and beyond history and that to talk of structures which remain the same is just as meaningless as to assume unchangeable spiritual impulses, tendencies, and dispositions. Both factors proved to be subject to historical development, and new stimuli associated themselves of necessity with new structures. Historicism in this sense is, however, not only the most valuable thing which Marx took over from Hegel; the doctrine of ascendancy which is tied to this, utopian and prophetic messianism, is at the same time the most dubious thing in the romantic heritage which falls to him in this way. He shares Hegel's conviction not only in thinking that by means of dialectic he has thus found the law of historical development, but also when he thinks he is certain of the direction taken by its allegedly rising line.

In the works of neither of them is the concept of ascendance unambiguously clear. Hegel, who sees the genesis, development, and individualization of cultural structures as processes of man's privation, alienation, and depersonalization—as a loss of his subjectivity and inwardness—also stands in the shadow of this danger when he ascribes to man the ability of saving for the absolute spirit his products—which have been objectivized and have deserted him—by taking them back into the subject. Marx, too, remains torn between an absorption in the objectivized products of labor and final release from an alienated society and its depersonalized culture by classlessness. Both find themselves delimited because crossing of the limits would be prevented by the principle of dialectic, the antitheses of the social forces which condition historical movement.

The scientific yield of thought in the form of negation and contradiction shows itself in innumerable variations: in the psychoanalytical theory of the two levels on which the individual moves when he "rationalizes" his irrational drives; in sociology, in which subjects think and act differently as members of a group than they do in other circumstances. It is present in the doctrine of class-consciousness as a completely different state from psychologically manifest consciousness; in the theory of perception according to which the subject knows of more than he perceives; in Cartesian philosophy, which is based on the contradiction and reconciliation of the ontological and cognitive sphere; in the Platonic doctrine, in which more is seen than is comprehended; and in Socrates' wisdom in knowing that he knows nothing. In all these cases thought transcends its logical limits or overreaches itself, which is not to say that it becomes irrational. Even dialectical thought is logical, if not monolithic. And just as not all questions which permit of contradictory answers are absurd, many such answers are more revealing than unambiguous ones.

We understand the meaning of dialectic and the significance negation is accorded in it only when we consider that this may contain an enrichment of mere affirmation and may in Hegel's sense contain it without fail. The negative concept which assumes the positive one represents a higher and more comprehensive stage of thought than the one-sidedly positive concept. The discovery that every position includes to some extent its own negation, that every movement is set in motion by it and thus for the actual motive force of development to which being as wholeness is subject, contains the origin of post-Kantian critical philosophy. This in its turn, like the whole social life, rises up to a new positivity. The origin of skeptical philosophy from the ideology of the disappointed postrevolutionary classes alienated from the now dominant bourgeoisie is obvious. Modern dialectic with its doubts and contradictions is the philosophy of these social groups, who see their right to existence questioned—and they question it themselves so as to arrive at a new self-affirmation by struggling against these dangers. Then, too—as the "negation of negation"—they gather from the ruins of their lost hopes the will to rebirth and to a continued though always jeopardized existence.

The self-alienation of the subject in the process of forming objects, his "unhappy consciousness" on account of the loss of his self-sufficient intimacy in contact with the external world, the depersonalization of the producer by the objectivization of labor, the lack of interest of the worker in the product of his hands because of the division of labor, the pauperization of the proletariat by the accumulation of the means of production in a few hands, the dehumanization of the sciences as a result of specialization and of art in connection with *l'art pour l'art* movement are merely forms of the same negation, the same disintegration of human existence and culture, but they are at the same time the seeds of renewed integration. Development leads from one form of frustration to another, but meanwhile also to resting points—and in the form not only of careless euphorias, but also of the indomitable regrouping of forces—which separate the periods of unrest, defeat, and hopelessness from one another.

The Dialectical Process

The origin of real *(Real)* dialectic is the elimination of the correspondence of factors, which as a result of the coming into existence of new productive forces, needs of existence, and conditions of productivity have lost their relevance or changed their function. The dialectical process consists essentially in the restoring of the balance which has

been shattered by the new elements by introducing a more flexible or comprehensive relation. It begins with the crisis in the functioning of existing institutions, with the conflict between the demands and the satisfaction of them, with the threat—which up till then had remained unnoticed or unconscious—to an insecure peace, and usually finds a more or less forced and always temporary conclusion by the reconciliation of the dominating needs with the given conditions. Crisis and conflict first assert themselves dialectically, however, when the conflict is joined by human beings. The society in which the process takes place is not an automatic machine, and the socialized beings not cogs in machines which are driven externally. Feudalism is perhaps the unavoidable negation of slave society, wage labor the negation of feudal service, the labor force involved in the class struggle the negation of the proletariat still incapable of coalition; but all these economic and social formations are the goal-oriented work of man, however inevitably they evolve from their historical assumptions. For a "historical necessity" is, as Marx said, a "disappearing necessity"[6]—that is, a set of rules which can be modified by men. With time, the different social structures become of necessity problematic, out-of-date, and untenable; those, however, which take their place at first have blurred outlines and remain in part flexible and undecided, that is, not devoid of all freedom.

A dialectical relationship exists only where the opposites—like north and south, attraction and repulsion, positively and negatively charged electricity—do not simply exist side by side but are, as moments of one and the same content, act, or process, inseparable from one another, where the tension between them belongs to the criterion of their existence and necessitates a state which, laden with conflict as it is, becomes untenable but which still proves to be corrigible by means of a new orientation of the conflicting forces. Thus, a dialectical relationship exists between the subject's will to and his means of expression, the continuity and discontinuity of cultural development, the traditionalism and rationalism of social activity. The inner struggle between the different tendencies which are inherent in every creative activity and which is only gradually articulated is of this sort. This struggle especially allows the artistic creative process to become a coherent one in which one moment after another, and because of the other, is validated as a result of the subjugation of the one by the other or their reconciliation with one another.

While the merely contrary, polar, or complementary phenomena which appear in nature as bound together can influence but not condition one another, the dialectical antitheses represent not only different modifications of a variable principle but, according to their

whole essence, interdependent facts. The productive forces exist, it is true, independently of the conditions of production and present these with an ontological primacy. However, as effective, practically functioning conditions of existence, they assert themselves only when a change of circumstances and a change in the configuration of needs or of the products being accomplished takes place. Such movements, changes, and alternations are first noticeable, however, when a renewal of the forces of production and of the abilities to produce is in the air. We can at best only talk about a priority of these forces in the sense that they replace each other continuously in the form of newly discovered materials, sources of energy, and methods of evaluation, whereas the already fixed conditions of production and property, legal practice, organization, and exploitation of labor tend toward conservatism. According to Marx these become the bonds of the growing forces of production which are pressing for use, and so antitheses, conflicts, and struggles arise between existing institutions and the new materials at man's disposal. New and old, tradition and reform, traditional and claimed law, the stasis and dynamism of forms of life, however, form an inner antithesis insofar as their support is the same social system, but certainly not in the sense that their conflict arises from the "self-movement" of the system.

At the root of dialectical antagonism lies the fact that in every conceivable being we have to think of a category of reason as a constitutive form and in every rational operation something alien to everything rational and conceptual has to be added as a substratum, although this is not a finished "object." After Kant every rational, empirically directed critique of perception stems from the dualism of this fundamental nonidentity. Almost the whole of post-Kantian philosophy attempts, however, to circumvent this nonidentity and, like Hegel, to forget that thought without opposition, on no matter how high a plane, is irreconcilable with the sense of dialectic and perception. Hegel opposes the division of the rational categories from naked ontological objectivity because he fears that in this way both the purely subjective forms and the purely objective "something" will forfeit their quality and assume a suspiciously abstract quality. He believes on the contrary that he will save their bond to life, and the relationship of the world of sense and thought, by clinging to the identity of the existing and the valid, the general and the particular, the object and the subject.

The association of these principles is made manifest, however, not by their apparent identity, but by their indivisibility in every cultural structure. If we think of their essential nature, we also have to think of the mutual effect which keeps them in a state of tension. If we wish to understand their function, we must measure the role of the resistance

which has to be overcome for them to be validated. Their unity consists not in their identity but in the fact that they assert themselves *uno actu*.

The concept of man as the "responding being"[7] also contains this characteristic of his dialectically conditioned nature. He responds when he sees himself faced with objective alternatives and when he reacts to them under the stimulation of his own needs. His responses are no more purely spontaneous than they are mechanically conditioned. They are the result of a bilaterally determined conflict between what happens in and what happens outside himself. New productive forces create new needs, which are only articulated when there is a chance of their satisfaction. Yet latent, unclear, and unconsciously slumbering needs can also become productive forces and create new conditions of productivity. The conscious, rationally endowed being behaves, even toward his darker impulses, as a "responding" being who selects and judges dialectically, who creates something entirely new and original from his data, stimuli, and nature which is just as alien to his innermost self as the dull objects outside him. The answer he gives to the questions, the challenges, and the tasks he faces is his own property, his product, his contribution to the reality which surrounds and stimulates him, and which is the presupposition for his existence as a subject able to react.

Abilities and talents become what they are—in the sense of Marx's manuscript from the year 1844—when they are functioning—that is, in the course of their controversy, their struggle, their battle with the difficulties and obstacles which they encounter on the way to success. We simply do not know what we are capable of when we meet resistance; we develop our abilities only when we are faced with new and hitherto unknown tasks. A positive achievement comes about generally after a series of unsuccessful attempts has preceded it. Negation contains the seeds of its overthrow and is the fruitful moment of development par excellence. With it the so-called volte-face which heralds a new epoch, a new social organization, a new trend in taste or style is accomplished. "Gothic art came into being grain by grain," says Paul Frankl, "but did the first person who placed the first proto-Gothic grain have any idea of the ultimate pile [i.e., of Gothic]?"[8] The volte-face to Gothic art came about without doubt by means of a negation, whether it was with the rejection of the last "Romanesque grain" or whether it was out of dissatisfaction with the single proto-Gothic grain and the need for the "pile of Gothic." How and when does a grain turn into a pile? The question is essentially the same as the more universal one—when and how does a volte-face take place in history at all?—and is connected with the more fundamental one—under what

circumstances and in what sense is a certain quantity transmuted into a new quality? In fact, all that can be ascertained is that a swing from Romanesque to Gothic took place somewhere and at some time, and it is also unquestionable that the change began with the negation of the earlier movement and that the "pile" of proto-Gothic grains somewhere ceased to be the mere sum of them. Besides negation there is, however, no determinable gap between the grains of the old style and the pile of the new. The beginning of the dissolution of feudalism, the rise of the new bourgeoisie, the renaissance of the cities, the crusades and their moral effect, the secularization of culture, religious emotionalism, the development of the nominalist view of the world and the interest in the individual and the particular connected with it are mere "grains" in the "pile" of the change. However, they contain as good as nothing that suggests the qualitative characteristic of Gothic art, its characteristic ideal of beauty, its enhanced sensibility, its rejection of strict tectonic form in the interest of differentiation, warmth, and emotionality. Those scholars who assert that in the history of art we can only talk about something like the number of grains would at least have to admit that the actual change in style—that is, the turning point by which the tendency to a style becomes a style—takes place at an indeterminable point and that in the development no decisive turning point can be determined except for "negation."

If dialectical contradiction meant nothing else than that the proletariat is driven to anger by the antithesis between its human nature and its existential situation,[9] the Marxist explanation of the historical process would remain superficial. The contradictions are, however, more deeply rooted and exist at the point at which the antitheses in the inner structure of a society which has become untenable have their origin. It is then a case of contradiction of principles in one and the same system. In slave economy, feudalism, and capitalism it is a case of acquiring the productive forces which themselves lead to the collapse or reformation of the particular form of economy. The fact that late Roman economy and society could not exist without the slave labor which was once so lucrative, or that the modern consumer-goods industry has to change its structure beneath the dictatorship of the trade unions and the danger of paralyzing strikes is a much more decisive moment of the class domination crumbling within it than the now more and now less manifest and operative class consciousness of the workers.

The explanation of sociohistorical developments does not emerge in such and similar conditions without the assumption of inner contradictions in the social structures. Athenian democracy was progressive according to standards of the tribal state aristocracy but completely

regressive from the plebeian point of view. Modern industrial capital-
ism is a social order of free competition for those capable of competition
and a battleground with the same chances of success for those capable
of fighting. It is, however, from the outset selective and exclusive since
it equips individuals and groups who may be part of the competition
with more or less suitable means of warfare. Thus, the contradictory
aspects of an art like that of Versailles make their appearance and now
bear a strictly formalistic and measured character, now a more expres-
sionistically exaggerated character, according to the stylistic context
into which they are brought and the standpoint from which we look
at them. Every undialectically one-sided point of view proves to be
false or insufficient in the face of it. It is obvious if we look at examples
of this sort that historical phenomena are not unambiguous, immutably
fixed states of affairs which are definable once and for all, but for-
mations *en marche* and power complexes *en acte*.

Hegel was completely aware of the difficulties which arise from
thinking in contradictions. "It is ridiculous to say," he wrote in his
Philosophy of Right, "that we cannot imagine a contradiction. What
is right in this assertion is only that it cannot end with contradiction."
Ernst Bloch must have been thinking of this passage when he declared
that according to dialectic, *A* can also be non-*A* but cannot *remain*
so.[10] This is the essence of Hegelian philosophy. Part of contradiction
is its resolution in a positive sense: the "negation of negation." What
is positive in a dialectical negation is preserved, while what is untenable
is thrown away. And just as every negative contains a positive, so the
positive content of a statement or attitude includes negative elements.
The sense of immanence is, in other words, just as unthinkable without
that of transcendence, as transcendence is if not confronted with the
idea of immanence.

The criterion of dialectic consists not in the fact that the historical
and social process is completed in an unbroken series of contradictions,
and that its growth and change are secured not by harmony but by
the discord of its factors. Dialectic manifests and asserts itself by the
fact that the negation with which it begins its course deepens and
extends the sense and the area of validity of the negated elements
instead of impairing them. Capitalist accumulation of wealth brings
its own negation and collapse through the coalition of workers who
were at first exploited. The negative results belong to the concretiza-
tion of the process to the same extent as the positive reasons for its
beginning.

Innumerable states of affairs, especially of an intellectual nature,
cannot be expressed except in such a paradoxical form. Kierkegaard,
the most obstinate protagonist of the paradoxical as the basic principle

of human existence, could have summed up his religious philosophy in the one sentence, God as the quintessence of omnipotence and omniscience chose to manifest himself through limited human reason. In a similarly paradoxical manner Plato expressed the riddle of human perception in his parable of the cave, Tertullian the relationship between knowledge and faith in the slogan *credo quia absurdum*, scholasticism the problem of logical contradiction in the doctrine of double truth, Nicolas of Cusa the contradiction of his view of the world in the *coincidentia oppositorum* and the *docta ignorantia*. Luther for his part expressed the incommensurability of salvation and service in the doctrine of predestination, Machiavelli the discrepancy between political goals and human concerns in a principle of "double morality," Descartes the puzzling relationship between being and thought in the doctrine of *cogito ergo sum*, Leibniz the gulf between immanence and transcendence in the concept of the "windowless monad," and the whole helpless aesthetic of the irrationality of artistic quality in the resigned confession *je ne sais quoi*. The most striking example, however, is a product of paradoxical Jewish wit. It is well known that to pious Jews the numinous are surrounded by so ineffable a holiness that they never speak the name of God and wherever he is called *Yaweh* in their prayers they have to read *Adonai*, departing from the actual text. Only once a year, on the highest holy day, at the most solemn moment of the service, does the rabbi say, while prostrating himself and covering his head with his cope, the word "God." Yet he says it in such a way that it is drowned out by the organ music and the choir and cannot be heard by the congregation. Yet these same Jews are on such familiar terms with their God that the following story is told. On the eve of the holy day just mentioned, the day of repentance and reconciliation, when people scarcely dare mention the name of the stern judge, the poor village Jew speaks to the Almighty in this free and open way: "O God! listen to me; There's our honest, decent butcher, who wouldn't swindle a penny out of anyone and wouldn't send anyone away empty-handed, while he himself and his wife often don't have a bit of meat to eat. Or our cobbler, decency and piety itself, has to look on while his mother dies in the most fearful pain. And our good rabbi, who is half-blind and will soon be totally sightless: I ask you, on this holy eve: Dear God, is that just? But do you know what? If you forgive us to-morrow on your holy day, we'll forgive you too."[11] Just like this, then, when we are involved with important things, with things which would be absolutely worth knowing and about which we ought to be clear, we express ourselves paradoxically rather than in an unambiguous manner, which could be readily understood.

Even Marx arrives at a somewhat paradoxical formulation of his dialectic when he states that thinking and being "are it is true, different but at the same time are in unity with one another."[12] In this way he sets up a thesis which is at first sight no less puzzling than Hegel's with the proposition about the rationality of all that exists. But "unity" for Marx does not mean identity. Even if thinking does appear in his works as a function of materialism, it was still left to later vulgar Marxism to depict the spirit as the product of material. For even if, in Marx's sense, we ascribe a quality of existence to consciousness, we will have to admit that it represents a special, "intentional," cognitively, emotionally, and volitionally directed being, even if it is stimulated to its intentionality from outside, while the mere material being, as a decisive, simply unavoidable element of all life processes, has to be mysticized in order to become the source of spontaneity.

Looked at dialectically, even the medium of language, like every means of expression which the artist uses, appears as a moment of resistance, an obstacle to be overcome which intrudes between the artistic intention and the product. The work is in no way the complete triumph of the will to expression over the means of expression, but rather a compromise between the two. The difficulty of this operation can no more be avoided than it can be prevented, for it is the case—as we read in the *Deutsche Ideologie*—that "the 'spirit' is from the beginning cursed in that it is 'burdened' with the material which occurs here in the form of moving atmospheric layers, of sounds—in short, of language. Language is as old as consciousness—language *is* the practical consciousness which exists for other people too and so exists first for me too as the real consciousness amid language arises, like consciousness first out of need, out of the necessity of intercourse with other people."[13] "Language" means in this sense every medium of communication which binds the communicating to the receptive subject, but which at the same time hinders their immediate contact.

The "immanent origin of differences" to which Hegel in the final analysis reduces dialectic makes the explanation of different forms of development on the basis of external interference both superfluous and nonsensical for him. The concept contradicts not only his assertion that dialectic is not a *perpetuum mobile* but also the fundamental dualistic principle of every dialectical ideology, which may well be an atheistic one[14] but which cannot remain rooted in any monism. It is true, as Marx believes, that man is by no means incapable of finding peace, but he is not from the outset a being who is not at odds with or who is reconciled with himself. And if materialism really were to mean an "explanation of the world from inside itself,"[15] then materialistic monism would scarcely be reconcilable with the dialectical

principle. Dialectic is a dualism which is oriented partly to objective conditions of existence and partly to subjective needs for life. As a utopia it may go beyond both factors, but it never begins on the other side of its contradiction. Existence has to be thought of as a conflict-laden relationship between subject and object before it can be considered an area of desires free from conflict.

Both Hegelian and Marxist dialectic assume on one hand the divisibility of the complex which is to be studied into its motifs, and on the other the possibility of expanding the motifs into the totality of a sociohistorical sense relationship. They depend on the assumption that such a relation consists of a series of thesis-antithesis relationships, that analysis will lead to ever more widely differentiated pairs of antitheses and will finally produce a global view of the complex in question. Dialectic sustains the hope that ideally the practically disparate moments of a development will meet somewhere. The movement, which ensures progress from one stage to the next, is still for Marx a somewhat mystically conceived "self-movement" which has its inexhaustible source in the so-called inner contradictions of the social structures. Even this, like every *perpetuum mobile*, is in reality driven from outside, and the process can be called an "inner one" only when the contradictory attitudes, interpretations, and evaluations take place in the same historical period and frequently in the same social strata. That is, the very conditions to which a tendency owes its existence may simultaneously threaten its continued existence. Which of the two possible results gains the upper hand depends on factors outside the system.

Dialectical logic is directed at moments of movement between antitheses which, in the course of the process, assert their individuality on one hand and enrich it with new characteristics on the other. It represents a process of development in which the unity of the changing phenomena is preserved. In contrast, formal logic persists in static relationships and is incapable of comprehending the movement of concepts as a development. Kantian philosophy broke through its bounds by replacing substances as transcendental essentialities with immanent categories of reason. The prosecution of the movement between immanence and transcendence occupied the whole of post-Kantian philosophy from Fichte to Hegel and Marx under the rule of the dialectical principle. The question is asked again and again in different versions: "How do we get from subject to object?" How does the essentially unknown transcendence form itself into a substratum of the essentially incomprehensible operation of reason? Where does the movement start? What is the primacy? And how far can we talk about primacy in this context at all?

For Kant the formation of objects, and what his followers understand by objectivation of alienation, is a completely ahistorical process; for Hegel and Marx, on the other hand, the process is purely historical. For Hegel every point in time is a historical turning point and human social existence is an uninterrupted historical drama. However, he to some extent dehistoricizes the alienation which takes place with every object formation while assuming that because of its supposed inevitability it is not bound to any particular time, place, or complication of needs and obstacles. For Marx, on the other hand, the breach between the ego and the world which results from alienation is in every case a concrete historical happening which has special assumptions and is repeated under any number of subjective and objective conditions. Thus, the worker alienates himself from his own work, from society, and from himself as a result of the mechanization of production, the division of labor in the manufacturing process, the accumulation of the means of production in a few hands, and the depersonalized relationship between employer and employee at the time of the change from feudalism to capitalism. For Marx historicality means the same thing as socialization. Man and society are, however, not confronted at every moment of their existence with vital decisions and epoch-making changes.

In the work of Kant the perceptive, feeling, and active subject is, with his categories, a static entity. The decisive step which leads to post-Kantian philosophy and its historical dialectic depends on the insight that the subject is not the representative of an ahistorical categorical apparatus but has essentially a changeable character which alters with its station. When Hegel declares that the truth is not a "minted coin which is complete and can thus be pocketed,"[16] he believes that it corresponds to a movement which suits itself to the objective processes, constantly starts again from new, denies, and in the complex sense of the word is *aufgehoben*. It changes its form, but in no sense disappears from the context of valid propositions. Even those mathematical and scientific truths of whose validity there is no doubt are not always used unambiguously. Even they assume a manipulable character, become parts of ideologies, and acquire a changing importance according to them.

Truth and perception in the work of both Hegel and Marx have a concrete sense and a practical value only within a system which coheres historically. As long as there are contradictions between the individual theses and doctrines of science, there can be no global and homogeneous picture of the world. However, it is part of the dialectical nature of history and thought that even unified and integrated views of the world prove to be merely temporary and sooner or later insufficient

syntheses, although both Hegel and Marx brush aside this dialectical principle as rashly as they do promisingly with their utopia of the realization of "absolute spirit" or of the "classless society."

The Concept of *"Aufhebung"*

Dialectic moves between the principle of negation, without which no development of thought or history could be set in motion, and that of *Aufhebung*, without which it would remain mere negation. Yet just as negation is not an answer but merely part of the questioning, so *Aufhebung* is not a single step, but already the sum total of the logical or the historical process. It represents in the positive sense of this complex concept the final yield of the whole dialectical operation. The *Aufhebung* of a state of affairs or of a *Setzung*, of a social form or an ideology can come about when the system which is no longer tenable has been eliminated, disintegrated, and destroyed. Examples of this would be when slavery collapses and disappears at the beginning of feudalism, the collapse of the belief in geocentrism at the point when heliocentrism took over, or the collapse of peasant art of the flat lands in the face of the spread of urban mass art. But *Aufhebung* also means the transposition of a thing to a higher level in the literal sense, like the rise of mechanical production from the level of manufactory to that of factory. Finally, the *Aufhebung* of a state in the strictly dialectical sense means its being overtaken by a more developed form in which the more primitive is partly dissolved and extinguished, partly retained and embodied in the remaining cultural material of society.

Through this remarkable change, which combines the negative role of the progressive steps of cultural development with a positive sense, the disintegrating effect of historical processes with the achievement of permanent cultural goods, their eternal problematical nature with a tradition which is stabilizing, dialectic achieves its actual significance, its suitability to define and solve problems which could not be handled in any other way. In no other way can a post which has been surrendered still be manned, or the validity of a truth which has been given up maintained. Only by dialectic can we explain how an artistic style like geometrism or classicism which depends upon the principle of subordination can surrender its role as a principle of taste and yet remain a constitutive factor in further development. The significance of stylistic products which were once attained is preserved dialectically not only in the sense that the Renaissance cannot be imagined without Gothic or rococo without baroque, and that each of these styles is contained in the succeeding one, but also in the sense that no really

creative style disappears without trace and cannot be revived in corresponding circumstances.

The act of *Aufhebung* constitutes not only the most strange but also the most fruitful part of the dialectical processes. Negation may perhaps also be a factor in development as indispensable as the negation of negation; if what was negated were, however, to disappear completely from the ongoing process, dialectic would remain a process which was essentially value-free instead of becoming one of the most productive forces in the formation of culture. In the phenomenon that contexts and norms lose their actuality but retain more or less their sense and value, we have the expression of the most significant characteristic of historical processes. It corresponds to the discernment that two antithetical standpoints, aspects, and views can, in spite of their contradiction, not only be correct but often because of their contradictory essence express a more all-embracing truth than many determinations which are not contradictory. If we once understand that a form of economy or government undermines its own existence while completing or focusing itself and that in the succeeding system the earlier one is nevertheless "preserved" *(aufgehoben)*, we have recognized the essence of dialectic, by which insights can be gained at which we could not arrive in any other way.

We can think of the "thesis," which is the beginning of a dialectical process, the "antithesis," which disturbs its stasis, and the "synthesis," which eliminates this disturbance, as being independent. What is really important in the process is the repeated negation and its *Aufhebung*. Thesis and antithesis are not two elements which can be added or subtracted, not separate parts of a correlation, and the synthesis is not a sum, but a fusion in which the components can no longer be distinguished from one another. Apart from negation and *Aufhebung*, everything is a remnant of the hackneyed school example of dialectic. What is essential is that the same thing can be judged correctly from two points of view and that certain moments of each of the two aspects can be preserved. One-sided judgment, whether it agrees or disagrees, usually proves false in the face of most phenomena. It is only in the twilight of dialectic that its true face is revealed. Phenomena like traditions and convention, stylistic formalism and subjectivism, moral intransigence and tolerance have to be looked at and judged dialectically if one is to do them justice. An undialectical attitude toward such forms and ways of thinking is not only shortsighted and perverse but usually ideologically false and confusing. Dialectic is not a question simply of logic and the critique of perception but also of ethics and politics. It is a humanistic philosophy which confirms and justifies the belief in the ineradicability of hard-won social values or at least their

partial continuance beyond all negation and impairment. As such it tends, from the beginning, toward optimism and contents itself, even if not with the salvation of mankind, at least with the possible rebirth of human cultures.

Hegel's confidence in the future, like that of most of his followers, is expressed in the trust that nothing is lost in history and that the spirit, as he says in the *Lectures on Philosophy and History*, "has moments which appear to be behind it, in its present depth as well." The inherence of the past in the present is the most essential characteristic of historical developments; it is the result of the *Aufhebung* of those stages of it which have been surmounted for the succeeding age. The caterpillar is no longer present in the butterfly, however much Hegel may declare that it is; however, the naturalism of the Renaissance, for example, remained unforgotten and is still present in the mind. It is the selective memory of society—which does not function indiscriminately—that is at work here, an ability of the social medium sui generis, which is only related circumstantially to the single psychological individual. The subject of *Aufhebung* is the group as the guardian and transmitter of cultural goods. The group is responsible for seeing whether achievements and products remain mere cultural monuments or whether they become productive forces of development, the stimuli for renaissances.

The historicity of phenonena also consists essentially in the fact that that, too, which disappears and is apparently dissolved potentially continues to exist and have an ongoing effect. Tradition as the bond between past, present, and future is the instrument of the *Aufhebung* of past developments and of cultural accomplishments which are threatened with extinction. This continued existence of what is effete is completely different in the sphere of history from the preservation of material and energy or the metamorphoses of what is organic in nature. Everything historical changes itself *objectively* only as long as it is alive; afterward the most that changes is our relationship to what has happened. Nature on the other hand changes even in a state of lifelessness and in its inorganic forms; however, it changes not in the way history does—that is, according to how we interpret it—but independent of us and the use we make of it. Even a lifeless natural being does not in any sense disappear from the circulation of the physical being. The "preserved" historical being, however, differs from this physical existence by a sort of havering between two different forms of existence and perpetuation. It no longer lives in the usual sense, but it is not dead in the sense that it only goes on existing in effete, disfigured, and constantly dissolving form. It exists sociologically, but not biologically or chemically.

The change of negation into the negation of negation, from a fixed quantity to a new quality—in short, the rise from one stage of development to a fundamentally different one in the sense of *Aufhebung*—represents the quintessence of the whole dialectical process. All decisive characteristics of dialectic proceed from its analysis. In the change of negative to positive of which the process essentially consists the various stages play a relatively small part. What is decisive is the new continuity of development which is created—in spite of all disturbances—part of the dialectical nature of which is that we are dealing with a unity of discontinuous elements and that a continuity of this sort can only be conceived as one which consists of discontinuous elements. In other words, a tradition exists only where what is passed down has to defend itself against possible discontinuities and the constancy of the traditional culture is divided by gaps. Yet, just as we cannot talk of a striving toward stability without threatening leaps and just as idle vegetation or immobile persistence in what already exists is the precondition of reform movements, so tradition acquires real meaning only in the history of a culture which is ready and ripe for renewal.

The history of culture is a network from which only single strands break off; the others are secured and spun further by the bonds of a fruitful tradition or the dominance of a conservative authority. Just as the old, the historically rooted, and what is clung to as residue can be completely torn apart as the result of an almost unexemplified cultural catastrophe, so the development of culture after the end of the natural condition never starts from the beginning. History evolving dialectically presents everywhere an enlivening of continuity and discontinuity, the ability to continue or to be broken off, reform and revolution, and still in the final phase complete divestment and revocation of objectivity into intimacy join each other.

Dialectical *Aufhebung* plays a role in the meeting of spiritual forces which is similar to the "cunning of reason." A rationality appears in it which not only is independent of the psychological consciousness of its bearers, but is often opposed to their conscious goals. The individual representatives of development may practice—as enthusiastically as they like—the negation and annulment of outmoded and historically passé positions; the "unconscious" social subject preserves them more or less intact and incorporates them into the new conditions of production and forms of government, ideologies, and norms. *Aufhebung,* as constancy in change, prevails without anyone wanting it to or—in the Marxist sense—so that no one knows what everyone is doing. It is the quintessence of dialectic, between the initial negativity and final positivity of which—the principle of hope and despair—humanity is fated to hover.

•

No critically thinking Marxist has ever assumed that *Aufhebung*—the stage of reconciled dialectic, antitheses, and the harmonious reversal of disharmonies—only means basically the preservation of the "old ideas," a reproach made of dialectic.[17] The sense of *Aufhebung* comes first from the change of an "old idea" into a topical one, from the actualization which an effete form undergoes as a result of the forces overtaking it, in short, from the functionalization of conditions which resulted from their earlier function. The preserved "idea" differs from the "old one" by bridging the gap between past and present, the juncture of actuality with the antiquated. The process begins with the double nature of historical phenomena, continues with the dissolution of one form by the other, and finally leads to their merging rather in the sense of Marx's words that man, while "affecting nature outside himself and changing it, changes his own nature at the same time."[18]

Art, like philosophy, is concerned, according to Hegel's dictum that the true is the whole, with the same goal in acquiring a total picture of reality. The immeasurable difference—even if it is not impossible to bring it into balance—between them consists in the fact that art represents reality in concrete form which is visible and perceptible; philosophy on the other hand reduces it to abstract, conceptually distanced forms. The totality of art as something "intensive" is complete in every authentic form. The totality with which philosophy is concerned meanwhile remains "extensive" and incomplete, like every abstract representation of reality.

Dialectic, however, both in philosophy and in art is directed toward the whole and not toward progress. Later philosophical doctrines get no closer to the ideal of truth than later artistic movements and products get to the so-called idea of beauty. Different philosophies follow one another as systems centered upon themselves, like the styles and creations of art, which are also centered on themselves. Their development consists not in the system of truth which is perfecting itself but in the repeating rotation with which they draw ever wider circles around their midpoint untouched by progress, a totality which is given as a possibility in art from the beginning but which remains an unattainable ideal in philosophy until the very end.[19] The concept of progress, which is not identical with historical development, is not suited to dialectical processes. The ideologies, philosophical systems, moral evaluations, metaphysical conceptions, and cognitive theories which follow one another dialectically—but neither commensurably nor consistently—reveal just as little of a straight-line progress as the other movements and creations of art which resolve one another. The relationship of dialectical processes and artistic developments consists in the fact that both signify a move in the center of the movement and

not a mere piling up of elements around the same center, as is the case in the exact sciences.

In no scientific discipline is the thrust toward the whole, the need to grasp reality as a totality, so strong as in philosophy, which can be regarded as the doctrine of sought after totalities. Its aim is to integrate perceptions which are otherwise atomized and to round them off to a unified and complete picture of the world, even if this is not definitive. It is all the more remarkable when people in the philosophical camp laugh at the striving for totality—in English the word is particularly focused—at *wholism* with its punning reference to *hollowism*, although there is an element of comedy in the way that dialectical jargon makes use of the term. The constant whining and lamenting over the lost homeland, which consists of nothing less than the whole world, may have become insufferable, yet "yearning," as Novalis called philosophy, is the true pain of never being at home anywhere.

For Hegel the decisive factor in dialectic, and thus for philosophical thought in toto, is the pursuit of totality, and not only in the sense of unity of cognition but also in the sense of the elimination of all insufficiency, all limitation, all dismemberment which bring with them, in any form, duress, pain, or impotence. The category of totality has swallowed the role of negation and the negation of negation, and replaced them in the dialectical process. If philosophy had always counted as the vehicle of liberation from the insufficient, the fragmented, and the discrepant in existence, then for Hegel every one of its steps is aimed at this goal, which is now *arche* and *telos* in one. Both the victory of the "absolute spirit" as this principle of totality and the realization of the "classless society" in the works of Marx depict the condition in which Ixion's wheel comes to a halt and man regains his totality.

The idea of totality, which becomes the central concept of dialectic in Hegel's work, is not a quantitative category and does not correspond to that of completeness. The totality of which we are here talking represents more than the sum of its parts. Already in the case of collective concepts like an economic order, a social system, or an artistic style we add something new to the components, something not contained in any single piece or in any sum of the parts. In this way the facts which are depicted by the appropriate collective or generic concepts acquire a new and peculiar quality, which informs all of their elements. The totalities which assert themselves in the dialectical processes are neither sensory things nor abstract universals or hypostases, but phenomenological realities which have to be thought of if one is to relate the objects of experience to one another and create a relationship between a general and a particular. It is only after this link

has been forged that the general and the particular become what they are, just as individual human beings only become social subjects and individuals at the same time as they form collectives. For Hegel and Marx especially, dialectic consists essentially in the idea that the general can have meaning and effect only in its particular individuations, and the separations only through their context. The concept of totality thus comes to the head of dialectical ranking, and the "abstract," empty, general form of concept which dispenses with every concrete specialty sinks down to the lowest possible stage of what is thinkable.

Art, as the most obvious example of the juncture of the general with the particular, thus becomes the prototype of all dialectical structures— at least it becomes a more complete illustration of their structure than philosophy, which places the totality and particularity of elements into an antithesis while art eliminates it. The tension between the general and the particular is also present in art, but in the authentic work of art it does not develop into a conflict which endangers unity. As Hegel says, "It is true that the originality of art consumes every chance particularity, but it only swallows them so that the artist can follow the pull and élan of his enthusiasm which is filled by the matter alone."[20]

Hegel's concept of totality is based on the assumption that the dialectic of the processes of development is capable of being grasped in its totality without giving up the concreteness of the individual phenomena which form its components. This combination of the general and the particular represents for him the truth and authenticity of all the subject's objective products—the validity of scientific cognition, the relevance of moral relations, the value of artistic creations. Structures, settings, and norms which dispense with this character of totality count as "abstract." Dialectically global and concrete thought always mean one and the same thing for Hegel, a connection of the general with the particular. Even with the doctrine that absolute knowledge is revealed only after the completion of its historical development, he thinks that he can support his philosophical tenet, the axiom that "the true" is "the whole " or formulated historically, that it is "only at the end what it is in truth."[21] The totality toward which dialectic aims is by no means a form which can be found ready-made anywhere and anyhow, and one which is preordained and remains unchanged. It is always only what we understand by a totality, that is, a structure which is completely historical, open, and incapable of completion. It, too, represents a form of being which is dynamic and not static, which is becoming, and not one that has become. It is a phenomenon which remains involved in the dialectical play of forces and becomes an ideology or a utopia. The tenet of totality is merely a claim; it is a postulate without which, it is true, philosophy would be senseless and pointless

but with which it is still in no sense at its goal. It is a hope and a challenge which is definitive and directive for thought but which can never be totally fulfilled. To renounce the totality of cognition, to ignore the duty contained in it, however unrealizable it may be, would mean renouncing philosophy itself.

Analysis and Synthesis

Nothing is more suited to the elucidation of the nature of dialectical processes than an insight into the relationship of analysis and synthesis. Satisfaction over the achievements of thought and of historical development finds its most lively expression in the enjoyment of synthesis. Those, however, who know neither the charm of the daring connected with it nor the joy of surmounting its dangers are never tired of warning irresponsible adventurers of the consequences of rash syntheses and of reminding them that the time of synopsis or what they derisively call the premature overview of "universal specialization" is not yet come. Such a time is of course all the less likely to come for them, because their idea of the meaning of analysis is just as insufficient and uncritical as their concept of the completion and function of synthesis. Above all, they do not know that analysis and synthesis in proper thinking and investigation form a pair of concepts which are dialectically inseparable, which make concrete sense only in relation to one another, that they develop *pari passu* and are interdependent at every stage of development. They condition, promote, and limit each other reciprocally; if one gets ahead, the other can do nothing but accelerate, and this causes a new synopsis to be made with every accomplishment in the area of individual investigation and forces every new total view to be examined in detail. A fruitful analysis can be accomplished only in the framework of an anticipated synthesis. In the exact sciences every synthesis is anticipated; it is merely temporary, and even in the other sciences every synthesis which lays claim to validity has to be defended on the basis of particular findings. The error of the "analysts" who love to collect but are often loath to think consists in the blind faith that successful detailed investigation without a vision of the relationship of details—be it never so fleeting—is possible. They particularly ignore the fact that the idea of the homogeneity of the components of a whole constantly changes in the course of investigation, that every new finding changes the concept of the system, corrects and enriches it and thus conditions a new totality.

The allegedly rash synthesis, the pretension, that is, of being able to form a suitable picture of a whole before the complete analysis of the material at hand has been carried out and before all the individual

facts which could be considered have been brought together, is ascribed to the supposed deception which was designated the "fallacy of wholism." What is not recognized in this process is the fact that the unified organization of the material at one's disposal and the formation of a total notion cannot be postponed until relevant facts have been investigated, collected, and ordered, primarily because the collection and ordering never ends, but also (and mainly) because we cannot start the analysis of a body of facts before there is a system of relationships and the assumption of a synthesis. However, the anticipated system demands continuous modification and revision to the extent that the previously unknown facts become visible and capable of investigation. Scientific work consists essentially in the reciprocal correction of partial points of view and a global view in the constant anticipation and the repeated suspension of totalities in the course of approaching an ever more comprehensive and tenable truth.

Every perception is burdened with a tension between the facts which we know about things and those which we would like to know and hope to find out. Without a minimum quantity of knowledge of certain perceptions, which may be united extremely loosely and immaterially, no process of cognition starts up. Without a total idea, however limited and untenable—a synthesis, no matter how temporary—a specifically scientific question cannot be formulated. For a question only has theoretical relevance in a context which is broader than the object toward which it is directed, just as it only has concrete content and practical purpose with relation to a particular object. We have to understand the place of the particular within the whole in order to make it the object of a scientific question. Yet we have to make a sort of synthesis of what is present in raw and unordered state even to make a selection of the material available. Just as the categories of reason are empty without perceptions, and sensual perceptions are blind without concepts, so the particular components and the total conception of perception assume one another.

Art represents the exemplar of this relation. Nothing illustrates it in a more lively manner than the structure of the work of art, which can only develop, form itself, and integrate, if from the beginning the artist has a vision of the product he wishes to make, no matter how changeable his view of the path he has to tread. For just as a work of art becomes meaningful and enjoyable only after we have understood the place of its components in relation to one another and we can determine their role in the genesis of the artistic experience, so the intellectual, emotional, and intentional attitudes must appear as moments of a united ideology, of an attitude which involves the whole

personality, and of a simply indivisible sensibility in order to be comprehensible in both their particularity and their totality.

Methodological and Ontological Dialectic

Dialectic as a logical-methodological guide to fruitful thought has a long past behind it and was frequently used in Greek philosophy. As an ontological theory, which is supposed to correspond to a real process, however, it only fully asserts itself at the beginning of the last century. The significance of dialectic as a movement and of the becoming which is inherent in the principle of movement was nevertheless recognized as early as Heraclitus. This dynamic principle is still active in many connections in Plato in spite of the stasis which his philosophy, like more or less all idealism, implies. It is fundamental to the Neoplatonists, especially their doctrine of emanation and their utopia of the return to the protoentity. Apart from individual earlier nominalistic tendencies, medieval dialectic (Realdialektik) plays a decisive role particularly in the works of the philosophers of mannerism, especially Machiavelli with his doctrine of "double morality" and Nicholas of Cusa, the apostle of the coincidentia oppositorum, but also in the work of Descartes, at least insofar as his juncture of ontology with noesis is concerned, just as it plays a more or less decisive part in the work of all later thinkers drawn to the problematic of the paradox. However, it first becomes a fundamental doctrine with the appearance of Hegel and Marx. They see in it the paradigm according to which the things of concrete reality divide and develop.

The methodological role of dialectic corresponds to its etymological meaning; it is the way, means, and medium of finding out the truth. As such it can be used in any number of ways, but never as the only suitable and successful process. It is a frequently successful technique for investigation, discussion, and explanation of reality which is developing spiritually, socially, and historically, but it is a formula which leaves the truth content and the political or moral value of conclusions untouched. When applied to the whole of reality, dialectic remains a hypothetically questionable construction; in relation to history on the other hand it acquires a positive value for reality by allowing oppositions to come to light which are pregnant with antitheses and which call for argument and Aufhebung in the processes themselves. In this sense it no longer represents a mere formula, a purely methodical process of thought, a pure manipulation of concepts, but meaty pragmatic truth. Its rules show themselves not to be the purely logical results of any old point of view or principle; they do not merely spring speculatively from a premise, perhaps by means of the substitution of

one concept for another. The impulse to dialectical development is always a real, concrete need, the feeling of insufficiency in a datum and in something which exists, and the imperative longing for something which the datum does not provide and which represents the opposite of what is available and what has become insufficient.

Hegel's maxim "contradiction moves the world, everything contradicts itself" does not yet point to this need, although he, too, is no longer concerned with a formal-logical conceptual dialectic but with a concrete *Realdialektik* in which the moment of contradiction retreats in favor of *Aufhebung*. He is no longer interested in the change of ideas in and of themselves but only in their change as factors and symptoms of the development of reality. The question is no longer how contradictory statements can be reconciled but how antithetical attitudes can arrive at a solution, where it turns out that their division was a stage which had to be reached and transcended in order to surmount a fatal crisis. In other words, dialectic is no longer a circling around facts but the "course of things itself." If it is still in Hegel's work not merely a doctrine of method, no purely heuristic technique for the explanation and interpretation of processes, in Marx it turns completely into a science of being—it goes from being a theory of history to history itself. The stages of its development are steps in the historical process itself.

If it is true that the feudal system became antiquated because of the appearance of new productive forces, mechanized production, and free wage labor and that the antithesis between the outmoded conditions of production and the new forces found a temporary equilibrium in early capitalism, this is not a metaphorical periphrasis or a philosophical interpretation of the processes but the naked representation of the process itself. In the sense of Marx, who saw every dialectic as *Realdialektik* and everything real as *dialectic*, there is no longer any gap between fact and theory.

Dialectic can be designated neither as a mere method of thought nor as a naked *Realprozess*. It is not an arbitrary point of view or a neutral principle of organization with which theory approaches reality. Certain processes can be grasped and explained dialectically; others cannot. There are phenomena about which dialectic has nothing relevant to say and others whose nature, if viewed undialectically, remains hidden. Even if it is many other things, a tree is always a tree to the botanist, the economist, or the painter but is never its opposite, but a phenomenon like capitalism would be impossible to define without the dialectic of its inner antitheses, especially of the growing socialization of production and the simultaneous monopolization of the means of production and without the class struggle and its corresponding ideology.

The application of the dialectical categorical apparatus is thus conditioned by the real processes, but whether a process can be thought of dialectically depends on the presence of the corresponding conceptual apparatus. No dialectic of concepts could be conceived without a factual contradiction, conflict, and struggle. No *Realdialektik* on the other hand could succeed without a thought apparatus which defined the points at issue and produced the means for the struggle. *Realdialektik* is not a reality which can be accepted without more ado; it is not a simple objective being. It is probably based in the real conditions and could not be constructed in thought without their disagreement, but it is precisely conceivable only in terms of the agreement of other conditions. Without categories like concord and discord, coordination and conflict, harmony and disharmony there would be no perceptible antagonism and no purposeful mediation of the contradictions. There would be merely a vegetative being on one side and simple destruction on the other. Dialectic, however, is a product which results from the meeting and reciprocal conditioning of things and concepts.

The industrial labor force functions as a disintegrating element within the capitalist system of the production of goods not because it thinks in a revolutionary manner, but because industrial wage labor, mechanized production, impersonal labor relations, exploitation dictated by the profit motive, the vulnerability of employers in the face of the socialized and organized labor force imply of themselves a revolutionary process. This process, however, becomes dialectical only when the reality of the conditions of production and the rational categories of its problematic become inseparable. A revolution, it is true, is a revolution no matter what the circumstances, but its dialectic, which is not just a representation but also an interpretation, would remain incomplete without the corresponding conceptual apparatus. The consciousness of revolution as a dialectical movement not only begins *post festum* but is an integrating part of the revolution which is taking place, part of whose being is that the revolutionary class recognizes it as its own.

The process of dialectic never completes itself solely in objective reality, but always in its reflections, in the relationship of people to it. To be sure, dialectic uses but does not change tangible objects; it merely changes their function in concrete practice. Its ontological meaning consists in its projection into the factual, concrete existence of human beings. Historico-dialectical changes do not only take place in people's heads, even if they pertain to concrete things only as their framework and basis and touch them only as bearers of their function. They involve certain data in the historical process and eliminate others, but they do not change any in their ontological nature. If the feudal

economy passes into capitalism, nothing is changed in the objective reality with which feudalism was concerned; what is changed is solely the relationship of people to it, although this takes place under the influence of new external circumstances. Certain objects, tools, labor forces, and labor methods are given up; others—new productive forces and means of labor—take their place. Yet, just as the spinning wheel does not change into a loom, so there is also no quarrel between the spinning wheel and a society which is no longer based on a feudal economy. The conflict is merely between feudal man, conditioned by feudal service and bondage, and the man who uses the new forces of early capitalist production and who modifies his thought, his economic mode and form of government, the conditions of property ownership and concepts of law accordingly. Just like the loom, American silver does not answer a dialectical question—that is only done by the man taking possession of the loom or the silver. The assumption for his answer is in any case the possession of such things.

The doctrine of *Realdialektik* according to which reality, as a result of an inherent impulse, divides into antitheses and is involved in contradictions, mediates conflicts, and stores negated forces is—whether it is based on idealism or materialism—dogmatic metaphysics. The dialectical process never proceeds purely immanently, but is always bound up with stimuli outside the system, with external, objective conditions or inner, subjective needs. People do not think dialectically because they want to but in the process of wanting to, and we form history according to dialectical principles not because we have to but in the process of having to.

Although from time to time Marx refers to dialectic as a "means of representation," that is, as a "method"[22] which explains every phase of development related to the totality of the phenomenon under discussion, as a phenomenon seen to some extent under laboratory conditions, he does not see in it, as Hegel fundamentally did, merely an indication of the road to right thinking and successful investigation. He scarcely bothers about the logical operation, but mainly and generally exclusively about the opposition of forces which is taking place in concrete reality in the formation of the historico-social being. For him dialectic is not a means of investigating processes but a tactic for carrying out a process, for direct activity and its successful conclusion; it is an ontological and teleological doctrine, a theory which consists fundamentally not of the rules of questioning, evidence, and conclusion, but of the schemata of structure and the typology of the developmental form of things themselves.

However unavoidably materialism seems to emerge from this theory, we cannot from the critical point of view talk of one unilateral factor.

We can speak neither of a basically dynamic-dialectical being which would set a static categorical apparatus in motion nor of completely spontaneous thought which would start up a sluggish material reality. Thought becomes dialectic only when it comes into contact with an order which is struggling with itself, in the conflict of its inner antitheses. However, the order in question dissolves not before but simultaneously with this contact. No matter what the nature of the subjective thought and the objective being may be—or whatever our attitude to this question, which is in the final analysis unanswerable—they are related dialectically; that is, they grow into what they are in a reciprocally constitutive relationship to each other. Material being becomes dialectic when it appears to thought as a unity which contains everything within itself and at the same time as endlessly differentiating multiplicity. The spiritual being on the other hand is that in which consciousness becomes aware of itself in conjunction with and in opposition to a nonspiritual being. Whatever the situation of the primacy of the spiritual or the material and the role of the categorical and real constituents of objectivity, the dialectical functions are no more purely materially than they are ideally determined. The dominance of either the one or the other principle would contradict the concept of dialectic.

We must have the categorical apparatus of the dialectical method ready in order to apprehend dialectic as an ontological phenomenon. Without the ontological-dialectical process proceeding in reality, however, the dialectical concepts would be simply unimaginable. In practice we have to start from the dialectical structure of reality or one which tends to the dialectical—which as such would per se be incomprehensible, even indescribable—but which does not produce the conceptual apparatus of dialectic any more than it is produced by it. In any case we have to regard ontological reality as the indispensable substratum of the concepts. It is the phenomenon so well known in sociology of the reciprocal conditioning and simultaneous development of categorical contents and categorical forms with which we are here involved. It is a relationship in which very little can be done with the principle of causality but which, as has repeatedly been shown, has to be explained in this way: it produces itself when its components come into contact with each other.

Dialectic, as an intersystematic process of thought and history which integrates the most diverse, even antithetical, factors and aspects of reality, proves that the substratum of the rational activities also changes with thoughts, desires, and actions and that history becomes what people make of it. It is always a question of an act of thought and not of a mere method of thinking. In one word, dialectic is a pragmatic and not just a theoretical process in which two different subjects or

two phases of a subject's behavior are involved. Problems are solved, possible solutions rejected, and more suitable ones chosen, in the processes of which concrete subjects come into conflict with each other or—according to their different stages of development, their abilities and tendencies—with themselves.

9

The Dialectic of
History and Nature

Critical and
Prophetic Theory of History

Marx's doctrine of dialectic, which does not serve merely methodological aims or metaphysical interests, is like every dialectic a historical theory. The phenomena which it tries to fathom consist of processes and potentialities which urgently seek actuality, development, and fulfillment. The processes may aim at a utopian, messianic goal which promises a final solution of the problems, and the facts from which they are made up may be a firm ontological reality. Marxist dialectic is concerned with investigation of the developmental process with its changes, its inhibitions, and its detours as the origin and goal of the processes. As such it has become the basis of a new, bold, exciting interpretation of history, which in spite of its limits cannot be harmed by the criticism which is expressed against it. Through it the historical process finds a strikingly valid explanation, whose simplicity is not gained at the price of its applicability. On the contrary it is one of the few philosophical doctrines which does not lose anything in depth or richness in spite of its simplification. The contradiction with which every situation in life, every intention and action, is more or less deeply involved, the questionability, inhibition, and negation whose shadow lies over opinion, the irreconcilability of satiated and outlived circumstances with newly arising conditions of existence, the destructive and at the same time preservative *Aufhebung* as the link between past and present, are mere determinations of the practice which can be translated into everyone's language and can be observed in the most significant as well as the most everyday events. What is questionable is merely the apparent universality of the doctrine, the assumption that all happening is dialectic; what is unquestionable and remains so is on the

375

other hand its validity as the most all-embracing doctrine of historical theory imaginable.

The nucleus of the Marxist theory is formed by that historicism which Leibniz formulated as "the present is pregnant with the future" (letter to Bayle of 1702) with which he simultaneously coined the motto for the whole of historical dialectic. The dictum of history as the product of man by means of labor sounds like an echo of it. In all of its variations dialectic modifies the theme of the historicity of all human activity. Its opponents who most refuse to be convinced are also the opponents of history, those conservatives who, as Nietzsche said, "believe that they are doing a thing honor when they dehistoricize it. . . . What is will not *become* something; what is in the process of becoming *is* not."[23] The most essential characteristic of dialectic, however, consists precisely in the principle of regarding everything which has *being* as something which has *become* and of explaining not only what is being but also what *has been* as a being which is in the process of becoming. That the new arises out of the old has been known from time immemorial, but that the old can achieve unknown characteristics in the light of the new and that according to the particular present from which it is viewed and judged it may present a changed meaning is a perception which was first revealed to modern historical dialectic.

History consists of the incalculable sequence of unpredictable happenings. There is no rule governing structure, no scheme of periodicity, no common multiple for epochs which can be applied to history as a whole. The interaction of tradition and innovation, stable institutions and changing needs, material data and ideal goals doubtless represents an essential moment of historical conditions and relationships, but it does not reduce them to an all-embracing, unambiguous, and immutable formula. In reality not only is it the prevalence of the one or other factor which changes but every individual factor changes its meaning and role according to the changes which are taking place in the other factors. The one not only changes the development of the other but develops itself and keeps pace with the development of the other. In accordance with this intertwining of constitutive moments, history forms itself not in relation to unambiguous, always existent, and immutably permanent principles, but in conjunction with tendencies and impulses which are caught up in an ongoing change and interaction, and with a past which itself reveals characteristics of a process of becoming.

Apart from the principles of negation and opposition, of revolution and tradition, or of dissolution and *Aufhebung,* historical dialectic does not work according to any constant scheme. The allegedly tripartite nature of developments bears the character of a dogmatic for-

mula, a sort of Holy Trinity. The idea of the three-stage progress of world history can already be found before Hegel and Marx, even if it does not refer to something like dialectic. Above all, Vico talks in this sense about the period of gods, heroes, and men, even if he still employs a mythological undertone. According to the historical philosophy of Rousseau and the romantics, the development into the freedom of the natural condition is divided into the loss of freedom as a price for the acquisition of civilization and the regaining of freedom by the Enlightenment and the revolution. Hegel was apparently not entirely uninfluenced by this conception when he designated the epoch of despotism as one of freedom for one man, antiquity as one for the few, and the modern age as one for all, or even later when he classified world history according to the so-called world periods of the original unity, the externalization and the self-completion of the spirit. According to the same idea, Marx constructed the well-known socialist formula of the freedom of original communism, alienation as a result of the exploitation of the propertyless by the dominant classes, and mankind's coming to itself in the classless society of the future. According to Hegel art, too, develops in three stages. In Greek art the aesthetic principle is truly and purely realized; in the Middle Ages and the Renaissance it is subdued by the religious and replaced by Christianity as the dominant view of the world. In the modern period both of the essentially outmoded principles are *aufgehoben* (preserved). The spirit preserves both the Greek-aesthetic and the Christian-religious idea and expresses them in the new, free artistic form of prose. Marx agrees with Hegel in seeing in the creations of the Greeks the zenith of art, but, as distinct from Hegel, he characterizes as the reason for its later collapse alienation, objectivization, and prosaic development, the increasing class domination of capitalism. He awaits its renaissance in the overcoming of the class system.[24] In the process he omits to mention the class character of Greek art, to the exemplary nature of which he clings.

The scheme of dialectic, the progress from what has been posited to negation and from this to the reconciliation of antitheses and the *Aufhebung* of the point which has been transcended, the global character and the endless repetition of the processes which are being "preserved," appears in no form so clearly and significantly as in history. Logical thinking may be organized dialectically, but the simultaneous affirmation and denial of a thesis is of a somewhat playful nature, to say nothing of the reconciliation of contradictions and *Aufhebung* of the negated principle in a higher, more definitive phase. In history, however, nothing happens without the participation of antagonistic moments. The positive and negative moment have the same weight;

production and destruction, evolution and revolution, tradition and reform all interact. World history is the world stage upon which an action not only comes about as an encounter to a challenge, not only plays the role which the opposing forces concede to it, but only comes about at all as the reaction to a stimulus. It is not only Alexander, Caesar, and Napoleon who owe their greatness to the opponents they fight; it is not only capitalism which becomes what it is through the order it denies and the forces which threaten it; it is not only the romantics who "read the classics as they should be read."[25] Even the philosophical systems and scientific doctrines develop as forms of movements and countermovements and lead their historical existence as question and answer in a dialectical dialogue.

The principle according to which the negation of a point of view has essentially the same validity and weight as the point of view denied means, on the other hand, only a play with concepts and is logically completely senseless. Only in the area of history do modes of behavior which contradict each other exist side by side. Here capitalism can at one and the same time be progressive and conservative, democratic and monopolistic, selfish and self-destructive. Baroque can be classical and anticlassical, rigoristic and liberal, naturalistic and antinaturalistic. Artistic creation can be spontaneous on one hand and conventional on the other, communicative and secretive; the artist can be both narcissistic and tired of himself. Contradictory determinations of this sort rely upon a historical rationality which is completely different from the truth of formal logic. If we examine it more closely, we see that not only does the predicate differ from case to case but also the subject of the judgments and points of view. The contradictory assertions, attitudes, and actions relate to substrata which differ and change in their historical development.

If the functions of question and answer, challenge and reply, satiety and disgust are carried out by different people who are empirically independent, then the opposition of which the dialectical process consists can only be designated literally as a controversy and argument with divided roles. Action and reaction are obviously different from one another. Yet structurally those who support contradictions, crises, and conflicts which take place within a changeable, yet unified and individual psyche and which—in the behavior of a thinking, sentient, acting subject who creates artifacts—lead to changes of meaning and reversals of will, inconclusiveness and vacillations, agreements and compromises, correspond to the individual subjects involved in interpersonal relationships. The rationality of dialectic asserts itself in both cases with the same stringency. Dialectic is not self-motivated either in the life of society or in that of the individual. The subject encounters

resistances in himself which are no less concrete, stubborn, and "objective" than in the external world. It finds or develops within his own person limits and obstacles which bring it to self-consciousness and self-actualization—it is only that in the process the dialectical dialogue becomes a soliloquy.

However, in spite of its variety, dialectic is far from spreading out over the whole extent of history, to say nothing of the whole of reality. History, too, is not always governed by only dialectical principles. Dialectical antagonisms and antinomies, conflicts and reconciliations belong, it is true, to the most common events of historical life, but not everything historical can be reduced to the interchange of consonance and dissonance, tension and release. Apart from the long and frequently recurring epochs of straight-line, consistently progressive development, even in the interrupted and changeable periods of development more than one way out of the resulting critical situation opens up for almost every interruption or change. We are generally confronted with a fork in the road where either direction offers a possible solution. "The inner dialectic," says Dilthey, "drives us from one point of view to another. . . . The difficulties which are contained in a point of view drive beyond themselves; but it is wrong to assume with the Hegelian school that they lead to the next standpoint. They can be resolved according to the principle of diversity of consequences in different ways. . . ."[26]

Dialectic does not produce a complete, unambiguous, and indubitable solution of the problems which arise; it merely makes those immediately interested in their solution conscious of the fact that there is a choice between "alternative decisions."[27] This is true not only of the moral risk which we run at decisive points in our lives, but also of the responsibility, the danger, and the chance with which scientific work and artistic creativity are linked at every step. Human freedom consists in the choice between the different possibilities which are both opened up and limited by the dialectical mode of thought and behavior.

Properly understood historical materialism is the most decisive step in the development of the science of history since romanticism. It is well known that it states that historical development has its origin and motive force not in ideas or entities, established substances or energies, which in the course of events produce mere modifications of their ahistorical being, but that it represents a process which, in accordance with its dialectical form of being, does not reveal anything static or eternally valid, but also nothing which has a one-sided effect or is unambiguously explicable. Rather, it is involved in a constant movement with all its factors and is subject to a constant change of meaning. The dynamic of this process, which is conditioned in two ways, goes

so far back that we never reach a point in history in which we were not confronted by the interaction of contradictory determinants.

However, what is just as essential for Hegel's and his successors' philosophy of history is that it rests not upon the establishment and validity of values, but upon an ontology, in that it is concerned with processes, tendencies, and directions and not with passive things and facts. It starts from a concrete, objective, unalterable reality, from objective, sensible, real conditions of being. It is, however, a completely historical, in no sense supertemporal, and a constantly changing ontology capable of development and seeking a final perfection which is definitive for it. It is concerned with being, which—like the truth—*is* while it is *becoming*. It is concerned with a feverish and dynamic existence, with that "bacchantic whirl in which no member is not drunk." with a whole of which every member, "while keeping aloof, is just as immediately dissolved."[28]

The primacy of historicity, which may appear questionable in relation to the ontological being of the things that form the substratum of historical changes, is unquestionable insofar as its structure, its composition, the coordination and subordination of its individual moments, and the form of expression which is common to the different cultural structures of a society and a historical period are concerned. The assertion that every structure is a historical structure from the outset is probably true, but it is not the whole truth. History reveals the untenability, the irresistible change of structures. Individual structures may survive certain historical changes even if they do not prove to be indestructible in all circumstances. Yet whether they maintain themselves from case to case or not, they are always linked in some way to a given historical situation. No structure persists or crumbles independently of the ruling conditions of existence or even in antithesis to its ideological effect, which determines intellectual formations. A purely traditional and blindly accepted structure only asserts itself at best as an inhibition against historically more deeply rooted changes within the conflict of dialectical forces.

Structure and historicity share neither a complementary relationship nor one of alternatives. It is neither as the doctrinaire structuralists think nor as their one-sided historicist opponents do, that we have to and can choose between structure and history, a transhistorical, timelessly valid nexus and a free spontaneity which is the prey of momentary arbitrariness. For just as the structures themselves are historical formations, so history, for its part, is always structured in some manner; it expresses itself in a language consistent with the occasion. Only the ahistorical natural condition, the purely vegetative being which reveals no memory and no tradition, indefinable chance and mechanical

biological development which permits no choice are without structure, unorganized and unsyntactic, in the sense in which we here mean it. To what extent, however, the principle of structure, the faith in the once established order of a system, or the historicity with the predominance of now one now another element asserts itself depends on the issue of the conflict between the different elements of the system. Neither the unformed structure nor history as an unorganized and unordered state of becoming is a given from the outset. Everything becomes and remains in a state of movement, but it is always a definitely qualified "something" which moves, a definite complex and context of elements. Just as the something is only perceptible as something which moves, movement always has its limits and measure in a static, meaningfully fixed something.

Historicism is just as historically conditioned, has just as definite historical and social assumptions as its antithesis, antihistoricism or ahistorical conservatism. It is the product of dynamic antitraditional, progressively minded societies, just as the static view of the world, indifferent to history, is the expression of a social order which opposes the change of current values and norms. The progressive or obsolete order never asserts itself unambiguously and independently. In both cases the judgment of the historical processes at a given moment depends on the dialectic of progressive and conservative ideologies. Reformism asserts itself when conservatism allows, and the conservative efforts prevail according to the measure of the reforming tendencies. If, however, historicism does not assert itself completely on its own account, this does not mean in the least that its truth content is just as limited and restricted as the recognition of its truth. History apparently has a nonhistorical substratum. The ahistorical, however, always appears in historical form. Everything historical comes about in antithesis to a nature which is alien to history, just as everything superhistorical which may become part of our existence is clothed in historical forms—or, if we prefer it, is disguised as such—while becoming the object of concrete, conscious, rationally controllable experiences.

History as the complex of continuous and discontinuous factors is the soil of freedom and bondage. Marxism starts with the material conditions of cultural structures, and this leads to the assumption of an unbroken continuity of historical development; the Hegelian fiction of the untrammeled, arbitrary world spirit leads to the hypothesis of the inevitable discontinuity of processes and to the doctrine of the "cunning of reason" as the only limit to human freedom. Strictly speaking, however, man is neither free nor not free. He is both—according to the situation in which he finds himself and the role which

the dialectical relationship of the principles of continuity and discontinuity allows him to play. What is continued is only what those tendencies of his spirit which lean toward discontinuity and spontaneity allow him to preserve. What is surrendered is what he cannot reconcile with the new conditions of existence in spite of the tradition which "burdens" him. The striving toward the agreement between continuity and discontinuity in human activities and ways of behavior would certainly not be the least satisfactory definition of dialectic. Just as complete steadfastness is nowhere to be found in the objective, living stream of reality divested of inwardness, history develops only where continuous traditions exist, even if these are destroyed from time to time.

Since the dialectical course of history never organizes itself according to any sort of definable scheme which would permit us to assume a periodicity of processes and thus a development which could be constructed, we can at best determine a typology of contradictions, conflicts, and forms or reconciliation of antitheses. This does not, however, let us conclude that there is a regularity with regard to the length and number of periods, and it allows long-lasting, consistent phases of development to follow short revolutionary ones. Dialectic is in any case irreconcilable with the periodic return of the same circumstances.

The mystification which transforms history into a fateful process with an issue which is determined from the outset is mainly connected with the exclusion of the individual from the dialectic of processes as a determining factor. The principle that transcends individuality in this way becomes—as Sartre, for example, stresses—as it were, a divine order.[29] The only thing he fails to observe is that the individual factor is essentially just as lacking in dynamism and dialectic as the supraindividual.[30] The individual isolated, so to speak, in a vacuum is no more spontaneous and creative, and in Sartre's sense is just as "inert" as the supraindividual social structures.[31]

The concept of an inevitable "historical fate" is one of the most crass forms of the mythologization of human existence. Economic and social forces have, it is true, their own logic, but they do not imply an inevitable *telos* of historical development which in spite of the solidity of its material basis does preserve a certain freedom of movement—movement beyond a supposed *telos*. Stopping at an allegedly unsurpassable and no longer endangered goal of development depends upon a mystical philosophy of hope, so that even Marx's empire of freedom, which is not threatened by a new stratification of social elements, remains a cloud-cuckoo land, no matter how carefully it is defined. It starts, we are told, "where work which is determined

by need and external expediency finishes. It lies then, according to the nature of things, outside the sphere of actual material production."[32]

Marx's prophetic messianism fulfilled a political function; his emotionally conditioned optimism, however, had deep metaphysical roots and did not lie as some supplementary adjustment upon the surface of his agitatory ideas. He had already said in his *Holy Family*, "Among the innate characteristics of material, movement is the first and the most excellent, not only as mechanical and mathematical movement, but still more as drive, life-spirit tension, torture—to use Jakob Böhme's expression—of matter."[33]

Utopian, prophetic, and messianic dialectic says what a thing ought to be or what it promises to become; scientific dialectic ascertains on the other hand merely what it is, what it was, and how it becomes what it seems to be. According to the total concept—which embraces all possible changes—every historical situation certainly contains something which points to the future and which—according to the standpoint of the observer—offers a spark of hope or a basis for concern. Every actual situation permits us to draw conclusions about potentialities, but no potentiality contains the sufficient reason for its actualization. This conditions the incalculability and irrationality of history. The assumption that it will come to a halt—whether by ascent or descent, by the self-realization of the spirit of the world and by self-victory of alienated man, or by classlessness as the result of the collapse of capitalism—the overcoming of an economy and society based on the division of labor and the fetish for goods is pure speculation, which supposes that there will be an end to the movement within the domination of the forces which are being spoken of. An end such as this is irreconcilable with the principle of dialectic as a self-perpetuating process. Hegel rightly believed that the dialectical operation of the intellect and the course of history beset with crises and conflicts correspond to one another, that fundamentally, history is moved dialectically and dialectic is historically based. However, it would be false to conclude that historical development as a dialectical process has a constant direction and a definitive goal. Marx's historical prognosis agrees only in part with the Hegelian conception. It refers expressly merely to the end of the capitalist system and only in the sense of a somewhat daring interpretation of the final goal of human history. Marx even seems to want to avoid this impression when he says that actual history only begins with the classless society and merely maintains that the present capitalist order is untenable because of its inner contradictions. Apart from the fact that he does not attempt to set a definite time for the decisive turn of events, he also prophesies only a "classless" but not a nonstratified formation of society free of

conflict. And although he regards the conquest of capitalist exploitation and the removal of the class privileges linked to it as a triumph without equal, its significance for humanity can be measured, while the taking back of the whole of objectified reality into the intimacy of the subject is simply incommensurable. Society freed from capitalism may begin a new history, but the world spirit no longer exposed to alienation—that is, in Hegel's sense, no longer needing objectification—is *eo ipso* void of history.

The Fiction of the Dialectic of Nature

To speak of a dialectic of nature as Engels does—Marx and his more cautious disciples avoid it—not only is irreconcilable with the dialectic of history but robs all dialectic of its meaning. If dialectic means essentially dialogue, question and answer, statement and argument, the removal of contradictions and the *Aufhebung* of positions which have become untenable, if it starts from a precarious position which is to be maintained by the giving up of a position and gaining a higher level and a broader view, if it makes out of a dumb and pigheaded protagonist an inert and indifferent opponent, a lively opponent consciously conforming to changing conditions of existence, its principle cannot be applied to natural processes.

Natural conditions constantly change and sometimes under the influence of needs and efforts. Nature in this case often seems to "choose" between different, even antithetical possibilities of reaction. However, in reality the reaction never comes about as the result of a dispute, a sort of controversy or persuasion—what happens is always what has to happen. Nature knows nothing of what it does, whether it reacts to a stimulus always in the same or in a different way. The way that it takes does not result from consideration or reflection, does not express a statement of will, and does not represent an action, however this may be understood. A dialectic in this sense is accomplished only between cultural functions and structures, work and thought processes, political and moral modes of behaviors, ideological attitudes and their forms of expression—in other words, the statements of individuals and social groups. In nature we find "negation" only in the metaphorical sense and "negation of negation" in no sense at all. Nothing is *aufgehoben* in nature, merely preserved or overcome. What is overcome is destroyed as a phenomenon and disappears. In other words, nature does not react to stimuli and influences in such a way as to preserve—in some manner—its individual form by accommodating to demands of an alien sort. The different stages of a natural being's development by no means correspond to the dialectically con-

ditioned stages of development of a cultural structure—which follow one upon another—or of an ideological form. Nature only reacts, but it does not answer. It lets itself be influenced, to be moved from one direction to another, but it does not come to any "decisions" which could in any sense be compared with human positions.

In the relationship between man and nature, conscious and unconscious, intentional and nonintentional agencies oppose each other, but never ones that state intentions on both sides. This is in contrast to the relationship between individual and individual, individuals and society, social structures and individuals or groups, where the social element, class, cultural stratum, institution, or the system of conventions does not it is true immediately "answer,"does not take obvious decisions, does not literally cooperate or oppose, but states intentions insofar as it supports a class consciousness, a point of view, a tradition, and manifests itself by individuals who cherish intentions. Dialectical interaction remains a dialogue even when the one partner takes part only indirectly in the discussion, indeed, even when the dialogue becomes an inner monologue of the individual struggling with himself.

The reason the concept of dialectic cannot be transferred to natural processes is simply that we can talk of inner conflicts only in a non-actual, metaphorical sense, while the relationship of social formations to one another is always bound up with antithetical interests and the domination of one element by the other. However complicated the life process of a natural being and the mutual conditioning of its vital functions may be, a purely biological organism "whose individual parts wished to exchange with other parts" is inconceivable.[34]

If nature becomes what man wants to make out of it and if an accommodation takes place between the two, the process is far from representing a dialectic of nature. It is, indeed, not nature which answers man and argues with him; rather, it is men who come to terms, somehow, with the natural data. If, for example, the climate of a landscape calls forth different reactions in men from time to time, it is not necessarily the climate but the tolerance of it which changes. In such a case it becomes completely obvious that the so-called dialectic of nature is nothing but a naive anthropomorphism.

If man changes his relation to nature, there is in his new behavior an unmistakable involvement of conditions which he has to come to terms with. He not only wins but is also beaten, however unarticulated the voice of the opponent is and however unintentional the slogan to which he must respond. Nature has nothing in mind for him and asserts itself against him without intention. It is only men who have intentions toward nature: nature at best exerts a passive resistance to them.

The development of a plant, to use Hegel's example, is straight line and takes place without interruption as a natural phenomenon. It appears to be dialectically divided only if there is a preconceived logical interpretation. The bud is no more the negation of the seed than the fruit is of the blossom and the bud, that is, the negation of negation. Interpretations of this sort are empty metaphors—all too free translations of nonconscious natural processes into reasonable alternatives and decisions. It is only playful reason moving *post festum* into action which changes the mechanical natural process into an intentional act which is dialectically structured in the form of contradictions, arguments, and decisions. Bud, blossom, and fruit are, it is true, distinguishable phases of the process, but they do not answer one another and do not represent any decisions which they would be forced to make. The later phases of development do not "preserve" the earlier in a positive sense, and the fruit is probably the end and, if you like, the "purpose" of this process, but it is nothing like a synthesis, a summary, or the logical "bottom line" of the process in a dialectical sense. In the process nothing happens which would justify Hegel's words that "in nature concept speaks to concept."

Universal dialectic, which includes nature and history to the same extent, not only historicizes nature—which can perhaps become a historical factor, but one which is essentially ahistoric (that is, it repeats itself regularly and periodically)—but also naturalizes history by making it a predictable natural phenomenon which excludes all coincidence and improvisation. Even Marx gets mixed up in its terminology from time to time—for example, when he speaks of a "natural law" of the movement of society and of a "natural historical process" of socialization.[35] What he wants to do, however, is merely to point out the stringency of social regularity and not the scientific calculability of the historical events.

The flaw in thought to which the assumption of a dialectic of nature is mainly to be ascribed consists in the fact that we regard many purely polar, complementary, and simply contrary phenomena as contradictory. North and south, right and left, positive and negative electric charges are merely polarities. Light and darkness, day and night, the infinitely large and the infinitely small in mathematics are complements. Poison and antidote, attraction and repulsion, old and new are nothing but contrary categories. Time and space, love and hate, fire and water are merely different eventualities or ambivalent attitudes. They have nothing to do with dialectic, that is, with contradiction and antinomy. A dialectical antithesis is always tied to an inner contradiction and ends in a division of those who support it among themselves. Such a division is absent in nature because there are no inner contra-

dictory facts, only inner contradictory points of view, principles, interests, feelings, and intentions toward the facts.

Modern scientific research relying upon doctrines like corpuscular theory and the wave theory of light assumes that there is in nature an inner dialectic independent of human thought and social practice. But the different, even contrary, laws which natural phenomena may follow have nothing in common with the contradictions between human needs, efforts, and demands. An antithesis does not of itself condition a dialectical process. It is only when the antithetical motives come into contact with one another, modify one another, and lead to the establishment of an equilibrium that a dialectical course of events results. This happens when one motive is surmounted and eliminated and the other is "preserved" and incorporated into further development.

Nor does a thing when viewed from differing standpoints and when it is thus differently reflected become a substratum of the dialectical process. The changing points of view may become the origin of complementary, ambivalent, or polar opposite views. Their difference, however, no more corresponds to an inner contradiction of the object at hand than it instigates a contradiction between its components. Impressions, aspects, and conceptions do not battle each other and do not become reconciled; only the subjects which use them for their own purposes, for the promotion of their goals, and for obstructing their opponents do this.

We must not confuse phenomena which are polar opposites, complementary characteristics, or ambivalent feelings with dialectical antinomies, for they do not stand in relation to one another and do not develop and change under each other's influence. The dialectically antithetical categories on the other hand do not emerge either in psychologically perceptible and logically conceivable or in historically or socially factual form except within such a relationship. There is no controversy or any unity between antithetical facts and points of view which are merely perspectively but not dialectically constituted. They remain impenetrable to each other, intangible, and unabsorbable. Phenomena outside the unity of history, society, and culture come into contact only sporadically and one-sidedly. We also change the social factors of history and culture into impermeable natural phenomena when we assume that there is a causality between them which operates on one level and in one direction instead of a mutual and total dialectic which determines their whole connection.

The meeting of positive and negative electric charges, the simultaneous corpuscularity and wave formation of light, the association between attraction and repulsion in the nucleus of the atom are not contradictions, merely antithetical or divergent phenomena. There is

no conflict between them; at most there is a tension between energies struggling to split up. The so-called struggle for existence exists not only between different animal beings but even within individual biological organisms, in which there is conflict between different tendencies having the same life interests. And we can talk everywhere, even in inorganic nature, of "struggle" or "conflict" in the metaphorical sense where there is a tension between different tendencies. In this sense the struggle suffers antitheses to exist side by side, just as we meet them in inorganic and partly in organic nature even in the unsocialized animal-human world while in the dialectical sense it always leads to conflict and defeat or victory for one of the antithetical moments.

Insofar as we can speak of something like a dialectic of nature it is a question only of the relationship of man to nature, never of one between natural phenomena themselves. Nature can only become dialectical for man and only on the path between the two.[36] There was apparently a play of the forces of nature before the existence of man, of human reason, of human needs and efforts, but a dialectical function, which would have supported or opposed such efforts, or which could be interpreted in any sense as question and answer, alternative and decision, was not there. It is impossible to conceive of a dialectic between the forces of nature themselves, unless we assume some form of spiritualism which permits spiritual powers of a nonanthropomorphic nature and superhuman power to rule in the universe. Antithetical forces like gravitation and repulsion in inorganic nature or assimilation and differentiation in organic nature—which is alien to reason—do not presume a consciousness or a capability of consciousness with which the inner contradiction in sociohistorical life is linked. Antagonisms which assert themselves in the class struggle in the antithesis of successive philosophical systems, in stylistic changes in the arts, or in the process of the production of the individual work of art are completely alien to phenomena like "natural selection," the differentiation of species, and their biological adjustment to a given milieu.

It is well known that Marx always relates the concept of dialectic to the concept of "work" and of history as the product of the laboring man. Its extension, as that of a creative factor, to being in general—that is, to mute, blind nature—comes from Engels, who proceeded less strictly. The fundamental difference between the doctrines of the two thinkers becomes particularly evident in this connection. Meanwhile, we are right to recall that Marx finally, apparently with a certain distaste, came closer to Engels's view and thought of a universal ontological substantiation of dialectical materialism.[37] Yet even then he

talks of a dialectic of nature only in the nonactual sense, in a form mediated and limited by history, which we know from his *Deutsche Ideologie:* "We know only one single science, the science of history. History can be looked at from two sides. However, the two sides cannot be separated. As long as people exist, the history of nature and the history of men mutually condition each other." However, in *Das Kapital* he differentiates ambiguously and definitively between history and nature: "The history of mankind differs from the history of nature in that we have made the one and not the other."[38]

There can be no question of a dialectic of nature not only because concepts like inner contradictions, dialectical arguments, and solutions like syntheses and *Aufhebung* are unsuited to natural processes, but also because everything we experience as the effect of nature upon our forms of life asserts itself through the social medium and in accordance with it. The influence of the most elementary climatic conditions reveals such social coefficients. Temperature may be an unchanged, passive factor, but people react to it differently according to circumstances. The significance for the dialectic of historical processes of objective conditions in general and of the natural ones in particular may be mediated so broadly and diversely that the most epoch-making revolutionary changes often seem to proceed without tangible motives. Revolutions do not take place when poverty and repression are at their worst, but only when the possibility of their elimination is in sight. The change of objective circumstances into historical forces has already taken place before they enter into consciousness as dialectical forces.

Natural forces may in and of themselves be in opposition, but they do not arise and persist because of this antithesis. Capitalism on the other hand owes its historical meaning and function to the opposition which it develops to the previous system; without this opposition there would be no capitalism in our sense of the word. The Renaissance would also not be what it is without Gothic, and baroque and mannerism would be inconceivable without the Renaissance. Antithetical natural forces exclude each other or mutually impair the influence which emanates from them. Historical movements and directions embrace their antithesis.

10 The Dialectic of the Aesthetic

The Paradoxes of Art

The genesis of art as an objective form, the structural formation of the work of art, the phases of artistic creativity, and the development of historical styles are sheer dialectical phenomena of the purest, most unambiguous and unmistakable kind. All the decisive elements of dialectic—the negation of the point of view from which we proceed, the conflict between what is antiquated and the new forces which are arising, the re-creation of another equilibrium in which those moments which have become untenable but which are still active appear to be *aufgehoben*—not only remain clearly discernible in them but also become sharper in their relationship to one another. In none of the other cultural structures do the individual stages of the dialectical processes appear so clearly and maintain their role to the same extent. In the area of theory, for example, the stage of individual stimulus is completely overcome and set aside from the dialectical process as an irrelevant psychological moment. In the area of the aesthetic, however, it can certainly be outstripped, but it appears incorporated and *aufgehoben* in the further, more developed, and more differentiated relationships—both of form and of content. The true work of art, for all its autonomy, retains traces of its origin.

The ideal of scientific theory consists in the most far-reaching possible freedom of perception from the individual motivations and personal interests which accompany the act of perception. In art on the other hand such a desubjectivization is neither possible nor desirable. The work of art, too, certainly strives toward objectivization, for the complete resolution of artistic creativity into subjective velleities would just as surely mean the end of the tension between those factors—an essential characteristic of art—as would the reduction of artistic cre-

ation to a subjectively indifferent, purely objective reproduction of reality. Just as pure objectivity in the aesthetic sphere dispenses with that characteristic which makes every work of art the expression of a particular personality, so a mere subjectivity not tied to any objectivity has a noncommittal effect in this area. The authentic artistic subject experiences itself, its own feelings, its way of thinking, sensibility, and conception of form and understands the world as the indispensable substratum of its experiences. It experiences itself when projected onto reality and experiences actuality by adopting it itself. Without this dialectical relationship between subjectivity and objectivity, every reflection of reality would remain artistically irrelevant and every statement of intimacy would be inarticulate.

Subjective inwardness and objective expression, depth of feeling and worldly breadth, spiritual immediacy and formal communication not only are indivisible in art but also only achieve validity through their mutual limitations. Not only is there no inwardness in it—however this may be designated—without some objective support and no objective correctness without a subjective coefficient, but also there is only as much inwardness as the objective world which is represented allows to appear and only as much abundance of objects as can be penetrated by feeling and sensitivity. Georg Lukács pointed out the extremes of this state in modern literature, as represented on one hand by Hugo von Hofmannsthal with his impressionistic lyric and on the other by Alain Robbe-Grillet with the objectivity of the *nouveau roman*.[39] In part the whole, purely objective world served merely as the opportunity to put spiritual attitudes and formal talents on display, and in part people were at pains to show that the whole of dehumanized and colorless reality is capable of being displayed and is worth displaying artistically. Mere emotivity, poetic pictures, or other formal structures no more stand on their own two feet than a world completely without pictures and formally indifferent can be made artistically obvious.

No intellectual activity corresponds so completely to the condition in which Sartre sees the downright criterion of dialectic and which he defines as the simultaneous "spiritualization of the external" and the "externalization of the inner"[40] as do the production and consumption of art. In the aesthetic phenomenon which is at once expression and communication, not only is objective reality completely fulfilled by the subject, but subject and object are bracketed together so inseparably that the one is only approachable by a detour through the other.

The dialectic of the aesthetic is, however, confined not only to the antagonism of the forces which achieve their effect through the subject and the object. The impulses which move the subject may also be involved in dialectical conflicts among themselves. The will to

expression itself is not always an unambiguous and irresistible impulse. The work of art can just as well be the product of an arbitrary subject which is battling against and cutting itself off from everything alien to and beyond the artistic personality as it can be of a subject seeking support and approval.

The work of art is a product of dialectic not only in the sense that all other intellectual structures are—namely, as the result of a conflict between the different factors which are represented by the subject and the object, the categories of reason and data which are alien to reason, spontaneous intentions and idle resistance—but also in the sense that in artistic creativity something comes about which corresponds to artistic volition and at the same time contradicts it both internally and externally. On one hand, art is an expression of the will to be in the world, of the affirmation of being and life, of the acceptance of the *condition humaine* and of the agreement to the rules of its game, on the other, it is criticism, denial, rejection of the facts, circumstances, and institutions of vital practice, according to how they appear to the observer when, according to his situation, they appear good and susceptible of improvement, or bad and threatening. At one time it is the representation of the world as it is given to us, freed from all doubt and reservation, at another the flight from it as a cruel and inhuman concatenation of facts. In the strict sense it becomes dialectic not even as a result of this opposition but through the fact that, for all its steadfastness to the factual, it has something in view which transcends the factual, something new which has never existed before, completely incommensurable, that on the other hand even its imaginary castles in the air are built from the bricks of reality. The dialectic of its being goes so far that its castles in the air have such a fantastic effect because they are built of such materials, and their realism amazes us only because conscious self-deception plays such a decisive role in the process.

It is scarcely possible to propose a worthwhile thesis about the nature of art without getting involved in contradictions. Riegl's theory of "artistic volition" *(Kunstwollen)* says, as is well known, that behind every aim and stylistic trend there is a particular intention and that artistic products are conditioned more by this intention than by the ability of their creators. The silent hypothesis which is connected with this is that there is no decisive tension between will and ability in art and that the artist's struggle with technical, material, and formal difficulties, with patrons and those interested in art, with the art market and art criticism is relatively unimportant—an obviously untenable assumption. Just as untenable, however, is the mechanical reversal of

the thesis—the assertion, that is, that the artist wants only what he is capable of accomplishing.

Engels presupposed the fundamental principle of Konrad Fiedler's theory of art when he declared that the hand was not only the organ but also the product of labor.[41] The dialectic in which artistic creation is involved is derived most clearly from this circumstance. The artist is not only the creator but also the creature of his art. He is not by any means a complete person when he takes up his work, but rather develops with the artistic creation which is coming to life and expanding. The relationships are extremely complicated, but what is clear is that the different factors of the creative process achieve their particular character only when they come into contact with one another.

The idea of the mutuality of such factors comes not from Engels, however, but from Marx, who already had developed them in his *Rohentwurf* in 1857/58 when he declared that it is production which creates the need for the producer's product, the sense to understand it, and the capability of using and enjoying it. The fundamental passage reads: "Hunger is hunger; but hunger which satisfies itself with meat cooked and eaten with a knife and fork is a different hunger from the one allayed by raw meat eaten with the help of hands, nails, and teeth. Not only the object of consumption but also the means of consumption are thus produced by production, not only objectively but also subjectively. Thus production creates the producer. Production produces not only material for need but also need for the material. . . . The object of art—just like every other product—creates a public which is inclined to art and able to appreciate beauty. Thus production creates not only an object for the subject but also a subject for the object."[42]

A similar paradox characterizes the relationship between an artist's work and his biography. Whatever the relationship is, it is something which is mutually conditioned. The artist's life history is determined as much by his work as his work is determined by his fate. He gathers together his experiences in his creations and sketches the material for his works in the events of his life when he tries to make of his life what he is capable of representing. Thus, his work becomes an echo of his biography and his life's history in part an anticipation of his works. He has his typical experiences because he has the means of a characteristic artistic structure at his disposal. The type of experiences he has changes with the change in his abilities to represent them. A new stage of his artistic development produces a new readiness for experience, just as a new and decisive experience can become the origin of a new creative faculty. A creative mode which has become all too typical can, however, lead to the stifling of the ability to experience, and an all too dogmatic view of the world—derived from one's own

experience of life—can lead to a limitation of the ability to construct. In any case the artist at the end of his work is no more the same person as he was at the beginning than the work of an old or mature master is the same as that which the beginner had in mind. Every successful work is, it is true, aimed at a totality, at the wholeness of life, but it is not always the totality to the same extent and with the same differentiation which is apparent to the artist. This, too, changes with the eventful life he leads.

The paradoxical nature of art goes back essentially to the contradiction that it is on one hand mimesis, reflection of reality, reproduction of experiences, the expression of feelings and spontaneous impulses, on the other the quintessence of artifacts, illusion, imaginary pictures, illusions, and ideals. It represents the simply paradigmatic union of freedom and coercion, anarchy and rule, deception and truth to nature, particularity and typicality, formal immanence and transcendence of system. The paradox of these antinomies consists in the fact that the antithetical aspects, attributions, and qualifications do not respond to each other as right and wrong, true or false, far- or near-sighted, but they all have the same claim to recognition. Significance of form and content, purposeful or purposeless beauty, spontaneous and conventional mode of expression, historically concrete and artistic motifs which are separate from history are no more mutually exclusive than the "reflection of reality" and "conscious self-deception." In fact, they rather belong together and make no sense without each other. We are therefore certainly not making a mistake if we see in the paradoxical the reconciliation of the incompatible, a fundamental form of art.

The basic paradox of art, in which its dialectical being is simultaneously manifest, is also expressed in the contradiction of emotional distance and the simultaneous emotional bond in the artist's relationship to his object, his figures, and the experiences described in his work. He achieves, as Diderot says, a representation of feelings which is all the more faithful the less feeling he brings to his work. Of course, he must have experienced what a feeling means in order to be able to conjure it up. Yet as an artist he is always concerned only with the *imago* of feelings and not with the feelings themselves. It is in this sense that André Gide's words have to be understood—that we have to surmount the lyrical condition in order to be an artist; but in order to surmount it, we have at one time to have been in the condition. In a similar sense T. S. Eliot declares that it is "not in his personal emotions, the emotions provoked by particular events in his life, that the poet is in any way remarkable or interesting. His particular emotions may be simple, or crude, or flat. The emotion in his poetry will be a very complex thing, but not with the complexity of the emotions

of people who have very complex or unusual emotions in life. . . . The business of the poet is not to find new emotions, but to use the ordinary ones and, in working them up into poetry, to express feelings which are not in actual emotions at all. And emotions which he has never experienced will serve his turn as well as those familiar to him. . . . It is a concentration, and a new thing resulting from the concentration, of a very great number of experiences which to the practical and active person would not seem to be experiences at all; it is a concentration which does not happen consciously or of deliberation. . . . Of course this is not quite the whole story. There is a great deal, in the writing of poetry, which must be conscious and deliberate. In fact, the bad poet is usually unconscious where he ought to be conscious, and conscious where he ought to be unconscious. Both errors tend to make him 'personal.' Poetry is not a turning loose of emotion, but an escape from emotion; it is not the expression of personality, but an escape from personality. But, of course, only those who have personality and emotions know what it means to want to escape from these things. . . . There are many people who appreciate the expression of sincere emotion in verse, and there is a smaller number of people who can appreciate technical excellence. But very few know when there is an expression of *significant* emotion, emotion which has its life in the poem and not in the history of the poet. The emotion of art is impersonal. And the poet cannot reach this impersonality without surrendering himself wholly to the work to be done."[43]

Hegel's thesis that the work of art belongs and does not belong to the author expresses the paradoxical, dialectical nature of art most sharply and meaningfully. The work is the product of its original creator and simultaneously of the society for which it is designed. But it is also only in a limited sense the author's property, because the author often does not know how the work acquired the form which it bears and does not give an answer to so many of the questions it poses. It is as if he would fill the fragmentary structure which he can neither complete nor explain with an unarticulated, fluid material, often with a blindly invented content, which life brings to him. However, Hegel's statement is mainly right in the sense that the completed work as a completely objectivized form frees itself from the author and becomes the property of those who enjoy and value it, and that the artist scarcely recognizes himself in the work's final and alien form. The work of art remains locked in the dialectic of the subjective and objective factors of its creation until it is completed; after that, the receptive subject takes over the role of the productive subject in the dialectical process. The argument now proceeds between the public and the completed work alienated from the author.

Guyau noted that at the end of the eighteenth century, when the pastoral with its sentimentality and frivolity seemed to govern art and taste most strongly, the world was closest to revolution with its realism and rigorism—that in fact, in his opinion, rococo culture was nothing but a superficial phenomenon.[44] But the solution of the problem created by this complicated situation is not that simple. Rather, it is to be sought in the complexity of motives according to which the forms of art are not the simple image, the positive reflection, and the immediate expression of social conditions but are determined by an unconscious background which is often hard to unveil, by suppressed urges and ideologically deformed goals. Therefore, instead of a direct and unambiguous causality in the formation of artistic structures, it is precisely that mediated and differentiated dialectic which is at play, of which we are continually talking here, and in this way the same epoch and the same society can express itself in different, even contradictory, forms according to the factors which assert themselves. Not only was prerevolutionary society divided into several classes and cultural strata which were interested in art, but the individual social groups themselves did not always share the same goals and ideals, and even the same interests, ideas, and efforts were sometimes interpreted, justified, and accounted for differently. Thus, the bourgeois feeling for life takes quite different forms in the work of Chardin from what it does in the work of David; the proximity of the revolution of which Guyau speaks calls forth in David a heroic attitude, beside which the art of Chardin, the older man, formally more closely linked to the rococo, appears in many ways to be more conservative. In the light of this example, to say nothing of the relationship between Voltaire and Rousseau, concepts like "revolutionary," "bourgeois," "progressive," and "conservative" appear by no means unambiguous and have to be judged on the basis of the dialectical forces which are definitive for the various movements. Guyau's simplifying method of looking at things leaps into view when we consider that rococo was by no means more shallow than the intellectual culture of the following period, that its artistic products were by no means inferior, that their supporters formed neither a negligible minority nor an age-group grown impotent, and that Watteau was no "more superficial" a painter than David and not inferior to him. The historical constellation may at first appear confusing; the contradictory judgment of artistic products—which is linked to different social loyalties and a view of art which is now formalistic, now humanistic—in no way, however, justifies the scorn which the dialectical point of view encounters from its ideologically blinkered opponents. The fact that there are ambivalent feelings like love-hate is no longer doubted by anyone. It is also generally agreed

that the psychology of unambiguous motives should be supplemented by a more complex one which differentiates attitudes like "rationalization" from those which are not entirely approved of yet which are not entirely legerdemain. What we find lacking in Hegel is that he follows similar principles, and we cannot forgive Marx for touching upon "immortal and indubitable" values with his dialectical principle.

Artistic Creation

Artistic creation represents a prototype of the dialectical process. On the one hand it has the antagonisms, the subjectivism of the spontaneously creative urge, and the readiness for communication; on the other hand it has the objective resistance which it meets in the refractory media of communication and which it has to surmount or circumvent. The contradiction of the definitive factors and the problematic bound up with it, the accretion and solution of problems, the replacement of temporary solutions by later ones give an absolutely exemplary concept of the functioning of dialectic. We can add to this the fact that achievements once made are preserved in part, the encapsulated series of modifications and corrections and of versions which are still unsatisfactory and in need of further correction, the redirection of the existing strata of a work, and the reevaluation of those elements which are to be kept.

In any case there is no area of human activity in which the mutual relationship of the factors, the needs and their satisfaction, the striving to expression and the means of expression, the contents of experience and the forms of representation come more clearly to light than in artistic creation. The interdependence and the struggle between the individual moments involved in the process form so tight a net that it is scarcely possible to speak of the one without taking the other into account. Above all, we cannot separate the meaning of the individual elements from that of the work as a whole. And the position is not only that the artist's idea of his own work is modified at each stage of the process but also that he cannot tell which of the different components will become effective later and which earlier. We cannot even establish with certainty whether and to what extent the first creative impulse to the production of a work issues from an inner vision of form, an emotional sound pattern, an expressive linguistic concatenation, or an already existent external medium of creation—that is, whether the visual, acoustic, or linguistic form is one that is chosen and used intentionally or a given and existing vehicle. In other words, the dialectical limitation of the elements is so firm that we never know whether the raw material, the plot still scarcely developed, the blurred

optical form, and the fluctuating lyrical mood condition the medium to be chosen or whether the medium which offers itself is the precondition for the choice of the motif to be represented. The principle that the dialectic of artistic creation expresses itself most unambiguously and in the sharpest manner in the mutual dependence of the contents of expression and the forms of expression, of motifs and media, of artistic vision and technique means essentially that the experience to be portrayed and the idea to be communicated are not ready-made before the necessary means of expression are available. The artist only knows what he has to say when he already knows how he will say it.

In no way does the process continue in such a way that the artist, at a higher stage of his activity, only develops and carries out more carefully, in greater detail, and more circumspectly what he has tried to accomplish on a lower, more inchoate stage in a more naive, spontaneous, and less thoughtful manner. The most primitive, still completely embryonic artistic experience is probably already a step on the way to the dialectical process which leads to the completed work, but to what extent the artist is conscious of it as such is the more inconsequential when even the most progressive stages of his creation still show characteristics which he does not account to himself for. He is not necessarily more conscious of the contradictorily conditioned nature of the creative act in the course of completing it; the act itself often becomes more contradictory and complex in the process.

As long as the creative process is not complete, both factors of the partly subjectively, partly objectively conditioned dialectic remain in a state of flux; that is, every change on one side creates a situation with which previously unforeseeable changes on the other are linked. However, if new and often heterogeneous motives which give an unforeseen turn to the formation of the work appear in the course of the process, then the already established elements preserve a constitutive character which is decisive for further development and for the final product. If the poet has once found the first line of his poem, the painter the first brush stroke, the composer the first chord and has preserved the form or the memory of it, he no longer disposes completely freely over his idea and its representation. He is just as firmly bound by what has already been formulated as by the ideas and feelings he wants to express. Every new element of the work represents a balance, a compromise, and an integration of a particular sort between all the components of artistic creation which are present. What has already been formed acquires an independent objectivity which is rigid, even stubborn, toward the as yet unformed intellectual content. It becomes an alien element beyond the subject, something which has to be conquered

by the creative force of the artist and a foreign body to be absorbed by the work which is coming into being. It conditions a struggle between the objectivized and the spontaneous elements of the creation.

In the light of these facts, the process of artistic creation can be described essentially in the following way. The first step determines the second, the first two steps determine the third, and all steps which have been taken determine subsequent ones. There is no single step and no number of completed steps which permit us to draw unambiguous and certain conclusions about the nature and the direction of the subsequent ones. No step can be explained without knowledge of the preceding ones, but none is calculable on the basis of all the preceding ones. Every new moment is, however, not only conditioned by the preceding stages of the creation but leads in conjunction with them to a new synthesis, a new, though provisional, survey of the whole of the process. The new aspect not merely ties in with the earlier ones but also represents their sum total. It acquires its meaning from what has already been accomplished while seeming at the same time to fulfill or limit a promise. Every new moment of the creative process points backward and forward. It creates a new promise or changes one that has already been given, expands or limits the elements already brought into play.

Thus, the artist in this process is guided not only by his original plan and his first inspiring ideas but also, and indeed in a decisive manner, by the gradually changing direction which his work takes on as it proceeds, so that he himself often no longer knows where the characters—which are emancipating themselves—and his apparently supplementary and chance ideas are leading. The "subsequent" which was perhaps from the beginning latent may essentially change the meaning of the "temporary." The existence of Sancho Panza is a classical example of the fruitfulness of such a supplementary idea.

The course of the creative process consists, apart from the logical expansion of the plot or situation which has to be developed, of corrections and settlements which are evolutionary and not dialectical, even if the parts of the work which came into being earlier in fact remain unchanged. Their meaning changes in the light of the later parts. Not only does a musical theme acquire a new quality of expression and a differentiation with each variation; not only does such a variation in an important musical work contain to some extent all previous variations and immediately give them a new value so that all the previous notes now resonate and gain in importance: the ability of the themes to be varied, the interaction between a motive, experience, or impulse of any sort and the interpretations and complications which they undergo, lend to every art a similar "musical" character.

Every step in artistic creation fulfills a double function. Taking what has been newly experienced and acquired for art, it surpasses everything which has already been achieved, formally realized, and technically solved, while keeping at the same time everything which is still capable of solving an artistic problem. Every new phase of the creative process takes apart the structure which was formerly created but restores it in a more complex form and gives to its components a new meaning, a new value, and a new structural role in the totality of the work.

The dialectic we are talking about here extends to the antithesis between not only the subjective and objective, the original and derived elements of content and form, but also the rational and irrational elements in the work of art. There is no stage of artistic production in which they are separated and independent of one another. However, it is not always completely clear which moments are to be regarded as the spontaneous and involuntary moments and which as the rational and intentional. The melodic element of a composition is by no means necessarily more original than its tonality or harmony. But even the emotionally irrational origin of components like musical themes, painterly color complexes, or poetic language forms is in no way synonymous with their spontaneity. What we generally understand by intuition or inspiration usually only brings to light forgotten or superseded experiences, and what appears to be an unmotivated idea or a sudden revelation is in reality generally the result of a long chain of thought which has long been prepared and is already well advanced but which has merely remained unrecognized and hidden. Talent is a free gift, but the work is not achieved for nothing or without effort; it is won by force: for it is a fact that "le hasard ne favorise que les esprits préparés."

The conflict between unconscious and conscious motifs which are the basis of the artist's work is just as sharp as the antithesis between his subjective efforts at expression and the means of expression he has at his disposal. We can see in the work of art equally well the synthesis of these motifs and the balance between spontaneous artistic inspiration and the passive resistance of the given materials and the medium. It is nothing more than a romantic myth that everything the spirit achieves from an inner urge, in an unconscious or irrational manner, has its origin at a deeper level and is a more varied context of spiritual motives than what it accomplishes in a sphere which is more accessible to the consciousness and to rational thought. The intuitive drives, inclinations, and abilities which are beyond reason have no closer connection with timelessness and universality than conscious attitudes and abilities which are governed by reason. The unconscious and the intuitive also

do not represent the unity and totality of the spirit, the totality and integration of the person, more fully than do rational and discursive thought. Spontaneous uncritical and uncensored expressions of the psyche are neither more homogeneous nor more coherent than derived, rational, and goal-conscious intellectual activities. Moreover, the unconscious of different subjects reveals no more unified a picture than do their origin, class situation, or education or their ideas and opinions which can be clearly formulated—in short, their conscious or potentially conscious attitudes. For this reason it is in no way the same sort of unconscious which is expressed in primitive art, children's drawings, lunatics' scribblings, and the works of a neurotic or psychotic of the rank of a van Gogh.

The conscious and unconscious sectors of the psyche do not form compartments which are indivisibly divided from one another—not even two neighboring spaces with a communicating door, or with one which does permit communication between them but which is, as Freud says, guarded by a doorkeeper. More accurately, we should look upon them as two communicating vessels whose contents mix in a sort of endosmosis, in other words, relate to each other through a dialectical dialogue. The conscious acquires its special quality only in antithesis to the unconscious, and we know about an unconscious only because we are conscious of certain things. The analogy of the reciprocity of the conscious and the unconscious with dialectical relations goes much further than the merely "dialogue" form. The unconscious and what is asserting itself mediately becomes a task for the analysis of consciousness, a "negation" at which we may not stop. The appearance of unconscious impulses calls forth an enhanced activation of the conscious abilities. Yet the more the consciousness is exerted, the more it is able to react, and the more understanding it has, the more are wider and deeper zones of the unconscious felt to be problematic, disturbing, and in need of explanation and interpretation.

When Marx talks of the difference between the products of men and animals—for example, an architect's buildings and those of a bee or a beaver—he departs to a certain extent from the principles of his own dialectic. He maintains that the architect, in contrast to even the "best bee," has a ready-made plan of his work in his head before he starts on it. In this way he gives consciousness, which according to his dialectic never seems to be completely independent, a primacy at any given moment over the conditions of labor, which are only gradually asserting themselves. Konrad Fiedler's conception of the process of artistic creation is much closer to the contradiction which arises everywhere and to the continuous duality of the process. According to this, the form of a work of art is never available in its complete state until

the work is completed. The structure emerges as a result of the inter-action between the intention and the possibility of its realization, im-pulse and instrument, motif and medium, and this does not leave room for any unilaterality of the constitutive elements. The starting point is by no means always the spontaneous intention of the formal plan of the originator. The given instrument, the available material, the possibility of action, and especially the externally imposed task may just as easily be the first moment of the creative process. Paintbrush and paint, a motor need and playful fashioning do not only act as the actual stimulus to artistic activity in children and apes, and amorphous materials or mechanical skills often play a significant role even at the highest levels of artistic creation.

Lessing thinks completely undialectically about the relationship of the intellectual and manual components of the artistic product, as we can see from his remark about the possibility of a Raphael "without hands." Fiedler on the other hand, who expressly and repeatedly de-clares that in the process of artistic creation "the hand does not execute what could have been formed completely in the brain beforehand,"[45] is completely conscious of the inseparability of hand and brain, some-thing which escapes Lessing and still escapes Marx. "Even in the most elementary attempts at pictorial representation," he says, "the hand does not do something which the eye could already have done. Rather, something quite new comes into being and the hand takes over the further development of what the eye does and continues it."[46] Or, as he says more clearly and obviously with reference to Lessing, "the process carried out by the hand [is] only the further stage of a unified indivisible process. . . . For if we assume that men had their whole intellectual organization but were born without hands, this would not, it is true, bring about an impoverishment of the world of ideas in the above sense, but the genesis of artistic ideas would be impossible."[47]

The origin of Fiedler's process of thought is without doubt to be found in Lessing, although the final conclusion of the point of view hinted at in *Laökoon* is the opposite. Lessing stands, with his hypothesis of a Raphael "without hands"—that is, of a painter not only who can have artistic ideas without being able to carry them out but whose ideas would lose none of their artistic value if they did remain unrealized—on strictly classical ground. Artistic realization, however, does not follow, as he supposes, directly upon the conception of the artistic idea and is not entirely conditioned by it. Rather, they develop so closely and hand in hand that we often cannot ascertain whether the process started with an ideal or a technical stimulus.

As a result of the conscious opposition to Lessing's point of view, the dialectical nature of artistic creativity is more clearly and unam-

biguously expressed in Fiedler's work than it is by Marx or Engels. The fundamental principle that the work of art is not the simple and direct representation of a vision, not the literal and mechanical translation of an ideal content—complete from the outset—into sensual forms, is formulated more strictly and with less misunderstanding by Fiedler than anywhere else. The means of representation completely lose the character of passive and neutral instruments and become completely productive moments of the act of creation which fructify the artistic vision and promote invention.[48] The realization of the artistic plan in the given material and medium is not an operation of secondary significance. On the contrary, it is identical with the actual artistic work which is being accomplished in certain sensual forms—the execution is the creative act itself.

According to Fiedler's dialectical formulation, an artist starts with an essentially indefinite, noncommittal, and indefinable concept of the work to be produced. Often a vague need, a more or less blurred expressive content, and a free-floating conception of form are the impetus to the first tentative and hesitant attempt to fulfill the need, to the first uncertain and tentative step on the path whose successful traversal remains questionable until the end. Even the next step does not merely lead to a new form-content complex but is already the result of an unforeseen, bilaterally determined development of the dialectical dialogue—the struggle between the original impulse and the first experimental move to follow it, the first approach to the manipulation of the material to be worked. This, like every further step— that is, the whole continuation of the first approach—represents the translation of an essentially immature and inexactly articulated vision into a foreign language, a medium which only defines and stabilizes itself. Everything except the individual, unobjectified intimacy is alien to this vision. It is not only the words, the notes, and the colors, not only the tool, the paintbrush, the mortar, the musical instrument, grammar, and prosody but also the artist's abstract abilities and talent which are alien to the object and have freedom of choice. The history of the genesis of a work of art is accomplished in the form of the reciprocal accommodation of means and end, desire and ability, flexibility and intransigence of talent. It starts out from an anticipated, even if very loosely delineated whole and from details which usually arise by chance and which are only loosely connected. The final meaning of the whole, as of the details, emerges only from their changing relationship to one another. With every new characteristic not only the stock, the number, and the complexity of details change but also the picture of the whole as a system—which, it is true, is not the sum

of the individual parts, whose global meaning, however, may be modified with each new detail.

With his concept of art Bergson seems to continue Fiedler's train of thought, though Fiedler's work was unknown to him. "The completed portrait," he writes in this sense, "is conditioned by the physiognomy of the model, the nature of the artist, the colors. . . . No one, not even the artist himself, could imagine, however, what the portrait should become, for to prophesy this would have meant a knowledge of its final form before it was there."[49] Thus, Bergson formulates more radically than Fiedler the thesis that the idea in art is asserted only in conjunction with its realization.

The inseparability of form and content, subject and object, will and ability contains the key to the understanding of the genesis and development of all cultural forms, but explains the nature of no historical process more clearly than that of artistic creativity and stylistic change. In no other connection is it so unmistakable that the setting and solving of problems appear *uno actu* and that the problem to be solved is grasped only when its solution is already in sight, that a critical situation thus becomes untenable only when there is a notion that it can be solved. It is in this sense that we probably have to understand Marx's words that humanity only sets itself problems which it can solve. Gothic has had its day only when the ideas of the Renaissance begin to dawn, the end of the rococo is scarcely to be distinguished from the beginnings of neoclassicism, and the revolution breaks out not when absolutism is at its height but at the point when the possibility of change in the social system comes into view.

Every phase of artistic processes, every stage of creative work and of stylistic development contains the following stage in nucleus, even if it becomes visible only at the end of the processes in question, just as every stratum of the structure of an artistic form reveals its meaning only in conjunction with the other strata. Just as the success of the individual work of art remains an open question until the last stroke, it can also scarcely be said where a style is leading before the last word in the dialogue of the constitutive factors has been uttered. The elements which are decisive for the qualitative value of a work are in so unstable, so precarious a balance that even in the case of the most important products we often have to ask whether effort and mastery or luck and happenstance were responsible for their success.

The Dialectic of Structure

The structure of a work of art is based on the antithesis of the successive parts. Every artistic structure owes its effect largely to this principle,

namely, the emphasis and the intensification which its elements experience as a result of this opposition, of the antitheses, the reconciliation, and the repeated conflict of motives which come about in the whole as in every component of the work. The antagonism which exists between art and the reality which is alien to art, which governs the connection between the creative impulse and the conventional means of expression and which conditions the continuity and discontinuity of artistic tradition, finds its repetition, continuation, and differentiation in the tension between the individual formal elements of works of art.

The dialectical, now analytical, now synthetic, sometimes dissolving, sometimes balancing function of these elements, which are sometimes progressive and sometimes regressive, appears most clearly in music and most unmistakably in sonata form. Beside the antithetical division of the thematic material into two corresponding motives, which is a trait of even the most simple song form, the movement of a sonata already reveals a classical tripartite structure. The exposition with its themes, which are usually contradictory in feeling and mood—and generally in key and harmony—is followed by the development—as an argument between the two enunciations—and the reprise—as the conclusion and recapitulation of the argumentation. The relationship of the different movements of a classical or romantic composition develops along the same lines of opposition. "Male" and "female," activist and contemplative, dramatically moving and melodically flowing parts follow one another. The interchange of lively, violent, feverish and relaxed, comfortable, melting moods also characterizes the structure of the essentially additive form, the variation, whose individual sections distinguish themselves antinominally from each other according to rhythm, tonality, and harmony.

The structure of a work of art can be visually represented most successfully according to the pattern of a score, in which polyphony, multistratification, contradiction, and simultaneous integrability of structure become plain. Every phase of a composition appears as the resolution and preservation, the negation and "logical" continuation of the previous ones. The movement of musical thought is expressed both vertically, as the harmonic unfolding of the basic tonal complex, and horizontally, as a continuous development of motifs. The dialectical principle asserts itself in thematic succession as well as in contrapuntal simultaneity and represents the paradigmatic amalgamation of the different strata of a work in every form of art. The artist always thinks in the categories of a "score" which brings the simultaneous phases of development, aspects, and relationships into play and balances them with one another.

Just as dialectically focused, if not as transparent, as the structure of a musical composition is the structure of a drama, which is constructed antithetically not only with respect to the various acts but also with respect to the scenes within the acts. A moral relationship which is from the outset contradictory leads, as a result of the negation of one of its motifs, to a crisis and, by the decision which the situation demands, to either a catastrophe or a happy ending as the solution of the dramatic antagonism. Tragedy, with the uncompromising opposition of its protagonists, the alternative of the moral principles in question, the destruction of the moral order as a negation, and its restoration as the negation of negation, shows itself, too, to be a prototype of artistic form. The structure of every dramatically focused narrative which revolves around a moral dilemma is, however, dialectical just because of the juxtaposition of antithetical characters. The relationship between Don Quixote and Sancho Panza is paradigmatic. And as far as dialectical form in general is concerned, it is not only tragedy which is divided, in Aristotle's sense, into "beginning, middle, and end"; every literary structure which is not a mere sketch more or less reveals this tripartite structure. Even the most simple lyrical poem consists of parts which can be labeled thesis, antithesis, and synthesis. The fascination of change plays the leading part in this division, yet the dialectical formula essentially creates the impression of unity and totality of artistic organization.

In the final form, visual art, freed from the process of genesis, it is harder to establish a dialectical structure. Since dialectic is itself a process, its phases are easier to point out in the temporal structures of music or literature than in the media which exclude the temporal element or reduce it to a spatial denominator. However, we cannot overlook in these media, too, the fact that the successful form establishes itself as the resolution of a tension between what are in the first instance contradictory assumptions—like sensually heterogeneous experiential material and homogeneous visibility, place, and time of a plot to be narrated and decorative figural composition, quality of mood, and coloration. Here, too, the partial moments are of such a nature as to correspond to the whole which has not yet been realized but which is already anticipated. With each new moment everything which has already been accomplished in the course of the genesis of a work crystallizes anew, gains a new priority even if it remains factually unchanged.

Above all, what is dialectical in art is the relationship between form and content—again, not only because a change in one element brings about a change in the other, but also because they are unthinkable without each other and we cannot say for one moment what form is

without thinking about what has to be formed and that something is being formed. Only when we are conscious of the presence of both factors and remain conscious of their inseparability can we grasp the fact that art consists of tensions and the release of tension, antitheses and reconciliations, differentiations and integrations. The work of art is the vehicle and product of interaction between the variable formulas of expression and the content of experiences, which is always being renewed, differentiated, and deepened. In its genesis we are concerned *pari passu* with two changing moments of a complex which is in reality insoluble. But if we explain the relationship by saying that form "turns into" content or vice versa, we are using a purely metaphorical form of expression. By using a metaphor, we say nothing about the process which is more precise or comprehensible. The expression belongs to jargon, not to the essence of dialectic. Form is neither the mere completion of content, nor does it simply grow out of it; and content is by no means the pure substratum, the invariable supporter of form. They develop step by step together as the indivisible solution of problems which they set each other. The content of a work is not more established from the outset than its form. They are only the theoretically divisible result of a practically unified process.

Form, however, stands dialectically as a contrast not only to the material and the plot, the final presentation of persons and fates but already to mimesis, the reflection of artistically unarticulated reality. The organization of a work of art according to the principles of unity, proportionality, order, and rhythm is fundamentally different, even though practically inseparable, from its saturation with mimetic elements which are related to reality and give the impression of being immediate experiences. Only as much mimesis enters the work as the formal structure—as frame and limit—permits, and the form asserts itself according to the extent of the mimetic materials which it has to embrace—it asserts itself at the cost of this material. Reproduced reality and form, however, only assert themselves antithetically; they come about only with each other's help. If mimesis is the substratum of form, it is so because it makes form the form of something, in the same way that mimesis becomes the reflection of reality only through the categorical relationship between subject and object.

As the tension between antagonistic moments and the balance between factors of a process directed toward synthesis which complement and compensate each other, the relationship between form and content represents the most obvious and revealing manifestation of the dialectical nature of art. In border-line cases everything may appear to be either form or content; in fact, the one moment is never absorbed and replaced by the other. The whole history of art moves between their

limits, without ever reaching the one or the other. There exists such an unremovable reciprocity and convertibility between them, even though it is constantly changing, that at times we can scarcely make out where the effect of one factor ends and that of the other begins. Death at the end of tragedy and marriage at the end of a comedy may appear as part of the plot but also as part of the formal structure.

The Process of Art History

As a process, the dialectic of art appears most immediately and least figuratively and metaphorically in the form of the development of style. In this connection the antithetical tendencies always appear with special individuals and groups which are more or less separate and which are struggling for recognition, influence, and success. The forces which find themselves in conflict cannot always be ascribed to either Peter or Paul, but the roles can always be divided among different authorities. They differ from one another, first, according to the priority of stimuli which are seeking expression and the means of expression available. The answer to the question, Where does the first stimulus to development come from? varies—as something which is purely historically determined—according to circumstances. It may originate from a technical accomplishment which asserts itself against older principles of form, or from a new conception of form, which can no longer be handled by the existing technical apparatus. The stimulus which sets the dialectical process in motion, whether it is purely technical or aesthetically formal in nature, represents the new "productive force." The old form in contrast to the new technology or the outmoded technology as resistance to the new conception of form represents the outdated "conditions of production," of which there remains always as much as the new productive force wishes to retain.

In the structure of a work of art the different formal factors assume an objective character as they emancipate themselves from their personal representatives. Their relationship to one another can only be called a dialectical one in the sense that it is the distillate of the stages of development, of the intentions and points of view of creative individuals which are being modified—not in the literal activist sense at all. However, we also have to understand the struggle between antithetical dialectical forces in the process of individual artistic creativity in a metaphorical sense. It asserts itself on the continuous psychological level of a person even if that person is stimulated by various social agencies. It is only in the history of art as a collective process that the different moments of artistic dialectic appear divided among different persons, groups, and strata. Here we really are concerned with subjects

who question and answer, are ready to make statements and ready to oppose, with real conflict and struggle, with victory and defeat, with overcoming and transmission.

The fundamental art historical event is the change of style and of taste, an unmistakable dialectical phenomenon, the result of contradictory tendencies which are at first irreconcilable. The particular difficulty of the question as to the nature of this change, of the meaning of continuity and discontinuity in the transition from one style to another, comes from the fact that the breach with the past and the attachment to it, that development and progress in art play a different role and rely on different factors from what they do elsewhere in the history of culture, especially in science and technology. In these, the historical process is fundamentally continuous and progressive; in art on the other hand it is disjointed, devious, and, as far as the quality of the products is concerned, irreconcilable with the concept of progress. The fundamental and central concept of art history, the collective style of a period, has an all the more strictly dialectical meaning because it acquires its meaning for the most part in the conflict between the tendencies and movements it encounters. An artistic style is a phenomenon which is in constant motion, which is newly constituted with every factor of production and reception, every work, and every criterion of taste which appears within it whether for or against. Its essence consists in becoming, not in being, and it exists as long as it "becomes." It never achieves the completion of a work of art but breaks off somewhere, changes direction, turns around, stagnates, oscillates without ever reaching its end, goal, and ideal.

Art history as the history of style is conceivable only on the basis of the dialectical category of *Aufhebung*. Every new art historical impetus "preserves" the existing stylistic forms, disintegrates them, and makes them antiquated while nevertheless keeping those elements which can be developed further. Art historical development reflects at every stage a process which proceeds in the form of antitheses, eliminations, and *Aufhebungen*. Everywhere, positive and negative points of view vivify each other in it. The fundamental axiom of its interpretation as the connection between outdated and topical movements is that the artistic creations of past epochs acquire meaning and relevance only from the point of view of a lively and productive present, and that it is only in this way that they become comprehensible and enjoyable at all. Scholars and thinkers engaged on an art historical or critical work are no more abstract subjects immersed in the theory of perception and independent of the practical and ideological conditions of their time than receptive individuals in general. They are equally involved in the dialectic of existence, class warfare, and ideological

struggle. This relationship is all the more complicated and the less soluble from its dialectical duality and ambiguity because tradition, by which, besides actual artistic practice, every attitude which produces a historical priority is determined, is by no means unambiguous but is itself in the process of development. For not only is the artistic production which is taking place codetermined by undestroyed or newly discovered and exposed art of the past but also the forgotten or neglected styles of outdated periods which are newly born and reevaluated take on a new form in the light of the developing artistic movement.

The practice and theory of art are so deeply rooted in dualistic notions that people have always been at pains to distinguish in art history and criticism between two opposing principles of endeavor and to trace stylistic movements back to them. Distinguishing between time-honored exemplars and avant-garde innovations, idealistic and realistic, objective and subjective criteria of art belongs to the earliest formulations of the contrast. Universalism and individualism, rigorous form and anarchy, rationalism and irrationalism, classicism and romanticism are later formulations, and naive and sentimental, Apollonian and Dionysian, abstraction and empathy, introversion and extroversion, the typical and the individual are the more modern ones. Nowadays we talk in the same sense of geometrism and naturalism, tectonic and atectonic, juxtaposition and subordination, formalism and expressionism. All of these concepts revolve around the same antagonism. It is time and again a question of the choice between submission to concrete reality and renunciation of it, between the preservation and the dismemberment of the reality of experience. In the change of stylistic movements the final temporal and spatial world is accepted or rejected, reflected or deformed, perceived as satisfying and promising or as threatening and hopeless. The subject subordinates itself to its rules or attempts to impose the law of a "higher" order upon it, of an ideal reality which should come about. Yet we are not always speaking of unambiguously antithetical categories in this typology. Styles, like Gothic, Renaissance, mannerism, and baroque, can, it is true, be looked at in relation to one or another movement, but they do not form a strictly closed and united pair of concepts with any one. Their relation to them is dialectical but more complexly and more diversely mediated than that between simple and unambiguous antitheses.

Even the classicism of the French Revolution, which sharply asserts the dialectical opposition to the art of the ancien régime, by no means emerges as unprepared and unmediated as is often assumed. Ever since the Gothic period artistic development has taken a course between the

two poles of a more or less rigid tectonics and of a freer expressionism, that is, between a conception of art which tends toward classicism and one which is opposed to it. Since this time, no stylistic movement has represented the simple negation, antithesis and synthesis of the preceding stylistic tendency. The development of style, too, is never again a completely straight-line one, proceeding in the one or the other direction. Those scholars who expect in a style like the classicism of the revolutionary era an unambiguous intensification of the preceding movement find it strange and actually contrary to the rules that the movement does not lead from the simple to the complex, perhaps from the linear to the picturesque, or from the picturesque to the more picturesque, but that the process of differentiation breaks off and rebounds to a stage which has already been overcome. Wölfflin is of the opinion that in the case of such a return, the stimulus is "more clearly founded in outside conditions" than is the case with uninterrupted processes of complication.[50] In reality, however, the "outside conditions" play the same part in both cases. On every level and at each stage of development it is an open question—which cannot be determined beforehand—which goal history will direct itself toward. To preserve the existing direction presents a problem which is just as contradictorily conditioned, needs just as much to be solved dialectically, and depends despite its "inner" intellectual dispositions just as much upon "external" material conditions as on their modification. The attempt to hold up the progress of the artistic tendencies of the ancien régime or to interrupt them does not demand any basically different strengths—even if it certainly demands different impulses and ideas—than does the wish to preserve or intensify their effect. The artistic style of the revolutionary period differs from that of earlier classicisms in that rigor of form acquires greater importance and finally dominates more completely than at any time since the Renaissance. David's art, however, does not lack all tension between external and internal stimuli and is just as firmly planted in the middle of antithetical stylistic possibilities as was every other change of artistic movement since the Gothic. It, too, represents a compromise and subjects itself to certain conventions, even if—like every significant art—in its own peculiar way.

What we understand by art history is above all change of criteria of taste, concepts of beauty, and conceptions of form; however, it also includes the development of technical achievements and of craft processes and instruments, the change of media and of vehicles of understanding. Changes in one area usually bring changes in another in their wake, but not only can we not ascribe pride of place to the one or the other, we cannot even talk of a causal relationship between

them. A new style is neither the result of the influence of new formal principles on the way older technical means of representation are used, nor the result of the influence of new technical achievements on the nature of earlier fashionings. It is the result of the dialectic between immanently formal and "transcendentally" or "abstractly" technical components. For this reason questions like whether the change in style from Romanesque to Gothic architecture was the result of an achievement in building technology—especially in the progress in the solution of the problem which the arching over of larger internal spaces posed— or of a new vision of form, a new conception of the spatial division which from the beginning favored a striving upward and in relation to which Gothic architecture merely performed a service function, cannot be answered in one single unambiguous way. Technology and optics are, in such cases, inseparable but cannot be reduced to each other.

There are few phases of art history in which the dialectical development conditioned by the antithetical assumptions of change in style would come to light more clearly than in the transition from Romanesque to Gothic. In any event we can here study, as is often the case, the stylistic change in the fine arts better than in works of literature. The explanation for this lies on the one hand in the fact that the practice of fine arts which were related to craft remained throughout the whole of the Middle Ages linked to a unified professional class. As a result of this they appear more clearly classified in their purely stylistic development than the literary production, which moves constantly from one social stratum to another, developing erratically from the outset. On the other hand the spirit of the bourgeoisie, which informs the new society—whose stability had been rocked—asserts itself more rapidly and immediately in the fine arts than in literature, which is culturally more narrow and more prone to dilettantism. The decisive change in the Western spirit of this transitional period, the return from the kingdom of God to nature, from ultimate things to the world of creatures, takes place in painting and sculpture earlier and more clearly. The representation of the living and organic, which had lost their meaning and value since the time of classical antiquity, meets fewer obstacles than in other forms of art. The words of Thomas Aquinas, "God is pleased with all things, for each one of them agrees with his being," sound meanwhile like a watchword for the whole new naturalism.

However, just as Thomist philosophy does not stand for a direct and unconditional nominalism, so the interest in art in the concrete, individual things of experience is only one of the disparate moments which are involved in the dialectic of a contradictory world view. In

art, too, we find the expression—as we find it in a philosophy which tends toward nominalism and in this epoch's feeling for life, which gradually differentiates itself individualistically—of the conflict between a transcendental otherworldly God and an immanent divine power working in things themselves. It is true that the principles of feudal society with its class divisions are still reflected in the ontological and metaphysical order of precedence, which still holds good. However, the new productive forces, the workers freeing themselves from serfdom, the change of personal services into impersonal labor rewarded according to production, and the mechanization of production organized by the division of labor can no longer be reconciled with the old conditions of production. The liberalization which is connected with this, limited though its effects may be, achieves artistic expression, so that even the pettiest manifestations of existence begin to appear unique and remarkable in their individuality.

We can no more talk of a one-sided naturalism which changes the whole of reality into the sum of sensual perceptions than we can of the total replacement of feudal rule by a bourgeois order of life or of the total expulsion of the spiritual dictatorship of the Church by a secular culture unlinked to a clerical one. The dualism of the dominating view of the world and the dialectic of the forces at work are nowhere more clearly expressed than in the conflict between the universalism and the individualism of Gothic. Nature in art is no longer the mute, passive, material reality it formerly appeared to be, corresponding to the Judeo-Christian idea of an invisible spiritual creator and ruler of the world. It is no longer completely without spirit but already spiritually transparent, even if it is not filled with spirit. Gothic idealism is at once a naturalism concerned with forming its ideal spiritual forms empirically correctly—completely in accord with the structure of early capitalism, which finds its way out of feudalism by linking the emancipation of the individual worker with the repression of the working class. It also accords with the new philosophy, which no longer sets ideas above but into individual things, thus clinging to the ideas but at the same time permitting the individual facts of experience to assert themselves.

This limited nominalism—which, it is true, does not deny the influence of ideas in the formation of ideologies but does not separate them from the things of experience—is the basic formula of Gothic dualism, in which the social background of the epoch-making change unmistakably appears. The "realism" of the struggle about universals corresponded to an essentially undemocratic social order, a hierarchy in which only the leaders counted while the subordinates had no sort of freedom. In contrast, this nominalism corresponds to the gradual

dissolution of the authoritative forms of government and the preparation of a more democratic social order in antithesis to the principle of subordination and repression. Philosophical realism is the expression of a static, conservative, and traditionalist society; nominalism is the expression of a dynamic, progressive, liberal one. The change from the one to the other signifies the dawn of the right to advancement even for those who stand on the lowest rung of the social ladder.

The dialectic which is at work in the conflict of feudal and antifeudal forces, in scholasticism's struggle about universals, in the change of style from spiritualism to empiricism also appears in the contradictory solution of the compositional problems of Gothic. On the one hand it replaces the essentially ornamental order of Romanesque art, which follows the principle of regular arrangement. It replaces this with a form which is closer to classicism and directed toward concentration. On the other hand it splits up representation, which in Romanesque had been governed at least by an ornamental unity, into partial compositions. Individually these partial compositions conform more or less to the rules of classical subordination, but in their totality they often form an indiscriminate accumulation of episodes. Thus, in spite of the attempt to loosen the rigid and compact Romanesque style, the principle of an additive organization—which is as far from the unity of classical form as it is from the diversity of the naturalistic—dominates here as well. It is caught up in the same dialectic as the whole social being, religious life, and philosophical thought of the period, which between traditionalism and rationalism represents the historical transition.

The antagonism which dominates the economy, society, religion, and philosophy of this time and is expressed in the relationship between consumer and profit economy, feudalism and bourgeoisie, the ultramundane and the inner world, universalism and nominalism and which determines the relationship of both Gothic spiritualism to nature and Gothic to Romanesque also appears in the dialectical relationship between the rational and irrational elements of Gothic itself, especially of its architecture. The nineteenth century, which tried to explain Gothic architecture in terms of its own technological view of the world, called it a "calculating engineer's art" which was determined by the principle of the practical and useful and which attempted above all to express in its forms what was technically necessary and constructively possible. The representative theoreticians of the century attempted to derive the formal principles of the architecture, especially its dizzying verticalism and the complicated functionalism of its elements, from cross vaulting, that is, from a structural invention. A technical explanation of this sort seemed fully in accord with the universal rationalism

which was in the process of superseding the traditionalism of the earlier Middle Ages. It is, however, remarkable that, in spite of this, irrational chance—which sometimes hindered, sometimes hastened the progress of building—and everything which appears as a chance departure from the fundamental principles of the structures played such a large part and one which was destructive of the actual dialectical process.

In the history of the genesis of Gothic, people at first represented the invention of cross vaulting as the essential creative moment and the other forms of construction as the mere results of this technical achievement. Later the relationship was reversed: people regarded the formal idea of vertical segmentation as the primary force and its technical execution as the derived one, both in the history of development and aesthetically. The controversy between the rationalists and the irrationalists was basically concerned with the same antithesis which had already existed between the views of Gottfried Semper and Alois Riegl about the origin of art.[51] On one hand people wanted to derive artistic form from the given practical problem and its technical solution; on the other it was recognized and emphasized that the technical solution itself was a part of or a variation on the aesthetic-visual form. On both sides people committed the same error even though the premises were different. Viollet-le-Duc's technical approach was just as romantic as Ernst Gall's aesthetic one, with the difference that the one started out from total dependence, the other from the total freedom of artistic will.[52]

In reality, formal principles and technical procedure are just as dependent on each other in every phase of artistic development as the factors of the dialectical processes in general. The establishment of the one or the other as independent variables is always arbitrary and irrational, the result of "romantic" nondialectical thinking. Their historical or psychological succession is of no consequence for their real relationship to one another, but it is always dependent upon so many incalculable forces that it has to be regarded as "chance." It is practically just as possible that the "groin arose for purely technical reasons and that it was discovered afterward that it could be artistically exploited"[53] as that a formal aesthetic vision preceded the technical invention and that the architect in trying to find solutions was guided by the idea that was still unarticulated in practice and perhaps, for him, not entirely conscious. What alone seems beyond doubt is that there is a reciprocally constitutive relationship between the aesthetic forms and the technical means. The formal vision is apparently not only the seed and the technical means not just a vehicle. The one factor derives from the other, without one or the other's having pride of place in their

relationship or without the primary stimulus—which in a given case emanates from the one—remaining the decisive one.

Art can be regarded as a paradigm of dialectical structures and not only as regards the steps which follow one another historically and which correspond to one another and augment one another but also as regards the coherence of the system, which rests—in all its forms and phases—on the antagonism of two basic principles. On the one hand it forms a structure which in *l'art pour l'art* sense is pure form, that is, it remains disinterested and disengaged vis-à-vis real things and the problems of life and as a result of its indifference to every form of practice cannot be brought into a positive relationship with it. In antithesis to the isolation and the autonomy of its form, it represents an engagement filled with concrete content, a doctrine, a message, and a challenge to the individual and the social life. As heterogeneous as both elements of this pair of antitheses are, the one is unthinkable without the other. The concept of pure form only has real meaning with regard to a being indifferent to form. Its autonomy can only signify emancipation from every link to reality. On the other hand *engagement* signifies the ostentatious rejection of nonbinding variations and combinations of forms. Form and content suspend themselves while suspending each other. For just as art only has meaning in its being different, in its distinction from a formal reality, so it only achieves that relationship to reality upon which its existence depends—which even if it is negative cannot be neglected—by denying the relevance of form in itself.

11 Limits of Dialectic

For all the significance which dialectic may have in the history of art, its validity is not by any means unlimited. We could certainly agree with the notion that the problem which faces art at every turn in its history is to be regarded as the expression of an inner contradiction and a latent conflict if every new style represented a choice between conflicting possibilities and would take a course which deviated from the preceding movement. This is by no means always the case. Rococo, for example, in spite of the fact that it corresponds to the taste of a society which is different from the preceding one in many ways, represents the continuation of the baroque rather than its antithesis. And baroque itself can just as easily be regarded as the continuation of the Renaissance as it can its antithesis. The antithetical nature of successive styles often seems to belong much more to the categorical apparatus of art history, to the scheme of its conceptual formations, than to the nature of concrete artistic phenomena. Thus, the idea of whether consecutive stylistic movements can be embraced by the formula of a dialectic of a fundamental antitheticality depends on where we place the gaps in development. According, for instance, to the way we divide up sixteenth-century Italian art and separate the late Renaissance, early baroque, mannerism, and mature baroque from one another or whether we regard them as phases of a process of differentiation, the century presents the picture of a consistent development or a series of antithetical efforts, with crises, conflicts, and compromises.

The forms of thought, feeling, and action related to reality usually develop by means of contradictory relationships and attitudes, but never exclusively by way of such conflicts. The contradictions and their reconciliation, the negation and *Aufhebung* of the negated

positions, the conflict and its settlement by no means exhaust the forms of historical development. It would be just as pointless and unfounded to cut oneself off from the view that the developmental process is completed at one point and changes into a revolutionary movement as it would be to maintain that the process in its very being proceeds inflexibly, directly, without reversals and contrary changes, that is, as pure development. Nevertheless, what remains questionable is whether revolution or evolution decides the issue at a given time. If we regard the events as essentially innovations and changes of course, and if we see the influential happenings of social history in the rise and fall of classes, of the history of philosophy in the change of systems, of art history in the change in style and taste, then there is no doubt that dialectic appears as the decisive principle of the processes. This is particularly true for periods when crises threaten and in which dis-continuity of development, interruptions of its line, and deviations from the direction once taken are typical occurrences.

It is, however, not only continuous developments which follow a straight line and a gradual intensification of the dominant stylistic tendencies which are free from dialectic coefficients; radical changes in the history of style are also not always dialectically determined. The new principle which determines such a change does not necessarily appear as the antithesis of earlier stylistic principles, and the balancing of antithetical tendencies does not always represent a synthesis. The transition from one to the other may take place, for example, in the manner in which night replaces day, fire is extinguished by water, or poison is made harmless by an antidote. It is not necessary that there be a contradiction between them in the Hegelian sense. The dialectic of changing tendencies, constellations, and aims is nevertheless a fun-damental form of the historical process and in any case one to which the most extensive validity is to be ascribed. It forms the only—if not universally valid, at least unconditionally typical—law of historical processes. Everything which can otherwise be said about the historical process refers to single completely variable phenomena which cannot be schematized.

In spite of the fundamental resistance which dialectic encounters from the conservative representatives of scientific method, we some-times find in their works historical theoretical fragments broken off from the doctrine as a whole which are often accorded a broader—though tacit and apparently unconscious—recognition than they de-serve. Thus, people usually ascribe to successive styles quasi-dramatic roles by assuming that the development of art consists of continued problem solving and that the problems present themselves in the form of alternatives. People have no idea that in using this formula for the

art historical process they are using Hegel's "heresy" of the "dead dog." Even Wölfflin, in whose works different styles are not linked systematically but purely chronologically, conceives of them in relation to one another as theses and antitheses. If he sees the history of style as moving between alleged antitheses like classic and baroque and regards this as posing and solving a problem, he neglects the fact that there is also a change in the history of art which does not involve problems and that the solutions of problems often permit a choice between more than two possibilities. The fork in the road in a situation demanding a critical decision may all too frequently lead into more than two directions. At the end of Greek antiquity the road is open for the formal classicism of the epigones as well as for the rhetorical baroque of the noble-aristocratic circles and for the trivial art of the lower classes. After the heyday of Gothic there follow different movements which are not subsumed in a mere dualism, that of the formalism of "international Gothic," of the emotionalism of the bourgeois view of art, and of the early Renaissance oriented toward classicism. The late Renaissance hovers between a classisistic academism, intellectual mannerism, and theatrical baroque. A dialectic restricted to alternatives appears next to the diversity of these ramifications as a dubious simplification of the historical facts.

Naive critics of dialectic often attack it for evaluating the same sociohistorical conditions both positively and negatively, for judging an epoch's stylistically similar artistic products in different ways, and for ascribing contradictory tendencies of style to the same society. They not only forget that one society's view of art is always part of a larger context which is differentiated according to station but also overlook the fact that ambivalence of tendencies and ambiguity of judgments is common to most human modes of behavior. Like the opponents of dialectical art criticism, people have made fun of the contradictory motivation of abnormal repressions, blunders, and neuroses without understanding that psychoanalysis recognized a pathological condition in the exaggeration of mental reactions, irrespective of whether these affected the particular stiumlus positively or negatively. They could only be explained as the object of an ambivalent interpretation, just as the Italian novella of the fourteenth and fifteenth centuries was properly understood as farce for the entertainment-seeking upper classes and as a weapon in the class struggle of the rising bourgeoisie. Its essence is contained in this ambiguity, just as the explanation of neurosis is contained in the ambivalence of mental attitudes. In the same way the crisis of the Greek aristocratic state called forth both tragedy and comedy, the collapse of feudalism bourgeois sentimentality and cynicism, the end of the Renaissance mannerism—

which was intellectually exclusive—and both rhetorical court art and the sentimental mass art of the baroque.

Hegel, for whom a thing meant itself and its opposite at the same time, found nothing puzzling about such contradictory functions and interpretations of the same historical phenomena. Marx on the other hand struggled all his life with the difficulty of producing the opposite from the thing itself. He was not struggling with mere chimeras, and it is too easy if his followers dismiss those who doubt the validity of dialectic simply by saying that they do not think dialectically. Contradictory attitudes to the same set of facts are not always dialectically conditioned, but are often merely absurd and thus rationally unacceptable. The suspension of formal logic is simply not the same as the suspension of rationalism; dialectic has its own rationality. Works of art and movements can be interpreted differently, but phenomena like naturalism and formalism have essentially a particular meaning which cannot be confused, however differently their functions may take shape with regard to the circumstances in which they are involved. We have a false concept of dialectic if we confuse the entity and the function of a thing and if we conclude from the fact that functions change that things and forms have no essential individual character.

Neurosis is inconsequential. Neither love nor hate is neurotic of itself, but their amalgam, love-hate, is. The ambivalence of tendencies is the psychological counterpart of dialectic, the psychological equivalent of the dialectically contradictory interpretation of cultural structures. It is the product of the simultaneous affirmation and denial of stimuli, and the expression of inconsistent aspects with regard to them, just as dialectic is the expression of inconsistent actions within a state of affairs having regard to one and the same period. The ambiguity of artistic phenomena is the result of the fact not that their ambiguity cannot be grasped or that they are now understood, now misunderstood, but that they often correspond to different ideologies and serve different ends.

Dialectical negation, which consists of struggling against forms of economy and government, political aims and institutions, the rejection of standards of value and norms, assumes the same order of categories of thought which is at the base of the simultaneous affirmation of these states of affairs, principles, and evaluations. The opponents of a system take their weapons first from the arsenal of their opponents, that is, from the defenders of the system they are opposing. The artist uses the same language, irrespective of whether he accepts or rejects the given social situation, whether he agrees with and propagates or rejects the norms and values which correspond to it, whether he criticizes it or tries to disqualify it. Since the revolutionary period, people both

as capitalists and as socialists have been creatures of bourgeois society. They have used the same forms of thought and speech to judge society both negatively and positively. Why should we not, then, interpret the same artistic forms in a different sense?

Dialectic, especially Hegel's, never completely sloughed off the heritage of the philosophy of identities; it remained the source of its falsest dogmas. The most well-known and the most fundamental of these dogmas for the Hegelian system was that of the identity of "true" and "real." The doctrine of the "reasonableness of everything which exists" which was expressed in the *Grundlinien der Philosophie des Rechts* [*Principles of the Philosophy of Right*] by the well-known formula "what is reasonable is real, what is real reasonable" is the sharpest interpretation of dialectic amalgamated with the philosophy of identities. It reverses the doctrine—unless we interpret it in the arbitrary sense as meaning that every stage of development of being has such a corresponding reversible reason, which was Marx's opinion. Reality, however, is neither reasonable nor unreasonable, but alien to reason; it either corresponds to it or contradicts it, according to the dialectical relationship into which it is brought with it.

It is well known that an objectivity is unthinkable without corresponding categories of reason, just as, without an objective substratum, it would dissolve into nothing in every philosophy which was not purely spiritualist. Their interdependence does not, however, in any way imply their identity. Interdependence free from all identity is more evident in the subject-object relationship of statements and artifacts than in the relationship of thing and reason, and the fundamental mistake of Hegelian dialectic in which identity of the subjective formation and the objective form plays such a large part is more momentous here precisely because it is less apparent.

It is a mere play upon words to explain subject and object as being so little different that the one always finally reveals itself to be the other. It is probably right that the content of an object is objectivized subjective thinking and that the subject itself becomes an object when it observes itself involved in its own activity and when it conceives of itself as something which is objectively existent. The statement, however, that they must therefore be regarded as identical makes sheer nonsense of the insight in cognitive theory which we have gained since the surmounting of "naive realism" which states that we move in the irreducible duality of a subject-object world. The division between subjectivity and objectivity proceeds in the ego itself, and the individual first becomes conscious of his existence when he is torn apart into a subjective and an objective factor. This still does not, however, change objective objectivity into a mere subjective category and does not strip

"consciousness" of its anthropomorphic subjectivity, which cannot be reduced to mere objectivity no matter how generalized and reduced it is. The inseparability of the general and the particular in every form of experience and particularly in the aesthetic experience does not make the thesis of the identity of antitheses in the Hegelian sense more obvious. To think of the one without the other may appear impossible; the two may actually involve each other, but their identity still remains unproved.

Even the theory of the spontaneous movement of mind and society—the doctrine, that is, that the origin of historical processes consists in the inner contradictions of phenomena—is still a remnant of the philosophy of identities and belongs with its idea of immanence to the shortcomings of the classical form of dialectic. The movement of economy in Marx also presents a problematical characteristic in that, like self-realization of the spirit for Hegel, it assumes a sort of *perpetuum mobile* of development. Even if dialectic were to correspond to a generally accepted law which governed the whole of history—which is not the case—it would be unthinkable as spontaneous motion. For a movement in the historical sense happens only where a particular need asserts itself. Such a need, however, conditions a division of the subject and the object.

The explanation of dialectic as spontaneous motion comes from the wish to establish it as a "first principle." As such, however, it "preserves" itself, since every dialectic begins with the antithesis of two principles, a stimulus and an opposition, and as long as the process exists it continues to be bilaterally conditioned. It is a nonimmanent principle beyond systematization which sets it in motion and keeps it in motion. The spontaneous motion of history would rationally assume just as inconceivable a spontaneity as artistic inspiration.

Even the concept of the change of a particular quantity into a new quality is only a metaphorical form of the spontaneous motion of the substratum of development. It is right that individual atoms begin to form a pile only when there is a given number of them, just as a certain number of people are necessary for individuals to change into a social group, and there is no doubt that the new quality—the reality sui generis of the whole which thus arises—was not present in the individual components of the pile or the group and is not the mere sum of its component parts. What we understand by dialectical change does not exactly correspond to the process which is accomplished with the genesis of a new quality in the social sphere. As different as the characteristic of a social group may be from that of its individual members, it arises only because the individual is from the outset determined to become socialized and the principle of the social already adheres to

him as an individual. It is here a question not of a "turning" of the individual into society, but of a process in which something socially unarticulated becomes an individual and a group at the same time. This certainty does not happen as spontaneous motion, but in part as individuation, in part as integration under the influence of external conditions of existence. The dialectical process begins only when individual and society face each other; their differentiation is thus not at first the result of a dialectical development.

As far as a change of its substratum through spontaneous motion should come about, its concept is unsuited to the historical dialectical process. Dialectical movement is, in contrast to biological development, discontinuous. The transition from thesis to antithesis, from contradiction to reconciliation, from argument to neutralization, involves at some point an unheralded leap. This leap is just as irreconcilable with the spontaneous immanent change of a measurable quantity into an incommensurable quality as it is with the metamorphosis of spirit and material into one another. The only adequate and clear form in which the dialectical movement from one stage to another can be represented is with reference to the gaps in the chain of mediations. It is already expressed in that axiom of the dialectical doctrine which states that every movement which corresponds to it begins with a negation. And since, in Hegel's sense, every real movement is a dialectical one, he and his disciples see the origin of every historical process and every process of thought in a negation. It is probably right that most historical phenomena lead via their negation and their antithesis to further and higher forms of development. However, the doctrine that negation first has to destroy before it is itself destroyed is a dramatizing mystification which simplifies and often distorts the true processes. To assume with Hegel that a state is expelled and replaced and—like the bud by the blossom—"refuted" is sheer logicizing and fetishistic rationalism. Reality is in fact of itself no more logical than a logical operation is ontological.

If we understand by scientific truth an unambiguous ascertaimment of facts, a statement which corresponds to the principles of the logical proposition of contradiction and the *tertium non datur*, dialectic cannot lay claim to any scientific basis. In the formal logical sense what is scientific is only an investigation or an explanation which leads to the same results under the same experimental conditions. Dialectic neither attempts nor is capable of meeting this demand. On the contrary it is part of its essence that the results it arrives at can be very different, even given the same external assumptions in the same natural milieu in the same period. A dialectically conditioned set of facts consists from the beginning of different, even contradictory, elements. The

concept of baroque embraces, in certain circumstances—especially in French baroque of the seventeenth century—characteristics which are alien to the style and are even classical. The contradiction between naturalism and formalism can, as in mannerist art, prove to be stylistically of no consequence, and the naturalistic Breughel may from time to time seem to be no less formalistic than the affected Parmigianino. To assert that such contrasts are founded in logic would be just as senseless as to declare that in reality they cannot be demonstrated and that they represent mere inventions or perverse distortions of simple, unambiguous facts.

Hegel's doctrine that every determination is essentially contradictory and thus contains the negation of itself—since the predicate, by declaring what a thing is, states at the same time what it is not—has a purely formal significance which does not affect the actual nature of the object in question. Marx criticized Hegel most sharply for this logical formalism, and he found, in the effort to derive reality from the idea, the paradigm for what he called mystification.

The axiom of Hegelian dialectic that every concept is accompanied by its antithesis leads to a piling up of antitheses and to an inundation of the theory with allegedly "dialectical" antinomies. As such, not only are complementary and alternative concepts adduced which imply opposite though not contradictory phenomena, not only unambiguous and pregnant ideas like right and left, large and small, finite and infinite which are not at all in a state of tension or conflict with one another, but also ideas like essence and being, law and morality, family and bourgeois society which are not even opposed to one another. Not even Marx is completely free from the weakness of the insatiability for antitheses and contradictions which he accuses Hegel and Proudhon of. He, too, seems to have more interest in the contradictions than in their resolution, something for which he particularly chides Proudhon.

We can justly assert that contradictory points of view and interpretations are often revealing for the understanding of historical processes; indeed, they are often indispensable, but they scarcely sustain the notion that they invalidate the proposition of contradiction in formal logic or that we have to accept their contradictions without more ado. It is rather that in every case that arises they pose a problem which is to be solved and a quality which has to be justified. Kant was still of the opinion that reason, when it emancipates itself from experience, ends up in a dialectic of irresoluble contradictions. Hegel first states not only that from the beginning contradictions move within the limit of reason but precisely that they set in motion reality which is otherwise static and have the same essence as reality caught up in movement, growth, and development. Even Marx apparently believes in the con-

stant mobility of the dialectically conditioned historico-social world, but he thinks he has found the motive force of the movement in a direction which is opposed to the Hegelian tendency.

The decisive moments of classical dialectic—Hegelian as well as Marxist—negation and the negation of negation, disharmony and harmony restored, discarding and *Aufhebung,* are aimed at the realization of the totality of human existence alienated and torn apart in the course of history, the rebirth of the "whole man," who has fallen victim to historical culture. The replacement of the fragmentary and atomized existence which mankind has led since the end of the mist-enshrouded natural condition and the beginning of problematic culture as it is known to us, by a unified and organically coherent existence, this ideal of an unalterable Rousseauism in spite of all its questionability is the ideal of all the dialectic of reality which embraces theory and practice. It is not a question for this dialectic of acquiring a philosophy as a key—central and global—science, but above all and time and again of the struggle against alienation in that sense where Hegel and Marx do not disagree.

We cannot perceive or grasp in any theoretical form the "totality" of truth, of perception, of society as a community of people, the unified context of their needs, norms, inclinations, abilities, and products. Even dialectic only expresses the will to grasp this totality. The extensive totality of global knowledge always remains incomplete; dialectical thought expresses merely the need of perception for supplementation and the attempt to achieve an integrated view of the world, not the possession of it or the certain road to its achievement. The precedence which dialectic gives to the category of totality over partial aspects of knowledge is justified by the fact that the individual moments of all human attitudes point beyond themselves and are directed toward accomplishment, whether or not this can be achieved. True, dialectic extends the knowledge of the contexts in which man, socialized and laden with cultural tasks, is involved, but the totality of relationships is still denied to it.

The characteristic ascribed to "dialectical totality" by orthodox Marxism, that its individual moments "bear within themselves the structure of the whole"[54] is in reality only shown in works of art. The individual components are of the same nature as their totality and unity only in a work of art. Only here does the same life pulse in their veins as in the organism of which they are members. The inherence of totality in the parts, which are designated in the present work as different from unachievable "extensive totality," cannot be found in any theoretical sense structure. It is the sign that distinguishes forms of art most significantly and most deeply from all other structures.

The concept of totality has, however, become the *idée fixe* and the idol of dialectical materialism without being subjected to any distinction of this sort. In the desperate struggle against alienation which the division of labor, the specialization of products, the depersonalization of the workers, and the atomization of society have brought in their train, the ideal of uninterrupted totality became the quintessence of the values which had been destroyed and an exemplum for that fetishization whose mechanism was precisely what Marxist theory pitilessly revealed.

Yet, to question totality, in spite of its mystification, as a model of the practice, the thought, of existence worthy of a human being, as the actual goal of philosophy, and to fail to recognize that philosophy only grew out of the sorrow over the loss of a unified and total picture of the world and the atomization and incoherence of existence, bears witness to a lack of sense for the nature and function of philosophy in general. However, it cannot be denied that the expression has become a mere cliché in the jargon of dialectic. Furthermore, even if we remain fully conscious of the meaning of the matter, we may become just as tired of the word as we are, for example, of the perpetual complaint about "alienation," which finally had to do service for everything repellent in the life of society. The misused word discredited the thing.

Nothing remained completely secure in the linguistic acrobatics of the dialecticians intoxicated with Hegel's virtuosity except the fetishistic terminology itself, which revolved around the magical solutions of negation, *Aufhebung*, identity, alienation, and totality. There was and still is a "word-magic"[55] at work which scorns to examine concepts whose usefulness counts as sacrosanct. The sluggish entity of words prevents thought from coming into contact with the facts. We may not think of excesses of this sort if we wish to listen to the all too ambitious Georges Gurvitch, who inscribed the Dantesque motto "let no one enter here who is not a dialectician"[56] on the gable of the house "of the sciences of man." Observance of Marx's words "the weapon of criticism cannot replace the criticism of weapons"[57] could prevent the exaltation of such pretensions. The validity of dialectic is not unlimited, even if its significance does not suffer any damage by the number of cases in which it does not prove itself.

Part Four

En Route from Author to Public

12 Address and Discussion

Art history, like art criticism—the doctrine of artistic genres and techniques—just like even the psychology and sociology of art, views and interprets works mainly from the point of view of the producer and only supplementarily from the point of view of the recipient. In spite of the fact that the object of artistic experience is the joint achievement of author and public no matter how devotedly the reader, listener, or spectator empathizes with the work he cannot be equated or brought completely into harmony with the creator of the work. It is not only a question of their being separate persons with different intentions and emotions even though they are similar people in their feeling for life and their attitude to society, but also that they are subjects who function differently and who have different aesthetic objectifications. Just as the aesthetician, the critic, or the historian—however finely developed their sensibilities, however deep their sympathy for the fate, tendencies, and idiosyncrasies of the author, however much they incline to live, love, and suffer with him—can never be confused with the author, so the novel he writes, the composition which is performed, is not the one which is read or the one the composer composed or had in mind. However insignificant the contribution may be which the reader, listener, or spectator makes objectively to the received work, the artist's creation is shifted into another sphere or onto another level when it is simultaneously or subsequently supplemented by the recipient. The shift may be completely inconsequential from the point of view of the theory or history of art; nevertheless, it results in one of the most decisive changes which any work of art undergoes. In the identity of all elements of its form and content, its function, its meaning, and its purpose change in the life of the subjects in question.

429

Art seems, in the main, to be determined by a need for expression and an urge to release tension, but it is essentially communication and information and can be regarded as successful only when the intended communication and understanding are achieved, but this seldom happens in accord with the original intention. Both the act of offering and that of receiving involve the cooperation and interaction of two subjects—the productive and the receptive: both, however, represent peculiar and unmistakable functions. Their difference consists, however, not simply in the fact that the artist is actually the active, the recipient the passive partner. If this were the case, the public for art would receive the proffered work unchanged and the artistic experience would be nothing but reconstruction, which it never is entirely and is less and less so as historical distance increases.

The assumption of the existence of passive and indifferent recipients corresponds to the legend of literature as the mother tongue of mankind. But in reality no poet simply addresses mankind, and he no more writes for any old reader than a reader reads without making a choice; but each one makes certain demands upon his reading matter, even if they are critically only slightly differentiated. The task of the sociology of art is to analyze and interpret the strata which the artist has in mind when he creates his work. It is also concerned with the sort of works which the public finds pleasing or satisfying, how the works are manipulated in order to appeal to the public, and how a stratum of society preserves or changes its identity under the influence of the works proffered to it. In short, the drama in which the sociology of art is involved concerns the expectations and fulfillments of the processes which play their several parts in it.

Books which are not read do not exist sociologically, just as a musical score which is not played or which is not heard by the inner ear is not music but merely notes. The artistic process consists of address and discussion; it has no ontological quality as reverie or unreciprocated monologue. A printed text achieves aesthetic reality only when it is read; unread, it remains a series of hieroglyphics.

The received work of art is in no way identical to what is produced, for the mere reason that the ways of the creator and the recipient—even if they cross—lead in opposite directions. The artist proceeds from life but is moved by one or another of its aspects, problems, or contradictions to create autonomous works which depart from life. The spectator starts off with independent works and seeks in them an explanation for, and an illumination of, life and the palliation of his own lot in life. The painter thinks of a particular painting when he paints a landscape, the poet of the linguistic music of a poem when he describes an experience, the composer of the complex of rhythms,

harmonies, and motifs when he tries to express his feelings. The spectator, reader, or listener often knows hardly anything of a work as an organized structure and thinks only of the beautiful landscape, the unusual experience, or the emotional upheaval which served the artistic creation as the opportunity, motive, or excuse. The artist and the public do not speak the same language from the beginning; the work of art has to be translated into a specific idiom in order to become generally comprehensible and palatable to most people. The gap which exists right from the beginning between the productive and the receptive subject grows not only with the distance in time which separates them but also with the depth, complexity, and individuality of the works. The immediacy and the breadth of their effect are in inverse proportion to the degree to which they are differentiated. The more exigent and sublimated the means they use, the more indispensable the vehicles of communication between an unconciliatory, even though highly ambitious, public.

However a work of art is constituted, it passes as a general rule through many hands before it finally reaches the consumers from the producer. Sensibility and associative ability, public taste and aesthetic discernment are influenced by a long series of intermediaries, interpreters, critics, teachers, and connoisseurs before some sort of standards and criteria of artistic worth are developed in relation to works whose quality is still to be determined but which are academically unvalidated and questionable in the public mind. The important role which is played by aesthetically irrelevant forces in this process—forces like snobbery, fashion, pseudoculture, and fear of lagging behind the arbiters of taste—is obvious. The more sharp the change of one artistic trend into another and the more newfangled the formal language of the trend which is taking place, the more significant the function of the intermediaries between author and public, between production and consumption and the cognoscenti and the multitudes who are ignorant of the new mode of expression. The lay public has first to be taught the elements of the new language before they can understand what is being talked about. The cultural monopoly which is tied to socio-economic privileges is not sacrificed without a struggle. Culture which is becoming democratic and the criticism of traditional values are the key to the liberation of the practice of art and language from the prison of rigidity and lack of expression. Yet this key does not open all doors and certainly not without wanting some reward. To the same extent that the intermediaries provide access to works which had previously been unapproachable, so those who have been taught by them often depart from the original and normative meanings of the works. The ostensible significance of works of a lost past is usually purchased at

the price of gross misunderstandings. Instead of the concept of a real artistic volition, we get the reflex, ruptured in many ways, of a historical context which cannot be reconstructed in its true form. Even if the reconstruction were to succeed as often as not, there would still be no more reliable a guarantee of the correct interpretation of an art which has ceased to be topical than there is, for example, of the apt prognosis of an art which has yet to be produced.

Goethe, as we know, declared that "a book which has had a great effect can actually no longer be criticized."[1] If what he understood by this was that stage at which a work of art exists after it has moved from the sphere of its originator into a public social area, then no work can be properly judged, or at least interpreted, in its author's sense. However, while it loses its original meaning with respect to the person of its originator or his public, it achieves another posthumous and anonymous condition compared with which the original authentic meaning threatens to become a mere illusion or an unreal ideal. According to the original artistic intention every effect of the functions which relate to the artist but which have been snatched from him may appear accidental and inadequate. A work, however, which is incapable of exercising any effect apart from the individual creative intention has no objective aesthetic quality.

In the sense that an authentic work of art is not just expression but also communication, it is also not just address but a discussion. Nobody talks to himself in verse, no one experiences nature in the form of paintings without wishing to make then visible to others. If we maintain that the artist is communicating something when he expresses himself, we must mean that he is speaking to someone when he discloses himself. Every artistic expression, every evocative depiction of ideas, feelings, and aims is directed at an actual or hypothetical listener or spectator. Even statements of an apparently purely intimate nature which seem to concern and give solace to only the speaker are by no means total monologues, but assume the presence of at least an ideal witness or an anonymous addressee. The "inner monologue" corresponds to the spiritual state of a persona of the writer, or to a role which he plays: he, the writer as such, does not speak in a monologue.

Artistic production and reception are interdependent, not only because the "I" who is talking addresses itself to a "you" but also because the forms of organization and the sense contents of the language have their reception in view from the beginning and move in the conceptual forms of both the receptive and the productive subject. The interaction between these two means not only that the creative act is in a state of constant change under the influence of the recipient's attitude but also that the audience's reaction is constantly modified under the influence

of the presentation; the spectators at the end of a play or the listeners at the end of a concert are not the same as they were at the beginning.

Both phases of the artistic process are socially conditioned because of the "I" and "you" which operate with respect to each other; every "I" becomes the object of a "you" and every participant acquires meaning and purpose through his relationship to a vis-à-vis. Productive and receptive behavior assume spontaneity and sensibility: on one hand ideas and feelings can be communicated; on the other recipients are able to resonate, to reconstruct, empathize, and come to terms with each other by means of a common formal language. The discovery of such a language is a fundamental condition of art.

The social character of art, however, is expressed not only by the fact that the artist uses a "language" the elements of which he takes over from and shares with others but also by the fact that his language must be subjected not only to the rules of grammar but also to stylistic principles, the standards of a more or less generally acceptable taste, if it is to achieve its end. This dependence remains undiminished no matter to what degree the recipients are educated by the producers and no matter to what degree we imagine them to interact. Nothing embodies the power of social forces for the artist so briskly and so impressively as public taste, which he may well defy but whose influence he cannot escape. There is no form of autonomy which can resist it, except at best the dialectical impulse of artistic creativity. Every work, however idiosyncratic and innovative, attaches itself more or less to prevailing taste, which also in fact changes to some extent with every new work.

The general rule becomes the oppressive bond of practice; the rule is, however, the productive principle of practice. A production first comes about when the possible use of the product has already become apparent. As Marx says, "Consumption creates the urge to production."[2] Thus, consumption forms not merely a regulatory or modifying element but rather one that is constitutive of the productive process. In this sense the forms of languages are not ready-made to serve expression; to use Marxist terminology once again, "Production creates the producer"[3] The origin of address like that of listening is the need for communication, the wish to link one subject with another.

The latest development, which puts into question not only one or another artistic trend but the whole of art, and which in the final analysis recognizes as art what counts as art, confirms the primacy of reception over production in the Marxist phenomenological—even if not in the positivistic psychological—sense. In one word, art is now what is consumed as art.

Language does not express the content of consciousness which is determined by language; this arises *with* language if not *from* it. The content and structure of expression develop *pari passu* and are just as indissolubly linked, though just as irreducible to each other, as being and consciousness, material and spirit, sensual perception and categorical apparatus. Language includes simultaneously the principle of subjectivity and objectivity, and art is, as a means of expression, as much subjectively organized reality, articulated spiritual content, and artifact as it is objective quality, *trouvaille*, and natural sound. Like every objectively communicable state of mind, every artistic complex of consciousness is something nonlinguistic, unthinkable, unconscious which has become linguistically expressible.

The work of art may have its origin in the need for self-assertion and self-defense, in the protest against injustice, or in sorrow over the human lot; it may proceed from the pride of the fluent, who can "relate what they suffer," or it may resound in the joy of "Seid umschlungen Millionen." It is and remains an evocation of ideas and feelings, a call to proclaim and act, an appeal to come to terms with the self and the world and to make peace. Its meaning and its being consist in the evocative. Whether it challenges, woos, persuades, or takes by surprise it persists in the form of an address, accusation, or speech for the defense.

Art has its origin, as the young Marx says of language in general, in the need for intercourse with other people. In art probably for the first time the phenomenon of consciousness is objectified, perhaps before the development of an articulated language, in a way which is perceptible for the speaker and for other people. In his *Deutsche Ideologie*, he says, "Language is as old as consciousness; language *is* the practical, actual consciousness existing even for other people, and language comes into being, like consciousness, only out of the need, the necessity for intercourse with other people."[4] Art is accordingly in any case a variety, if not a prototype, of language.

In the past, most works of art and the most important ones had their origin in express commissions and were accordingly at least indirect allocation. Works of fine art hardly ever came about in any other way up to the time of the Renaissance. And composers like Bach and his contemporaries, even his successors, composed their works as commissions, or so as to fulfill their official duties as "spokesmen." Haydn wrote even his last great masses in order to fulfill the terms of his contract with Prince Esterhazy. Mozart worked for the most part under the pressure of often insupportable conditions and of the task of producing pieces for his own concerts or else of meeting the wishes of all sorts of singers and instrumentalists. Even Brahms in the last years of

his creative work inspired by his friendship with the clarinettist Richard Mühfeld made himself an interpreter in what for him, as a solo instrument, was a new medium.

Many of the most important problems of art revolve around the connection of the autonomy of aesthetic forms with the everyday practice of the subjects who receive works of art. As true as it is that every authentic experience of art includes the decisive experiences, interests, and aims of the one experiencing it, it would be wrong to expect or demand that the life of the recipients—indeed, of the artistically most sophisticated and critical—should be oriented to art. Love and understanding of art do not mean the wish that life should revolve around it; on the contrary, art should revolve around life. It is senseless and useless to complain that the "sphere of feeling" only begins when "business time" ends; yet this is the rule. However, art is not intended for aesthetes but for practical people who have an aesthetic sense and feeling for quality. The evil begins when we feel the distance of our own professional life from an aesthetic mode of living, judged by formalistic criteria of beauty, as something which we lack. While we wish to continue our practically useful existence undisturbed, we demand and patronize an art which is as far removed as possible from everyday things so that we are not reminded in the one sphere of the other and so that we can recuperate in art from life and in life from the all too demanding forms of art.

The statement of Walter Benjamin that "concern for the recipients" proves unfruitful for the perception of a work of art and that a poem does not concern the reader nor a picture the beholder nor a musical composition the listener[5] is presupposed by the assumption that the essential thing in a poem or a work of art in general is neither "communication" nor "statement." Certainly what Benjamin calls "the ineffable, arcane" belongs to its essence; what he does not mention, however, is the fact that the ineffable and arcane in art consist not only in what he calls "form."[6] The whole thought process which concerns the problem of artistic communication revolves around the question of the translation of poetic works and seeks to emphasize that the criterion of a good translation lies in the grasp of the mood, the music of the language, the undertones, in a word the "transparency" of that "secret" which is not expressed in any element of the content. The work of art must from the beginning be conceived of as something like a translation, the indirect representation of an objectivity already captured in artistic categories, so that it can be dissolved in an unequivocal concept of form which is without tension and which is of itself nondialectical.

The artist's effort is directed toward solving the problem of finding an immediate and comprehensible form for the expression of his experiences and his feelings. His feelings and his visions become artistically useful material when they move from the sphere of sheer inwardness and change from amorphous fluid moods and inclinations into articulated receptive stimuli. The most primitive and embryonic artistic idea is already concerned with communication, and every comprehensible communication presupposes for its part a more or less developed system of signs which is the common property of a social group of media of expression. The media are conditioned by the urge to communicate, the communication by the means of expression available.

Now, even if we can maintain that all art is a sort of language, we can in no way declare that a structure is "artistic" because it is linguistic, which is the basis of Heidegger's thesis that all art is essentially poetic.[7] Language is not literature, he says, "because it is protopoetry (*Urpoesie*), but literature happens in language because this preserves the original essence of poetry."[8] The other arts are just as "linguistic," communicative, and evocative as poetry, and this is no more the mother tongue of the human race than the other forms of art, none of which conceals within itself anything which is more or less profound, unfathomable, unsaid, and inexpressible than poetry.

In poetry, communication means, as it does in art in general, the establishment of understanding between the productive and the receptive subject. It signifies the sum of the vehicles which ply between works of art and their reception—that is, "mediation"—but only in the sense in which a sense content which is already artistically articulated is transferred to an artistically blank sheet, not, however, in the more radical objectivizing sense in which mediation means that a still completely unarticulated material is formulated in certain categories of reason and in specific objectivities which correspond to them. Thus, it does not correspond to that principle which in the theory of historical materialism links infrastructure with superstructure, and seems to replace the leap between being and consciousness, material and spirit, nature and culture and to bridge the gap between them. When the artistic expression is communicated, the aesthetically constitutive mediation is already complete. Being and material have become significant and culture bearing; what remains to be communicated is the completed artistic structure. It is only the individual works which are now in need of further hermeneutic mediation.

A work of art is a dialectical structure not only as content that has been formed, not only as address which a "you" who is addressed brings into play alongside the "I" of the speaker, but also—and, indeed,

primarily—as an utterance which develops by continued interaction between author and audience. As Hegel says, "A work is not *for itself* but *for us*, for a public which looks on and enjoys . . . a colloquy with everyone who stands in front of it."⁹ "In the wildernesses of the southern forests the bright, highly colored feathers of birds shine unseen, their song sounds out unheard, the torch thistle which blooms for only one night withers without being admired. . . . The work of art, however" he says in another place in the *Ästhetik*, "is not as free of itself, but is essentially a question, an address to the echoing breast, a call to souls and spirits."¹⁰

The question demands an answer and is put in the expectation of one. The persons addressed by the artist are not merely recipients, mute and passive listeners, or spectators, but partners in a dialogue. It is true that their voice is heard only indirectly through that of the artist. Nonetheless, besides the primary contributions, the work contains a further series of contributions which, as an objectivity reacting to the spontaneous subjectivity of the artist, lead to the development of a structure which is unmistakably that of a dialogue. The public plays an anonymous and concealed role as a partner in the developing dialogue; its part in the artistic process becomes perceptible only when this has been completed and the factors of reception have become analyzable. In the creative process, however, the artist himself always has the expected reception of his product in front of him—whether it be judged correctly or incorrectly. The construction of his works takes place as the constant wooing of public assent with the anticipation of objections and the estimation of the possible echo on the part of the great unknown which makes itself heard during the act of creation as the "inner voice" of the artist struggling for success.

The recipient only emerges immediately from this indirect function when the receptive act has been accomplished. Only in the form of a concrete experience of art, of understanding or misunderstanding, of assent or rejection, of the subsequent accomplishment which either does or does not happen, does the dialectical discussion between the artist who is revealing himself and the recipient who is making himself audible lead to a final answer to the question posed by the work. The artist has said all he has to say and remains silent: the recipient starts to speak, and the further history of the work, in which the artist plays the anonymous and indirect role, takes place in the forms of reception. It is in this subsequently developing life of works of art that the largest part of art historical development is contained.

In any case, it is not only pure artistic volition, the structure totally sought for by the artist, imagined by him, and merely completed "on the inside," but also the objectively unreceived work which is without

concrete sociological reality. To communicate oneself and render oneself comprehensible is only the first step in the complex sociological and artistic process; it is only the interaction of the work and the recipient that testifies to its completion. Only when the artist stands face to face with a real receptive subject who expresses himself unequivocally and the artist becomes the witness of the reaction of a spectator or listener who is experiencing his work and who paves the way for a reciprocal dynamic process between the two does what was purely a psychological process and a mere technical accomplishment change into a dialectical, historico-sociological happening. The metamorphosis achieves its significance through the fact that the mere coexistence of artist and public, work and effect, artistic achievement and the experience of art in no way guarantees reciprocal dependence and does not even ensure that they will correspond to each other in any significant way. The decisive change takes place when works of art as the substrata of receptive experiences acquire symptoms which they did not possess as mere supporters of creative efforts. The characteristics of the products which appear in this manner are so significant that we should have to look for many of the most fundamental principles of the sociology of art in the aesthetic effect, the attitude of the public toward artistic offerings, and the meaning which the works acquire en route to their reception if we did not already know, as Marx taught, that production presupposes consumption and that the common social structure of artist and public is not just the result but rather the origin of that effect.

As long as art expresses nothing but a purely subjective formal vision or an emotional stirring and only exists in the form of a confession and the release from an inner pressure, it is only concerned with sociology inasmuch as none of these functions is accomplished in a totally private or intimate way, but each presupposes a concrete or imaginary witness. The process which develops between speaker and listener is not first the result but already the source both of the act of creation and of the experience of reception and runs its course from the beginning—irrespective of whether an actual "dialogue" takes place as a happening involving two participants. The criterion of the sociological nature of artistic phenomena consists not only of the externalization and the sensual objectivization of inner visions and of sensations which are restricted to individuals, but also of the participation of others in the creative impulse and in the act of objectivization of subjective processes. It is apparently a question not of the externalization of experiences, but rather of the involvement of passive witnesses in the process of creation.

"The positive activity on the side of an apparently merely passive element" in relationships like those between artists and recipients was already observed by Georg Simmel, and he stated that "the speaker who faces a meeting and the teacher who faces a class seem to be the only leader, the one who is for the moment in charge. Yet everyone who has found himself in this situation senses the determining and guiding reaction of the apparently merely receptive mass which is being guided by him. . . . All leaders are led . . . this can be most crassly observed in the case of the journalist, who gives content and direction to the opinions of a mute mass, but who has in the process to listen, combine, and sense what the crowd's actual tendencies are, what they wish to hear, what they want confirmed, where they want to be led. While the public seems to be entirely subject to him, he is in reality equally subject to them. A highly complex interaction—whose mutually spontaneous forces certainly take very different forms—is here concealed under the appearance of the pure superiority of the one element over the passive readiness to be led of the other."[11]

The reciprocal effect to which Simmel refers is obviously a dialectical one, in which it is not an active subject and a passive object which are involved but two active principles. Not only the recipient of the impression changes in the course of the effect which is made upon him, but also the activity which is directed toward him develops and differentiates itself in the same measure and sense as the opposition it encounters. In this way the originally active and apparently individual element absorbs the mode of reaction of the supposedly purely passive principle.

Now, however indispensable may be reception as a part of the process of the sociology of art, to identify it with the sociological essence of the aesthetic and to reduce everything which is intrapersonal in this to artistic effect does not work. Scholars who try to do something of this sort[12] fail to recognize to what extent the effect is itself a product of social forces which generate artistic creativity as the source of the effect. The reception which then takes place may be anticipated by production, but nevertheless it represents only one of several possible effects, so that every possible effect is the result of a selection and is not primary, is not an artistically independent variable. Reception seems to be less spontaneous than production only because it represents subsequent completion and psychological empathy. It is by no means more generalizing and more alienated from the individual than the act of creation, which already represents a privation of the ego and—as a result of the objectivization and emancipation of the spiritual contents—a surrender of inwardness.

13 On the Experience of Art

When we define the reception of a work of art, we think of the two basic functions which are incumbent upon art, propaganda and diversion—mainly of the latter. The one-sided consideration of one of the two functions is what makes the adequate understanding of the process most difficult. The artistic experience is, it is true, above all delight and sensual pleasure: a successful painting is a joy to behold, a successful composition a pleasure to the ear, a beautiful poem an enchanting linguistic structure. But no work of art exists purely for our pleasure. There are, of course, innumerable works of delicate, light, frivolous art which no connoisseur or lover of art would wish to do without. Pure enjoyment of a culinary epicurean nature has, however, nothing to do with a securely differentiated taste and is unsuited to the deeper destiny of art. The sensual pleasure and serious, profound satisfaction which authentic works of art offer us are probably generally inseparable, but still they cannot be reduced to one another.

The satisfaction created by the experience, the act of cooperative completion, the taking of inner possession of works of art, is not a cheap, effortless, unalloyed joy, but for the most part a hard task, a harsh intellectual and moral test. The complete reception of an authentic work of art never comes about as a pleasant and easy, comfortable and undemanding entertainment. There is nothing fundamentally hedonistic, sensually purposeful about it though there is a lot that is sensually mediated. The sensual charm which no work of art can do without is always directed toward something suprasensual, humanistically substantial which lies beyond form, and in this something it acquires meaning.

440

Artistic creativity is not a fruit ready to be plucked; in order to enjoy it we have to continue a process which the artist himself did not complete. The adequate comprehension of an important work thus not only demands maturity, concentration, sensibility, a feeling for quality, and critical ability, but also presupposes an ability to complete and not merely reconstruct the artistic achievement. It is man in his universal, demanding reality of life who receives the products of art with the utmost harnessing of his powers. The acquisition of works which often fall effortlessly into the lap of the artist as a gift from the gods costs us a hard struggle. Essentially one is born an artist, but for the most part educated to be a connoisseur. It is not the road from nature to art, but that from artist to connoisseur which is the longer and more winding. Both are not only individually but also socially conditioned. But the education of an artist consists in the development of a talent the predisposition to which is generally already present; the aesthetic education of a connoisseur on the other hand consists frequently in a more elementary and incomparably more multifaceted operation.

First and foremost, it is the hardening of the creative subject's intimacy into a firm form, into an independent, immanent artistic structure which disengages itself from the original experiential context that makes the reception of a work of art into the difficult task we are dealing with here, and it is this that prevents the recipient from attaching himself immediately to the subjectivity of the artist and having the experience of art become the simple completion of the creative act. The emancipation of the artistic structure from its origin, its secession from the person of the producer and the circumstances of production do, however, only allow the development of the idea of autonomy when a work of art is interpreted and repeatedly reinterpreted. To maintain that the reception of a work of art is not the simple subsequent completion of its production and that we should not see in the reconstruction of the creative process a mechanical completion is not to be understood as saying that every period, every society, and every individual is capable of reconstruction but rather that those who are capable of it complete the action each in his own way. "Two people may," says William Empson, "get very different experiences from the same work of art without either being definitely wrong."[13] The legitimacy of different criticisms of a work of art places aesthetic phenomena in a special category—one which diverges fundamentally from the sphere of validity of other statements. Above all, it excludes the risk of relativism. The alternative, that one point of view is "right" and another "wrong," hardly arises when we are dealing with degrees of sensibility and differences in taste. Just as a work of art cannot be

simply "true" or "untrue" but is conditioned by innumerable other criteria of value, there are also many varieties of sensible and nonsensical interpretations of works. They are convincing, enriching, topical, sometimes stylistically progressive, sometimes retrospective or meaningless, alien to life, not rooted in history, without meaning for the present or the past.

Moreover, in the course of the history of their reception and critical evaluation works of art change not only the exchange rate of their emotional factors, not only the aesthetic significance of their formal elements, but also the criteria of their social function. Thus, for example, as has been remarked, a mass-produced article has been made out of Chopin's "aristocratic" music under the influence of the popularization of the means of dissemination and the concert and the recording industries.[14]

In the case of many of the greatest poets and artists, like Shakespeare, Balzac, and Dostoevski, Delacroix and Courbet, Berlioz and Wagner, the most powerful creative act is combined with an uncertain, wavering problematical taste. Usually, as is the case with Shakespeare, the discrepancy is the unmistakable result of a divided public taste which the author tries to make concessions to. Often, as in the case of Balzac or Dostoevski, it is the result of the intolerable conditions of work under which the impoverished writers had to deliver the installments of their works before they had come to terms with the organization of their material. Taine's explanation of Balzac's characteristic style, of his essentially self-intoxicating torrent of language, his cheap pathos, his contrived metaphors, of the sheer enthusiasm and the plaintive emotion of his lyrical style, is well known. It begins with the fact that the *Comédie humaine* is no longer aimed at the epicurean and reserved public of the courts and salons of the seventeenth and eighteenth centuries, which—as a result of the unbroken tradition in which literary taste was rooted—did not respond at first to such urgent, shrill, and harsh tones as Balzac's. It was aimed, rather, at a for the most part half-educated public which was accustomed to the rough fodder of serialized novels.[15] Thus, the truth of the priority of consumption over production is once again proved.

The public which today fills cinemas and dissolves in tears its feelings of joy and sorrow still belongs at bottom to the same social and cultural stratum as Balzac's emotion-filled readers. Thomas Mann remarks somewhere that we never cry over the really great works of literature like those of Homer, Dante, Shakespeare, Cervantes, high Greek tragedy, and the masters of the modern novel, but we shed our tears over the fate of fictional people in the irresponsible darkness of the cinema. That sounds captivating, but on closer examination we see that it does

not hold water. Even great poets do not always resist the temptation to open their readers' tear ducts, and even Dostoevski sometimes works with effects which are not even overshadowed by those of *Little Dorrit*. For just as it was not the same Dickens who was read by the lower and the upper bourgeoisie, so it was not the same Dostoevski who owed his fame to the end of *The Idiot* or *The Brothers Karamazov*. Now they reflect the sensibility, now the sentimentality of the public whom they serve. In their unequal feeling for style there is a constant competition between two cultural strata and representatives of taste. They are the servants and the masters of the consumers, who lead them while being led themselves.

Just as the creative subject takes the first step that leads to his work not as an artist but as a practical man and approaches production in an "unprejudiced" manner, so the receptive subject is not simply an inexperienced and unprejudiced being, however much he may appear to be lacking in anticipation and to be open to the impression which he is to receive. He brings with him so much that has already been experienced and so much that determines his reaction to the particular work of art that the artist is always only partially responsible for the effect his work of art has. Yet moments are involved in the complex of artistic experiences not only that have influenced the receptive subject before the genesis of the work in question, but also that have subsequently come into being and have modified the effect of products which have long been in existence.

Although works of art do not by any means always improve in the course of history, their effect does become more complicated and they can achieve a depth, a profundity, and a richness of correlations which they did not possess from the beginning. Homer's heterogeneously compounded art which looked back over a long prehistory and certainly assumed no particularly unselective audience was probably never so "naive," spontaneous, and original as legend would have it. However, it gradually assumed characteristics which already bear the marks of an almost rococo grace and certainly did not belong to its original nature. The millennia which have passed since the final redaction of the epic have played just as much part in the effect which it now exerts as the centuries did in the form which it acquired before the appearance of the poet whose name it bears. Moreover, high and significant art, even when it remains as "simple" as can be, can scarcely be understood appropriately any more by posterity. Homer may have been readily comprehensible to his contemporaries, or at least to those of his contemporaries for whom the poems were intended: this is no longer the case. To revert to a "childlike" state as Marx wanted to does not happen according to one's wish and would not help us very much.

On the contrary, we have to be very adult and nonnaive in order to enjoy the extremely artful Homeric verse, which presupposed conditions which have disappeared without trace and to which we have found our way back only through the mediation of neoclassicism, the Renaissance, Dante, and Virgil.

It is incredible to what extent the simplest communications and chance remarks change when they go from mouth to mouth and from one person to another. The more complex the thought which is transferred and the more personal the message, the more incisive the change can be which it undergoes in sense and in form in the course of the process. The experience of art as the change of the production into the reception of artistic expression can be regarded fundamentally as such a distortion and falsification of the original vision. The question is only how far the displacement of production by the receptive aspect is taken into account from the outset. Does not every artist have to come to terms with the necessity for a more or less severe exaggeration and coarsening of that vision, just as the actor has to reckon with the distance of the audience from the stage? In fact, does not the expression of inwardness by the sensual work of art finally consist of this brutalizing ostentation? Is it not this exhibitionism which moved Hegel to the declaration that the completed work no longer belongs to the artist? In any case it remains partly his own and at least expresses the fact that he has first become aware and possessed of his intimacy—even if in stylized form—through art. His struggle for the public's favor is at the same time a struggle for mastery over himself. As a result of the projection toward the outside and of accessibility from the outside, the artistic processes are accomplished in the social medium from which they arise and they evaporate into the ineffable.

The fact that the things which the artist communicates to his public are not entirely those that he wanted to say is a result of the fact that subjective artistic volition and the objectivized expression, the urge to create and the experience of art are not identical, and reception is not just a reconstruction of production. This is not only because the recipient is not a performer and because construction and reconstruction assume different talents and inclinations, but also because the creative and the receptive process represent different stages of a dialectical development. The response to the artist's questioning comes on one hand from the completed work and on the other from the experience of the work by the recipient, who may misunderstand it or who may understand it better than the creator.[16] Goethe may have had the feeling that he had penetrated more deeply into the idea of *Hamlet* than Shakespeare, and Schlegel may well have felt the same thing about *Don Quixote*. Unamuno finally actually makes the claim that he has seen

a meaning in this work which Cervantes could not possibly have thought of. The idea that the artist cannot know everything about the secret depths of his works—even does not wish to know everything—has become a commonplace since the development of psychology. If on the other hand we hold the view that the artist's conscious intention is the most reliable guide to the understanding of his works, every later or strange interpretation, indeed, every merely receptive—and as such, secondary—experience of art, seems to contain a more or less risky misunderstanding. Not only is it art as a whole and the particular types of art which are historical phenomena changing with the development of society, of taste, and of styles, but also every individual work changes its meaning from time to time in spite of its having an established concrete form once and for all. Even if we do not take into account the fact that different artistic styles can be adequately understood and correspondingly appreciated only in particular historical conditions while remaining unnoticed and unappreciated in others, it can scarcely escape our notice that often the same works, particularly musical ones, are interpreted quite differently within short spaces of time. The experience and the interpretation of a work is not infrequently more complex than its conception and its original structure. The reception of older works of art usually involves a combination of two styles: that governed by the stylistic principles of the period during which it was created and that of the period of its renaissance. Production is the result of artistic development up to the time a work is produced; reproduction is the result of subsequent development. Many of our own contemporaries still have a lively memory of the "romantic" method of performing musical works in the classical repertory, especially of the technique of Clara Schumann, a tradition which served as a model for the last generation but one. Yet now this not only seems old-fashioned but is regarded as a style which actually falsifies the true character of the works.

The function which the work of art fulfills for the author is, from the beginning, different from what it plays in the life of the recipient, of the contemporary or later reader, listener, or spectator. For the artist the work is the definition, articulation, and organization of chaotic mental states which are for the most part unconscious and initially unnameable, the resolution of a tension which has become unbearable in its ineffability and lack of articulation. For the subject of the receptive experience, it is a means of catharsis, of a better understanding of the world and of himself; it is a guide to the proper, meaningful life, a school of clarification by means of identification with the author who holds himself accountable and an absorption with situations into which the artist places characters who have became conscious of themselves.

It serves the author as a vehicle of liberation and relaxation, the recipient as a way to empathize with other people's fates so that he can elucidate the problematic of his own existence.

For symbolists like T. S. Eliot and Paul Valéry, artistic creation is a process of depersonalization and in their sense of the term a sort of dehumanization. The artist as an individual must disappear with his private life as completely from the work of art as "the children of Lady Macbeth" do from her tragedy. This isolation of works from everything which does not belong to their concrete content and their separation from each other are what we have to understand by immanence and autonomy, the defection of their being from their genesis, their alienation from their creator and the native soil in which they are rooted. Their alienation may go so far that they mean something quite different from what their originator intended to put into them. That is the meaning of the point of view held by many people that the characters, the action, and the denouement follow their own path and not that of the author. To interpret a work of art in this sense and to regard it as a closed microcosm is doubtless part of the proper understanding of its essence, even if it does not contain the whole truth about its nature. The motives for the genesis do not always appear simultaneously and equivalently with the criteria applied to the aesthetic structure. To pay attention to the genesis may distract our attention from the formal beauty of the work and even destroy the artistically adequate enjoyment of it. Genesis and validity, production and consumption, autonomous form and ideological commitment are, however, never so rigidly separated from each other in artistic practice as in aesthetic theory. Nevertheless, it is essential that in artistic creativity the principles of both orders—the genetic and the phenomenological—are fused, whereas in the authentic receptive experience the traces of the origin of the individual motifs are blurred and must remain unrecognizable.

14 The Consumers
of Art

Between social organizations, artists, and those interested in art there exists a coordination which accords with the circumstances of the time and which changes with them. The primitive hunting community represented the social basis of the Paleolithic age; the producers of art were magicians and medicine men, and the consumers of that art were the parasites who believed in imitative magic and who exploited the gifts of nature. It was in the Neolithic age that an economically productive agrarian society first developed, with both a collective and an individual demand for art, a production which accorded with animistic rites for the community and one for personal use which was conditional on the private household and restricted to decorative works. Ancient Oriental despotism then produced the type of patron who was religious and political in his interests and created the bases for the existence of the dependent artist working in the temple and palace economies. The medieval clergy used art as an instrument of authoritative Christian culture by binding the artist to the monastery, the diocese, or the stonemasons' lodge. The burghers, freeing themselves from the bonds of feudalism and emancipating themselves from the authoritarian Church, first developed and thereupon destroyed the autonomous orders of guilds, laid the foundation of the free practice of craft, of the independent practice of art, and prepared the forms in which individual interest in art could function. Thus, there began the private consumption of art, and a market for art was created untrammeled by institutional ties and dependent upon a constant, though fluctuating, public.

The gradual dissolution of the royal households of the ancien régime and the development of the new financial capital paved the way for

the collector in the modern sense—someone who no longer collected art entirely, or almost entirely, for the sake of prestige but who was the prototype of the connoisseur, who remained personally in the background of the trade in works of art. The latter was able, it is true, to conceal himself for a short while, but the type of works he favored soon became authoritative, and the interest in collecting—which now develops—provided a new and effective means of mediation between artist and public. The collector took on the characteristics of the connoisseur or else used the connoisseur as an adviser, thus providing him with honors and material reward. The consumption of art became objectivized and was conditioned more and more by form and technique. To the extent that the relationship between producer and consumer was slackened, the common objective interest of artistic creation and reception became tighter. The recipient alienated himself more and more from the producer; meanwhile, the depersonalized work became more familiar to him.

The decisive changes in the relationship between the artist and those interested in art lie on the road which leads from permanent employer, slave owner, and feudal lord to patron, customer, and buyer, connoisseur and friend of art, participant in auctions and collector. The most obvious stages in the development from slavery, feudalism, ecclesiastical tutelage, and guild discipline to emancipated bourgeoisie and the predominant financial capital—expressed in the categories of artistic production and reception—are the artist who disposes of his own work, the free art market, the producer no longer forced to execute direct commissions, and the collector who chooses spontaneously from what is available at a given time.

We can no more talk of the existence of a public as a collectively receptive subject than we can of a creative group of subjects qua collective. Just as it is always only single productive individuals who can be recognized, so, no matter how closely they join together, how immediately they stimulate each other, cull the initiative of others, represent and replace each other, it is always only separate individuals who experience works of art. In other words, a work is experienced by each individual in his own way although the massing of individuals into compact audiences may result in a sort of psychological infection and a more or less broad similarity of reactions. The denial of the principle of collective initiatives does not necessarily mean that the reaction of the individual to artistic influences is unaffected by the nature of the group to which he belongs. The concept of the public as an intellectually active unity is, it is true, merely a hypostasis, which does not assert itself at all concretely and remains a fiction of a way of thinking which is reduced to a numerical category; nevertheless,

there are groupings of the public according to the constitution of which the artistic experiences of individuals differ from or agree with one another. No matter how imprecise the concept of the "public" may be, the individual categories of the public are sharply differentiated. In historical times there was never a unified art, because there was never a unified public and because the different groupings of the public conditioned particular forms of art which were ideologically and intentionally irreconcilable and differed in meaning and value, complexity and subtlety.

Unambiguously definable groups of the public correspond to single cultural strata and within them to different, ideologically differentiated groups. Yet no one art, whether high, popular, or populist, has a homogeneous following. Just as the high art of the cultural elite is to a different extent and in a different sense "high" and popular art is in a different way average, so the public on each level comprises elements which not only as individuals stand at some remove from the typical artistic ideal of their cultural stratum, but also as a whole are separated from the public for art in other strata by fluid boundaries. A certain flexibility of outlines characterizes all social groups and forms a common characteristic of every stratified society organized according to class and rank. Social mobility, the rise from one stratum to a higher one, meets less opposition in the area of culture than in economics and politics, although the ascent, even on the cultural ladder, does have prior economic and political conditions. Nevertheless, one cultural stratum and the public for art which corresponds to it often unite individuals who are socially and economically quite differently situated. The literature of the French Enlightenment, for example, was apparently directed at the same educated and progressively minded public, but to assume that Voltaire and Rousseau, for example, were read by the same people, or that they received the same recognition from their readers and found the same absolute understanding, would represent an uncommonly simplified concept of the Enlightenment and a dubiously schematized idea of its representatives.

If it is true, as has been suggested, that we do not understand the French burgher if we do not know Voltaire,[17] then it is also true that we do not understand Voltaire if we do not grasp how deeply rooted he is in the middle class in spite of all his lordly allures, his fortune, and his royal friends. His intellectual sympathies and prejudices are bourgeois through and through, and so are his sober classicism, his lack of interest in great metaphysical problems, his anticlerical religiosity, opposed to any form of mysticism, his dislike of anything romantic, unfathomable, unclear, and inexplicable, his trust in common sense, his conviction that we can grasp and judge everything

worth knowing by means of reason, his clever skepticism, and his rational ease in what is nearest to him, in what is immediately accessible, in what the day offers and demands. All this is bourgeois, even if it does not exhaust the concept and even if the subjectivism and emotionalism which Rousseau preaches is the other, equally relevant side of the bourgeois spirit.

The smaller a group of the public is, the more immediately and personally intimate and intense the appreciation of art which it develops can be. The most extreme example of this sort is the mute, lonely reading of poetic works away from the outside world. In other artistic genres, above all the theater and the concert, the power of the effect grows with the size of the audience. The lyrical drama, say, of Hofmannsthal or Maeterlinck, intended for the modern "intimate theater," does exert an effect similar to reading in depth, but the rule is that emotional suggestion—as a characteristic of mass effect—asserts itself in every sort of theater and concert hall. The remarkable phenomenon that the art of the theater—"democratic" by nature and resting upon the emotional leveling out of the audience—found such a response in the royal courts of the absolutist period is explained by the fact that the agreement of the audience was there from the beginning and did not first have to be created by mass suggestion. The common feeling that grew in the audience of Versailles and especially Athens as the number of those present increased was the sort of reaction which accompanies a ceremonial attended by crowds rather than that of a pure artistic experience. The cohesive force of an artistic effect becomes the more palpable the more mixed the composition of the audience and the closer the relevant conditions come to those prevailing in the Middle Ages or in Elizabethan England. There, the audience is really a huge melting pot in which class differences and the demands of different cultural strata are relatively easily balanced and the criteria of taste seem to be identical by virtue of their reduction to a common denominator—often a very low one. The similarity of effect, however, never prevails in more differentiated social conditions with regard to all factors of the experiences, and even those artistic means which prove universally effective do not go equally deep for all the participants.

The creations of authentic, qualitatively valuable art could always only reckon on the support of relatively narrowly bounded strata of society. In this respect the works of Shakespeare were no fundamental exception, for the effects which attracted the masses to his works are not the most valuable parts of his works. These found universal approval not because of but in spite of their artistic quality. Nevertheless, there were, we may object, artistic components which made what was offered—even if unconsciously and without motivation—attractive and

effective. For it is not the moments of which we are conscious when we experience art which play the decisive role in our judgment on the work. The consciousness of factors of artistic effect has merely psychological relevance. For the "naive" (that is, the normative) recipient who appreciates the work of art in a practical context which lies beyond art, the artistic value may be hidden and remain of no account: he does not even have to know that he is dealing with art when he is under the influence of artistic agencies.

Every artistic experience—whether creative or receptive—has its roots as to both its origin and its effect in a community, if not necessarily in the consciousness of a community. The common characteristics of the experience of art by different individuals may have nothing to do with the conviction that these individuals belong to the same social order or social group. In primitive communities governed by ideas of magic or animism, the social limitation of artistic experiences, even if not the consciousness of this peculiarity may have been stronger than in later, more incoherent social structures. However, the character of solidarity of effect in times of more far-reaching atomization—where a communal experience which reminds us of the reactions of earlier, more closed and more compact societies mostly happens in performances of a larger nature, primarily in the theater—is not just dependent upon the size of the audience. In the concert hall, where numerical criteria such as applause also obtain, there is less often a mass effect of this sort, and it is always in a diminished form, however loud the applause of the young audience may be which has just been won over. In the theater there are apparently moments inherent in the drama which play their part in making the magical contact between the stage and the audience, and these are not present in a concert. The immediate embodiment and presence of the actors certainly must be an influence. The contact between the actor and spectator in a play is to some extent somatic and sensual, that is, in the literal sense intrapersonal and not suprapersonal or physically indifferent, like that which exists between performer and audience at a concert.

The mere fact that the artist is addressing his work to a particular reader, listener, or spectator instead of an imaginary one only conditions the social implications of his activity to a relatively minor extent. It is only when he is no longer talking to a singular "you" but a plural "you" that he moves into the social sphere. For just as confession does not create a relationship between priest and penitent which could be designated as "social" but, rather, one which is completely impersonal, free from everything interpersonal, so the singularity of the singular "you" does not remove the artist's confession from the private realm. The social process only begins when a group is involved in the process.

Where does the participation of a group in the utterance begin? The loneliness of the isolated individual seeking contact certainly ends with the presence of a second person, but the group, in the sense of the audience, does not come into being either with this alone or with a circle whose members are so familiar with one another that no form of tension, opposition, or conflict, no antagonism of a dialectical nature, can develop which needs to be arbitrated.

The relationship of two persons, whether in the form of a marriage, friendship, or business partnership, does not produce in this sense anything which is social or dynamically dialectic. For an artistically fruitful dialectic we need at least a third party. When there is a relationship between three people, "every element," says Georg Simmel, "works as an intermediate authority for the other two, and shows the double function of such an intermediary, as something which both divides and unites. Where three elements, A, B, and C, form a community, we have in addition to the immediate relationship which exists, for example, between A and B a third, mediate one which they have in their common relationship to C. . . . Disputes which the antagonists could not adjust on their own are settled by their involvement in an all-embracing totality. Not only is the direct relationship strengthened by the indirect; it is also disturbed. There is no relationship between three which is so intimate as to exclude the fact that the third party is always at one time or another felt by the other two to be an intruder. . . . The sociological structure of the relationship between two is marked by the fact that two things are missing: both the strengthening of the bond brought about by the third party or by a social framework which transcends both of them, and the disorder and diversion of mature and immediate reciprocity."[18]

The relationship between "I" and "you," unless the partners are quite indifferent to one another, is characterized by either an unbridgeable chasm or a proximity completely devoid of tension. It is only when a third party is introduced that the relationship is enlivened, as the distance between them grows now greater, now smaller. The artist in his relationship to the public is constantly seeking applause and recognition, especially the favor of those free elements who at first take no particular position and who play the part of the third person in the alliance whose approval can be either won or lost. This personally uncommitted role which has to be played, even if not without individual assumptions, characterizes the nature of the independent recipient making a free choice and an unprejudiced decision.

Of course, even three people do not form a practical social group which could be designated as an audience. But the difference between two people and three involves the most essential shift in their com-

position and in the inner relationship of their members. The third person may form a strengthening bond or a barrier which places a distance between the two. It may endanger the intimacy of the relationship, but it can also bring about an understanding when dissension threatens. In any case, an audience which is to achieve an objective critical view of artistic presentations and which meets with opposition which has to be overcome in the process only begins to form in the presence of a third person.

True, it is always an individual who reads books and—in the time of individual collectors and patrons—enjoys paintings and sculptures. However, books are not written according to the writer's original intention for individual readers, and pictures and sculptures—even if they are produced for individual collectors and connoisseurs—are not intended for them. Even when we are trying to define a public for art, we are dealing, as in so many other sociological categories, with the change of a quantity into a new quality. When do "grains" start to form a "heap"? The well-known question is not essentially a numerical one and is not concerned with the minimum number of elements involved, but is mainly a qualitative one and can be answered only if we talk in terms of a leap by which separate individuals interested in art concentrate into a coherent group, in the process of which the private, personal relationship between patron or donor and artist ceases to exist and gives way to the more objective relationship between free producer and consumer. Employer and patron, permanent clients and steady customers do not form a public for art in the strict sense of the term, for such a public does not exist where relationships are insecure and changeable, even if not permanently precarious. What belongs to the concept of this public are in any case the mobility of the strata who set the fashion, the diminished security of individual artists, and also the increasing chances of the artists as a whole and the participation of both parties—producers and consumers—in the fluctuating market economy.

As a result of the end of patronage, which afforded artists—or at least a considerable number of them—material security and as a result of the rise of the free market, which called free competition into existence, in the sphere of art, too, there arose an artistic proletariat with hitherto unparalleled needs. The founding of the so-called welfare states in the West and the universal desire for education of the growing middle class, which was becoming increasingly wealthy, soon mitigated the severity of this process of proletarianization. These factors even created conditions in which artistic experiment met with response and support, so that we can confidently assert that the public patronage of the burgeoning trade in works of art amply made up for the loss

of the former individual patronage, even if indiscriminately and in-commensurately with true values. The uncritical public, scared by progressive artists, also reacted to the most malicious affront with applause. The more audacious the rebels were, the more certain they could be of their startling effect. The only successful defense the bourgeoisie had was that they simply did not feel themselves to be affected and that they joined in the abuse. The consciousness that the tolerance of the bourgeoisie toward the revolution which was taking place in art did nothing to change the practical lack of influence of the militant artists brought the latter to the edge of despair but permitted those who were under attack to applaud, as long as they felt themselves secure in other ways.

The public consists of various types, all of which are represented in different sorts of art, but which are most easily distinguished in literature. In literature even those who are constant readers cannot claim to rank as a literary intelligentsia, but merely wish to be enter-tained by literature even if they are not completely indiscriminate in their reading. The majority of the reading public belong to this type, especially in those periods in which ideological consciousness is limited to a thin social and cultural stratum and class consciousness is blurred as a result of the diversity of factors which determine status. Distinct from the representatives of this type, which is now more, now less ideologically conscious, are readers who are linked to the author by virtue of personal, emotional, or intellectual tendencies, or who as professional men of letters, critics, and literary historians form part of the main body of his audience and who advise and lead the rest of the readers by dint of their feeling for quality, their sensibility, or their historical knowledge.

However, even this typology, like all historical ones, is defective and incomplete; new types appear as new tasks and prospects of success arise, and they persist in an open system which grows more and more differentiated. The rude audience of the pre-Homeric bards becomes the more demanding public of the rhapsodists, who try to satisfy a much more diverse audience and who want to please not only the company at the royal courts but also people at fairs and folk festivals. The man of letters—that is, the person who is interested in style, familiar with history, and capable of making aesthetic judgments—is, with his international orientation, his cultural centers, and his spe-cialized tasks, first produced by Hellenism. Economic division of labor and the new supranational Hellenic capitalism's principle of the ac-cumulation of wealth form the basis of the association of literati, which is not a professional guild but is also not a diffuse readership constantly changing and merely seeking entertainment.

The Middle Ages in accordance with its authoritarian spiritual culture restricts not only writing but also reading to a particular stratum: the clergy, who were responsible for ecclesiastical propaganda and the development of feudal-ecclesiastical ideology. The heroic epic, the chivalric lyric, and the popular theater flourish in the shadow of spiritually authoritarian literature or are, from time to time, pushed aside by it. However, the scribe who is educated in the church and inclined to it is still in no way the same as the habitual and critical reader of modern times. It was not until Renaissance humanism that a concept of a reading public developed which departed from medieval notions and was based on the example of the intellectual elite of Hellenistic students of literature and was dependent upon its own complicated ideology, which was founded in part upon talent and secular culture. One of the presuppositions of humanism was a public which was still unknown to the early Middle Ages and which arose in the second half of the medieval period. This public no longer formed part of more or less extensive groups listening to oral performances of the heroic lays, legends, Biblical incidents, and saints' lives, but began to read books whenever possible in private. At the turn of the twelfth century a type of writer appeared in northern France who was in many ways very like a modern author: he no longer wrote songs and narratives for performance but wrote stories to be read. The old heroic lays were once performed to a military nobility; the courtly epics were still recited to an aristocracy enlarged by the *ministeriales;* the love and adventure stories which now began to appear were on the other hand purely for entertainment and especially for ladies. Albert Thibaudet, who ascribes the greatest significance to this function of the new narrative literature, considers the changed composition of the reading public caused by the addition of women as the main cause of formal changes which took place in Western literature.[19] He maintains that it is only now, when literature becomes reading matter, that its enjoyment turns into a passion, to which from that time on we have never ceased to be enslaved. Reading is now turned into an everyday need and a pastime which is no longer linked to festivals but which we can turn to at any hour of the day. Thus, literature loses the last vestige of its sacral, mythic character, and it is no longer in absolute need of any conscious self-deception: it becomes pure, unadorned "fiction," an invention in which we no longer have to believe in order to be interested in it.

In contrast to recitation, reading conditions a new narrative technique and permits the use of special effects which had previously been as good as unknown. Works intended for singing or recitation mostly used juxtaposition as a means of composition; they were composed

of individual, more or less independent parts and episodes. The performance could be broken off at almost any point without harming the totality of the work. The *Chanson de Roland* was still composed in this way, as Karl Vossler remarks.[20] Chrétien de Troyes on the other hand is already working with effects which provoke tension, retardations, and interpolations which no longer result from the individual parts of the poem but from the relationship of their elements to one another. The poet can use such artistic devices—which would be almost out of the question in a small-scale and frequently interrupted performance—only when he is writing for a *reader* and not a *listener*. Novels of this sort intended for reading mark the very beginning of the new narrative literature not only because they are the first romantic love stories in the West in which lyricism and emotionalism are more important than anything else but also because they are the first *récits bien faits*—to paraphrase a well-known dramaturgical concept which refers to surprise theatrical effects.

As a result of the reading matter which has now become a constant need and a pure habit, the devout, solemn listener becomes the blasé reader, who leans now toward the formalism of stylistic connoisseurship, now toward indiscriminate mass consumption. For all of their antitheses, the two attitudes have alienation from the principles of practice in common. Both literature which is intoxicated with precious words and turns of phrase and writing which is devoured wholesale stay apart from life and are unconcerned with true existence. Each of them may partially fulfill functions which were always incumbent upon art, but the weaning of the reader from practice inevitably takes place in both of them.

Art has never had it so easy and has never enjoyed such widespread and virtually unopposed recognition and support as recently, but it has also never been so apparent that its greatest products are opposed to most people's instinct. The weary tolerance toward modern artistic trends, however aggressive these may be, and the cheap success of best-sellers and hits are not an adequate answer to the question which is contained in the existence and function of art. What art means for society does not depend upon the number of enthusiasts for art and the amount of money which we award to artists as prizes and scholarships. The present development of people interested in art in no way corresponds—in spite of the enthusiasm with which we brag about it—to the liberal tendency which asserted itself against Le Brun's rigid conservatism and the sequel which the democratization of participation enjoyed in the subsequent century. At the time of the Enlightenment, we see the formation of a constantly growing group of art lovers which no longer consisted merely of specialists, artists, patrons, and collec-

tors, but also of laymen who felt encouraged to make their own critical judgments. Previously, the academy had permitted only professional people to join in the discussion of matters of art. Afterward the qualification of laymen to judge art was more and more decisively advocated and above all, as Roger de Piles suggests, because people had become convinced that even unrefined, naive taste had a justification and that on one hand sound common sense and on the other the unprejudiced eye could have justice on their side in the face of learned art criticism.

The change in the estimation of the lay public and the composition of an authoritative public naturally had some economic assumptions. The allowances which artists had received from Louis XIV dwindled as the king's reign drew to a close, and the academy had to make up for the lack of royal support by interesting a broader public. DuBos drew the conclusion from Roger de Piles's premises that art had to "move," not to "teach," and that it was feeling and not reason which was competent to judge it. Yet feeling was inevitably blunted in people who were constantly concerned with the same things, whereas in laymen and amateurs it remained fresh and spontaneous. The change in the composition of the public for art did not come about overnight, however, in spite of the preromantic point of view which was dominated by "naive feeling." For even naive, emotionally conditioned understanding, even mere interest in art had certain cultural presuppositions which people could not live up to without more ado. Nevertheless, the public for art grew in extent, embraced more and more diverse elements, and finally formed—at the end of the *grand siècle*— a stratum which was by no means as unified in its thought or so unambiguously able to be led as the cultured public of the Le Brun era. This is by no means to say that the public for high classical art was completely homogeneous and restricted to court circles. The archaic rigor of form, impersonal typology, and loyalty to conventions and traditions were certainly characteristics which essentially fitted in with an aristocratic feeling for life better, and ideologically more naturally, than they did with the view of life espoused by the new liberal bourgeoisie, which was not committed to any inflexible norms. For a class which bases its privileges upon age, birth, and behavior, the past is more concrete than the present. Breeding and family are more real than subject and individual, moderation and good breeding more venerable than feeling and spirit. However, as far as the rationalism which classicism laid claim to is concerned, we should not forget that the bourgeois view of life had deeper roots in sound common sense than the aristocratic one did. The nobility may have declared itself never so decisively for clear, logical thought, free from sentiment, complacency, and emotional stupor; it was the bourgeoisie—opposed

to every form of theatricality or rhetoric—which first developed the rational conception of existence, the principles of an unostentatious, reasonable, abstemious way of life which took into account the means at its disposal. The industrious bourgeois, conscious of the limits of his means and his powers, conformed earlier to a rationalistic, realizable, maintainable plan for living than did the aristocrat forever harping upon his privileges, which daily grew more problematical. For this reason the bourgeois was more responsive to the clarity, objectivity, and simplicity of classicism, which had been freed from baroque ornamentation, than was the aristocrat seeking his pomp and circumstance and desiring only to impress. While the aristocracy was still under the influence of the fanciful, bombastic, capriciously extravagant Spaniards, bourgeois connoisseurs and collectors were enthusing over the lucidity and normativity of Poussin, whose works—which were painted for the most part during the time of Richelieu and Mazarin— were bought and collected by members of the bourgeoisie, civil servants, merchants, and financiers. It is significant that Poussin took no commissions for decorative paintings on a monumental scale. And since he could not inwardly relate the official art of his time to the classical ideal of style of which he still had a recollection, he seldom accepted any ecclesiastical commissions.

What, then, was the origin of and how were the standards of value validated according to which Poussin and most later artists painted their works and whose traditions proved so vital that even Cézanne acknowledged them? Poussin himself was no more responsible for creating them than the bourgeoisie was for producing the principles of form of Corneille's—the Rouen lawyer's—dramas, although rationalistic classicism would be unthinkable without the bourgeois admixture in the public or the stylizing theatricality of the royal court. Both *la cour* and *la ville* played their part in the origin of the antagonisms of classical baroque. As pertinent as it may be that the representatives of cultural development were generally a particular class or a particular cultural circle, nevertheless an all too simplistic conception of this function and especially a completely homogenizing view of the arbiters of taste falsify the picture of the true process.

The artist may create his works with a particular circle of interested parties in mind, but he does not create them simply and solely according to the group's criteria of taste. Also, they do not always find their way into the hands of those for whom they were intended and even more seldom do they remain their property. Every artist naturally wishes that his creations should come into the possession of his followers and tends to regard those who buy his works as his "friends." In the strict sense of the word, however, these do not even belong to

his actual public and they often do not really know what he was trying to do when he created the work. However that may be, the so-called public for art is an extremely mixed group, whose individual strata are divided from one another by fluid boundaries.

If a painting does not come into the right hands—hands which will guarantee its proper enjoyment by the owner and its availability to people who are capable of appreciating it—then the situation is like the one in which a book is "out of print" or is said to have been "mislaid" by a library. In order to have a "public," works of art not only have to be separated from their author but also have to pass from hand to hand and from mouth to mouth. The artist himself, however, does not necessarily have to know about this circulation. After the collapse of the old system of patronage and the artists' loss of the material security associated with it, after the start of the trade in works of art in the modern sense and the corresponding anonymity of the relationship between the producer of art and the consumer of it, a situation develops in which the artist not only scarcely knows any longer who owns his works but also cares less and less about it. He no longer faces individuals, but the enormous, unknown, and unfathomable colossus which is called the "public for art." He may be flattered if his paintings come into famous collections, but the collectors' agents and advisers are just as responsible for this as his rank as an artist and the artistic quality of his pictures are. He is no more in a position to seek out customers for his works than the dramatist or the composer is to choose the people who will be present when his plays or compositions are performed. It is generally more difficult to frighten them away than to catch them. Often the sharpest attack upon a stratum of the public will not keep it from admiring its attacker. Insolence, however, is no more sure of success than flattery.

The consumption of art for reasons of prestige has always existed; but it increases from day to day and becomes more incalculable because of the fluctuating economy. Even qualitatively, the extension of the art market has a different effect in different cases, and its influence on the formation of artistic taste is uncertain. As the interest in art increases, so the feeling for quality usually becomes more and more refined and the critical power of the public becomes stronger. The increase in the number of people interested in art may be connected with a lowering and a lack of standards. There is clearly little to be gained if, when works of art are presented, more people are prepared to be bored or to reduce their demands in order to be entertained.

It is and remains the principle of the development of interest in art— no matter how the extent and the composition of the public for art may change—that today's progressives are tomorrow's conservatives.

Progressiveness and conservatism are conditioned not by the character and temperament of the representatives, but by the particular historical constellation of the time. When Matisse exhibited his epoch-making work *La joie de vivre* in 1906, Paul Signac, himself an important and progressive painter and at that time vice-president of the Salon des indépendents, was one of those who protested most sharply against the "crazy" picture. A year later Matisse reacted equally impatiently to Picasso's *Les demoiselles d'Avignon*. He described the picture as an assault upon the whole modern movement in art. Thus, it was mainly artists who were once members of the avant-garde and not reactionary philistines hostile to art who barred the way to success for the revolutionary moderns. In 1908, as a member of the jury of the Salon d'automne, Matisse rejected the works of Braque just as unscrupulously as the cubists rejected Duchamp's in 1912.[21] The "bourgeoisification" of the revolutionaries and the ossification of the avant-garde form an endless process in which not artists and laymen, but different stages of development—usually within one and the same generation—oppose and reject each other most sharply. Artists change into a biased, often narrow-minded critical public when they encounter a younger generation of artists which is trying to transcend the achievements of its predecessors. Thus, we are concerned with the public not as an ontological but as a functional category.[22] That is to say, people do not *constitute* but *become* a "public" under distinct conditions.

Art is, however, not first and foremost for artists but for laymen, for people who at first have nothing to do with it even if they eventually learn to have a great deal to do with it. It should be within reach of people who have a need for it, but it cannot be forced upon anyone. It is neither a duty nor a virtue to love art, but a test of strength and a triumph.

15 The Mediators

The doctrine of the spontaneity of artistic creativity has its counterpart in the doctrine of the immediacy of the artistic experience, of the sudden possession of the work of art by the receptive subject. In both cases the basis of the theory is the concept of an irrational, indivisible, and irreducible act, which comes about by inspiration and enlightenment without mediation and without outside intervention. However, just as there is no intellectual attitude which is related to reality which is completely uncompounded and completely unmediated or which would depend entirely upon the subject and his constitutive categories, so the idea of purely subjective and individual, entirely autonomous and immanent attitudes toward both the production and the consumption of art is a fiction which could scarcely be maintained without the mystification of artistic dispositions and abilities. Artistic creativity assumes a formal language which is generally comprehensible, the validity of historical traditions and social conventions, artistic reception, hermeneutic communications, guidance, and training. The more progressive a stylistic development, the more novel the works which have to be considered, and the less understanding and competent to judge the receptive subjects are, the more versatile and substantial the mediations have to be.

The relevance of interpretative mediation is most unmistakable in music, where the form of expression set down by the composer which appears immediate consists merely of a series of abstract signs which have less in common with the work's acoustic structure than ordinary script has with the text of a literary work which is read or recited. A certain stage of concretization of the musical notes has to take place before the sort of interpretation which is important to literature can

be started. The naive music lover hears absolutely nothing if he just sees notes, which are soundless to him and have no artistic meaning. Yet structures which are set down by the authors of works in the other arts are scarcely more directly comprehensible than notes are for the person unschooled in music. Adequate reception takes place here, too, only after the completion of a process which has many stages and which leads from form without content or meaning to a complex in which every characteristic acquires sense and content according to its place in the particular system.

We usually have no idea how extensive and widespread, intricate and tortuous this way is, and how clumsily, helplessly, and confusedly we would face even the most important and appealing artistic creations without being prepared for what to expect from them and how to adapt to them in order to make sense of their symbolic language, which is often a sort of secret language. The necessary understanding of the prehistory of the works before us and of their special sociohistorical station, of the role of the artist's exemplars and competitors, of the means available to him at a given time, of the problems which could be solved with them, and of the criteria for qualitative values, and a sensibility at its very peak can generally not be accomplished at a more advanced stage of development without the right mediators: teachers, leaders, interpreters, and critics.

When an artist passes on his work, it is by no means sociologically complete—it is only completed by its reception. It is therefore of the greatest importance to find out at what stage an artistic idea begins to correspond to an aim which is related to the recipient. Is the artist's vision intentionally conditioned from the beginning, and can the mere hint of it, as, for example, in the composer's notes, be regarded as the expression of it? Or does not the sensual realization rather belong— as always in fine arts and by the playing of the musical notes—to the concretization of the artist's vision and intentions? Is not the attitude of the recipient first conditioned by this concretization? From the standpoint of idealism, subjective vision and objective formation are essentially identical, and from the purely formal aspect, the question of the physical presence or absence of the receptive participants has no decisive meaning. As the instrument of a social practice which is beyond form, however, art realizes its true intention only when it participates in the concrete receptive act.

No matter how spontaneously and under what irresistible urge the artist may unbosom himself, he needs interpreters and mediators in order to be properly understood and duly appreciated. Only in the rarest cases does the recipient receive works immediately from him. Usually he has need of a whole series of mediators and instruments

of mediation in order to understand what the author intended with his work and what means he used in order to formulate his vision and organize his material. A new formal language still unknown to the general public loses its strangeness and unapproachability only through the agency of these mediators. The aura of the secret, the magic of the miracle that something which is beyond form and apparently ineffable should achieve a form is never lost by art if it really is art.

The work of art not only *means,* but *is* something and remains a sort of fetish which owes its inexplicable, or partially inexplicable, effect to its peculiar existence, which is mixed up with its meaning but is independent—sometimes alienating, sometimes beguiling. And just as a work of art not only means something but also is something which is simply inexplicable, it forms both an autonomous as well as a committed point of view toward the world and reality. Art as mere form, as arabesque or ornament, would actually destroy itself if its content were abolished as a relevant element, for it is only conceivable as something which is the form of something which is not "form"; in the same way formless content is not "content" and reveals itself to be unthinkable as such. Art takes reality in its stride, accepts and absorbs it, criticizes, corrects, and yet at the same time rejects it. It submits to it but makes itself autonomous in the face of it. Yet every time—in the face of these antinomies of meaning and existence, of form and content, of commitment and noncommitment—it settles on one principle and excludes another, the one which has been sacrificed to the other is destroyed; indeed, it destroys the whole system within which art has its being with this sort of choice between alternatives. For the genesis and development of art is, no matter from what point of view we look at it, a dialectical process whose antagonistic moments are inseparable from each other and can be changed only in relation to each other.

The receptive experience of art is just as much a product of social cooperation and an expression of intellectual community, a result of authoritarian achievement and subordinating adaptation, as creative artistic activity. Both are the result of a process in which a personal initiative reveals itself as an undertaking which affects many individuals. In the end an experiment becomes an institution, something which exists and can be continued; from something personal and private a product develops which can be acquired and passed on. Art as the possession of society—no matter from what angle we look at it—is the work of a collective in which the inspirer and the offerer, the recipient and the mediator are all equally involved.

Every person or institution which intervenes between the work of art and the experience of it fulfills either a useful or a useless function

in mediation. The people who portray or interpret the work—from the most primitive dancer and *mimus,* singer and narrator, bard and rhapsodist to the actor and the musician of our own day, from the earliest scholiast to the most sophisticated and knowledgeable student of art, from the first humanist epistles to the journals of the Enlightenment to contemporary newspapers with regular reviews of artistic happenings, of new works of literature, and of innumerable concerts, from the first art lovers, patrons, and protectors to modern connoisseurs and collectors—are all intermediate authorities who smooth the path from artist to public. They strengthen the relationship between them but complicate it at the same time; they link them but also remove and alienate them from each other. To the extent that the role of personal mediation increases and multiplies with time, so the institutional structures differentiate and distance the contact between the productive and the receptive elements of the artistic process. The chivalric courtly circle of the Middle Ages, the royal and matriarchal courts of the Renaissance, the literary salons of the seventeenth and eighteenth centuries, the classicist academies and the romantic poetic coteries, the naturalistic and impressionistic colonies of painters, the museums and exhibitions, presses and concert associations, theater, radio, and television ensembles, art tours and evening courses are mere bridges which narrow but at the same time emphasize the gap between production and consumption. Art as the object of institutional care objectifies itself the more jealously it is administered. The ambivalence of the study of art is also expressed by the fact that the approach to the author of a work may result in an alienation from his work. Nonetheless, the immediate and adequate understanding of a work is often connected in principle with indifference and the feeling that the author's person is in the last analysis irrelevant.

Just as the genesis of a work of art is not confined to components which have their origin in the creative individual and his private experiences but come for the most part from his intellectual heritage and his sense of community with his contemporaries and his professional colleagues, so the factors involved in the reception of a work do not come entirely from an immediate relationship between the receptive subject and the experienced object. Innumerable institutions are involved in the mediations by which works become accessible at all. These give them a meaning which the public can cling to, and they remove the strangeness connected with their novelty, set aside the impression of confusion, reconcile them with what is familiar, and so create that continuity between what has gone before and what is yet to come without which art would sacrifice its historicity, its continuity, and its capacity for rebirth. We have these mediations to thank for the

fact that a *vulgata* develops out of an apparently secret "mandarin" language, the nonconformist avant-garde acquires a more or less acceptable sense, and their rebelliousness, which is aimed mainly at bewilderment, becomes tractable and to some extent respectable. The routine of regular art criticism in the daily newspapers and journals, popular literature on the theory of art, and picture books which deal with the history of art, of prescribed visits to art collections and exhibitions, of the constant presentation of new products in drama and music, of constant television and radio programs may in themselves be of questionable value, but they create an atmosphere in which art becomes an everyday phenomenon even if it is for the most part neglected.

The authentic experience of art assumes a certain immediacy, an essentially spontaneous, uninhibited, unreflecting, sensual reaction to the impression made by the work. This merely means, however, that the normative experience is conditioned concretely, in a manner which differs from person to person both emotionally and according to the individual's position in life. However, it by no means implies that during the formation of the experience there is a lack of stimulating factors which further the impression externally. A capability of appreciating art without the aid of any form of mediation is one of the rare gifts of connoisseurs who are extremely well informed and involved in the determination of new criteria of value and in the intensification of artistic sensibility. Such people with their special and peculiar talent stand, so to speak, on the border between the production and the reception of art. In general, the significance of the mediator increases, the higher the quality of the works involved and the lower the level of the recipients' education. Mediation between artist and public can raise the level upon which reception takes place; the popularization of art through the increasing number of mediations and the reduction of the demands which they make of the recipient, however, can also contribute to the lowering of the plane upon which works of a demanding nature are accepted. An artistic experience which is achieved by the dilution and vulgarization of its substratum is not an achievement, for we do not arrive at the adequate evaluation of high art by tolerating what is inferior. The ability to appreciate authentic art assumes an arduous path toward the formation of taste. We achieve this only by patient education, and finally by a leap and not by a graduated progress from imperfect and mediocre products to more and more genuine and more and more demanding ones. The development does not consist in change of objects but in change of attitude. No matter how many assumptions and preconditions it may require, we suddenly discover what real art is, as if everything which had been

experienced and learned beforehand had nothing to do with the rev-
elation. We comprehend what art is as if by chance, just as we are
suddenly able to swim. We have only to jump into the water, even if
we have had to have a swimming instructor whom we no longer think
about.

Just as an adequate relationship between works of high art and their
reception can now take place at a certain stage of culture without any
particular mediation, so popular art, too, needs no mediator between
its producers and consumers, who are often the same people and always
belong to the same social and cultural stratum. However, to the extent
that Western civilization spreads and a mass audience for popular art
grows, the sphere of folk-art is narrowed on one hand and the number
of connoisseurs in proportion to the rest of the recipients is reduced
on the other. It is natural that, in accordance with this development,
the number of people and institutions mediating between the art of
the elite and the increasing mass of those interested in art increases.

The decisive difference between possible attitudes toward art is de-
termined on one hand by the point of view of the connoisseur, of the
expert in art history and theory, and on the other by the point of view
of the naive recipient, who feels no necessity to compare the work of
art he is confronting with any other and who indeed is not capable of
doing so. The naive spectator experiences the work of art as a part of
reality, as the extension of his experience of life; the critical observer
judges it as pure fiction, however significant—as a form of conscious
self-deception, as a product of creative talent and the ability to imitate,
reshape, and reinterpret things, as a form of the spiritual force which
every artist possesses to a particular and individual degree. The con-
noisseur's enjoyment of art is always connected with the evaluation
of this talent. Of course, the authenticity, vitality, and depth of the
artistic experience depends in part upon spontaneity of reaction, even
though there is a consciousness of the artfulness with which we perceive
the simulated phenomena and of the manner in which the critical
criteria assert themselves. This spontaneity is more or less preserved
under all conditions. On the other hand the half-serious, playful fact
that we are dealing merely with an artifact is never entirely absent,
even in the course of the most unsuspecting enjoyment of art. No
artistic experience is completely naive or completely sophisticated, just
as none is completely direct or indirect.

The creative realization of artistic volition is achieved at the price
of certain concessions and, as we know, betrays the idea, the artist's
original idea. The reception of the work—the experience of art by
subjects who complete the act of creation and receive the objective
creation, which is already burdened by certain compromises—

represents, as a result of those mediations which intervene between artist and public, a further deformation of the creative vision. However, just as the act of creation not only disfigures the original conception of the works but at the same time develops and defines it with the aid of the means of concretization which are used, so reception promotes a return to the intimacy of the artist by the means of mediation it employs. The whole artistic process consists in this way of a series of dialectically antithetical steps. It is a process which embodies moments of production and reception, vision and expression, alienation and repeated intensification of alienated spontaneity just like all activity which bears reference to reality. The process is not unaccompanied by danger. For as indispensable as the function of the professional artist may be in the relationship between artist and public and as indubitable as it is that the connoisseur is the first to be able to grasp and judge the aesthetic quality of a work of art, the specialist often misses some aspect which confers upon the spontaneous experience of the layman a special authenticity in spite of all the rest of his shortcomings. In the autonomy of art criticism and the separation of the connoisseur and the artist on one hand from the naive recipient on the other, we have an expression of a principle of specialization and division of labor which is foreign to the essence of the coherent artistic experience.

Georg Lukács maintains that everybody who rises above the "spontaneity of the mere impression" in the reception of a work of art also experiences its relationship to a genre.[23] Depending upon the educational level of the receptive subject, categories of consciousness and associations of this sort must certainly also play a part in the reception of a work. It is, however, questionable whether, as Lukács believes, they belong to the primary aesthetic essence of the experience and do not rather condition a departure from the norm of concrete sensual impression. A connoisseur sees in a painting not only a particular representation, the reproduction of an individual object, a particular figure, or a landscape, but above all a "painterly" achievement, the solution of a problem which is posed by the medium of representation. But such an aspect, which for the expert is still part of the aesthetic experience, invalidates in a more naive, less complex contemplation the homogeneity and the inclusiveness of the artistic sphere.

It is relatively easy to interpret a recognized work of art of the past, to evaluate and to accept it, that is, to go along with the consensus of educated people. The difficulty for the recipient consists in the problem of distinguishing what is good from what is inferior in the chaos of everyday production, of finding the authoritative voice whose leadership can be trusted and finding the right path between narrow-minded and straitlaced conservatives and uncritical hangers-on. The

novelty of an artistic achievement is one of the absolute assumptions for its aesthetic worth; the ability to decide whether it has a claim to originality is one of the most indisputable criteria of aesthetic discernment. Knowing the current values is at best a sign of solid education; the ability to recognize and validate new values is the sign of the true connoisseur.

People who are able to appreciate only the most important artists and accept the most outstanding works are not always members of the group who have the most immediate and personal relationship to art. They appreciate those artists whom their teachers and their textbooks recognize and recommend, but they do not possess a secure criterion of artistic values based on their own experience and judgment.

The creative role of the connoisseur is not simply to know and appreciate new artistic trends, but also to recognize new discoveries, reevaluations, and reinterpretations of styles which are past, are misunderstood, or have become incomprehensible. This role is all the more important, as we said, since the history of art consists of a series of "resurrections," or as we would say today "renaissances," whereby the historian of art and the critic, just like the artists themselves who are involved in the renaissance movements, have to act as midwives.

The creator of artistic values is the originator of the works who meets needs which arise; the creator of artistic reputation is the connoisseur, critic, and interpreter of the products. The artist creates the form of the works, the mediators their legend. Not only are the Homeric epics, the works of Dante, Shakespeare's dramas, the works of Michelangelo and Rembrandt in part creations of their posterity, not only do the creators of Balzac's, Stendhal's, and Tolstoy's novels, of Goethe's, Hölderlin's, and Baudelaire's poems, of Bach's, Mozart's, and Beethoven's compositions become mythical personages, but contemporaries like van Gogh, Cézanne, Kafka, and Proust change into mythical personages before our very eyes. Tahiti has become a place of pilgrimage, and Illiers has become not just a Combray but a sort of Ithaca. This mythologization goes so far that works of art are often no longer judged according to their intrinsic worth but according to the name with which they are labeled. The name in the catalog of an exhibition or in the concert program serves as a yardstick, and if there is a mix-up and the wrong name appears, the visitor to the exhibition or the concert would sooner rely upon what he reads than on what he sees or hears.

In our modern period—so rich in media—the multiplication of technical instruments of mediation between artistic creations and subjects ready to receive them has been as sudden as it has been significant. The different organs of the press, journals, magazines, reproductions

and slides, the phonograph, film, radio and television bring the masses of the public closer to artistic products which are essentially alien to them. This is, however, usually achieved at the price of sacrificing their individuality and personal aura. The instruments of mediation are generally confined to forms of reproductive technique.[24] Out of something which is fundamentally unrepeatable there springs something which is endlessly and changelessly repeated. The mediation which is supposed to bridge the gap between production and consumption intervenes as an insurmountable hindrance to contact between the two. The teacher, interpreter, or critic may alienate the receptive subject from the art object, but he does deepen his involvement in artistic creation. On the other hand the technical apparatus of the film projector, phonograph, radio, or television receiver is, as a means of reproduction, a box of mechanical conjuring tricks—it starts this way and stays that way—which not only is itself dead but also deadens to a certain extent the senses of the listener or spectator and deprives works of their uniqueness.

Nothing expresses the popular concept and the often overestimated role of the mediator between the work of art and the public better than the exhibitionistic participation of the conductor in the work of an orchestra. In the eyes of the concert-going public he is the symbol, pure and simple, not only of a leader in the technical organizational sense but also of a charismatically chosen initiate who more than any of those present is the one who can read the secret language of the composer correctly and can communicate it. Nothing reveals the histrionics and illusion, the mere gesture and the empty grimace of the posing mediator more crassly than the conductor's wild gesticulations. Of course the terpsichorean, the physically demonstrative, the sensually suggestive all belong to the legitimate artistic means at the conductor's disposal, and his exhibitionism—for all its importunateness—serves to bring the composition closer to his listeners, who are also his spectators.[25] The evil actually consists in the fact that he tries to assert himself not only at the cost of his fellow musicians but also at the composer's. In all this we may not forget that romantic and postromantic music is predicated upon the conductor's role as a commander-in-chief.[26]

The interpretation of the formal and ideological factors in art which is intended for the lay public is based upon a specific, though tacit, order to take over this office. Everyone who reacts sensitively and spontaneously to artistic impressions and who is competent to make judgments in artistic matters and in taste fulfills a more or less important role in this activity. In the face of the diffuse and imprecisely defined nature of the intelligentsia this function is based neither on a specific

profession nor on a special qualification, except in the case of special groups like professional critics and men of letters. There is simply no question of a "monopoly situation"[27] like that of the Chinese scribes, medieval clergy, Renaissance humanists, or men of letters of the Enlightenment. Individual critics and interpreters of works of art no doubt enjoy a personal reputation which gives their judgment unconditional authority in what is always a rather restricted circle, but a monopoly situation of definitive interpretation would presuppose a coherence of culture and a consensus on valid criteria the lack of which is most sensitively demonstrated by present-day conditions. However, mediation between the production of art and its consumption is brought about even by the most diverse agencies, and it is far from being restricted to one special group in our present-day society, which is dominated by the idea of mobility. It is, however, also the sign of a controlled and by no means anarchistic situation in which vehicles of rational mediation appear side by side with spontaneous production and reception, in many different forms and with many different effects, and operate in opposition to the complete collapse of artistic culture.

16 Art Criticism

The most important task in mediating between the author and his public falls to the lot of the critic as the professional representative of mediation. He advises the recipient of artistic impressions with what is, supposedly, unconditional authority about the criteria of meaningfulness and quality with which he should approach the objects of his experiences.

In order to exercise the art of criticism there must be a thirst for knowledge in the sense of Baudelaire, who described the aim of his review of a performance of *Tannhäuser* in the following terms: "My delight *(volupté)* was so great and so fearful that I decided to determine the grounds for it and to transfer my delight into knowledge." The meaning of this declaration was obvious: when he carried out his project, he wanted to know more not about the work of art but about himself. And he knew more about himself after he understood the artist and his work better.

Criticism often means nothing more than making people aware of and formulating feelings, notions, and ideas which appear fleetingly in the recipient during the artistic experience and remain unarticulated. But critical analysis actually enters its real element only when it begins to correct the superficial, indistinct, and inadequate interpretation of a work. The function of criticism consists here more in the correct interpretation of artistic creations—which penetrates the ideological background and the decisive problems of life—than in the formation of appropriate value judgments on their aesthetic quality. In an age like the present, when the most significant works of art are the most difficult and the most misunderstood, their interpretation is all the more authoritative when informative interpretation embraces proper judgment;

the judgment itself on the other hand explains almost nothing of its meaning content. Without critics like Winckelmann, Diderot, Lessing, Friedrich Schlegel, Coleridge, Matthew Arnold, Baudelaire, and Paul Valéry, who were first and foremost interpreters and not judges of art, the trend-setting and in part epoch-making movements in the art of their day would probably have remained unknown or misunderstood.

Ernst Robert Curtius, Charles DuBos, Albert Thibaudet, Sartre, Edmund Wilson, and T. S. Eliot and academics like Allen Tate and William Empson still played a decisive part in forming the idea which people held about the stylistic efforts and the artistic means of the most modern literature. They had their knowledge and learning to thank, in the first instance, for their role as authoritative interpreters of works of literature. Yet they arrived at their eminently fruitful method, as it is manifest, for example, in Edmund Wilson's exposition of the story of the wound of Philoctetes or Allen Tate's analysis of the final chapter of Dostoevski's *Idiot*, only by combining their close reading of the texts with their poetic temperament. Yet it was not just a case of formulating the unarticulated notions of the reader or of revealing latent values which were operating in the unconscious, but also of supplementations which were completely authentic though they were not in the text.

A critical observation of this sort represents not merely a "translation" of the works under consideration but their transformation, which for all its originality remains true to the author's conception if not his formulation. However, while a mere paraphrase is not criticism, a translation can become a creative interpretation. A translation which has literary merit is at the same time a fruitful interpretation of the work being translated. It does not repeat something which is already in existence, but creates a new form in the light of which the original form takes on a meaning which had need of a translator in order to become apparent.

Just as in every sphere of human activity, in art criticism it is not values and judgment but instincts and the inclinations and needs which correspond to them which are primary. We can no more start with values in art than we can in any other area of human or social activity; we can only infer them on the basis of needs. These are what first condition those values which only an unworldly idealism sees as heaven-sent. But no matter where they may come from, criticism does not actually bother itself about their possible relation to each other, their congruity, or their identity in different works of art, but rather emphasizes and preserves their individuality and peculiarity. Their unique validity which is tied to individual works of art characterizes

their concrete essence, just as the universal validity of values in other spheres is a mark of their abstraction which is alienated from practice.

Art criticism as hermeneutics is essentially descriptive. The critic points to characteristics of a work which are directly or indirectly perceptible, manifest or latent, and asks, Do you see what I see and what I think? If we see what he means, then he has attained his goal. Without making express judgments he has drawn our attention to the presence of values which have been realized even if they were previously unnoticed, and he has made possible an act of appreciation to which the way was previously blocked. Yet even the most informative criticism does not master the whole task of reception: it merely points to a meaning to which the reader must find his own way. After it has reminded him that a secret is at hand where there had seemed to be an open, unmistakable formal structure, criticism leaves him alone with the work.

There is no interpretation of a work of art which reveals the only possible or only acceptable meaning of the structure; every interpretation only hints at one or another of the possible meanings. The criterion of the acceptability of various interpretations of meaning consists in the fact that they complement rather than exclude one another. If the proper interpretation consisted merely in revealing the author's intention, then there would be only one real approach to every work. This intention is, however, all the less capable of being discovered with certainty, as it is not necessarily known to the author himself. For this reason critical analysis has so much less to do with the psychology of the artist than with the structure of the work, the inner relationships, and the reciprocal functions of the elements of the work. Compared with these relationships, all extra-artistic assumptions about creativity lose their meaning for the critic who is concerned with formal quality. The work of art as a formal structure preserves, as far as he is concerned, total autonomy and immanence.

Critics as mediators between the artist and his public are certainly indispensable; the only thing is that the general idea of the role they play is least in accordance with the real facts. The most important works of art seldom work of their own accord and are those which call most frequently for explanation and interpretation. Mediocre artistic products, the works of mass art and the entertainment industry are on the other hand those which have the most immediate effect and owe their popularity precisely to directness of effect. The critic as interpreter owes his existence to the alienation and antipathy, and not to the sympathy, which most people bring to the great works of art.

The critic is the man of letters par excellence—the literary specialist. Hand in hand with publishing houses, journals, and newspapers, which

intrude as the organs of mediation between artistic production and consumption, there comes the professional critic, the expert who stands for universal, though historically conditioned, standards of value and develops and validates the principles of taste for a particular time.

The ideal critic is by no means always the ideal judge of art—and it is not necessary that he should be; where possible, however, he must become the ideal reader, who is capable of recognizing and making others recognize what is in the work. Sainte-Beuve already established this principle and formulated it most convincingly in the well-known dictum, "Le critique n'est qu'un homme qui sait lire, et qui apprend à lire aux autres."[28] There is no critic just as there is no person who is historically limited and restricted, to whom all the characteristics of a cultural picture are visible at the same time or with the same precision—not only because they are not all defined and present from the beginning but also because they are only revealed according to the historical situation in which the artist finds himself. However, not all contemporaries or all authoritative critics of the same generation are capable of seeing everything from the same perspective; the same critic does not always judge in the same sense. "A critic is a reader," says Friedrich Schlegel, "who chews cud. He ought to have more than one stomach."[29]

The feeling for quality and the ability to judge works of art according to their aesthetic quality can never be absent in a critic, but they are not among the most indispensable prerequisites for the fulfillment of his task. Of greater importance is the correct interpretation of the meaning content of an artistic creation even if this sometimes means that he will set too high or too low a value upon its formal quality. An overestimation of this sort took place—after all the philosophical implications had been taken into account—of the works of James Joyce, Franz Kafka, and Samuel Beckett; an underestimation—because of the lack of philosophical importance of the works in question—in the case of Victor Hugo, Tennyson, and Dickens.

The appropriate interpretation of the meaning content of works of art is a question of intelligence, maturity, experience of life, and the proper assessment of problems of existence, social points of view and humanitarian problems. The ability to judge formal aesthetic values is a question of feeling for quality and the sensibility which underlies this. The two aspects and abilities are completely distinguishable, but they are by no means independent. There exist between them an interdependence and reciprocity, but they cannot be reduced to the same principle.

A certain degree of sensibility is the prerequisite for solid taste and artistic judgment. The two gifts belong together but are not identical.

Taste is the more complex category, sensibility the more original datum. A fruitful change of taste presupposes a refined or more coherent sensibility which embraces a whole series of qualities at once. Where there are defects of sensibility, a certain brutalization of taste results. How can we judge sensual impression if we are "hard of hearing" or "short-sighted"? Of course, sensibility is not a purely natural, merely physiological or psychologically conditioned capacity, but an ability which develops historically and which makes cultural differentiations. A person who is essentially less sensitive can be a more suitable critic of an artist than one who is more sensitively attuned to him but whose cultural roots lie elsewhere.[30]

The discipline of thought is artistically just as unfruitful without the opposition of a sensibility which asserts itself irrationally as sensibility and sense of quality are without training in reason and concern for valid conventions and traditions. The sensibility of which we are talking has, to be sure, nothing to do with emotionality, feeling, or sentiment. There are people who compensate for their lack of feeling with a preference for sentimental art and others who, because of the genuineness and directness of their own feelings, find all sentimentality repellent. The question is, however, by no means one of whether the emotional or the intellectual reaction to works of art is the right one; the "right" reaction always results from a form of dialectic of both.[31]

The doctrine of the New Criticism of which so much was heard in the forties, especially in America, drew our attention to shortcomings in romantic-historical and impressionist-subjective criticism which had already been noticed and censured in other countries, especially Germany. The disciples of the New Criticism emphasized above all that the psychological effect of a work of art is no more conclusive for its aesthetic quality than its psychological origin. What they meant by this was that the structure of a work of art can be just as independent of the author's intention as its qualitative worth is from the emotional effect it makes upon the recipient. The fatal mistake was that they did not make a proper distinction between genesis and value, between psychology and sociology, and regarded everything which lay outside the formal immanence of the work as irrelevant.

In the urge toward cultural integration people have termed the differentiation between belles lettres and criticism a "regrettable" division of labor, in spite of the significance ascribed to the different points of view. They also termed poets and critics in relation to one another "alienated" specialists, as if there had, in the past, been something like a universality of literature in which inner-directed literature and extrovert criticism formed a homogeneous unity. In periods before humanism and the Enlightenment when the world of letters was divided

professionally there was no literary criticism in the strict sense of the word at all. It started out fresh in the Renaissance and the Enlightenment. It can therefore scarcely be held that in the new industrial society the writer (as critic) made a profession out of his inwardness.[32] The whole thesis is nothing but a part of that one-sided social criticism which is oriented toward the mystic concept of the division of labor. A real division of labor which corresponds to the facts results from the literature of art criticism itself. In this—with the development of the world of letters since the Enlightenment—different branches of criticism became specialized and the academic practice of art historians and university teachers was separated from the reporting of literature, film, concerts, theater, and art exhibitions in the daily newspapers.

Between the journalists who developed this sort of activity and the truly creative art critics there exists, as Henry James suggested, no similarity at all no matter what its nature.[33] They differ in the tone in which they write. The one shows frequent crudity and petty desire for revenge, the other usually—though there are exceptions to this—objectivity. They differ chiefly, however, in that the periodic reviews of artistic happenings are designed above all to inform and orient and to draw the public's attention to processes in artistic life which would otherwise go unnoticed, whereas the academics who are themselves also creative critics strive to create an independent literary genre with its own intrinsic value. But although in this way a sort of division of labor takes place within criticism, neither of the two areas is completely dominated by the urge to subjective expression or objective factual account.

Both types of criticism are by-products of and their representatives are accomplices—who receive indirect subventions—of the forces who are interested in preserving the social status quo. The dependence of newspaper critics upon the system they serve is more apparent; that of academic critics upon the establishment which decides who is to fill university chairs is more veiled. Yet this in no way prevents journalistic criticism from being often more impressive and influential than academic. The reviews of an Edmund Wilson are not only more original and more fascinating but also more effective and authoritative than the blustering outpourings of most of his rivals.

Imaginatively, creative criticism reveals as much about the critic as about the work being criticized. It is a confession, the expression of personal perceptions, ideas, and illusions, just as original literature is. Essentially first person, expressionistic criticism is shown to be just as inadequate as purely impressionistic and descriptive criticism. The chief task of authentic critics practicing their own profession may be the interpretation of the works being reviewed; nevertheless, the pass-

ing of value judgments upon artistic quality is one of their obligations. Criticism which avoids value judgments as a matter of principle and merely makes subjective interpretations was the product of a time when there were no binding norms or any universally recognized needs. Its role was played out by the end of the impressionist-expressionist period.

Normative criticism of art conforms to objective criteria without necessarily lapsing into an ahistorical supertemporal dogmatism in the process. A balance between relativism and dogmatism which is constantly in progress characterizes the dialectical process in which it is involved. The critic always judges the work of art from a sociologically and psychologically determined perspective: but his judgment no more disappears as time passes than does the work of art itself. It corresponds to the demands of the day but is not necessarily more ephemeral, and it retains its relevance not only as a document of passing time but also as the seed which in the right circumstances will flower again.

Criticism occupies a special place in the processes of questioning which revolve around artistic creations. It is concerned with the immanent meaning and the unmistakable quality of individual works, what they actually are, and what they ought to be for the recipient. Aesthetics are concerned with the definition of the peculiar constitutive categories of artistic objectivity, the history of art with the sources and reciprocal influences of various artistic movements and trends, the essay with philosophical and ideological questions deriving from the work of art and often only associatively dependent upon it. The critic always interprets and judges the particular individual work; the art historian views difference in style and the whole phenomenon of the change of style. The aesthetician seeks to work out the structure of art in the whole of its different genres and elements, and the essayist tries to do justice to the wealth of relationships which an artistic creation has to the beholder, for whom art and life are inseparable.

"Criticism is at once an experiment with the work of art," said Walter Benjamin.[34] This definition brings the critic closer to the essayist, who does not set himself any hermeneutical or evaluatory tasks but seeks a form of expression which serves the work of art as an opportunity of and a pretext for talking on and on. Criticism may not go this far, but it is not concerned with a doctrine which can be proved or with a completely unequivocal judgment. In praising or finding fault with a work, the critic often indulges in an indirectly motivated declaration of love or in an outpouring of concealed *ressentiments*. He talks about what he likes in the works or what he would rather have seen formulated in a different way, takes one or another motive as his starting point, develops, enriches, and varies it like a musical theme.

Different critical observations about the same work are actually related to each other more as variations than as competing solutions of a problem. They can best be compared not as more or less correct, apposite, or authoritative but as they reveal a greater or lesser number of instructive characteristics of the work in question. Whether we are dealing here in general with an objective, rationally indisputable observation or rather with a point of view which lies on the border of truth and fiction, theory and practice, remains an open question. Authentic criticism certainly conforms in part to the principle of control, but it is equally certain that no work of art can be entirely nonsubjective, removed from its time, eternal, and definitive. Every criticism is essentially contemporary criticism which is based on the standpoint of the conditions obtaining at a given time. For this reason the opinion of a critic who sticks to contemporary problems, aims, and stylistic trends is of greater relevance to his contemporaries than that of an observer who is essentially more important, more thoughtful, and more capable of judgment, but who is concerned with concepts of style, principles of form, and criteria of beauty which belong to the past.

Of course, it cannot be determined without more ado to what extent professional criticism, in addition to the other forms of influencing the public—direct propaganda and the private spread of acceptance or rejection—is responsible for the final success or failure of the works in question. There is justice in the view that judgments we hear from friends and acquaintances have a more decisive influence on the chances of a play's or a film's success than the newspaper reviews we read. The most authoritative and fruitful criticism is usually anonymous. Its genesis and development are spread over the whole public which has to be taken into consideration, and the verdict represents the quintessence of public opinion of the different people interested in the works. Like every other form of a group's intellectual testimony, it is not a spontaneous collective achievement, but an attitude which is always conditioned by single individuals, by sociohistorical conditions, an attitude which emerges dialectically and is in a constant state of development and change.

If the first step in criticism is directed toward interpretation of the conscious intention of the author, there follows a more decisive one— that of searching out motives for which he can only partially account or for which he cannot account at all. The difficulty of the task lies in the discovery of hidden and apparently inextricably complicated motives of artistic creativity, of their enigmas, their ambiguity, the solution of the problem in the determination of the secret constituents of the effect. If there is a secret at the root of everything which is

genuinely artistic, then all informative criticism makes us clairvoyant and very quick of hearing.

The theory of criticism in the sense that it reaches behind the intention of the artist and discovers motives which not only go beyond the conscious intention of the author but even assert themselves in antithesis to it is based mainly on Marx's ideological doctrine and Freudian psychology—in short, on the view that art like so many other human manifestations contains more than its representatives know. The most simple linguistic expression or hint, a mere gesture or expression contains meanings and indications which can be interpreted in different ways. The poet always allows a number of these hidden allusions to intrude into his express communications, but suppresses and neglects many others. But even the meanings of the effective expression which are thrust into the unconscious play a more or less decisive role in every poem, and the analysis of the contexts of meaning which are concealed in this way is one of the most important parts of hermeneutic criticism.

It is only since the development of revelatory psychology in the last two centuries—chiefly since the revelation by Marxism and psychoanalysis of the unconscious drives which govern our inclinations, judgments, and actions—that it has become customary to talk of "creative criticism" and to free ourselves from the naive acceptance of literary findings. In this sense Wilhelm Dilthey distinguishes in his hermeneutics between an "analytical" and a "descriptive" psychology and demands of a fertile literary criticism that "it understand an author better than he has understood himself."[35] George Bernard Shaw declared accordingly to Bergson, who was protesting Shaw's exposition of his work, "My dear fellow, I understand your philosophy much better than you do."[36] Unamuno, too, maintained that Cervantes was incapable of understanding his own hero.[37] The well-known saying of Max Liebermann also belongs in a way to this sort of statement; Liebermann, replying to the objections of one of his clients about a portrait, answered, "The picture is more like you than you are yourself."

As far as the objectivity and the truth content of art criticism are concerned, Oscar Wilde was completely right when he said that nobody bothers any longer whether Ruskin's judgment of Turner was objectively right, and nobody bothers their head any longer whether Leonardo ever thought about what Walter Pater read into the *Mona Lisa*. What really counts is that the picture gained a further meaning through him: and Wilde draws the conclusion from this that it is the artist "as critic" who invents the innumerable meanings of beauty.[38] Whether Ruskin was right about Turner was only important for their

contemporaries, and whether Leonardo was concerned with ideas which Walter Pater ascribes to him is only important for the history of art. For even if Ruskin and Pater err objectively, their art criticism does have its own validity beside the state of affairs represented by the artists. It is creative in the sense that it adds a new dimension of meaning to a work with every new layer which it discovers in the structure of a work, thus adding a sense unknown both to the author and to earlier critics.

Critics like Diderot, Dr. Johnson, Lessing, Sainte-Beuve, and Matthew Arnold were still concerned with the exegesis of the concrete contents of works; they wanted to ascertain what was really present in artistic creations. Romantics like Friedrich Schlegel or Coleridge and the precursors of impressionism like Ruskin, Walter Pater, and Oscar Wilde on the other hand saw beyond the structure and discovered contexts of meaning, elements of form, and complexes which were not present in the works they were discussing and had first to be guessed at and formulated by them. They were far less interested in the objective nature of works than in their own "impressions," for the goal of criticism as far as they were concerned was, as Wilde finally declared, the registration of processes on the soul of the receptive subject.

Like the whole theory of the creative quality of criticism, the idea that the critic is the actual artist, especially, goes back to the romantics and mainly to Friedrich Schlegel. The doctrine of the primacy of art over nature and the precedence, for example, of a good painter's landscape over its original together with the conclusion that natural beauty lives on art like a parasite just as art does on criticism was faithfully adopted and developed by the later impressionists, primarily the Goncourts.[39] Oscar Wilde's dictum that it is not art which imitates life but vice versa is the well-known formula on which this view of art, which depends on the concept of reception and criticism, is based. But art, too, which is supposed to be so imitated by life, like criticism, from which art—in its diversity and depth—is supposed to be derived, is only a copy and not an original. Both of them are, as it were, metaphors—bound to something primary and would be inconceivable without a firm, binding objectivity, although the objects as they are represented by them would not be available anywhere without them. Every artistic representation just like every concrete idea is, in this sense, metaphorical: none is a mere imitation of naked reality. Each is a new peculiar structure, an autonomous form, which it is true does relate to an objective reality but is never enough like it to be mistaken for it. Thus, the completion of the act of creation in the receptive experience is also never the true reproduction of the conception which

the artist had in mind and which the critic wishes to communicate—especially because the subject who empathizes with the work and who is completing it is no longer of the same nature as the artist accomplishing the act of creation, but also because a common psychological denominator cannot guarantee an identity of results in this sphere of sociohistorical processes.

A critic like Sainte-Beuve, for example, still believed that he could find the authoritative explanation of the quality of a writer's work in his character and fate, and so he was more interested in psychological and biographical questions than in textual, hermeneutic ones. But he generalized on the basis of insufficient material, just like Lombroso, who said that art had its origin in a form of psychosis, or Freud, who taught that it was to be derived from a form of neurosis. The allegory of Philoctetes' wound belongs to this type of explanation, according to which we have to reckon that for every talent there will be an inadequacy, a susceptibility, and an affliction. None of these explanations, no matter how often they prove true, reveal the whole truth. All leave open the question of why it is always a relatively small number of sick, crippled, melancholy people who are artists, and what is the principle of selection.[40]

The objection—both the psychological and the social one—to the genetic method which is generally raised amounts to saying that it generally neglects or disparages artistic values as such. However, it is a question, so it is said, more of the unequivocal presence and the unmistakable meaning than of the origin of these values. Nonetheless, the question arises whether they can be conceived of and whether they have any meaning as independent immanent phenomena closed off from the outside. For apart from the fact that they would never come into being unless there were corresponding needs, they would never assert themselves if they were not directed toward a goal outside their immanence. It is in this way that we have to understand a passage in a lecture by F. R. Leavis: "I do not believe in 'literary values' at all, and you will see that I never talk about them; literary critics' judgments are judgments on life."[41]

The part the critic plays in the aesthetic education of the public is obvious; what is questionable, however, is whether he exerts an educative influence upon the artist and influences the direction of his creations. The artist scarcely ever becomes converted by criticism into a new artistic volition. Yet criticism is also least intended for the artist, and when it addresses him with objections, advice, and directives, it is generally found to be superfluous. What is above all untenable is that the artist should be called upon to play the role of a competent critic of his own works. He is in no way capable of doing this because

he has produced his works himself, and his ability to produce works of art embraces his competence to evaluate them adequately. His particular interest, his prejudices conditioned by rivalry, and his one-sided sensibility may even impair his competence and his judgment. Apart from the fact that criticism practiced by an artist generally not only is limited by his own artistic volition but also has its origin in envy, jealousy, and *ressentiment,* the most serious objection to such criticism is that, as Winckelmann remarked, it makes the overcoming of technical difficulties a criterion of artistic worth and neglects the significance of effortless creativity.

Poets contribute most impressively to communication between art and the public by the myths in which they clothe their own person. Not only do they allow artists like Dante and Vergil to appear in allegorical form in their works, but they try, certainly after the romantics, to replace saints, heroes, and rulers by poets and people with artistic natures like Novalis by "Heinrich von Ofterdingen," Keller by "der grüne Heinrich," Proust by "Marcel," and Thomas Mann by his thin-skinned bourgeois.

The self-examination to which the artist subjects himself in the course of his work forms an indispensable part of his activity, but it cannot be called "criticism" in the real sense of the word. All the two functions have in common is the characteristic of being conscious of operations dependent on art. The act of consciousness, however, with which the artist accompanies the spontaneous moments of his creativity is far more pertinently designated as a form of inner censorship, an inhibition raised to the sphere of consciousness than as an essentially objective, autonomous, and independent criticism. Artistic creation consists in considerable measure of conscious manipulations which assert themselves as the rejection of certain technical methods. The consciousness of the process finds its limits in the moments of the creative act which assert themselves as spontaneous, just as the consciousness of actual criticism independent of the artist is limited by the innervated elements of tradition and convention which have grown to be second nature.

No matter where we actually see the task of art criticism as lying, whether it be in explanation, interpretation, or judgment of the works in question, it is not restricted to judging the artist's technical problems but consists far more in the feeling for what is artistically significant, special, and original. Openness toward novel artistic effects and the ability to distinguish what is outstanding, what is inferior, and what is more or less successful among novel artistic achievements are the criteria by which we recognize the authentic critic. And if it is perhaps going a little too far to say that every important art meets first of all

with public misunderstanding and resistance, the only important exception to this rule is still Shakespeare. But even his art is not nearly as novel as it is important. A number of extra-artistic, even anti-artistic moments played their part in Balzac's or Dickens's success, which seems to contradict the rule, and as for Byron, for example, he no more belongs among the great poets than *Werther*—in spite of its enormous immediate effect—does among Goethe's most important works. So the assertion that a fundamentally new and as such basic trend in art has a confusing effect and that generally speaking we stand helpless in the face of it *is* true. The first impression it makes is that we are being addressed in an alien, indeed deliberately bewildering and confusing idiom. The "language instruction," however, which the critic gives us is linked to a double danger; either we persist in using a secret language which is only for the "initiated," or we change the language of art into a common tongue, in the process of which its content is diluted and its originality sacrificed. In both cases, the critic loses his influence as mediator, teacher, and judge. Instead of creating a foundation upon which—in the light of the new art—he can explain and affirm the laymen's ideas which have grown turbid and shaky, he either becomes the spokesman for an avant-garde in which both he and they are not understood or he betrays it.

Where it is a question of known and recognized unproblematical and unquestionable works, the mediation accomplished by the critic can be carried out by the aesthetician or the art historian. The judgment of quality and of the importance of novel creations lies nevertheless with all its weight upon the critic, and the responsibility connected with it grows less only when the validity of standards is, as Johnson said, "secured by their long and continuous recognition."

The mediation between artistic production and reception peaks in the legend in which art and the artist clothe themselves when they become the object of the respect accorded them by the critic. At this point we no longer have to depend strictly upon given persons or artifacts, but we may accord intrinsic value to the structures into which they have changed. After Friedrich Schlegel stated that the "true reader must be an extension of the author" and Matthew Arnold maintained that it was the critic who determined the intellectual atmosphere of a particular century, Oscar Wilde only had to take one more step to place the critic above the artist. This preeminence of criticism over the work of art led finally to the readiness to put up with a surrogate for the original and to come to terms with a guide where the thing itself has become unapproachable. People would rather read what was written about books and writers and hear what was said about music than experience the works themselves.[42]

Fetishism usually indicates a depravation of reality. Art criticism, however, is most fertile where it produces fetishes and idols. The full greatness of masters like Dante, Shakespeare, Michelangelo, Rembrandt, Goethe, and Tolstoy is only revealed in their legend, the image of them which with its many aspects succeeding generations develop into a rounded whole. Such a legend is generally the work of a long posterity, but sometimes it starts to grow in front of our very eyes. People who yesterday were still called Proust or Kafka are today the personifications of the magic power which underlies their works. The most trivial facts about their lives become elements of that aura which surrounds them. Not only Botticelli's figures but even the songs of Reynaldo Hahn are roused by Proust's grace to a new life. Completely indifferent things gain a new value and charm because he loved them and because they belong to his myth. A fetish is, however, only a fiction, and the following story shows what blind belief in an object which has become a fetish can degenerate into. In the year 1837 a Beethoven trio and one by someone called Pixis were both to be performed. However, on the program the names of the two composers were reversed and the audience, which consisted of cultured—by no means musically unschooled—people, heard the work by Beethoven— which they thought was by Pixis—without the least emotion, but applauded heartily after the piece by Pixis ascribed to Beethoven.[43]

The age of art criticism in the actual meaning of the word begins when men of letters as members of that privileged stratum which have the task of judging, justifying, or rejecting artistic products assert themselves on their own authority independent of poets and artists.. The change comes about mainly as the result of the fact that the period of the Enlightenment is the "critical" age pure and simple, and the political change which is being prepared creates a favorable situation for professional criticism from the outset. At the beginning of the century the public's chief judgment of art criticism was still reproof of the malice and the frequent incompetence of its representatives. Even Swift and Pope still found a lot to find fault with in this direction.[44] Addison, however, who was himself the publisher of an important critical journal, sees things in a different light, and about the middle of the century—under Johnson's stimulus—the view starts to gain currency that literary criticism is one of the most ifluential methods of education in the nation. There develops first—still partly in the sense of the feudal ideal of culture—the idea of the critic as one who fuses the merits of the scholar and the man of the world and who has the task of training competent readers who are sufficiently well informed to be able to approach the reading matter which is placed before them. Finally, with the indispensability of book reviews in

journals, the concept of the professional critic is formed, and when its effect can no longer be mistaken, the consciousness of its role as propaganda in political and social life also develops. Criticism now belongs to the advertising apparatus of publishers of books and newspapers, governments, parties, classes, private interests, and cultural strata. The corruptibility of its representatives gets to such a point that they often no longer represent the interests of the group to whom they belong ideologically and with whom they should identify in the long run, but represent the goals of those who are in a position and are ready to make a better offer overnight.

In publishing and the press, the critic—in spite of his apparent independence, even his dictatorship—assumes the function of a handyman. He belongs to the establishment and fulfills, as the guardian of *idées reçues*, a vital task in the preservation of the dominant system. Meanwhile, he commits the most serious sins against the Enlightenment's principle of freedom of thought and conscience. He leads once again, as his predecessors did, a parasitic existence on what is present and apparently secured, speculates on man's intellectual idleness and tendency to conservatism, and instead of being in the vanguard becomes the enemy of progress.

The growth of the function and reputation of the critic is a sign not only of the commercialization of the press and the indispensability of art and literary criticism as one of its attractions, but also of the democratization and leveling out of the public. Tied in with this above all is an extension of the circle of readers and a raising of general cultural needs. There are more people interested in art and literature and people are more interested in artistic products of a higher sort than ever before. The democratization of reading and of criticism does not, however, necessarily lead to its liberalization and progressiveness, and subsequently this is less and less the case. Sainte-Beuve, one of the most typical representatives of journalistic criticism and one who had more followers than any professional critic before him, is at the same time the exemplary representative of conservative criticism, who allows himself to be driven by public opinion instead of guiding it. The bourgeoisie which created modern avant-garde criticism in its romantic-progressive youth professed—in its conformist-accommodating maturity—a reactionary, romantic, classical, academic journalism, which Sainte-Beuve represented. The literary critical feuilleton sacrificed its original flexibility but strengthened its nature as political and social propaganda. The extra-artistic conditions of criticism were never more evident than at this time of change. It was only after bourgeois "salon romanticism" and neoclassicism had died away that it regains its former malleability. Wordsworth, Coleridge, Keats, Shelley, and

Tennyson now receive the most diverse criticism—just like most of their French and many of their German contemporaries—in accordance with the sentiments and point of view of their critics. Jane Austen suddenly disappears into the background and then comes back into the foreground of attention, while Dickens's posthumous fame moves in the opposite direction. Dickens's popularity, his undeserved disparagement, and his repeated recognition follow immediately upon each other in a sort of spiral, which surrounds its object and becomes visible from a constantly shifting standpoint rather than revealing itself from an ever higher level.

For these reasons wrong judgments in the history of art, in spite of all critical progress, do not occupy less room than apposite judgments, nor does their number decrease with time. Johnson failed to recognize the greatness of Donne, Milton, and Swift, just as Goethe underestimated the importance of the whole German romantic movement including Hölderlin, Kleist, and Novalis. Yet at the same time he greatly overestimated Byron and considered Béranger and Delavigne to be no less considerable poets than Lamartine and Victor Hugo. Matthew Arnold had little time for Coleridge, Shelley, Keats, Tennyson, or Swinburne. Sainte-Beuve condemned Balzac, Stendhal, Flaubert, and Baudelaire in the most naive manner. Gide, as a reader for Gallimard, is known to have advised against accepting Proust. F. R. Leavis neglected the French novel and was not especially enthusiastic about the Russian, with the exception of *Anna Karenina.* Contemporary critics failed to recognize, almost without exception, the significance of the end of *L'éducation sentimentale.* Referring to the indecent passage which the good-natured Princess Mathilde praised with unconcealed enthusiasm, the "diabolical" Barbey d'Aurevilly wrote that Flaubert was polluting the brook in which he washed himself.[45] And the similarly masterly, perhaps even more magnificent, ending of Dostoevski's *The Idiot* had to wait for Allen Tate to find an appropriate interpretation.[46] Yet, as sad and often as fateful the false judgments and neglect of the critics may be, they do not in principle alter the correctness of Matthew Arnold's thesis that it is they in the first place who determine the intellectual atmosphere of a period.

Even in the classical century in France—one of the periods of Western culture most fruitful in literature and most competent in criticism—writers are not ranked at all according to their artistic merit. Nevertheless, the critic Boileau communicates a more correct idea of the spirit of classicism than does, for example, the poet La Fontaine, the dramatist Racine, or the philosopher Pascal. The courtiers of Versailles would hardly have counted these unanimously and unconditionally as the greatest representatives of their time and would probably have

preferred a Quinault to a Racine and a Benserade to a La Fontaine and probably would not have regarded Pascal as an immortal of the *grand siècle* at all. Even such cultured and judicious readers as Saint-Evremond and Mme de Sévigné did not find any particular pleasure in the works of Racine. Only Boileau, the critic, who did not enjoy any particularly unopposed repute in his time, recognized the importance of the works, which are still today regarded as models.

Even in the tolerant eighteenth century *Manon Lescaut* and *La nouvelle Héloïse* were condemned for their "immoral" tone. Even Voltaire—by no means a puritan—found nothing to recommend in these works and rejected Rousseau's novel, especially on the grounds of the "vulgarity" of its author. Of the more well known lyric poets of the romantic period, the most insignificant ones, Béranger and Délavigne, were the ones who were held in the highest esteem, and of the poets and novelists of the Second Empire many of the greatest— Baudelaire, Stendhal, and Flaubert—were treated the most perfunctorily. In spite of his greatness, Balzac did save his problematic taste and Flaubert had the cause célèbre about *Madame Bovary* and the fact that he like most of his readers was a rentier to thank for his not having so large a following. It would have been almost impossible to set anything before this public—which acted and behaved in such an ideologically consistent manner, conscious of its class, yet all the more confused because of that—which it would not have swallowed. No more talented writer was completely ignored no matter how deeply he himself despised his readers, but none of them received—no matter how important he was—the praise he deserved. The official criticism of this intimidated and most impudently criticized public was on one hand more impatient, on the other more tolerant, than the class whom they served. It supported the principles of taste in which they saw the guarantee of the continuation of the existing system.

The generation of French writers born about 1870 produced, with Gide, Valéry, DuBos, Sartre, and Merleau-Ponty in the van, a group of critics who not only did not fail to pay attention to any important literary happening but also were scarcely guilty any longer of Sainte-Beuve's lack of sensibility. Reviews of artistic happenings intended for the literary public were transferred for the most part from the hands of journalists into those of academic teachers and of critics who were working more for the journals than the daily newspapers. As this was happening, the number of people who read art and literary criticism declined while the number of those who found advice and guidance in other information media—radio and television, advertisements and placards—increased. Criticism has never been plied so enthusiastically as it has from the moment when people recognized that a new art uses

a new language which has to be and can be learned, but its reputation was never lower than from the moment when people found out that a radically new art finds as little favor among critics as among laymen. Even the impressionists were rejected equally violently by both sides, and writers with avant-garde tendencies like Joyce, Kafka, or Samuel Beckett were catechized as closely as Baudelaire, Rimbaud, or Mallarmé before them.

Immediately before and after the Second World War, expressionist and surrealist movements in art became generally more accessible. But in the fifties and sixties the gap between past and present grew larger and art took a more strongly antitraditionalist turn than it had since the end of antiquity or the Middle Ages. Beside the complex, antiromantic, and antinaturalist offshoots of expressionism and surrealism, the savage, despairing, unarticulated outbursts of artists alienated from themselves and from society, the frighteningly regressive babble or roar of the mass neurosis known as "pop art" forced people to take up a new critical standpoint.

The formalistic view of art, which had since the Renaissance largely been the standard by which artistic products were judged, especially their immanent values and those which concerned coherence and proportionality, now proved irrelevant. Art criticism was now directed less toward the meaning and structure of individual works and more toward the problem of the position of art in the whole of existence. And if the thesis of the primacy of criticism over art cannot be sustained, at least art changes itself into a criticism of art and places the whole of the justification of its own being in question. Many modern novels, especially since André Gide, and a considerable part of modern poetry from Mallarmé on revolve around the description and analysis of the way in which, in the present circumstances, novels and poems are created, and they pose either directly or indirectly the question of how much longer they can count upon being created.

17 Institutions of Mediation

The institutional arrangements for mediating between the production of art and its consumption which form more or less well traveled paths of communication in contrast to the improvised vehicles which operate as the case may be represent, as it were, the network of the mobility of the sociology of art. These institutions, like the courts, salons, coteries, *cénacles*, artists' associations and colonies, workshops, schools, academies, theaters, concerts, publishing houses, museums, and exhibitions, and the unofficial avant-garde and secessiomist groups which are constantly being replaced find compensation for the disadvantages of conventionality in the length of time they endure. They form the tracks upon which artistic development moves and determine the direction a change of taste will take. They make it most clear that the artistic act of creation, like the receptive experience of art, is a social process and that the content of a work of art is not poured straight out of one mould into another from one individual to another, but passes through a number of both personal and objective stages before it finds approval.

Institutions like the theater, the concert, and the publishing business, museums and exhibitions, journals and the daily press which seem—as means of communication—to be ready-made for those who seek a connection with the world of art are in fact just as much in a constant developmental process as the contents of the communication which form their substrata. The theater, for instance, not only changes with drama but is, at the same time, the dialectical counterpart of dramatic literature. They condition one another reciprocally so that neither form precedes the other and neither claims primacy over the other; rather, they achieve their full sense and real meaning only in relationship to

489

one another. It might be conceivable that an instinct for buffoonery, an urge to make-believe and exhibitionism preceded interest in dramatic actions, complications, and conflicts, but we would have to ascertain that even the most primitive theatrical offering was based upon a dramatic situation, even if this was sometimes expressed as a monologue. Thus, it is the fact neither that the dramatist is in possession of a theatrical apparatus from the very beginning nor—as Bertolt Brecht would have had it—that an apparatus of this sort should possess and dominate the dramatic production which feeds him his material. No one disposes of the other freely and without opposition. Dramatists and composers no more use an apparatus consisting of the stage, directors, and actors or orchestra, conductor, and soloists "over whom they no longer have control" than the apparatus uses them and subjects them to its mechanism. The institutions of mediation are, as vehicles of reception, neither "for" nor "against" the producers. It is true that they are always instruments which are available in a certain state, but what they do is dependent not only on their objective nature but also on the manner in which they are used and on what forces oppose them.

The audience for the theater or for a concert is a product of the works whose performance they attend, whether they applaud or reject them, and of the authors, who release different potentialities of reaction in one and the same audience. While the public is to this extent the product of the artist, the work is at the same time a creation of the public. The influence is reciprocal and the resulting social process the common result of the presentation and its reception. Under the one aspect it appears as a concrete artifact, under the other as a subjective disposition, an individual or a unifying collective attitude. Stimulus and reception move in the framework and according to the measure of this relation. They are, the one and the other, now the river, now the bed. The bed of social relationships seems to be the more objective, the more factual, and the more stable, the river of personal initiative the more active and spontaneous element. If we stand on the riverbank, the river moves; if we are carried along by the stream, the landscape on the bank changes. The one element becomes stable while the other becomes more fluid.

There is no form of art in which reception takes place without a special institution which serves that reception. Plays are not performed without actors, musical works without an orchestra, choir, or soloists, and without these they only become an experience either as an exception or to a limited extent. And just as a play needs a director and actors, a musical composition a conductor and musicians, so a ballet needs a choreographer and dancers for its realization. Even the enjoyment of literature presupposed personal mediators for long periods

of history. Up to the time when the printing press became predominant and books were distributed for solitary and silent reading, the reception of literary products was bound up with a social framework with external mediation and with the institutions connected with it. It scarcely ever takes place without a reciter, a singer, or a narrator and a social circle which is prepared to take care of them. In all these cases it is a question of a collective process with divided functions which seldom permit the duties to be united in one person.

The earliest social institutions which supported art are the royal courts—anxious for pomp—and the seigneurial households of early historical periods, the temple and palace economies of the Ancient Oriental priesthood and of the dynasties which were allied to them, which—as centers of culture opposed to individual caprice—form conservative institutions based on authority and preserving tradition. The decisive break in function between this institution of mediation, with its fixed traditions, and a more liberal practice which is more uninhibitedly suited to individual tendencies and which is more flexible comes about when the centers of culture move from the royal courts to the salons. These salons—with the exception of individual chivalric courts in the Middle Ages—appear more frequently at the beginning of the Renaissance, and their mediating influence on the relationship between artist and public on one hand and different trends and individual representatives of artistic production in the seventeenth and eighteenth centuries on the other becomes decisive. The forms of coalition of late medieval urban life, especially the guilds, the urban corporations, and the confraternities, lead from the beginning—with their special artistic problems and criteria of taste—to a far-reaching differentiation and relaxation of the forms of mediation between the producer's artistic volition and the artistic experience of the recipient. The more sharply the new citizens divide up into different property and cultural groups, the more ramified and ambiguous becomes the group of those interested in art, which is fundamentally heterogeneous although more and more obviously emancipating itself from the aristocratic norm, even though the process is not a continuous one.

The public for art and the process of the sociology of art are no longer completely unified, even in periods in which the process of the urbanization of art is interrupted and a culture develops which is for the most part homogeneous, as was the case with the ancien régime in France. *La cour* and *la ville*, royal, aristocratic Versailles, and the Paris of the haute bourgeoisie cannot be confused as far as their ideological and artistic attitude is concerned, however numerous their points of contact may be. Above all, the courtly society removes itself from its classisistic dogmatism and moves in the direction of the literary

salon. The salons for their part then give up their still somewhat one-sided protectionism and make way for free art criticism and the open art market.

The shift of the centers of mediation in literature from the permanent patron to salons, journals, daily newspapers, and publishing houses has its counterpart in the fine arts in the development from production in the service of a seigneur and a patron to production for people of differing interests and for occasional clients, and to exhibitions and auctions organized for a public which is more and more heterogeneous in its composition. The biennial salons of the Ecole des beaux arts at first formed a strict academic institution just as the literary *alcôves* were little unofficial academies. Both structures grew democratic with time, but they preserved—even increased—their institutional, pedagogic role of loyal mediation between the productive and the receptive elements of artistic practice. Of course, from the beginning they carried the seed of innovation within themselves. The temple and palace industry, the monastic studio, the stonemasons' lodge, the guild workshop, and the *botteghe* were still first and foremost concerned with mediation between different generations of artists. It was only the academies and exhibitions, the salon criticism and the free art market which became effective mainly as institutions of mediation between the different strata of society achieving artistic influence at the same point of time in history.

In the theater and the concert, the role which mediation plays in the experience of art is most apparent, and it is as the vehicle of understanding not only between the work presented and its reception, the ensemble presenting it and the audience, but also between the different strata of the two groups. It is here, too, most evident that the real mediation—within the framework of certain forms of sociability and professional representation—in contrast to the mere display of the works, is a creative product which supplements the work of the poet or composer. A theater or concert performance creates values which the texts of the plays and the scores do not contain intrinsically. It changes them into substrata of new and unique experiences, even if these are limited dialectically by their sources.

Actors and directors are, however, not only interpreters of drama but also representatives of the standards which demonstrate the right of a piece to be staged. The theater is at the same time the crucible in which different cultural strata of a society mix. In Rome, as Erich Auerbach says, it was simply an intellectual bridge between the educated and the populace.[47] Film as the heir to the theater in this regard performs a similar function today.

The similarity between the two media is, however, disturbed by a crass difference in character. The essence of the theater consists in the urgent and unmistakable interpersonal nature of the process in which actor and spectator, player and audience are spiritually and physically linked. In the case of the film we cannot talk of a reciprocity of relations of this sort. In the cinema the psychosomatic involvement of the spectator, who lets the cool and distanced outlines of the film slip past his eyes, is completely one-sided. The theatrical process is quite different; it unfolds under the influence of the audience in the same way that the public's attitude is created by the lively presence of the actor. A play, indeed, as a result of this partly physical contact between those who are taking part, has a sort of magical character, which is intensified even more by the public, quasi-ritualistic presentation.

In spite of the more general popularity of certain films, the theater public is the only example of a group—mixed in origin, culture and class status—which thanks to the common institution of mediation, can find the same sort of pleasure in the same artistic creations, although Shakespeare is probably the only really great dramatist who addresses an arbitrarily mixed, in every respect heterogeneous, audience representing as good as every social stratum and enjoys an undivided success with them. Of course, it is questionable whether works which consist of such different components as his found approval among the different groups of the public by the same means. Greek tragedy was from the beginning such a complex phenomenon, and participation in it as a result of the different political and religious motives involved was so diversely determined and was so selective because of the restriction of entry to free citizens—apart from limited examples at relatively infrequent festivals—that its attraction for the whole of the citizenry can scarcely be assessed. Again, medieval drama, which was probably just as accessible to everyone as the Elizabethan, had no great works to show for it, so that its popularity does not constitute a problem for the sociology of art in the way that Shakespeare's dramas do. This problem, however, is not essentially that the greatest poet of the time was also its most popular dramatist and that those of his plays which we like best were also the most successful in his own day but, rather, that the audience, however representative it may have been as a result of the generally appealing nature of the mediation, judged more correctly than did the cultural elites. Shakespeare's literary fame grew less, as we know, around 1598—that is, at the time he reached the peak of his literary development—but the general theater public remained loyal to him and even confirmed the position he had won before.

As a way of counteracting the assumption that Shakespeare's theater was something like a mass theater, people pointed to the small capacity

of the theaters of his time. The paucity of theatrical houses, which was, incidentally, compensated for by the fact that there were daily performances, scarcely alters the fact that the public was composed of all strata of society. It was in any case the audience of a folk-theater in the sense of a medieval institution with its roots in Christianity. For if the people in the pit were in no sense masters of the theater, they were present in such a relatively large number that they could play a decisive role in determining the response to the play. Although the upper classes were better represented in the theater than they were as a percentage of the total population, the lower classes in fact—who formed by far the greatest part of the urban population—represented the majority of the theater-going public.

If we talk of a relationship between artistic creation and its more or less appropriate reception in the theater, we cannot avoid asking whether the meeting of popularity and quality, as, for example, in the case of Shakespeare, rests upon a meaningful relationship or mere coincidence, even misunderstanding. The public seems, in any case, to have liked Shakespeare's plays not only because of the coarse jokes and bloody fights, the loud declamation and wild action, but also because of the more tender poetic effects and the deeper psychological implications; otherwise, an effect of this sort could not have played so large a part in the plays. It is, of course, possible that the poetic element had its effect upon the pit after the mere noise and overheated dramatic mood, as may be the case with a public which is naive yet delights in the theater. Yet we may not overestimate the difference in education even between the different strata of Elizabethan society and assume, for example, that only the uneducated parts of the audience enjoyed the double entendres and the obvious action. They were welcomed by educated and uneducated alike. On the other hand a play like *Hamlet* had the same success in the more popular, "open" theaters as in the more aristocratic, "private" theaters. On the whole the theater, as an institution, played a more unified role than we usually assume, especially in less differentiated and sophisticated periods.

Shakespeare did not write his plays so that he could hold on to certain experiences or in order to solve ideological problems, but first and foremost in order to enrich and refresh the repertory of his theater. Yet in saying this we may not overextend the idea of the plays' right to be staged by forgetting that they were intended for a folk-theater but created in a humanistic period when people were also doing a great deal of reading. It has not escaped the attention of scholars that the majority of Shakespeare's plays were too long to be performed in the usual two and a half hours without being cut. It is possible that in performance it was precisely the most valuable poetic passages that

were cut. In any case the length of the plays seems to point to the fact that in writing them the poet was thinking not only of the stage but of their publication in print.

The theater—whether it is dance and mime or linguistic and gestic—is one of the oldest and at the same time most entirely and unmistakably social forms of art. In both its inner structure and its external appearance it is interpersonal. A literary work which has as its subject a conflict-laden discussion and which is not presented to an independent audience is not dramatic. The dramatic process is the result of a double antagonism, an antagonism which exists between the various participants in the dramatic conflict and a further one, that between the productive and receptive participants in the performance.

Drama may have its origin in rituals which were still essentially nondialectic and alien to art, but it derives, especially in its tragic form, the idea of the nature of human existence endangered by hostile forces and the memory of the sacrificial customs at the death of a hero from the primitive religious or quasi-religious world of magic. Even the coarsest buffoonery and the most naive farce contain something of the sinister nature of the fear-ridden feeling for life which is expressed in and derived from primitive magic actions. The symbol of a sacrificial act and the association of stage and altar suggest themselves in every play.

What we understand by the atmosphere of the theater is the product of a collective in which the cooperation of everyone with everyone else plays an irrationally suggestive role. The irrationality of the processes expresses itself not merely in the partially improvisational nature of a never so carefully prepared performance against which any film creates a more or less rigid and lifeless impression, but above all in the feeling of the spectator that the actor is a vital, unaccountable person, subject to surprises of all sorts, and that he is not an artifact. The magic of the theater comes mainly from the fact that playacting is an art of the body and that the stage effect asserts itself as a reaction to spiritual and physical change in the actors. Just as the change of the actor into a fictional person is to some extent an act of magic, so the spectator is subject to a certain magic when he surrenders his doubt about the credibility of such a change.

If we proceed from drama as literature, fable, or discussion and see in it the original, intentionally authoritative moment of theatrical presentation, then we shall regard the theatrical process merely as the vehicle of mediation. If, on the other hand, we view what is dramatic and theatrical as the meaning and the point of the production, drama and stage change their roles and drama becomes the mere substratum of the play instead of forming its substance. The theater as an institution

of mediation does not necessarily bring us closer to the author's intention; it can also distract us from it. Its materialism, its sensuality, and its assault often make the adequate grasp of the intellectual essence of the dramatic action more difficult and sometimes prevent it altogether. Primitive drama—which was still identical with, or at least essentially related to, the dance—Greek and Roman comedy, antique and medieval mime grew out of the principle of the theater of the need to playact and dress up. In the modern theater on the other hand, with everything that springs from its spirit, it is of secondary importance and serves at the best to explain and render sensible the literature of the stage. However, it may, according to the prototypical relationship of institution and improvisation, have preceded the drama, that is, the substance which it later serves as substratum. Since the last century in any case, the drama which became ever more productive in the literary sense has been looking for a stage appropriate to its manifold ideas and problems and not the other way around, the theater looking for suitable material to produce.

Drama written to be read, a product of a literature which had no home and which often lacked a stage as a means of mediation, is an uncommonly problematical literary genre. It is usually received by individual readers, but if it is ever produced in the theater, it is never the origin of a really massive effect. Its purely poetic values, its finely graded effects which depend upon the linguistic music of diction, its lyrical undertones dependent upon mood and atmosphere are, it is true, more accessible to the solitary reader who can ponder detail at leisure than to the spectator in the theater: what is vehemently passionate, ostentatiously rhetorical, and sensually gripping is lost to him. This ostentation of expression and the collectivity of the reaction which accompany the theater cause it to count as the paradigmatic form of the institutions in the sociology of art which mediate between production and reception.

The history of the modern theater tends toward intensified intimacy and follows the tendency which has led—since the end of the Middle Ages—to the introspection of this form of art, a development interrupted, it is true, by some more drastic phenomena—the Elizabethan drama, the romantic terror play, and the *pièce bien faite* with its mainly primitive psychology. Ibsen, Strindberg, Chekhov, Maeterlinck, Hofmannsthal all point the way to the final victory of introspection over the heroic-rhetorical. The dramatists who follow in the line of development after these authors, who depend on lyricism and impressionism, especially the surrealists and their followers, are ambivalent since at one time they use crude effects, at another intellectually more demanding nuances.

The late nineteenth century produced very different types of theater, which corresponded to the individual classes and different cultural strata. Along with the great state theaters and opera houses, there were middle-sized houses devoted to the conversation piece, operetta and variety stages, and new intimate theaters. No matter how small their capacity may have been and no matter how different they may have been in other respects, they all had one thing in common: the group character of the happenings which took place inside them on principle. The theater is a place of sociability; the degree of public enjoyment of art which it offers is variable; its social essence is, however, constant. Everyone present is a mediator and at the same time the product of mediation, while the people who go, for example, to a picture gallery do not at best take notice of one another.

Every theater audience, the most exclusively aristocratic and the democratic one put together without any principle of selection, is divided according to different strata, yet it nevertheless forms a more or less closed, even though ephemeral, community which seems to be linked by similar interests within the limits of similar forms of life and criteria of taste. The coherence of the group is expressed not only in the more or less unified emotionalism and the intensification of the effect of what is being presented which this unity creates but also in the more or less clear consciousness of the audience that they form a community. As a looser form of community, which was the mark of the audience for Greek tragedy, for medieval religious drama, and baroque theater we find a superficial communality, which—like the mere acquaintanceship of the habitués of the bourgeois theater of the last century—becomes completely secularized. Yet the expression of applause contains the remnants of the ritual that joins together the representatives of an intellectual communion. Every rite can be called a ceremonial self-deception, and nothing recalls so vitally the role of the deception to which we submit ourselves in the theater as the applause,[48] which is not merely the expression of pleasure and agreement but also of a much more complex and elemental state of mind. Not only is it released by a mechanism which—in moments when we are deeply moved—serves as a safety valve for repressed feelings, but also at the same time it releases the psyche from the tortured anguish which the bewitchment of reality, the change of personality, and the loss of identity bring in their train. The eruption of applause not only lightens the weight of the cultic action which burdens the serious theater, but also serves to justify the trick which the playing of a role plays on us. The audience goes along openly with the wanton amusement in which it finds pleasure.

Even in museums art does not remain what it originally was. They, too, fulfill the duty of institutions of ambiguous mediation designed to bridge the gap between production and reception. They lead to reevaluation—and thus first to the preservation of artistic creations which are historically distant and both sociologically and psychologically alienated—while they create new values when the old ones have lost their currency or are threatening to do so.

The first duty of museums is the choice of qualitatively valuable or historically important works of art out of the huge number of second-rate or valueless ones. They also have to form criteria according to which representative products can be distinguished from ephemeral or indifferent ones. Their other task—which is almost as important—consists in the collection of monuments of art which are suited to communicate a more or less comprehensive picture of the stylistic efforts of a period, a nation, a landscape or, where possible, of the most important phases of the development of art in general. Just as a single work of art of a great master is only seldom in a position to give a sufficient picture of the extent and nature of his art, so the formation of a concept of a style, a people's artistic ambitions, or even a series of artistic trends as steps in a general process of development demands a more extensive collection of objects which fit in with the complexity of the phenomena. However, museums always achieve this by the conjunction of products which are aesthetically incompatible. Their function consists in the creation of meaningful connections between things which appear essentially independent and isolated and trapped in their isolation. The collection of products of a particular school or period is, in the real sense of the word, no more a "museum" than that of the works of a single artist. A museum only begins when what is individual resolves into a new whole. The dissolution of the particular work, of the individual artist, the local school, the national style, is like the decline of the individual in society, the price of a culture which is establishing itself in the form of more or less permanent institutions.

The museum is, as people complain, a monstrosity, in part a renunciation of art, but a sacrifice which is not without some compensation. The concept of art in general as an achievement which embraces and concerns the whole of mankind is in a certain sense the product of the museum. Without the institution of the museum the idea of "world art" as a parallel to "world literature" is almost inconceivable. The collective concept which is here being spoken of seems to have played such an important role ever since the founding of museums that we have to ask ourselves whether the first Hellenistic collections which set out to represent the whole development of Greek sculpture had

their origin in an idea which was didactical and theoretical or in one which was concrete and aesthetic. The didactical principle would seem to be supported by the fact that people laid greater store by the completeness of the collections than by the originality and authenticity of the objects displayed.

Museums have been called mausoleums in which works of art—cut off from the life out of which they grew and in which they fulfilled a practical function—lead their abstract, self-sufficient existence. As they are placed or hung according to some principle of arrangement which has nothing to do with reality or the work itself or any stylistic or decorative principle, so they lose their original connection with practice and enter into a relationship with one another which had previously not been suspected. They become examples of a style, of a movement, or simply of art which embraces devotional pictures, historical paintings, portraits, landscapes, genre painting, and still lifes in one and the same breath. They are no longer icons, idols, ritual or ceremonial images, representative drawings, solemn monuments, or simple practical tools, but works of art with a common denominator. In this sense the earliest and most modest private collections in which artistic works were preserved for their own sake carried the seeds of museums within them.

From collective structures to which works of art in museums served as supplements, there derived—with the development and spread of photographic reproductions, illustrations in books on art and slides used in schools of art history—what André Malraux called le *Musée imaginaire*[49] and what has also been called the "museum without walls." As a result of the juxtaposition of different artistic products within the same framework and their reproduction in the same way in the same books and magazines, the impression arose that they were parts of a unified world which was infinite in extent. Prehistoric idols, heathen pictures of the gods, Egyptian tomb sculpture, Indian temple decoration, jewelery from the period of the migrations, Christian Bible illustrations, Renaissance compositions, baroque portraits, naturalist-impressionist landscapes, cubist and abstract-expressionist formal structures were all brought together under one roof. However—as a result of the community into which they were brought with each other and with things like themselves—they burst open the walls of the museum and now lay buried in a common cemetery in order to make room for a reality which had up till then been unknown. The idea of the unity of art which derives from the institution of the museum thus rests upon a deception. An independently conceivable concept of artistic activity which is undifferentiated and independent of its different aspects in this way is not the product of museums, but it is rather the

museums which owe their existence to such an unclear and incoherent concept of a homogeneous art and the idea of *l'art pour l'art* which goes back to this concept. The seeds of *l'art pour l'art* principle reach as far back, however—as we have seen—as Greek archaism, the Ionian colonization, and the specification of values. Without the idea, however feeble, that artistic products somehow belong together, no museum would have been founded. But the first museums were a long way from counting as temples of art. Up to the eighteenth century they preserved something of the character of a curio cabinet or peep show and remained what they had been from the beginning, collections of artifacts which had lost their practical function.

The metamorphosis of an artifact from the substratum of a social function into the object of an aesthetic experience and its transference from the realm of sheer practice into the sphere of phenomena subsumed under the name of "art"—which appears most obviously in museums—does not, as we have said, have its assumption in earliest collecting. The institution of the museum is, rather, the result and the place of fulfillment of the objectivization which alienates the work of art from its practical function and makes it into a display piece. Thus, however we judge the metamorphosis which the work of art undergoes on its way from its original destination into the museum, we misunderstand its nature if we make the final product of the process—the work of art as a museum piece—responsible for the objectivization of the living artistic intention. It is the tendency toward coagulation and alienation of the vitally flowing form which is the origin of the process.

The opinion that the museum is the grave of works of art, where they lose their original and actual meaning, was already defended by Paul Valéry long before it was by Malraux.[50] The loss which they suffer seemed to him, however, far more fateful than it did to Malraux, who was not concerned about their fate at all. They petrify, Valéry felt, crowded together in the vacuum of museums without any relationship to the outer world or to each other, and become mere shadows. Their careful arrangement is organized disorder. The mood of the crypt's fearful homage surrounds them. It is true that we talk a little more loudly in their presence than in a church but much more softly than in everyday life. We are seized, but we do not really know why we came there. Was it to expand our education to know more than we did previously? Did we expect an intensified pleasure, a more complete mystification? Were we looking for a new and deeper sense behind the collected works, which cannot be compared in their solitude and which were isolated by their own completeness? Was it a new meaning in which all participated and which communicated itself to everyone that we were looking for?

For Valéry the essence of art consisted in the individuality of every genuine work of art which not only excluded the simultaneous idea of different works but also rejected the validity of all comprehensive aesthetic terms like that of art in general, of a common style, local schools, and artistic movements limited by their time. The picture of the universe of art which is created by a museum is for him in no sense compensation for the loss of immediacy, uniqueness, immanence, and autonomy which the individual, incommensurable, and unmistakable works suffer when they are objects in a museum.

But it is not simply the walls of the museum which petrify works of art—neither for Valéry nor for other unsympathetic critics of the museum as an institution. The pictures of the Palazzo Pitti are just as alienating—to some extent more—in their original setting, which is packed with objets d'art, than those in the Uffizi. The milieu which was once alive mummifies itself. Thus, it is by no means the external difference in the framework which alienates us from the works of the past, but their changed function in our existence, the disjointed point of view from which we look at them, the continuously changing aspect under which they appear to us—like memories of "lost time" for Proust—their changing perspective, which Theodor W. Adorno has aptly compared with Valéry's change in meaning of the works.[51] Proust's thoughts on these lines are entirely concerned with the connection of artistic experiences which change with a changed outlook on life and changing forms of existence. Thus, for him works of art can remain more intact on the walls of a museum than in the familiar surroundings of our own home, no matter how artistic or alien to art it may be.

For Proust as for Malraux works of art show their true essence and their special value in practice. However, they do not acquire their meaning entirely from it and they do not lose it entirely in the museum, which has no practical function. They may hinder the approach to one another because of the way they appear to be heaped up, and their proximity to each other may veil their image: yet they can be freed from the artistic conditions of the museum, and their functionality and actuality can be restored. Malraux did not believe in a suprahistorical, timeless essence of art; he merely clung to the possibility of renaissance and the significance of styles which is linked to every such renaissance. Proust also set no store by the permanence of meaning of principles of style. Their change is for him a symptom of life, the expression of the changing way life appears to him, the changing quality of the medium in which he is conscious of himself, his memories, and his victory over the disjointing effect of time. For him, too, art is concerned not with things but with functions, It is not a matter of individual

works of art or of art as a system of values objectifying itself but of what is artistic as a form of existence—of the single aspect of existence which promises some sort of totality, which comes into question as such alongside practice. We may lose sight of this form, but we can hardly give it up after we have once grasped the meaning of the "museum without walls." In looking for it, Malraux goes through the museums, following its traces calmly and studiously, with a stoic equanimity steeled in the long practice of research into the secret which is buried there. For the person trying to restore what is "artistic" as a memory of a lost existence which is connected in a sensible way, every work is a clue which leads to the goal which disappears from time to time, changes its perspective and its meaning, but which is nevertheless a secure one. He wanders patiently through the rooms of museums and looks amusedly at the monuments of an existence, some more deformed than others, an existence whose secret he tries to discover both inside and outside the museums. However, it is not only these monuments themselves that are products of their time but museums, too—like all institutions which preserve the changed face of things and make them into the object of new interpretations. Even these glass covers over a vacuum as they appear to be in their lack of practical function belong to the continued existence of works of art which have to be forgotten and revivified, which decay and are destroyed in order to gain a new lease on life over and over again. Adorno quotes Proust: "Ce qu'on appelle la posterité, c'est la posterité de l'œuvre." They continue to exist not in spite of but because of their decay. What destroys their original being and their intentional meaning is their continuously regenerating function.

The inadequacy of Proust's view of art consists in the total dissolution of the works in functions and in the neglect of the fact that they do not refer merely to changing needs and inclination, but are at the same time determined by an objective principle, by the logic of an identical, even if flexible, structure. Just as for Proust the experiences of life acquire their real meaning and expression only in memory, so the great works of art can, in some circumstances, mean more for posterity than for their contemporaries, because posterity is also part of their product. The confidence Proust has in the museum is based on the conviction that art plays an indestructible, though changing, role in our existence, that meaning and function of individual works do indeed change, but that the idea of what is artistic in the Platonic sense is indestructible. Valéry, on the contrary, believes only in the substantiality of an individual qualitatively unique work, which, in a museum, either aesthetically destroys, or is destroyed by, all the other works it comes into contact with. Since the meaning of life according

to Mallarmé's doctrine (with which Valéry agrees) consists in the production of particular incomparable works, the museum—according to this conception—robs the world of its meaning. Malraux on the other hand, who believes neither in the absolute idea of art nor in the individuality and unequivocality of the individual work of art, places his hope in the reinterpretations to which they are subject in the museums in which they spend their posterity. Their life consists in their history, and their history in a constant movement away from their original meaning.

Valéry's idealistic objectivism, which simply and solely affirms the idea of the individual work, and Proust's nondialectical subjectivism, which has the work of art dissolve in the stream of experiences, of time, of forgetting, and of remembering, are avoided in Malraux's historicism. In their place we have the idea of style in which both the individual unequivocal artistic structure which is no longer readily available to posterity and the unique and unmistakable creative intention more or less vanish. Museums carry Valéry's aesthetic fetishism *ad absurdum*. The work of art removed from practicality objectifies itself to such an extent that its relationship to the living subject and to actual culture in general appears to be placed completely in question. Separated from life it proves—in spite of the axiom of the independence of what is aesthetic—to be a mere fragment of a ruined whole. "We become scholars," says Valéry with reference to the change in function of artistic creations which is here under discussion and which is brought about by museums, "but scholarliness in the things of art is a defeat. It explains what has nothing to do with sensibility and delves into the inessential. It replaces experiences with assumptions, miracles with a stupendous memory, and adds an inexhaustible library to the museum. Venus has changed into a document." With bated breath he flees from the tomb into the open air.

The encouraging fact—which promises some salvation—to which Proust unlike Valéry clings and the perception of which lends weight to his view of art, in spite of the subjective idealism in which it is entrapped, consists in the fact that the way to "freedom," the way back to life and actuality leads through the museum. In consonance with his whole philosophy that every experience achieves identity, real and essential life, only when it is recalled, Proust admits to the view that works of art achieve the quality by which they can again become topical and relevant only through museums. The alienation in museums, however, which seems to be the lot of the art of the past also seems to seize on current works of art as soon as they leave their creator and objectify themselves before being received back into a subject's inwardness. Alienation is here most obviously the price paid

for the revivifying intensification, the renaissance of continuous reinterpretation and reevaluation, to which genuine art owes its indestructible life.

The library is in many ways the institution which comes closest to the museum in the mediation between production and reception. In many ways, however, they are completely dissimilar. Both are certainly collections of works which are to be preserved and which are intended for perpetual, constant display and reception. In the one case, however, it is a question of original artistic products, in the other of mere records whose significance is only validated by reception. The sum total of books in a library does not create a new objectivity, no sense content which would be essentially different from individual books. The limits and contours of a library are, when compared with those of an art collection, often chance, trivial, flexible according to the determination—which changes in every case—needs, interests, or taste of its founder or owner. The books turn their covers to one another. They may complement one another in their content and belong in the same category, but they do not form units in the sense of artistic styles, movements, or schools. Even the most extensive libraries do not present the substratum of a concept like "world literature," unlike art museums, which, however modest, are concerned with forming a collective concept.

The difference between a private and a public library is in many ways more drastic than that between a public and a private art collection, although in both cases the public institution may have been initiated privately. The characteristic which distinguishes most sharply between the plan of a private and a public collection consists in the fact that in the first case the act proceeds from an already existing positive relationship between product and reception. In the other case, on the other hand, this has first to be created. The collector is the mediator and his collection the distillate of the communication already achieved between the work of art and the enjoyment of art. The collection, on the other hand, which has no individual principle of selection behind it as the initial impetus or standard is destined to become an instrument of a mediation which has first to be established.

In the Hellenistic age and in the Roman Empire public libraries were first foundations of the rulers, who were pursuing primarily political aims.[52] It was still the case in the Middle Ages that the division between public and private libraries was unknown insofar as the kings and emperors had the collections of books which they founded and maintained freely at their disposal. State libraries in the modern sense did not exist; where possible, their role was played by the royal libraries. Libraries which are no longer mainly subject-oriented but already have

a superpersonal character and permanence appear first in the framework of ecclesiastical activity, especially in the monasteries. However, they are just as much at the disposal of princes of the Church as the court or royal libraries were of the secular rulers. The Vatican Library does have a superpersonal character; but the popes nevertheless have a personal relationship to it, and even if it is not salable, it does belong to the papal household.

Public secular libraries attain their independence from the individual holders of power only within social organizations in which the rights of disposal are no longer in the hands of one person—that is to say, not before the late medieval urban councils have a say in cultural and artistic matters. The local libraries now really become common property and are, as such, universally available, although in fact not equally to the whole population. Because they originate in the collections of the patricians, they remain for a long time bound to their ideology and the needs of their representatives. Public libraries in the modern sense are not present even in embryo before the time of progressive humanism and the spreading Reformation, when they are, it is true, still inseparable from the needs of the cultural elite yet at the same time serve as a means of reforming it.

The reformers—in accordance with their doctrine of the immediacy of God's fatherhood and the self-responsibility of the faithful—encouraged the founding of public libraries. For just like the means of grace, so the means of culture were to pass from the hands of the clergy into the hands of the community. The humanists wanted to use the libraries as a further means of loosening their ties to their powerful patrons. Since the Enlightenment and the development of newspapers, publishing, and the book trade, libraries have become cafés and clubs where the printed word reigns—the *bureaux de change* of the intellect.

18 The Art Trade

Just like other forms of mediation the trade in works of art plays an ambivalent role in its mediating function. As a vehicle of trade in products, it links ever wider circles of society to art and creates people who are ever more deeply committed. At the same time it intervenes as a distancing element between the productive and the receptive subjects and contributes to the objectivization of artistic creations. This it does by changing them into articles of trade, into depersonalized goods which can readily be bought and sold. Thanks to the dealers' publicity, works of art can come more often and more easily into the possession of new enthusiasts, and they acquire a relationship to them more rapidly and more unconditionally. This relationship is more superficial and short-lived than under the conditions of a personal relationship between employer, client, patron, or connoisseur, on one hand, and the artist, on the other.

The trade in works of art suffers from the fundamental evil of every market economy. It changes the work of art—whose significance was previously in a "use value" and which came from the pleasure and joy it brought to the beholder—into the substratum of a barter value. It is no longer judged by its aesthetic quality or by the artistic rank of its creator but according to the economy and exchange value of the particular artist, style, or genre on the art market. The change in the commercial evaluation of the same or similar works of art may come about as a result of a change in style or taste, or it may simply be the result of more or less subsidiary circumstances which are alien to art and independent of the artist. The trade developed in conjunction with markets—which grows disproportionately to the economy, which only fills need—is characterized by the paradox that instead of selling some-

thing so that the seller can buy something for which he has a greater need (as is done elsewhere), people now buy in order to resell what they have bought. Thus, works of art go through a series of hands before they come into possession of the interested parties who intend to preserve them and finally keep them for themselves.

The new values created by the development of the trade in works of art and the expansion in the art market are mainly determined by the scarcity of the objects to be sold. In every form of collecting, scarcity vies with quality and often does away with quality as a standard of price. The works of a painter of whom only a few pictures are known or can be bought not only have a higher market value but are often more highly regarded than those of a greater, but more prolific, master or one who is less sought after by collectors or museums. Scarcity value is often a product of fashion, which favors a particular artist or a particular movement. At times, however, the existing scarcity increases the demand in one or another direction and interacts with fashion, which may be determined by other motives.

Since authentic works of old masters do not multiply—or at least only modestly as a result of new discoveries and attributions—they are as a rule safer objects for investment than the products of contemporary artists. The former lose their value only if there are radical changes in taste, the latter as a result of incalculably many happenings of the day. Devaluations like those undergone by the works of the Bolognese baroque master, which were once recognized as classics in the highest sense, however, seldom take place. The rule is, rather, that the value of old masters increases. The rapid increase in price of works of more or less immediate contemporaries like the impressionists, the postimpressionists, and many of the present avant-garde is mainly to be ascribed to the mania for investing free capital. It recalls the flourishing trade in tulip bulbs in seventeenth-century Holland. In such cases, demand apparently conditions the criteria of taste and it is by no means the artistic values which develop independently of the market which prove to be definitive.

The trade in works of art develops hand in hand with the spread and final domination of collecting as a form of the consumption of art, with the gradual expulsion of the patron by the buyer who orders or chooses directly from the stock the artist has in his studio. The patron, the permanent employer, the immediate contractor, and the supporter of the arts are phenomena which are connected with medieval and ancient feudal and patriarchal conditions. In contrast, the collector who buys the works of one or another artist as opportunity presents itself is a representative of the liquidity of capitalism, on one hand, and the artists who work freely and dispose of their works indepen-

dently, on the other. Collecting, the open art market, free competition, and initiative, emancipation, and loss of security condition one another.

The specialization of painters in particular genres is one of the most important results of the trade in works of art to develop since the end of the Renaissance. It arises from the fact that art dealers are constantly demanding the same sort of works from their suppliers, ones which have shown themselves to be the most economically viable. Thus it happens in the area of art that there is the same division of labor as that which is well known in industrial production. This confines the activity of the one painter to the representation of animals and that of the other to the production of landscape backgrounds. The trade in works of art in this way also fulfills an ambivalent function. It standardizes production but at the same time stabilizes demand. It ties artistic production down to static types but at the same time regulates the otherwise anarchistic circulation of stereotype goods. The art dealer creates a regular demand by frequently intervening when the immediate buyer is lacking. He mediates between production and consumption, too, by informing the artist of the public's wishes—and the conditions of salability of the one or the other type of goods—more completely and more promptly than the artist could himself. But at the same time this sort of mediation conditions the alienation of the artist from his public. The buyers generally get used to buying what is available and to regarding the work of art as just as impersonal a product as any other sort of ware. The artist on his part is just as ready to get used to working for strange and, to him, personally indifferent buyers— for people about whom all he knows is that they are ready to buy now this sort of picture and now that. Thus, he alienates himself from his customers just as much as they alienate themselves from contemporary art. Also contradictory is the effect of the art trade upon the prices the artist wants for his works. The supply to the art market may increase and prices may collapse as a result of the increased supply. The dealer, after the public has got used to buying from him rather than from the people who produce works, becomes the artist's real employer and depresses and dictates prices where he can. As goods flood in, copies and forgeries also begin to circulate; they count as originals and help to reduce the value of authentic works.

In spite of this, the trade in works of art tends to act as a mediating rather than an alienating force, not just because it helps to bring works of art to the individual and keep the buyer's interest in works alive but because it stabilizes conditions in the area of art by creating a clientele which is constantly interested and because it relieves the artist from time to time from the necessity of wooing his public. The mere fact that the buyer and the seller approach each other and meet—in

the art dealer's sphere of activity—at the crossroads of their interests signals the beginning of a process of mediation which functions in an exemplary way and which regulates itself. This happens because a situation is created in which the buyers have to seek the desired works just as much as the producers have to seek recognition, success, and rewards.

However, the art dealer is of use to the artist not only as a trade representative. It represents a gain in prestige for the artist to have a permanent agent who will take over his products. A well-known dealer guarantees a sort of pedigree and often affords more security to the buyer than the name of the artist himself. Yet even in this connection there is a certain degree of mistrust between the partners. Neither can forgive the other for the part he is playing. The artist places the guilt on the shoulders of the dealer for the fact that his works—which are invaluable—are treated as goods, although their character as goods is conditioned by the trade economy. The dealer for his part looks down with resentment on the artist—either as the confidant of the buyer with a bourgeois sense of superiority or as an outsider fancying himself a member of the profession.

It is only after the Hellenistic period with its international capitalism that we can talk of an art market in the actual sense, of a free artistic trade in goods with a constant supply and a corresponding demand, fluctuating prices, and available cash. The period which creates the first museums, research institutes, and libraries—the first universal centers of culture—also creates for the trade in works of art new bases of mediation between production and consumption. The most important assumption of international research was that of the eclecticism which determined the intellectual atmosphere of the age. This also corresponded to the general eradication of the great national communal cultures by the progressive individualization and the later combination of economic interests and social ideologies. According to the rule by which the Hellenistic bureaucratic state mixes its functionaries up without concern for their origin and national affiliation and the way in which capitalist trade economy separates social subjects from their birthplace and homeland, so artistic and cultural structures are torn from their organic context and brought into artificial contexts.

The same eclecticism which expresses itself in the insatiable second-hand hermeneutic thirst for knowledge in the learning of the historically oriented age, which is ready to absorb everything there, also asserts itself in the uninhibited way in which the trade in works of art is carried on and in which products of the most diverse schools are collected. The totally unselective attachment to everything historical which is decisive for the foundation and development of museums is

at the same time an impetus for the formation and differentiation of new movements in art. As a result, there are more different stylistic principles than ever before.

The royal and the private art collections were from the beginning inorganic, that is, jumbled haphazardly, and even the Hellenistic museums for the most part lacked the closed unity which was striven for in building up public collections after that time, even if this was seldom realized. The "completeness" of the glyptotheques in the Hellenic cultural centers which present the whole development of Greek art—even if most of it was in the form of copies—must in any case have created a heterogeneous rather than a homogeneous impression. And in bringing the most diverse products together under one roof, they made the eye grow accustomed not only to putting up with a diversity of artistic movements at one and the same time but to regarding them as evidence of a flourishing production of works of art.

The artistic efforts of earlier epochs, too, were, as is well known, not always completely unified, and we find in these, too, alongside an upper-class art which is usually formally rigorous, a more formless, lower-class art, or, alongside a sacred conservatism, a profane liberalism. However, previously there was scarcely a period in which totally different principles of style and trends in taste would have applied to the same social class, as was the case in the Hellenistic period when naturalism, baroque, rococo, and classicism certainly develop sequentially, but were able to coexist for a long time.

The manufacture of works of art organized on capitalist lines, the unusually busy copying activity in the sculpture studios, and the extended trade in works of art—usually in copies—are symptoms, but at the same time causes, of the eclecticism which goes on intensifying. The sculptors, who were engaged in making copies of creations of the most diverse sort, tended from the outset to experiment in their own works with different styles and manners. The public's interest, which was aroused in many ways, led to the extension and ramification of the trade in works of art. This trade then also acted as a stimulus to artistic sensibility and the feeling of purchasers for quality by means of the rich material which it made known and spread.

At the close of antiquity and with the temporary end of its money economy, the trade in works of art also comes to a standstill. In the earlier Middle Ages—up to the time of the rebirth of the towns, which had been depopulated and grown insignificant, and the revivification of international trade in the twelfth century—it is almost completely dead. It is only after a long period of atomization of the economy and its restriction to meeting the immediate needs of individual princely domains and courts, after the intellectual isolation of different countries

and peoples that—as economic and cultural trade is renewed—a start is again made in the exchange of works of art. This is mainly in illuminated manuscripts and products of craftsmen, first by occasional gifts or by mere usurpation and deportations from one country to another and only sporadically as a result of commissions and purchases. This is the beginning of a new phase of the trade in works of art, and it develops almost unopposed even if it is initially fairly limited. The trade takes place between different territories in the Western world, in which the southern areas generally participate as producers and the northern as consumers.

Between the twelfth and the fifteenth centuries commercial acquisition of works of art on the basis of supply and demand is relatively rare. The demand is generally met by the work of permanently employed artists or by the execution of specific commissions. In Italy, especially in Florence, the ecclesiastical endowments made by wealthy and prominent citizens, together with the royal foundations, which served propaganda purposes, form the basis of the production of such art as comes into question. The average citizen, if he counts as a consumer of art at all, usually buys average works of craft. There are nevertheless, even before the end of the quattrocento, *botteghe,* which develop something like mass production as far as the concentration of freely disposable capital in a few people's hands permits.

In the early Renaissance, where we find a few isolated examples of systematic art collecting, an independent trade in works of art divorced from personal connections of the producers is hardly known. It begins to develop first in the later Renaissance with the increasing demand for works of antiquity and the lively interest in the creations of the famous masters of the day. The first international art dealer whom we know by name, Giovanni Battista della Palla, makes his appearance in Florence at the beginning of the sixteenth century. He orders available objets d'art for his most important client, the king of France, and buys not only from artists but from private collections, too. After him there soon appear dealers who order pictures as speculation in order to sell them again for a profit.[53] An isolated example of early commercial interest in artistic products is the written order of a merchant in Prato.[54]

The trade in works of art—which is not confined to the occasional activity of individual agents but which forms the regular profession of a special class—originates in the fifteenth century in the Netherlands and consists at first mainly of the export of artistic products, miniatures, tapestries, and icons, which were popular and sought after in the Middle Ages from the studios of Antwerp, Bruges, Ghent, and Brussels. In the sixteenth century the trade in works of art also remains

in the hands of artists who not only try to sell their own works but also buy and sell the works of others. It is a very common sideline and enables them to keep their heads above water. Many carry on this activity in the same way that others sell tulip bulbs. The majority of Dutch people who buy pictures at this time, who are neither speculators nor art lovers, do it as a stable investment. If this practice wins art lovers, it bears a fruit it did not sow. Nevertheless, it is probably not infrequent that simple people keep their pictures if they do not need the capital they have invested in them and if the originally unassuming possession of works of art pleases their children or their grandchildren and becomes the basis of regular and considerable collections.

The phenomenon of the participation of many Dutch painters (among them famous ones like David Teniers the Younger and Cornelis de Vos) in the art trade in the seventeenth century would have been unthinkable in France or in Italy, where the artist enjoyed a high standing. But even here conditions change as time goes on. As a result of the increasing production, the decrease in patronage as an institution, and the reduction in the number of wealthy and influential patrons, the art trade changes even in Italy. Here the domestic trade was usually confined to cheap objects, etchings, and small pictures, and— as in Dürer's time—took place partly at fairs or at the church door, relying more and more on purchasers from abroad, from France, England, Spain, and Germany. Although commercial trade between recognized masters like Bernini, Pietro da Cortona, Annibale Caracci, Poussin, and Claude Lorrain and important patrons, art lovers, and collectors was mainly a direct one, art dealers played an important role at least by introducing young and still unknown talents to the artistic life and by strengthening the bonds between artists and collectors. Even Caravaggio used the services of a French dealer at the beginning of his career, even if he did not need him later on.

The appearance of the art dealer and the extension of the art market did not, however, signal the end of the traditional royal method of acquiring works of art by plunder. Many of the crowned heads and their ministers, like Francis I, Rudolph II, Philip IV, and Charles I, Mazarin, Richelieu, and Archduke Leopold, were real connoisseurs. The art of Raphael, Titian, Holbein, Rubens, Vandyke, and others merely served their patrons as means of propaganda, and rulers like Gustavus Adolphus, Queen Christina, the Tudors, and some Hapsburgs regarded their art treasures as booty, which they took into pawn in order to further their political aims.[55]

After the mainly legal collecting by art lovers in the Renaissance— the Medici in Florence, the Gonzagas in Mantua, the Burgundian

princes, the Valois in France, the Hapsburgs in Spain—there again followed in the Thirty Years War and the Napoleonic campaigns periods of looting and plundering as a means of acquiring works of art. After the sixteenth century the new international market for art developed in a thoroughly organized and stereotypical way. This came about as a result of the spread of mannerism and of the increase of monarchs, princes of the Church, ministers, and financiers, all of whom were passionate collectors. It is true that the art trade had only a few centers—the most important in Flanders, Italy, Prague, and Munich—but their branches spread far and wide and actually extend to all the workshops in which there is a rationalized production and a regular trade.

The Thirty Years War brought in its wake (among other things) the plundering of the Rudolph collection in Prague and the Palatinate library in Heidelberg. The treasures of the Hradčany remained mainly in Hapsburg hands and simply got as far as Vienna, but the Palatinate holdings became booty for the invaders and were incorporated in the Vatican Library. This hidden form of robbery became for a long time the pattern of the exchange of works of art in the grand style. It remained in practice with some exceptions during the whole period of absolutism. Old collections which were not robbed often had to be sold after their owners like the Gonzagas got into financial difficulties. Just as the art treasures of Mantua went to Charles I, so the Wittelsbacher ones went to Gustavus Adolphus, who did not, incidentally, confine his plundering to Bavaria but extended it to the whole of Europe. Christina was a good pupil of her father; she filled her palaces with booty, even if she did subsequently restore a good part of the plundered treasure.

The plundering and selling of collections which had been accumulated with love and understanding certainly called forth repeated and violent protests from the contemporary world. Yet their dissolution and dispersal would have been unthinkable without on one hand the expanding capitalist idea of the mobility of property and on the other the iconoclastic mood of the Reformation period. The spirit of capitalism loosened ties to every form of property, quite apart from the fact that "useless" and costly art collections were suited to appear to the reformers as monuments of an antiquated world.

The largest and most valuable part of the works of art which changed hands in the seventeenth century did not, however, appear on the open market. However, with the end of the wars of religion not only does iconoclastic indifference toward the fate of works of art disappear but also social structures develop which are more favorable to the continuation of the normal trade in art. First of all, the hereditary nobility,

especially in France, was greatly enlarged by the created nobility *(Brie-fadel)*, and the nobility was then replaced—as the pillars of culture— by the bourgeoisie. As a result of the changes in wealth connected with these processes, the art trade, too, gains a new impetus. It now becomes the pure and simple form in which possessions change hands in the sphere of art; there is a constantly increasing supply and an appropriate demand, and we now see the emergence of the independent merchant who is prepared to take commercial risks and the unprivileged buyer who gains influence in proportion to his ability to buy. The work of art becomes a commodity in a more strict sense than ever before, a commodity which is in principle obtainable by everyone and available to everyone. With the accumulation of capital and the increase in the number of private collections, especially in America, there is a strengthening of the feeling that the private possession of art treasures is to be regarded as a temporary condition which is preparing the way for the transfer of the works into a public collection. For in this way the role of collecting as a mediation between art and the public can first be fulfilled. As long as this does not take place, the acquisition of works of art may arouse animosity against the collector, who takes hold of something which is common property.

Such a feeling appears especially justified with regard to the royal collectors of the manneristic period in the Hradčany, in the Escorial, or at the court in Munich, who maintained toward their favorite pictures an intimate, almost erotically jealous relationship. The works were intended for their boudoirs and not (as is generally the case) for their public rooms, and the monarchs so much regarded them as their own property that they would probably have liked to take them with them to their graves in the manner in which Oriental tyrants took their wives and horses. American millionaires are perhaps no less selfish, but they are better calculators and finally receive the immortality for which they paid their money after their collections have become part of a national museum. Their names are printed in gold letters above the doors of the rooms in which hang the paintings their dealers discovered or chose for them.

The fact that an artist (as is usual for a member of society) lives from the fruits of his work, and that he generally, even if more rarely than other members of society, works only in order to live, has for so long been taken for granted that no one thought of the possibility of doubting it. It was only when the artist left the direct service relationship to his employer and began to work for different buyers with different demands and commands that the concept of artistic freedom developed as an ideal and that that of payment for artistic products was seen as a possible danger. It was the romantics who first emphasized, as a

result of their unrealistic idealism, the antithesis between the ideal and the real value in art. And the objection that the "commodity nature" of artistic products might conceal their aesthetic being only arose when works appeared which only wanted to be disposed of and the view of their ability to be turned to account threatened their artistic value. Before the bourgeois era of the eighteenth and the nineteenth centuries, which found its expression in romanticism, no one came face to face with the fact that works of art have a market price and that their ideal value is linked to a consumer value. And ever since, the only people who have protested against this conjunction and against the principle of the derivation of values from needs are those who profit from their ideological separation. It is only when we try to smuggle a hidden ideology into people's consciousness that we begin to awaken doubts about the character of the embodiment of "ideal values" as labor in the form of marketable goods. The extension of the rules of labor to art is in no way synonymous with the narrowing of the concept of a salable art product to that of a commodity. If we were to write books only in order to sell them through publishers and booksellers, literature would certainly be subsumed by the concept of the commodity, just as painting would be subsumed under craft if the painter were aiming at reproducing a salable object in as many examples as he could sell. To fulfill the conditions under which an artistic structure becomes the substratum of a complete interpersonal happening—that is, of the accomplishment of a productive artistic process—we need to have the act of a change of possession between the creator of the work and the private or public purchaser. Following the laws of the market which transcend the work is one of the criteria for a successful sociology of art.

The moment of salability can only be regarded as the first step in the process which Walter Benjamin calls the loss of the aura of the magical authenticity of the original. He sees as the end of this process the reproduction of a film into as many copies as we want, where original and copy are indistinguishable.[56] Already the printed word— even one which has been written down—lacks the magic of the spoken word, for the formulation not only unites but also alienates. Expression, communication, repetition, reproduction take us further and further from the inwardness, the uniqueness of the creative experience by making it available to ever wider circles. An ambivalent character is linked to this function in the trade in works of art. It isolates an art-buying elite from the museum-visiting crowds, who at best buy reproductions, but at the same time it democratizes the art purchasers by increasing the community of connoisseurs through the growing circle of those who possess works of art. There is no doubt that the

possession of works of art is a strong impulse to a deeper understanding of art. The objectivizing effect of the art trade, however, is expressed not just in the impulse it gives to the production of similar types of commodity to those that have shown themselves to be salable. It is also expressed in the fact that through trade works of art increasingly become objects of commerce, pass ever more frequently from hand to hand, and are sold as easily as a piece of beef and often more casually than a piece of land.

Of course, a work of art does not belong to the person who buys the canvas on which it is painted. Anyone who has appreciated a painting with understanding, with a feeling for its quality, and with insight into its structure can possess it more completely than the purchaser who puts it into his collection as a new acquisition. It can no more be possessed merely by buying it than a literary or musical work can be possessed as book or score. Because of the incomparability of the monetary and the artistic value, it is also completely irrelevant whether we pay $x or $100x for a picture. Art can at best be compared with art, and we can only ask if the price we pay for one work could have been better spent upon another. Still, the question of whether the value of a work of art can be expressed in a price category at all is left unaddressed. The assumption of an analogy between value and price in the area of art would be the worst example of that objectivization which robs a state of affairs of its meaning. However important the institution of the art trade may be as a means of communication between artistic production and reception, the determination of price on the art market has more to do with fashion, rarity, prestige, investment, and ostentation than with that quality which determines artistic reception. It is the business of the art dealer and of his manipulation of the public, not of the artist and his world.

The dealer, however, administers to the public not merely by organizing buyers into groups, defining directions of taste, creating fashions, channeling the consumer's receptivity, but also by taking over—in relationship to the artist—the role of the patron and the person giving the commission. He secures the artist's existence by regular advances and gifts, and he buys at his own risk when the purchaser from the public keeps him waiting. In this way Durand-Ruel takes over the leadership of the impressionists after Monet has rejected the responsibility for it, and none of the artists—neither the faithful Pissarro nor the always reserved Degas—is suited to play the part. The dealer ceases to be merely an agent and identifies—partly as a result of his sixth sense for the market tendency, but also partly because he can allow himself to have his own "trade mark"—with and will represent in more than one way a school like the impressionists after this

has already lost its original impetus and the ramification of personal tendencies within the unified movement threatens to become ungovernable.

Impressionism was, moreover, the last stylistically coherent movement to embrace the whole of Western development. Since that time, styles have been differentiated so frequently and so diversely that not all their forms could be represented by special dealers and the works corresponding to them could not be found in special art shops specializing in one particular movement. There were (and still are) dealers who restrict themselves to the old masters, modern art, or works of the avant-garde. Probably only the last-named have some idea of a cultural program or the pursuit of a particular principle of taste without their concentrating upon one or another of the many progressive movements, which in many cases would scarcely prevail any longer than it takes to repaint the signboard.

19 Understanding and Misunderstanding

Friedrich Schlegel would have called the object of the following study "The Understanding of Understanding." Now, if we wish to retain his terminology we must first and foremost not lose sight of the difference between *understand* and *determine*, intentional and genetic context, meaningful coincidence and causal necessity. Understanding rests upon an illuminating explanation, but not on evidence of any kind. It comes from immanent hermeneutic analysis; determination, on the other hand, from a synthesis which takes place beyond the work and which is derivative. We can only understand a work of art from within itself, but its existence can be explained by many circumstances which lie outside it. The reason for the existence of a work of art can be connected with the most diverse facts but leave innumerable others out of account. Its understanding, however, presupposes the comprehension of the total context of its components by way of the participation in the completion of the creative act by the receiving subject.

If we say that we first have to learn the "language" in which the artist expresses himself in order to understand his work, this can be taken almost literally. Language here means simply an instrument of communication, not only of logically discursive processes of thought, but also of spontaneously discovered irrational signs and symbols, even if these are based upon practice and are tacitly agreed upon. If we have only comprehended the conceptual content and those moments of a work of art which can be completely expressed in practical language, we have understood as good as nothing of its special artistic quality and its aesthetic structure. Its mode of being lies between the lines and can remain unexpressed, for all the unequivocality of expres-

sion. Characteristic artistic vision and form has no conceptually un-
equivocal equivalent. A sensually impressive sign may inspire the
receptive subject to complete the event experienced or imagined by the
artist. Yet the experience which stimulates artistic creativity or which
is stimulated by a longing for creative expression is not contained in
the sign and reveals nothing which really corresponds to the so-called
empathy of the recipient for the feelings and ideas of the artist.

The inadequacy of the genetic interpretation of works of art comes
not only from the essential irrationalism which forms their basis but
rather is connected with the fact that the logic of causal scientific
thinking proves unsuited to the judgment of art, even though it, too,
follows a logic sui generis. The categories of this logic, visuality in the
fine arts, harmony and rhythm in music, the development of conflict
into crisis and resolution in the drama, are not rationally stereotypical
formal media, but functions of changing content. An artistic form does
not of itself have its own unambiguous sense. It is not capable, as for
example a word is, of being inserted at will, of being conjugated and
modified, like a verb. It never pursues anything but a particular goal
according to the given content, without being identifiable with one or
another moment of the content. The mechanical taking over of a ready-
made form is a purely "linguistic" exercise, which remains unfruitful
in itself. We can no more conclude an unconditionally suitable form
from a motif of content than we can derive a particular content from
a formal characteristic. The two-form antinomies of a dialectic mu-
tually condition each other. Starting from one or the other in the
understanding and enjoyment of a work of art is always a provisional
step after which another step leading in the opposite direction always
follows. Yet not only are the individual steps of understanding a work
conditioned as antinomies, reception, too, is also a form of *Aufhebung*
and reversal, like the taking up and repetition of the creative act. The
empathetic experience and the inner acquisition of a work of art—even
in the case of effects which can be adequately designated—take place
on different levels according to the ideology and culture, the intellectual
preparation and moral outlook of the receptive subjects. The reaction
to artistic stimuli moves between a purely conceptual understanding
of the motifs represented—or the fleeting, moody impression which
they make—and a completely vital experience which takes hold of and
changes the whole personality of the receptive subject.

Yet, however much trend, depth, and complexity of understanding—
according to the given historical point in time, social background, and
intellectual level of reception—may vary, every work presents the re-
cipient with an objectively binding task. Even if this task often remains
unfulfilled—or is not capable of being fulfilled—it is a challenge which

ought properly to be met with an immanent criterion, although challenge is always subject to constantly changing assumptions. The reception of art has, like its production, immanent, structural functional conditions and ones which lie beyond the work that are in part social, in part individual. But even the most favorable constellation of conditions cannot guarantee either basic comprehensibility of works of art, nor the chance, which grows with their artistic quality, of their being adequately understood. However the work may be fashioned, no immediate relationship comes about between artifact and person, communication and recipient, form and intent, as happens when—seized by love or compassion—soul pours itself into soul. There is always something interposed between speaker and listener, if nothing else than language.

There is a thesis that a work of art, as soon as it is complete, emancipates itself from its creator and his intention, and this corresponds to the fact that cultural structures of the past are always misleading and that in time it always transpires that their creators, when they seem to be saying something which corresponds to contemporary thought, always mean something different from what we do. This is not just because they are caught up in a different thought context but because they are thinking out of a different life context.[57] If they are incapable of understanding this, we must not forget that the interpretation which they make of their own works is no more authentic than that of anybody else—in the sense in which Paul Valéry says, "Quand l'ouvrage a paru, son interprétation par l'auteur n'a pas plus de valeur que toute autre par qui que ce soit."

The genetic-causal explanation of a work of art which, in contrast to the immanent-analytical interpretation, always goes beyond the limits of the work in question can be conceived of as a revelation of the psychological reason for "rationalization" of an inhibited drive, a hidden tendency, or the revelation of the sociologically, locally determined and ideologically conditioned stimulus for an attitude or an action—it is logically possible and practically conceivable, even if it cannot always be carried out. The aesthetically immanent interpretation of a work for which the causal connections of its genesis are irrelevant and indifferent has, in contrast, irrational motifs, whose essential validity is problematic and of which the authors often know little more than their readers. Shakespeare would probably have had to give the same answer to a question about Hamlet's relationship to his mother as Samuel Beckett did when asked what he meant by *Godot*. "If I'd known," he is said to have said, "I would have said it." The fact, however, that neither the one nor the other could give a sufficient answer does not mean that they had no ideas about the problematic

figures and the situation in which they found themselves, or that there was nothing more to say or think about them. It merely means that the attempt to interpret artistic structures in such a case is seldom possible without questionable moments. Inadequate understanding or misunderstanding is not only the normal form of reaction toward the art of the past, not only the temporary form of a later understanding which is more suitable, but the regular form of reaction which the work of art releases, when its historical assumptions cannot be repeated.

Works of art change (independent of the change in aspect by which they appear from one person to another as soon as they lose their topicality, their original function, and the practical value which is attached to this) into more or less veiled shadows of their erstwhile essence which is involved in the reality of the moment. As soon as they appear to be dependent on themselves they are no longer what they may have been for their creators and their original recipients; yet they do not necessarily have to become more alienated and counterfeit as time passes. They may even, under favorable conditions, become more familiar to the beholder, the reader, or the listener, without giving up the secret which is part of their meaning. What has been said about Beethoven's last quartets—that in fact no one who pretends to be thoroughly familiar with them really understands them—could be asserted about all great works of art. The aura of impenetrability and the feeling of total self-reference is part of their paradox.

It can certainly be said that only a completely adequate understanding or a hopelessly wrong misunderstanding of a work of art is possible and that every relationship to works of art which is not at the height of the intensity and complexity of their world of ideas and feeling has to prove damaging. This does not mean, however, that one has to be a connoisseur and capable of reconstructing the creative process in order to have a normative relationship to art. Even Mozart's music would only be adequately understood by a few people if the unconditional assumption for a proper hearing of it were the conscious following of the motifs created by the composer, their thematic realization, and their harmonic development. In order to achieve a proper reception of a work, even if this is not totally exhaustive, it is often sufficient that the recipient be stimulated and show a readiness to catch fire at one of its moments, just as otherwise we can remain indifferent no matter how authoritative and capable of judgment we may be. What would it mean, otherwise, if essentially difficult composers like Schönberg or Webern demand that their listeners approach them no differently from Mozart, or when T. S. Eliot says that he enjoyed

certain French literary works long before he was capable of translating even two lines of them properly?

The tension which exists between the creative artist and the recipient who has to be stimulated to the artistic experience makes itself felt particularly strongly in the change of stylistic principles and principles of taste. What makes the understanding of new artistic vision and modes of expression particularly hard comes from the fact that we are dealing with contents and experiences which cannot be conceived or formulated in another way than that chosen by the artist. They can only come about by the means he has chosen. There is no direct way to acquire the sensibility and the complexity of his art. The sense organs have to accustom themselves slowly to the new tone, the new complexes of form, and color values. Artistic intelligence and the feeling for quality have to earn through discipline the ability to perceive and evaluate. A sudden illumination may open the path to new, as well as to old, art, but it does not spare the trouble which has to be taken to conquer it. The ear is essentially deaf to musically different impressions; the eye cannot react to painterly effects. This is the way in which the allegory in Schopenhauer's *Parerga and Paralipomena* has to be understood; the conjuror produces his most spectacular work for an audience which turns out to be blind. The interpretation of an artistic communication which is always in part trying to communicate something ineffable is threatened by the possibility, indeed mostly by the inevitability, of misunderstanding. Even if the communication is completely rational and can be translated into discursive forms, the way we take account of it, the way it reaches us, and the criteria according to which we judge its relevance may be totally illogically conditioned, partly as a result of moments which are free of concepts and unanalyzable. The dependence of artistic reception, of critical theory of art, and of the formation of concepts in art history on vital practice at a given moment—in other words the agreement between artistic sense content and its interpretation—comes, as opposed to the independence of scientific perception and of the peculiarity and consistence of its view of reality, from the particular nature of the "understanding" with which we approach works of art. This view is, in contrast to exact scientific explanation, related to life and feeling. The failure to recognize the nature of this understanding, which is rooted in life and feeling, comes from the assumption that creative achievements are, of course, linked to history and society, but that their interpretation is neither linked to history nor conditioned by society.

Wilhelm Dilthey saw the actual difficulty, but at the same time the special attraction, of the investigation, description, and explanation of historical structures and happenings in the fact that they could only

be comprehended in an immediate bond with being and life and that in judging them from the given sensual signs we had to derive an "inner" which was suprasensual.[58] This difficulty, however, in no way begins first in the complex signs and symbols of art. The most simple intellectual statement, an ordinary letter or a chance word, may form a problem of interpretation to which nothing in the world of natural phenomena corresponds. An intellectual statement only makes sense in a total context and changes its meaning according to the context in which it stands. A natural phenomenon is sufficiently explained if we explain the causality of which it is the result. An intellectual expression, the most spontaneous gesture, like the form richest in associations, can only be understood as a result of the identification of the observer with the subject of the expression. The relationship between the productive and the receptive subject does not merely correct the objective form of the expression but is what constitutes it. For this reason an artistic representation can acquire a new meaning with every new interpretation and can finally reveal a whole series of meanings, whereas a natural phenomenon can only have *one* correct explanation.

The limitation of an unequivocal interpretation of works of art to relatively few, even exceptional, cases follows from the decisive part played by socially and individually variable and irrational components in their formation. However decisive a role the rationally explicable, socially considerable, technically testable, and what can be reconstructed from individual to individual may play, artistic structures are by no means always accessible and are never completely susceptible of an impersonal, emotion-free observation. The latent emphasis upon feeling belongs just as much to their meaning as the manifest conceptual content and the explicit social function. Concepts and practical aims may be completely clear and, as such, comparable; emotions, on the other hand, have a unique and singular form in every authentic work of art. For this reason the "understanding" of artistic expressions, on the basis of personal emotional feelings, is always tied up with the danger of misunderstanding.

The question of the assumptions for understanding in the sense of a condign artistic reception can never be answered unequivocally. We can completely understand or misunderstand a scientific thesis; an emotional, intellectual statement, a pouring out of a confession or of fleeting movements of feeling which are emotionally conditioned, can neither be fully understood nor, in the form of a spontaneous reaction, fully misunderstood. No emotion can be completely reconstructed from external signs; every intellectual expression is, however, to some extent "responsible" for the effect which it has. The unconditional

lack of understanding with which a theoretical statement can be received corresponds—in relationship to the work of art—to a lack of every direct effect, that is to say, complete obtuseness and vacuum, not a lack of recognition of what might be meant by the statement, but a lack of recognition of the fact that anything was meant at all.

If Goethe must have had the feeling that in the sight of posterity he also had a part in the creation of *Hamlet*, and if Unamuno imagined that he could read a meaning into *Don Quixote* which the author not only might not have known but did not even want to know, it was in the sense of the warning, "Do not rely on the writer, rely on the narrative!" Yet if we still cling to the view that the conscious intent of the artist and the outlook of his contemporaries are part of a complete understanding of the work, then we must draw the conclusion that posterity cannot help but misunderstand it and must find a new path to its understanding.

A subsequent beholder's experience of art is always accompanied by a feeling of strangeness, which, it is true, lessens as the work is viewed more closely, but never disappears so far that the essential difference between the art of the past and that of the present can be lost. The former becomes a part of culture and education, the latter remains immediately linked to vital life and concrete practice. The bridging of the gap between the two categories belongs to the most important tasks of a theory of art directed toward uniformity. The tension, which—in this connection—cannot be resolved, between knowledge and feeling and the continuous revision to which past movements in art must be subjected without their ever becoming more suited shows most clearly how inapplicable the idea of progress is to the development of art and judgment of art. Just as we have no better understanding of Raphael today than we did two or three hundred years ago, just because we happen to have a few more facts about him and his art, so we also do not understand Greek tragedy better, though we may have a more fundamental philological knowledge than at the time of the baroque or of classicism. We interpret them (as we do, for example, the *Divine Comedy* or *Don Quixote*) as excogitated, though magnificent, fictions which are possessed of a massive linguistic power and imagination. Even Shakespeare's psychology shatters rather than convinces us. We simply have to forget certain characteristics of historical styles—like the reverse perspective of medieval painting, the carefully constructed central perspective of the quattrocento, or Renaissance coloration in general, which was totally conditioned by composition—if we are to evaluate their achievements. Yet can we, in the face of such limitations, changes of aspect, and shifts of accent, still speak about an adequate understanding of the works? Are they

at all the same things about which people have been talking in the course of the centuries? Yet if Cervantes, for example, and Shakespeare, Raphael and Rembrandt would hardly have agreed with our interpretation of their creations, does this mean that everything which the connoisseur, the historian, and the critic have added to them from their different points of view can be rejected as irrelevant? Does not the picture which later generations have painted of them belong to the body of the works themselves? Have they not gradually come to be what they now are? Is the growth still distinguishable in any way from the original stock? Has not the "authentic" Shakespeare or Cervantes disappeared once and for all? Is not the misunderstanding of them the unavoidable price which we have to pay for our relationship to them, of whatever kind that may be? Do we not see a cultural structure of the past only when we tear it from its original context and place it into the context of our own world view and culture? Is art to be different from philosophy, where (as we know) we usually find in our agreement with an earlier thinker that we are talking about the same things by different names and that apparently identical ideas always have their own function and correspondingly their own meaning?

It does not require much wit or a particularly deep critical ability to reveal the inadequacy of nondialectical one-sided historicism. Nothing is more obvious than that at least different degrees of understanding have to be known in order to talk of misunderstanding. If we were not in a better position to understand the art of the Renaissance than that of Oriental antiquity or if the ancient Greek view of art were not more familiar to us than that of the Indians, we would presumably not know that an art can be misunderstood. And if we did not succeed in discovering diversions and mistakes in interpretation, we should be completely incapable of perceiving the tension which exists in the attitude toward the artistic volition at a given time between a historically critical and an ideologically prejudiced view. Nor could we distinguish between a view which takes into account the motives of artistic effect and a semiconscious reveling in art which is uncommitted. It is a tension which can never be completely resolved but which may be more or less reduced. These inadequacies of historicism were not discovered first by Malraux's critics; but historians take them into account in order to avoid the more crass inadequacies of nondialectic ahistorical thought. The fact that history is always the history of an essentially nonhistorical substratum and that in the different variants of a scientific or artistic aim there is always an expression of an identical intellectual force within these changes was known long before the criticism of Malraux's works and of modern historicism. Since the time of the Eleatics no one has an undisputed claim to the discovery that historical

structures would simply be unapproachable and incomprehensible if the intellect, as the ontological substance of happening, changed completely in the course of history.[59]

Antihistoricism as the expression of the fear that the reevaluation of historical structures by succeeding generations is linked to an unavoidable relativism reveals itself on closer examination as essentially unfounded. For just as we can have different views of life and the world at different stages of our own being and still not have to assume that they do not correspond to any sort of objective reality or are unable to communicate anything of this sort properly, we would also not have to assume that different ideas of self-negating historical—especially art historical—developments are not valid in any way.[60]

The past is essentially pointless and meaningless. It achieves meaning and importance only in relation to the present. For this reason every present creates a new past, and for this reason history always has to be written anew, artistic creations must be reinterpreted, and the works of world literature must be translated again. And for this reason—in spite of the reservations which may be justified with respect to complete historicism—it is by no means so wrong to state that every alleged understanding of the past includes a fatal misunderstanding, for the point of view itself from which we look at history and judge it does not lie outside history but is also a product of history. The meaning of the past is a teleological concept. The question is always "meaning"—for whom?—"meaning" in what sort of context?

With a change in point of view not only does the picture of the past and of the immediate future change, but also that of the past which is being revealed. Every culture has its own genealogy, its own heroic history; there is a different path of development to each one, a path which is clearly demarcated only when the goal has been reached. Mannerism, for example, was not only first discovered with the coming of modern expressionism and surrealism, but also only became an integrated and precisely defined phase of the history of art in the context of it. Manneristic works were of course there before, but they seemed to have come about without sufficient cause and not to have a corresponding continuation. The decisive characteristics of continuity and discontinuity were lacking in its genesis and development. With the enigmatic and ambiguous nature of modern art, it is not only the picture of the works themselves which suddenly changes but also the sense of classical art which preceded it, the self-sufficient harmony and apparent unproblematic regularity of which bore within itself the seeds of mannerism and seem to have acted as a challenge in reaction to it.

The mere taking into account and registration of processes is not in any sense "history." For though people knew of individual mannerists and their works before the modern expressionist period, they were not part of art history. They were soon dead and forgotten, and not because people rejected their works as artistic creations, but rather because they had no real relationship to them, because they meant nothing, even in a negative sense, for the period from high baroque to the end of impressionism.

The past, with all its statements, is a product of the present, not simply because every historical constellation lies on a particular line of development with its own assumptions, which form the past of a particular present, but also because different aspects of the same processes are made apparent according to different points of view at a given time. In this sense we can confidently talk, with Nietzsche, of the "retroactive force" of the present.[61] Bergson only forces this idea upon us when he maintains that the present does not merely reveal hidden sides of the past but actually produces moments which were never present before, not only revealing them, but actually creating them for the first time. When, for example, he recalls that the origins of romanticism are to be found in classicism, he is precisely of the opinion that what is there is nothing but a product of the retroactive force of the romantic view. We perceive signs of what is to happen in history, because we already know the course which the development has taken. The alleged signs are in reality back-dated results.[62] In this way Bergson mysticizes the true observation that the romantic traits of classicism would have scarcely been perceptible without later romanticism. They would doubtless have been present, but barely distinguishable from the dominant characteristics of classicism and would thus have remained indefinable. It is only right that romanticism form the presupposition for a more exact differentiation of the characteristics of classicism; what is wrong and untenable, on the other hand, is the hypostasis of a purely historical theoretical concept as historical reality. For when we call something which counts as classical romantic, we merely introduce a new category and discover at best a new aspect, but no new reality. In the works of T. S. Eliot the thought of the constitutive role of the present for the meaning of the past acquires a more exact character, but sticks essentially to the Nietzschean and Bergsonian concept of historical time. Even for him it is a question of changes which phenomena of art history undergo from the perspective of later events, but according to him it is only the context which changes through the genesis of new truly creative works, and the reciprocal relationships of artistic monuments remain unaffected in their being.[63]

Of fundamental importance in the communication between the present and the past is the fact that as a result of the development of a new artistic conception older works can acquire a new value, but this can equally well be a decrease as an increase in value. Old masters like Frans Hals, Rubens, or Chardin seemed to anticipate the artistic vision of Manet, Delacroix, and Cézanne. They gain in importance as the newer artists appear and at the same time fulfill their promise. On the other hand, a Perugino loses in value as soon as Raphael establishes himself, and Signorelli makes a pedantic and monotonous impression beside Michelangelo. The older masters seem in these contexts to be merely "forerunners" who only prepare the later achievements, but in no sense anticipate them. From the point of view of impressionism, the late style of Titian and Velazquez acquires a new dimension. Beside the works of Rembrandt, however, the whole chiaroscuro style seems to be a mere mannerism. In all these forms of relationship between present and past it is a question of communication in two different directions. At one time the experience of modern art brings an understanding of older art closer to the onlooker, at another the knowledge of older art deepens the consciousness of contemporary artistic efforts.

Understanding and misunderstanding of art are by no means as sharply separated as it appears, but are, rather, linked by a whole series of transitions. Theodor W. Adorno erects in music a widely differentiated typology of reception, which moves between adequate listening and total lack of sensitivity.[64] Similar types can be found in the spheres of other arts, but they are apparently not so diverse and clearly defined as in music. At the head of Adorno's ladder stands the expert, the ideal listener, pure and simple, who hears everything which is played in a manner which does complete justice to the intention and with complete consciousness of the musical process, who misses nothing essential, and who can take proper account of everything which moves him. He hears everything which has been played, is being played, and will be played—as intended in all music which is thematically consistent—at the same time and with the same sympathy. He perceives the musical work as a homogeneous unit in which the whole content transfers itself into form and the form—the thematic development, the rhythmic and harmonic antitheses, the melodic line and the modulations—is there to carry the musical "thought." Technique, as the "logical" form of the emotional and ideal substance of the work, is simply inseparable for him from the musical argumentation. The representatives of this type are restricted today to professional musicians. Yet so many professional mediators of music separate the craft which they practice from the actual sense of technique and

do not always themselves understand what they should be making explicable to others.

The next type in order of precedence, as Adorno designates him, is the "good listener," who is able to appreciate the composition spontaneously in its context and is able to judge both the musical sense and the artistic quality. He does not allow himself to be misled either by the prestige of the composer nor by one or the other of the immediately pleasing elements of the works, but he is not always completely conscious of the technical media by which the individual effects are achieved. This type, who occupies a middle position in the ranking of recipients, is represented less and less and threatens, as Adorno asserts, to disappear altogether. "We see a polarization of the typology toward the extremes. There is a tendency for the individual to understand either everything or nothing."[65]

Between this and the next type, the so-called cultured listener, is the most sensitive gap. Spontaneous love of music and the immediate involvement in it are replaced by a sort of respect and feeling of duty. The "cultural consumer" is insatiable, would like to know everything, to have heard everything, if possible to possess all the phonograph records which can add to his prestige. To be informed is, at this level, the compensation for a lack of insight into structural necessity; the enjoyment of isolated compositions, exquisite melodies, piquant rhythms, ennobling harmonies is the compensation for the integration of these elements in the experience of the work as a whole. He loves "good passages" or modish composers who are approved of by "good society." Yesterday he was a Wagnerite, today he is a Berlioz enthusiast, tomorrow he will rediscover Mendelssohn. It is only what is really current and what points to the future that he does not understand. His taste is conservative because he does not possess individual judgment. His conformism not only excludes all ability to enjoy art, but also excludes him from the satisfaction of validating a new art on his own. The sociological relevance of this type consists in the fact that his conformism is the surest basis of the dominating convention and that the conformists—because of the fact that they constitute the standard audience for concerts, are the regular operagoers, visit festivals, and form the majority of the committees, boards, and administrations that determine programs, conductors, and soloists—hold a key position in artistic life.

The other types are separated from music as such by a more or less extensive misunderstanding of the actual sense of musical compositions. The listener whom Adorno calls the *emotional one* has absolutely no immediate relationship to music as musical structure or to an objective product which can be judged according to purely artistic

qualities. His reaction to music is more spontaneous than that of the "cultured" listener who has firm standards, but is less consistent, more irresponsible, more haphazard than these. His emotions are sincere but consist mainly of eager emotions which are unselective and uninhibited, whereby the music plays the role rather of an excuse than of a sufficient reason for their genesis. They are nourished with all sorts of moods and expressions of enthusiasm and melancholy collected from all sides and discharged at every opportunity. Music of every sort is sufficient to make him dissolve into tears. He embodies the professional man alienated from art, who seeks in music distraction and disinterested experiences as a substitute for everything which he misses in life. It serves as the stimulus for daydreams, imagination, passions which he is incapable of developing himself. However, no matter how low this type of listener stands in the hierarchy of reception, the emotionality which characterizes his experience of art plays a larger part in the effect of music at the highest level than Adorno will apparently admit. Eduard Hanslick, too, with his doctrine of the freedom of feeling of proper musical reception may only be right insofar as he is talking about an emotivity, a readiness for emotion rather than an unequivocal, unmistakable emotion. The inadequacy of the theory of the emotionally conditioned reception of music consists merely in the fact that emotion and intellect are perceived and misunderstood as antithetical principles, and that emotions are based on intellectual assumptions and can be accompanied by the rational consideration of them. The difference between the types of listener which diverge in this way reveals itself entirely in the fact that in completely proper reception the emotional effect is a coefficient of understanding which does justice to the structure. In listening conditioned purely by emotion, music becomes merely an opportunity to do justice to subjective needs.

Whereas the types which have been analyzed up to this moment correspond to a more or less positive attitude to music, the other types which Adorno takes into consideration allow us to see only a negative tendency which rejects the highest values of music. The type of listener designated as the *ressentiment* listener presents in some ways the opposite of the cultural consumer, the listener who approves of everything which is established and more or less officially recognized and is anxious to make it his own. The listener filled with a quiet, impotent rage and excluded from creative existence despises and denies publicly accepted and institutionally recognized music. He attacks it as uninhibited, conventional, corrupt, and ready to make any concession in order to succeed. He rejects what is successful not for an avant-garde, not for a hope for a future which goes beyond what is acceptable, but from

a conservative, even regressive, impulse, which goes back to a so-phisticated, nobly antiquated past, which is as far removed as possible. So we see the development in relatively wide circles of the modern Monteverdi fashion, like the Bach cult of former times, the lively interest in Vivaldi and the other eighteenth-century masters, the re-stricted interest in almost all romantic music, and the lukewarm feelings toward all musical production between Bach and the latest avant-garde. The best of modern performers with their *tempo recto* instead of the older *rubato* and their rejection of emotional license are demonstrating against the high box-office receipts at the old and tried classical and romantic programs. The most striking characteristic of the *ressentiment* against the art of the last century, which is still regarded as unexcelled by most of the audiences, is an antiromantic, sometimes reactionary, sometimes nihilistic tendency which denies that art is a relevant vehicle of communication, understanding, and communal culture.

In protest against official art and culture even if perhaps only here, we find the Adorno type of jazz expert and jazz fan linked to the *ressentiment* listener. The pop-art enthusiast is also related to him, but Adorno does not treat him. What they have in common with each other is a demonstrative dislike of the classical-romantic inheritance, although they usually betray a secret, even if generally hardly dis-guised, tendency toward romantic melancholy. They still strive to give their protest against the "cultural swindle" a "technical-sportive" character. [66]

Adorno reserves a special category for the listener for whom music is nothing but entertainment. In reality, however, this listener is scarcely distinguishable from the other types below the level of the expert. For however rewarding the many-sided differentiation of lis-tener types may be, the one decisive gap is the one which divides the expert from the nonexpert. For him music is nothing but relaxation, that is, entertainment without effort, without a particular task or re-sponsibility. He enjoys it or hears parts and fragments of it with plea-sure and satisfaction, without grasping compositions in their entirety. He does not take possession of them and comprehend them in a manner which corresponds to their musical rationality—strictly coherent and necessary in the sense of an immanent obedience to certain laws. The boundaries between the different types of subexperts are fluid, and the development moves toward their further commingling and assimilation in the form of a mass which receives even the best music in an unsuitable manner. The "good listener," the "cultural consumer," and the amateur of archaic antiromantic styles who is limited by *ressentiment* can hardly all be subsumed under one category of an unequivocal mass public, in spite of the regrettable inadequacy they all share. This is true

particularly because the mass consumption of stimuli and pleasure media, whether they are sexual, culinary, aimed at an increase of comfort, or of an intellectual nature, correspond to habit rather than need. People miss such means of pleasure when they are not present, but they scarcely notice them when they are available. In America radios blare out everywhere without cease—in the dentist's waiting room, at the hairdresser's, or in cafés. People apparently believe that they will escape their loneliness by means of background music. The constant droning isolates them, however, even from those who are sitting at the same table. This music is a soporific, and people only do their work even more mechanically as they listen to it. It proves to be the most undemanding social companion, leaves one in peace, and only makes us listen for a few minutes when there is a familiar hit or a melody from a musical. Music which serves merely as a distraction needs "distracted" listeners, who are neither clear about, nor think about, submitting the effect to which they are being subjected to any sort of conceptual criterion or critical standard. If they are at all able to suffer intellectually, they suffer from an intellectual pride in mendicancy. "I like it or I don't" is their verdict, "whatever the know-it-alls may think about it." Here, however, the boundary which surrounds the musically *indifferent, unmusical,* or *antimusical* is crossed. The impetus to shut oneself off, or to reject, in this case (if it does not have its origin in a physiological or psychological inadequacy, as so often is the case) also resides in that pride and rebelliousness which sets itself against the society that denies its less-privileged members the prerequisites for participation in the treasures of a common culture.

The question in connection with different types of reception which is in most urgent need of clarification and response is apparently whether, and to what extent, the one type is capable of producing for the other services of mediation in the interests of a better, more adequate understanding between artist and public, production and consumption. Is the cooperation of teachers, critics, performers, collectors, museum directors, and concert societies indispensable for successful communication, or does the mere juxtaposition of the different types of reception prove to be essentially so stimulating? Does it raise sensibility so much that the lower types become more visually and auditorily sensitive under the influence of the higher ones? Whatever the case, the changing distance between the average and the ideal types, the differentiation of reception, is, to a great extent, socially conditioned. It is mainly a case of the continuing stratification of cultural classes as a result of the multiplication and mobilization of different propertied and professional groups. Just as the formation of reception types is dependent on social conditions, so also is the rise from one

type to another. A liberal and progressive social order promotes—an antidemocratic and regressive one hinders—the increase in proximity of the different stages and types.

Nevertheless, liberalism may level out the social subjects, but yet weaken cultural coherence while conservatism may strengthen the principle of coherence despite all the inequality of those who support it. In the latter case it is the forces of continuity and tradition which triumph, in the former those of discontinuity and emancipation.

The success of the mediation between different stages and forms of reception also has, however, besides social assumptions, a series of natural psychological and biographical ones. The change from a naive recipient into a connoisseur often demands not only a long education, which may absorb a person's whole youth, many tiresome years of learning, but also a change in personality, which—with the best will in the world and the greatest effort—may not be capable of achievement. The person who is not born to it may perhaps never become one. Social education can only develop and guide tendencies which already exist. In some circumstances it is possible that a not particularly sensitive person may be educated to become a good, critical listener or spectator who can react more or less correctly to differences in quality. Even completely correct reception may, like completely successful production, develop from a tiny seed, but always only in conjunction with innumerable favorable social and individual conditions. Mere mediation, instruction, example, guidance, and correction on the part of experienced teachers, incisive critics, and tested connoisseurs or of more sensitive laymen do not make a connoisseur out of a person without sensibility for artistic qualities, without a sense of the implications of an artistic task, and without a sound judgment for the most simple criteria for artistic success. However, we can—on the road to artistic mediation, toward true artistic enjoyment—train capable "cultural listeners," good readers, and visually receptive lovers of painting, who, even if they remain incapable of penetrating the innermost secrets of the greatest works of art, can find true joy in them. The authoritative mediators belong to the indispensable medium in which social education of "good" and "cultured" recipients takes place. The fact, however, that many, many professional mediators are incapable of guaranteeing success points to the limits of communication in the sense in which it is here meant and in the area of which we are talking. The influence of the mediator does not pass directly from one person to another, from intellect to intellect, but through a series of objective or objectivized natural or conventional and institutional data. Even the most personal influence proves in part to be indirect.

20 Success and Failure

Rilke defines fame, especially the fame of the artist, as the sum of the misunderstandings which are formed around one name. What he apparently wanted to say by this was that the artist never receives what he deserves and that the recognition of his services rests upon just as inadequate a set of bases as their nonrecognition. In any case, the criteria of recognition, even when they prove to be deserved, are inconstant and unreliable. A well-earned reputation can just as easily come to naught as an undeserved lack of recognition. Nothing, it is true, succeeds like success, but success piled upon success can collapse. It is doubtless one of the most effective stimuli which the artist can experience and often encourages him to achieve the most daring and successful products. Yet, at the same time, it corrupts and spoils him, too, when he becomes wanton and irresponsible and relies too much upon his good fortune and prestige.

The artist strives for success in order to earn his means of livelihood, for his material independence, and to secure reputation and influence. Many apparently selfless products are often only vehicles to this end. The media of seeming to create new and original effects—particularly— more often serve the aim of establishing himself, of leading an existence beside others rather than serving the desire to express his own being and to communicate himself. Exaggerated individualism is evidently a symptom of increasing competition and a means of directing the attention of the public to himself. The emotional stylistic tendencies of hellenism, the egocentric extravagance of manneristic art, the subject-oriented romantic movements, and the whole lyricism which dominated the nineteenth century in Western poetry and music appear in periods of overproduction, of a market flooded with goods, of free

competition, material independence, and the simultaneous vulnerability of the producer. Eccentric, exaggerated characteristics which are quite new become trumps in the game of success, a showpiece for the public, and a means of seduction of the artist—threatened by the danger of lack of effectiveness—who offers himself for sale at any price.

It is part of the inveterate blind faith of the disciples of psychologism and of the unproved dogmas of antiquated art theory that real talent cannot be destroyed and that it always prevails in spite of all opposition, constant lack of success, and perpetual misunderstanding. Of the talents which do not prevail and whose voice is gagged of course we know nothing. The concept of misunderstood talent is in any case not merely the comfort of untalented charlatans. Yet the assumption that a genius remains for the most part unrecognized in his own time and can find no one who might be capable of preparing the way for his later recognition is a sign of the same ahistorical thinking as the idea that someone is capable of hurrying on ahead of his time and anticipating the future.

Nevertheless, there are enough pessimists who believe and assert that hindrances, lack of understanding, and lack of success belong to the spur which a creative spirit needs in order to produce his best. The fact that obstinate characters, filled with *ressentiment,* and pathologically ambitious do exist does not change the rule that understanding, support, and cooperation are positive social forces and that the competition which is stimulated by them bears richer fruits than the desire for fame which is nurtured by anger, envy, and jealousy. It would be as rash to conclude that all important works of art have their origin in selfless feelings free from ambition as it would be axiomatically unauthenticated to assume that they are immediately, unconditionally, and nonarbitrarily directed to humanistic ends. Kierkegaard, already, warned of the error of confusing the genius and the saint, but it would be just as wrong to conclude from the fact that art is a blessing that the artist is a benefactor. Even the ethos of the creative personality is a dubious form of link between artistic production and reception. It can be completely lacking or be without effect, and the contact between the author and the public can be achieved by other means; but it can also aid the separation of the work—as an intentional expression—from the person having the receptive artistic experience. In this way it can enhance the expression of the inwardness of the artist by production, which is not of itself an ethical act and which does not seek to validate the immediate moral effect. The work mediates everything which is expressed in a different way from the formal language of the artist—it interposes itself between this and the recipient even while it seems to be joining the two. The imago of the artist which appears in

the form of success and reputation is one of the least reliable links between production and reception of art. It determines criticism of the work with a particular ideal in mind and impedes that flexibility of interpretation and evaluation which keeps artistic creations alive.

The bond which proves to be the strongest between author and public is unquestionably the common social vantage point and the ideology which corresponds or is similar to it. A progressive point of view toward political and social questions on one hand hand and a regressive one on the other is often, if not by any means always, the reason for lack of success of works which are of themselves successful. This lack of agreement is all the less the exclusive and sufficient reason for lack of success, since the contradiction may, in certain circumstances, lie in the personality of the artist himself without affecting his relationship with his public. A politically conservative or even a reactionary person can think and feel as an artist completely progressively. Sometimes this sort of contradiction is the precise explanation of artistic success in those cases, for example, where a conservative public puts up with progressiveness in art because of the artist's political tolerance, or where a progressive public clings to an outmoded artistic movement because it had its origins in revolutionary ideas, and people still regard its antiquated content as authoritative because of a lack of feeling for historical distance. This is the explanation of the phenomenon which today causes the Russians, for instance, to want to stick to the art of the middle of the nineteenth century as exemplary and to regard all art that has been produced since Balzac, Courbet, and Dickens as suspect examples of bourgeois decadence.

We meet examples of the case of an artist's unsuccess in spite of being competent in his field relatively late in history. Euripides was, as we know, if certainly not the first, without doubt the first famous, writer whose works were not properly appreciated by his public. Yet this happened for instance not only because his predecessors worked for permanent patrons or were commissioned by established authorities and institutions while he led the existence of a mainly free writer, but also because there had previously been relatively few works to choose from, whereas now there were too many rather than too few. The domination of poetic technique by pure craft which once assured a certain success was no longer sufficient for a poet's success.

The main reason for Euripides' relative lack of success lay apparently in the lack of an educated middle class which would have shared his ideological and aesthetic values. The old nobility was a stranger to his attitude, the new bourgeois public to his culture. The successful Greek poets are now—and remained for a long time—conservative in their views, just as at the time of high classicism, although their artistic

naturalism which comes to a point in the urban, bourgeois forms of life no longer corresponds to their political ideas. Their divided loyalty and the ambivalence of their feelings find their most remarkable expression in Plato, in his philosophical idealism and his artistic realism which recalls the style of the plebeian mime.

The strange constellation repeats itself—even in as late a historical period as the eighteenth century—in the works of Watteau and Marivaux, two artists who were often compared with one another. They were also similar in the fact—among other things—that they both expressed themselves in the most extremely cultivated and conventional forms of good society without proving to be especially successful. Watteau had only a few faithful followers, and Marivaux's works constantly failed. Watteau's artistic media were—for a large circle—too fine and unambitious, and Marivaux's effervescent dialogue was rejected because it was mannered. They present the same sociological problem. If, however, in the case of Watteau we allow the explanation to hold that he was too large for his time, we cannot accept the same explanation in the case of Marivaux, who was not a "great" poet. Their lack of success has nothing to do with the artistic quality of their works and can only be explained as a historical displacement. Their contemporaries do not reveal the new nuance in their otherwise conventional form of expression. The next generation comes face to face with the new trend mainly in the watered down or coarsened form, which the epigones gave especially to Watteau's art. Posterity—especially that which was drawing near to impressionism and which would have been capable of explaining it stylistically in a more fitting manner—cannot bridge the historical gap which divides it from the feeling for life and the artistic urge of the master. The nineteenth century faces in Watteau's works an already thematically antique world and can only save for itself the sublimated form of his art.

Postrevolutionary romanticism, and with it the artists of the whole bourgeois nineteenth century, developed a cult of misunderstanding and lack of success. Its appeal to posterity and its faith in later fame was, however, for the most part an arbitrary rejection of the assent of the contemporary world and a mere gesture of defeat. Alienated from society by the revolution, which had for the most part been wasted, the romantics and the rebels pretended (to the next generation) to be proud of the misunderstanding and the lack of success with which they met. Instead of surrendering and making concessions to the public rooted in its concepts, they tried to confuse it by obscurity and extravagance and to make themselves into challengers, where in reality they were the defenseless victims, of the bourgeois society which had come into power.

The postromantic bourgeoisie, the public of Courbet, Daumier, Baudelaire, Flaubert, and the impressionists, certainly had money and position but—as Walter Benjamin noted— "no more prestige to distribute." The artists took their reward from the despised and betrayed bourgeoisie but did not even enjoy the reputation—mixed with distaste—that had still been the reward of the romantics. In spite of the growing number of people interested in them even in conservative circles, and in spite of their greater economic security, they felt themselves more and more degraded, and they compensated for their lack of political influence, the questionable nature of their social rank, and the lack of real understanding even on the part of the interested bourgeoisie with insults, poison, and gall.

There are, however, aspects of lack of success under which its significance is harder to judge and where the artist finds no compensation for his unsuitability and the defeat which he has suffered. The same work may appear to him to be successful and unsuccessful, and both may appear improper and unjustified. Even if he knows what he wanted to achieve, he by no means always knows whether and to what extent he has succeeded in achieving his goal. His possible public success compensates him far less, and far more infrequently, for his dissatisfaction with himself than his consciousness of the public's lack of responsibility for external lack of success. Inner success is moreover always problematic, for even in the case of an apparently complete success the creator of the work has to ask himself whether luck and chance did not play as great a part as his urge and ability. He can never be completely satisfied with himself. Only the dilettante can be that. Only he reaches what he strives for and is satisfied with it.

The real artist's satisfaction with his work increases with the feeling that he has understood himself better, expressed himself more fittingly and convincingly than ever before. Basically, however, he is just as alienated from the "successful" work. Indeed, this may appear more alien, more inadequate, and less satisfying to him than it does to someone else. He conquers reality and loses himself in it.

21 Social and Antisocial Motives

Examples of the rule which says that almost nothing can be asserted about art of which the opposite cannot also be said, the contradiction that it is at one and the same time individual and supraindividual, spontaneous and conventional, historical and ahistorical, close to and removed from nature, that it has purpose and does not have purpose, can be extended to the thesis that it can have both positive and negative social effects. Art which serves the need for communication and understanding, as well as the task of socialization and unification, at the same time becomes the substratum of the most personal, intimate, untranslatable experiences, a means of concealing jealously guarded secrets, and the source of a pleasure which is the more intense the greater the demands it makes upon the people enjoying it. For all its practical expediency, it acts as an anesthetic, often developing a lack of responsibility to the most burning questions of life and as something by which we make light of the wretchedness of so many of the conditions of our existence. It may become the object of a cult which permits us to forget that we no longer really believe in anything or the instrument to simulate sympathy, which moves us to shed noncommittal tears. One of its most glaring paradoxes is that it is equally egocentric and altruistic. It may have its origin in a communal need, but it reaches its special aesthetic, formative goal only when it permits the creative individual to enjoy his life in a completely egocentric microcosm and separates him from other individuals. Even these ambivalent artistic goals represent only one of the aspects of the Hegelian thesis of the divided possession of the work of art, a thesis which states that the work of art belongs and does not belong to its originator.

Insofar as we can talk of the sociology of art, the artist is inconceivable without an audience, but it has also been correctly asserted that "he is never at one with any particular public."[67] He may identify with one or another class, but he does not form a completely coherent community—dissolving the principle of individuality, spontaneity, and originality—with any of them. He may, in an unreconstructed past, have lived in undisturbed harmony with the society of the time and may perhaps merge completely with a future one. But as far as our historical knowledge extends, he has always lived in a sort of exile and has had to come to terms with the fact that he would be more or less abused and misunderstood. In any case it is one of the most startling contradictions of the historical period to which our life and consciousness is restricted that the artist who expresses himself par excellence in a social medium so often feels himself to be an asocial being incapable of socializing and that he has always to turn to others to assert himself. He not only shies away from them but even abhors and despises them. He usually performs his services in the interests of socialization and communalization involuntarily and unconsciously. In any case, he benefits mankind without realizing it. He himself is in need of contact and love, but is not infrequently—like a large part of his public— sentimental and selfish. The humanitarian aspect of his art consists in the effort to represent the *condition humaine*—in its concern for its own existence—truthfully, without self-deception and cheap concessions, and to support others while preserving his own skin.

The suspicions nourished by masters and clients about the artist are just as justified as those which artists who are employed or commissioned have about their masters and clients. They need one another, make contracts with one another, make forced concessions to one another, and live together for the most part in a precarious armistice. They praise and extol each other in order to be praised and extolled, but there is seldom any cordiality in their relations. For all the happiness which people owe to art, they nourish a secret, though often ill-concealed, suspicion and anger about it. The old caution against its seductiveness and its danger—which is probably rooted in magic—is also expressed in Lenin's fear; he is, according to Gorki, once supposed to have said, after hearing Beethoven's *Appassionata*, "I could listen to it every day. What marvelous superhuman music . . . but I may not listen to music too often, it gets on one's nerves; we say stupid, nice things and want to stroke people's heads who create such beauty, yet they still live in this dreadful hell. We should not stroke anyone's head—he might bite off our hand." Lenin was by no means unartistic: on the contrary, his fear demonstrates that he was a person receptive

to art. He recalls the conscious atheist who is closer to God than the regular churchgoer, for whom daily prayer has become a habit. He finds himself in the company of many other people who admire art just as much as they are ready, in a spirit of sacrifice, to be a friend to suffering humanity and who ask themselves how it is possible that such beauty can be created in "this hell." The problem of the relationship between the producer and the consumer of art is not a question of particular works, styles, or trends in taste, but simply of art, namely, of the question as to whether society, as it is, can allow itself the pleasure of art at all.

The artist nurtures from the beginning antisocial feelings, in that he sees in every continuing institution, every rigid organization, every order which is nonsubjective a principle hostile to art. He opposes every institution and convention, without being aware of the fact that art itself is an "institution," an order sui generis, and contains just as many conventional as it does spontaneous elements. Aside from those original motives of alienation which art contains as an autonomous structure, the artist's opposition derives from the dubiety of objectives in a world in which the idea of the brotherhood of men has been lost. It leads to a progressive isolation and a readiness to defend oneself against everything which is strange and which is imposed from outside. The artist's creative activity may, in spite of its social and, finally, humanitarian sense, make itself felt as either misanthropic or philanthropic. Of itself, it certainly does not guarantee the solidarity of everyone with everyone else, neither that of the artist with the nonartist, nor of the artist with his fellows. Competition, ambition, emphasis upon individual method divide them from one another, no matter how close their ideological and stylistic solidarity may be.

Nothing is changed in the social provenance and essence of art by the fact that the artist often seems to be alone with his work, that he tries to keep everything personal, intimate, and secret for himself and suppress anything which is exhibitionistic, oratorical, and theatrical. Art becomes a supposed refuge from a society which the artist can deny but not exclude. The solitary lyric is merely the other side of the coin of communal art: both are socially conditioned; it is just that the one is directed toward the positive values of socialization, the other toward its unsatisfactory forms.

Since the dissolution of homogeneous cultures, whether pervaded by the principle of community or that of unconditional authority, every form of art is related to the experience of alienation. Thus, even mannerism becomes the slave of this feeling for life, even though it is more an expression of anxiety, uneasiness, and confusion about

something in the future than the symptom of a process of alienation already accomplished. The phenomenon of alienation in this sense does not belong to a principle of style and an element of form but to the raw material of artistic creation which has to be mastered. Certainly, the concern of the artist about this development, which threatens to assert the mastery of depersonalization and lifelessness, by no means excludes the possibility that his own works will become manifestations of alienation, that is to say, lifeless, mannered, and not merely manneristic. It is one of the inner contradictions of mannerism that it battles against the formalism and conventionalism of the Renaissance but is at the same time dominated by strongly formalistic, conventional, and aestheticizing principles foreign to the freedom of the creative subject. In the same way, it is part of the nature of present-day art that it is—because of its origin, nature, or aim—asocial, individually capricious, or moved by suprasocial, irrational forces, because it will not pretend to be at one with the appearance of socialization at any price.

The unarticulated nature of the art of our own day, its difficulty in finding words, its stuttering and stammering, its resignation in the face of the inexpressibility of what is alone worth expressing, does not mean that it is in a social vacuum but merely that it balks at confusing the medium in which people pass by one another and talk past each other with a sphere in which they could reach an understanding with one another. The acknowledgment and the acceptance of the fact that society functions in contradiction to its sense and aim, and the passivity connected with this admission, do not mean that because of this we are outside the social sphere, but merely that we have comprehended the difference between a society which is incapable of meeting its obligations and a humanity which might be in a position to think and act according to its idea. The dissatisfaction and the desire to admit it are much more striking proof of social consciousness than the appearance of an understanding which does not actually exist. Passivity is negative, but it is not a lie.

The negative traits, which are ubiquitous in present-day art, do not consist in the absence of a common denominator which—in the atomized society of our industrial, commercial, and competitive economy—could preserve something of the spirit of a once existing communality. They also consist in the absence of the forces, drives, and tendencies which would reconcile man, as a social being, with himself and others and save him from the fate of the Narcissus of our time, from the curse of the artist's turning from being the champion of fraternization into the opponent of self-expression and reconcilia-

tion. From Narcissus (the lonely artist, thrown upon his own resources and in love with himself) to Orpheus (the loving and beloved singer) there stretches the longest, most difficult, perhaps impassable road of mediation. In their unmediated and unreconciled juxtaposition, they embody the ambivalence of which modern art is full.

Part Five The Differentiation of Art according to Cultural Strata

22 Class and Culture

The title of the following remarks contains two easily misunderstood concepts that are hard to define: that of "culture" with its limits—in antithesis to the sociologically more fundamental and unambiguous concept of "ideology"—while "stratum of society," which is composed of a mixture derived from many origins is opposed to the original and more coherent concept of "class." The idea of a cultural stratum consisting of many, originally heterogeneous, elements has in this connection to replace the insufficiency of the purely sociological determination of artistic values. Membership of a class and class consciousness are never quite equivalent, for these and the social position of the artist, the status of the members of his profession, and that of its adherents never directly and exclusively determine the stylistic character and the aesthetic quality of his works.

The category of cultural stratum is certainly not the most fundamental and standard form of social organization, and a sociology based upon cultural differences between groups would have to be a superficial approach to socialization. However, to the extent that—especially in the sociology of art and culture—the economic and social community of interests proves an insufficient motive for integration, so the cultural factors—with the corresponding reputation and the intellectual influence associated with them—acquire more and more significance. Continuous tradition, increased sensibility, refined taste, increase in creativity, talent, and self-criticism fill out the space left empty by the historical, materialistic explanation of artistic productivity. But in saying this we should not ignore the fact that culture, which fleshes out the materialist motivation, itself has materialist assumptions and is connected with the socioeconomic privileges of relatively thin strata

of society. Guyau suggested—revealing his partiality for romantic aestheticism—that art in itself was supportive of society and created solidarity. In reality, because of cultural privilege, it creates as many barriers and antitheses as it does feelings of community or evidence of solidarity.

Alfred Weber's thesis—which many accept and which was elaborated by Karl Mannheim—of "free-floating intelligence"[1] was nowhere more eagerly seized on than by artists who felt themselves to be situated all too narrowly and uncomfortably within the bounds of a materially limited class. The determinism—which lies beyond subjectivity—of class structure seemed to them to assert itself at the cost of actual artistic values. What, however, led the adherents of the doctrine of "free-floating intelligence" astray was the obvious fact that the intellectual, especially the artist, is far less restricted in his movement between classes than most other members of society. True, he is by no means "classless" and does not lead an existence beyond class and indifferent to it, but he is able and generally ready to revise his class adherence, to question it, and to join a class community which may be quite different from the one to which he originally belonged on the basis of his origin and with which he had formerly declared his solidarity. The concept of a cultural group as an open category with fluid boundaries and liberal conditions of entry corresponds to his idea of a social form to be affirmed better than does the concept of a rigid, propertied class, though even this—in contrast to walk of life, family, and kin—is a relatively flexible, pliably organized, loosely knit community of interests. It is well known that Pareto saw the essence of elites in this mobility and in circulation as its particular form. Not only do single individuals sometimes enter the elite of the day or sometimes leave a threatened elite, but elites themselves supplant each other in the constant change. A circulation of this sort not only characterizes the transition of those who support culture from the aristocracy to the bourgeoisie, from the upper to the middle class, and from the middle classes to the heterogeneously constituted intelligentsia which is determined by stand, but also the surrender of the dictates of taste by the representatives of one artistic movement to those of another. Pareto's doctrine of the fall of cultural elites has—in spite of the formulation that "history is the graveyard of aristocracies"—nothing to do with the fate of inherited nobility and its hereditary privileges. It corresponds rather to the principle of the general circulation of privileges, somewhat in the way that Henri Pirenne sees the circulation of the economic domination of society—the elimination of saturated strata from active economic life and the approach to the places thus freed by new groups who do not, up to that

point, participate in chances of success, in short, the concept of social mobility pure and simple.[2]

Artistic productivity and receptivity are, it is true, closely linked with the existence of privileged strata, but artistic ability and social privileges are not the same as one another. Without a certain freedom from care and the ability to dispose of one's free time, no one can acquire culture, and without a training suited to the situation at a given time, no definitive art can be produced. The stage of artistic education which can be achieved is not determined exclusively by the material means available, and the quality of the works produced is far from corresponding to the extent to which the artist is protected from care and concern. What, rather, is part of the production of high art, as Hegel already noted, is sorrow and tribulation, the blows of fate and tests against which power and economic security offer no shield. Artistic creation moves between an indispensable minimum of spiritual, and a still tolerable maximum of ability to suffer material, sorrow.

There can be no doubt, an artist does not create his works only for his peers; but he also does not, for example, create them just for "mankind" pure and simple but always only for certain parts of it, for special groups and classes. Beethoven intended his quartets for a Western public and not even for the whole of that public but for an audience which was already familiar with Mozart's and Haydn's chamber music: and as far as his later quartets are concerned, even this audience has to be limited. The members of the audience who were capable of understanding them could scarcely have been the same as those who played and enjoyed his early quartets. The late quartets corresponded to a taste and understanding of art of a public which no longer consisted simply of members of the wealthy and cultured middle class, not merely of "good" but also of "expert" listeners; that is, it consisted of people who comprehended and judged the pieces according to the composer's intention and with a full consciousness of what was happening musically. Beethoven's different styles not only presupposed different stages in the history of the composer's development, but also presupposed different cultural strata as listeners.

Instead of orienting the sociology of art toward different "national spirits," "spirits of the age," or immanent art historical "sleepers," we should take into account the fact that every society has just as many different sorts of art as it has strata which support culture. There are always as many simultaneous styles as there are categories of feeling for life and supporters of culture that correspond to them which can be distinguished historically and sociophilosophically. The lack of a unified stylistic character and level of quality is not a modern phenomenon. There were, alongside the high Attic tragedies, already

popular, common mimes, just as alongside late romantic drama there
existed the *pièce bien faite* and the melodrama of the popular theater,
Delacroix alongside Delaroche, Courbet alongside Corot, Bouguereau
alongside Baudry, Flaubert, Maupassant, and the Goncourts alongside
novelists of the antiartistic bourgeoisie, like Paul Bourget and Georges
Ohnet. Apart from such extremes, however, there are transitions which
increase in the course of development and assert themselves alongside
every more or less advanced historical stage. In the early periods of
human history when an art may have been produced—which was more
or less unified—for the whole population, there was probably only
one cultural stratum which could be considered a consumer of art. All
those concerned had a similar cultural background, or lack of one;
they were permeated by the same magic or animistic view of the world
and the same feeling for life. The whole art of magic, the people, and
the priests revolved around them: the rest of the community had no
artistic needs, made no artistic demands, and developed no kind of
aesthetic concepts of value. Where needs are unequivocal and homo-
geneous, so also are the values, and indeed to such an extent that they
do not appear as such; that is, they remain undifferentiated and brook
neither opposition nor competition. More recent criticism of culture
has accustomed us to trace the insufficiency of our spiritual achieve-
ments back to the loss of the former unified view of the world. The
factual connection between the two phenomena may exist, but its
assessment remains questionable. In this connection, complexity or
simplicity are of themselves to be judged neither as a higher value nor
as an inadequacy—the one like the other can, according to its function
in the whole of the process under discussion, be of value or be valueless.
 If we look at authoritative strata of culture in the present state of
cultural development, we can distinguish folk-art, popular art, and the
art of the social elite. Folk-art is the poetic, musical, and visual creation
of naive workers, generally rural and not urban-industrial. They par-
ticipate in their proper artistic products not only as receptive, but
always as productive, participants as well, although they never appear
in their creative roles and never lay claim to personal authorship.
Popular art, on the other hand, counts as an artistic or pseudoartistic
production suited to the needs of a half-cultured, often miseducated,
mainly urban public which tends to be stereotypical. While in folk-art
the producer and the consumer are hardly distinguishable from one
another and the boundary between the two remains fluid, in popular
art we are dealing with an essentially uncreative public which is com-
pletely passive and a professionally accomplished production geared
to changing demand. As significant as it is, however, that folk-art goes
beyond the circles of its creators, whereas the products of popular

art—the "hits," trashy novels, melodramas, and the like—all come from the pens of professional upper-class writers who remain linked to their class, the fundamental difference between the two categories lies in the fact that the public is always a different one. The participants in folk-poetry, now more and now less active, are those who are unread even if they are able to read, who live in the country, in villages, and in farms, while the buyers of horror stories and dime novels, comic books and oleographs belong—in contrast to the authors—to the urban lower classes, a population completely distinguishable from the cultured classes.

As there are at any time as many artistic movements as there are cultural strata, a fitting representation of artistic development should be organized in cross sections rather than longitudinal ones. In this way, the fact that in more developed periods more parallel traditions are always exerting an effect would be more emphasized and would dispose of the legend perpetuated by romantic philosophy that everything which happens at the same time is "organically" connected. The differentiation of artistic styles according to whether individual movements emanate from the intellectual elite, the urban masses, or the rural population, and whether this leads to a bifurcation of high and popular art beside folk-art, would be the next problem, and it would be relatively easy to solve. We would still have to find out how every cultural level and class situation are generally related—which special, dialectically conditioned antitheses exist within individual cultural strata, and how tensions between motives conditioned by class on one hand and culture on the other achieve a state of equilibrium. The difficulty of finding the satisfactory solution to this problem derives mainly from the fact that the nature and extent of culture do not correspond simply to economic and social circumstances, but they are also formed independently of these—that is, according to individual tendencies and abilities—and that their limits and components now expand and now contract according to the total historical situation at a given time. The value and meaning for art which is ascribed to culture as critical consciousness changes from time to time. In the Middle Ages, for example, culture—in spite of the tremendous reputation enjoyed by scholastic education, knowledge of Church dogma, and the "right" thinking which corresponded to this—is not a necessary assumption (and one which lies particularly on the artist) of work which could be regarded as successful. It only became this in later phases of development when art emancipated itself from alien influences like the rules of craft and guild but subjected itself to the cultural principles of the humanist, the man of letters, or the academic.

The artist-craftsman, like the pious admirer of Christian art, is not necessarily cultured. It is only since the Renaissance that art has been mainly directed at the cultured, even if earlier it was adequately understood only by particularly capable connoisseurs. In Oriental and classical antiquity considerable strata were still excluded from the enjoyment of art or from participation in certain forms of art. In the Christian Middle Ages a part of artistic production, especially painting and Church music, was intended for the broad masses, but not for a public as an audience for art. The fact that the uncultured were incapable of enjoying and appreciating works of high art in a suitable manner does not need to be specially stressed; what we should not forget is that these works were in no sense created with the intention of affecting everybody as works of art. And although there is always a certain difficulty in determining who enjoys a work of art, why, and to what extent, even in a time of committed art like the Christian Middle Ages, this determination is difficult enough in respect of the cultured class, that is, the clergy. Who could say with certainty how many of the members of the ecclesiastical building commission who were responsible for the design of a Gothic cathedral really knew what the artistic function of their office was?

A treatment of the history of art according to the three determining strata of culture could only be planned for the period after the Renaissance or perhaps even only after the Enlightenment, in a time when the different categories of those concerned about art emerge more independently and are more sharply defined. The principle of a differentiation of this kind would certainly have to be extended to much earlier phenomena, even if the limits are much less clear, and not just to obvious examples—in antiquity and the Middle Ages—like the juxtaposition of the official Athenian theater and the popular mime or the immediate succession and close proximity of heroic poetry of the warrior nobility with the ballad, which had lapsed into the popular. Such a point of view would certainly simplify the classification of many more modest sculptural products—mainly objects of worship—presumably produced for a lower class. But the distinction between works of folk-art and those of popular art—and this still applies to the Middle Ages—would remain for the most part infeasible simply because the boundary between backwardness based on class and on personal lack of talent is hard to draw. Alongside the high art of the Church and the courts, it is probable that we can at this stage of development speak of folk-art, but we can only talk with reservation of popular art in this sense.

At a time when the ruling class—for example, the audience for the Homeric rhapsodist—is in the process of disappearing, we can call an

art which has "sunk" down to the people "popular art" in contrast to a truly naive artistic practice which has its origin in the folk. In the early Middle Ages during which there are no works of high art and no certainty of the existence of folk-art, we can speak of the "popular nature" of art, although of course there is still no connection with the massed inhabitants of the cities. Thus, if, in general, we are also to assume that there was from earliest times a folk-art alongside the art of the ruling classes, an art of the uncultured peasants and rustics, we cannot be certain in the early stages of history whether in the individual case this art was a depravation of the art of the ruling class, mere imitation of an art of the elite, or pure folk-art. The art of the Neolithic period, like that (at least partially) of the time of the migrations, was folk-art and art of the rulers in one. It was the art of a peasant society. On the other hand, in order to be able to distinguish in the early developmental phases of literature the remains of an oral tradition, as people have been successful in doing in the later development of the Homeric epic or the *Nibelungenlied*, no one furnishes proof of their original naive, popular origin. Be this as it may, the outlines of an artistic production in which neither the socially elite nor rustics were concerned and which serves the purposes of a middle class which is partially urban and not very wealthy—even if not poverty-stricken—first appear at the end of the Middle Ages. The graphic tracts of the transitional period, which were offered for sale at church doors and at fairs and disseminated by itinerant vendors and hawkers, belong to the earliest products of this sort.

The gap between high and popular art, or folk-art, has constantly widened since the beginning of the courtly aristocratic and the upper-middle urban class period of the seventeenth and eighteenth centuries. Since the predominance of industrial industrial/commercial economy in the last centuries, both extremes (the art of the elite and folk-art) have become less attractive and significant in comparison with popular mass art. Folk-art disappears in one country after another, and the art of the connoisseurs, though it may win a larger public than ever before, loses more and more of its numerical superiority in proportion to art designed for entertainment. Meanwhile, between the middle of the last and the middle of this century the authoritative culture of the cultural elite forfeited its exclusive dominance and those who supported folk-culture were absorbed into the hybrid masses, while popular art established itself as the truly representative art of the period.

The inadequacies of folk-art and banal entertainment—compared with the art of the cultured, the connoisseurs, and the experts—seem from the beginning to be more marked and determining than the positive traits which they have in common with this other art. High, fully

developed, strict art which presents a self-evident picture of reality and has as its object a serious discussion of life's problems and of the constant struggle for a meaningful existence can scarcely be placed in the same category as folk-art. The latter aims to be nothing other than diversion and pastime and is seldom anything but playful persiflage. When we think of creations like those of Bach and Beethoven, Michelangelo and Rembrandt, Shakespeare and Tolstoy, we cannot count the peasant songs, decorative art, best-sellers, and "hits" of the masses as art in the same sense. Even if we can empathize with the romantic enthusiasm for folk-art and democracy's optimism about popular art, we would still not be prepared to speak of an operetta by Franz Lehár or Leo Fall—even an operetta by Offenbach—in the same breath as a Mozart opera. Whoever knows the emotional shock which is bound to the experience of a true work of art will not be taken in by the cheap effects employed by popular art. Indeed, the more one feels the former experience to be threatened, the more one inclines to the view that there is only one art, with unalterable criteria, which, if diluted, lead to nonart.

However, although Mozart and Lehár cannot be reduced to a common denominator, many transitions graduate the distance between them. Works of art do not arise in the vacuum of a homogeneous spiritual world. Artistic creation rests on, and embroils itself, in the most diverse way, in nonartistic or quasi-artistic activities. The success of the creative enterprise is constantly at stake and exposed to the danger of compromises and simplification. Works of high art almost always include elements of a lower one. Even the most noble work of art wishes to please, entertain, and often makes use of media and methods of the most undemanding amusement. The romantics discovered, or overrated, the childish innocence of the artist, who never creates so naively or so spontaneously as they would have wished; yet his earnestness is always tinctured with a certain playfulness. Just like the child's imagining, so the humbug of the common jester is not entirely unknown to him. Paradoxically, the most desperate struggle for the meaning of existence and the harshest self-criticism exist in art along side the most frivolous entertainment and the most self-complacent affectation.

The work of art is not homogeneous as to either quality of social motives and efforts. It always contains parts which are more or less successful. The perfect, unalterable, and matchless artistic figure pure and simple is just as daring a philosophical fiction as the idea of divine inspiration by which the artist comes into possession of the prototypes of being. Perfection is not one of the conditions for artistic success. Works of high art cannot, it is true, be mistaken for mediocre ones,

but they also rub shoulders with forms of folk-art and popular enter-
tainment and often suffer no damage. They descend to the unpreten-
tiousness of folk-art and rise from the simplicity of popular art, while
these act as a source of new inspiration even for the most demanding
art. For just as an art song may be ruined or improved when it becomes
a folk song, so an artist who wishes to do nothing but entertain and
please can either prostitute himself or conquer paralyzing inhibitions,
which stem from his narcissism.

As a result of the many-layered and qualitatively manifold form of
works of art, it is often difficult—and the further we go back into
history the more difficult it becomes—to say to which social circles
the artist actually intends to address himself. It is well known that
even in Shakespeare's case it is just as difficult to draw the line between
real literature and mere wordplay, between tidbits for the boxes and
nourishment for the pit. In the same way, in the Middle Ages it is
often impossible to distinguish between works of an art which have
been unsuccessful for the learned clergy and the more or less successful
products of art produced for and by the people. As things develop and
progress, it becomes easier and easier to determine the social origin
and the intention of works of different sorts. Up until the nineteenth
century in individual genres, especially the theater, everything which
serves to entertain the public is mixed in character. The relationship
of the play to cults or bear dances seems ineradicable. On the other
hand, in other genres there is a radical qualitative change, but no
stylistic difference which takes place because of a distancing of pro-
duction from one stratum of the public and its approach to another.
Thus, for example, Dürer's drawings at first undergo a gradual change
in the hands of his successors who are popularizing the master's art
but still maintaining it as high art, but they acquire a popular, com-
pletely reversed character in the picture sheets of the eighteenth
century.[3]

23　The Art of the Cultural Elite

The forms of art which are differentiated according to different strata of the public—high, folk, and popular art—do not represent super-temporal, systematically complementary types which are determined once and for all. They represent historical categories not only because they emerge in succession, but also because each of them is involved in a process of historical growth and change and stays like that. They fulfill different functions in the history of culture, assume a particular position in the conception of the world at a given time, and achieve in relation to one another a significance which is constantly changing. Popular art which has become "debased cultural material" may once have been a "high," even the only, form of art practiced. Popular art, which at the moment represents the production and consumption of the half-educated and miseducated masses, existed in antiquity and the Middle Ages as mime or—in the baroque and classical periods—as popular songs and served as inspiration for the creators of exalted art.

As social structures which grow more and more differentiated, cultural strata are less strictly delineated, not only as categories of a caste or family, but also as those of a class or federation the continued existence of which is also subject to historical bonds but which maintain their character the more unequivocally the longer they stay in being. Social mobility, turncoats, and proselytes play an incomparably more important role in the history of cultural groups—not just of elites—than they do in economically and socially more completely integrated strata. Nevertheless, the limits of the level of culture, depending on what art and culture they refer to, remain fluid to a differing degree. As the bearers of popular art, the peasants of the flatland and the population of small villages (as those who support folk-art) represent

the most homogeneous and stable cultural stratum. But as soon as alien norms of taste and new measures of value penetrate their form of language, folk-art begins to decline and dissolve. As a rule, it is the sophisticated art preferred by the less naive and less loyal urban population which displaces their traditional prototypes and traditional practice. What is left is confined to the fading memories of dying generations and the discoveries of scholars interested in antiquity and folklore. The conservatism of rural strata of the people is uncommonly resistant, just like their instincts and inclinations. However, if the rural population once comes into contact with forms of life which are easy to come by and apparently more comfortable, then their loyalty to innervated customs, traditions, and mores collapses astonishingly quickly. Nor is there any trace of the romantic nostalgia with which higher cultural strata cling to their lost traditions. The cultural elite as the supporters of the high, strict, uncompromising art have a tendency toward stability because they respect everything which is institutionally secure. However, thanks to its realistic critical sense and its consciousness of historical time, it is clearly aware of the boundaries of the validity of what is transmitted and of the inevitability of the change in the composition of the groups which support culture. Entrée into this elite is not barred, but it is not come by easily. There are often difficulties in the way of social advancement which are hard to surmount. The boundaries are most flexible around the circle of producers and consumers in popular art designed merely to entertain. This is characterized above all by a flexibility of contours and owes the demand in which it stands to the stimuli which it receives from above and below, and which emanate from it in all directions in spite of the inferiority of its products.

Yet the concepts which differentiate the art of the cultural elite and that of the uneducated and half-educated masses from one another in this way are misleading. The doctrine that an art is the more autonomous, the freer it is of social bonds, the more aesthetically immanent it is, the more serious, strict, and uncompromising its criteria, cannot be unqualifiedly supported. In reality art aimed at the broader and less educated strata of society proves more stereotyped, less flexible, more rigid, and more closely bound to the conventions, fashions, and models of its day than the practice of art of the social and cultural elite which obeys more immanent principles. In the final analysis, however, neither higher nor lower art corresponds to a completely homogeneous public, unchanging and completely unequivocal in its demands. Every public is more or less mixed, however clearly and unmistakably its criteria of taste and its measures of value may be formulated.

The concepts of high art, of folk-art, and of popular art are ideal types; they seldom if ever appear in abstract purity. Historical reality moves between their meshes, and hybrid forms of them are almost the only ones known to art history. Art forms like jazz, film, or pop art cannot be subordinated into any of the categories which correspond to them. All show several heterogeneous traits from different and culturally distinct spheres of art. The definition of almost every concrete example demands a more precise differentiation of the categories of the basic cultural strata. Beethoven's *citoyen,* Schubert's bourgeois, Schumann's romantic rebel, Brahms's pompous haut bourgeois, Tchaikovsky's sentimental late romantic, Mahler's uprooted intellectual, Richard Strauss's decadent scion of high finance are related—but equally interchangeable—heirs to the same social class.

And just as the members of the same class may be culturally differently equipped and aligned, so members of the same cultural strata can represent different social elements. Since culture is essentially a social product, we can no more talk of autonomous cultural, attitudinal motives and media than we can of the physiologically and psychologically determined subjects who are socially undifferentiated and indifferent. Even the development of inclinations and abilities in animals is, in part, a result of their way of life and their group struggle for social existence.

High and significant works of art which correspond to the demands of the cultural elite reveal a far richer variety of types than artistic products designed for the lower strata. They move more freely, are less hindered by one another, and are more independent. It is true that as structures of social activity they are not free from convention, not even free of every formalistic element, but each of them is unique in one way or another. What distinguishes them from the products of folk and popular art consists above all in their refusal to use structures which automatically recur, which can be produced mechanically and used as clichés, even if they do use more complex and demanding formulas.

Great works of art revolve around the meaning of life, the conditions of the *conditio humana,* the price of an existence worthy of a human being. They ask questions about the validity of values which may serve to distinguish the good from the bad, the better from the worse. They owe their significance not to the answer they give but to the questions they ask. In them, the problems of the individual and society appear in a more encompassing perspective, the assumptions for the good life in a more complex relationship. Their influence allows us to understand ourselves and others better. They urge us to "change our lives." They become the stimulus for examining ourselves and passing judgment on

ourselves. Where would be their seriousness, their high idealism, the reward for the trouble which they seldom spare us if not in the feeling that the "hell" from which Lenin saw a work like the *Appassionata* arise can become purgatory, if not paradise?

The satisfaction we gain from high, exalted art can in no way be described as an experience which is simply "pleasure." Rather, its adequate comprehension poses a severe intellectual and moral test. It demands unconditional surrender, the most extreme effort and readiness to make sacrifices, acceptance of the sorrows of life and reconciliation with them, a test, as we have said, not only of the examinee but also of—for all our joy in the beauty afforded us by a work of art—the examiner. We pass this test and "change our lives" when we become ready to bear more and more responsibility and feel more and more consciousness of guilt and inadequacy. If anywhere, it is here that the paths of the cultural and the economic elite diverge. The strata which are merely higher because of their social position are by no means more suited to bear the burdens and sacrifices associated with the proper experience of high art and the associated consciousness of guilt and inferiority than are lower groups subordinated except for their intellectual advantages.

The limits of the cultural elite are evidently more narrow than those of the social elite, and those of art connoisseurship narrower than those of culture. The unquestioned validity of high, classical art, its exemplary nature and unmistakability, is therefore—even as far as the educated are concerned—a legend. Great art is seldom obvious and simple, and even if it is seen as such, such a definition corresponds to neither a positive nor a negative criterion of value. But if the difficulty of content and the complexity of means do not represent, in themselves, any other artistic value, they are nonetheless more suited to the development which is taking place and which is complicating interpersonal relations than a simplifying, unequivocal, and one-dimensional presentation of the circumstances, which tend today to become more and more complex and opaque. Within a closed and continuous phase of cultural history, the development of works of art thus corresponds from the beginning to the principle of complication.

If we disregard the processes of antiquity, artistic structures have since the Gothic period become more and more complex and complicated and are composed of ever more heterogeneous and contradictory elements. Wölfflin pointed particularly to the simultaneous complication and dynamizing of visuality at the time of the transition from classicism to the baroque and adduced as an example the representation of a moving wheel, which now—more or less anticipating impressionism—loses its spokes.[4] This development, however, is not

an uninterruptedly progressive one: in neoclassicism the wheel gets its spokes back. It is only in romanticism, naturalism, and impressionism that we return to the process of complication.

The doctrine of the supposed "simplicity" of all true art stems from the democratizing thought of the bourgeois Enlightenment period aimed at the popularization of cultural values. It is a sign of the process of rationalization in the course of which French classicism of the seventeenth century endeavored to oust the extravagant and bizarre mannerism of the preceding stylistic period. In spite of classicism's orientation toward the court and the partly aristocratic, partly upper upper-middle-class, class consciousness of its supporters, it tended toward bourgeois logic and sobriety.

Great works of art correspond as little to universal thought and taste as they do to simple, naive common sense. Even Periclean classicism was in no sense the intellectual property of the majority, and the same is true of the later high points in art of the Gothic or the Renaissance. Pericles himself, as we know, said that the greatness of Athens owed more to the heroic deeds of its warriors than to the poems of Homer. The temples of antiquity, the cathedrals of the Middle Ages, down to the churches of the baroque may show more points of contact with the everyday life, thought, and feelings of their contemporaries than present-day works of art, but there was certainly no greater understanding for them. Great art does not first alienate itself from a stratified society gradually: as a part of a cultural monopoly, it is alien to it from the outset. In such a society it is only the art of the cultural elite which counts as authentic; every other art which comes from a middle or lower cultural stratum appears inferior to it, no matter how ideologically significant it may be. It is only pure folk-art, preserving its originality, which succeeds in producing true artistic structures, moving songs, wonderful fairy tales, charming jewelry, and useful articles, even though this art is in part "debased cultural material." But this certainly does not justify the claims the romantics made on this score.

Every creative and significant art is stylistically advanced and as such, as Ortega y Gasset said, unpopular. It always only pleases a few people: this does not in any sense mean that it does not wish to please or that it cannot entertain. The entertaining moments of a significant work are not, however, antithetical to the seriousness, the strictness, and the difficulty of the work—they are on the contrary inherent in its exalted being. In this heterogeneity of artistic effect, there is not a question of a dialectical antithesis of the sort which exists for example between the retention of fruitful traditions capable of development and a creative avant-gardism aimed at essentially new formal principles. Without the antagonism, the conflict, and the resolution between continuity and discontinuity of development, there would be no real art.

Authentic art, if it is to assert its identity, has to rely upon the perseverance of certain forms of expression, which cannot, however, remain static without falling into a sterile academism and a pure epigoneity.

As a result of the antithetical nature of the conditions, the art of the cultural elite seems at one moment to be bound by its past, at another—in the sense of its creative nature—to be changeable and in principle progressive. A similar formula of change from one extreme to another also characterizes folk-art, which for a time clings obstinately to its traditions but is then astonishingly willing to give them up. Indeed, the difference between the two consists in the fact that high art preserves its quality both in traditional and in avant-garde structures, while folk-art, in giving up its traditions, ceases not only to be what it was, but even to be considered as art. The popular art of the urban masses is from the beginning completely uninhibited by either tradition or avant-gardism. This art—the product of the entertainment industry—knows no other norm than the harmless change from rigidly observed clichés of the moment, the keeping up with constantly changing fashion, and the greed for innovations, which are often supported not in order to meet a need but to create one.

The public both for high art and for folk-art grows constantly smaller, and—in spite of appearances to the contrary—the extent and role of the avant-garde grows less. The only continuously growing stratum of the public—and one which is growing with remarkable speed—consists of the devotees of qualitatively questionable popular art. This public is growing not only as a result of the advancement of the masses which were formerly not interested in art but also as a result of the partial collapse of the former elite and the depravation of taste from which no denizen of a modern metropolis is completely protected. Considerable numbers of the upper classes cling to the "ostentatious consumption" of cultural materials purely for the sake of prestige. Thus, at least functionally, high art becomes popular. Art forms like the opera or serious drama may lose their actual meaning for the "educated public," but they continue to live upon their former prestige. A season ticket to the opera can be supported as "conspicuous consumption" and the reading of the classics as "conspicuous leisure" even if the corresponding inner need for it no longer exists. But we are no longer dealing with the same phenomenon as in those cases where works are received by the public for which they were intended. Even those who cover the walls of their homes with valuable originals instead of cheap reproductions in order to create the impression of a cultivated milieu live at the cost of borrowed intellectual means, however good the originals may be.

24 Folk-Art

The Theory

It is not sufficient to mention the problematical value of the production which stands midway between the sublime art of the cultural elite and the art of the naive folk and which is not linked intimately to either of them. We have to question the unequivocality, purity, and aesthetic validity of naivete in art at all. The artistic creations of the folk are not completely "naive," completely instinctual, without guiding principle or critical approach. Art begins where intent, means, and skill meet; automatic design without plan and uncontrolled by criticism has nothing to do with it. The "simple, natural man with healthy instincts and unspoiled taste" who would in art be the equivalent of the Rousseau-esque ideal does not exist any longer, if indeed he ever did. "Unspoiled" good taste is not a gift of nature, but a benefit of culture, and good art—indeed, presumably art of any kind—is unknown to the purely instinctual man. It does not come, as people are wont to say, from ability, but from perception, choice, and judgments. Beaver dams, spiderwebs, and ape paintings are not art, however fluid the passages between their products and the sketches and rejections of an artist's conceptions, the planning and accommodation of his plans to the given means may be. Culture within the framework of which and according to the norms of which conscious creativity—accompanied by critical standards—takes place is at once the origin of the artistic artifact and the disappearance of natural man. Even the most primitive and spontaneous folk-art is no longer "natural"; it arises from cultural needs even if it is subject to natural conditions.

Folk-art and popular art have few points of contact in spite of their apparent relationship. Folk-art is mainly only a copy of high art, and the values it creates seldom stand in a proper relationship to the loss

of artistic quality which the prototypes suffer in the process. The view—which is sometimes met with—that the art intended for today's mass audience is the continuation of earlier folk-art rests entirely on the characteristic of what is "popular" which is supposed to be common to both of them, but which every time actually has a special meaning. Folk-art and popular art are in the logical sense highly contingent concepts; they may have a common origin in high art even if this is by no means similar or is not validated simultaneously, but they by no means continue each other. They develop out of the art of magicians, priests, and rulers in two different directions. Folk-art is comparatively simple, clumsy, and antiquated; popular art on the other hand is sophisticated in its own way, technically highly developed, even though vulgar, and changes, though seldom for the better, from one day to the next. Folk-art takes great examples of high art, sings them to pieces, breaks them up, or simplifies them; popular art dilutes and corrupts them.

If we understand by folk-art the artistic production of uneducated rural people which is created for their own use without previous prototypes (and so in this sense, naive and unsophisticated), it could be considered in certain circumstances and at certain times as the original form of art. However, at a time in which—apart from the few who lead and govern them—no one particular rank or privileged class asserts itself besides the population to which the virtual and actual producers of such an art belong, we cannot talk of a social class which could be labeled "the people"—a class which is lower in character in comparison with the rest of society and which would produce a "folk-art" which deviates from the art of the ruling class. Such a concept assumes a social stratification, which is not present in these conditions.

During the whole of its existence folk-art also maintains above all traces of a primitive communal practice of art, insofar as we can scarcely distinguish, in principle, producer from consumer. The boundaries between the two factors appear blurred in the sense not only that at any moment a consumer can become a producer, but also that it is generally from the beginning the same people who fulfill the functions of production, reception, and reproduction.

The fact that a social group consists not just of a heap of individuals and that the individual when bound to it behaves differently from the way he does when he is separated from it—that is to say, as a member of the group he develops characteristics in common with the other members and reacts to impressions in accordance with these characteristics—is well known and has proved to be a fundamental principle of sociology. On the other hand, it seems inadmissible, as has already been shown, to hypostasize such a unified group outlook as an

independent intellectual force which would be capable of developing the ability to think and act apart from the other members of the group. This is the teaching of the historical school about the folk-spirit and romantic ethnopsychology about the folk and group soul. The collective behavior of the group would thus appear not only as the manifestation of the reciprocal adaptation of different temperaments, wills, and aims—that is, as a mere function—but also as an ontological substance. There is no original cause but an end effect which corresponds to the group soul as a meaningfully applicable scientific concept. There is no agent which is present and active from the beginning, but only a result of actions already taken which become apparent later and which are personified as a result of their compatibility. We are dealing here merely with a collective concept which as such is conceivable only "after" we have grasped its elements and never "before." The group soul consists entirely of factors which the individual members of the group develop as they coordinate and cooperate. Neither biological nor psychological reality corresponds to the subject which comes into question as the supporter of the reciprocal adaptation of the different moments. There are at best only related actions and reactions which are aimed at each other and follow their own "logic." However, apart from the single concrete individuals, there is no real substratum that could bear these manifestations. And if there is something like collective spiritual property which we could, for example, imagine folk-art to be, there is no supraindividual, unified, spiritually integrated creator to whom the origin of the individual parts of this property could be ascribed.

The folk-soul is simply a psychological construct: we can ascribe a precisely definable meaning to it, but no spontaneous and autonomous intellectual activity. A collective artistic creation which did not consist merely of individually independent contributions would be inconceivable both in the course of events and in context. The concept of it as an indivisible unity belongs to that myth of the "genius of the folk" which—in Wilhelm Dilthey's opinion—is as unsuited to the explanation of historical processes as is, for example, the concept of vital force for the problems of physiology.[5] The work of art is a product of an individual not only as to its final totality but also in all its aesthetically indivisible parts. Just as the folk-soul, as the bearer of an artistic function, had to be given up, so we have to give up the concept of a social group or class as a personification of the creative process. Not only is every individual folk song or every version of a fairy tale the product of an individual author, but even the most impersonal artistic forms, the most insignificant variants of a song, and the smallest peculiar elaboration of a decoration which is otherwise identical come

from individuals. Society, station, or class, the ideology of a community of interests no more possess hands and eyes for painting, ears and lungs for singing, collective experiences and collective will than the folk-soul or the folk-spirit.

Only the individual can paint, sing, or express himself comprehensibly even if he always does it at the "behest of" or as the "mouthpiece" for a collective and is, from the beginning, part of a group whose spirit he supports—an ideology which cannot otherwise be asserted. If we look upon artistic creativity as an activity inseparable from the individual, it is not because we assume that the genesis of a work of art is inevitably linked with the effectiveness of an inspired being and presupposes the indivisibility of a mystically endowed and motivated spirit. The necessity for the individual's participation in the creation of a work of art can be sustained even if we do not cling unconditionally to the principle of the unity and homogeneity of the creative factor. The different intellectual faculties, functions, tendencies, and aims of an individual which are asserted in the creative process—the ability to conceive artistically and carry out the concept properly, technical skills, criteria of taste, self-criticism, the will and courage to correct and accommodate, the suiting of the media and the content of expression to one another—presuppose just as great a split in manners of behavior within the intellectual equipment of the individual personality as do the most careful differentiation of tasks and the most specific division of labor within the most complex of collectives.

The idea of a communal spiritual ability as the origin of artistic creativity is as unthinkable as that of an artist who would express himself in completely personal forms entirely derived from himself and referring to himself, without thinking of a listener or an audience, the public or a communication between you and me. If, however, the individual always thinks, feels, and creates in conjunction with a group, there is, except for him, no possible principle for the group as those that support thinking and creativity. The idea that the communal spiritual property of a people, its morals and customs, conventions and institutions, art and poetry, are the creations of a common spiritual effort and the result of planned coordinated work or collective improvisation is nothing but romantic fantasizing. There is no moral norm or standard morality, no principle of belief or law, no artistic or poetic idea which owes its origin to a purely collective, anonymous, completely impersonal impulse. Even the most simple ornament, the shortest love poem, and the most naive fairy tale are individual products, even if they are taken up in the shortest time by a social group and by adoption, reproduction, or variation become "folk-art." There is no such thing as a folk-soul which feels induced or wishes to compose

a song or a poem, invent a story or a decoration, even a new figure of speech or the simplest uncommon form of language. A song, a story, or a decoration may of course become so popular that finally no one can any longer say who invented them and as a result of continuous repetition and constant adaptation take on such a conventional appearance that their unique, individually conditioned features disappear. Their authors nevertheless remain individuals, for even the least change in the structures like the bending of a line in an original pattern or the replacement of one word by another in an otherwise faithfully transcribed text is an individual undertaking, although the innovator's consciousness may have absolutely no sense of having undertaken and accomplished something.

The whole romantic theory of folk-art rests on an error in thought: it fails to recognize that many individuals can work on a song *after one another* but never *at the same time*, and that the work comes into being as the constantly changing result of gradual adaptation and not as the unanimous decision of a sort of action committee. Folk-art is— like every style in thought and art—the creation of individuals and the property of many; and just as there is no work of art which completely represents a historical style, there is also no version of a folk song which can be regarded as the only authoritative one—all versions are relevant and reliable. The collective character of folk songs consists in the fact that they go from mouth to mouth rather than in the less frequent phenomenon that they are sung by many at the same time.

Romanticism deprived folk-art of its concrete historical features and changed it instead into a conceptually imprecise phenomenon undefined as to its origins in order to emphasize its supposedly universal and prototypical nature. The irrational ideas of romantic philosophy of history and art clung nowhere as tenaciously as in the folk-epic, folk song, and folk-tale, which—in the form in which the romantics represented them—were not their discovery but, on the contrary, their invention. It was a long time before scholarship succeeded in freeing itself of the notion of a folk improvising collectively and persisting in the unarticulated medium of prehistory. After a long time it finally became clear that every product of folk-art, every folk song, and every song motif had its hour of birth, its place of birth, and its own particular author.

The so-called naive and natural plantlike organic and instinctually unconscious growth of folk-art was for the romantics the prototype of the secret act of creation from which they thought they could derive anything which had artistic value. The points of contact between romanticism and psychoanalysis are nowhere more obvious than in the turning of this apparently occult act into a fetish. The psychoanalytical

interpretation of spiritual structures found its most fruitful source of research in folk-art, and there was no modern scientific method which gave romantic folklore greater inspiration and apparent confirmation than psychoanalysis. The identification of the folk with its poets and singers is apparently stronger and more consistent than that of educated people with their leaders and mouthpieces. It is, above all, in this sense that folk-art creates a psychoanalytically valid situation. It is in this that we have the root of the communal character, and it is on this that the popularity of the works rests. The lack of distance between producer and consumer in folk-art is countered by the incoherent and spasmodic nature of its inner structure. The incoherence of ideas and images which often afford an immediate insight into the unconscious becomes, as usual, just as valuable a source of information for psychoanalysis as the total identification of the receptive with the communicating subject. As a result of this, what is missing in works of folk-art is that resolution of contradictions and the caulking up of cracks which otherwise prevail in artistic representations and which blur the treacherous traces of unconscious thought, instincts, and tendencies.

The uniqueness of folk-art consists mainly in the fact that the influence of the individual—in spite of his indispensability—is reduced to a rather insignificant role. As the productive supporter of the artistic process, he is in a much stricter sense the representative of the unified artistic aims of his group than is the case with the author or recipient of works of high art. For if even the smallest element of a folk song or a piece of peasant craft is an individual product, so its most complex forms, too, are such that every member of the community may feel himself to be their author. And although a folk song cannot be composed by each and every member of the community, it is true that indeed talents are individual spiritual interests, and the experiences to be recounted communal and constantly repeated.

The public for folk-art is neither capable of nor inclined to see art as art and to criticize it according to formal standards. This is a contrast to the public for high art, which judges a work of art to be a victory of its author over a technical difficulty and is more interested in the vicissitudes with which artistic creation is bound than in the fate of the fictional hero about whom the work is written. The supporters of folk-art know nothing of such difficulties, and the authors of popular art are often proud of precisely the fact that they have never come into contact with them. Because of this formal insouciance, folk-art seems already to stand in immediate relationship to the unconscious.

The fundamental division of folk-poetry from poetry "proper"—made by the romantics in the sense that the art of the people was

something which grew organically and which was propagated according to an unbroken tradition, while the art of the cultured was a conscious and planned experimental activity—is still accepted by Alois Riegl.[6] That is to say, he excludes from folk-art everything which smacks of professionalism and defines it merely as the domestic activity and industry of the peasants who make and decorate their own utensils. In the process he passes over, most importantly, the question of peasant housing construction and the production of most ecclesiastical furnishings and sculptures. It is true that the people apparently play an incomparably larger part in the production of their own art than the ruling classes or the urban population which is in close contact with them. Most of the figural representations, woodcuts, and etchings which decorate their rooms, the furniture of village churches and places of pilgrimage, however, come for the most part from craftsmen, who are generally of the people, but who can hardly be reckoned as belonging to the people in the sense that these productions do.

Riegl still holds to the romantic theory of the unity of the folk-spirit and emphasizes that traditional forms of art are the common property of the people and not the property of one particular class. He overlooks the fact that we can talk of folk-art only when class and cultural differences exist and only in antithesis to the art of nonpopular cultural strata. Folk-art is not a communal art but—like artistic production in general—a class or caste art. Riegl may have been led astray in his identifying folk-art with peasant art by the fact that modern folk-art has for the most part peasant origins. But even if all folk-art were peasant art, not all peasant art could count as folk-art. In the Neolithic period or at the time of the migrations, we can talk, as we have already said, of peasant culture and peasant art, but hardly of a folk-art in the actual sense. For alongside the art of the peasants as the overwhelming majority of the productive population, there is no art of the ruling classes—whether in the form of jewelry for rich peasants and a few rulers—which is different from other peasant products. If, then, the social and cultural differentiation which belongs to the concept of folk-art is lacking, we have to call the whole production of the t me "folk-art," and this obscures the actual meaning of the term.

We can scarcely think any more of a "primitive communal culture" at, for example, the time of the migrations when the Germanic peasant tribes were those who supported culture since the spiritual attitude which lies at the root of such a culture had already been destroyed, although the different cultural strata, in the later sense, still do not exist. In any case it is questionable whether there was ever a communal culture as Hans Naumann romantically conceived it[7] and whether the concept of culture from the beginning does not, on the contrary, in-

clude the concept of a split society. One stage of development at which poetry in our sense could appear must already have grown out of that communal state. For it is simply unthinkable that people should have written poetry before they were able and ready to think of themselves as individuals and distinguish themselves from one another. Individuation may, as is always the case in folk-art, recede into the background; nevertheless, it is one of the assumptions of all artistic activity. In no case can art have taken place in a natural state removed from history. The need for art, the ability to produce it, and artistic values are historically conditioned phenomena, which only assert themselves after the completion of a purely instinctually determined development and with the start of a conscious planning and organization of individual activities.

Folk-art can no more be identified with provincial art than it can with peasant art. Its antithesis to the art of the cities and the urban-oriented centers of culture is, it is true, one of its most striking characteristics; it is, however, not an art which would wish to be urban and cannot do so. The art of the provinces, in contrast to urban art, is caught in a constant dependence upon the taste of the metropolis and thus always shows traces of an inferiority complex. Even folk-art is of course influenced by the higher art practiced in monasteries, at court, and in the towns, but it never strives consciously and intentionally to become this art. It may be a secondhand art, but it is not one which wishes to compete with other artistic movements, nor does it wish to be like these in exchange.

The people in possession of their own art and their own cultural traditions still stand on the side of the commercial and industrial economy which is motivated by competition. They do not strive for an emphatically individual art which is fundamentally different from that of the other social strata. "A conscious folk-art, that is, one which is intentionally created, has never existed," a leading folklore authority has asserted.[8] The fact that most folk songs are not composed in dialect but in the literary language[9] is the best sign of how free the people are from any complacency and self-righteousness. Dialect songs come for the most part from professional poets who think they have to lower themselves to the people, whereas the people when they write poetry are not—as the romantics believed—"natural" but are presenting themselves emotionally and linguistically in their Sunday best.[10] The idea that folk-art is "debased cultural property" has become a commonplace. Nobody doubts any longer that subjects or individual motifs, stylistic movements, and formal structures, emotional and conceptual elements move downward from higher culture to become the property of folk-art. According to today's generally accepted view, the people

are essentially unproductive: they scarcely produce any art but, on the contrary, reproduce. Views that the people "cannot compose, only arrange, or at best write variations, that they do not create but merely choose"[11] or that most folk songs are mere plagiarism[12] can be explained in part as reactions against the romantic doctrine of art which socialist art criticism—in spite of its realistic ideology—approves of in this regard. The judgment of folk-art was always political, and we still interpret one and the same trait—for example, its renunciation of individuality and originality—sometimes positively, sometimes negatively, depending on which camp we are in. In any case, no matter from what aspect we look at him, the folk-poet is the typical dilettante who thinks of all sorts of prototypes as soon as he sets himself to writing. He cannot free himself from the songs, the pictures, the turns of phrase which stick in his mind. His ambition, however, does not lie in originality either. He has no competition to fight against and needs no advertisement. The doctrine of "debased cultural property" includes the thesis of the backwardness of folk-art. Stylistically, folk-art is always limping behind the art of the cultured and the connoisseurs, at a greater or lesser distance in time. In the early phases of its development, there is often no other criterion of its special nature than that of backwardness.

The art of the cultural elite forfeits not only its topicality by being popularized, but also its aesthetic quality. The people withdraw from it not only by evaluating it by standards unsuited to its nature, but also because of its practice of creating artistic objects which are seen as "art" only by the educated. The people themselves create art without being conscious that they are producing something which goes beyond the boundaries of their daily forms of life and their needs. The people lack not only the concept of art for its own sake but also the ability to distinquish the better from the less good in art. It is well known that the peasant when called upon to sing always goes through his whole repertory and mixes true folk songs with weak imitations and hits far removed from folk song.[13]

The aesthetic innocence of the people, however, does not in the least mean that everything which it produces in the way of poetry, music, and decoration is artistically inferior. Emile Faguet's well-known dictum "La littérature et l'art ne sont pas populaires qu'à condition d'être médiocre"[14] is only so enticing because it so radically clears away the romantic legend of folk-art. Actually, the judgment that the people are certainly unreliable and uncertain in their taste but that in their artistic creations are not only guided by taste would be more correct. But we must beware—even if we assume a creativity of this sort: something which ignores the critical element—of ascribing to the people abilities

which are inspired by a higher power and intelligence. The fact that in its urge toward creativity with the accompanying embarrassment the folk seize upon traditional forms which they do not properly appreciate does not mean that the forms come out of the blue. They, too, can be traced back to individual products, and we have to recognize in folk-art the accumulation of such products either at first or secondhand. We do this according to whether we see in it rough repetitions, as do the proponents of reception theory, or, like the protagonists of the production theory, original creations.

Modern research on the folk song led to discoveries which show that folk songs are for the most part "art songs in the mouth of the people." But in spite of this, we can only accept reception theory with certain limitations. We have first of all to tone down the harsh antithesis between "elevated" and "debased," "cultured" and "uncultured," art for the connoisseur and art for the folk. As elsewhere in history, we have also to imagine the processes in this connection as roads with crossings, bridges, and side roads, instead of direct accesses. The stimulating conception of works of high art—in the positive sense—does not always originate at the highest level. And it is not only the disciples and epigones who try to make the work of a difficult artist available to a wider public at the price of making concessions. The masters themselves, however strict and intransigent they may be, may smooth the path for a cooperative popularization in the process of their own creative work.

The romantics themselves pointed out the fluidity of the boundaries between art poetry and folk-poetry. Achim Von Arnim remarked in this sense in a letter to Jakob Grimm that there was no absolute "natural poetry," because as he pointed out "there is no moment without history."[15] By "history" he meant, however, that sphere of transitions and communications in which a quantity can change into a new quality and the fundamental differentiation between high and low, natural and artificial, spontaneous and conventional is only to be used with the greatest caution. With the beginning of history as the actual element in human existence, the state of nature comes to an end. From then on there are only transitions between nature and artificiality, instinct and determination, inclination and adaptation. The concept of folk-art which accords with this cannot be achieved by either the production or the reception theory. Both draw the line too sharply between spontaneity and convention; in both, the concepts used are more or less unreal and romantic. Even the reception theory refers to the myth of a creative force functioning undialectically, which is simply taken over from the spiritual property of the cultural elite and automatically transferred to the people. The validity of this theory is, however, in reality

limited by the fact that the adoption of forms and motifs by folk-art is always attached to certain conditions. Reception by no means follows mechanically but always reveals a principle of selection so that we are constantly obliged to ask from which points of view the borrowing took place. The productive part of the process is, in spite of all adaptation, by no means unessential, and the logic of the transformation to which the folk subject what they have received from the higher strata is apparent. It is not easy to say what the criteria of form are in folk-art, but the "folk tone" of the works—whether it is a question of an original or a borrowed motif—is evident. The actual question which we have to answer in this connection is not concerned with the characteristics which folk-art exhibits but rather with the qualities which a work of high art must have in order for it to be adopted or varied by the folk.

Another problem lies in the influence of folk-art upon the art of the higher cultural strata. The fact that the folk song and folk music from time to time have a decisive influence on the literature and music of the connoisseurs and masters, and that alongside a "sinking" cultural stock we can also talk of a "rising" one, is beyond doubt. Folk melodies were used just as often by the authentic representatives of classical music—like Haydn, Mozart, Beethoven, or Schubert—as themes for variation as were the themes of folk music by the later romantics, especially in eastern Europe. But—aside from the cases in which high art only takes over what was originally its own and what was borrowed from it—when it is a question of the influence of folk-art upon the creations of high art, as is always the case with external influences, we are not dealing with a real creative inspiration but only the opportunity for innovation which is spiritually immediate and which has become capable of being carried out. Even Béla Bartók's discovery and evaluation of Hungarian folk music was partly an expression of his own artistic volition in which his rejection of the late romantics and his partial rejection of impressionism were expressed. Both the selection which he made among the village songs which he discovered and the formulation which they underwent in his compositions were so unique and creative that we now have learned to hear the whole of authentic Hungarian folk music in his way. Thus, the limit between reception and production is also hard to draw on the ascending curve. Wherever it lies, the mere fact that high art receives stimuli from folk-art reveals, of itself, as good as nothing about the artistic value of the structures from which these stimuli emanate. For a real artist the most diverse incidents prove fruitful, while in the case of artists of different rank even the same stimuli and influences have different effects, depending

upon the circumstances. Liszt's Hungarian style and Bartók's musical idiom have nothing but a superficially generalizing title in common.

The folk song differs most strikingly from the art song from which it derives, or to which it leads, by its wide distribution on one hand and by the homogeneity of the social group which is interested in it on the other. High art, too, certainly conforms to the demands of a more or less unified social stratum, but it always appeals to an individual within this unit and refers to experiences, feelings, and moods which distinguish him from other members of the group and which enhance his particular feeling of personality. Folk-art in contrast only expresses spiritual feelings which are common property or which can become common property. This means, above all, that it is unclaimed goods and that no one person can or will establish any rights of ownership over its creations. The works are not necessarily anonymous, but they are always impersonal. They may from one or another point of view and at one or another stage of development be original, but they never aim at originality. The enhanced conventionality of folk-art has nothing to do either with a heightened sense of community or solidarity which peasants hardly ever feel nor with a lack of all ambition or even every vanity, but simply with the special role of art in the people's life. Since folk-art seldom represents a means of livelihood or an object of competition and is thus free from the exaggerated subjectivism of the intelligentsia, it is not felt to be an expression of the personality, even if it often possesses personal characteristics. It is well known how gladly the folk cover their decorated objects with names and the date although on the other hand they have no interest in portraits and other objects which stress personality.[16] In this connection, however, there are historically conditioned differences between individual folk communities; and just like individualism in the higher stratum, so the consciousness of personality develops even among the folk, depending on the circumstances of the time. In some places the peasants still live in their homogeneous medieval unity; in other countries they approach the differentiated and dynamic forms of life of the urban workers.

Instead of inspiration the romantics applied the concept of improvisation to folk-art to designate the way in which the divinely-inspired poet went about creating his works. Both concepts derive from the intellectual heritage of Herder, who is one of the first to talk of "nature" poetry in the sense of a spontaneous, naive, and unconscious communication by the folk, who talk and sing like the birds and flourish and grow like plants. For the romantics the spontaneity and naiveté ascribed by Herder to folk-poetry was also the most significant trait of art poetry. The romantics were, however, aware of the limitation and insufficiency of this point of view. "The poet dreams," as Charles

Lamb already knew, "of being awake—he is not ruled by his subject but exercises authority over it." Malraux merely changed the thought when he said, "The child often behaves artistically but is not an *artist*, for he is governed by his talent but does not govern it." In the same sense, Marx maintained that the thing which differentiates the very worst builder from a bee is that he has the plan of the building which he is going to build in his head from the start. The folk—as producers of works of art, in contrast to the artist, who consciously plans—belong in the same category as the child, the primitive, the psychopath, and the animals. All these beings who work instinctively are mere vehicles that are not the drivers of their talent.

However, it would be wrong to assume that the improvisation of the folk singer is entirely naive and is a completely instinctive and spontaneous communication. The choice of fixed formulas, traditional motifs, typical turns of phrase, fixed epithets, repeated comparisons and images, stereotypical beginnings and endings of certain episodes is made on the basis of judgments by which they have become capable of making the choice. It is possible to improvise successfully only when the picture can be put together out of the small pieces which are available.[17] Poetic formulas do not become conventional after they have been improvised; they can be improvised only when they are based upon already fixed conventions. This is equally typical of the Homeric singer and of the singers of Kirgizhia and Serbo-Croatia.[18] But it is precisely this harmless use of pat formulas—which the romantics saw as a sign of naiveté—that seems to bear most striking witness to the artificiality of their method.

In spite of its formulaic nature and conventionality, folk-poetry is not entirely stationary and unsusceptible to development. The individual turns of phrase do repeat themselves, it is true; the structure of whole pieces is, however, subject to constant change and alteration. The folk song is in a state of flux and never grows out of it. It has no permanent form; every version of it represents a stage of transition. Every break in the stream of development which occurs with every important work in the art of the masters never takes place in folk-poetry. As a result of this lack of interruption, it can stand in a certain respect as the model medium of art history. The growth of folk-poetry can only be arrested artificially if we take one out of many different versions of a work. In this sense, Steinthal states that folk-poetry is a *nomen actionis* and is a phenomenon like language which is continually changing. There is no such thing as an authentic version of a folk song. Each of its versions is as definitive as the others. In this sense it represents the antithesis of what joins classical aesthetics to the concept of a work of art. Nevertheless, the distance between a work

of folk-art and a work of high art is less than it may appear to be at first sight. For on the one hand the works of the great masters preserve traces of that fortuitousness and mutability which forms of folk-art reveal, so that every solution even on the highest level is one of several possible ones and perhaps not the best that the artist could achieve. On the other hand the work of art changes its meaning, idea content, and value with every new interpretation, even if its author appears to have given it its one authentic form. Different generations extend the works of the masters as they write poetry, paint, and compose, just as the folk go on changing their songs and fairy tales. We can look upon this work of the centuries as a result of renaissance, but if we like, we can also see it as destructive interventions and contributions of posterity, just as we can see the poetry and the songs of the folk as a process of singing to pieces and of decomposition.

The History

However susceptible to development a folk-art which has continued in practice may be, it is questionable whether we can talk at all (or at least with what reservations) about a continuous history of the artistic activity of the folk. Its closed history cannot be constructed because of the sensitive gaps which the material available reveals. The extant products are also less well preserved than those intended for the upper strata or even for the Church, and even those which are relatively well preserved cannot always be ascribed with certainty to the folk. Often it is almost impossible to determine whether we are dealing with the work of a fake, of a retarded provincial, or of a folk artist. Because of these gaps and difficulties in attribution, the development of folk-art seems to be more erratic than in other forms of art, in spite of the fact that different stylistic tendencies generally seem to be preserved in folk-art for a long time. Cultural catastrophes or shocks in intellectual standards which so often affect the life-style of the upper strata and which threaten their role as rulers do not generally reach the lower strata and scarcely affect the continuation of their traditions. The fact, though, that works of folk-art cannot simply be classified in the categories of general stylistic history, that they are often only able to be dated incidentally and, as has been said, do not present the rhythms of "early, high, and late stages,"[19] in no way means that they are removed from all historicity. If the rhythm of history appears less clearly articulated in them than elsewhere, this is connected to the fact that they take over certain findings in the history of art ready-made and as a result leap over certain stages of development.

Just like timelessness and ultrahistoricity, so the originality of folk-art is pure legend. Its beginnings may be as old as the hills, but the thesis that it stands at the head of the history of culture and that national literatures always begin with a period of folk-poetry[20] is unproved and will probably never be able to be proved.

The earliest known artistic monuments do not allow us to assume an origin of artistic activity which is related to caste or class. The almost exclusively figural motifs of Paleolithic cave paintings do not in any case point to a folk style in the later sense of the word. It is only in the New Stone Age that we find decorated domestic utensils which, like the products of folk-art in every age, must have had their origin in domestic activity; and their geometric style of ornamentation with the disorganization and schematization of natural forms bears witness to this. There is no satisfactory explanation for the persistence of the geometrical style in folk-art. Rationalism with the change from the unplanned existence of the prehistoric hunters and gatherers to the organized life of cattle raisers and farmers at best explains the change from naturalism to stylization; the continuance of geometrism as their particular form, however, still remains a problem. Just as Bartók traces the stylistic characteristics of Hungarian folk music back to Asiatic origins, so we assume for other genres of folk-art—like, for example, the ornamentation of Rumanian peasant art—motifs which go back for millennia, and we connect them with Neolithic decorative forms. But we have to be content with conjectures.[21] The stylistic relationship of earlier and later folk-art which bridges a gap of about six to seven thousand years is based apparently neither upon an uninterrupted self-propagating tradition nor upon a constant spiritual disposition, but on the similarity of the conditions of existence under which those who supported this continuity lived. During the general processes which revolutionized the structure of society, no station's forms of life have changed so little as those of the peasant. This accords with the fact that in no branch of industry were the methods of production so little influenced by the development of the means of production and the metamorphoses of capital as in agriculture carried on by peasants.

In any case, up to the time of the migrations folk-art does not seem to have exercised any more precisely definable influence upon the art of the upper social strata. Now, however, it forms the origin of an artistic trend which is generally disseminated. If we assert that after the collapse of an urban civilization the renewal of art emanates from a "youthfully fresh," unspoiled, and uncorrupted folk, we are usually talking about nothing more than romantic enthusiasm for the mysticized state of nature. Even the description of the geometric dipylon style as the "start of Greek art"[22] is nothing else. For—as a phenomenon

which is completely different from Oriental art—this art does not have its origin in the geometric decorative style but in later archaism with its substantiality, its statuary corporeality, and its tendency to be faithful to nature. The connection between the geometrism of the art of the migrations and later medieval artistic developments is completely different. Just as epic materials go over into Western Christian art from late Roman representations, so Christian art draws the principle of abstract ornamental beauty of line from the arts and crafts of the period of the migrations and remains true to the principle of stylization while clinging to the epic materials.

Georg Dehio describes the art of the migrations simply as "folk-art," although it was in reality *peasant art*—the artistic practice of the peasant tribes who were overunning the West and who were culturally bound to original production. If we look upon peasant art as essentially folk-art or upon folk-art as production intended from the beginning for the rural population, then the art of the migrations can be summarily described as folk-art. If, however, we understand by folk-art an activity which is not carried on professionally or by specialists, it can scarcely be regarded as such. Since most of the products which have come down to us presuppose an artistic skill which is more than dilettantism, it is inconceivable that they were produced by people without specialized training and long practice and by people who were mainly engaged in this activity. Among the Germanic people of the period, craft was doubtless still partly a domestic activity; the production of jewelry which is still extant today could not, however, have been carried on as a sideline.

Just like the goldsmith's art, the literature of the early Middle Ages, which romantic literary history designates as "folk-epic," had no connection with the folk. Like the Homeric epic it had nothing to do with the common, naive folk either through author or audience. The encomia and heroic songs which were the origins of the epic in the Middle Ages—as they were in Greece—were the purest class poems which a ruling class has ever produced. They were originally neither sung nor disseminated by the folk, nor were they intended for the folk and geared to its interests and ideas. They were completely art literature and the art of the nobility; they sang of the deeds and the virtues of a ruling warrior class, flattered their desire for fame, praised their tragi-heroic moral principles, and addressed them not only as the only possible audience but borrowed—at least in the beginning—their poets from them. The peoples of the time of the migrations also developed—prior to this literature of the nobility and probably simultaneously with it—a communal literature of ritual forms, charms, riddles, gnomic verse, and social lyric—that is, choral songs and dance and work songs,

which they recited at cultic acts, burials, and feasts. This literary pro-
duction formed the common and for the most part unified property
of the folk. The encomium and the heroic lay seem, however, to be
the invention of a migration which has already taken place successfully.
The aristocratic character of these songs can be explained by the rev-
olutions which were connected with the invasion which had taken
place and which put a finish to the unity of earlier communal condi-
tions. With the more stratified society which corresponded to the new
conquests, seizures, and foundings of states, there arose alongside the
communal forms of literature and in their place a class literature stim-
ulated apparently by the new elements of the successful warrior no-
bility. This poetry was not only the special possession of a privileged
stratum which cut itself off from below and emphasized the dignity
and power of its class, but in contrast to the older communal literature
it was an art which was learned, practiced, and heterogeneously con-
stituted, the creation of professional poets who were in the service of
the ruling class.

The short lyric poem is the most fertile and most frequently men-
tioned form of folk-poetry. The greatest number and the most suc-
cessful of their creations belong to this genre. The folk song also
represents the genre of which the romantics were thinking above all
when they talked of folk-art, and it was around this that the contro-
versy between the protagonists of the production and reception the-
ories revolved. There is no genre in which one can point out traces
of borrowings from art literature more easily, and there is none in
which the artistic talent of the folk is more clearly expressed. We find
in it the most crude plagiarisms, but at the same time the most charming
poetic inspirations. Even Hans Naumann, the most radical exponent
of reception theory, admits himself that the postulated prototypes of
the lyric—primitive work songs, marriage songs, laments, charms, and
other similar cultic poems—may have been the product of a sponta-
neous, even if in his sense "collective," poetic creation.[23]

The folk song in the usual sense—if we are to judge by the examples
which have been preserved—is nevertheless relatively young. None
of the songs known to us is older than the troubadour lyric, which
must have been its richest source, and most of them are younger than
the first classical songs to be sung in company which were performed
by the elite in the period of mannerism and baroque. What we generally
understand by folk-art does not come about at all until the eighteenth
century, and this is true not only of the oldest known folk songs but
also of the whole decorative treasure of modern folk-art, which is
unmistakable in its uniqueness. Most examples of textiles, embroi-
deries, and laces have their origin in this century as well as the favorite

ceramic ornaments, the essential forms of domestic furniture and folk utensils. This is when the stereotypical themes of picture sheets are created, the circle of ideas surrounding folk wisdom, proverbs, and moral rules. The nineteenth century merely enriches the store by adding ballads about murderers *(Moritaten)*, sensational and horror stories, and in this way brings folk-art closer to popular art which is, however, alienated from the people.

Today there is, so to speak, no more folk-art, because, as has been asserted, there is no more "folk."[24] This is true at least as far as the West is concerned and especially the Anglo-Saxon countries, where not only the population of the industrial cities but also that of the country have nothing more in common with the representatives of earlier folk-art. The spread of urban culture by modern means of transport, press, placards, film, radio, and television leads—with democratization—to a leveling out and uniformization of culture which the individuality of folk-art cannot keep pace with. The folk sing urban hits and forget their own songs, copy the trivial machine-made "handicrafts," and have no taste for the beautiful old peasant patterns. They buy the most hideous ceramic mass products and replace their own charmingly decorated plates and jugs by them. In Hungary real folk music has long been equated with "gypsy music." Bartók and Kodaly had not only to collect the old and mostly forgotten folk songs, but actually to dig them out. Only the old people in the village remembered them.

25 Popular Art

Definition

Boredom—as the source of popular art, entertainment, and refreshment for the average half-educated and uneducated person—is a product of the restless sensation-hungry urban form of life. The peasant does not get bored; when he has nothing to do, he sleeps. In any case he knows nothing of the unhealthy fear of inactivity and the empty urge to activity which motivate the inhabitants of big towns. Like most of their intellectual demands, the urban masses' need for art is merely a material hunger which has to be satisfied in order to keep the machine which they serve in motion. Art itself is nothing but fuel—a miserable stopgap. The feeling of deprivation from which they suffer may be real, but they do not know what they lack. They have to read novels, see films, play their radios at full blast or at least as background because they do not really know what to do with themselves. Reading in the eighteenth century and listening to music in the nineteenth grew, for the middle classes, from a rare pleasure into a passion. The enjoyment of art in our days has changed from a passion into a habit, into the satisfaction of a need, which we only recognize when it is not satisfied.

The seriousness and rigidity of the high authentic artistic creation soon sinks in popular art either to the level of the pleasant and agreeable or to noncormittal sentimentality and crass sensation. Mere diversion and entertainment tend to be surrogates for real art. They become a mendacious idyll, a cheap sentimentalism which flatters the senses and anesthetizes the critical consciousness or else a wild bombast of powerful, unbridled nihilistic passions.

Entertainment, relaxation, pointless, even capricious, play are indispensable conditions of life; they belong psychologically and physiologically to the preservation and renewal of vital forces and to the

stimulation and enhancement of flagging activity. Pure art, on the other hand, although it represents for many pure self-fulfillment, is not a practical necessity. The compatibility of relaxation with exertion, of the game with what is wagered are among its paradoxes. High and subordinate, difficult and simple artistic forms are oft closely related and condition each other mutually. The inadequacy of popular art does not merely stem from the fact that it is entertaining, amusing, and lighthearted. Doubtless, Molière and Cervantes wanted to amuse, even Couperin and Mozart composed music for entertainment, and facility in the works of Offenbach did not mean a reduction in quality. The evil does not stem from the intention of creating attractive, appealing, effortless works, but from the readiness of the artist to make compromises unhesitatingly and to sink below his own level in order to achieve success.

Art is produced and represents a value only when there is a need for it: but it loses its worth when it is created merely to create a need or to enhance one. Every authentic art fulfills a social function, but the qualitative value of art does not disappear in its function. What is socially instrumental must contain a special quality which cannot be expressed in sociological categories in order to be artistically effective. Sociology does not have an answer to the question of what this quality is any more than any nonsociological discipline has to the question of what is social sui generis.

Hannah Arendt interpreted the enjoyment of popular art literally as that which is, in the sphere of the aesthetic, most like economic consumption. She stated that the products of popular art are actually used in a certain way, are used up, and after being used are thrown away as useless.[25] This interpretation of the art intended for the insatiable and uncritical strata of the public—which in contrast to the art of the cultural elite is really nothing more than an ephemeral stimulant—is nevertheless based on a metaphor. For the works of high art, too, are also "consumed" and metabolized. The consumption of spiritual goods always means a destruction, which in the historical context—both in popular and in high art—can also result in a metabolic process in the positive sense. Just as a sublimation, so a depravation, in quality can take place in both categories and not just in the process of reception, but even in the process of production. Works of high art may—as a result of their all too wide distribution—assume the characteristics of cheap, unpretentious entertainment. However, they often acquire such characteristics as a result of their authors' willingness to accept without demur the conditions of widespread distribution.

According to the generally accepted principles of modern art criticism, popular art owes its mastery and the constant expansion of its

audience to the victory of democracy, the relaxation of educational privilege, the pursuit of economic output and competition in the area of art, and the continuously improving prospect of participating either actively or passively in the process of spiritual trade. The salient character of the works—as goods—is significant of all artistic production in the industrial-commercial age and is no more peculiar to popular art than to other forms of art. The difference consists entirely in the fact that the decisive role of the market and of trade is more covert in the one case and more obvious in the other.

The commercial character which works of popular art continuously reveal is especially emphasized because of its blunt expediency. High, serious, uncompromising art has a disturbing effect, often distressing and torturing; popular art, on the other hand, wants to soothe, distract us from the painful problems of existence, and instead of inspiring us to activity and exertion, criticism and self-examination, moves us on the contrary to passivity and self-satisfaction.

The strata who are underprivileged both economically and culturally do not assume an unambiguous attitude toward either high or popular art. The success which they accord artistic creations is determined by nonartistic points of view. They do not react to aesthetic values as such, to what is artistically good or bad, but to motifs which make them easy or uneasy in their sphere of life within the area of their practical interests and their realistic thoughts and aims. They are not, in principle, against appreciating and affirming what is artistically valuable if it represents a vital value for them, corresponds to their needs, hopes, and wishes, calms their fear of life, and increases their feeling of security. The chances of success of important works are lessened by the fact that the new, the unusual, and the difficult have of themselves a disturbing effect upon an uneducated and not especially artistically experienced audience and move them to take up a negative position.

Popular art, which merges with the cares of everyday life, leads to evasion, to escape from facts of a higher order, from the seriousness and dangers of a moral existence, and it seduces us into attempts to flee from every duty and all responsibility. The fear that conditions this sort of attempt at escape inspires not only the classes which are threatened from above but those which are threatened from below as well. The ruling middle class—with the exception of those parts of its intelligentsia which are uprooted—regards the future with just the same anxiety as the lower classes which they dominate. It is the widespread nature of this fear which explains the unusual extent and the irreducible mixture of the audience which is interested in popular art. It is pa-

tronized because of the anesthetic effect which emanates from it in all directions.

But we cannot lay the responsibility for the low quality of popular art simply and solely at the door of an undemanding public. It is in no way justified by saying that people only get what they want. Every art is directed more or less toward the taste of the public for which it is intended; it is simply that the works of high art exceed every wish and expectation. Whether the average audience is offered the sort of art which is consonant with its demands and which it can enjoy or whether it first has to be trained to be satisfied with what is set before it, the quality of the art which it has to put up with remains unaffected. To answer the question which arises here, in the sense that people receive what they deserve, says nothing: they ought to get something better. For in this connection it is not a question so much of extenuating circumstances in the judgment of a felon, but of the assessment of the quality of products which are to be judged unequivocally—where there are neither extenuating nor aggravating circumstances.

Art intended for large parts of the public is certainly not completely manipulated and forced upon people: it corresponds at least in part to genuine, spontaneously felt needs. The genuineness of the demands does not, however, guarantee any aesthetic value, just as the manipulation of needs does not necessarily nullify the qualitative value of the products. High and popular art are also not so far apart from this point of view as they might appear to be by definition. There is not only a high art which is attractive to the large half-educated strata, but there is also a popular art which may please a public which is intellectually demanding and critical of aesthetic values. Chaplin's art had its roots in the popular music hall and the circus; his followers came from all strata of society; and he owed his fame first and foremost to his acceptance by the intelligentsia who created the legend of his genius.

The most common and striking characteristic of popular art consists in its holding fast to traditional and easily accommodated formulas. To be formulaic in nature is not of itself to be opposed to art: even the highest and most successful art, like the Homeric, used, as we know, stable formulas and consists in good part of these. Their use corresponds to a more or less mechanical principle and is tied to a danger for artistic quality, even if, as in Homer's case, it may be highly successful.

The fact that popular art, in contrast to the flexibility of high art, clings inflexibly to the rules, the standards of which seem to be the secret of best-sellers, hits, and smashes, is one of the most remarkable characteristics of this form of art. The schema which has once met with success is maintained no matter how obvious its rigidity and how

worn out it may be. The formal principles of utilitarian art, which serves purely for relaxation and entertainment, scarcely ever change for immanent reasons. Their stylistic form does change under the influence of innovations in the sphere of high art—which serves as a pattern for popular art. The latter with its tendency toward stasis and its dependence upon extra-artistic circumstances takes part—if only in this way—in general stylistic development and is in no way cut off from the history of form, except perhaps from the avant-garde.

Democracy and socialism do not mean that art is reduced to the cultural niveau of the majority and has to accommodate to its limited understanding of art and its uncritical taste. They mean on the contrary that genuine artistic creations are accessible to broader strata of society and should be made comprehensible step by step. Popularization of art in the good sense can only exist if the lower cultural strata are advanced and not in art's descending to the level of the stupid and those who react to art in an unsuitable manner.

The attempt to raise the level of the production of popular art and of lukewarm artistic reception—and the belief that this can be done—can be linked most rigidly with the quality of the products. However, to expect that—in the place of an audience which is culturally differentiated—there will ever be a public which is culturally totally homogeneous and which acts according to identical principles of taste is as utopian and illusory as to hope for a society without stratification of power and gradation of abilities.

Statistical data on the number of books published and the dissemination of best-sellers or of qualitatively indifferent works may be extremely revealing to sociology as a discipline without value judgments and within the limits that are set to such a discipline, but they have relatively little value for a sociology which is dealing with art as an intellectual or spiritual activity. It may not be a matter of indifference what books uneducated or half-educated people—who have no sense of artistic values or who do not care about them—read. It is also certainly not pointless to know how such readers are turned into more serious, more mature, more critically receptive subjects. However, it is still fundamental to the sociological analysis and definition of complete artistic aspirations and products. These were—as far back in history as we can go—and still are the preserve of a cultural stratum which has remained limited although its limits are not fixed for once and for all and may give way to pressure both from above and from below, without ever completely vanishing. The solution of sociological problems which are posed by bad and problematical taste constitutes not only an important, but in part a more difficult, task than the

determination of the social conditions which determine the mastery of positive artistic values.

Popular art cannot simply be dismissed for the reason that it is not entirely without merit, but exhibits now more and now less satisfying products. The question of whether it is "art" at all is pointless. If we can establish the principle—vis-à-vis the problematical artistic efforts of the current avant-garde—that art is what counts as art, then we must also show the same tolerance toward the less demanding forms of popular art. Just as the value and essence of culture correspond to situations which are constantly changing and, though distinct from the characteristics of half-culture, only differ in degree, so high art cannot be confused with popular art and is incommensurate with it, but not impenetrably walled off from it. Since the Enlightenment, educational privilege has no longer been a cultural monopoly, and the special quality of the art of the cultural elite is certainly unmistakable but by no means restricted to a group of initiates. However strongly we may deny that we can judge popular art—which serves merely for entertainment and diversion—by the same criteria as we can the art which demands for its proper understanding a feeling for quality, sensibility, maturity, and seriousness, we must still insist that even the most modest form of a sensually concrete reflection of reality—which in its effect, even if not in its origin, is autonomous and immanent—contains something of the special quality which distinguishes and sets off all art from the rest of the world.

There is constant shifting in the relationship of folk-art, popular art and the art of the cultured. The gap between the popular art of the broad and mixed public and the high art of the elite is qualitatively larger than the distance between folk-art and the art of the elite. From the point of view of historical development, however, the matter looks different. Many of the most important forms of art, especially the drama of the Elizabethan age and of the "Golden Age" in Spain, the modern social novel in both England and France, have their origins in popular artistic movements often of doubtful aesthetic value. We should not from the outset give up the hope that there will be a successful end to modern light fiction and commercial music. In any case, the unscrupulousness of popular art makes possible innovations which—in higher realms of forms—have obstacles placed in their path by the more rigid norms obtaining.

The fluid limits of what is popular in art, especially music, make themselves felt because many works of high art, because of their distribution, take on a "popular" character. This is in spite of the fact that their popularization, as for example in the case of Beethoven, does not affect the true quality of the creations and actually bars the road

to their adequate understanding. The artistically uneducated and in-experienced listener, even if he really seems to enjoy works of genuine art, generally extracts single components from their context and thinks that he understands a symphony and has command over it, if he can whistle a motif, perhaps the first lyrical theme of the first movement. He does not realize that in a work of art every item has its function as part of the whole. There is a possible route from not understanding an artistic structure to understanding it, but not one from a half-understanding, which is in fact a misunderstanding. A half good inter-pretation in the realm of art is a thoroughly bad one.

True, there are composers, like Schubert, whose popularity is less alien to the original character of his works, even if not entirely in accord with it. Here it is obviously a matter of something like the popularity of Dickens—with the difference that in his case the indi-vidual cultural strata of which the public is composed are more suited to the quality of different levels within the works. In the case of Schubert the wider public grasps what is lofty and less lofty on the same level—a level which is now more and now less close to the inner value of the creations, but which never corresponds completely to their essence. Dickens, on the other hand, often from the beginning moves on the level of that part of his readership which is reduced to the lowest common multiple.

Popular art which is produced for the urban masses belongs ideo-logically to the petit and middle bourgeois, no matter from where the groups come which flock to be its audience and adapt themselves to it culturally. Popularity cannot be related to the proletariat as far as social consciousness is concerned or even to the attitude of the working classes and their mouthpieces. The strongly socialistic naturalism of the middle of the last century also had as good as nothing to do with popular art in the sense in which we are using it here, and the move-ments in art which, in the current century, move in the same direction cannot be connected with it at all. Expressionism, Dadaism, and, in part, surrealism are of a politically progressive essentially socialist, nature, but they produce no popular works at all, that is, works which could be enjoyed and understood without considerable cultural as-sumptions. Their authors, it is true, usually felt a solidarity with the proletariat, but they deceived themselves when they thought that they were expressing the ideology of this class. Their art had as little in common with proletarian class consciousness as it had with the "bour-geois decadence" of which they accuse the protagonists of "socialistic realism."

Readers who belong to the lower-middle and working classes usually enjoy the same type of literature. The books which they read corre-

spond to the escape fantasies, compensatory satisfactions and inhibitions, the passive acceptance of fate by the underprivileged and the identification of their heroes with those privileged by the ideology of the middle class. This ideology is promptly adopted by members of the lower social strata to the extent that they sacrifice their class consciousness and they quickly succumb to its narcotic effect in art, where they think they are not immediately involved in the class struggle.

Popular art is in no way identical with proletarian art, not only because "popularity" is a cultural concept while "proletarian" is a class category, but because in the strict, that is, not purely propagandistic, sense, there is no proletarian art. If, for example, the tragic feeling for life is seen at the outset as being antiproletarian and decadent because it contradicts the optimistic Marxist trust in the classless and supposedly conflict-free society of the future then "proletarian" is aesthetically a senseless and valueless concept. If, on the other hand, we understand by proletarian-minded art a representation of the sad splintering of society from the humane point of view, then every true art can be regarded as proletarian from a certain point of view.

The permanent bridging of the gap between the art of the lower cultural strata and that of the cultural elite is, given the present-day state of affairs, impossible. For even if we were successful in bringing works of high art to wider strata and of having valuable works of art created in their midst, authentic art would—in present economic and social conditions—have once more to become the property of a thin, privileged stratum. The way to general comprehension would not only practically—but as a matter of principle—meet with almost insuperable difficulties. These would consist here, too—as in the whole realm of culture—mainly in the fact that we would have to stop the course of development for the less cultured to catch up with the cultured. The operation has been aptly compared to changing a wheel when a car is running. The interruption of the developmental process would create a situation in which the problem to be solved does not appear at all, for the task would consist not of catching up but in keeping pace with a constant process.

The directive to the participants of the Second International Congress of Composers and Music Critics in Prague, "The Congress urges the composers of the world to create music which combines faultless craftsmanship with high quality and true popularity," sounds unbelievably naive and contradictory to the apparent principles of the proclamation. A Marxist-directed view of art would have to be clear that movements in art do not come about to order, for then they would be able to come into being at any time and under any conditions, which is exactly what Marxism denies.

In no form of art is the depraving influence of popularity so obvious as in music, which everyone imagines they can understand. Works of literature or painting are in themselves either important or trivial, serious or frivolous, demanding or paltry. On the other hand, in music, even creations of the most sublime, most difficult, most profound nature can be reduced by superficial and mechanical reproduction to mere entertainment, fun, and pastime, to hedonistic pleasure of a culinary sort. For what Constant Lambert called "the frightful popularity of music"[26] does not consist of the phenomenon that so much miserable music is produced but far more in the fact that so much good music is consumed by so many in a quite unsuitable manner and that so few people have the courage to admit that music is something they could do without. Music has never—even high classical music—been so widely disseminated as it is today thanks to the radio, records, and the many, generally reasonably priced concerts. Listening to music has, however, not only won new friends but also lost much of its earlier magic. What do we gain if in going to a concert we read the program notes instead of listening, or listen to Beethoven while drinking an espresso or to Bach's *Chaconne* when we have a tooth pulled? The terrible injustice that popularization does to the great works of music lies in the hedonistic support of a passion which has become a mere habit and in the distracted listening which takes place because of divided interests, whereby the orgiastic intoxication of the true musical experience becomes a euphoric tipsiness.

The special nature of music, its enhanced sensuality, and its predominant formalism, a characteristic to which the early Christians took exception, is connected with two things: first, the alienation of its reception, but also the dilution of its production, the fact that—as has been rightly observed—today's light music is almost without exception bad.[27] In no other form of art does so great a part of the production belong, from the beginning, to a "light" genre. Nietzsche's dictum "Everything which is divine treads lightly" seems to have been coined precisely for music. In no other form of art could what is "light" simply be called "divine": in no other could we make so many compromises with what is light.

The interaction of light and serious music is characteristic of the whole of music in the classical-romantic period, beginning with Bach on through Mozart and Beethoven, into the works of Schubert and Chopin. The *Magic Flute* is perhaps the best, even if not the last complete, example of the balance of both elements. Starting already with Schubert and increasingly in the works of the later romantics, earnestness, melancholy, and nostalgia begin to win the upper hand, and in the case of a composer like Offenbach the light and the gay

often seem to be compensating for a lost innocence in which light and heavy were not so sharply divided from each other. Richard Strauss still wishes above all to reconcile the lighthearted and the melancholy. But nothing is more characteristic for the development which has taken place than the melancholy which in the works of Mozart leaves what is lighthearted unencumbered, but which in the romantic and especially the late romantic bourgeois period always overshadows the expression of the light and the gay. Nietzsche, it is true, plays off the praise of lightheartedness in Bizet's *Carmen* against Wagner; but light no longer means merry, and this is the sense in which we understand Schubert—who himself wrote so much light music—when he said that he no longer knew any merry music. The balance between light and heavy, playfulness and seriousness, relaxation and composure, is broken, although Schubert will have known nothing of the bourgeoisie's later precarious situation and will scarcely have been affected by the danger which lay ahead.

Even modern jazz belongs to those forms of light music which hardly have their counterpart in other artistic genres. Jazz is essentially dance music, that is, utilitarian music for entertainment but which reveals in contrast to other light musical productions characteristics which have no counterpart in literature written solely for amusement or in painting which is merely intended to decorate the wall. The regressive simplicity of the merriment of operettas and the weak sentimentality of salon music give place in jazz to a rhythmic originality and a piquancy of tone color which mark the beginning of a new movement in Western music and which also exercise a creative influence on the development of serious music. But jazz remains utilitarian even if composers of the rank of Kurt Weill, even Debussy or Stravinsky, make use of its devices. It is most evident in examples like the *Threepenny Opera* that there is also good popular art, just as Verdi's operas, especially those of his middle period, show that thoroughly good music can also be really enjoyed by nonconnoisseurs. The complexity of relationships between popularity and the standards of the cultural elite, convention and avant-garde, utilitarian art and autonomous art, becomes especially striking in the case of someone like Debussy, in which the moments of giving and taking are almost indissolubly linked.

In the enthusiasm for the obstinate rhythms of jazz and the simultaneous development of the phonograph as a means of communication, we already find the most obvious expression of the obsession with automation and machines which develops and interacts with the rejection of what is mechanical and reaches its high point in McLuhan's apotheosis of electronics. The fascination with increase in speed, the anesthetizing inevitability and monotony of express trains, cars, and

airplanes ousts the romantic dislike of automation and not only dom-
inates jazz, and ephemeral music styles like, for instance, Honegger's,
but also dominates the art of masters like Stravinsky and, to some
extent, Bartók.

Yet no matter how mechanically certain artistic media of jazz may
be used, jazz music—in spite of the conventionality of its forms—
preserves in the hands of its inventive representatives a certain flexi-
bility in contrast to kitsch, which clings to set formulas. Kitsch is
complacently able to be enjoyed with little intellectual effort, and meets
hedonistic desires. It, however, differs from popular art first and fore-
most because it makes the unconditional claim to be considered "art,"
while the products of the entertainment industry which the half-
educated or uneducated consume as music, literature, or painting sel-
dom if ever make such a claim. Both sorts of popular art, kitsch and
the simple means of passing the time—which seem to know nothing
about real art—have besides their flattering daintiness this in common:
that they are at one with the world and its course. Their passivity is
synonymous with the counterfeiting of a happiness, a peace, and a
completion of which we are simply not part. It is the assumption of
the untroubled representation of daydreams, illusions, and false views
of life, of the simple putting aside of worries, duties, and insoluble
tasks, which every real art tries to overcome or to sublimate, instead
of casting them aside or denying their existence.

Kitsch arises out of the belief in the irrelevance of social antitheses
and the wanton optimism that we can simply move from one social
class to another, out of the world of illusions into reality, from the
realm of dreams into the cloud-cuckoo-land of fulfillment. The film
in which the boss marries his secretary merely because he has seduced
her and the novel which proclaims—as the final piece of wisdom—that
"everyone is responsible for his own happiness" can be seen as ideal
types of trashy art based on social romanticism.

However high it may set its sights, kitsch is pseudoart, art in a
cheap, sugary, sentimental form, a falsified, mendacious representation
of reality. Kitsch is in essence dream-kitsch, an ideal portrait of ex-
istence mostly in an unreal, sentimental style. But, as we have stressed,
there are also other forms of kitsch, like those of the "drawing room"
or the "grand salon," an inner and an extrovertedly demonic, a religious
and a patriotic, a frankly innocent and a lascivious kitsch.

Kitsch assumes on the part of its producers no higher form of talent
or intellect than does popular art in general, but a glib ability which
the authors of dime novels, theatrical smashes, and popular hits do not
usually possess. Kitsch is not art which "would try but fails," but a
successful antiart, the deliberate lack of taste. It does arise by chance

and unconsciously but—as Emile Faguet says of the melodrama[28]—we have to believe in kitsch in order to produce good and successful kitsch. In this way beauty is turned into prettiness, nobility into pride, sublimity into boasting, worth becomes ostentation and love prostitution.

Kitsch and bad taste correspond to one another, but they are not equivalent. Popularity and lack of taste are also not necessarily connected. In the case of many of the most important writers, stature is linked to a questionable taste. Balzac above all hardly ever wrote a work in which good taste, in the Flaubertian sense, was not impaired by the most vulgar devices. Equally problematic are the criteria of taste which guide Dickens and Dostoevski.

Stages of Development

Popular art appeared in the sense in which we are using it here in the Hellenic period at the same time as the eclectic movements in style and taste. The rise of the middle classes brought about a remarkable change in the composition of the public for art, which was now a group of interested people who had the ability and the will to pay. A capitalistically organized art industry endeavors to fill the growing demand and contributes with its production—which accommodates to fashion and renews itself periodically—on one hand to a rising eclecticism and on the other to a progressive leveling out of standards. Alongside the increase in ceramic workshops—which were already producing goods on the scale of factories—the wholesale copying of masterpieces of Greek sculpture begins. This activity leads, it is true, to the spread of classical principles of beauty, but at the same time it leads to a game with the forms of the paragon of the particular time. By emancipating the dominant style from its original background, it also creates the prerequisite for a popularity which is far more loosely rooted.

In contrast to older monumental works of plastic art, painting becomes the late Roman art pure and simple and a special form of popular art which speaks a rough language which all understand. There had never previously been such a mass production of painting, nor had it ever served such trivial ends. Everyone who turns to the public with his private concerns, who wants to convince them of the justice of his cause and win them over, does it most effectively in this pseudoart, which has now become an instrument of propaganda. Apart from the pleasure derived from the anecdote, interest in authentic reports, evidence from documentation, the joy of the masses in painting attests to a primitive interest in show and a childish preference for illustration in and of itself. It is extremely naive and highly unartistic. It wants

to see everything immediately with its own eyes, receive nothing at secondhand, see nothing represented in that distanced view which reflects reality but which is far from reality, in which the actual essence of art consists. This raw communication shows most clearly what popular art means for the effective development of art history and art criticism. It was a form which at first presumably mainly reflected the taste of the uneducated elements of society and out of which gradually the epic style of fine arts developed—the art of Christianity and the occident pure and simple.

The fact that art in the Middle Ages became more and more independent of the courts and the rulers and—as a result of its attachment to the Church—entered into an immediate relationship to the community of the faithful by no means indicates that it was more comprehensible, especially in the Romanesque period, than in antiquity or in the early Middle Ages. For if, for example, Carolingian art is determined by the taste of the educated court circles and remains alien to broader circles of the community, art in the later Middle Ages was in the hands of the clerical elite, which is more all-embracing than the aesthetic court circle of Charlemagne, but the circle of those who sustain art certainly does not embrace the whole of the clergy. Clerical art becomes an effective means of ecclesiastical propaganda but only insofar as it puts the mass of the population into a ceremonial religious mood, which is on the whole, however, undetermined and artistically unarticulated. Because the forms of Romanesque art became simpler and more expansive, they did not become more popular and impressive. Simplification and stylization do not indicate any sort of compromise with the taste and discernment of the lower strata but on the contrary a further approach to the view of art of the ruling classes, who insisted more on their authority than their culture and preferred the monumental to the differentiated. The ambiguity of the concept of the simple and the stylized, which appeared in this process, is a striking example of the equivocations which repeatedly threaten the sociology of art as a strict science.

In the Middle Ages the limits of popular art are fluid both at the top and at the bottom and the character which we would be inclined to ascribe to it is so difficult to distinguish on one hand from high art and on the other from the naive art of the people that we can hardly cite with any certainty indisputable examples of it before the end of the period. We find in the drama most traces of the blurring of limits and the heterogeneity of the elements of an art which might be labeled "popular." This genre is not an original creation of the folk, yet it is a continuation of a popular tradition which was propagated from antiquity and was taken up by both popular and ecclesiastical drama.

Motifs of literature, especially Roman comedy, also found their way, by means of the mimes, into the drama of the Middle Ages. Ecclesiastical theater especially remains something like "popular art" in that not only the audience but also the actors belong to the same stratum of society and testify to the balance between production and reception. The "popularity" of the performance is shown by the fact that all strata of society participate in it. The members of the ecclesiastical theatrical ensemble, at least, are clergy, merchants, craftsmen, and, in part, hangers-on, in a word—dilettantes—as opposed to the actors in the secular theater, who are professional mimes, dancers, and singers.

Dilettantism, which never asserted itself as a stylistic factor in fine art, achieves in literature—almost with every change of stratum in those who determine taste—a more or less considerable importance. The troubadours, too, were at first dilettantes and only later became professional poets. After the collapse of medieval court culture, however, they became unemployed, for the bourgeois was neither rich nor cultured enough to make up the deficiency and to employ and feed them. The place of professional minstrels is again, in part, taken by amateurs who follow their own bourgeois profession and practice literature in their spare time. They carry over into literature the spirit which informs their craftsmanship. They join together even as "poets" into guildlike organizations and submit to rules which are formulated according to the guild statutes. These rules appear not only in the literary practice of the craftsmen-dilettantes but also in the works of the professional poets of the time, who significantly enough call themselves "masters" or "mastersingers" and regard themselves as, God knows how, far above the mere minstrels. They develop a school poetry, which is bourgeois, even petit bourgeois according to the origin of its authors, but which would avoid the appearance of popularity.

There was doubtless already a popular form of fine art in antiquity, at the latest in the period of Hellenism: but in the Middle Ages there is scarcely anything recognizable as such until the fifteenth century. The lower strata of society will certainly have had their own decorative art, but to order and buy pictorial representations before the invention of the woodcut was obviously only possible for the upper classes. Even printed pictures certainly only gradually found purchasers in the more humble classes, though it is hard to say how the purchasers were distributed over the different classes, and it is hardly possible before the eighteenth century to draw a halfway definite line between the buyers from bourgeois, petit bourgeois, and rural circles. In fifteenth-century Italy, a considerable amount of production of a pictorial nature can already be recognized, although because of the cost of the products these were still only bought by the wealthy classes.

While medieval popularism is preserved in literature in the drama of the Elizabethan period, there is not a single popular trait in the fine arts of the Renaissance or of mannerism which can be identified as stylistic. It is only with the dissolution of mannerism, which was intellectually and emotionally difficult, and with the change of Catholicism into a popular religion that we begin to find popular criteria of taste in representative art, especially that which is destined for ecclesiastical purposes. The Counter-Reformation marks the hour of birth of that devotional painting which numbers not only parts of the lower strata of urban society but also parts of the rural population among its audience. Many of the most essential elements of popular art have their beginning in this very place. The cult of suffering and emotional excess, of mystical ecstasy and martyrdom—moments which are always present in the baroque—ushers modern emotionalism and subjectivism into the fine arts and prepares the path of later romanticism. In the works of the average artists of the time, those shallow emotional clichés begin to appear which characterize popular art of the present day.

The collapse of the old system of patronage, the irrelevance of the royal courts and the aristocracy as arbiters of taste and the beginning of the almost exclusive dependency of the artist upon the open market, marks the end of the prehistory of modern popular art. Its actual history begins with the interest of the upper and middle bourgeoisie in the literature of the Enlightenment in England and the cheap novels of the seventeenth and eighteenth century in France.[29] With the growing hunger for reading material, the rising demand which the better authors were not able to meet and the development of new preromantic criteria of taste, comes a gradual drop in the level and an almost universal coarsening of the tone of successful literature. Sentiment has that naive uncritical admiration bestowed upon it from which soon only very few authors can escape and as a result of which literature is made into a sort of analysis of feeling, and so, by and large, it has remained until the present day.

The most important discovery in the realm of commercialized literature is the concept of the penny dreadful. This is the form which unites the most important elements of today's sensational literature: crime, love, secrets, cruelty, and horror. Many of these were already present in old chivalric and adventure novels, others come from sixteenth-century picaresque novels and folk ballads, but most of them have a pseudohistorical source and are connected with the interest which the preromantics had in the Middle Ages. The immediate descendants of the genre are the street ballads of the first half of the last century, which make no pretension to art. They give way at first to

a tamer form of adventure novel and finally emerge on the one hand as detective stories and on the other hand as the modern social novel with all its vicissitudes. A parallel and, to some extent, a model of the process can be seen in the development of the sentimental drama of Lillo and Diderot via the melodrama, the music hall, and the *pièce bien faite,* to the film hit. The feuilleton novel composed of sensational love stories and the popular dramas of the late nineteenth century, which are in the same spirit, are the first complete examples of popular literature in the modern sense. Their public consists of all strata of society, with the exception of the peasant, but is always dominated by half-educated elements without artistic pretensions. The popular novel—which in the first half and around the middle of the nineteenth century still includes works of authors like Balzac and Dickens—declines so quickly and essentially that it sinks to the level of an Octave Feuillet or a Marie Corelli.

The Second Empire, which produced artists like Flaubert and Baudelaire, is at the same time the period of the beginning of bad taste and the commonest kitsch. Bad painters and writers of course had existed before, just as there were sketchy works and botched up artistic conceptions alongside those which were carefully worked out, but the inferior was clearly inferior, unpretentious, and inconsequential. There was no cultivated trash skillfully done up. Now, however, rubbish becomes the norm and superficial appearance of quality the rule. Art as a medium of entertainment, where artist and public sink below their own level, is the invention of this epoch. It dominates all forms of artistic production, but mainly that which is most absolutely and unobjectionably audience art—the theater.

After the middle of the century, dramatists' efforts are directed toward creating a propaganda instrument for bourgeois ideology—for its economic, social, and moral principles—and as such the theater becomes the representative art of the period. No society ever had such a love of the theater as did Dumas's and Offenbach's audience. There was none to which a premiere and a full house meant so much. Francisque Sarcey, the most influential critic of the time, rightly asserted that the essence of the theater was the audience, that it would be easier to eliminate everything else from the production of a play than the audience, which was always right, even though he knew all too well that the old cultivated public, among which there was a true consensus of taste, had dissolved. All that was left of the old habitués was a group of regular theatergoers—the audience which attended premieres.[30]

The gradual coarsening of taste is most evident in the operetta, which, with its careless pastoral merriment in a time of precarious social conditions, was essentially problematical and could only be

explained by the frivolity of a society doomed to collapse. As such it bore the seeds of disintegration from the outset, but it developed— out of Paris, with a master like Offenbach, via Vienna and Budapest— from a delightful social satire into a silly and mendacious idyll. The potential of the operetta, however, was only fully realized with the inflated media and the rollicking hits of the spectacular revue and the film musical. The mixture of showy sensuousness and restrained intimacy, of brutality and sentimentality, the passion for what is colossal, the overpowering of the audience by what is noisy and strident with all the emotional ecstasy which is part of the success of the film is not new. What is new is the constant and unavoidable lowering of standards. Of course, "bad taste" does not date from yesterday or the day before. The history of the ready-made cliché, the play with extra-artistic feelings and effects, the attack upon the tear ducts, the extortion of sympathy and of acquiescence is very old. There are few periods in the history of art in which it would have been completely possible to oppose their allurements. The modern period differs from older phases of popular art only in the fact that kitsch and rubbish are produced with such a sure hand and with a skill never before known.

The history of bad taste in the present-day sense also begins in eighteenth-century painting, when the arbiters of taste changed from the aristocracy to the bourgeoisie, most obviously in the works of Greuze. This is when literature bursts in upon painting, as a result of which we not only have pictorial representations with a literary or philosophical content (such were almost the rule until the advent of impressionism) but also have pictures which have only literary, and almost no artistic, content. This is the beginning of the history of the banal, sometimes baldly moralizing, sometimes commonly lascivious dream and anecdotal painting, which spares the spectator any effort and which is linked with the reduction of forms to a lowest common optical multiple and with the attitude toward the problem of justification of visual representation as a medium.

The next step in the victorious march of bad taste is the rise of the bourgeoisie as the sole ruling class in Second Empire France and in Victorian England. The earlier lack of feeling for quality is mated with the parvenu nature of the whole artistic enterprise, a need for art, and a consumption of art purely out of motives of prestige. The needs which have to be met are just as false as the material with which they are satisfied. Morality is mere cliché, decency an attractive facade, chastity ambiguous coquetry, just as marble is mere stucco, stone only mortar, and gold gilded wood.

26 Mass Art

The media of mass art are the products of the most up-to-date technical developments: its presentation is produced by mechanical means and is suited to the production of effects which can be reproduced under any circumstances at all. Of course, every individual piece of music and every painting can be reproduced, but they are not conceived for this purpose. Works of mass art—on film, in radio, and in television—are on the other hand not only capable of being reproduced but created in the spirit of mechanical reproduction and made to be reproduced. They have the industrial character of consumer goods and can be taken care of in the category of business known as the "entertainment industry."

Industrial production brings with it not only signs of mechanical distance but also signs of depersonalized similarity. Every social culture has a unifying effect which to some extent balances out the individual differences of its members and the means at its disposal. Modern mass culture, however, has such a leveling effect that the special norms and values of individual attitudes and products often fall victim to equalization and, at times, to an accommodation which also has a leveling effect. The freedom which the individual or the particular group enjoyed in earlier—nonmass—societies has now given place to a dictate which leaves the radio listener or the television viewer no other choice but to switch his set on or off. Appealing to the public's wishes is a lame excuse where the standards of the criteria governing the public's wishes are dependent upon the same administration as the one that satisfies them so unsatisfactorily.

No form of art which was produced in the course of history and which was intended for different rulers, governments, churches,

597

masters and patrons, and connoisseurs and collectors was completely autonomous and free of every unwelcome interference, even if periods like the eighteenth and nineteenth centuries did give the artist a great deal of freedom of movement. To speak of an "administered" art in the present-day sense would, however, have been unsuited to the spirit and practice even of authoritarian cultures like the ecclesiastical culture of the Middle Ages or absolutist courtly culture. The pressure of ruling ideologies and conventions appeared from time to time now more and now less vexing and weighed more or less heavily upon different individuals and groups. In present-day mass society and culture forms and formulas dominate, to which those who command and reward are just as subject as those they command and reward. Thus, it is evident that it is not individual rulers but systems that govern and that masters, too, are their servants. Ideologies and conventions—which are the result of a dialectic between spontaneity and material conditions—and the temporary adjustment of inner contradictions gain mastery over the attitudes of those who support them, irrespective of whether these are positive or negative coefficients of the common "style" and the ruling principles of order.

Docile conventionalism, which is to be seen in popular art since its earliest beginnings, is the determining factor in mass culture. Even art forms like the manneristic madrigal or the rococo minuet reveal rigid conventional characteristics, but they never entirely excluded the spontaneity of invention and never became as trivial—never everyday art to the same extent—as the products of the entertainment industry do. The conventions which they followed did not become a mechanically applicable cliché, and the consensus which underlies them was not as low a common multiple as the conformism which dominates the criteria of taste of today's masses. Formerly, conventionalism permitted innovation and invention of every kind, whereas the mechanistic principle according to which mass art is produced leaves no doubt of how a choice must be made or a solution found. An artistically authoritative convention can be not only the quintessence of stylistic unity but also the diluted form of an originally creative, but self-consuming, style. Spontaneous consensus can become manipulated conformism.

Works of art were created as goods from time immemorial, for they were mostly—apart from prehistoric times and the conditions surrounding the rise of folk-art—intended to be sold and were not for the artist's own use. But they only gradually developed into what we today understand by "goods." The decisive step was taken with the emergence of conditions in which the customer, in contrast to the former employer and patron, was generally unknown to the artist and was therefore an impersonal character. In the full sense of the word,

the artistic product only became a commodity as a result of this development, in the course of which, like the mass production of the industrial economy, it was produced and sold, became fashionable and went out of fashion, and became valueless, and in this sense seemed to be "worn out."

In the age of mass production, popular art takes on completely commercialized and highly rationalized forms, since it is intended to produce large numbers of easily and quickly salable goods in the shortest possible time. Standardization of patterns is the most important prerequisite of a practice oriented in this way. The secret of the desired success consists in the establishment of prototypes which will last, in holding on to them as long as they promise to be productive, and in rejecting them as soon as their yield threatens to fall off. The profitability of the industrial economy depends directly upon the extent to which production is standardized. A source of alienation in the sphere of human activity—the schematism which is tied in with this—has a particularly alienating effect in art, where individuality of products seems to belong to the essence of the medium.

The almost unlimited extent and heterogeneous composition of the public are probably the most significant characteristics of mass art, but it is by no means true that the different elements which participate receptively in this form of art do not reveal any element of selection and articulation. The audience for film, radio, and television is, it is true, composed of all strata of society, but it is not the same programs which they look at, or listen to, or which they enjoy. And even what pleases them has different qualities which they consider valuable or interesting. Thus, not only does a selection take place which allows higher cultural groups to arise as arbiters of taste alongside the masses which at the moment numerically dominate the circle of consumers of art, but also within the average mass public there is a multifariously graduated stratification suited to the subjects' taste, understanding of art, and critical ability. In this way we see not only different consumer groups, but within each of them subgroups whose special receptivity—for lack of an unequivocal social and psychophysiological specification—seems to be dependent upon imponderables.

We relatively seldom come into contact with a previously determined limitation of every sort of public for art. Only in times of absolutist courtly and class practice of art was the number of people who could attend a musical or a theatrical production limited from the outset. Segregation was mostly according to education, although many economic and social privileges formed the prerequisite for education, and these could not simply be compensated for. No one, for example, was directly excluded from attendance at the salon, but to begin with many

were not interested in the works displayed. The Paris theaters, too, were, at the time when Versailles dictated to art, themselves open to all, but most people were kept from going not just by the high prices of admissions. Just as, on the other hand, mass art today owes its popularity not just to the fact that the entertainment industry—film, radio, television, paperbacks, etc.—offers its goods so cheaply. It is not only need which creates and heightens demand; the apparatus of production which has been set in motion and the products which have become easily attainable themselves stimulate the desire for their enjoyment. The growth of the public and the lessening of educational prerequisites for the enjoyment of art are mutually conditioning and are dialectically linked.

With the disappearance of individuality from the public for art, especially with the increasing number of people who read books, the level of taste of the middle class has sunk most perceptibly. In the last century the members of this class perhaps read more, but certainly worse, literature than previously.[31] Flaubert recognized the evil and characterized it: "Combien de braves gens qui, il y a un siècle, eussent parfaitement vécu sans beaux arts, et à qui il faut maintenant de petites statuettes, de petite musique, de petite littérature!"[32] The extended circle of those interested in art causes the decline in the quality of products, and the less demanding works encourage, for their part, more and more people, who are less and less critical, to become consumers of art.

The sociology of art makes it easiest for itself when it restricts itself to the determination of the numerical participation of the public in the reception of artistic production. But in this way, it only achieves statistical information and succeeds in setting up a sort of sales table without answering the actual question of how it achieves the salability of the products sold, in what way and by what criteria it succeeds in filling the demand. It also has to find an answer to the question of how customers are influenced by consumption of cultural goods at a given moment. It is only of limited interest to discover what sort of books particular strata of society prefer to read without knowing or sensing why they prefer one sort of book to another, what circumstances condition their demands and evaluations in this area, and what change in their culture and their relationship to the culture of other strata comes about through the change in their reading.

The value of statistical information is—with respect to these connections—problematical from the beginning. Apart from the fact that numbers and names merely answer questions about the extent and object of the enjoyment of art but not about the quality and significance of the experiences, questions about the public's taste, demands, and

standards of value can only promise to be useful when the answers of those questioned—for example, about books which they say that they read and enjoy—and also the lies and excuses which they make use of prove instructive.

One of the most important problems which arises with the emergence of mass art is the explanation of the changed relationship of the artist to his public, which is now growing beyond bounds. Already the elimination of the patron—and the customer who was personally known to the artist—by the appearance of impersonal consumers in the open market complicates a relationship which was formerly a simple, though not always easy, one. The more the number of those interested in art increases and the more their interests are incapable of reconciliation, and the more decisively the earlier group of consumers, which formed a culturally and socially closed entity, changes into an amorphous mass, the more problematical and indeterminate is the relationship between production and reception. Though perhaps in Georg Simmel's sense they meet somewhere on the declining level of a common denominator: "The more people come together . . . the lower we have to look for the point where their motives and interests are on common ground."[33]

No concrete subject—as supporter—corresponds to mass art as an activity. Just as there is no group soul which can be seen as the creative origin of folk-art, so there is no mass soul which can be seen as a spontaneous force independent of the individual and intellectually superior to it. The mass soul, like the folk soul, is an image without substance, that is, the conceptually constructed substratum of spiritual statements which are always made by individual subjects who may be joined together in groups. There is no art which could be created by the mass, just as there is none that could be immediately created by a collective of the people. Mass art, like folk-art, consists of individual products which do not owe their existence, but only their characteristics, to relations of individuals to one another.

The mass public does not represent an integration but—in contrast to its apparent concept—an atomization of the receptive group. It consists entirely of individuals essentially isolated from one another without a true intellectual community and significant common experiences. The audience in a cinema still show signs of a communal character, thanks to their origin in the theater and their participation in large numbers in the receptive process. They also show a manifest, though generally superficial, solidarity of interests which the attitude of the radio listener or the television viewer no longer does. The one unmistakable sign of the mass public for art consists in the blend of social subjects and the loss of their individual character, which is not

replaced by a consciousness of community. They are together in space but do not belong together, and they may have common demands but they mean as little to each other as, for example, the spectators at a sporting event do.[34]

Vastness of numbers is the most common and striking characteristic of the mass public. What has been called the "big audience"[35] characterizes the circle of those interested in film, radio, television, novelettes, and illustrated magazines in the same manner. The larger the public, the more passively, undiscriminatingly, and uncritically it behaves in the face of artistic or pseudoartistic impressions and the more readily it lets itself be fobbed off with products which emanate from standardized and well-practiced effects. Thus, from the beginning, a considerable number of recipients are necessary for a selective and critical public to turn into one which is artistically indifferent.

The first prerequisite—even if by no means the sufficient cause of the emergence of mass culture—was evidently the rapid growth in the population of Europe as a result of which the number of inhabitants almost doubled in the course of a hundred years. The birth of the mass as the supporters of culture was, however, not simply the result of the massing of the population but the result of a complicated process which at most began with the growth of society. Local consolidation—through the participation of broader circles in better conditions of life and higher intellectual satisfactions—led to a leveling out of values, a democratization of culture, and a more decisive role of the average man in cultural life. Such contradictory values were united in the democratization and the leveling out of culture.

Ortega y Gasset ascribes absolutely no special significance to the increase in population in the West during the last century in the emergence of mass society and its culture. The people who form this society and support its culture were already there at the turn of the century, even if not as masses, but separated from one another, isolated, and scattered in small groups. The novelty consists, in his opinion, in their massing, their conformism, in the gradual loss of those idiosyncrasies which had distinguished them from each other. A conformity of individuals to one another takes place in every form of socialization, but in the groups which have no mass character the decisive tendencies, norms, and goals correspond to personal inclinations and efforts which may be just as nonconformist as conformist.[36]

Popular art first assumed the dimensions and characteristics of mass art under the conditions of the modern industrial and trade economy. Genres like the ballad and chapbook which had been in circulation since the Renaissance, it is true, earlier had a "popular" character which distinguished them from folk-art. They filled the needs of a

heterogeneous public which consisted of visitors who thronged together to markets, fairs, and kermises, but we cannot speak of a mass art and expressly mass media before the time when industrial workers massed in the cities and mixed with the lower strata of the bourgeoisie. Popular art became mass art only after this and in the double sense that it provided artistic entertainment for an uncommonly numerous public and marketed uniform products in quantities so huge that they would have been unimaginable up to that time. The mass public for the arts was the result of the democratization of culture, and the mass production of art objects the result of the latest business and marketing methods, which were conditioned by the progress of electronics.

The process of change from popular to mass art was under way since the middle of the last century. The popular novel, the boulevard theater, and lithography were already unmistakable symptoms of the development which led to film, radio, and television. They introduced the technological period of art. Mechanical, toollike, more or less mechanical aids to art are of course as old as art itself. Every artistic form presupposes a technical process. Every form is linked to an instrument—an appliance—whether the instrument which the artist uses is a paint brush, etching needle, or loom. The mediacy of expression belongs to the essence of art and is inseparable from the process of turning spiritual content into mere artifacts. The prehistoric potter's wheel was already a "machine," and there is only a graduated difference between it and the technical apparatus of the artist of our own day. However, development does not proceed without leaps, in the course of which the invention of mechanical graphic reproduction at the beginning of the modern period was evidently the most significant. With this invention, the work of art lost its "aura," which consists in the individuality, the irreproducibility, and the inexchangeability of the painted picture or the modeled sculpture.[37] The most important further turn of events came with the extension of technology, which made it possible to show the same film in many thousands of cinemas to an audience consisting of millions of people. What was gained was that the public for art was expanded into a limitless number; what was lost was the immediate trace of the artist's hand. Yet it would be a dangerous fetish to make a myth out of the artist's "handwriting" or the "aura" of the original work of art. Uniqueness only represents a criterion of artistic value when it is part of the artist's original intention. A hand-painted copy of Rembrandt's *Night Watch* may be completely valueless from an artistic point of view, but individual copies of the master's etchings may still be regarded as authentic works of art, if the artistic value—which in a painting seems to be linked to every individual brush stroke—remains unaffected by the mechanical nature of the graphic

reproduction, and when this technique is an absolute prerequisite of the intentional form and not an alien and supplementary extension of it.

Mechanical reproduction and the mass supply of works of art connected with it may underline their character as commodities, but it is not the origin of their function as goods. A painting which is unique of its sort may just as easily be produced as a commodity—and count as such—as the copies of an etching or the photographic reproduction of an original. However, while the value of a painting is inexpressible in the form of its price, the value of an etching as a commodity can be more or less adequately determined. A piece of graphic art increases in value as it becomes rarer and only becomes priceless when it is the last and only extant example of the prints from a particular metal plate or stone. Again, a photographic reproduction—in contrast to both a painting and an engraving or etching—remains under all circumstances a commodity and represents (as, for example, a phonograph record does) merely a record, a sort of *aide-mémoire* without any individual marks of value worth mentioning. It represents an original which simply cannot be reproduced, and thus, it differs not only from the artistically authentic print but also (in essential ways) from the copy of a film, primarily because a film consists only of copies without an "original" (for even the negative is only a mechanical reproduction) or because it consists only of copies whose original only exists in the form in which, for example, the idea of a painting can be thought to exist side by side with the painting itself.

The artistic value of a work is not dependent upon the nature of the technical means which the artist uses, but merely upon the way that he uses them. For just as the change of the craftsman into a machinist does not mean that his intellectual powers atrophy, so the assumption that modern technical means of artistic production mean a reduction of its aesthetic quality is equally at odds with the facts. The film form, it is true, excludes certain artistic effects, but creates in their place prerequisites for new artistic values.

A drop in standards is often associated with an increase in production, and thus the quality of works suffered—because of the excessive demand for literature—even in so creative a period as the eighteenth century in England. But in the great periods of art history like the Gothic, the Renaissance, or the baroque, too much rather than too little is produced. This practice, however, becomes dangerous only when it leads to the monotonous repetition of patterns—within the limits of epigonism—or to a rigid school program. Of course, no style manages without a certain conventionalization of forms. It is just that the part played by what is conventional and stereotypical in mass

products, which are impersonal par excellence, is greater than it is in the high art of the masters, which is determined by individual criteria. The actual difference between the two forms of art does not consist in the presence or lack of conventions but in the rigidity or flexibility of them. The minuet was not less conventional than the tango: it was only more flexible. The mastery of conventions in high, essentially autonomous, art means only that the artist battling with the material he has to organize is standing somewhere on terra firma and can begin his work without paralyzing doubts—but not perhaps that he can circumvent all the dangers which threaten him from the beginning. His way, too, is interrupted by abysses which he can scarcely ever cross without audacity or even presumption. Those who see in conventions nothing but crutches do not know how dangerous it is to rely on them alone.

The two conditions of industrial mass production—the production of parts which are easily replaceable or for which substitutes can be found and putting them together with the exertion of relatively little labor[38]—also apply, with certain changes, to the mass production of art. However revolutionary the operation of the method of production may be at the present, it is in principle not new. Roman, even Egyptian, sculptors worked with stereotypical, mechanically combinable components. The artistic value of such a method is dependent—as is most evident from Homeric poetry—not upon the number and frequency of repetitions, but upon the ability to provide innovative expression by the formulas which are used. In modern mass art this is exactly what is lost; standardization does not produce any formulas which can be used at will, but clichés which are never really suitable.

The special characteristic of present-day mass art consists not in the wish to produce products which can be easily and widely distributed—people already wanted to do that before—but in the aim of finding a production scheme according to which the same types can be brought to the individual in the same audience without opposition or waste of time. The knights of the entertainment industry are usually reproached with clinging to tried and tested types as long as possible, for it is only the salability of the same type of products over a long period which guarantees real profitability. Yet at the same time they are also reproached with artificially creating a need for new types and a desire for rapidly changing fashions in order to increase consumption. As Simmel said, "An article is not produced somewhere which then becomes fashionable, but articles are produced in order to become fashionable."[39] In reality both methods—clinging to a profitable trend in fashion and frequently changing fashions—combine and alternate according to conditions. The organization of present-day mass

production of art also rests upon a manipulation of needs which works against natural development no matter whether it creates a demand artificially or lengthens the time something is in demand. Certainly as far as the entertainment industry is concerned, nothing happens which educates the masses to critical thought and artistic judgment. The accusation against publishers, theater directors, and film producers that they are in a conspiracy against the intellectual maturity of the public is, however, an all too dangerous simplification of the matter.

The ideological manipulation of the demands of the art market should not, however, be placed into question when we say this. Naturally people want to earn money and secure the means of doing so for as long as possible. To this end people also choose bad rather than good art, first of all because they generally have no idea of the difference between the two, but also because it is easiest to get rid of poor quality art products than more demanding ones. People interested in the success of the culture industry are in no way independent of their class ideology, even if perhaps they are not among the most enthusiastic representatives of it. In any case they seem to preach thoughtlessness rather than excessive fanaticism. They simply want to win and satisfy the custom of not only members of their own class but, as far as possible, everyone else. The ideological principles which they follow reveal, in the face of an apparently ruling liberalism, negative rather than positive traits. Dangerous questions are simply not asked.

The low quality of the products of mass art can be explained—at least in part—by the democratization of culture and the continuation of capitalistic competitive economy. However, the conclusion that "either exploitation or democratization must be eliminated so that culture will recover again"[40] does not sound exactly convincing. The ways and means of improving mass art which are tied to economic and social conditions presuppose the disappearance of neither capitalism nor democracy. The way out of the cul-de-sac is to be found not by merely tearing down barriers between classes and overcoming material obstacles which stand in the way of natural selection. The expectation of a flow of new talent as a result of the opening of culture up to whole new strata has not been fulfilled. Creative talents are not marching through the open gates, and the ability to distinguish artistic qualities from one another does not proceed immediately from the freeing of natural tendencies and instincts. Good taste is not the root, but the fruit, of artistic culture; it does not represent a primary datum but gradually becomes a factor which it is called upon to shape.

The routine of modern industrial society, the mechanical regularity of life in the big city, and the involuntary and generally unconscious adaptation of individuals to common forms of life bring in their train

a disposition toward lack of individualism. This disposition is enhanced by the mass media—the daily press, radio, cinema, television, newspaper advertisements, and street hoardings, in short everything which we see and hear. The facts which have to be discovered, the questions which have to be asked, the views which have to be shared are placed before us ready-made. The number of people who feed upon them grows continually, but it would be wrong to assume that the masses— even if there were less of them—ever behaved differently from today. They were actually never opposed to having their intellectual food predigested. If the works of art which they came into contact with were of a higher order than the ones that are available to them today, we can explain this by the fact that they were not directly intended for general use. But, however little conditions may have changed in this respect, the results of the fact that now ever wider strata of society have become consumers of art cannot be avoided. Mass culture not only levels out artistic criteria of quality at a relatively low level, not only makes people mentally inert and unfeeling, not only leads to conformism and irresponsibility, but also opens many people's eyes to things and values of which they were never before aware. Thus, it contributes to the people's spiritual defenselessness but also smooths the path to criticism and opposition.

Every time a circle of the art public suddenly expands, there is a resultant lowering of the level of taste. The most striking and most often quoted example is the transition from the courtly-aristocratic culture at the end of the rococo to the bourgeois culture of the Enlightenment. Similarly deep rifts come about with the cultural advancement of the bourgeoisie after the middle of the nineteenth century and the appearance of parts of today's half-educated middle class as a public for art.

Present-day mass art is rooted in the ideology of the popular art of the eighteenth century: in the concept of the work of art as an impersonal commodity and of the enjoyment of art as distraction and emotion instead of as clarification and absorption. The masses who participate in art today are not simply an extension of the public for yesterday's popular art. They are composed of more mixed social elements, and their relationship to art is more diversely motivated, even if, on the whole, it is more shallow and impoverished in content. There was also an unambitious art and a nondemanding public earlier, but the concept of a fundamentally simple, thoroughly unproblematical art which could be understood without difficulty and a public suited to this form of art—and having no knowledge of any other sort—has only now come into being. What we today understand by "light music," "popular fiction," or "wall decoration" was formerly almost

unknown. Entertaining books, flatteringly melodic, rhythmically pro-
nounced, easily memorized music, pretty and attractive pictures were
mostly by-products and means to an end, seldom an end in themselves.
Of course, art always wished to please and usually entertain as well,
but the people whom it tried to please and the means by which it tried
to entertain differed from culture to culture, from taste to taste, and
from public to public. Cervantes, Voltaire, and Swift wrote the most
amusing books; Mozart created the most charming music; Watteau
painted pictures which were sheer joy to the eye. Yet concern for the
seriousness of life and the thought of the precariousness of human
existence was never far from what they were engaged in. They amused
themselves and amused others by portraying the remarkable and often
startling paths and crises of life, but any thought of fleeing from the
facts was far removed from them. They may have made fun of the
topsy-turvy world, but it never occurred to them not to want to admit
its existence.

Making fun of the insufficiencies of life may be a harmless form of
defense against the threats of reality—noncommittal sentimentality is
a more dangerous one. This is no longer harmless make believe but
a dangerous lie which poisons human relationships. No one is so
moved by the fate of unhappy fictional heroes as the reader who never
feels any sympathy in his own life. His emotion is like the sentimen-
talism of romantic generations, the expression of a deprivation, a sub-
stitute for his lack of active participation. No generation finds such
pleasure and satisfaction in emotional stories and melodramatic situ-
ations as one which cannot develop its own emotional life freely. In
the same way the individual compensates for his lack of love by
sentimentality.

Even the authors of the sober, rational eighteenth century do not
avoid heart-rending effects in the least, but they never appeal only to
the heart but always at the same time to the reader's reason and often
recall him quite harshly to everyday life. They know and respect the
secrets of the heart, but they do not mystify them. In modern, popular,
mass literature, however, feelings are depicted as a sign of an excep-
tional disposition which is accompanied by an extravagant and often
morbid trait, instead of showing them as a natural and merely limitedly
relevant factor in spiritual life which finds its balance in reason and
in a sense of decency and bearing. Sentiment is an unabreacted, over-
compensated substitute for something which we cannot in any case
allow ourselves in life, and as a result it rises into the ideal and unreal—
exaggerated and overvalued.

The greatest attraction of today's successful novels and films consists
of this emotional unreality where the flight from reality is usually

expressed in a total identification of the reader or the spectator with the hero. The vicarious participation in the fates, battles, successes, and failures of an author's characters always played a decisive part in the receptive enjoyment of art, so that art as a whole can be looked upon as the satisfaction of a desire for an alien ego and a utopian existence. However, people never indulged in ideals of the sort so uninhibitedly as they did since the romantic period and its echoes in popular bourgeois literature which is content with mere surrogates and since the final triumph of the best-seller and similar artifacts. From this time on, the identification of the reader with the author's hero took on that dimension which veils and spirits away every gap between literature and truth, artist and public, creative and postcreative experience. While the author takes the reader into his confidence, he permits him to lay claim to the privileges of his hero in life and to dispense with the duties of everyday existence. In the generation after Flaubert, every little shorthand typist could envelop herself in a hopelessly inextricable deception about her life—like a sort of Madame Bovary who herself already usurps a special place in life—and completely forget who and what she is.

The heroes of the greatest literature of all times were ideal figures, ideal exemplars to whom the reader or spectator could look up and whom he often envied. Before romanticism, no ordinary mortal would have dreamed of measuring himself according to their yardstick and of assuming their rights or of completing or correcting his own unfulfilled or unsuccessful life according to their image. However, it would be a psychology which indulged in an uncommon simplification of the true facts which explained identification with the fictional characters of his favorite novels and films simply as the expression of daydreams and imaginary wish fulfillment. Only a small minority of readers and cinemagoers really hope for a Hollywood-style "happy end" to their sorrows, however often they may play with the idea. The illegitimate, illusory, smug relationship that most people maintain toward their ideals consists as much of self-dramatization and self-pity as of self-deception and conceit. Their optimism and their pessimism have the same illusionistic character. They are just as moved by the thought that they have missed something irretrievable in life as they are heartened by the secret hope that for them at least everything is not lost.

The modern culture industry simply by its extent, its mass, and the ubiquity of its products has gained a power over its consumers which is of doubtful value. The language of Hollywood and the best-seller has become the lingua franca of the West. Now, what is the greater evil in this hypertrophy of production? reading too much or too little?

having too large or too small a part in the culture industry? The answer is by no means as simple as it might seem to be from the purely civilizatory point of view. The danger of saturation and paralysis with which the narcotics of culture threaten their victims was recognized by Coleridge as early as the beginning of the nineteenth century. "For as to the devotees of the circulating libraries," he wrote, "I dare not compliment their *pass-time*, or rather *kill-time*, with the name of *reading*. Call it rather a sort of beggarly day-dreaming, during which the mind of the dreamer furnishes for itself nothing but laziness, and a little mawkish sensibility. . . . We should therefore transfer this species of *amusement* (if indeed those can be said to retire a *musis*, who were never in their company, or relaxation be attributable to those, whose bows are never bent) from the genus, *reading*, to that comprehensive class characterized by the power of reconciling the two contrary yet co-existing propensities of human nature, namely, indulgence of sloth, and hatred of vacancy."[41]

27 An Interpretation of Mass Culture

Marshall McLuhan's doctrines—which use striking formulations, consist mainly of metaphors, and are often confused—are an original, though strongly romanticized, interpretation of mass culture. They represent not only an explanation and criticism but also the product of mass culture, the expression of its desire for ostentation and sensation. They are typical examples of the exaggeration and simplification with which the media of mass culture present phenomena. Yet in spite of all the insufficiency in his mode of thought and expression, McLuhan's service has been to bring to the general consciousness the significance of inventions like radio and television and the influence which they exert upon our outlook and way of life. In any case, he was the first to point out—with the proper emphasis—that the effect of these media is essentially different from that of a book or a film, that they use specially formed media and effects, and that they presuppose, technologically, the electronic civilization of our age.

McLuhan started his statements by establishing the change which Western culture underwent through the invention of the printing press and the domination of interpersonal communication by the printed word. From this he arrived at the assumption that the release of thinking, feeling, and expression from alleged servitude was first made possible by the change he labels the end of the "Gutenberg era."

According to McLuhan, experience consists of numerous irreconcilable sensual components. We acquire simultaneously visual, acoustic, tactile, olfactory, and gustatory impressions. Their variety and simultaneity provide such a complex picture of reality that every attempt to depict them unambiguously and by homogeneous means may lead to a distortion of the experiences—even if the chosen vehicle of

representation is of itself not unsuitable. The spoken and audible word is, in any case, in McLuhan's sense a far more adequate medium than the written or printed word, which impoverishes and deforms the auditive quality and the natural form of communication. The written word sets narrow limits to the spontaneity of the living language, which hovers between different possibilities and reduces its diversity and kaleidoscopic variability to a single, rigid, lifeless, logical sense.[42] McLuhan's extravagant focusing of correct observations begins already with this statement. The impression made by the spoken word may, because of its immediacy, be stronger than in a written communication; the liveliness of the impression does not, however, guarantee a deeper interpretation with more nuances of the communication in question. A written text at least offers more reliable clues for proper interpretation than the fleeting sound of the spoken word.

The invention of printing and habituation to the written text increased—according to McLuhan's doctrine—the evil connected with writing. The monotonous regularity and the strict sequence of the printed line, the routine passage of the eye over similar signs which are easily recognizable formed the paradigms of logical thought, expelled and replaced the more concrete, richer, sensually saturated forms of the spoken expression. After Gutenberg we experience most of what we know about the world and people without coming directly into contact with them. Printing, with its movable, stereotyped characters, causes an abstraction of the concrete contents of consciousness and a fragmentation of spontaneous human intercourse because it operates with completed forms and makes available to the private reader—isolated from his fellow beings—autonomous categories of thought and means of expression. The danger, however, that printed literature could destroy the culture of the living language and poetry is just as small as it is that typography would lead to the nullification of the meaning which its characters form.

McLuhan mythologizes and mysticizes both the past and the future of culture by his all too strict differentiation between the spoken and the written word. His concept of "tribal community," as opposed to the routine of reading, with which he connects the magic of the spoken and audible word, as the medium of communication rests upon a myth. His idea, too, of electronic media which will automatically produce a new community and a new general participation in cultural works has a mystically utopian character about it. Even the statement that the written or printed word inevitably loses the undertones of the spoken word is a mere construction. Poesy has, since the rhapsodists of antiquity, consisted mainly of "literature" of written works which were in part also read, which did not owe their artistic quality and

effect to an improvisational technique of production and an impressionist momentariness of reception. They owed it on the one hand to experimentation and constant correction, on the other hand to a repeatedly interrupted and comparative reading of the poetical works. But even the apparently most immediate improvisation chooses and compares and alienates itself at the same time from the original inspiration. Writing down and reading are only further steps in the process of alienation from the inner self which is part of every expression and every mode of address and which no development, no matter of what sort, can produce in its purity.

McLuhan never ceases to repeat that the visual homogeneity of printing was the prototype of industrial technology and the strongest stimulus to the mechanization, rationalization, and depersonalization of life. The introduction of printing was the original sin from which all the evils of industrial civilization stem. Modern man—technically adept, industrially productive—is, as McLuhan insists, the product of Gutenberg. But Western culture gained from his invention the fixation of the *succession* of perceptions, ideas, and associations, not a means of integration, at best one of homogenization on the level of an individual sense organ and a medium of the continuously reading eye and the consecutively printed line.

Through the achievements of electronic technology, that spell has been broken. We have come into possession of the means of expression which allow media to come into effect—which consist of heterogeneously compiled auditory and visual elements instead of a single "visual" typographical form. In the place of succession we have simultaneity of impressions, and the complexity of compound sensuality replaces the simplicity of homogenous expression and straight-line argumentation. Even if it perhaps is true that the significance which television—above all else—has gained in present-day life is linked to a heterogeneity of the media of communication, McLuhan's assertions must still be corrected even in this connection. For although typography makes use of purely visual signs, and television in contradistinction also uses the auditive processes, there is no question but that it is more fitting to see in the change which takes place with television—and basically with the film, too—the victory and not the defeat of visuality, perhaps in the sense of Belá Balázs's theory.[43] The visibility of typographical signs has none of the sensually concrete, objectively sense-filled nature of visuality about it toward which the fine arts are oriented. This has nothing to do with printing and only becomes a decisive element in the prevailing view of life when the film becomes a popular medium.

McLuhan, moreover, also falsifies the real state of affairs when he says that the use of multifarious, heterogeneously limited acoustic-visual media is an innovation of television. In fact, homogeneity of the media of expression was already forfeited in the talking picture and actually even in the theater, indeed in the most primitive dance accompanied by music or rhythmic sounds.

Yet what gives special significance to McLuhan's theory in spite of all its shortcomings—apart from the insight that typography made an essential contribution to the idea that the processes of perception and consciousness were continuous and irreversible—consists above all in the fact that it introduced into the realm of culture the idea of "technical reproducibility," the triumph of which Walther Benjamin ascribes to the film, with its interchangeable and repeated types.[44] Even for Benjamin, however, the new technique meant, in contrast to McLuhan, a means of releasing both concrete visual sensuality from the dominance of abstraction and poetic expression from that of literature—from the printed text designed to be read.

When McLuhan asserts that the "printed book" represents "the first exactly reproducible, mechanically produced mass product," he seems to be picking up Walther Benjamin's concept of the "technical reproducibility" of the work of art. Yet he may have had no direct knowledge of his predecessor. And however similar the technical process may be in both cases, an immense difference lies between the reproduction of a printed text and that of a piece of graphic art. Every copy of a woodcut or an etching represents one and the same work of art; yet no printed text is identical with the literary work in question, but constitutes merely a series of signs which conjure up the form of the work in the mind of the reader.

The linear and additive structure of the printed text represents to McLuhan a symptom of monotony, which he thinks he can recognize everywhere in the culture of the Gutenberg era and which he sees as being overcome only in the electronic age which succeeds it—thanks to the multimedia forms of art. The tendency toward differentiation and multiplication of the media may be essential to forms of art like television and the film, but today's art tends rather toward more simple, straight-line structures composed more on the principle of addition. This develops in music, for example, instead of the more complex and dialectical sonata form, the forms of the fugue, canon, and variations; instead of more flexible harmony, a strict counterpoint; and instead of freer execution, a more rigid serial technique. In spite of this, McLuhan regards the newest forms of art and communication as being conditioned simply by the complex sensory nature of their media. All sorts of information, messages, and directions which we receive from

the news services, the propaganda instruments, the whole apparatus of commercial advertizing, and the other media of communication appear to him to be on the same multimedia level. Yet no matter how deeply he is affected by these influences, his feelings are ambivalent in view of the image which is put together out of heterogeneous elements. He is a contemporary fascinated and made ambitious by spectacle, and he tries to do justice to the demands of the day while nevertheless remaining a romantic who laments the dissolution of the "organic" unity of the former outlook on and feeling for life. On one hand he praises the electrotechnical achievements which mark the end of the Gutenberg era; on the other he holds them responsible for the intellectual passivity into which industrial society has fallen.[45] With the thesis of the Gutenbergian atrophy of the senses—which he sees as following one epoch of sensual development and as being the precursor of another—he falls into a double romanticization of the historical process. He constructs a golden age which should be lost and a utopian one in which the lost unity is to be found in a different form.

One of the most fundamental tenets of McLuhan's theory states that the new heterogeneously conditioned media are electronic extensions of our nervous system. This explains, above all, that the different cultural structures, even if they do not form an integrated whole, are coordinated and that new art forms—film, radio, and television—owe their nature to the same achievements, the same turning away from straight-line, successive, and individual forms of communication to multidimensional, simultaneous mass production and reception. The diversity of sensory media and the multiplication of media which characterize the new forms of art condition the character of our whole urban environment. The daily press and illustrated magazines, advertisements and placards, the phonograph and loud speakers all use the same language. With all this, McLuhan is at least right insofar as we can no more escape from them than we can from our own nerves and that the physiology of our nervous system and the electronics of the media of communication are equally foreign to our intentions.

The thesis that the "medium is the message" is McLuhan's most famous and most discussed dictum. It represents the sharpest and tersest formulation of his doctrine. The identification of the medium with the message, the means with the content of the communication, the instrument with the intention means that everything we have to say is the product of the way in which we can express it. At first sight this explanation may seem to be pure nonsense, for the intention and the instrument of a statement are conditioned in their relationship to one another primarily by the fact that the one is different from the other. The medium obviously serves to communicate a message and

is neither identical with it nor part of it. And although it may be right
that the form, the structure, the whole system in which the art of an
age achieves expression is just as characteristic for the society in ques-
tion as the ideas and feelings which are to be expressed and that for
its contemporaries it can become just as deep, gripping, and often
overpowering an experience, it nevertheless remains true that the ve-
hicle of expression is the antithesis of the message and the medium
begins where the content of the communication ceases. Medium and
motif, like form and content or convention and spontaneity, can also
only be exactly defined in a dialectical relationship.

However, this in no way prevents the form of a presentation and
the media of a communication from frequently influencing people more
strongly and intensely, more diversely and persistently than the con-
tents of the communication. Sensations and ideas, feelings and
thoughts, commands and messages are considered, accepted, or re-
jected; media of expression, on the other hand, are often adopted
without thought and are used without proper account being taken of
them. Many people realized only after reading McLuhan the fact that
forms are parts of experiences, that they are the eyepiece which con-
ditions the colors of objects, and that they become—like the structure
of a windowpane—a part of the characteristic of the landscape which
extends beyond the window. It is to this perception, which was by no
means new and had already been presented by Ortega y Gasset,[46] that
McLuhan owes the greater part of his influence. The mottolike thesis
that the medium is the message is perhaps the best example of the
stylistic tricks which lend to even the most pertinent of his observations
a suspect sensational character. But no matter how much the value of
his statements is diminished by his coquettish formulation, McLuhan
would not come into his own if we were to deny how much he has
contributed to arousing people's consciousness to the fact that the
medium is not only the bearer, but also a constituent part, of the
message which has been communicated. For all the shortcomings of
his statements, he can claim to have pointed out more emphatically
than anyone before him the tension between spontaneity and conven-
tion and the dominance of existing forms and standardized media over
living and changing originality—even if he does it frequently in an
oddly wretched jargon.

Apart from the obvious importance of his statement that the message
is in part a product of the medium, McLuhan may also have thought
of the fact that the actual message of our time may consist not just of
the content but, on the contrary, of the diversity of the media at our
disposal and that these are often idling without communicating any-
thing because of their superfluity. We have a host of media of com-

munication which we do not know how to use; we are rich in techniques, instruments, vehicles of expression; but we have a poverty of ideas worthy of being communicated. The variety of materials which television (especially) treats—and this is McLuhan's special interest— arises from the ability of the medium to swallow everything that comes its way, but in no way from its ability to come to terms with the most important problems of the day.

McLuhan's doctrine of the "global village" agrees with the simultaneous narrowness and breadth of the media at our disposal. According to this, the earth, because of the lessening distances and social leveling out, appears to have become smaller and really to have shrunk to a "village." This metaphor expresses a daydream and at the same time a nightmare of contemporary man wrapped up on one hand in his democracy and on the other constantly afraid of loneliness. The "global village" has, however, as little in common with a village commune as the contact which television makes between people who live culturally and geographically apart and the old tribal community. It is indeed nothing but an equivocation when McLuhan represents the interest which unknown, alien people or exotic societies show in life— an interest which changes every half hour—as a sign of community or participation.[47]

The illusion of the global village is all in all a symptom of the same tendency toward regression which dominates the whole of McLuhan's criticism of culture. The desire to retire from the printed to the spoken word, the longing of the urban dweller for the village, the tendency to reduce the innumerable messages which are sent to us hourly to the relatively small number of media are only different forms of the same romantic nostalgia with which people mourned the passing of the spinning wheel when the textile industry was mechanized.

28 The Mass Media

The Best-Seller

The best-seller, with its widespread and transitory success, represents the prototype of artistic mass production. The large number of printings which follow one another in rapid succession expresses most obviously the tremendous commercial success of the products of the mass media. Works of serious literature, however, are not perhaps distinguished from best-sellers in that they need a longer time to achieve a similarly broad readership. There are works of the highest order which are never widely read. Quantity, which is one of the criteria of popularity, plays no decisive role in the determination of a classic.

The triviality of best-sellers is not only conditioned by mass productivity and readers' indiscriminate consumption nor by their readiness to accept deceptions and lies in their enjoyment of art, but rather by the fact that these lies are so obvious and naïve and the simulated goodness so perfect. Popular literature always tended toward triviality, but some of its works—until the emergence of the modern best-seller—could also be enjoyed by a more demanding reader. Since the coming of the best-seller, there are, as Sartre remarks, two completely different types of literature: bad literature which is unreadable, although in fact it is read a great deal, and good literature which is not read.[48] This means that the readers of good literature do not count for anything against the readers of best-sellers.

The best-seller satisfies needs, wishes, and hopes and completes the realization of idealistic demands which are never fulfilled in life. It acts as a surrogate for the actual solution of problems by circumventing the real difficulties. The goal pursued by the mass media consists in keeping at a distance or suppressing anything which might disturb the peace of its recipients. Unconscious urges which we do not wish to

know about threaten the peace of mind of the persons involved precisely because they are suppressed and represent a danger to them as long as they are not uncovered, not made conscious, and not recognized for what they are. Authentic art inspires us to attempt to clarify a reality which is often confused and to take up the fight against these secret dangers. The easy enjoyment of mass art offers cheap entertainment at the price of veiling the true problems and the pretence of a cheap happiness for which in the end we do have to pay heavily.

Best-sellers address themselves—like the mass media in general—to a public which reacts slowly and is for the most part passive. It is a public which permits artistic impressions to flow over it without contributing much of its own to the components of the experiences. It persists in a dull passivity which cannot resist emotion and lacks imagination—a sort of defenseless hypnosis. It is only in the reading of cheap novels that the passivity of the recipient is less evident than in the rest of the mass media. The comfort which the media offer to the consumer of their products remains unchanged, however. Films invite the public—by the constant availability of cinemas—to visit them; radio and television are at people's disposal at home; phonograph records are not only available to the possessor at all times but also arouse in him the feeling that he has to some extent become the possessor of the music itself. The best-seller lets us skip as many "uninteresting passages" as we like, without missing anything of importance. In the case of most of the mass media, like film, radio, and television, the public is passive as to both the reproduction and the reception. In the theater or the concert hall there is a dialectical interaction between cast and audience, executant and listener. The reception of productions not only is stimulating but also sets limits to the artistic products and gives them a direction which is to be followed by all the participants. Films, radio plays, and television offer themselves on the other hand as something ready-made without the listener's or the viewer's being able to have the slightest influence upon the shaping of the products.

Although the best-seller represents the prototype of the mass media, it is by no means the most widespread and popular form of art. The lower strata of the bourgeoisie and the working class as a whole read almost nothing but their newspapers, and the number of those who read books is negligible beside the number of cinemagoers and listeners and viewers. The best-seller presupposed whole series of motifs for the film, the radio, and the television; the mass public as a whole skipped literature and only got to know the most successful stories and figures of world literature in the derived forms of the mass media. The people who formerly made up this public only had the installments of Dickens—which they waited for so anxiously—read aloud to them;

today they would not even do that with corresponding literature. They would probably be capable of reading the novels themselves, but would doubtless prefer the more conveniently enjoyable film or television versions. Thus, artistic regression is expressed not only in the fact that popular literature of an earlier age—among whose representatives we can count Dickens—has given place to the best-sellers of Warwick Deeping or Margaret Kennedy, but also in the fact that the majority of the mass public is not a reading public at all. McLuhan may comfort himself with the thought that the new media are more than in a position to offer recompense for the loss, but up to the moment we have yet to find a "Dickens" among them. *Sorrell and Son* and *The Constant Nymph* proved in any case to be more successful bases for films than *David Copperfield* or *Oliver Twist*.

The public for best-sellers is just as unhomogeneous as that for popular literature or art. It is manifold and changeable as far as both its class composition and its historical development are concerned. The middle class, it is true, forms its nucleus and encompasses those elements who admit without embarrassment that they are readers of mass literature, but there are a number of shamefaced readers of trash and even more who take no account of the quality of what they are reading. Just like the lower cultural strata in general, most consumers of mass literature do not react especially to artistic quality as such, not to what is formally valuable or inferior, but to elements by which they feel themselves strengthened or threatened in their security. Best-sellers are generally filled with angst, the feeling of uncertainty and the desire for defense measures which the middle class develops in the face of the enemies which threaten it from above and below or which seem to threaten it. Behind its philanthropy, its helpless vulnerability and naive sentimentality are hidden irrational prejudices and anxiety complexes, aggressivity and desire for revenge, *ressentiment* and envy. Detective and gangster stories serve to dissipate a violence which finds a sublimated expression in the less socially threatened strata.

However great a part that which is unconscious plays in the consumption and effect of mass literature, its production usually takes place in the light of serene and untrammeled consciousness. The authors of best-sellers know their public and satisfy the often unworthy wishes of their readers with a clear conscience. They do not in any way need to fall below their own level in order to write successful kitsch. They have to be in possession of special, sometimes significant, auctorial abilities, but they may not believe that they would be in a position to produce something better if only they wanted to. It is true of them what is true at every level of artistic activity: you have to believe in the stuff you lay before people in order to be successful.

The Film

The decisive step on the road to the origins of the modern mass production of art came with the blending of the bourgeois middle class and the industrial workers as one cultural stratum and the participation of almost all classes in the film audience which filled the cinemas. For even if the film was not the first artistic genre in which broad circles took an interest, the people who approved of it represent for the first time a mass public in the present-day sense.

The film, however, did not develop, like for example the best-seller, from a form of popular art, but from an experimentation with a technical discovery which was completely alien to art. And at the beginning it was not an art for the masses, but found its first followers in those relatively eccentric circles which form an appreciative public for any sort of new trick. It in no way began with the ambition of being "art" pure and simple. The creators of the first films, groping blindly around, and the astonished onlookers had just as little or even less feeling that they were participating in an artistic process than the exponents of folk-art had when they sang their songs or decorated their utensils.

The first pictures which were produced and continuously projected by the technique of moving photography—which was discovered by chance—were not actually films, but merely small episodes from everyday life, short, mainly comic scenes or short-winded theatrical, or partly acrobatic, productions which had only one thing in common: "movement." A process which is photographed and projected onto a screen is still not a "film," for an artistic form is not the product of a mere medium, but of a dialectical relationship between a spontaneous intention and a substratum of the intended expression which is in a state of tension with it. The medium may be there earlier, not only as a form which derives from the dialectic already mentioned, but also as the artistic problem which leads to the dialectic. We have become accustomed in the development of art to taking our starting point from problems and to seeing the products as solutions to these problems. The history of the film now, however, points most imperatively to the fact that in art solutions can be found even when no problem is posed and that development does not necessarily lead from a problem to a new technique, but rather that it can also move in the opposite direction.

The film shows a certain similarity to folk-art insofar as there is less tension between quality and popularity in the film than in the general realm of art. As a result, a good film's chances of success are better from the beginning than they are for a successful novel or painting. With the exception of the film, every advanced form of art expresses

itself in a sort of secret language which is completely comprehensible only to the initiates. To learn it requires a tedious and laborious preparation which cannot be shortened and if once missed cannot be caught up with. The language of the film, however, could be learned effortlessly by the last generation without any special assumptions. Still, today it is in a certain sense common intellectual property, although the formally correct "filmic" mode of expression—especially since the film has been in competition with the theater—has always concentrated more upon specific avant-garde goals. The commercial film, on the other hand, suited itself to theatrical media so that the division which keeps connoisseurs and laymen apart in the other arts also began to split the film public in two. The idyllic harmony in which the film public had lived up to that time thus came to an end.

One of the advantages of a young art is that it can be universally comprehensible without being superficial. The understanding of a more progressive stage of development presupposes familiarity with earlier ones which are already overcome, even if they have not disappeared without a trace. The development and interpretation of modern art are linked to the separation of the moments of autonomous poetry and popular literature which were often indistinguishably linked to each other—of nonprogrammatic music and occasional music, mere decoration and the creatively visual representation of reality. The only form of art in which this dichotomy was scarcely perceptible—until the very latest developments—was the film. In no other art form would works which were artistically as progressive as the films of Chaplin, Eisenstein, Pudowkin, and René Clair have achieved audience success in such wide circles.

To understand an art properly means grasping the relationship of its formal components and those which make up the content and seeing immediately the way in which they merge. A work of art appears meaningless if its form has no function or appears to have been arbitrarily chosen. As long as an art is young and relatively free from tradition and reveals no fixed or rigid formulas, forms and content arouse the impression of a natural and unproblematical solidarity. They develop together or else there is a direct and apparently inevitable route from the thematic to the formal. On the other hand, it is significant that for every further artistic development the forms—while detaching themselves from the particular subject matter as independent and interchangeable structures—become more and more abstract and lacking in substance, so that they can eventually be understood and enjoyed only by the trained and experienced connoisseur. In the case of the film the development of the autonomy of forms has only just begun; the process of their alienation from motifs is, however, already under

way. As a result of this, here, too, we are dealing partly with a popular art which is dependent upon a mass public to support it and partly with an avant-garde elite art supported by a gradually decreasing circle of productive and receptive elements. In the main, however, the film develops into a mass medium whose technical and economic assumptions it bore within itself from the beginning. The methods of its production, reproduction, and distribution determined from the outset that it would take the form of a wholesale article and would become a model for the entertainment industry. It soon had all the means— word and picture, sound and color, unlimited human material and inexhaustible properties—at its disposal to measure up to the task.

Every form of art translates the picture of reality onto a particular level and reduces the complexity of experience to a more or less homogeneous form. Art achieves many of its profoundest effects by this indirectness of expression, while assuming in the recipient the ability to transpose his own experiences in accordance with the medium. The complexity of artistic structures and the profundity of the enjoyment of art rest, on one hand, upon the ability of the artist to express himself by indirect hints, on the other in the ability of the listener or spectator to fill out the elliptical expression. Film proves in this connection, too, to be the source of a particularly effortless entertainment suited to the masses. While art otherwise demands uncommonly intensive thought and imagination, the film contains per se the result of the act the recipient has to perform and leads the spectator from one complete idea to another. It has been called with justification a sort of *biblia pauperum,* "a picture book of life for those who cannot read."[49]

The assumption that a form of art at the present stage of its development—even if it is using essentially new media of expression—could start over again without precedents is untenable. The simplest story still borrows certain formulas from older literature. The film, the public for which consists mainly of the average level of the lower bourgeoisie, entertains today's cinemagoers mostly with yesterday's fictional subjects and stage effects. Film production owes its greatest commercial successes to the perception that the psychology of the petit bourgeois is the midpoint where the people of the masses meet. The sociopsychological category which corresponds to the petit bourgeois type in the sphere of art is far larger than the socioeconomic category which is its foundation. Apart from the middle class, it embraces fragments from above and below, elements, that is, which can attach themselves without reservation to the interests and aims of the middle classes everywhere except where they are actually fighting for their immediate existence, that is, above all in their apparently harmless entertainment. The mass public for the film is the product of this union, and the

commercial exploitation of the broad interest group which comes into being in this way depends upon the class responsible for the egalitarianism. The bourgeoisie all along took up a position midway between the opposing communities of interest. The bourgeoisie had voluntarily offered itself to the lower strata of the intelligentsia and the professions as a means of leveling out social antitheses, particularly since the rise of the new "middle class" with its army of "white collar workers," petty civil servants and private bureaucrats, traveling salesmen and clerks. Feeling itself threatened from both above and below, it was always ready to compromise and was more ready to give up the pursuit of its actual interests and opportunities than of its vain hopes and alleged opportunities. The middle bourgeoisie wanted to be part of the upper classes, although in fact it shared the fate of the lower strata, so that the film industry when making its production plans could rely confidently upon the obscure social consciousness and the disoriented feeling of solidarity of this class. The formula for a successful film could be based with certainty upon the superficial uncritical optimism which determined their feeling for life and upon their belief in the inconsequentiality of social antitheses, which permitted the worthy secretary to move from one social class to another by marrying the boss.

But the film is governed not only ideologically but also structurally by the principle of discontinuity, the juxtaposition of incongruent elements. Just like the whole of modern art which rejects the classical principles of unity, so the "filmic" form is based upon the juxtaposition and erratic juncture of antithetical realistic and imaginary, rational and irrational, temporal and spatial motifs. The structure of the film which develops in this way is expressed most obviously in the principle of montage. By the abrupt series of longer and shorter shots, the unpunctuated sequence of different points of view instead of continuous camera movements, the repeated change in point of view, the increasing and decreasing distance from the object and the continuously changing "planes"—the extreme long shot, the two shot, and the close-up—the film acquires its particular character, which can only be compared with the surrealistic montage and collage of the visual arts and the elliptical mode of expression in modern literature.

From moving photography as the origin of the film, the way to the art of the film as a creative interpretation of reality led through the use of the close-up by D. W. Griffith and the method of interpolation developed by the Russians—the so-called short cut. The frequent interruption of continuity in photographic movements was, of course, not discovered by them; what was new in their method was the continuous use of atomized montage pictures restricted to short moments

while expediently rejecting the interpolation of long shots aiming at orientation. The revolutionary significance of this technique did not consist at all in the brevity of the cut—that is to say, neither in the tempo and the rhythm nor in the accelerated sequence and the instantaneity of impressions which reached the very limits of perceptibility—but in the fact that it was no longer the phenomena of a homogeneous objective world but completely different existential elements which were being compared and linked together. Thus, Pudovkin [sic]* in *Battleship Potemkin* linked men with machines, arms with wheels, and sweating faces with red-hot boilers as the phenomena of two completely heterogeneous realities, a human world and a world of objects. His montage technique thus presupposed a view of the world which meant the denial of the autonomy of the realms of existence and rested ideologically upon historical materialism and the dialectic of history.

The fact that we are here dealing not simply with metaphors but, on the contrary, with equations—in the sense of antinomies—which condition and involve each other, and with confrontations which are not merely metaphorical but also concretely dialectical, became more evident when montage no longer showed both of the antagonistic phenomena, but only one of the two, and moreover, instead of the one which would be expected in the context of the process, the one which was dialectically opposed to it. Thus, Pudovkin in *The End of St. Petersburg* depicts the ruined power of the bourgeoisie by means of a rattling chandelier, or the innumerable authorities and the almost unattainable peak of the bureaucratic hierarchy by a steep flight of stairs which appears to be endless and which a tiny, helpless human figure is seen to be climbing. In Eisenstein's *Strike*, executions are represented by scenes in slaughter houses. Everywhere things take the place of ideas, things which reveal the ideological nature and the objectivization of ideas. No sociohistorical situation has ever found a more direct expression, even if as a result it is a more simple one, than the crisis of capitalism—and the Marxist philosophy of history, which is oriented toward it—did in this montage technique. A chest full of medals without a head signifies military imperialism; new solid military boots represent blind, brutal military power and the merciless war machine. However, the identification of the phenomena juxtaposed sometimes becomes so dead in the process that dialectic threatens to degenerate into an empty series of metaphors. Moreover, we must not forget that the photographic technique of the film with its interest in

*Translator's Note: This is obviously a *lapsus calami;* Eisenstein directed *Potemkin.*

detail and its preference for real props meets the materialism of the reflection of reality halfway. Yet it still remains questionable whether the whole technique of placing the props in the foreground is not itself the product of an already existing materialism rather than a process of conditioning such a materialism. For the historical coincidence of the birth of the art of the film and its dialectical montage with the exploration of the ideological nature of thought can no more be sheer coincidence than the fact that the first classicists in the art of the film who used montage were Russian.

However, the epoch-making novelty which changed the whole course not only of the film but of art in general consisted not in the technique of montage but in the use of changing points of view, shooting angles, distances, and standards in the reproduction of reality. And the origin of this instability was not the observation of ever newer and more exact aspects of the particular facts of a situation or process, that is, not the emphasis on a detail by enlarging it or by moving it from a long shot to a close-up, but the breaking up of the artistic unity which had previously seemed to form an indissoluble, closed, immanent totality and the cutting up of the work into relatively small, successive, and interchangeable elements. By using direct, unedited, nonartistic shots of *objets trouvés,* on the one hand, cinematic representation bridges the gap which otherwise divides the work of art from the reality of experience. On the other hand, by using the technique of montage—which serves to atomize the work—it creates distances between the individual parts of the work itself. A similar reversal of conditions also takes place in the relationship of the receptive subject to the work. The microcosmic character of an artistic structure generally no more permits the reader, listener, or beholder to become involved in the fictional process than it forbids the figures of an artistic fiction to enter into relationships beyond the work and change the point of view within the work—at least this was the case until the development of analytical cubism. Monet paints as many different pictures of the cathedral at Rheims as there are changes in the external conditions in which he views it. The restriction of a work of art to a single point of view is—as far as literature is concerned—no longer as exclusively the case as it was, and in drama especially it is the rule not only that the individual characters view themselves and the proceedings through eyes which correspond to their own being but also that the author and the audience identify with them by turns. The breach with the principle of immanence and of a frontality directed toward the recipient is the origin of the characteristic identification of the spectator with the different characters and motifs of the film—something which, when compared with the other arts, is completely new and peculiar.

This principle had previously prevented both penetration from outside into the works' closed system as well as alteration of conditions within the system by changing the standpoint of the observer.

The peculiarity of the filmic experience thus expresses itself not so much in the identification of the recipient with one or the other of the characters and fates themselves as it does in making the whole receptive process dynamic. It consists also in the impression that we move with the creator of the film and his instrument, that the processes are not brought to us but that we have to go all the time to the place where the events are taking place. The spectator in the theater sees the whole performance from one and the same aspect, from the same distance, and from the same point of view. He remains tied to his seat throughout the whole play and cannot see what is happening on the stage from different angles and from different perspectives. He also sees them in the course of an act or an unbroken scene only in one—"logical"—succession. The epochal significance of the film which opened a new era in art now consists in the fact that the receptive subject enters the inside of the work from the outside, constantly changes his identity, and removes the immanence of aesthetic objectivity. This mobility of the spectator certainly agrees with the atomization of artistic structures and is apparently connected with the surrealistic disintegration of the view of life in the era of late capitalism. The direct dependence upon capitalism for making filmic experiences dynamic as has been suggested[50] is based upon a mere equivocation and an unwarranted generalization.

While the basic element of one part of the arts is space and another time, that of the film is a particular combination of time and space. It is not without significance that the art of Oriental antiquity, in accordance with the Ancient East's static social structure and its traditional culture, was overwhelmingly concerned with space and that literature—as an art concerned with time—only comes into the foreground of development when Greek society became partially dynamic. The dynamic principle of culture finally developed so far that in the film the category of space itself resolves into time.

Time as an element of existence acquires more and more importance in the interpretation of individual and social processes from the beginning of Greek literature—and especially since the Greek Enlightenment—up to the evolutionism of the last century. The concept of the "struggle for existence" becomes central both in scientific and in sociological thinking; and in the victory of the stronger over the weaker, the drama of the struggle—which takes place in the medium of time—finds its culmination. The advocates of the rising classes, like Courbet and Zola, are optimistic as far as the outcome of the drama

is concerned, however pessimistically they may view the present in which they live. In contrast, spokesmen of the ruling classes, who are for the most part identical with successful authors, regard the future with fear and alarm. For the first time—in this historical perspective—time appears as a friend or foe. For Flaubert, Maupassant, the Goncourts, and their like it is the archenemy. Flaubert is absolutely obsessed with the disaster of time; everywhere it dominates, he sees decay and collapse. Time, which is running out and abdicating, is the actual theme of his novels. It is the principle upon which his characters wear themselves out and perish. In the process of their disappearance, time buries them in the hollow, monotonous, invariable succession of hours, days, and years. Flaubert's novels and practically all late naturalistic and impressionist novels revolve around the quiet erosion and consumption of life by time.

The idea of constant change and continuous shift of aspects, which dominates the impressionist feeling for time, is linked to the achievements of modern technology. The incessant and constantly accelerating replacement of old tools and articles by new ones leads to an indifference not only to their material but also to their spiritual possessions and hastens the usual changes both in fashion and in artistic taste. The tempo of technical advance permeates spiritual life with a stormy dynamic, and the impressionist experience of time—in all its restlessness and instability, its devaluating and revaluating effect—becomes the essential expression of a generation moved by the technological feeling for life.

Proust's concept of time, which characterizes most impressively late impressionist ideology and its transition to postimpressionism, at the same time expresses most dynamically the constantly changing perspective of experiences. However, although the domination of time reaches its high point in Proust's work, it already changes abruptly into its opposite. Memory, which in his view is also the essence of art, forms a defense against the depredations of time and the escape from its curse. We do not experience events in the Proustian sense if we actually participate in them—not in the time which is "lost"—but when we remember the past and "find time again."

With this revaluation of time, Proust departs from Flaubert and also from Bergson, whose philosophy was in part the inspiration for his departure from the Flaubertian conception of time. Already for Bergson time no longer represents the principle of dissolution and destruction. It signifies, on the contrary, "duration," the continued existence of the past in the present, and its penetration into the future. This idea of time is given a new meaning in the art and literature of the twentieth century, especially in the work of Proust. The emphasis which Bergson

laid upon the confluence of different periods of time and the fusion of temporal and spatial factors of experience is strengthened and the division between time and space which had been decisive from Lessing's time to the end of impressionism was basically negated. On the contrary, what is now emphasized is the simultaneity of these factors in the consciousness, their fluid limits, and the impossibility of determining accurately in which element we are actually moving. Proust presupposes certain aspects of later artistic development with his notion of the reciprocity of time and space: not only those in which past and present merge and form an indivisible unity or according to which the length and the dating of different personally experienced phases of time are relative to their content, but also the characteristic that time is absolutely relative to space. Certain places and points in time are just as closely bound up in our memory as the different occasions on which we had the feelings and thoughts and which we can no longer separate from one another. A place we remember means at once a moment in our lives and has no reality for us apart from this temporal coefficient. The memory of a point in time can again be so inseparably linked with a particular place that the spatial circumstances expel the temporal ones.

There is no form of art in which the interaction and unification of time and space are so impressive—and so decisive for the structure of a work—as in the film. The suitability of technical media to do justice to the spatial and temporal moments of experiences is so complete that we get the impression that especially the representation of time in the whole of modern art is conditioned by the film.

The concept of filmic time is rooted in the epochal consciousness of standing at a turning point in historical development. Man is today just as full of the importance of the present as he was of the afterlife in the Middle Ages or of a promising future in the Enlightenment. Everything which is actual or linked to the present moment is important to him. This explains the raised sensuality which has been acquired by simultaneity and by the significance of the concept of time which has been extended by the spatial moment. The consciousness that we are capable of experiencing so much that is different and contradictory and that so much that is similar is happening in parts of the world farthest removed from each other, in other words, the perception of an all-embracing expansion—not satisfied with any limit—is the origin of the new concept of time. This concept corresponds in modern art not only to the simultaneity of different moments but also to the erratic nature of their relationship and also explains the discontinuity of plot and the disintegration of characters. It is the loose relationship of elements beyond the erratic plot and contradictory

characters, that is, the elliptical development of arguments, the un-
heralded appearance, and the apparently arbitrary interpolation of new
motifs, the lack of unity and the incommensurability of measurements
of time, which recalls, in the works of Proust, Joyce, and other rep-
resentatives of the modern novel, the montage technique, the cuts,
leaps, and flashbacks of the film.

The most characteristic and significant aspect of the filmic medium
does not consist in the special quality of time which we encounter in
this genre but in the fluid limits between time and space and the
heterogeneous traits of the element, in which space acquires a quasi-
temporal character and time a partially spatial one. In the fine arts,
space remains, for the most part, timeless, stationary, unchangeable,
without aim or direction. The spectator moves freely within its limits,
for it is the same in all its parts and no area has per se a priority over
another. In literature, on the other hand—mainly in drama—time
manifests an emphatic tendency toward movement and has an objective
goal which is independent of the feeling for time which the reader or
spectator may have; it corresponds to the order of a straight-line series.
At least this was the state of affairs before the development of the
modern, postimpressionist concept of time and the decisive influence
of the film. The individual arts differed from one another mainly
through the predominance of one or another form of sensual perception
and the homogeneity of the aesthetic media which corresponded to
them. Today, after the triumph of the film and the subjection of the
arts to its leadership, this principle forfeits its significance. Space loses
its static character, its passivity, and its finality and acquires a char-
acteristic impelling dynamic. It becomes to a certain extent mobile and
changes itself, so to speak, in front of our eyes. Filmic space has its
own developmental history in stages which are not in the least similar
or equal in value. One stage represents a more primitive, the other a
more progressive stage of spatial orientation. The close-up, for ex-
ample, is a step in the temporal flow of the film; it demands a certain
preparation and a period of slackening off and of dying away.

Just as space is rendered dynamic and takes on temporal coefficients,
so temporal relations acquire spatial characteristics and reveal a more
or less extensive license in the sequence in which they are realized. The
spectator moves in the intervals in the film, just as we go from one
room to another and return to the first, in the process of which we
may spend more time in one and less in the other. Thus, time loses
not only its steady standard but also its unbroken continuity and its
irreversible direction. At one moment it seems to stand still, to go
backward, or to go forward, at another, certain of its phases are omitted
or repeated according to whether we use close-ups, flashbacks, or fade-

outs. Simultaneous happenings can appear after one another just as ones divided in time can appear simultaneously, that is to say, cut in or mixed. "You have to admit," was the reproach to one avant-garde film director who insisted on the autonomy of his medium, "that a film must have a beginning, a middle, and an end"—"Certainly," he replied, "but not necessarily in that order."

The technical means of interrupting the continuity of a scene at any moment and the ability to change at will the direction in which the camera is shooting, the standpoint, shooting-angle and distance, plan and perspective contain the key to the solution of one of the most important problems of filmic representation. This problem is the parallel, intermittent direction of a dual plot and the clear depiction not only of cross-references but also of dialectical relationships between the different motifs. Apart from the movement of the camera and the change in point of view, it is above all montage which—with its confrontation and intersection, change and overlapping of the elements of the work, its simultaneity and the antagonism of the sense contents and the emotional moments—serves this dialectical principle of composition. And the whole of modern art has a "filmic" effect because it strives to assert this dialectical method in the expression of contradictory feelings, thought, and ideas. Futurism, cubism, expressionism, and surrealism have at least one characteristic in common. They represent phenomena and experiences which are often widely separated in time and space as events which are taking place simultaneously and adjacently. The way in which in the same painting two different views of an object are shown—for example, the profile and the *en face* view— or how already in early cubist pictures one eye appears to be seen from the side and one from the front can already be seen as the introduction of the temporal element into spatial structure. Two different aspects within one and the same work represent a dynamic relationship, the indication of a tendency toward movement which leads from one view to another. Essentially we are dealing here with the abolition of Lessing's "fruitful moment," of the principle of that static visuality according to which movements can be depicted without the involvement of time. Simultaneity, as a fundamental principle of montage, mainly means in this sense a rejection of the naturalist-impressionist method, whose essence consisted in the reduction of moving phenomena to momentary impressions.

From the beginning of the Renaissance to the end of impressionism what was understood by pictorial representation was the restriction of artistic expression to purely visual components, the reproduction of exclusively optical impressions and the exclusive consideration of what the eye can comprehend in a single moment with a single glance.

Everything which is purely intellectual, not visual, or which appears at a point of time different from that of the representation, is excluded. In accordance with this visuality temporal phenomena had to be reduced to spatial categories in order to find a legitimate place in the fine arts. After the change in our sensual perception which took place with the film, time now becomes simultaneously the fourth dimension of space and leads—while seeming to change everything into its function—to the general dynamization of the visual arts in accordance with dialectical thought. In this way all moments of the presentation acquire a character which is, so to speak, historical or part of a process, and change their being into their becoming.

It is certainly not without significance that the film (this epoch-making, new artistic form which is the first essentially original one to be developed for millennia) developed in America, which is relatively free from traditions, and not in one of the homelands of the old arts which had become classical and exemplary. We would apparently have to free ourselves from the traditional forms which have become sanctioned by tradition and understanding and the supposedly timeless principles of unity in order to start all over again from the beginning. It seems just as significant that the next decisive step in the history of the film was taken in revolutionary Russia, which is, to some extent, separated from Western development.

Until the thirties, every element of progress in the history of the new medium meant a further removal from well-known and long cherished artistic principles of form. It was only the change which then took place—in the process of which a good part of the "cinematically faithful" art media were sacrificed—that there is a certain return to Western tradition. About 1940, representative films became more theatrical, that is to say, they were less ostentatiously filmic, if not necessarily antifilm. They remained forms which could not be replaced by any other and whose loss would be irreplaceable. While the artistically definitive films of the West—between 1940 and 1970—adapted themselves to the ruling surrealism and its resonance, they not only strengthened a tendency which suited their stylistic principles from the beginning, but at the same time flowed back into the riverbed of European artistic development from which they had branched out. The renunciation at this point of certain filmic forms which had previously been used did not necessarily mean that a good film threatened to become photographed theater, only that there is an attempt to avoid certain effects which are achieved by different points of view, different distances and tempi, maneuvering of the camera, changing of planes, montage, interpolations, retrogressions and flashbacks, tricks of copying and fade-in, fade-out, and mix.

The most important formal innovations which have taken place in film since 1930 were the results of the introduction of speech into what had been till then a silent medium. They represented an enhanced naturalism, simply because people who are acting and relating to each other in their doings are accustomed to talking and are seldom deaf mutes. Language, however, especially dialogue, could not be interrupted and broken up as often as the succession of shots by changing the point of view, changing distance, and cutting up the reel. Devices of this sort suddenly seemed artificial, forced, and mannered when linked to stable dialogue and came across—though they belonged to the indispensable vocabulary and to the inalienable syntactical models of the language of film—as being the more artistic the more sparingly they were used. The variety necessary for the optical animation of the film was now achieved by the utilization of different levels of the same space instead of by changing points of view, discontinuous montage, and the black arts of printing. Instead of the camera it was now the actors who moved, whereby the film lost a lot of its former trickery and gained as much in dramatic power and immediacy. The usage was seen most clearly in Orson Welles's *Citizen Kane* (1941),[51] a work which moved on much more solid ground, but which was by no means less dynamic and lovely than its restless predecessors.

While the new film technique claimed the whole depth of the set instead of always showing a part or an angle and directing attention to this detail, the spectator is now faced with the special problem of choosing the decisive moment for the understanding of what is going on. In the process it is no longer so easy to follow the development of the plot of a film and the intention of a director as it was before. The new technique at best makes things easier for reception insofar as it allows us to dispense with complex optical play, lateral or diagonal tracking of different attitudes, and the jumping backward and forward of montage. Today's leading directors tend to linger as long as possible on individual scenes and attitudes in order to preserve the continuity of what is happening in time and space. Actually, the understanding of their films is by no means easier than that of older, visually more erratic films. However, the difficulty does not perhaps lie in a more complex symbolism. The film is absolutely not a form which is particularly suited to symbolic expression. It is essentially a form of art which is true to nature and the symbolic references inside its realistic framework usually have a rather painful effect. It is the elliptical mode of expression, the incoherence of characters, the inconsequentiality of motivation, the atomized episodes—which are compiled additively—which in this, as in the other forms of modern art, make interpretation

difficult or cause us to avoid it and which point to the fascinating structural forms themselves.

The antisymbolic nature of the film is most apparent in a work like Michelangelo Antonioni's *Blow Up* (1967), which actually revolves around the thought that every interpretation of a striking picture, of a concrete situation, of an actual process is arbitrary, irrelevant, even misleading. A photograph, a visual reflection and representation, is first and foremost a picture and not a replica or a symbol, that is, it is what it seems to be and nothing more.

In the works of directors like Luchino Visconti, Roberto Rossellini, Federico Fellini, the Frenchmen Jean Cocteau, Robert Bresson, Alain Resnais, Jean-Luc Godard, even Ingmar Bergman with his tendency toward symbolism, visuality is the actual theme and not merely the medium of artistic expression. Even in a film as laden with content as Resnais's *Last Year at Marienbad*, the obvious picture is always more interesting than the abstract meaning, the psychology of the characters, or the labyrinth of the plot. The processes, spiritual motivations, and thought relationships are veiled and problematical; the situations, the photographic representation, and the individual shots, on the other hand, are exciting and remain in our memory.

Radio and Television

Radio and television developed into mass media par excellence. They are now the most widespread and favorite, even indispensable, media of entertainment and passing the time, in short, the stopgaps which permit us to forget that we do not know what to do with our leisure. Without them, life for most people would be almost unbearable, and there is actually—with the exception of certain rural dwellings—scarcely a household without a radio and, if possible, a television. They are suited to mass consumption not only because of the lack of discrimination in the amusement they offer, but also by their affordable prices.

Both media, in distinction to other forms of art, lack any trait of solemnity or peculiarity. Even the film maintains a certain distance from everyday routine with its need to be shown at a certain place and time. Radio and television programs take their part in the normal scheme of things with their unchanging schedules and their weekly serializations. We listen to the news at six or nine o'clock; on Monday we hear the news of the week in review, on Tuesday a concert, on Wednesday a travelogue, an interview with a famous singer, or at another time pop music, etc. Even the trimmings of the main course change according to an invariable menu.

Nevertheless, in all this we have to take into account two different forms of product which have different aims and which must be assessed differently: those which are devoted purely to information and teaching and those which serve entertainment or a supposedly artistic end. The two functions are not only distinguishable from one another but often antithetical. The didactic use of radio and television transmissions cannot be doubted, but their artistic value is often problematical, even if not always negligible. In any case it will not do to assume artistic worth because of their pedagogical value. Their charitable and artistic functions have even less to do with each other. They are a blessing for old, sick, and tired people even if the communal effect which people praise them for is a mere legend. On the contrary, they isolate people from one another, help them to form a cocoon with their set in their own solitary existence or in the most intimate circle of their family and surrender themselves to the stupid magic till, half asleep, they almost fall from their armchairs.

It could be argued that the film, in contrast to the theater, brings the spectator into the vicinity of the objects of his observation, instead of bringing events to him and leaving him sitting quietly in his seat. In this sense the film can be seen as a means of dynamicizing the recipient. In reality, however, something quite different is happening. The spectator also stays put in the cinema, and it is not he but the director, the cameraman, and the eye of the camera which move. After these are no longer present and have already left the scene of events, before reception has begun, the spectator is condemned to an even greater passivity than in the theater. In the theater he is able by his presence and his reaction to influence the actors decisively, however carefully the piece being performed has been rehearsed. The recipient of a radio or television transmission behaves, on the other hand, as a result of the absence not only of the actors but also of an actual more extensive audience, more passively than the spectator in the theater. He must from time to time feel that he and his set are on the often cited "desert island." Radio and television, however, do not create a community either among those who enjoy listening or viewing or among the viewer and the people whose suffering and trials he gets to see. Different transmissions follow one another with a mechanical rapidity and are commented upon with such a neutral journalistic objectivity that the viewer remains completely apathetic.

The fact that there is—in the theater—an incomparably more intimate, immediate, and significant relationship than there is in the cinema between projectionist and audience or, in the case of radio and television, between transmission and reception certainly does not mean that it is merely the physical presence of the actors which exerts the

idiosyncratic—otherwise unattainable—effect of the stage. The feeling of community which comes about in the theater links the members of the audience more strongly than it does the audience to the actors. The fact, however, that this feeling can be decisive when experiencing art in the theater or the concert hall but is lacking in the effect of a film or a radio or television transmission is finally explained by the difference between the living, always unique, process in the theater and the unchangeable automatically repeated offerings of the electronic media of communication.

The audience for the mass media differs from that of every other form of art above all in that it submits to the productions it sees rather than seeking them out. At any moment they have a relatively small choice of programs and all are more or less organized on the same principle, so that the critical listener who does not wish to see or hear them can do nothing but turn off his set.

The institution of radio and television is no more an independent organ of public opinion and the unrestricted vehicle of personal expression than, for example, the festival theater in Athens was a truly democratic forum for the expression of opinion. If the direction and the tone of the products of the mass media are not directly determined and supervised by the state, the government, or the political majority, then it is true that the ruling economic majority expresses its ideology indirectly and latently through them. True, it is part of the rules of the "liberal" game that "party political" broadcasts are open to both sides, but the administration of the moment has at its disposal innumerable ways and means of influencing the offerings in its own interests—just as the ruling class which is ideologically more or less analogous to it does.

In a society like the democratic liberal one of the present, we can of course scarcely speak of a cultural dictate or even of a plot which binds the representatives of conservative cultural policy and the conservative economic system. The thought of such a pact is just as absurd as the assumption that the leaders of the entertainment industry took upon themselves the task of deliberately lowering the standard of public taste and trained people to accept inferior products. Certainly, on their side nothing happens which educates the members of the mass audience to independent thought, understanding of art, and consciousness of personality; moreover, this is something which they could not readily achieve. For although it is apparently an easier task to operate with marionettes who have no will and do not think than it is with self-conscious and critical personalities, it is one of the characteristics of the masses that their members cease to be personalities as soon as they become part of the mass. The captains of industry concerned with

fabrication of best-sellers, films, and records are concerned from the outset with people of this sort, but to blame them for conducting a malignantly organized struggle against the maturity of their audience is a misunderstanding and overestimation of their business policies. They want first and foremost to earn money and are not always aware of the ideological mainsprings of their success.

Every conspiracy theory which tries to explain the agreement between mediately and immediately interested economic subjects includes the principle of denial or neglect of the doctrine of ideology. Those who are interested in the manipulation of cultural media use much more indirect and much less transparent methods to mislead their victims and reach their goals. Not only can the voices of criticism and protest be heard against direct attacks on the freedom of thought and of conscience perpetrated by radio and television, but the people themselves can no longer be caught so defenseless. But no matter what the state of affairs, the idea that by switching off his set the listener or viewer can protect himself from the danger is just as naive a simplification of the state of affairs as is the construction of a conspiracy by the entertainment industry against the maturity of the audience. Just as we make use of the fantastic idea of a secret society when in reality we are dealing with an ideological innervation in the effect of mass media so we are operating with the concept that the masses are suborned into thinking and acting according to the interests of an ideologically antithetical minority, and we fail to recognize that we simply do *not* turn off the set as soon as we have become accustomed to its voice, indeed, that we no longer notice that we are absorbing something which is unacceptable to us. All previous operations to which we have submitted play into the hands of the following ones, and every repetition favors the tendency to conformism and conservatism.

The thesis that the essence of mass art consists in the consumability and final exhaustion of its products is nowhere more apparent and drastic than in radio and television. Radio and television productions generally disappear once and for all after they have been broadcast. Insofar as the individual product is destined to be consumed and to lose its substance, it persists only in the contribution it makes toward making products of its nature into indispensable consumer goods.

Radio is a thoroughly ambivalent medium. Its ambivalence begins with the fact that its didactic value is just as indisputable as the nature of its artistic significance appears problematic. The simultaneous good and ill which it does is most clearly seen in music. We have radio to thank not only for acquainting large strata of the public with the works of great composers, but also, as Constant Lambert said, for the

"terrible popularity" of their music. Without radio it would be almost impossible to conceive of the present almost universal, though generally superficial, knowledge of the works of Mozart, Beethoven, Schubert, and Chopin. Yet however limited this is in itself, it has to compete with the popularity of the works of Tchaikovsky and Dvořák and has to accept—next to itself—the symphonies now of Sibelius and now of Mahler according to changing fashion.

The radio and the phonograph record, which has also become a mass medium, offer much more good music than the mass audience is in a position to enjoy properly. Forms of active music-making, dilettante strumming and fiddling, lay domestic and chamber music—no matter how primitive—brought a profitable harvest and led to an adequate reception's keeping pace in a salutary manner with the extent of the material to be received. But the mass media now relieve the listener of the responsibility for the great body of music which he hears and absorbs. However, they also take from him the means by which he can judge the suitability of his musical ear. The technical and aesthetic analysis of compositions which is offered to him on occasion in connection with their performance generally uses a language which he as a layman cannot understand. The musical education of the public by the radio is thus certainly inadequate, yet the performances which we hear in this way are qualitatively so much better than those of amateur music-making and adequate performances are so frequently repeated that the deficiencies of the medium are compensated for and often more than simply made good.

Of all the mass media, television has the greatest following and counts the greatest number of members of society among its audience, which, however, as a result of its heterogeneous composition and its fluid limits is the hardest to determine. The medium itself—which can be defined more exactly—represents the entertainment industry at the zenith of its material and often at the nadir of its intellectual productivity. Mostly it merely serves to kill useless free time. People who, in the evening or on Sunday, have nothing better to do sit down in front of their televisions and imagine that they are using their leisure pleasantly and at the same time usefully, or else they think nothing at all about it. Yet no matter how unconsciously, how much it is manipulated by others, and how ideologically mediated their interest may be, if they are addicted to the habit everywhere on earth day in and day out, there must be a real need at the basis of the practice. They obviously enjoy the feeling that the world is nicely packaged and can be obtained cheaply and effortlessly. It represents for them the triumph of technology over nature, the view of the *theatrum mundi* from their armchair, the participation of everyone in everything. The world in

miniature, however naive that may sound, is not an idea which is alien to art: every work of art attempts to achieve it. The chief charm of art consists in the reduction or the regression of artistic creation to this infantile wish-fulfillment, which at the same time represents the substitute satisfaction pure and simple for everything which is denied to us.

It is one of the most remarkable features of artistic representation that the limitations of usual experience which are linked to the idiosyncrasy of their particular medium so quickly lose their inadequate character and that its reflection of reality appears as a totality. The television viewer forgets in an instant that he is looking at tiny pictures instead of life-size figures; he does not notice at all the absurdity of the fact that little dolls are speaking in normal voices. The two-dimensionality of the screen and the depth of the space represented form an inner antithesis in all naturalistic painting. The principle of the "unities" of classical tragedy raise to the status of a rule the contradictions of stage representation which are inherent in the theatrical medium. Even the life-size figures on the cinema screen are flat, unsubstantial, two-dimensional shadows which disappear when touched by an invisible magic wand. The multiplication of artistic media in the framework of the individual media by no means reduces the distance between the material and the instrument by which reality is formed; it merely complicates their relationships. Just as the enrichment of optical effects by the addition of language in no way destroyed the artistic achievements of the silent film but merely substituted and extended, in part, acoustic for visual means of expression, so television, which is richer in sensual media, does not devalue radio. The two genres exist intact side by side in contrast to the silent and the talking picture. The multimedia means of expression is essentially neither more nor less valuable than one which is limited to a homogeneous means of expression. Number, extent, and form are aesthetically neutral or in any case factors of secondary importance.

The variety of artistic media in the electronic age which McLuhan praised marks not only achievements but also limitations in the ability to experience. Goethe's fear that the simultaneous employment of sight and sound in the theater could prove disadvantageous to "reflection" seems to a great extent well founded with respect to the multimedia form of expression and point of view of the television. The surmounting of the sensually narrowly determined medium of Gutenberg by the immediacy of the spoken word and the direct picture leads to a reduction rather than an extension of imaginative activity. In any case the victory of the television over the book, even over the theater, the cinema, and the radio, represents the triumph of idleness over liveliness

of the spirit when we allow ourselves to be carried off by a machine as if it were a vehicle.

The immediacy and the intensity of effect which is apparently concentrated upon the individual viewer is one of the most striking—but at the same time most difficult to explain—characteristics of television. Missing is not only the physical presence of the actor but also the stimulating uniqueness of the production from which the effect emanates. The deep involvement of the viewer in the productions and the feeling of finality with which he hangs on to them can only be explained by the constant proximity of the set, the intimacy of reception in his own home, and the narrow circle of participants in the reception. The large audience, the broad publicity, and the exalted ceremonial factors which elevate the effect of the theater to what is monumental and ritual are reversed, and the small familiar box produces in the narrow space of the home, sometimes without the society of others, an equally strong, but completely different, effect.

The products of the mass media are, it is true, always intended for a large number of consumers, but not necessarily for a public which attends the productions en masse. The public for television is much more comprehensive than that for the theater or even the cinema, but it consists of atomized receptive elements, and while there is generally a relatively large number of people present at a theater or a cinema, it is individuals or very small groups who sit in front of the television. Their mass character does not consist in their mass presence but in the fact that so many people, even if they are separate, participate in the process and put up with the same products. The narrow intellectual community of a theater audience is not of a depersonalized mass nature, but the millions who—dispersed but standardized—receive television programs form by and large an impersonal mass.

Television is, like the theater or the talking film, a partially visual, partially acoustic medium. McLuhan's assertion that it is essentially a haptic form of representation cannot be defended. The three-dimensional tactile impression is in no way stronger than, for instance, in the talking film and incomparably weaker than in the theater. The figures on the stage and the props are actually spatial phenomena; television pictures, on the other hand, are two-dimensional projections, and McLuhan's differentiation between "light on" of cinematic objects and "light through" of television phenomena is no more than a play upon words, that is, the arbitrary differentiation of two media which are both two-dimensional and in this sense of equal value.

In spite of the apparent intensification of depth and tangibility, McLuhan designates television as a cool medium which demands a high degree of creative participation on the part of its viewers. In spite

of its spatial limitation it is—as a medium—saturated, and its lack of value as an invitation to the viewer to participate creatively derives from the saturation of its forms with concrete sensual characteristics, so that the viewer has no problem left to solve. McLuhan is here presumably confusing the elliptical with the inadequate means of expression. That is to say, he is failing to recognize the fact that ellipsis inspires an intensification and profundity of reception which is seldom achieved in a presentation in which there are no gaps and almost never in one which is incomplete. An art which has at its disposal the means of expression it aspires to but which does not use them all seems to be inexhaustible and to inspire an ever deeper penetration into the unfathomed creations which do not wish to give up their secret. An art, however, which has fewer means of expression at its disposal than it needs blocks the path to participation and makes the possibility of a decisive interpretation questionable. The masking of contours is an annoyance in television as a consequence of technical inadequacy, whereas in art it is a valuable means of creating atmospheric effects.

The formal principles of television differ from those of the film first of all through the limitation of different points of view and camera angles, of montage effects and tricks of printing, the predominance of the close-up and the premier plane shot and the stricter preservation of continuity of time and place. In spite of these limitations, namely, of spatial depth, theatrical arrangement is just as consistently avoided as in the more undistorted film, so that in spite of the narrowness of the venue in which most short episodes take place, we never have the sense that the "fourth wall" of a stage is missing. Yet a television play is closer to a stage play than to a film.

One of the most important conditions for the birth of artistically successful television products is the avoidance of competition between picture and sound which still dominates the construction of the talking film. The spoken text on television is merely the basis of the visual form which has to be mastered, even if it is not at all neutral. It may not interfere, but may also not distract attention from the picture and concentrate upon itself. Television may replace reading but seldom inspires people to read. Scholars who make the investigation of this medium the basis of their research even maintain that the most faithful television viewers are the most reluctant readers.

29　Pop Art

Homogeneous and
Heterogeneous Characteristics

From both the productive and the receptive points of view, a new group has recently been added to the three groups according to which art, until recently, could traditionally be divided. This group has idiosyncratic demands and special standards of value—which were up to now unknown—which can be applied to the works to be created and judged. It not only is more heterogeneously constituted than any of the older ones but also obeys—in each of the different arts—principles of form which are more varied and harder to reconcile than those which we used to call classical, popular, or folk.

Alongside the familiar genres which were differentiated according to the cultural level of their advocates, "high art" of the cultural elite, "popular art" of the half-educated population of the cities, and "folk art" of the uneducated peasants, so-called pop art now appears as a new genre. The most striking difference between this and the forms of art which had formerly existed consists in the fact that while the producers and consumers of the individual arts had previously had a more or less unified cultural character, both the producers and the consumers of "pop art" differ in origin and education from one category to another. Poets and literary figures probably always constituted a category of their own; composers and painters or sculptors, on the other hand, as far as their social and cultural position was concerned were more closely linked than, for example, the representatives of pop music or pop painting are today. The producers and consumers of pop art represent, nevertheless, a fourth unique and especially comprehensible cultural stratum. They assume a place—with their artistic

needs and criteria of value—between the supporters of high art and the followers of popular art.

The lexical definition of "popular" as the quality which corresponds to the understanding, taste, and needs of wide strata of society is fully suited to the description of popular art. However, it is quite inadequate for what we understand by pop art and cannot be used for it. Popular art is the product of the entertainment industry, a consciously developed and carefully organized creation of entrepreneurs who finance its production and distribution, but as far as the intellect and mode of creation of the authors of individual works are concerned, it is simple and more naive than pop art, which owes its existence to a real cultural need and an expressed dissatisfaction with the dominance of the social elite. Popular art is depraved high art—sometimes unconsciously and unwillingly. Pop art on the other hand is the result of a cultural—even if politically generally unexplained or veiled—revolution. The moment of cultural criticism and of social purposefulness brings it closer to the cultural elite than to any other stratum. Yet it remains, certainly as far as music is concerned, mass art.

Popular art, which is merely intended for entertainment and relaxation, is conformist both ideologically and stylistically. Pop art, on the other hand, is loath to conform to the general rules of the game. It questions fundamentally the validity of all tradition, conventions, and norms. Its attitude of rejecting ideology, politics, and culture is apparent, but it is all the more difficult to determine what is positive about it. From the qualitative point of view, too, it is difficult to evaluate it in spite of the high level it reaches from time to time. For even if it is true that it expresses a situation which is critical stylistically and in need of renewal and that it exerts an influence which is felt at the very highest level of artistic practice, the qualitative value of most of its products is questionable.

However, it is not only difficult to relate pop art and popular art; the concept of pop art itself is by no means unequivocal and generally cannot be defined without further ado. The qualitative criteria, historical assumptions, and effects of the works are different in the various forms of art, in music, painting, and literature. Both the creators and the public for pop music and pop painting belong from the outset to different cultural strata and different social classes. The difference between them affects, above all, the individual relationship which they have at a given moment to amateurism. The more indispensable the preparation in a craft is for artistic activity, the smaller the role the amateur can play in it. In music this preparation is from the outset greater than it is in painting. A work of pop painting is, however, not

necessarily of greater value, more complex, and stylistically more definitive on this account than a pop music composition.

The relationship between productive and receptive elements, too, is generally different in pop art from what it is in the older forms of art. What comes closest to earlier conditions is the relationship in painting in which production and reception can have assumptions as different as they ever were. People looking at the works of a pop painter take no more significant part in the process of artistic experience than the recipient of the works of any of the old masters. The relationship is essentially different in the case of pop music, where the listeners are often the performers. The fusion and the occasional identity of the audience with the authors and performers of pop compositions reminds us of conditions in folk-art even if the conditions in the two areas are never sufficiently similar to be confused.

In all genres of pop art we can observe one phenomenon which corresponds to the loss of so-called painterly values in the fine arts. Pop music is mainly an art for dilettantes, and, no matter how talented these may occasionally be, neither their rhythmic, their harmonic, nor their melodic ideas demonstrate those signs of musical continuity which would be comparable to the connection of jazz—for all its originality—with the impressionist-expressionist heritage. In literature, so far as we can talk of a pop movement at all, the rejection of metaphor and symbol corresponds to the loss of painterly values. The texts of pop songs scarcely count as literature, and even elsewhere there are at most very scattered turns of phrase in literature which recall the style of pop painting or pop music. The simplest examples from the *nouveau roman* of which we might think are still too complex and too deeply rooted in older literature to be brought into line with the direct appeal of pop music or the simple registration of things in pop painting.

The group to which the producers and consumers of pop art belong lies between the disciples of high and popular art on one hand and between this and folk-art on the other. In common with the audience for popular art it has a need for undemanding entertainment, the acceptance of stimuli at second hand, and satisfaction with second-rate products, although it is capable of accepting stimuli from the area of high art. The spirit of communality binds them to the devotees of folk-art; this spirit is expressed in the lack of distance between authors, performers, and audience, and the impersonal, individually neutral, almost ritually stereotypical tone of expression.

The following for pop art consists of the most different social elements, who come, however, mainly from the lower strata and only to a small extent from the cultural elite. People have tried in vain to find the origin and the foundation of the movement in working class

artistic pretensions and criteria of taste. As far as fine art is concerned, the higher social and cultural level of the participants is evident. In music, on the other hand, where the devotees and supporters of the movement form an uncommonly diffuse group whose members are divided among the lower bourgeoisie, a mostly rootless and un-class-conscious proletariat, and a sort of *Bohème*—which can in some cases be economically very successful, but who, partly at least, lead a very precarious existence—the situation is much more complex. Alongside popular elements, professional avant-garde musicians—who even if they did not come from the cultural elite at least sympathized with them—early on attached themselves to the original pop musicians who at first showed no signs of being a special group. They were often of more than average ability and frequently pursued in a conscious and competent manner the technical achievements and the progressive tendencies of jazz—which transcended the late romantic style—with goals which lay beyond mere entertainment.

Pop art pursued and still, in general, does pursue no artistic goals. It is a revolt against the conventionally bourgeois way of life, a manifesto of nonconformism by unorthodox and rootless elements who wish to stand out and startle by virtue of their extravagance and who, especially in music, are "acting out" as the mouthpiece of the "wild youth" who are now ubiquitous. For all its antiromanticism, it is an uncommitted, emotional youth movement. What is romantic is its opposition to every norm and convention, its principle of arbitrariness and lack of restraint, its preference for tumult and noise just to raise hell. In view of its wide dissemination and its belonging to one generation, even if not because of its inner significance, it represents one of the most significant nonconformist youth movements since romanticism. Its participants, too, lead mostly just as questionable an existence, lacking in influence and responsibility, as most of the romantics, who were disillusioned by conditions after the revolution. Of course, we do not know exactly the proportions of the more or less questionable social elements in it. At pop performances we see masses of apparently unemployed young people in extravagant costumes or provocative rags with all sorts of exotic baubles and geegaws around their necks, and we can only ask ourselves where they get the means for this carnival masquerade. To which class do these jokers belong? Are they out-of-work proletarians? Are they bourgeois? Are they living off their parents? The stars who are extolled and the regularly employed television performers cause no problem. The most spoiled are even among the founders of that propertied class who owe their well-being to mass hypnosis into which every virtuoso, whether tennis or football

player, chess master or conductor, can be put by a public capable of enthusiasm and willing to pay.

In contrast to Dadaism, which always pointed a negative polemical knife at the throat of society, the present, and the establishment, pop painting takes real things as they are—even if with an ironic parodistic undertone. They may appear to be torn from their usual context, but they retain their realistic characteristics, which at best—as a result of the emphasis on their banality and their objectively stereotypical character—acquire an aggressive character.

In spite of its mockery of modern industrial society, pop painting represents with a certain gusto the "landscape" of the American city as the scenery of its mechanically created artifacts. It views this world of substitute means and props with fear and fascination. It is no longer a once familiar nature with fields and meadows, orchards and vegetable gardens, chicken roosts and workshops which surround us and nourish us, but a world of consumer goods which remains mute and alien. Nevertheless, we take up an ambivalent position with regard to this denaturalized reality in which service stations and billboards have become components of the landscape, and we discover in the dimensions and the number, in the precision and the cleanliness of their products, which pour out ceaselessly, something which we cannot do without and which is unalterable. Not only do we reconcile ourselves to and accept this denaturalized reality of consumer goods, but it becomes a second, indeed an actual, nature. The other one seems to have disappeared, to have become a myth. Thus, the mass products of mechanized industry, the stereotypical forms of all available goods, an economy directed only at increasing consumption, the dominance of competitive position and commercial propaganda, the prescribed formulas of needs and values, the increasing manipulation of life, and the directed nature of intellectual life become the motifs of the reality reflected by pop art.

Yet the ironical tone of the representations never allows us to forget that we are dealing not only with a simple acceptance but at the same time with a criticism of the alienation of present society, which reduces reality to mere goods. The urban environment becomes an object of painting, not in spite of, but because of its banality. Pop art rejects the self-satisfied sensibility of atmospheric painting, just as it does the emotional extravagance of jazz or salon music. Of course, it is only excessive sentimentality of the old sort which is despised; the dirges and laments of the pop singers have their own plaintive sentimentality.

Nevertheless, works of pop art no more owe their aesthetic value to the feelings they express than they do, for example, their historical role to the aesthetic values which they wish to present. Pop art is far

more a form of life than of art. The influence of the pop artist begins when he turns his back on the ivory tower. He carries on his business for pleasure, fun, or enjoyment. He transmits no lesson, no message, no creed. He is not committed, lacks responsibility, is hedonistic, and is as erotically concerned as he is aesthetically.

Pop Music

Pop music corresponds most completely to the concept which we generally have of pop art. This is above all on account of the cultural stratum upon which it is based, its loose relationship to both the naive folk and the audience for popular and high art, and the fact that it is not entirely independent of the artistic efforts of these audience groups. In many ways it is less complex, simpler in its melodic structure, more stereotypical in its rhythms and harmonies—in other ways, however, more ambitious and closer to classical criteria—than jazz. Its production and reception in no way assume the participation of exacting cultural strata, but do not exclude their participation in the disjointed artistic process which goes off in all directions.

Pop music, in spite of the anonymity of its producers and the spontaneity of its creation, the community and the fluid limits between author and audience, is no more a form of folk music than it is a variety of jazz. Both pop and jazz have their origins in light popular music, but they are often strongly influenced by the formal principles and the criteria of value of serious, authentic, and autonomous music. The talented creative artists who are technical masters of their instruments and the untalented, unoriginal dilettantes insufficiently prepared to practice their art are in both cases easily distinguished from one another, even if the distance between them is smaller in pop music. The individual, particularly ambitious pop musician often owes his inspiration—more profoundly than the jazz musician—on one hand to classical tradition and the avant-garde and on the other to popular music. On the whole, however, jazz is more closely connected to both of them than pop music is. Incomparably wider circles are involved in the production and performance of pop music than in the practice of jazz. Jazz exerted from the beginning a stronger influence on the development of advanced music than pop music did, even as represented by its best products.

Jazz, in spite of its origin in black music, is more original and, in spite of its perversion to standardized commercially exploited entertainment, more complex and differentiated than pop music. Neither of the two forms represents anything like folk-art. Pop music has, in spite of the collectivity of the artistic experience whose object it is,

nothing to do with the phenomenon of the folk community. Jazz, too, has irretrievably lost—in the course of its change to a popular, urban, localized commercial music—the folk character which it may have possessed in its beginnings.

The composers of pop music are, apart from exceptions like the Beatles, incomparable with jazz composers, as far as originality of structure, stylistic significance, and the rhythm, harmony, and timbre of their compositions. And if the influence of the classical tradition on the formation of pop music is not entirely lacking, the influence of this music on further, stylistically definitive, developments is in the main a negative one. It consists in the contribution it makes to the destruction of the barrier which until very recently separated art and practice, artistic form and vital function, even if the composers were most deeply committed. For no matter how much the creators of pop music may have studied their art, their aim of removing the barrier between immanence and ultraartistic reality is a symptom of the problematical nature of art as an activity which enhances life and explains the meaning of existence.

The Beatles, who have become the embodiment of the idea and the ideal of pop music, are neither folk singers nor aesthetic artists rooted in a historical tradition and standing in the van of an avant-garde development. They take their raw material where they find it, namely, everywhere on the road from the romantic art song to Negro spirituals, but their songs are just as incommensurate with the songs of Schubert as they are with the blues of the American blacks. If they prove to be—as is the case with their models—not particularly fastidious, their avant-gardism is equally unequivocal and undirected. They stick mainly to the well-tried clichés of old variety songs, rock and roll, and their own hits. Their rhythm remains stereotypical even if it is less monotonous than most pop musicians'; their harmony reveals new characteristics, but these are by no means revolutionary; and their melodies are, it is true, richer but just as flattering to the ear as popular light music. Harmonic and coloristic effects are often of secondary significance in relation to melodic ones or are subordinated to the rhythmically and dynamically insistent effect which underlines the quasi-ritualistic impression of pop music as a mass medium.

It has rightly been pointed out that we listen to the songs of the Beatles with the same enthusiasm and the same assumptions as Dickens's own mixed audience listened—in its day—to the readings of his novels. Not only the interest of the average audience, but also the partly negative and partly positive attitude of the higher cultural strata may be the same in both cases. In spite of this similarity and their popularity, the Beatles seem to have as good as nothing in common

with Dickens. Even the assertion that the novel in Dickens's time played just as questionable a role as pop music does today[52] is an untenable one. On the contrary—apart from the fact that he was part of the favorite reading of many educated people—he already had a long and respectable past behind him and was by no means one of the most modern artistic phenomena, let alone the most tentative manifestation of the avant-garde.

Pop and beat music, on the other hand, shares with the modern avant-garde—in spite of the sentimentality into which it lapses—a deep aversion to the cheap sentimentality of romanticism. It is, however, all in all, just as much opposed to the academism of nonfunctional music as it is to the functionalism of commercial music and, as a typical youth movement, is imbued with romantic tendencies. Moreover, it is not only the demonstrative subjectiveness and sweetness of its melismata which is romantic, but also the hysterical shouts and the exhibitionist passion of its singers, the ecstatic roar and convulsions of the audience which takes part in the uproar, in a word, the whole excess of the process, which in the end has less to do with romantic rapture than with the violence and unruliness which is connected with all areas of modern life. The generation factor cannot be ignored in our evaluation of the effect of pop music. Of course, its audience embraces almost all social strata and age-groups but is obviously dominated by teenagers. For them the Beatles—with their liberalistic even anarchistic morality, their shrieking talent and urge to dominate, their apparently easy triumph which means "honor, power, and woman's love"—embody a spiritual and a physical ideal. Pop music performances have been described, with some justification, as mass masturbation and are certainly full of exhibitionist and regressive characteristics.

The beginnings of pop music—which go back to the middle of the 1950s—with its expressionism and exhibitionism, the brutality of its effects, its assault upon the audience, and the problematic and often degenerate existence of its adherents were the results of the social situation in which postwar youth found itself. Family ties were loosened for wide circles of the lower bourgeoisie and the working class. A considerable part of the younger members of the armed forces who had been demobilized were not prepared to meet the demands of a regulated civil existence; for most of them war had been a school of violence and anarchy and for all of them a warning to remain conscious of the destruction which in the given circumstances awaited the world. The nihilism of a generation fitted out in this way also of course left its traces in the music of these young, headstrong people.

Between 1957 and 1961 nothing remarkable happened in the area of popular music apart from the collapse of jazz. Rock and roll became

more and more tame, lost its vehemence, and tended gradually to become pretty and agreeable. It was not until after 1963 that the Beatles became fashionable. After a few years they also forfeited the reputation of their magic powers and had to be content with a more modest role in the youth movement. At the time of the student unrest in 1968 it was already clear that the representatives of pop art were uninterested and disoriented.

The feeling of community and the consciousness of belonging which people thought they could connect with the pop art movement are certainly expressed relatively most strongly in music—more than in any of the other forms of art. It is only here that the emotional congeniality of the participants calls to mind the effect of magic rituals. Nevertheless, we are dealing with the mere pretense of a community, for the social background which corresponds to it is a fictional one. The ritual magical character to which the well-meaning, but all too credulous, panegyrists of pop music refer proves on closer inspection to be mere fetishism and myth building. The production and reception of pop music may have the appearance of a ritual act, but in reality it has nothing to do with an archaic ceremonial of this sort.

Pop Painting

In spite of the fairly close connection of its representatives with the cultural elite, pop painting gets its name because of the banality and triviality of its subject matter (of the origin of its motifs in the world of standardized industrial economy), but chiefly because of the simplification of its representations—by neglecting idiosyncratic painterly values, graduated color tones, and atmospheric effects—its improvised line drawing, and the individual brush stroke. The feeling of oppression and alienation, of irony and derision with which pop painting represents the lifeless and concrete products of the modern city is most strongly expressed in this cold impersonal tone. The mass production of stereotypical household articles and tools, of means of transportation and bathroom fittings, of canned goods and nylon stockings, of placards and illustrated magazines has changed the world into a wilderness in which mankind—deceived as to its real needs and moved by sado-masochistic desires—leads its existence. The mockery with which pop painting views this changed world gives it its character of protest and opposition, which is either mitigated or completely lacking in the other forms of pop art. Nevertheless, it often makes an entertaining and comic impression and creates a friendly, happy atmosphere which permits us to conjecture that political opposition and social criticism do not penetrate all that deeply and that, in spite of everything, people

somehow feel at home in this multicolored, harsh, loud, and turbulent world, even if they have a bad conscience about it.

The art critic Lawrence Alloway who coined the term "pop art"[53] used the name to describe the products of mass art in the media of advertising, of illustrated magazines, of film and dance music. The term was, according to its definition, least applicable to pop painting. Alloway was already aware of the antithesis between pop art and popular art, but saw it as one between earlier folk-art—for example, the decoration of inns, fairground booths, and similar works, variety songs, and trashy literature—which was for and by the people in the narrower sense and pop art created for the people in the broadest sense by trained professional artists. Even if this fiction could not be sustained for long, it is incomprehensible how it could ever have arisen. For as simple and crude as the motifs of pop art may be, only the spectator's understanding of their ironic significance, that is, only where there is a developed critical sense, could they be artistically effective—just because of their banality and primitive nature.

The pop art of Roy Lichtenstein, Andy Warhol, and Robert Rauschenberg does, in any case, contain more elements which can please a public which thinks according to the values of high art than pop music does. This is essentially more popular, uses more naive, more spontaneous, and usually more brutal effects than pop painting, which is not completely emancipated from the traditional principles of cultured taste even if it is just as radically involved in cleaning up-impressionistic tricks. What is "painterly" in atmospheric moods, the play with broken colors and blurred contours, the sensual attraction of the spot of color, and the brush stroke lose, it is true, their artistic value; but it is not "natural sounds" which take its place but only visually less differentiated moments. The simplification of drawing, coloration, and structure in no way means that pop painting can be seen as "art" by the naive viewer or is better understood than painting of a more differentiated sort. Its artistic quality remains unrecognized, while pop music is felt by the naive listener to be essentially the same as classical music, quite apart from whether he is, or is not, aware of the difference in values.

Pop art denies the autonomy and immanence of the individual work. The picture of a girl in a swimming costume by Roy Lichtenstein shows no more individual traits than Andy Warhol's cans. Their simple unequivocality and formulaic nature, their sharp outlines and monotones, their schematic drawing and composition—which lacks any tension—everything about them contradicts the individuality of the work of art in general and points to its reproducibility in this particular case. The personality of an artist like Lichtenstein may be unmistakable

and recognizable in all his works; every one of these works is, however, conceivable in an infinite number of examples and antithetical to the idea of what is individual and unique. The appearance of individuality is not lost in this case—as, for example, in the case of the graphic arts—as a result of mechanical reproduction, but by the placardlike technique and the oversimplified and outsized forms which work as eye-catchers rather than sources of visual pleasure.

The depersonalized manner of expression, the neutralization of the "handwriting," the imitation of industrial methods of production, the representation of experiences gained at second hand, the flatness and lack of substance of the objects represented, everything contributes toward giving even figural motifs an abstract character. The result is an apparently mechanically produced mass article, no matter what the actual number of copies produced is.

Pop painting thus is not only commercial in spirit like the other forms of pop art, but also uses the techniques of the commercial media, placards, magazine illustrations, and newspaper advertisements. Of course, the impressionists also found a source of inspiration in mechanically reproduced graphic art and in photography, and Daumier—with his lithographic technique—really created the prototype of pop painting. But while the graphic arts are still oriented toward the phenomena of reality, pop painting does not depend upon the impressing of actual articles but on their schematicized representation in media of commercial advertising, which are generally artistically neutral. Its distance from concrete reality is a double one. It attempts to reflect the picture presented by commercial advertising—which is poor in true-to-life characteristics—of the consumer goods with which urban life is filled and thus removes itself even further from the objective world. Instead of immediate reproductions, it consists of quotations from a text which already represents the material of reality as translated into artifacts. We can see in this second-hand retreat from the original data just as many signs of a fear of coming into contact with natural reality as of the expression of the perception that nothing is left for us of the originality and immediacy of nature.

A work of pop painting is in the best case a good and, in a certain sense, an artistically more or less interesting production of a banal artifact. By means of this "interestingness," a sort of artistic quality may be created. As a result of the lack of interest of the medium in humanistic values and its lack of concern for—indeed, its ostentatious rejection of—treating them as important, pop painting assumes the form of an antiart, a neo-Dada. The fortuitousness in the choice of the motifs to be represented is like the principle of collage and photomontage. The justification of the claim of the developing antiart to be

treated as art is based on the assumed legal right to call everything art which calls itself art. In the form of assemblage, pop art loses the last remains of the homogeneity which is otherwise peculiar to the fine arts when it gives up two-dimensionality. It becomes a sort of super-Dada. In "happenings," the artistic product loses even its structural character and asks only to be understood as a process. Its ontological being is resolved into pure becoming.

Dadaism was originally an anarchistic movement with a predominantly nihilistic cultural tendency, but also with a strong political undertone. It fought as a product of the postwar bourgeoisie the culture the value of which it denied. While making the freedom from traditional artistic motifs into a principle, it wanted to free itself from the conventions of bourgeois society. Pop painting denies the mechanized and standardized character of bourgeois civilization just as decisively, but without letting the political point of the movement come to the forefront and, falling into a total nihilism in the face of the products of the system, excites suspicion. It accepts its forms as the elements of a milieu in which we do not necessarily take delight, but which must be accepted because there is no alternative.

Part Six The End of Art?

30 Concepts of the Demise of Art

This is by no means the first time that people have talked about the end of art as something in the immediate future or, indeed, as something which has already begun. The difference is that up to now people were thinking of the end of a certain period, movement, or function of art, of one of its heydays or otherwise decisive epochs. It is only since Hegel that we have begun to talk about the collapse of art as a part and a symptom of total cultural development which has apparently come to an end. At the moment, it is, however, a question neither of a mere change in style or taste nor of the end of the history of art. The present doubt about the continued existence of art is connected rather with the excessive emphasis on civilization's nonartistic productivity. What we understand by the end of art is its failure compared with the extent of scientific achievements. A threat to art and an indication of its dissolution is seen in the fact that it would prove useless and valueless in our scientific and technological age.

What we have to understand by "the end of art" of which people are now talking is a point in time, like, for example, that at the end of the classical-romantic phase of Western literature, when masterpieces lost their definitive meaning for the further development of art. It is in no sense a turning point in time after which no further works of consequence can be expected. If we judge the break in which we now find ourselves to be an unbridgeable gap, we are ascribing the measure of a crisis to the catastrophe. We can hardly assert this about a period when we have a fruitful, even if problematical, period of art, as we do today. In any case, however, the feeling that we have reached the end of an epochal development in art gives the most recent practice of art a special significance, although it does not have an unprecedented

657

significance if we consider the changes in forms of life and art which have been survived—for example, in the Neolithic age or at the time of the birth of Christianity. A similar feeling of derailment and instability can be found at the beginning of romanticism. However, the collapse of classicism—in spite of the radical devaluation of former criteria of taste and principles of style—did not call the further existence of art so much into question as the discontinuity of development at the time of mannerism did. The situation was even more acute at the time of the change from the Old to the New Stone Age or of classical antiquity to Christianity.

The paradoxical view which is so characteristic of the modern view of art, that everything is art which counts itself as art, can just as easily be the end of art or the beginning of a completely new idea of what constitutes what is "artistic." Because of the lack of its once unequivocal criteria and as a result of the loss of the reciprocal functionality of artistic structures, art has become indefinable. We have not only lost the measure by which its practical and humanistic value can be judged; it has also become questionable to what extent we are dealing in art with reality and fiction, with realistic ideas and directions, or with mere formal—verbal, musical, and line—structures. If need be, like McLuhan we identify the messages which are to be transmitted with the media of communication and imagine that we are talking about art when we are merely talking about principles of form, tropes, spatial relationships, rhythms, harmonies, colors, and tones. We hardly ever mention what makes an artifact into a work of art or a dabbler into an artist.

The authentic communication of a view of the world, an ideology, and a message by means of art has become so dubious that the artists themselves are often the most ready to renounce the claim to be artists. Yet the successful communication of an ideology or a message is often independent of the means and the process which the artist uses and of the ideas with which he goes about forming his work or which he has about its effect. As the individual, concretely determined talent which expresses itself in vivid forms, he remains the responsible creator of his works, no matter what he thinks about his acts of omission and commission, and the time when he functions may be a period of the greatest artistic significance, no matter how problematic the function of art as a whole may be in the culture of a given time. Iconoclastic periods of history may produce works of art of a higher order than epochs whose aims and values are governed entirely by aesthetic principles.

Byzantine iconoclasm reminds us most emphatically that antiartistic intentions do not have to have antiaesthetic motives. Even a movement

like Dadaism, which was expressly opposed to art and whose aggressiveness exceeds all previous movements of this sort, can still be characterized as aesthetic. The dominating view of art of the moment is opposed to the aestheticism of the last century and of the fin de siècle, but is nevertheless connected with the depersonalized, mechanically conceived "technical reproducibility" of works in Walter Benjamin's sense. The moment of undifferentiated repetition which obliterates personal characteristics is by no means new. Mechanical elements of this sort were peculiar to art from the beginning because the production of works of art was always associated with the use of tools and the adherence to more or less invariable processes which resisted creative stimuli. The similarity of reproductions of a prototype constantly increased as techniques developed, but the recent use of machine tools shows a progressive leap in the profitability of the process which is partially intellectually and partially materially conditioned. The material-mechanical component was never in a position, and will scarcely ever be, to displace the spontaneous spiritual one. However, as long as reciprocity of these factors continues, we can only talk of the end of art in a figurative sense—whatever doubts we may have about its timeliness and expediency.

The negative effect of the dialectic between stimulus to artistic expression and its outer substratum (that is, on one side, the alienation of the work of art from the artist, on the other, that of the artist from the reality to be represented and from himself) in any case starts to be unmistakable when artistic structures are mechanically reproduced. Previously, "alienation" merely meant the objectification of consciousness in the Hegelian sense; now it means the emancipation of the products as "goods" from the producer—as the protagonist of depersonalized production with division of labor. The "end of art" would in contrast mean extreme alienation, which would completely nullify the aesthetic effect, a development which is inconceivable within the continuity of the existing cultural period.

Art's time is only past when we cease to think not only about the possibility of solving artistic problems but about the problems at all. Its end is expressed in the failure of its social function. It can neither order itself to be condemned to collapse nor announce it: if it does so, it still exists. The criterion of its collapse is its lack of function. The birth of Christianity seemed to have introduced such a situation, but the change which took place with the collapse of classical antiquity consisted entirely in the fact that art found a new calling and significance—in the service of the Christian creed and ecclesiastical authority—to replace its shrinking secular tasks. And just as at that time it found a new source of life while its former practical function

atrophied, so the beginning of the modern period and the crisis connected with it feeds, in a more and more objective and almost entirely utilitarian world, on increasing leisure and on the apparent lack of function and the sportive excess of its products.[1]

Yet even if such a crisis does not necessarily have to result in the end of art, it does not mean that cannot be the result. Every prognosis with regard to historical happenings of this sort rests upon questionable assumptions. What we can say, with some certainty, is merely that the function and, thus, the form of art hardly ever remain unchanged in a changing society. But however incisive the social changes may be, art can continue, though in a changed form, and preserve the connection with its traditional forms. Just as Hegel's prophesy of the collapse of art originated in the experience of postrevolutionary events and their expression in romanticism, so present-day fears that art could be coming to an end have their origin in two world wars, their conditions, and their consequences. But the most abstruse and presumptuous examples of the practice which we are accustomed to call antiart still belong to that development the artistic legitimacy of which—however inadequate—is unquestionable.

31 Presuppositions of Present-Day Art

Ideological Conditions

The concept of modernity has fluid boundaries. We ought therefore to determine more exactly the actual beginning of the period the limits of which do not completely agree with conventional chronology. There would, in the process, be a considerable number of questions to be asked. Where is the break which divides today's avant-garde from the progressive artistic trends of the previous century? What sort of movements were already under way? What was it about it which from the beginning was so unexpected and alienating? Which of its characteristics fit into the continuity of the development of art, and where are the discontinuities in the succession of its phases? In other words, how far was the turn toward today's predominant artistic tendencies prepared for stylistically and culturally, and how is it that today's art is still connected with the epochal breakthrough at the beginning of the century?

The howls about the supposed "end of art" have their origin in the ideology of the upper class, in spite of the fact that most of the people who proclaim it are artists who are led by the nose from above and are unaware of their own situation. Political conservatism tends from the outset to relate advanced art immediately to social progress and to condemn it to being unsuccessful. Of course, there is a relationship between social and artistic progress, but it is a dialectical one, that is to say, it is by no means so direct, unambiguous, and consistent as the ideology of the conservative social strata would like it to be. The cultural principles of the classes who dominate society and who cling tenaciously to their dominance are not all equally static, traditional, and conventionally directed, and the underprivileged classes are never as dynamic, brave, and experimental as we might expect.

661

As the period of modern art, the twentieth century really begins after the First World War—around the twenties—just as the nineteenth century began around 1830. The war acts as a turning point in the development which is taking place only in that it affords us a choice between possibilities already available and created by phenomena of the prewar period—capitalism, haute bourgeoisie, late impressionism—and the possibilities which are created by reaction to them. The main trends in modern art have their origins in the expressionism of the turbulent art of van Gogh, Munch, and Strindberg which rejected inwardness of impressions, in the formal rigor of Cézanne and Seurat, in the almost surrealistic metaphors of Rimbaud and Mallarmé, in the cubism of the young Picasso and Braque, and in the abstract formal structures of Kandinsky and Klee. The almost unbroken continuity of artistic development after this corresponds by and large to the stability of contemporary economic and social circumstances.

Up to about 1914 only the socialists talk of the collapse of capitalism. In the ruling strata of society, people may be aware of the danger threatening from beneath, but they believe neither in the "inner contradictions" of the system nor in the insurmountability of its crises. It is only in the thirties that we hear on all sides about the failure of the competitive economy of parliamentary democracy and of the liberal rule of law, and the inevitability of a revolutionary change in conditions. And there is no social class in which people are as conscious of the critical state of bourgeois existence as among the bourgeoisie themselves. The precursors of fascist and communist dictatorship agree with one another in viewing the democratic bourgeoisie as a corpse which is only awaiting burial. The intelligentsia for the most part take a position on the side of the authorities, demand order and discipline, are enthusiastic about a new church, a new scholasticism, and a new Byzantium. They preach, on one hand, unconditional, indisputable, unforgettable values and wish to divest themselves of all responsibility connected with any form of rationalism and individualism, but hope on the other by mystifying the communal idea—of course, under the dictatorship of the social elite—to make contact again with the society from which they have alienated themselves.

For its part, the liberal bourgeoisie, while trying to take account of the precarious situation in which it finds itself, emphasizes the common traits of dictatorship so that they will be mutually compromised. It represents the extreme political creeds and the attitudes which correspond to them as mere "techniques" whose functioning depends on the sheer authority—and not on the right or worth—of their administrators, of the engineers of social machinery, and of the manipulators of public opinion. But whatever the nature of these techniques, no

ruler any longer dares to admit that he has anything but everyone's welfare in mind when he makes his demands and decrees. In this sense we find ourselves really in the domain of a social order in whose sway the masses are involved, at least to the extent that people have to take the trouble to mislead them.

For the currently dominating philosophy of history and criticism of culture, nothing is more significant than that we feel the need to relate the crisis which has taken place and which threatens to become fatal to decadence and to the "revolution of the masses." We do this whether we stand on the Right or the Left and whether we are idealists or positivists, spiritualists or materialists. Symptoms of discontinuity between the two successive centuries begin to become ever more recognizable in spite of the apparently unbroken development. The reaction against the past reveals itself in art most sharply as the rejection of impressionism, in which crisis the approaching end of naturalism—which had dominated since the end of the Renaissance—becomes evident. The task of complying with the character of empirical reality was never questioned in Western art since the end of the Middle Ages, in spite of the constant swing of the art historical pendulum between formalistic and antiformalistic tendencies. The postimpressionists were the first to reject the earlier illusion of reality and express their view of the world by a conscious and often strongly emphasized deformation of natural phenomena. Futurism, expressionism, Dadaism, cubism, and surrealism from the beginning and with the same determination oppose the impressionists, who affirm nature and who are tied to reality. In spite of the difference in their artistic urge, even Chagall, Kandinsky and Klee, Braque and Picasso, or Henri Rousseau and Max Ernst always leave us with the feeling that we are in a supernatural sphere, a sort of superworld where we lead a double existence and which—for all its characteristics taken from ordinary reality—has a character which is not congruous with this world.

What is antiimpressionistic in these new artistic movements is—apart from the tension which still exists toward the principle of closeness to nature and truth to life—especially the trait that their products are fundamentally "ugly" and that they usually reject the harmony, the exuberance of line, and the colorfulness of older art in an ostentatious manner. They often betray even an anxious flight from everything which is merely decorative and pleasing. The clear and cold tone of Debussy's music, which is directed against late German romanticism, and the strict and rigid structure of the pictures of the later Cézanne and Seurat are enhanced in the work of Stravinsky, Schönberg, and Hindemith, on one hand, and in cubism, on the other. They develop into an outspoken antiespressivo, which no longer seems to have any

connection with romanticism and its offshoots. The struggle against the sensual, hedonistic feeling for life of a generation which still imagines it has the same security is expressed in the same rigorous way—devoid of changes of mood—in the dark, oppressive, and tortured tone of the works of Camus, Kafka, and Joyce. The final renunciation of the romantic naturalist tradition which collapsed with the general mood of crisis, the convulsion of the bourgeois capitalist regime, the consciousness of the senselessness of the sacrifices of the First World War, and the increasing desperation about its effects came through the works of the Dadaists. "People had lost hope," said Marcel Janco in their name, "in a more equitable condition of existence in our society. Those among us who consciously recognized this problem felt the weight of an enormous responsibility. We were beside ourselves over the suffering and degradation of mankind."[2]

In contrast to Dadaism—which represented a phenomenon of the war, was mainly a protest against the conditions which led to it, and was therefore far removed from art in the traditional sense of the word—the new movements in art received valuable inspiration and gradually expanded the previously restricted area of what is artistic. Nevertheless, the new movements struck to the end an essentially negative note, something they inherited from Dadaism. In this way they not only marked an irreconcilable turning point in the continuity of stylistic development, but also represented a deep-seated and long-lasting breach with the past which was unprecedented even in the history of the most intransigent iconoclasts. Just as expressionism, cubism, and the abstract painting of the twenties had their origin in the negation of the fin de siècle, so the later forms of abstract expressionism and early surrealism, of the depersonalized *nouveau roman*, of epic and absurd theater, and of atonal music, the twelve-tone scale, and serial technique, continued every sort of stimuli which they had received under negative signs. Painting becomes an art without "painterly values," music a conglomeration of noises and electronic sound effects which are sensually almost impossible to perceive, the epic genre becomes the antinovel and the rationally thinking and emotionally unambiguously involved person the *homo absurdus*. Language as the vehicle of expression pure and simple becomes a mere stammering, if not a sheer failure of words and a stolid silence; art becomes pure antiart.

Everything which was left of art in the authentic sense is filled with a foreboding of a danger which threatens the existence of every more or less peaceful society, indeed the whole of civilized mankind. The foreseeable future lies in the shadow of the atom bomb, of political dictatorships, of unbridled violence and a cynical nihilism. Hitler,

Mussolini, and Stalin left, as a permanent testament, a feeling of fear and apprehension which cannot be mastered.

Adorno, as is well known, doubts whether it is possible to write love poems—at least with a good conscience—after Auschwitz. Bertolt Brecht apparently shared his thoughts: "Was sind das für Zweifel, wo / Ein Gespräch über Bäume fast ein Verbrechen ist, / Weil es ein Schweigen über so viele Untaten einschliesst!"[3] [What sort of doubts are those, when a conversation about trees is almost a crime, because it includes being silent about so many misdeeds!] And Marianne Moore must have differentiated between relevant and irrelevant verse with the unforgettable words, "There are things that are important beyond all this fiddle."[4]

Yet we might also have had doubts after Auschwitz about the courage or desire to bring children into the world. Yet we write love poems and procreate just as we did before, because we have too short a memory and too little imagination to conceive of the repetition of Auschwitz. How else could we permit people to be led to war and to slaughter? Not only do we permit it, but we praise it and educate children to be war heroes. We should not be surprised when the songs and the children turn out to be something different from what they were before. The greatest works of art stem from pain and sorrow, although sometimes the poets lose their voice when singing of them. In the same way, the victims of the gas chambers lost their voices in the face of the inconceivable crying out and whimpering incomprehensibly, and the mothers, children, and animals in Guernica lost their identity and became the bleeding and festering wound which was once called Hiroshima. The monstrosity that happened there is and remains more immeasurable and more inexplicable than the inarticulate stammering and the terrible silence of the avant-garde can ever be.

In spite of the most dangerous crises, Western art and literature have not suffered a total overthrow in the course of their fluctuating history. From time to time, certain of the threads broke, but others remained unbroken and intact. The combination of continuity and discontinuity in the sequence of developmental components ensured the continuation and renovation of culture. Since the beginning of the developmental phase called "historical," they represent a more or less closely knit unity even if this is constantly changing and is frequently stratified.

But the refusal to agree that crises like the present signify the end of art does not by any means suggest that they are timeless and intransitory. Just as they had a beginning, so they can also have an end. If we recognize that art arose out of cult and magic, we can also admit that it may change into perception and knowledge. What we cannot admit, though, is the possibility of a prediction as to how and when

it will change from one state to the next or even the assumption that science—to which it could give way—would play the same part that art played and to some extent still plays. Even magic as art ceased to be just enchantment, even though it was still put into the service of magic ends. It was not the same animal any more that simultaneously exercised a magic and aesthetic effect in Paleolithic painting. Both functions may have been extremely closely related, but they were not exactly the same. The answer to the further development of art in a particular direction is never an explicit "yes" or "no." It does not unequivocally exclude what lies furthest from it and does not simply fall silent, however hard it may be for it to find an answer. However long it has to stop, there can be no talk of the final silence of art so long as it appears problematical to itself and can formulate its questionability as a lack of articulation.

It was the collapse of liberal humanism which gave present-day art the decisive impulse toward its problematic nature. The materially conditioned productive forces of developing capitalism and the methods of production which correspond to them could not stop the benevolent effect of humanism and liberalism on art and culture. The individual only loses his dignity and sovereignty in mass society, and the work of art forfeits its aura of individuality and irreplaceability only when it becomes a technically reproducible commodity. But even the stereotypical mechanically reproducible work of art which renounces the particular characteristics of a unique product originates in the talent and skill of an individual artist. The final form of its reception, however, emerges from the conditions of industrial trade economy and the mass consumption of goods. Its assumptions go back to the middle of the nineteenth century and the first two decades of the twentieth. However, conditions only come to a head—as a result of the increasing role of the electronic media—in the third decade to the point where the development of art now reveals a breach which cannot simply be bridged. The feeling that we are on the eve of a catastrophe certainly makes itself felt much earlier, and once again it is Baudelaire who pronounces the bad news. "Le monde va finir," he says in his *Jorneaux intimes*. "La seule raison pour laquelle il pourrait durer, c'est qu'il existe."[5] "Le monde est désert," continues Gerard Nerval in the same strain,[6] and in the formula "Malaise in culture" Freud sums up three generations of strangled feeling for life. To describe the situation as a mere crisis seems to be to choose all too lackluster a word. Walter Benjamin was not himself satisfied with Adolf Loos's expression that a prophet like Karl Marx was standing on the threshold of a new age; he was, thought Benjamin, standing on the threshold of the Day of Judgment.[7]

Since the Second World War, there has been no more peace on earth. The world is divided into two camps and is preparing for the next war. It is protected from the "final reckoning" only as long as the means of destruction are equally divided, but for just as long will the fear and horror of the first atom bomb in the war—which may well be the last—be equally great.

Ortega y Gasset stated in his essay *La deshumanización del arte* that when he once had to write an article about Debussy he came to the realization that the shortest way to solve the problem was the sociological one and that in doing so he had to start with the unpopularity of modern music. He certainly recognized that every new style begins with a period of unpopularity, but he was of the opinion that contemporary art was not only unpopular but also antipopular, that is, in principle directed against the instincts of its potential public. The majority of people who are interested do not understand the new art, in contrast to the people who rejected Victor Hugo's *Hernani,* for example, simply because they *did* know what the author was about. Ortega y Gasset was, strictly speaking, correct; he was only wrong in thinking that the division of the audience into those who understand art and those incapable of judgment is a new phenomenon. He was also wrong in thinking that since romanticism authentic art has only been directed toward a cultured and especially capable minority. He distinguished the negative attitude toward new art as a rejection of works which are understood but not liked from an attitude toward artistic products which we are not in a position to judge and by which we feel humiliated. In doing this he neglected to take into account the most all-embracing group of the public for art, namely, the people who not only understand nothing about a radically new art but do not have the remotest idea that they are missing something that is there to be understood. After the masses had for a century been told that they had an immediate part to play in art, he overlooks the immeasurable difference between the number of people who can be taken in by this and the number of those who lead their lives entirely outside the aesthetic sphere and continue to be excluded from authentic artistic experiences.

Art in the sense in which we are talking about it here is the product of those factors in economy and society which always only partially affect culture but never completely negligibly. Art is always bound to be given means of expression, tools, and instruments, and these are more unequivocally and unmistakably creations and reflections of objective socioeconomic conditions than its other components. In the period of which we are talking, they are the products of capitalist, mainly electronic, industry. Instruments like radio and television sets

are not of themselves neutral means of communication—innocent of our misery—which are, according to how we use them, either useful or harmful: we are just as much their masters as their servants. They form parts of the reality which surrounds us; they determine our possibilities, give direction and limits to our aims; they are products and symptoms of mechanical industry in its late phase.

The crisis of art reaches its culmination at the end of the sixties. With the exception of a small number of aesthetes—the last stragglers of the former patrons of the arts—no one any longer believes in the work of art as the bearer of a valid message or as the trailblazer of a promising future. Artists despair of art and fix their eyes upon its end, not only because the public is for the most part incapable of judging it properly, but also because the consumption and the production of artifacts which count as artistic are from the beginning beyond art— technological forms of expression which are alienated from real, concrete life, which have degenerated from the real culture which controls practice and are manipulated by the managers of our consumer economy. The consumer does not choose when he decides to take one or the other product: he is chosen and determined by the same trade economy as the producer, no matter whether he agrees or protests, collaborates or tries to make off. Demand, too, is an artifact and not the expression of a spontaneous need. The crisis of art expresses itself just as much in the rigidity, inadequacy, and sterility of reception as of production. Even the opposition against manipulated art is more or less manipulated and takes place in artificially created circumstances. No one is completely free in a world which is administered like the one we live in. Everyone is faced with a mechanically functioning apparatus; no one is absolute master over the instrument once it has been chosen, which is not so much chosen as forced upon us. At best we can turn our radios or televisions on or off, but even that takes place under a sort of pressure. We usually turn our sets on earlier and turn them off later than we should or want to do.

The feeling that we are at the same time master and servant of artifacts, and that art in the world of the industrialized consumer and of trade economy no longer fulfills its original function, was apparent before the period of electronic technology. It is almost as old as the century. Virginia Woolf stated in one of her essays written in 1924 that people had already changed their essence around 1910,[8] by which she meant above all that art had ceased to be what it had been for them up to that point.

The phenomenon of an art which is completely split, which no longer communicates any communal experience, is apparently related to the decline of the bourgeoisie, which had still been united and

unified as the supporters of the Enlightenment and neoclassicism. There is no question but that the structure of the bourgeoisie as a class was more closed before the beginning of subjectivistic romanticism than it was afterward and that the rationalist objective view of the world fell victim to the new emotionalism. What is questionable, however, is whether social reality was ever as closed, homogeneous, and total—no matter from what aspect we look at it—as classicism liked to make it out to be. In any case, art moved further and further away from this notion in the course of the following periods.

The *taedium vitae* of the romantics, Baudelaire's *dégoût,* the growing alienation of the symbolists, and the existentialists' disgust for life are symptoms of the sharpening protests against conditions of life in the new period, which tears vital forms and conditions of production out of the balance of subjectivity and objectivity. The two world wars, fascism, concentration camps, and the disappointment which the realization of communism in Russia brought in its train (with the experience that the absorption of the proletariat by the upper classes in no way helped to solve social problems, even that the class struggle generally grew sharper as upward mobility became easier) made dissatisfaction sharper and reduced the concept of class consciousness to the lowest common multiple. The seriousness, bitterness, and hopelessness which were connected with these circumstances penetrated art as it did the whole contemporary feeling for life. The more cruel and repellent the circumstances became or threatened to become, the lighter the hearts with which people gave up the comfort which art was in a position to give them. For if Hitler and Auschwitz, Nazism and Guernica, Stalin and Hiroshima do not mean the end of art—and it is hard to see why catastrophes even of this size should—it is nevertheless unthinkable that they could have had no influence on the structure art took. In any case, it is necessary to explain their aftereffects as a flight from all kinds of reality and rationality, from psychology and logic, from the coherence of a character and a plot into unarticulated hermetic expression or into the absurd or silence. We accept these attempts at flight as pathological symptoms if we agree with Freud that we are all "sick." Georg Lukács sees in existentialism—as the philosophy of total pessimism, of complete alienation and separation, of the desolation and hopelessness of human existence—the particular seed and cause of the "sickness," which he calls the "destruction of reason."[9]

Existentialism is not antirational, only irrational, and the art corresponding to the doctrine of the inadequacy of existence is probably illogical and contrary to reason. It is, however, governed by a logical will to order, which is all the more grotesque and absurd in its effect,

the more unsuccessful it remains. It may—as a result of its irration-
ality—often appear to be questionable, but in the existentialist sense
it is less so since according to this doctrine not only philosophical but
also artistic relevance begins where reason gives up. Existence and
death, fear and care, hope and desperation, decisions and renuncia-
tions, concepts around which existentialist thought revolves, are
inexplicable and unfathomable; yet they are an inexhaustible source
of the most revealing experience for the artistic representation and
interpretation of the *condition humaine.* The supporter of existentially
directed art, the person caught in the cares and plans of everyday life,
does not think systematically but according to the interests of his actual
existence and continued existence. Existence possesses for him the
unquestionable primacy of ontological essence. However, it remains
an open question what we understand by "existence." We can, for
instance, simply regard it as meaning that the difference between being
and essence—as in nominalism—almost entirely disappears, in contrast
to existentialism, in the actual sense in which the emphasis is on the
lack of balance, or even to psychoanalysis, which—one-sided, too—
regards the existential and irrational drives which are forced into the
unconscious as the essential spiritual facts.

Existentialism, especially in the Heidegger version, sets everyday
existence, as a distorted form of being, in sharp contrast with onto-
logical existence in the metaphysical sense. This deformation mainly
affects the human being who loses, in this form, his individuality and
alleged substantiality, and according to Heidegger's word becomes
man ("one"), a being without individual qualities or special actuality.
This exposition of the doctrine also involves the question of authen-
ticity and the relevance of the personality for the literature of the whole
century.

Neither existentialism nor psychoanalysis sticks to the empirical
facts; both want to determine standards for behavior. They proceed
from the predominant state of malaise and inadequacy and agree that
the individual has to see clearly the state in which he is, look his
problems in the face, and solve them in a practical manner. In doing
so, the main thing is to avoid self-deception and lies. Both systems
are, according to their goals, realistic but subjective as to their origin,
but they conceive their realism in a more narrow, and their subjectivism
in a broader, sense than the dialectic of subject and object permits.

The situation of aloneness, of solitude and separation, is the general,
eternal, and unchangeable fate of mankind, the *condition humaine* pure
and simple. The best known representatives of the existential feeling
for life are, like Julien Sorel, Fréderic Moreau, or Raskolnikov and
most of the heroes of the great naturalist novels, torn from the com-

munity of man. Their existence seems to be, to a greater extent than that of their predecessors, free from time and unchangeable, natural, and fateful. As substantial and autonomous characters, they do not become what they have always been by blood and instinct. In this connection, the most important present-day writers show that they have been decisively, but not exclusively, influenced by existentialism. The characters, for example, in the works of Proust, Camus, Kafka, Joyce, and Musil function in a historically and locally changeable world—in spite of their ontologically determined being, which is more invariable and subject to fate than that of their predecessors—and in the unique and singular society, as the typical representatives of which they have been conceived. The characters of the *nouveau roman*, on the other hand, since they are completely existentially conditioned, are enclosed in abstract space and abstract time; they behave like marionettes apparently without purpose or goal. Their stereotypical, universally human existence corresponds to a world without substance sinking into the void in which Beckett's characters, too, still function. Existentialism may have become obsolete and of no consequence as a philosophical doctrine, but as far as art is concerned it is a completely progressive view of life whose influence especially upon literature has been very stimulating and is still a productive one. This essentially unrealistic and irrational philosophy proves most effectively true as a vehicle of the artistic reflection of actual reality with its somber feeling for life. Its inadequacy as a philosophical doctrine does not exclude its conversion to art and its significance as the origin of important literary creations.

In the existential sense, the consciousness of commitment, of a human social link and obligation—like that of guilt and sorrow, conflict and decision, struggle and death—is a "borderline situation" without which there is no human existence, no existence worthy of humanity. To be sure, being committed in art means not only to speak a word in the interests of better conditions of life, but also—where there seems to be no hope—not to be satisfied with a lie, that is, not behave after Auschwitz as though there had been no Auschwitz. Genuine art must correspond to the facts of existence within the framework of which it is created. It must correspond not only to the knowledge that no art can be more real, more true to reality, than the ideology of a society out of which it arises, but also to the consciousness that it can contribute to the salvation of mankind from its present state of disaster and that it can only do that in a world which is already on its way to salvation. The actuality of the concept and representation of existence which is permeated with existentialist thought follows from the consideration of the "nonredemption" of the world, its enmeshment in

evil and deceit. The meaning of artistic commitment does not rest on the unconditional belief in the renewal and improvement of interpersonal relationships and the creation of an individual situation which is morally less problematic, but on the feeling of satisfaction which is linked to the consciousness of obligation freely entered into and the taking over of a joint responsibility for what takes place and what affects the community of man. It is not in the solution of crises and conflicts that the criterion of the fruitfulness of art consists, but in the avoidance of the deceit that—in the midst of dangers and in the shadow of the omens of collapse—we live in a world which is not threatened. Commitment means the affirmation of a message, regardless of whether it can be carried out or not. It is consciousness of the world in contrast to unworldliness, interest—not lack of interest—in the fate of man, a sense of reality instead of illusions which alienate us from and keep us away from reality. Art which is dominated by the existentialist doctrine by no means always succeeds in reflecting the facts of existence without distorting them, but it does not gloss over the difficulties and appease those affected by them. If it does falsify truth, it does not do it by extenuation, but by exaggerating the evil from which we suffer.

Yet the decisive question is by no means whether the repetition of crimes like those of Auschwitz can be avoided by the work of artists and whether their apparently useless efforts would not be better undone, but whether products of the sort which their works represent—in a world in which an Auschwitz was and is possible—can remain repeatable. We can argue about their use and value but hardly about their ability to be repeated and their apparently unavoidable repetition, even if concentration and extermination camps continue to exist. Auschwitz and art would perhaps be irreconcilable if artistic creation and reception had their origin in happiness and the joy of living, and their justification in pleasure and enjoyment. But art comes from misery and sorrow and instead of lessening the sorrow and distress of humanity, it merely increases their ability to suffer.

"Good" and "well meaning" are by no means the same thing in art. These words often denote qualities which are even antithetical and which are by no means mutually advantageous. Art of itself—no more than culture—is not a defense against the evil which threatens mankind. Indeed, it was precisely in culture—as the inhibitor of instincts—that Freud saw a source of evil. The concept of culture as a form of decadence is, however, by no means new. It was repeatedly at the center of historical philosophical thought from Rousseau to Nietzsche. What is new is merely the idea that the subject on the way to his cure—whether by direct satisfaction or by the sublimation of instincts and desires in the role of a judge who can never be completely satisfied,

what Freud called the "superego"—meets an unavoidable authority against which there is no appeal. The superego is for psychoanalysis personified society: the organ of the strongest bond and of the most powerful revolt of people in relation to one another. It combines within itself everything which we understand by conscience, ethos, moral authority, and absolute divine authority. In contrast to the Christian idea of God, however, it is a force which is always the source only of duty, pain, and sorrow, which burdens the subject with a constant sense of guilt, and which consigns it to a struggle with an apparently intransigent force—the unconscious. This is for the most part a pointless and hopeless struggle and in spite of that the only one which in the present unheroic and skeptical world gives some deeper meaning and tragic seriousness to human existence.

Human beings are often as unaware of the guilt with which they are burdened as they are of their social position, their class situation, and their true interests. We encounter a lack of the consciousness of guilt—even if the torture of a feeling of guilt is present—just as often as we encounter a lack of class consciousness, in spite of self-evident signs of belonging to a class. Nevertheless, the consciousness of guilt, under the pressure of the often exaggerated and irrational rigidity of the superego, contributes just as much to the moral education of mankind as—under the pressure of social relationships, tasks, and responsibilities—commitment does to the aesthetic education of the artist.

Whether the agony to which the superego subjects the unbridled individual giving way to all his instinctual urges and tendencies is capricious or unavoidable, it does exercise an inexorable effect upon his motivations whether it is imposed by himself or another. And whether the judge is correctly designated by the term "superego" or not, his power comes from the fact that as far as people are concerned he seems to possess a higher power. As long as this appearance can be maintained, the punishment which is meted out, however harsh, is bearable. It will only become unbearable if it loses its higher origin as the result of a sublimation of its justification, because of the demands of socialization. Thus, the present appeared as the "age of anxiety"[10] only after the superego had become a pointless and senseless torture. For suffering is unbearable only as a result of its pointlessness, never as a result of its lack of moderation.

It is certainly no coincidence that Freud and his followers came up with the idea of a relentless judge at the same time as the artistic avant-garde's feeling for life was expressed in forms of a strict representational abstraction, a flight from plot, the depsychologization of narrative and dramatic literature, the removal of heroic and personal qualities from their heroes, and of the negation of traditional and conventional values.

It cannot be a coincidence that in view of all this he came simultaneously to the idea of unavoidable sacrifices, renunciations, and making do with substitute satisfactions and conceived the idea of the superego whose influence and authority is independent of whether we acknowledge or deny its validity. The idea itself, it is true, was suggested in the course of history in different ways and on repeated occasions, but the authority of a highest judge as a moral norm was never so decisively proclaimed and so categorically denied as in his time. It was never so decisively asserted that man, whether conformist or rebel, leads a completely pointless existence, that everything he does is finally useless, that he wastes himself and loses his time whatever he does, and alienates himself from everything he comes into contact with. The scene of the most concentrated population, of the most varied communication, of the most diverse media of expression became the most barren wilderness. Man lost the authenticity, genuineness, and credibility of his utterances when he lost the functionality of his actions. He is no longer what he seemed to be since he became *homo faber;* the producer of works changes into a mere consumer of goods.

Freud's pessimism about the pointlessness of attempts at civilization, while suppressing man's natural instincts and inclinations, and the disproportionately high price of culture, certainly comes closer to Marx's theory of alienation than that of the prophets of the classless society. The present—in the state of its deepest alienation—everywhere reveals traces of Freud's cultural pessimism, however blurred they may be. We are already paying the high price for culture, but we have not come appreciably closer to Marx's ideal society. We may admit that the propertied classes will be done away with, but the idea of a society without selection and stratification, without a privileged authority which makes decisions, belongs now as it always has in the realm of utopia.

After the turn of the century, Marxism gained in influence in art alongside existentialism and psychoanalysis. In philosophy and the study of history, it proved to be the most fruitful and solid of the three predominant interpretations of existence. However, in the formation of motifs which determined the most recent artistic changes, it remained—with its utopian optimism, which is the opposite pole to existential pessimism and Freudian displeasure over the "malaise in culture"—a relatively inconsequential factor. Almost all Marxist-oriented literature was an indictment of existing society. There was hardly any echo worth mentioning of the confident prognosis of the coming realization of socialism in it.

Stylistic Assumptions
Modernism

The principles of style which are the assumptions of the present-day practice of art are essentially antinaturalistic and as such antiimpressionistic. All the progressive artistic movements of the new century from futurism and Dadaism to expressionism and surrealism renounce the effect of the illusion of reality and often express their picture of the world and their feeling for life in an outré deformation of empirical experience. The consistent, though differentiated, reaction of the century to the naturalistic-impressionistic and, for the most part, aestheticist attitude to art is already prepared in the impressionist period and in the impressionist styles themselves. In these it is no longer a question of an integrative, synthetic, homogeneous representation of reality, of the confrontation of the subject with the objective world as a totality and a unity, but with the beginning of the process, which has been called "annexation," in other words, the immediate occupation of parts of reality. In postimpressionist art, it is no longer a matter of the immediate reproduction of phenomena but of their forcible conquest, not of substitute mimetic structures but of express artifacts, which do not substitute for the natural objects but exist as independent entities alongside them. The antiaestheticism of the period is combined with an antiimitative impulse; its aversion to hedonism, with the wish to dissolve the impressionist images. It wishes instead to refer to reality through a capricious system of signs, like the pictorial language of the symbolists, the structural analysis of the cubists, or the "automatic" spelling of the surrealists, and either to deform its picture or to replace its totality with fragments in the form of so-called *objets trouvés*.

In futurism and expressionism, in cubism and surrealism, we are faced with a pluralistic view of art and the world which corresponds to the reaction against the one-sided and apparently coherent bourgeois capitalist social system, even if it is already threatened. All new stylistic movements are based upon a many-faceted reflection of reality and open up a view of things which is diverse and often heterogeneously constituted. It is in surrealism and in stylistic forms based on the principle of montage and collage which derive from it that the plurality of aspects and structures first becomes basic and definitive.

The formal principle of montage and that of the use of *objets trouvés* are the same in essence. Both follow additive rather than synthetic and integrative methods of composition and operate with motifs which lock into one another and both prefer to use rough "natural sounds" rather than naturalistic imitations of experience. They aim at the pil-

laging rather than the mastery and conquest of reality and seek the thing, even if it is fragmentary, rather than the illusion, however complete that may be. Montage changes what is static in the unified and homogeneous artistic aspects of being into a dynamic process of becoming. It changes the finality and immutability of a product into the process of a production which is already in progress. The categories of time, the resolution of the dialectic between past and present in the visual arts and the additive forms of music, thus, gain supremacy over the timeless media of space and the acoustic simultaneity of polyphony.

The crisis of present-day art recalls most vividly mannerism as a turning point in cultural history, although the moderns cannot be regarded in any sense as the continuation or repetition of the stylistic crisis which interrupted the continuity of the Renaissance and the baroque. Artistic styles, like all historical phenomena, are solitary and unique. Thus, mannerism and modernism may be typologically similar, but they are by no means similar stylistic movements pursuing the same aims. The similarity of their historical function does not permit us to regard them as periodical sequences of style which recur regularly, in the sense of Wölfflin's "principles." It is true that mannerism remains an undercurrent of art historical development and is now more, now less easily recognizable. At times of revolutionary changes in style, which are connected with serious intellectual crises like the transition from classicism to romanticism or from naturalism and impressionism to postimpressionism, it appears more predominantly on the surface but it is never subject to a law of periodicity. Nevertheless, variants of it appear at different intervals and as a result of different causes. Thus, romanticism can be regarded as a revolt against classicism's antimanneristic view of art. The result of this revolt is that the manneristic undercurrent of what is paradoxical, bizarre, and capricious gains the upper hand, especially in the works of late romantics like Baudelaire, Gérard de Nerval, and Lautréamont, and of the symbolists like Rimbaud, Mallarmé, and Paul Valéry.

In the sense in which we are here talking, modernism as the form of a new sensibility and lyrical harmony first appears in the work of Baudelaire. As a challenge, modernism is first expressed in statements like Rimbaud's "il faut être absolument moderne." However, there is no doubt that it is with Baudelaire that it starts, as fundamental nonconformism and antitraditionalism, as the expression of the new taste for nervosity and nuance. Baudelaire's poetry also represents a decisive step in historical development insofar as he strikes the dark note which dominates the whole of modern art. However, Baudelaire is—with his unique sorrow which never leaves him—not only the first modern poet, but, as a disappointed romantic, an uprooted urban dweller, and

an alienated intellectual, he is purely and simply the first modern man. What is especially modern is the ambivalence of instincts and the dialectic of the emotional and speculative tendencies which move him and which are also reflected in the dual attitude toward his own intellectual origins and his partly positive, partly negative attitude toward romanticism. What is romantic is the way in which he uses the poetic metaphorical language of his predecessors, the tropes and symbols and their whole exuberant and emphatic mode of expression. On the other hand, what is not romantic is his obvious antipathy to everything sentimental and unrestrainedly emotional.

He is poetically most successful in his contradictory mode of thought and feeling, which is manneristically broken, self-conscious and self-critical, and full of coquettish piquancy and theatrical grimaces which distort the inner and the outer world. Proust also points these out as the most important traits in his analysis of Baudelaire's art.[11] For Proust, however, what seems more important than the often grotesque, reflective, and dramatic passion for suffering and the ability to suffer is the affinity between his own concept of time and Baudelaire's. He sees in *Les fleurs du mal* the first step toward the reevaluation of the temporal distance from past events, which is at the bottom of *A la recherche du temps perdu* and in a sense all modern literature. But he is not so concerned with the consciousness of the distance from experienced time and its experiences as with the difficulty of revivifying them, of remembering, and the effort which it costs to sort through the ruins of the treasures which time has buried. In the last part of his novel, Proust turns to the investigation of different forms of the concept of time, above all of spontaneous reminiscences of "involuntary memory," and observes how differently from all the older conceptions Baudelaire views this. He quotes examples from *Les fleurs du mal* in which he is reminded of his own experience with the *petite madeleine* as the beginning of the stream of memories of which his magnum opus—which stems from his *volonté involontaire*—is composed. Even if they are not unique in Baudelaire, he believes they are "more numerous, less capricious than elsewhere and therefore of decisive importance."[12]

Symbolism, which became the leading stylistic movement after Baudelaire and Verlaine—though his work was further removed from the origin of modern art—is closer to mannerism insofar as it is a thoroughly intellectual movement in contrast to Baudelaire's sensualism and Verlaine's impressionism. Its spiritualism and idealism are decisively opposed to the earlier naturalistic and materialistic view of art. For the older generations, sensual impressions and empirical observations were something final and irreducible. For the symbolists,

on the other hand, all experience is an inferior substitute for a reality which never existed immediately and which is lost forever or else the irreparable deformation of a world of ideas which was allegedly once the only true and proper one. In this sense it brings about the breach between the centuries-old naturalistic tradition and the pioneering preparation of the new, essentially antinaturalistic art.

Symbolism is a movement which includes the rejection of impressionism because of its sensual feeling for life, of the *Parnasse* because of its formalism and rationalism, and of the whole of romanticism and postromanticism for its excessive emotionalism and the shallow conventionality of its metaphorical mode of expression. Thus, it may be seen as a reaction against the whole of older literature. The symbolists discover an artistic phenomenon in the form of *poésie pure* which was previously unknown or at least undreamed of before mannerism, a characteristic poetry suited to their medium—a sensual, nonconceptual language. In contrast to the verbal designations in usual communication, poetic symbols are to exhibit the quality of not having been used and of an unequivocal, though nonlogical, precision. Instead of logical precision, this language is to express the sensually concrete, plastically evident, and lyrical-musical character of the ideas, nuances of color, and overtones which are part of the linguistic formulations which adhere to experiences. The limits of the possibility of realizing *poésie pure* consist in the fact that the words and turns of phrase have a meaning—beyond tone and color quality—which is of primary intentionality but which may change and grow dull with time but which is never entirely lost. As a result of the sound and color which are superimposed upon it, it loses some of its clarity and unambiguity but retains traces of its rational origin.

Mallarmé anticipated Paul Valéry's belief in the "sanctity of language" without, however, lapsing into Flaubert's mystification of the mot juste. He and his followers delighted in the richness of color and nuances which were to be found in language, but they did not overestimate the value of the individual word. The one seemed to them as good as the other and a play with several words often better than the choice of a single one, no matter how suitable. They chose the words, as Verlaine said (not without a certain scorn) as means of communication with others and often remained conscious of the fact that the words often miss the mark, indeed often *have* to miss it. In this way they expressed the sense of the coincidental and the relative value of artistic products, which had up till then—according to presumedly timeless and unconditional aesthetic values and the apparently secure idea of culture—simply appeared as successful or unsuccessful. Meanwhile, the symbolists had, for all their suspicion about the exactness

of the individual word, in general an unlimited faith in language and believed that it could never entirely miss the mark and peter out.

The belief that there is in language a magic which basically never fails and in the hallucinatory nature of poetic creativity which knows no rational limits comes, in the symbolists' sense, from Rimbaud. He was the first to talk of the prophetic nature of the poet, of the demand to wean the senses from their normal use, and of the hope that poetic media would be denatured and dehumanized. All of this accorded not only with the ideal of the artificiality of the means of expression which Baudelaire had in mind, but also contained a characteristic of which there had previously only been hints, namely, that of deformation, of violation and distortion of phenomena, as a symptom of the expressionism which began to make itself felt in Rimbaud.

The concept of *poésie pure,* which lay at the root of the symbolists' efforts, emancipated itself both from nature and from reason. It is well known that Flaubert was toying with the idea of writing a book without a subject, which was to be pure form and style, a mere linguistic structure. Mallarmé took up the idea when he proclaimed the principle of an autonomous poetic meaning and expressed the view (which propagated itself until the time of T. S. Eliot) that we could enjoy a poem without fully understanding the meaning of the text.

Valéry expanded Mallarmé's well-known dictum—if it was he who first said it—that we make poems with words and not with ideas, by stating that the secret of poetry lay in the domination of words over sense. The charm of poetry, which is today often linked with the failure of words and the effect of what is not said, was still ascribed by the symbolists to the sound of words and their total articulateness. In any case, they believed that the hidden meaning of a work of art increases rather than lessens its attraction for the right audience, for it at least prevents people from being indifferent or inattentive to it. What must have been decisive for them—or at least for Mallarmé, with his preference for everything that was indirectly expressed or hinted at—was the insight that every great art has its own secret and that none of them will surrender it without ado. The phenomenon which he called "the mystery of the name" and which meant for him the simultaneous decoding and encoding of things best expresses his concept of the essence of poetry. It points at the most meaningful contribution of symbolism to present-day views of art. Since that time we have understood the artistic representation of an object to an unequivocally and one-sidedly definable achievement, but rather the product of a completely dialectically conditioned process in which every positive moment is linked to a negative one and is paid for by it. In the process,

this—namely, the veiling of the meaning, the hermetic part of artistic intention, and the problematic of success—is the price to be paid.

Symbolism, no matter how deeply rooted it is in the nineteenth century, becomes the signpost to the present, since it anticipates the new art's purely suggestive means of representation. Mallarmé's well-known thesis, "to call a thing directly what it is is to suppress three-quarters of the value of a poem," serves as a key to the understanding of later artistic movements whose meaning and individuality consist in the indirectness of their approach. But this is only another word for "aesthetic distance," without which no art can be conceived of as having meaning. For even the aesthetically fundamental concept of "conscious self-deception" is only one aspect of this distance. Where there is no "willing suspension of disbelief" in the credibility of an artistic representation, there is no need for any self-deception. The dependence and detachment of a work of art really condition each other. The imitation and the rejection of empirical perception form, in other words, antinomial attitudes in the aesthetic dialectic, which can only analyze concepts, but which can never be divided up according to experience. Beneath the burden and the simultaneous magic of reality there arises the need for works of art, in which we think we own the world while substituting for it artifacts which are at once so similar and so dissimilar to it that they appear, on the one hand, to be its concrete fulfillment and, on the other hand, in Schopenhauer's sense, a salvation from its adversity. The precondition for the genesis of every art is experience of the reality to which it is attached and from which it differs. All true art starts out from it and transcends it. The alienation which is expressed in the experience of "aesthetic distance" presupposes a reality which is "stored" by artistic representation, the reliability of which is re-created by "conscious self-deception." The whole process takes place as a result of possession, abandonment, and recovery.

Avant-Gardism

The creed of the first expressly modernistic artistic movement was Marinetti's *Futurist Manifesto*, which he wrote in 1909—in the midst of the late- and postimpressionist experiments. The creed, with its attack on the romantic doctrine of the "organic" and its acceptance of the principle of what is mechanical and dynamic, corresponds to Walter Benjamin's thesis of "mechanical reproducibility" as the origin of modern art. Thus, we can derive the century's view of art just as easily from the aesthetic of futurism as from the spiritualism of the

symbolists, the subjectivity of the expressionists, the formal rigor of Cézanne and Seurat, or the nihilism of Dadaism.

In spite of their essentially sober, fundamentally antiromantic nature—with their tendency to abstraction and analysis—all of these movements, and subsequent ones as well, reveal a characteristic which derives from romanticism, namely, that of unconditional avant-gardism. Their justification is thought to be found not so much in the assertion of what is new and spontaneous as in the negation of what is old and conventional, and its ideal style is seen not as a form which has already been discovered and realized but as one which has yet to be discovered and realized. It does not accord with something which is complete, but with a readiness, and means not only that everything in the present must give way to something in the future but also that what prevails is inferior to what is coming. Novelty belongs to the characteristics of what is artistically valuable in every period, but since romanticism it is not only an assumption and a criterion but also the meaning and goal of artistic efforts. The growing reputation of the avant-garde is apparently connected with the romantic overestimation of youth at the cost of the mature and of the traditional. It is open to all future movements and feels itself burdened and hindered by every form of tradition. Its dream is immortal youth and a permanent revolution. Its tasks and products at a given time are always linked immediately to the continuity or discontinuity of the artistic development which is in process. In a period of social mobility and instability like the present it plays a far greater role, with its opposition to what has been handed down and what exists, than in one of stability and security.

One of the most important questions which needs to be answered in this connection is to what extent and in what sense the representatives of the avant-garde are the predecessors of future development. It is connected with the question raised above about the prophetic gift of the artist and the function of art as something which points the way and is in advance of general historical development. As we mentioned, the history of art knows epigones who limp behind the general developmental tendency, but no pioneers who are capable of anticipating future relationships, means of production, and social relations through their personal charisma or shrewdness. Even the most progressive artists are not prophets; they may, however, be ahead of many members of their generation, those, that is to say, who are lagging behind the general development. Part of the concept of the avant-garde is certainly originality but not being unprepared, freedom from the bond of epigonism but not from the ties of tradition.

The intransigent avant-garde proceeds from the fiction that the development of art can and should always start afresh and shares the

romantic belief that the conventional forms, ready-made clichés, and worn-out commonplaces of communication can be set aside, while the pure, unblunted meaning and charm of the language of art can be protected from the danger of alienation and depersonalization. Although the avant-garde in this sense stands up for what is natural rather than what is artificial, it is essentially stylistically independent. In a period of academic classicism it can be progressive, but in a period of academic romanticism it can have a regressive effect. It embraces the principle of inconsistency, of a historically conditioned relativism, of a constant change in prevailing values. Its existence can be a source of confidence or anxiety, can inspire paralytic uncertainty, but also a morbidly explosive feeling of well-being.

All antitraditional, reformistic, innovative art may, with more or less justification, be termed avant-garde. The most essential criterion of an authentic avant-garde consists in the demand that the barriers between life and art be broken down. Genuine art presents no laws which are alien to reality, suprahistorical, or timeless; and criticism which is to be taken seriously works on the principle that every generation has its own aesthetic standards of value. The experience that yesterday's avant-garde are today's academicians and tomorrow's epigones does not ensure a passport for every rebel. The approval of all that is novel and concern for every innovator is no more evidence of an authentic understanding of art than its rejection is necessarily evidence of a lack of artistic sense. The avant-garde essentially represents a vanguard of artistic developments of a nonconformist sort and expresses a protest which is directed just as much at an audience which is all too ready to accept artistic innovations indiscriminately and without understanding as against one that is from the outset against them. In both cases it proceeds from the assumption that the public must be shocked in order to be made conscious that in the avant-garde's work it is facing things with which it is as a rule unfamiliar. The avant-garde demands of the recipient an accomplishment which epigonism—which dishes up to him the predigested artistic effect which he should digest himself—does not demand of him.

The symbolists' interest withdrew from the emotionality of the late romantics and the sensuality of the impressionists to the nature of the media as a vehicle of expression and to formal structuring which results from artistic effort. In accordance with this, the process of creation proceeded from the artist's sensibility and feeling for proportion and nuance and not from his thought and feeling, his character, and his fate. From the human and social point of view, the symbolists remained just as uncommitted and politically just as passive as the impressionists were. They showed themselves to be in agreement with the prevailing

conditions and espoused a completely aesthetic view of the world. Even as artists they were in no sense revolutionaries, however revolutionary their works may have been in the art historical sense.

Aestheticism and thus the nineteenth-century view of art to all intents and purposes came to an end with the First World War. Nothing is more characteristic of the break in stylistic development than the death of Debussy in the year 1918. Debussy was not only the last offshoot of impressionism but also one of the most influential opponents of romanticism. With his unromantic use of melody, which avoided excessive emotionality, and his harmony, which was transparent and avoided flamboyant late-romantic orchestration, he was one of the authentic forerunners of the new century. At the same time, intellectual symbolism was universally established, and the essentially naturalistic art of the previous period was finally finished with.

T. S. Eliot declared at the beginning of the twenties that Joyce had killed the nineteenth century, and his judgment of the situation became a commonplace. For, even if aestheticism had received the coup de grace much earlier, it was only completely finished when Joyce's *Ulysses* was written. Cézanne's and Seurat's formal rigor, van Gogh's and Gauguin's expressionism, Italian futurism, and Dadaist nihilism had already proved fatal for the impressionists and their offshoots. The fashionable *Jugendstil,* as well as impressionism, was also immediately threatened by these movements. This movement, though itself antiimpressionist in attitude and coming from the practice of craft, tried to reform the whole of artistic practice according to the principle of the practicality of craft, and in Vienna where it was known as *Sezession,* but elsewhere as art nouveau, it dominated the tastes of broad strata of society.

Fascinated by the magic of the colorfulness of the scenery and costumes, the piquancy and exoticism of the music, the virtuosity and elegance of Diaghilev's dancers and choreographers, Jean Cocteau became infatuated with the Russian ballet. In this way, he became an enthusiastic, though unconscious, protagonist of art nouveau. He only perceived the breach with the former century—without distinguishing between the more deeply rooted stylistic tendencies—when he published an article in 1917 in which he speaks in the same breath and in the same sense of the works of artists as different as Wagner, Debussy, and Stravinsky and lumps them all together as "impressionistic," which for him means superseded by the new music.[13]

The anemia and the emotionality of the ornamental style, which are also properties of the figure drawings of Beardsley and Klimt, explain in part the barbarism, the tastelessness, and the aesthetic indifference of Dada. Yet the attack upon art, however wild it was and however

little regard it seemed to have for what is artistic, was still carried on in aesthetic categories. Even the conviction that art had become useless and lacked function and that it was coming to an end had to be expressed—if it was to make an impression—in concrete forms of art, however extravagant these might be. Its survival of crises of this sort tells us nothing about its future, nothing about its suprahistorical nature and intransitoriness, but it does show that civilized people were no more able to dispense with it then than they are now. However far it is from being the "mother tongue" of humanity, it is also not an evanescent idiom, but an integrating constituent of the dominating culture, however inadequate this may be.

Although the art nouveau movement and, in a certain sense, symbolism—indeed even the art of Cézanne and the neoimpressionists—can be regarded as the beginning of modernism, the radicalism of the antitraditional view of art—the rejection of classicistic, romantic, and naturalistic-impressionistic principles of nineteenth-century style—begins with futurism. This was the first really revolutionary movement in art and literature which questioned traditional and officially sanctioned art as well as the vital function of institutions like universities, museums, libraries, and art schools. The origin of futurism, with its obsession for movement, speed, and dynamic, mechanical production in the industrial trade economy, is obvious. In this way, the concept and experience of the time is brought into the center of artistic interest. In painting, the relationship between time and space—something which already had interested Lessing—became a central problem. In the theory of artistic perception, too, just as in the critique of the categories of thought in general, the simultaneity of individual processes taking place at different points in time became one of the most significant objects of consideration. The connection of the two spheres with one another does not only mean the preservation of the relationship of persons to the background of their function—as the futurists themselves believed and declared—but the creation of a much more comprehensive complex, a unity which includes the whole of inner and external reality and which closes the breach between them. This marks the beginning of a new epoch in the history of art in which the analysis of experiences is at once the synthesis of subject and object, of temporal action and its spatial substratum. Since this time, the production of such a total structure has remained as the object of modern art, and the special relevance of the futurists is that they initiated the goal.

Whereas previously all antiimpressionist and antiaesthetic movements, including futurism, followed artistically more or less unified and logical programs, Dada never had a program.[14] Dadaism insisted upon freedom, the right to free improvisation, and the arbitrary co-

ordination of motifs to an extent which, up till then, was unprecedented. We are not dealing with an art or an artistic style in one of their known senses, but with a conglomeration of things whose sheer accumulation was declared an "artistic" achievement. The claim to be art—when such a claim was made—usually consisted in the mockery of the fiction that artifacts play a decisive role in our existence alongside the real facts. In all of this we can see the anticipation of the principle that "art is what counts as art," and also the conviction that it is all over with art. At least, people seem to have been closer to the "end of art" than they are today. Dada was nothing but a disguised protest and a mere excuse to express despair and disgust about the prevailing conditions. On the other hand, today's art is from the very start an aesthetic statement which shows itself, in practice, to be more or less without use or function. Dada was pure parody, anarchistic vandalism, or cynical nihilism, but today, in spite of art's playfulness or its destructive ebullience, there is a critical earnestness which leaves no pretense or disguise.

If there are any stylistic laws of Dadaism, they are to be found in the coincidental nature of the discovery of the subject to be portrayed, a principle which was present at the very moment when the name of the movement was chosen. It is seen in the casual collection and juxtaposition of motifs, the arbitrary replacement of one with the other, in ostentatious disorder as a compositional principle, and in the nonsense of the way in which objects are placed and their function altered, like the placing of a man's head upon the bust of the Venus di Milo or the laying of a donkey's body upon a piano. The "deeper meaning" of the joke evidently was to show that so-called serious art is not essentially different. What was axiomatic was the concept which lies at the base of all art, that there is an absurdity in the relationship between the essence and the representation of reality.

Expressionism

Futurism and Dadaism did not represent movements which were basically new or essentially different from the nineteenth-century view of art, in spite of their playful and nihilistic tendencies and their temporal-spatial categories of perception. Ideologically, they did express a protest against the aestheticism and conformism of the fin de siècle, but stylistically they merely marked a turning away from the self-righteous and self-sufficient formalism of the impressionist view of art, without surmounting its unequivocal sensualism and objectivism. The decisive antiimpressionistic change of style which served as a signpost for the art of the new century pointed in two different revolutionary

directions—both as to the content of expression and as to the form of expression. The one which was the goal of the strictly geometric cubist movement probably came from Cézanne, from the formally disciplined artist who had renounced the nuances of mood of actual impressionism. The other, which was from the beginning introverted, showed itself to be opposed to the emotional motifs of the raw material of impressionist passivity, which was saturated with passions and expressions of will. It emphasized the new values of expression now coming into their own in its neglect of impressionist principles of beauty.

Expressionism was the most artistically fruitful phenomenon of the years immediately preceding and following the First World War. Its productive years stretched from 1910 to 1922; the movement came to an end about 1924, although it continued to exercise an influence until 1933 and only ceased to play an important part after Hitler had seized power. In spite of important representatives like van Gogh, Chagall, Kokoschka, and Munch in painting, Rimbaud, Strindberg, and Rilke in literature, Stravinsky, Bartók, and Schönberg in music, it was mainly a German movement, an expression of the German will to power and of the German defeat.

The extraordinary amount of artistic production was matched by the amount of scientific activity. This embraced psychoanalysis, Husserl's phenomenology, the neo-Kantian critique of perception, the philosophy of the Vienna "circle," the new intellectual and social history, gestalt psychology, and the dialectical-ideological interpretation of cultural development. The expressionist struggle against naturalism and impressionism is at the same time an emphatic expression of the opposition to the narrow-mindedness of academic traditionalism, the undialectical historicism of the romantics, the petit bourgeois outlook of the Victorians, the capitalist flamboyance of the Second Empire, and the ostentation of the Wilhelminian period.

Bourgeois culture with petit bourgeois taste would be unthinkable without the sudden economic boom of the period. The contradictory nature of the factors involved was most clearly expressed in the role which the different motifs played in the formation of quality in artistic productions. Bouguereau, Regnault, and Cabanel were still the painters most sought after and best paid by the wealthy public of the seventies. "A Meissonier fetches three-hundred thousand gold francs; an impressionist painting, if the artist is lucky, a hundred."[15] The backbone of the regime was the wealth of the bourgeoisie, and its basis lay in the means and methods of its trade economy. The capitalism and industrialism of the period certainly trod paths which were already well known and established, but now for the first time they begin to pen-

etrate the daily life of a considerable number of social strata. With the growing need for luxury, they expand and at the same time make artistic demands more superficial. Bad taste, of which there was never a lack, becomes the fashion. The new wealth is considerable enough to want to shine, but not old enough to shine without the desire for ostentation. It is unhesitating in the choice of styles which it takes as a model and indiscriminate in the use of real and spurious materials which it acquires and mixes together. It makes bedfellows of baroque and rococo, Venetian palace and Loire château, Pompeian atria and Louis Seize tapestries. The pretentious material is often only a substitute, marble is merely stucco, stone nothing but mortar.

The fight against the confusion of taste of the so-called higher cultural strata began almost everywhere with the development of a sense for functionalism, objectivity, and the material authenticity of products, with a discipline of work and a work ethos. These governed most uncompromisingly the Weimar Bauhaus and marked the end not only of aestheticizing impressionism and its derivatives, but also of the playful elements of art nouveau. At root this view of art based on craft and on the principle of functional form had nothing to do with expressionism—which was saturated with emotion and expression. It did, however, cut itself off more decisively than any of the earlier reform movements from *l'art pour l'art* tendency of the fin de siècle and became the representative of a commitment whose connection with expressionism cannot be overlooked. Both the work ethos of the craftsmanship of the Bauhaus and the will to expression which characterized expressionist art conveyed an ideological realism, a sense of reality which was concerned with practice which had hardly been seen in the period of aestheticism, in spite of its naturalistic-impressionist factors. Expressionist "realism" had nothing to do with naturalism as an artistic style and was at the time of its most important achievements even further removed from everyday experience than impressionism. Chagall's hallucinatory memory paintings divide up the objects of experience into their elements and combine them in a way which mercilessly violates manifest empiricism; yet they represent the processes of consciousness so faithfully and convincingly that they give a complete sense of authenticity. For who in the world is going to take exception to the fiddler on the roof playing his fiddle while the village animals play, or to the bridal couple floating blissfully in the air while the bridegroom sits on the shoulders of the bride and raises a glass?

The signs of the change of art from outer visible phenomena to inner psychic processes are, through the influence of psychoanalysis, immediately visible in the work of Kokoschka, but they can also be seen elsewhere through certain emphases and distortions of the substrata,

experiences, and memories. Usually the distortion of the objective form point to specific intellectual contents, but the distortion often takes place merely to show that there is a psychic existence alongside the physical. It is precisely by this splitting of experiential reality that expressionism becomes the most fruitful ground for further artistic development, especially for surrealist dualism. Mannerism had already distorted the empirical picture of reality by its excessive lengthening of forms and used this method not only to express elegant, affected, mincing mannerisms but also in a much more essential sense to intellectualize its motifs. Finally, however, it distorted forms merely for the sake of distortion, which had now become a convention. The distortion of the human figure by lengthening had already become an expression of intellectualization in Gothic art and became a conventional matter alongside its symbolic role in the same way in which the development of Egyptian frontality did. As a result of the conventionalization of their means of expression, artistic styles lose much of the force of their original meaning. This change, however, belongs to the rule which separates forms from creative intentions and changes the substrata of expression into independent structures.

Georg Lukács, as a representative of "social realism," regards expressionism as the "expression of petit bourgeois opposition." He sees it as carrying on a sham struggle against imperialism and fascism, against the depravity of the bourgeoisie, and as changing into right-wing criticism of the bourgeoisie, that is, into a merely demagogic criticism of capitalism.[16] The justness of the assertion that expressionist antibourgeois feeling smacked of the Bohemian concept of bourgeoisie is not to be denied, but to assert that the expressionists were allies of the fascists and, as such, servants of reaction is a direct inversion of the truth. They may have become the tool of the ideological misuse of their views, which were often irrationally formulated, but they were opposed to war and militarism, and their express demands were for freedom from oppression and the establishment of human dignity. Just as nondialectic as the identification of their true aims with the unforeseeable results of their particular situation is the fundamental separation of the contradictory aspects of such complicated artistic phenomena from one another. Lukács judges this historical phenomenon as the expression of bourgeois culture at odds with itself. In taking this view, he falls into the old prejudice of seeing classicism as an art at one with itself, whereas romanticism and expressionism are the art of the decadent bourgeoisie.[17] Bourgeois classicism, however, according to the dialectic of such a progressive stage in history, is not so free from romantic traits and expressionism not so "decadent," that is, as opposed to classicism, as Lukács would like to make out.

In expressionism sometimes the content of expression and sometimes its form seem to be in the foreground. Sometimes things seem to be intensified by the impression which they make, dissolved in the emotion and the mood which they call forth; at another time, the emotions and the excitement seem to detach themselves from the psyche as self-sufficient forms. Both aspects are essentially misleading. It is true that every art is expression, but expressionism consists of something more than feeling and only becomes an "expression" through the component in it which is alien to feeling. Even the definition of expressionism as a style in which apparently genuine, unarticulated, and unorganized feelings gain the upper hand over categorical thought and critical rationalism is nondialectic and thus untenable. Feelings depend upon things, and things are experienced to the accompaniment of feelings. Even a lack of feeling expresses itself as fear, alienation, flight from one's fellow beings and the conventional forms of their relationships to one another, that is, as an emotional reaction.

The art historical function of expressionism reaches its zenith in the absurd concept—which comes from romanticism—of the uncommunicated communication, a *contradictio in adjecto*. Every change of style is a sort of linguistic renovation and consists of a more or less intentional and extensive change of the form of expression. Since romanticism, this has always been a matter of a conscious and clearly declared fight against ready-made, comfortable, and worn-out forms of language and the opposition to the seductiveness of clichés which hide the individuality of objects and impede spontaneity of expression. The romantics already wanted to re-create language in its original and virginal purity and avoid its alienation and institutionalization, its evaporation in objective and impersonal culture. It is only the present that became aware of the fact that the price of linguistic understanding is commonplaces and clichés and that literature is a language which is doomed to become worn out and is, as such, an unproblematic, immediately comprehensible form of expression, although it is not by any means always equally satisfactory. This paradoxical nature of the media, which are "master and servant," authoritarian and self-destructive, remained significant for the present day and led to doubts about the continued existence of art.

If today we talk about the "nadir of literature"[18] or of impersonal, flat, objective style in the sense that Sartre does in his essay on Camus's *L'étranger*,[19] it is still the concept of a completely transparent and neutral form of expression which is responsible for it. It was the contradictory role of language—which became evident through romanticism—which led to this via expressionism and its surrealistic epilogue. Style, which seemed to be the essentially artistic component of literature, became

the "wings" which concealed the prospect they were supposed to open up. The crisis of expressionism, which began to question the right of art to exist, arose out of the ambivalence of feelings which people had as to whether an artistic structure was not only the expression but at the same time something which could not be interpreted by expression and which the individual could not take his eyes off of, that, in other words, it not only consists of statements about other things but is simply there. People suddenly became aware of what they had never seemed to notice before, that the artist as the subject of the expression is often silent and that he lets the artifacts have their own way— language writes for itself, musical instruments sound out unimpeded, the film camera turns of its own accord—and, in Heidegger's words, he is gripped by the marvel of metaphysics, that something is there and not nothing.

Wilhelm Worringer considers that expressionism was already finished in 1920[20] and maintains that it, in accord with the dialectical bifurcation of the history of style, continues in two opposing directions in cubism and surrealism.

Cubism

The idea of art as pure form is almost as old, and sometimes seems just as attractive, as its function as expression and mimesis. Even Flaubert played with the idea and anticipated the principle of cubism as rigor of form and abstraction before the new strict style of formalism could make itself felt. In cubism—as the antiimpressionist style par excellence—the principle of abstraction finds its pure classical expression unsurpassed since ancient Eastern and early Greek art. Nevertheless, as is well known, it has its beginnings—in accordance with the contradiction of historical dialectic—in impressionism. Cézanne, its oldest representative, whose origins are in impressionism, not only renounces the nuances of mood and the color values of impressionist painting in the interest of stable structure and physical substantiality, but also gives up a series of other naturalist-impressionist conventions. He is the first person since the Renaissance to circumvent the rules of one-point perspective, with its unified point of view and the limitation of pictorial space to the perspective plane as the framework and stage of the scene being represented. He tilts horizontal planes for clearer visual orientation; by the use of broader brush strokes he emphasizes— in spite of all the substantial corporeality and the absorbing spatial depth—the planar nature of the picture; he groups his figures in the classical compositional style of Poussin, whose style he attempts to translate into the language of modern art. He is the first modern painter

to conceive a picture as a structured form, although he does not present the objects of his picture in strict profile or *en-face* and does not subject them to a geometrism of bald horizontals or verticals.

Actual cubism, as a style of solid substantiality, in which antiimpressionist objectivity, the feeling for what is stable and lasting in things, and in which the need for order, unity, and finality of structure achieve a fundamental significance, appears first—after various beginnings in late and postimpressionism—in the early works of Braque and Picasso around 1910. The desire for permanent characteristics in the artistic representation of phenomena is apparently a symptom of the concern about the continued existence of a world which is becoming ever more disintegrated and unreliable. The interest in the structure of objects and the analysis of their composition, in the various aspects from which they can be seen, in the dissection of solid bodies—instead of momentary and summary views of changing figures and the simultaneity of different prospects—is a mere sign of the change from impressionist subjectivism to a concrete objectivism and from an illusory to a realistic view of the world.

Contemporaneous with the development of cubism we have—in the artistic efforts of Kandinsky and the circle around *der blaue Reiter* which Paul Klee was soon to join—an abstract stylistic movement of an intellectualized, hallucinatory, and dreamlike character. This "abstract" painting, however, has nothing to do with the abstraction of logical operations and preserves the normatively obvious character of artistic structures. It may use figurative motifs (and this is often the case especially in Klee's works), may develop its motifs from natural, vegetable, or animal forms, or—as in abstract expressionism—may have a psychologically concrete content. Only in its purely geometric form, as, for example, in the work of Mondrian, does it lose its concretely objective basis and become an expression of a universal, formally conditioned system of coordinates, a nonfigurative art sui generis.

Of course, abstraction always was and presumably always will be an indispensable component of artistic form. Even in the most extreme naturalist art, it is not entirely lacking and is among the constitutive factors of aesthetic objectivity. Abstract and concrete are not only conceptually but also practically indivisible. They belong to the antinomies to whose dialectic art owes its existence. Abstraction certainly appears, like its opposite pole, to a different degree in different historical situations, social orders, and stylistic movements. The individuality of the present asserts itself above all in cubism and in the nonfigurative or figuratively deficient art of the period with the same resoluteness and brings about the actual breach with the imitative style

of previous centuries; in other words, it makes the final breakthrough to modernism. With the victory of surrealism, abstract and concrete, subjective and objective, rational and irrational appear in immediate juxtaposition, and what is really new vis-à-vis the art of the past is the combination of the two principles. Cubism itself, however, tends toward abstraction and is dominated by the principle of the analysis of form. We talk wrongly of a "synthetic" cubism; collage, which has been regarded as the realization of this style,[21] is already surrealist in nature. Actual cubism does not assemble the structures but dislocates them into parts, aspects, and views taken from different perspectives. The points of view which get displaced have a dynamic effect and carry becoming, happening, and time into the spatial element. Thus, cubism, thanks to its space-time complex, becomes an element of the art historical development in which futurism, film, radio, and television follow one another.

Cubism only has the effect of being predominantly formalistic, static, and stereotypical because of its rigid structural analysis. In reality it is by no means so inflexible. Totalitarian societies, whether progressive or reactionary, usually pursue an antiformalistic policy in art. While they cause the ideologies latent in art to become manifest propaganda, they imagine that there is danger in every form which, like cubism, is not readily susceptible of such manipulation. Radically socialist criticism of art, accordingly, sees in artistic movements which are ideologically harder to interpret and manipulate the more avantgarde and the more restricted to a small group of connoisseurs they are, the greater expression of "bourgeois decadence." But if we understand by "decadence" a lack of balance in the subject-object relationship, there is no movement in modern art to which this diagnosis is less applicable than cubism. In cubism both the personality of the artist and the objectivity of the work of art remain untouched. Cubist structural analysis in no way denatures the organs of sense in the way that Rimbaud, for example, wished to. It merely activates them in a particular direction in a more lively fashion than is usual. And its kaleidoscopic fragmentation of aspects does not annul the unity and wholeness of the objects, but merely lets them be observed from different points of view. Just as the elongation of forms in the works of El Greco did not derive from a defect in the artist's vision, so the split views of a violin in Picasso do not permit us to conclude that we are dealing with a "bourgeoisie which is at odds with itself." The formalism with which "social realism" reproaches the artistic avant-garde is that much the less applicable to cubism in that it is aimed not at subjective expression but at objective structures. It cannot by any stretch of the imagination be called formalistic in the sense of a playful aestheticism

untroubled by objectivity. The *what* of the objective structure remains more important to its adherents than the *how* of structural analysis.

The century's view of art revolves around what is objective in spite of the predominant interdependence of form and content. Thus, even a formalist as intransigent as Mondrian paints strictly geometric structures which have a symbolic meaning and which are the expression of a harmony which permeates the whole universe. True, the content is still abstract in comparison with the norm of the emotional and sensually differentiated abundance of the experiential reality and totality of art. The change of cubist abstraction into an intensified concreteness and an immediate sensuality takes place only with the development of the surrealist view of art and the translation of existentialism into the realm of art. From cubism itself there is still no path to freedom, and thus it remains at best an experimentation with forms of a "new realism."

If the pressure toward abstraction is really—as it is expressed in Dadaism, futurism, and expressionism and as it is interpreted in the aesthetics of expressionism by Wilhelm Worringer—a sign of discomfort and anxiety,[22] then we ought to see in the "new realism," even in its surrealist form, an encouragement to a new hope in the future. In reality, however, the realistic art which is conditioned by existentialism expresses more of an intensification than a diminution of the feeling of uncertainty and discomfort. Both present-day abstract as well as concrete art express pain and sorrow. Euphoria and happiness are only expressed in kitsch and trash. Even real art only points out how we can overcome the feeling of helplessness and desperation; it does not bring immediate comfort and salvation.

As every artistic form draws its material from an objectivity which resists the subjective impulse of the author, there is, in the strict sense of the word, only realistic art. We can only talk of abstraction insofar as there is distortion of natural forms in the artistic efforts of a given time. This itself is the expression of a reality, even if it is one which turns from outside to inside and from a physical to a spiritual direction. In the change, it is only the object and not the principle of the process which alters. Even new art, which may reject, antirealistically, the present conditions of existence as a whole, remains realistic with regard to the elements of which its negatively oriented view of the world is composed. The truth and credibility of the characteristics of the reflection of reality which are distorted by either vision or illusion are not based upon any intelligible view but on concrete internal and external experience.

People thought until recently that art and literature followed unconditional laws like that of unidimensional time, three-dimensional

space, one-point perspective, unified, logical, and psychologically consistent plot centered upon itself and contained organically developing characters, because these seemed to be the facts. The idea was first given up after it had been discovered, or it had been thought to be discovered, that these facts had no equivalent in reality. The pros and cons of the assumption were based upon a multiple conceptual confusion. Sensual perceptions, conventions, and artistic laws of form are in fact three entirely different categories. Conventions like polite forms or legal norms represent standards of behavior, not autonomous realities. Art forms, like the dramatic unities, the time continuum of action, or the tonality of a musical composition, do, it is true, present certain characteristics of a conventional sort, but they are not simple rules of a game, but complicated compromises between invention and convention, and are not taken from reality, but imposed upon it. Sensual experience is rightly considered as being by and large equivalent to reality even if it does not exhaust reality or even if the apperception does not consist entirely of sensually perceived elements. Art reflects reality only when it creates a mirror which is suited in its own way to reflecting it. What speaks in favor of artistic realism is that is proceeds from empirical experience, and what speaks for the limits of its realism is the fact that every authentic art contains an element that does not occur in ordinary experience. A painter's female figures are not women but "pictures." The artists who paint landscapes and still lifes structure them not only so that they correspond to reality but also in the way they correspond to the categories of painterly objectivity, the criteria of visual sensibility in general, and those of different artistic personalities in particular.[23]

Our concept of the work of art does not completely correspond to its purely aesthetic nature, which is distanced from reality, nor to its completely realistic nature, which coincides with our usual relationship to reality. We misunderstand it just as much if we judge it according to its aesthetically formal characteristics as we do if we judge it exclusively on the basis of its practical, functional ones, which are not distanced from life. The majority of recipients misunderstand it when they react to its impact as they do to the reality of experience, and if they are incapable of understanding that the proper receptive attitude assumes a partial dehumanization, but also a partial wrenching, of the motifs represented from the context of life in which they are normally seen. It is an equal misunderstanding if we understand by the dehumanization of a work of art an effect which merely concerns aesthetic sensibility but which leaves the rest of the person unaffected. Authentic art probably always finds its proper reception only in a specially appropriate and limited way, but it affects the whole person. The fact

that the work of art is not just a reflection of the object but is itself an independent object, a thing which has its own meaning and which makes its own demands for uncommitted consideration and judgment, does not mean that the rest of the world—with its significance for people and the ability of people to master it—is shut out. It is merely suspended; that is, it is for the moment "put into parentheses."

Surrealism

The modern movement which started with Baudelaire and was developed by the impressionists and the symbolists reaches the zenith of its development in the second decade of the twentieth century. In the third decade, the demands and goals of "modernism" are no longer topical, and poets like Paul Valéry and T. S. Eliot are no longer considered complex and extravagant innovators but "classics" whose importance is indisputable but who have already played out the most fruitful part of their historical role. The breach in development which took place is unmistakable, however numerous the threads may be that join the two periods together. The strongest link is between the ebb tide of expressionism and inchoate surrealism. The two have in common an intellectualistic reaction against impressionistic subjectivity in spite of the fundamentally emotional basis of expressionism, on one hand, and the nonemotional nature of surrealism, on the other. The surrealistic deformation of reality appears actually to be a direct continuation of its expressionist distortion, and we tend to blur the distinction between the two stylistic movements if we ignore the difference between subordination and coordination as compositional principles.

Dadaism grew out of desperation about the practical inadequacy of art and cultural forms and preached the return to chaos in the sense of a radical romantic Rousseauism. Surrealism, which, in a certain sense, recalls Dadaism, replaces blind iconoclasm by taking refuge in the underground streams of instinctual life and expresses the positive belief that it will find the source of a new truth and beauty in the chaos of the irrational, the unconscious, and the unsuppressed regions of the soul. The exponents of its earlier period of development believed that in the psychoanalytical method of free association and the exclusion of all rational, moral, and aesthetic censorship, they had come into the possession of a recipe for good old romantic inspiration. They also tried to rationalize irrational instincts, but their practice was far more pedantic and dogmatic than the principle to which their understanding of art, selective taste, and conscious criticism was usually directed.

Since the decline of additive forms of composition which followed the pattern of seriation and which were the dominant ones in baroque music, modern artistic styles were guided by the principle of thematic development and of dramatic conflict between the different elements of the work. In surrealism, however, subordination is once more displaced by juxtaposition, which now finds more or less general recognition in art and is at first more obvious in painting than in music. Previously the law of homogeneity held good for the composition of the components of a work and that of synthesis for balancing of the discrepancy. Surrealism now puts the motifs unhesitatingly together, but although their connection no longer follows the principles of classical art, which preserves the unities, there is not a total lack of coherence between them.

This relatively loose, even if by no means anarchistic, structure is best designated by the concept of montage, the open form which seems to be able to absorb everything, accords with no former norm, but is so structured that we seem to be able to recognize in its *post festum* an independent structural law which is independent of content and expression. The replacement of the organic structure which embraces the whole of a work and links all its components together by montage means, contrary to the concept of stringent composition, a principle of relative discontinuity and a mixture of different sorts of reality and media. The direct derivation of the disintegrated forms of art from the social and cultural atomization of the period would be pure equivocation. Its explanation as a symptom of the universal loss of unity and concentration, on the other hand, could not be censured in the same way.

The quality which is completely unique and which characterizes surrealism most emphatically consists in the composition of its material, on one hand, of elements which correspond to empirical experience and, on the other, of a supernatural hallucinatorily unreal or unconsciously irrational reality. There are two spheres of existence here side by side—a world and a superworld—and two styles—realism of details and irrationality of a whole. It is like the dream in which true-to-life details which correspond to empirical experience with the utmost accuracy are joined together in a fantastic framework and an improbable context. This dualism dominates the whole authentic art of the century, from the twenties to the present day. It is nowhere more sharply expressed than in the works of writers like Kafka and Joyce who, although they had nothing to do with surrealism programmatically, represent the movement in the broader sense just as faithfully as all the other stylistically advanced artists of the period.

It is with the discovery and development of this two-world system that the history of present-day art begins in the actual positive epoch-making sense. The spiritualistic transparency, the metaphors of communication, the feeling that behind every immediate reality there is an occult, only mediately comprehensible sense, the absurdity of what is immediate, and the doubtfulness of the value of communications form the essential characteristics of the new style. Above all it was the experience of this dualistic being which resided in two different spheres which brought home to the surrealists the relationship of their work to the work going on in the study of dreams. The experience caused the dream texture—in which reality and unreality, logic and fantasy, the sublimation of the rationalized being and the triviality of immediate existence formed a unit—to become the paradigm of artistic structure. The further the surrealists and their followers developed in the direction of metaphysical visions, the clearer it became that their works were not dealing with symbols of psychoanalytically analyzed and interpretable dream stories. Jean Cocteau already recognized that dreams leave reality untouched, that is, unaltered, however much they may distort its otherwise well-known picture, which is observed with a wakeful eye and comprehended by a watchful sense. The paintings of Giorgio de Chirico, Max Ernst, or René Magritte are no more dream visions than Kafka's *The Metamorphosis* or *Der Bau*. What is dreamlike in them is merely the finally inexplicable, unreal, fantastic connection between the real details which correspond to immediate perceptions. It is only the senseless juxtaposition and the improbable function of objects which are like the dream, not the noctambulist security or the unusual sharpness with which they appear. For in whatever way a dream may distort individual characteristics and the usual context of phenomena (and it may well express the idea that one cannot find one's watch in the pocket in which it usually is), it will hardly suggest that it is hanging over the edge of a table like a pancake. We may dream that a woman gives herself to us or rejects us but not that she opens up or closes her treasures like a drawer. It is not the discovery of the unconscious which causes a shock—for this seldom happens in this way—but the unreasonable combination of things which actually points to the absurdity of every combination, and its discomfiting, ghostlike, uncanny effect is generally achieved by careful calculation and only in exceptional circumstances by an automatic relationship to the unconscious.

The painstaking naturalism of detail and the unnatural, fantastic arbitrariness of their combinations, the ingenuity of the components and the nonsense of the whole, which are combined in surrealism, however, not only express the feeling that we are living on two different

levels or in two different spheres. They also express the thought that these areas of being penetrate each other so completely that the one cannot be either subordinated to the other[24] or contrasted with it as an independent area of power.[25] The actual meaningful content of the pictures is the inconsequentiality of existence, which has an effect all the more striking and disturbing the more independent the elements of the fantastic coexistence are. Simultaneity and juxtaposition, in the forms of which lack of simultaneity and irreconcilability are expressed, convey the desire to create unity in the atomized world, no matter how paradoxically, and at least to arouse the impression of a *coincidentia oppositorum*.

If we disregard the secondary characteristics of surrealism and regard, as the criterion of the essentially new art, a picture of the world which falls into two spheres and a view of art which is composed of two styles, then writers like Proust, Kafka, Camus, Gide, and Eliot can be seen not only as contemporaries sharing the same fate but as surrealists in a broader sense. Montage as a principle of composition is decisive for them all, at least in the sense of the heterogeneity of the elements of the artistic whole, the discontinuity of motifs, the free interpolation of episodes, the reversibility of the sequence of time, leaps backward and forward, the ability to repeat processes or to displace them perspectively, in short, of the dismemberment and the arbitrary composition of objects. Yet the attempt to connect these stylistic phenomena with the social mobility of the period again rests purely upon an equivocation and thus plays into the hands of the archenemy of the sociology of art and culture.

The lack of restraint in montage is expressed first in the apparent contingency of the motifs which are suited to surrealistic representation. But it is also apparent in the methods of artists like, for example, Picasso, who remarked that he never knew ahead of time what he would actually create. He would allow himself to be guided by his brush in the alleged autogenesis of his pictures; if there were no blue available, he would use red. In this way everything can become the object and medium of art. Everything is within its reach, so that a sort of mania for totality takes over. Everything can be related to everything else; everything seems to mean something other than itself and to achieve in this manner a double meaning and an enigmatic quality.

Surrealism, with its erratic transitions from one motif or aspect to another, follows the principles of filmic montage, which when measured against the order of all earlier art appears to be an anarchistic form of composition. This connects surrealism with Dadaism as the origin of the aggressiveness which is peculiar to modern art and places it among the century's characteristic and refractory avant-garde move-

ments. It wants to disturb, confuse, and alienate when it would be treason to encourage conformism. For surrealism the world consists, as it does for the film, of heterogeneous and isolated phenomena; a work of art consists of different points of view, close-ups, and long shots; artistic creation—in almost every form of art since futurism and cubism—consists of the analysis of perceptions and their structure. The only synthetic function of surrealistic montage takes place both in painting and in film by the grasp of the *simultanéité des états d'ame* and the representation of the simultaneity of conscious processes.

Since the adoption of montage as a form of composition, art has been affected by the film. The principle of montage is obviously at home in the film, and although we could previously come across structures which had the character of montage, their method first affected the other arts since the film. But it certainly is wrong to attempt to derive an artistic culture like the modern one from one of its forms. The film with its montage is, like the rest of the culture, a product of the same circumstances.

We have already pointed out the pedantic and dogmatic way in which the surrealist division and linking of motifs takes place. The method is linked to inadequacies as well as to valuable stimuli, but it would certainly be wrong to see in it, as Georg Lukács does,[26] a greater danger than in the other stylistic forms of present-day art. To borrow the term "decadence"—which is of itself a problematical one—from Nietzsche, who is all too flippantly rejected, would simply be too controversial. Ernst Bloch is far more objective and just, even if he does not differentiate sufficiently between the surrealistic and the expressionistic form of expression. With a sharpness of perception, he judges the linguistic peculiarity of modern literature more leniently and perceptively than Lukács. "What otherwise," he writes, "would be spoken, spoken wrongly, or made a play of words of in times of fatigue, in pauses, in a conversation, or in the mouths of dreamy or careless people is here completely out of hand. Words have become unemployed, dismissed from their sense connection; language now moves like a worm that has been cut up, now combines like a piece of trick photography, now hangs like a grid in the action. . . . Language scarcely follows grammatical rules, hardly ever logical ones (today's); its source is supposed to be a primarily tonal relationship, its meaning the release and the apprehension of subconscious existence; in this way it is brought back to life and the words are given back their prelogical value. . . . That is the highest and most crowded, the most unstable and the most productively grotesque, grotesque-montage of the late bourgeoisie! Trickery of every kind from a lost homeland, without paths, with mere paths, without goals, with mere goals."[27] However

stern this judgment may sound, it leads us to see—and this is the most important difference between Bloch's and Lukács's points of view— that without expressionist-surrealist montage it is impossible to think of any important artistic achievement even today.

The meaning of the current development can be seen from the situation into which we have come through the loss of trust in a reality which can be completely grasped by art. In the process of this development, art gambles the last remnants of its authenticity, and the otherwise closed microcosm of its reflection of reality everywhere shows flaws through which raw fragments, like direct quotations from nature, find their way into its system. Instead of creating a personally determined and objectively closed picture of the world, we grasp at fragments, reproduce impersonal structures, and try to reflect the world, which has grown meaningless and alienated, by means of disconnected, unarticulated exclamations, contradictory statements, and absurd references. Art which is striving toward surrealism by means of montage and *objets trouvés* already made itself known in impressionism. Impressionism prepared the way for a development which was not always directed toward an integrated representation of reality but sometimes to an emancipatory confrontation of the subjective and the objective world and chose the method of substitution in preference to that of imitation.

It was recently stated once again that what is found by chance is often more fruitful than what is sought after deliberately and achieved with great effort. But in reality, as Marcel Duchamp noted, his coincidence is not everyone's coincidence. Coincidence, like inspiration, only favors those who are able to grasp the opportunity presented to them. The film, in which coincidence as *trouvaille* of every sort plays such a large part and which tends to preserve the inspirations of the moment without changing them, is, in this connection, too, the prototype of the works of surrealist art in the success of which luck and skill, planning and chance discovery are equally involved. The belief in spontaneity and improvization is the basis of the doctrine of surrealism, which springs from the irrationality of artistic creativity, its origin in the unconscious, the faith in "automatic style," the doubt in the consistency and homogeneity of the elements of a work, and above all the unhesitating manner in which the real and the unreal are amalgamated in one continuum.

Surrealism is not dialectical. It denies the contradictory nature of the experiential and the imaginative elements of artistic representation, refuses to find and establish a rationally acceptable explanation of their relationship, where the border between them lies, and how their polarity can be harmonized. Its basic formula is the metaphor, just as it

was for mannerism, which is in a similar way conditioned ideologically. It functions like this because it is the completed stylistic medium of a pictorial language which is out, not to reduce the distance between picture and thing, but to increase it.

Ortega y Gasset mentioned the metaphor—in his statements about the dehumanization of art[28]—as the most creative form of the human intellect, the only one which breaks out of the reality of experience. In the process, however, he pointed to the taboo which avoids direct contact with reality, just as metaphors avoid the direct naming of objects.[29] According to this, metaphors were originally cover names which people used if something numinous or magic was threatening and which they did not wish, or which it was dangerous or forbidden, to call by its proper name. Surrealism exercises its influence in the same way, thanks to the tension which exists between two different but linked objects whose indissoluble nature forms the basis of the metaphorical relationship between thing and picture. Their combination first of all alienates, but then illuminates, an affinity which would otherwise be hidden. The creative quality of surrealism is completely like this sort of trope, which both reveals and conceals.

32 Symptoms of Crisis in Present-Day Art

Sincerity and Credibility

After the completion of the beginning of the development of modern art which we have just described, the modern age actually enters the critical phase of its history. There is a growing doubt about its practical function and the feeling that it is facing a fate in which it will be replaced by other products, in short, that it is approaching its end. The sense that it can scarcely pretend to be what it formerly was overwhelms its creators as well as its public. The doubts which are now being expressed about the continuing existence of art accord neither with the Marxist utopia of a classless society—in which art, too, would lose its special position—nor with Hegel's hope that history would end with the dominance of philosophy and absolute intellect. But it does not rest either on the impatience of the academically educated, conservative public toward an art which appears ideologically suspect or on the inability of the half-educated and artistically unresponsive classes to keep pace with the avant-garde. It is mainly a question of the predominant and, for many classes, decisive skepticism of artists and connoisseurs with regard to the meaning of their own works and of the ones intended for them.

In view of the impossibility of defining art logically and the difficulty of determining where it begins and ends, people are now satisfied with the dictum "art is what counts as art." People approach what counts as artistic structures with this totally unprejudiced and, in this sense, ready-made concept. After the leap from the usual categorically mixed experiential reality into the essentially homogeneous and immanent sphere of artistic sensibility and invention has been made, the gap between aesthetic and other conscious contents opens, and there is room for the particular phenomena—whether artistic or quasi-

702

artistic—of which we are here talking. If, however, this space, which is divorced from practice, though still communicating with it in many ways, is freed, then in principle anything can fill it out. It can be inferior or sham art. The quality of the stimulation to aesthetic experience changes nothing in the nature of the process, within the framework of which the effect is achieved. The liberal view of what can count as art is probably based on the concept of a transition from effect to acceptation, which has constantly to be surmounted, but it contains no explanation about the prerequisites for the leap that has to be taken, so that we can move out of the sphere of ordinary experiences into that of aesthetic ones. A leap of this sort takes place even at the lowest qualitative stage, for even if everything can count as art, nothing does count as it without certain, at least subjective, conditions.

We can only talk of a definitive end of art if we let it dissolve into practical functions which will one day lose their actuality and if we think that we can solve the problems which it was originally called upon to solve by other means, for example, as Hegel suggested, by science, or if we deny completely that the function of art can be changed. Two conditions undermine our belief in art: the first is the widespread pessimistic and nihilistic feeling for life and the conviction that mere ideology cannot help in the circumstances that persist; the second and more important, the scientism and technics whose media call into question the claim of art to be counted as a completely suitable means of communication. The romantics' objection to all nonromantic art consisted, as we know, in the complaint that these were not sufficiently spontaneous and not organic in the sense in which a plant grows. At the moment, on the other hand, what we find fault with in art is the striving for spontaneity, for an artificiality which is alien to the world and the resistance to the depersonalized mechanical factors of their technologized media. The popularity of the documentary, of reportage, of the scientific novel, of the pseudoscientific film, of the film in general, of radio and television as forms of electronic reproduction is symptomatic of the problematic of art at the moment. It bears witness to not only an interest in a new form of artistic pleasure but also the rejection of all previous sorts, without saying anything about the value of the surrogate which will replace them.

The most revolutionary innovations of one period can, as we know, very quickly degenerate into the most insipid conventions of the next. Every period of art, every style, every movement in taste begins with a struggle against the principles of form and the concepts of beauty of the preceding period. But never before was the militant readiness to disavow and negate what is traditional stronger than in the romantic

movement. The assault began with the attack on the benumbed and barren conventions of classicism and developed into a denial of all valid principles of inherited artistic practice. In this regard, the present seems to be the high point of the romantic revolution, although in other connections it represents the nadir of its influence. The current avant-garde with its distaste for emotional and one-sided subjectivism is completely nonromantic, but it can still be regarded, because of its anticonventionalism and nonconformism, as the continuation of the romantic crusade against past traditions and standards of value. Of course, on a level of culture which is so highly developed as the romantic one, there is no value which is completely free from worn-out and confusing conventions and no form which is completely free from dead and meaningless traditions.

The emancipation from certain traditions is an unquestionable condition for artistic progress, but the rejection of all traditional and conventional media of communication, of all media commonplaces and clichés, would mean the end of art and literature. For we do communicate through them rather than in spite of them even if they are only counters in the game of mutual understanding. The most original forms of expression fade and grow trivial with time, but at the same time the circle within which they can be used is broadened, no matter how much their qualitative artistic value is reduced. When the present-day neo-Dadaists introduced so-called ready-mades into art, they did succeed in confusing and often enraging the viewer. However, the direct use of trivial objects in alleged works of art, like a real coal shovel or part of a bicycle, soon became an empty convention and lost the power of protest against the tasteless fetishism of figurative expression which was carried on with older, less obviously foolish forms. Essentially, however, even the most unconventional mode of expression is still not artistic, and for this reason everything is not art which counts as art or which proclaims itself to be art.

Although the whole of today's art is derived in a certain way from expressionism as the reaction against the emotion-free, though atmospheric, impressionistic reproduction of reality, we do not understand it if we ignore its antiexpressionist, realistically unromantic nature and its indifference to feeling. We have to take its structures not only as "signs," symbols, or equivalents of something which they are not, but also as independent artifacts, things in themselves, objects which "are there" without meaning anything and before meanings can be attached to them. The antipathy toward the romantic emphasis on feeling and the subjective perspectives of impressionism develops in current art to an express and demonstrative anti-espressivo, which is certainly subject oriented in that it is based upon the perceptions of

an observer. However, in contrast to the novel of the generation of Gide, Joyce, and Proust, which represented not only an objective action but at the same time the developmental history of the time, it excludes the person of the author of the particular work and rejects the depiction of his own feelings, thoughts, and tendencies. This means, in any event, the loss of certain elements of the artistic structures, but by no means the collapse of art, which was never just expression, even if that was generally what it wanted to be.

The reduced role of subjectivity asserts itself in the theory of art first of all and most impressively as the explanation of the irrelevance of sincerity. Hypocrisy itself, as a favorite literary motif, is as old as mannerism and is obviously related to the phenomenon which we meet in the economic, political, and religious development of the period and which is known as the "Copernican act."[30] The fact already that the hypocrite, flatterer, and deceiver has become such an interesting figure seems to be significant for the period in which he is popular. However, it represents an essentially different circumstance than the admission that even the feelings to which an author admits may be insincere. The increasing significance of the hypocrite may be symptomatic for the society which takes pleasure in his characterization, but the interest in this type of person is by no means the same as the idea that insincerity of expression is more unobjectionable and suited to the essence of art than sincerity and openness. Diderot was the first to declare in his *Paradoxe sur le comédien* that deceit and sheer pretense are actually a condition of higher artistic truth.

Even Freud, who thought that he had recognized in the unconscious the unfalsified form of true instincts and inclinations, must have seen in their artistically sublimated forms vehicles of their distortion and denial. Now, however, no matter how much we owe to Freud's insight into the mechanism of deep psychological processes and no matter how much we may wish to preserve his doctrines, we no longer regard the unconscious in Sartre's sense, for example, as an area which lies outside our control, so that we have an undeniable responsibility for the processes which take place in it.

Sincerity, which is, moreover, not an aesthetic, but a moral and romantic concept as well, presupposes that in a work of art the author is talking to us in his own person, and, even if he is not identical with his hero he is at least identified with the narrator. Since the abandonment of the romantic theory, the place of this unambiguous person who is always identical with himself was taken by the changeable figure of the artist who does not have to have learned about the fate and the problems of his characters, does not have to possess their character

and inclinations, but merely has to have the *imagines* of their potentialities at his disposal.

Diderot did not condemn Rameau's nephew, but merely the society whose conventions produced characters like him. The antagonism in the attitude of such a person, who from the beginning exercised such an exciting effect, was first correctly recognized by Hegel and judged to be that contradiction which allows an amoral being and heroic rebelliousness to exist side by side. Hegel reproaches Diderot himself with not having emphasized this contradiction sufficiently and with not having recognized the significance of the "divided consciousness" of the whole Enlightenment. Hegel believes that it is precisely the hypocrite who is honest and unalienated, the person who does not become the servant of society but who protests against the rules of its game. This sort of interpretation, however close it may be to the latent dialectic of Diderot's process of thought, idealizes his unheroic hero by depicting hypocrisy simply as pride, though there is no indication of this in his work. For Diderot the social being was essentially an insincere, untruthful, rationalizing subject suppressing his natural instincts. Marx, in spite of his fundamentally positive attitude toward society as a whole, was just as enthusiastic as Hegel about *Rameau's Nephew* as the paradigmatic depiction of an insincerity which is produced by depraved social existence and the people who are corrupted by it. Both of them conceived the work as a call to revolt against the enslavement of the conformist being, alienated by conventions, a being who, in Hegel's words, would dominate through "absolute intellect" and who Marx would see achieving his freedom in the "classless society."

The Pressure to Escape

It is the loss of credit which "conscious self-deception" enjoyed which seems to be the most essential difference between modern art and earlier views of art. The reader no longer believes in the inventions of the author and considers his alleged feelings, tendencies, and views as mere fictions. That is to say, he considers not only the "I" behind which he hides himself to be a pure construction, but also the persons with whom he surrounds himself and the events by which he brings them into contact to be ready-made formulas. The "I" of the author appears as a personification of conventional attitudes, his characters seem to be manipulated like chessmen, and the events in which they are involved have the character of artificial patterns of action.

The release from the need to be sincere was apparently the beginning in modern art of attempts to escape, to shake off the chains of the past,

the traditions of outlived practice, and the conventions of its own contemporaries. Many of them had been prepared for a long time; others have only recently established themselves. The flight from sentimentalism, subjectivism, and naturalism which took place in the first generations after romanticism represented the first decisive step in the differentiation of this century from the last. Almost from the beginning there is an irrationalism attached to the unrealistic and impersonal tendencies of the later development. This is a flight from the logical and psychological consequence of action, from the inner motivation of attitudes and wishes, and from the attachment to a unified time and a continuous space which is clearly stratified. In partial conflict with the nonrealism of the new century there developed, on one hand, an indifference toward the artificially constructed and usually stereotypical plot and, on the other, a disdain for the authentic, individual artistic signature. The one sprang from the fact that the means of communication were multiplied bringing a need for documentation and for immediate and reliable information, the other from the discovery of the mechanical reproducibility of works of art.

The flight from hedonism of every sort is one of the most significant and meaningful statements of the new movement directed toward freedom from the past. After the impressionist stylistic goals, the avant-garde has particularly intransigently rejected anything which is pretty or pleasing, anything which is pleasantly enjoyable without effort, in short anything which we could call a "culinary taste" in art. The fact that art is not a pure unmixed pleasure and that the recipient has a hard task if he is to appreciate significant works of art adequately was obvious for a long time and proved unmistakable with respect to the older forms of art. What is new, on the other hand, is the perception that this task becomes daily more difficult in proportion to the degree to which resistance to what is pretty and delightful becomes a principle of the *anti-grazioso* and proves to be as irrevocable as that of the anti-espressivo.

The renunciation of cheap effects in art does not merely point to the seriousness with which its adequate reception is connected but also strengthens the shock effect which moves the beholder to look at the work from a new and more instructive viewpoint than would otherwise be the case. This effect scarcely comes about without a certain violence and without diverging from the usual and generally accepted order of things. In fleeing from all the traditional artistic media in the interest of contemporaneity and relevance art gives up, one after the other, sentiment, plot, and the hero, whose behavior is psychologically motivated, but it saves itself especially in the *nouveau roman* from what is quixotic, excessive, grandiose, and rhetorical—as forms of what is

fictitious, mendacious and unauthentic—by lapsing into banality as the last refuge of truth and reality. Art becomes undemanding, unobtrusive, nonprovocative; it learns to make do with modest means. Already for Stendhal beauty was merely a promise of good fortune and Walter Benjamin states, perhaps thinking precisely of Stendhal's words, that the participation of beauty in good fortune would be too much of a good thing.[31] A state of happiness is not entirely suited to the enjoyment of art, even if it is not completely antithetical to it. In any case, for a time like ours the words of Robert Musil are more to the point when he says that he collapses at the sight of the beautiful.

The elements which do not become merged in the organic whole of a work, beauty, harmony, euphony, play of melody and line, the "beautiful parts," for example, arias, even in Wagner's work, have lost their unique value in the art of the present. Today's antiimpressionism is opposed to all beauty as an expression of a harmonious existence. The art of the avant-garde is ugly and unattractive on principle. It destroys the colorful "painterly" values, the linguistically powerful poetic images, and in music as good as everything that impressionism preserved of classical and romantic melody and harmony. The anxious flight from what is purely decorative and pleasing, which—for all his impressionistic grace—began with Debussy and which opposed warmth of feeling with cold tonality and pure structure, was intensified in the works of Stravinsky, Hindemith, and Schönberg into a style which is at once antiimpressionistic and antiexpressionistic, and which completely eradicates all traces of the effects of the nineteenth century. People would like to write, paint, and compose on the basis of intellect, understanding of art, and criticism. Yet it is not the freedom and joyousness of rationalism which emerge from this but opposition to sensual happiness and a critique of what is purely instinctual. This is what creates the gloom, oppression, and torture of writers like Kafka, Joyce, Musil, and Beckett, of painters like Rouault and Picasso, most of the surrealists, and of the composers of the Viennese school. Linguistic images and linguistic music already begin to lose their old luster in the style of Camus and Sartre. Their art does of course consist of linguistic structures, but of ones that renounce all external beauty which exists in itself.

In this way the artist imagines that he can free himself from all obviously artificial elements, from everything which is purely constructed and mediated, and can reduce his material to original, untouched, and unmanipulated perceptions. But aside from the question as to whether or to what extent this is possible at all, it is still doubtful whether such perceptions can be expressed immediately and unadulteratedly. The epistemological question becomes more complicated by

being combined with an aesthetic one, namely, that of the existence of contemporary art at all. Perceptions can only be formed, communicated, and received with the help of a formal system, of a linguistic, musical, visual, or haptic apparatus. The media of expression, however, not only are essentially different from the material being represented and not only adulterate, from the beginning, the uniqueness and purity of perceptions, but also are highly artificial and at best form a dialectical unity with these perceptions in which the original quality of the perception is no longer present. However, in order that the aesthetic problematic become a "linguistic" one, that is, a question of medium, the doubt as to whether art has the right and ability to exist remains. The legitimate criticism of its maintenance can certainly only be answered by art itself. For even the doubt about art's right to exist and the continuation of art in a valid form bears witness to a lively artistic sense, to artistic sensibility, and to a feeling for aesthetic quality. Science, which people think may replace art, is not even in a position to measure its inadequacy. And science itself would not be what it is for us if there were no art in relation to which it took its place in the cosmos. If we need science, we need art, though of course for other purposes. It fulfills an indispensable and irreplaceable role even in the most critical phases of its development, even though doubts about its continued existence are voiced.

With the flight from plot, the propensity of the present for the factual and the authentic, faithfulness to what can be documented, the change of interest from what is fictional to what is real, to reportage and photography, several advances toward a new form of art and literature are beginning to appear on the road of modernity. These advance especially toward a new form of the novel and the film, but they are in no way essays which lead away from art, however decidedly people try to regard the phenomenon as a rejection of art and what is—beyond doubt—artistic in it as an unintended and insignificant by-product. Hero and plot, in the sense of nineteenth-century literature, seem to be empty stereotypical constructs, especially to the authors of the *nouveau roman* and the authors of the newest and most progressive films who are connected with them. "We want neither to create characters nor to tell stories," says Alain Robbe-Grillet, in a definitive sense. But even the works of Joyce, Camus, and Sartre are no longer concerned with heroes in the style of older examples of the genre, and the authors themselves are no longer psychologists in the sense in which Balzac and Flaubert were. The psychic processes may still be depicted correctly just as the details of a surrealist painting can be faultless in spite of the unreal totality of which they are a part. Nevertheless, the changed function and method of psychology is one

of the most significant signs of the change which present-day literature has undergone. The works of the successors to the great novelists of the nineteenth century are not "psychological novels" in the sense that *Eugénie Grandet, Madame Bovary,* and *Anna Karenina* were. There are no heroes—who correspond to stories which are reduced to atomized perceptions and which are totally lacking in tension—who function as substrata and focal points of the action. There are no protagonists, who would move in a particular psychological sphere of being which is antithetical to objective reality.

The depsychologization of the modern novel actually begins with Proust, who, as the master of perspectively differentiated and of caricaturingly enigmatic character drawing, represents the heyday of psychological narrative technique. At the same time, he takes the first step toward the disintegration of the psyche as the substratum of action which is developed in the novel. In naturalistic literature, psyche and character signified the opposite pole to objectivity, and psychology the dispute between subject and object, self and nonself. The significance of psychology changes with Proust. The psychic processes no longer form a mere hemisphere but the totality of the reality which appears to be worth representing. The psyche now becomes the intersection of what is within and without, instead of being the polar opposite of the outer world, and psychology ceases to be taken from a section of the encyclopedia of modern culture and becomes its summa. In this sense, Joyce's *Ulysses* is the direct continuation of Proust's *A la recherche du temps perdu.* It presents the whole picture of today's world and knowledge, just as it appears as the action of one day in a city. This day is the novel's actual protagonist.

Just as plot becomes document, so the psychologically differentiated and individualized hero of the novel becomes an anonymous person, a chance representative of the *condition humaine.* He is already without a name in Proust's work and is only very seldom—apparently arbitrarily and unintentionally—called by his first name. Kafka's protagonists are often called just K. instead of being given a name. In Beckett the chief character is usually anonymous or changes his name in the course of the narrative. The flight from the hero as a psychological unit appears to be more and more decided. The fate of the pillar of the action does not revolve around a crisis or a central crisis any more and does not aim at a psychic solution as the objective of events, but changes into a boundless flood of instincts, stimuli, and associations—which does not debouch anywhere—into a stream of consciousness, an "inner monologue," a dialogue without an interlocutor. The emphasis lies on the continuity of the psychic movement, the "heterogeneous continuum" of experiences, which is capable of absorbing

everything, of consuming it, and of destroying everything which is concrete and objective. The turn away from subjectivism which had been in process since the end of the romantic period and was completed by the impressionists led—as a result of the pressure of the disillusionment, despair, and hopelessness at the time of the two world wars and afterward—to an objectivism devoid of illusions. This objectivism found its expression successively in futurism, Dadaism, and cubism and was finally forced into the path of the "inner monologue," that undisciplined, mechanical movement which again and again strays into subjectivism.

All the attempts at flight which have been undertaken by present-day literature, the emancipation from emotions and hedonisms, the giving up of plot, hero, and psychological motivation amount to a flight from the communication of messages and rules of conduct, as is recommended most emphatically by the writers of the *nouveau roman*. In this sense Robbe-Grillet quite evidently maintains that the artist has nothing to say, and other representatives of the movement declare correspondingly that his task consists purely in the communication of his perceptions. However, they do not by any means always restrict themselves to tasks of this sort and sometimes with the best will in the world do not fulfill them.

The Principle of Negation

The rejection of the heritage of the past and the suspicion of everything which is traditional permeate the whole of modern art. The dislike for the emotional and sentimental, however, dominates the avant-garde's view of art, even if the half-cultured and those with no artistic pretensions still make the expression of feeling the criterion for their interest in art. The nonconformism of the progressives gains in trenchancy and intransigency as a result of the growing opposition to social conventions in the present period of criticism, revolt, and interest groups who grow more and more aware of their aims. The earlier forms of protest against the tacitly accepted rules of the game now develop into an express refusal to take part in the social game at all. All undertakings which are called "attempts at flight" can be interpreted as rejections and protests of this sort.

The avoidance of situations which are artificially created, of actions which are complicatedly developed, of sudden, surprising changes and *coups de théâtre* means that the artist is not prepared to accept human existence in its ubiquitously supervised state and that he wishes to see it reflected in its true uncounterfeited form. Fictitious actions, stories of strange, unusual happenings, and the pleasure taken in inventing

remarkable and strange events lose credibility and power in today's conditions of existence, where day after day and hour after hour the same activities and tasks are repeated. The amazement which Marx experienced at the continued effect of the *Iliad* in the day of the printing press increases in our mechanically ruled world—with its standardized products—to the point where everything marvelous is rejected in literature, unless it bears the stamp of phenomena which belong historically to the past. The news of happenings which were once communicated in the form of the saga, the epic, or the fairy tale comes to us today as authenticated information, and the most modern literature insists upon being topical and reliable.

The flight from plot and the reduction of the work of art to the document are justified, however, in modern literature not only by the avoidance of the outmoded traditions and conventions of the older epic, but also by the expression of the existentialist feeling for life, especially the conviction that in human existence nothing changes essentially, that decisions are seldom taken, although according to existentialist doctrine the taking of decisions belongs to the "borderline" situations, that is, the key situations of existence. A play like Beckett's *Waiting for Godot*, this paradigm of modern literature, has as good as no action. Its content consists in the vain struggle with a situation which remains unchanged, however unbearable it may appear to the participants. Even in a novel as rich in crises as Michel Butor's *La modification*, it is not the action which develops and changes. The situation at the end of the work is the same as at the beginning. What changes is merely the aspect from which it is viewed, and the author is talking only about the idea that it might change. There is never a real decision and an actual change in the critical situation.

The renunciation of "plot" as a means of promoting the credibility and contemporaneity of the story to be narrated is a completely modern phenomenon. The negation of heroism in principle is, it is true, first emphasized in modern literature, but a certain tendency toward the antihero can be seen in the whole of the development of the novel as it frees itself from the epic. This is true even if we disregard comic caricatures, the rogues of the picaresque novel, the ambivalent characters of manneristic works like *Don Quixote* or *Don Juan*, and the prototypes of the realistic novel like *Tom Jones* or *Robinson Crusoe*. There is no hero of a novel who is heroic in the sense of the heroic epic. Novels are not concerned with heroic courage, victory or defeat, but in the slow development of sober existences which are stranded and unsuccessful, which are slowly worn away and die and are either disappointed or resigned to the facts. The antihero, however—in the sense of a character which makes itself ridiculous, but from whom we

may expect a heroic attitude—is an invention of the nineteenth century and apparently a reaction against the romantic heroicization of the figure at the center of a dramatic action. The first important example of the negative hero is Myschkin in Dostoevski's *The Idiot*. From the end of romanticism and the beginning of modern disillusionment, no poetic figure is more of a hero, even in the relative sense of heroism in the novel. Even the heroes in Stendhal's novels are too complex and contradictory to achieve a "heroic" effect in the actual sense, and Flaubert's Gustave Moreau, Joyce's Leopold Bloom, Kafka's and Beckett's tramps represent deeper and deeper stages of degradation.

The deheroicization of the protagonists in modern literature began with the replacement of the courtly novel by the social one and of high tragedy with domestic drama. The change in both genres is connected with the Enlightenment and the transition of intellectual leadership to the middle class, even those living in more modest circumstances. The bourgeoisie came to power thanks to its criticism of the upper classes and preserved its intellectual superiority thanks to its criticism of itself, using in the process the services of the intelligentsia, who had allied themselves with it. Dialectic, which dominates today's philosophy, begins with this criticism and self-criticism. Nonconformism, which lies at the root of the whole way of thinking and which sees in everything at the same time a positive and a negative, an affirmation and a negation, solidity and dissolution of its own being, is without doubt one of the most important assumptions for the deheroicization of the hero in modern literature. The phenomenon of the antihero signifies not only a lack of the heroic, but also the reversal of the affirmation of the hero into his negation. In the dialectic connected with the process, we have the clearest expression of Hegel's "unhappy," anonymous consciousness which is at odds with itself, the consciousness, namely, which corresponds to the situation in which man finds himself as a result of the mechanization of his actions and his isolation in the midst of the mass industrial society.

Works of art have to confine themselves to what their authors really experience. They have to give up the plot as a mere fiction, the hero as an ideal picture, or even as the bearer of firmly delineated characteristics and psychology, as the hypothesis of context and the unity of his attitudes. In this way they have a more realistic effect than in older art, but they remain unconcerned with the epistemological problem of realism, as one of the distance between reality and illusion. They are thus basically unrealistic, autonomous and immanent, individual structures justified by their own individuality.

The negation of plot, of the hero, and of psychological motivation lead to the depersonalization and objectivization of the characters in

a novel, a drama, and other similar genres. The objectivization and immobilization of characters are most striking in the film, namely, in the art form in which this tendency is most sharply contrasted with the dynamic principle of representation. The emphasis upon the physical existence of the characters is especially impressive as a result of the contradiction between the dynamic and static moments of the structures. Their existence becomes a considerable and rationally impenetrable, simply irreducible point *(Diesda)*.[32] This is not to say that films with characters, objects, and attitudes of this sort are completely incapable of being interpreted. For what sense would there be in carrying out research on the interpretation of these phenomena if—as has been asserted—they cannot be interpreted?

The depsychologization of literature by no means signifies the nullification of the validity of psychology where there is a question of real psychological processes. For if we recognize a psychological competence, we can no more reconcile ourselves to violations of the laws of psychology than we can to contradictions of empirical truth in the case of objects of experience. Psychological motivation must, however, in such a case, be regarded neither as exhaustive nor finally as definitive. Attitudes and actions, feelings and processes of thought may remain impenetrable and incomprehensible in spite of psychological evidence. The literature of the present, significantly enough, is turning with heightened interest toward precisely these obscure phenomena.

In the period of doubt and suspicion which followed the period of romantic disillusionment and the effect of the two world wars, the depth psychology already practiced by Marx and Nietzsche was picked up again and further developed by Freud,[33] and it still stands the test as a completely valid method of psychic motivation. The cloaking of libidinous drives, which are forced into the unconscious, into acceptable, rationalized, or sublimated forms pursues a principle of denial just as much as the rejection and resolution of this disguise and the exposure of these drives, tendencies, and desires for what they are. Freud's method, which represents the interplay between disguise and revelation as the struggle between the ego and the id, does not remove any doubt about the authenticity of the psychic processes and does not lead, as Sartre maintained, to an explanation of the psychic mechanism, which would have a calming effect on us. On the contrary, Sartre stresses that Freud's division of the psyche into a conscious ego and an unconscious id does not assure us of an escape from treacherous concealments and revelations, but deforms psychic life, which—in spite of all its complexity—does reveal a basic unity.[34]

The psychic forces which Freud called the ego and the id and which he involved against each other in a war of extermination are actually

most closely connected with each other by a dialectic interaction and prove to be indispensable to each other. The ego is not so far removed from the id as Freud at first assumed; and the functions of both must be explained as phenomena of consciousness, now more, now less. In any case, psychic life is more unified than psychoanalysis would have it appear. The ego—in spite of its victory over the id—is not as unendangered as it appears to be on the surface. In other words, the individual psyche speaks—even if it basically appears to be one unit—not with just *one* voice. Freud himself recognized in the course of the later development and revision of his teaching that certain parts of the ego remain submerged in the darkness of the unconscious.[35] To insist upon a negation is here, as is usually the case, a sign of nondialectic thinking. It is a fact that every negation in our relationship to the world and our own psychic attitudes corresponds to an affirmation. The same is true of our judgment of art.

All the attempts at flight from the increasingly problematical categories of art, genres like the novel and the drama which led to the concept of the antinovel and the "epic drama" in Brecht's sense or of phenomena like antihedonism, antiheroism, and the dehumanization of artistic expression, which culminated in the principle of antiart and brought in their train the proclamation of the end of art, are symptoms of a nondialectic intellectual attitude. If people can declare that everything is art which claims to be art, then we can with the same justification cast doubts upon whether anything, no matter what it is, can finally count as art.

Present-day art has to be regarded in part as its own denial, that is, as a phenomenon which has at the same time positive and negative characteristics. Even what is artistically negative, what seems to have changed into qualitatively neutral statements, into mere invocation propaganda, or message, into pure information, science, or pseudoscience, moves—insofar as it has an effect upon our minds—in more or less unmistakable aesthetic categories. This is the case even though it does not present itself in the form of microcosmically organized, autonomous, and immanent units which could be called "works" in the traditional sense. In Adorno's words, "The only works which count today are those which are not works any more."[36] Or more clearly in a historical philosophical sense, "It is not the composer who fails in the work, but history which fails the work."[37]

Just as art has become historical and did not always exist, so it can also have an end, although every prognosis on these lines, like every historical prophecy, is dubious and cannot claim any unconditional validity. For just as art is not the mother tongue of humanity, so it cannot claim to be the substratum of a timeless value or a sediment

of eternal values. Crises in the history of art are constantly recurring and were, on occasion, very serious, but there was never even temporarily an end of art—at the most, some periods of art came to an end. Since the history of art has nothing to do with the progress of its quality, it may well happen that artistic production falls below the level it has already achieved and shows signs of collapse. Hegel observed such signs and drew the conclusion that art, "if we look at its highest destiny," had now become "a thing of the past for us."[38] In saying this, he was not thinking at all about the depravation of artistic quality, but of the inability of art to correspond to a standard of "truth," in the relevance of which he saw the criterion of what is artistically valuable. In this sense he says in his *Lectures on Aesthetics* that "art is no longer for us the highest way in which truth achieves its existence."

As limited as Hegel's influence has been for a long time, the renunciation of art has been in the air ever since he made his prophecy, in spite of the aestheticism which dominated the cultured view of the world until the beginning of the twentieth century. It did not just belong to the fin de siècle mood, unless the concept is applied to the close of an epoch which had lasted for several centuries and which corresponded to the end of a situation which had developed since the Renaissance, had lasted till the end of the last century, and was conditioned by rationalism and naturalism and industrial and trade economy.

Every normal artistic practice rests on dialectic, on the simultaneous continuity and discontinuity of its constitutive factors, on the simultaneous presence and interaction of the material to be expressed at a given time, the given media of expression, the structures to be received, and the ability to receive them. The language of art is handed down continuously, and the audience for art, even if it is reduced under certain circumstances, never completely disappears. But cracks do appear from time to time in the continuity, and they often seem to be signs of disastrous crises. We come across breaches of this sort at the end of the Paleolithic period, in the transition from classical antiquity to Christianity, and, perhaps less incisively, at the beginning of the romantic period, as well as at the end of the late- and postimpressionist styles, and finally at the end of the fifties and sixties of the present century. It is this last break which—only perhaps because we have witnessed it immediately—seems the most serious and seems to warn us of the approaching end of art.

The revelation that the paradox of existence conditions a meaningless, absurd art does not mean that it is superfluous and condemned to collapse. Even in our most painful misery and our most extreme inability to find words to describe our sorrow, we cannot renounce

it. For even if we find no immediate comfort in it, we are aroused by it to a consciousness of our misery, and, while we know "how we suffer" even if we cannot say "how we suffer," we have a vague idea in pointing out our misery that there is a possibility of overcoming an otherwise insurmountable danger which threatens us—as the work of evil powers. Even the most tragic form of art which points toward the most desperate state of humanity, because it is apparently inexpressible, gains meaning and aim through the idea or the illusion that what cannot be expressed can somehow be formulated, and so made tangible and conceivable.

Ever since the First World War, the aim of the avant-garde has been to discredit and undermine art. After the Second World War this tendency grew stronger, and since the sixties the aim of its authentic representatives has been and is still almost entirely to negate and dissolve principles of form which were formerly definitive. Nevertheless the work of destruction was carried out by artistic means. It was a new art of the ugly, the shapeless, the almost inarticulate, or of pure information, of direct propaganda, of publicity and incitement, which robbed the older art of its reputation. Apparently all these means had their origin in the practice of existence. The negation of a "final rationality, the meaningfulness of the world, of its openness and comprehensibility for the individual" with which Georg Lukács reproaches the avant-garde,[39] is not only its raison d'être—the justification of its influence—but also the reason, and the decisive one at that, for the change in style which it pursues. The media of expression which have turned to negation and inadequacy are just as much communications of immediately incomprehensible subjectivity as the positive and successful media of expression are of the directly approachable artistic volition. The old romantic ideal of the immediate expression true to the intention of the artist is less and less capable of realization in the age of increasing communications and of media which grow more and more autonomous. However, the obstacles which its fulfillment come up against are not essentially different from the old ones. The more strictly administered and the more rationally organized practice becomes, the less the chances are that irrational subjectivity can be expressed. However, a certain rationality of the media of expression will always assert itself in the face of the will to expression. What is new in the contradiction, which has been familiar from time immemorial, is merely the fundamental renunciation by artists of the domination of the content of what is to be expressed and the change of the fear of its invalidity into the desire completely to disfigure and devaluate it.

The radical denial of art could only take place by way of its total self-destruction, its arbitrary silence and rigidity. However, what seems at the moment to work as its forced abolition, and appears as though it were about to commit suicide, is, in reality, only its fear of being killed by a stranger. Definitive works of art are filled not with the will to self-destruction but with the fear that they will perish with our present society. The expression of this fear and the resistance to the fulfillment of such a fate is precisely evidence of its desire to live and of its vital force. As long as these exist, art will remain "art," and its apparent end is nothing but a bad dream. Even the structures the content of which is formed by the collapse of art are still works of art since they express a concrete outlook. They depict a state which is just as worthy of artistic depiction as others which create calm and comfort. Mondrian maintained that art is a substitute for the lost harmony of, and the lack of balance in, the reality which surrounds us. It is this, even if it expresses, however inadequately, the intolerable nature of our condition.

In Thomas Mann's *Doktor Faustus* we find—among the numerous significant statements and remarks about art, especially music—one particularly noteworthy passage. Leverkühn, the "hero" of the novel, had finished his last composition, the cantata *D. Fausti Wehklag*. After the exertion of all his powers, something which the composition of his work had called forth—a work, incidentally, which will never be heard while he is alive—he invites his friends, acquaintances, and all those who want to be present to listen to him play excerpts from the piano arrangement. Leverkühn merely wished to pour out his poor, tortured heart, and he says things, in introducing the recital which are shattering and almost unbearable—as unbearable to communicate as they are to hear. Then some idiot among those present calls out, "It is beautiful. It has beauty." The comment of the narrator contains the passage which is the whole point of the argument: "Some hissed," he said, "and I turned to the speaker, for I was secretly thankful for his words. For, although they were silly enough, they placed what we were listening to in a soothing and accepted light, namely, the aesthetic one, which, as unsuitable as it was and however much it annoyed me, did give me a certain relief. For it was as though an 'Oh, I see!' of relief went through the group. . . . Of course, people did not believe it for long, the *bel âme* view was not tenable for long."

The sense of the passage is not only that art—and it is in this that the full complexity and significance of art is expressed—is comfort, consolation, and message, but also that it serves life as a means of delivering people from sorrow and as a vehicle of aesthetic distance.

It further has the effect of intensifying life by its principle of *l'art pour l'art* and may ensure refuge from the most wicked iniquity.

More or less balanced elements of contradiction, that is, more or less completely resolved dialectical antagonisms, are present in every artistic attitude and achievement. Every aim meets with resistance, and everything which is allegedly definitive is questioned sooner or later. The principle of negation, which dominates present-day art, makes itself most decidedly known in the doubtfulness of the authenticity and relevance of the sincerity and importance of the author's apparent intention. None of the contradictory moments of the subjective urge to art and of the objective artistic structure are lacking in the process of the production and reception of the work of art. Yet its contradiction—the subject's struggle for recognition and the resistance of objectivity to the incursions of the subject—was never so focused as it is today. The emancipation of the work of art from the urge toward art corresponds to the reduction of the subjective moment which is expressed in the creative intention. The work of art is seen as an immediately tangible sensual object which cannot be reduced to an intellectual prototype and which creates its effect by its mere existence and by being what it is; it is "there" rather than "signifying something."[40]

The concept of aesthetic distance unites most unmistakably within itself moments of objectivity and subjectivity. Works of art are dominated by subjective impulses since they distance themselves from the facts of reality. However, as soon as they set themselves off from the external and internal reality which surrounds and fills the creative subject and stand there as closed and immanent subjects within themselves, they represent an objective principle which is alien to subjectivity. During the process of alienation both subjective and objective constituents validate themselves reciprocally. However, a work of art which has broken away from its creator is something objective, just as the creative intention directed at the work is subjective. The benevolent objectivity of aesthetic distance may show itself to be "untenable," and the work may become the raw material of another dialectical process. However, as long as it is distanced from reality and remains apart, it is not threatened and acts as an opiate.

The Crisis of the Novel
The Dissolution of Genres

All representative genres go through a crisis at one time or another, and this seems to threaten that they will succumb. These crises are usually the result of the destruction of the dominance of the social

classes or groups which supported them and whose ideology they praise and disseminate. The crisis of the epic began with the inchoate decline of feudalism, that of high tragedy with the Enlightenment and the rise of the bourgeoisie as the bearers of culture and taste. The crisis of the novel, which had taken the place of the epic, and that of the domestic tragedy, which had replaced tragic drama, began when our fathers' generation came of age and the capitalist bourgeoisie became a questionable entity. We, ourselves, are still deep in the critical situation and struggle with it, for if we do not roundly reject naturalism in art and literature, we do change its meaning in such a way as to alter the relationship between subject and object, and we eliminate or modify the originally constitutive factors of the novel—plot, character, and psychological motivation.

The crisis of a traditional genre and the creation of a new one which has changed conventions as its basis generally comes as a result of a criticism of a worn-out realism, whatever we may understand by the new realism. Robbe-Grillet emphasizes the fact that the *nouveau roman* starts with the inadequate realism of its naturalist predecessor in the nineteenth century and stresses that every change in style has its origin in criticism of this sort. Every artist regards himself as being more realistic than his predecessors; the question is only what we understand by "realism" at a given moment.[41] Realism appears as rationality to classicism, as irrationality to romanticism, as objectivity to nineteenth-century naturalism, and as corresponding to the perceptions of the authors to the partisans of the *nouveau roman*. The psychological atomization which presents the picture of reality as consisting of individual sensual experiences reduced to minimal contents has not been described without cause as a sort of *pointillisme*. It renders precise the realism of the reflection of reality, just as Seurat's and Signac's neoimpressionism did with the style of their predecessors.

The principles which unite the authors of the avant-garde, especially the representatives of the *nouveau roman*, into a particular category are negative rather than positive. They reject almost everything which had allowed the nineteenth-century novel to become an autonomous form, and this moment of negativity permits us to talk of a general attitude of rejection and particularly of an antinovel. The dissolution of the old form of the novel was taking place long before the new one was developed. The assertion, however, that Proust and Joyce had already destroyed the nineteenth-century novel, in which they themselves were still so deeply rooted, was nevertheless generally accepted and soon became a slogan of literary criticism.

First of all, the novel lost its fictitious character. The change as a result of which fiction had to give place to the document, was a symp-

tom of the turn to scientism and theory which had long been in the making. The great epic of the postromantic era has become a sort of philosophical essay and a pseudoscientific analysis. The scientific element which was to be found more or less sporadically in the novel from the beginning already plays a significant role in the nineteenth century. We know that Balzac anticipated sociological, and Dostoevski psychological, perceptions of a later period of development. Scholars and thinkers like Marx, Nietzsche, and Freud willingly recognized their services in this area. However, no one assumed, as they do today, that art was in danger of being superseded by science.

Documents may contain more valuable information than art, but art cannot be traced back to any sort of information which can be documented or which should be documented. In the same way, what makes art art cannot be replaced or even bested by any form of science. Every genuine art has a content of truth and should have one, but no scientific truth has the character of totality which a work of art has.

The scientific novel—no matter how diversely and multifariously it is labeled—which is to take the place of mere fiction suffers, in contrast to artistic truth, from a lack of that intensive totality which is part of every authentic artistic structure. Scientific states of affairs and their theoretical formulations are of necessity incomplete and fragmentary and will remain so until—in an unforeseeable future—an extensive totality of science is achieved. Art begins with a vision of the whole; science on the other hand ends with questions which remain unanswered, however small the range of the topic.

The scientific categories in which the reflection of reality may appear do not assure the novel any higher level of realistic validity than artistic mimesis contains in itself. Proximity to reality and truth to life and nature depend upon more complex factors than the use of those categories. The simultaneous regard for the various factors of artistic authenticity makes it more difficult to answer questions in relation to realism. The stylistic situation with respect to the degree of realism became particularly complicated, ambivalent, and generally contradictory with the development of surrealism and artistic practice influenced by surrealism. Joyce's and Kafka's novels, like those of Robbe-Grillet and Butor, are in many ways more realistic—in spite of their frequent emphasis upon the unrealistic—and more concerned with the exact observation of detail than those of older nineteenth-century writers committed to the most extreme form of naturalism.

The new literature's most remarkable stylistic characteristic consists in the fact that we can see in it just as much a reaction against the naturalism of the nineteenth century and an experimentation with unreal, irrational, and obscure aspects of existence as we can an enhanced

need for the communication of reality. Both tendencies, as they now appear, represent a rejection of the artistic efforts of the postromantic period. Yet the traditional forms of literature are more threatened in their essence and existence by the new mass media, film, radio, and television, than by science. Their crisis, which is becoming acute, becomes most obvious—whether in the drama, the novel, or the lyric— because of the changed form and function of the linguistic medium. The most striking sign of their disintegration and disorientation makes itself felt in surrealism and is expressed in the artistic medium of montage which developed from the film or parallel to it—a form of communication as a result of which literature only retained in a figurative sense a purely "linguistic" character. The almost unlimited freedom of use of language and media in general is used by many of the most advanced writers of modern literature, like Joyce or Beckett, as a way of handling means of expression so as to give the impression often that we are dealing with a juggler or a conjuror. Ernst Bloch describes this with the virtuosity of those who take part in it. "Here language is reduced to nothing but beginnings, to the degenerate beginnings of jingles. . . . The action moves between inner dialogue (which says everything that is going through a person's mind), underworld, crossworld, and overworld . . . obscenity, chronicle, twaddle, scholasticism, magazine, slang, Freud, Bergson, Egypt, tree, human being, economy, cloud, weave in and out of this stream of pictures, mingle, and penetrate each other in disorder. . . . Today it is all first and foremost a jigsaw puzzle of the exploded consciousness."[42]

The arbitrary displacement of the meaning of words and their bizarre connection with each other, the ambivalence of their function and the doubtfulness of their symbolism are the keys to this idiom. What is difficult is not the comprehension of the symbolic meaning but answering the question as to whether we are dealing with a symbol at all. This uncertainty arouses in the reader the feeling that he is in the presence of a mirage—even in the work of a writer like Kafka who is a highly disciplined master of language writing with classical restraint. The sensual phenomenon moves within touching distance and achieves an immediate clarity, but the hand which is stretched out toward it clutches at thin air as soon as it tries to take hold of it. Language—in spite of all the simplicity, clarity, and lack of ornamentation—is on the way to dissolving into a loose, allegedly abrupt process of consciousness which manifests itself directly—a solipsistic conversation without an interlocutor, an enforced, automatic, and ceaseless talking to oneself.

With the reduction of complex narrative forms to the simplest possible unmanipulated and verifiable perceptions in the *nouveau roman*

and with the elimination of everything fictitious in the so-called an-
tinovel, modern literature enters a decidedly new phase of its devel-
opment. The total abandonment of any form of plot or action may,
however, be as unrealizable in narrative form as the romantic ideal is
of immediate, nonclichéd completely spontaneous mediation of the
contents of consciousness in every communication. The elimination
of the fictitious does not only mean the restriction, but the total and
complete destruction, of the epic element. The artistic element which
is linked to every fiction represents in many ways the opposite of what
is artistic; in a certain sense, however, everything which is artistic is
also artificial, that is, it is the opposite of what has grown spontaneously
and organically, of what is unfailingly right and apparently necessary.
Just as every art is condemned to artificiality by the forms of com-
munication, so every form of narrative is condemned—because of the
action involved—to becoming antirealistic fiction (by dint of its
content).

The novel is the modern narrative form par excellence. As a narrative,
it is tied to a fiction, to a structure composed of conventional ready-
made components, as a modern artistic form, to a form of realism in
the present-day sense. What we expect above all from the author of
a novel is that he will tell an interesting story which will develop
organically and logically according to certain traditions and conven-
tions. The center of the story will be a protagonist or a group of
participants or a central problem, excitingly narrated and organized
by gripping complications and surprising solutions. It should have no
gaps, no unmotivated turns, should keep the reader's interest, and
stimulate it. However, we also wish that the story which is told should
not contradict the facts, in short, that it should seem as if the narrator
had actually experienced the things he is writing about, that he had
witnessed the events, although they are clearly fictional and appear
real only because there is a tacit agreement between the reader and the
author.

Now, can we still call a literary genre "novel" from which the
narrative has disappeared? It is in any event in the process of disap-
pearing, and the signs of this have been visible for a long time. "The
narrator—as familiar as the name sounds," says Walter Benjamin, "is
in no sense present to our minds in his vital activity. He is something
distant to us and something which is growing more distant all the time.
[Experience] tells us that the end of the art of narrative is in sight."[43]
The story which can be told in the novel becomes less and less relevant
with each succeeding generation. It is not the happenings, but the
things, the objects, which are and which are at rest, which often appear
more interesting and impressive than the characters and the action.

The crisis of the novel arises from the insight that the two constitutive factors of the genre—realism and the narrative form—as they have developed in the course of the last two centuries have become problematical as criteria for the acquiescence of the reader. After the critical examination of perception as a component of the structure of consciousness and of the analysis of the narrative as the reflection of reality, it transpires that even Proust's cautious and laborious penetration into the origin of his memories and of his development as a writer was self-delusion and self-deception.[44] In comparison with the complexity of the real psychic processes, even the most subtle psychology is revealed as all too mechanical, even though resting upon a sound principle. In view of motives of behavior which are left in the dark or the half-darkness and the instincts and desires which are unconscious or enter our consciousness indirectly, it loses its usefulness as a means of depicting the innumerable and complex processes which take place inside a person. It seems most sensible to *nouveau roman* authors who are in agreement with this view to register characters without commenting on their behavior, without trying to explain their doings, their attitudes, associations, fantasies, and inner monologues, and to reproduce their own perceptions as neutral observers without any construction or manipulation, without any theory or interpretation. Even the arbitrary, mechanical stream of consciousness which is without witnesses and is presented as a monologue seems to them to be an all too artificial and stereotypical aid. It seems to belong to the romantic heritage whose essence consists of the belief in the immediate expressibility of the psychic processes.[45] The criteria of artistic quality change radically in this way, and the aesthetic problematic becomes a purely linguistic one. People think they can save themselves from the dead end of psychology sometimes by the autogenesis and autonomy of language, sometimes by the noncommittal attitude of what cannot be expressed or articulated, by the ambivalence and multivalence of words, or simply by complete silence.

Beauty and elegance of style, the music of language, and the power of figurative language are in the process of losing their special value, although precision, flexibility, originality, the vitality and daring of expression retain their artistic significance. They belong to the criteria of realism in contrast to the irrelevance of "beautiful" style, which—at least in the novel—grows insignificant. A similar ambivalence of media can probably also be seen in the other artistic genres. However, we must consider that in the present crisis no other form of art, neither painting nor music nor even the other literary genres, has to cope with difficulties like that of obligation to narrative structure and of the simultaneous liberation from plot in the sense of a stereotypical an-

ecdote, the elimination of the hero as the psychological center of the action, and his retention as the protagonist. They are not faced with the devaluation and indispensability of language. Thus, we can talk most suitably of the present day—with regard to art—as the period of the "crisis of the novel." Music has given up tonality, the conventional forms of classical harmony, rhythm, and melody, and romantic-impressionist tonal quality. Painting has got rid of the need for perspective depiction, of color harmony, and of the balanced arrangement of the parts of a composition. The novel did not succeed in making such short work of the conventions with which it was burdened. Its history reveals from the beginning of the modern period a more tortuous development. Its products are not only the favorite reading of the multifariously stratified bourgeoisie but also the actual element of the literary avant-garde. The succession of its various movements reveals the conflict not only between realism and nonrealism, objectivism and subjectivism, but also of a continuous interchange of historical continuity and discontinuity.

Every new work of art is a unique happening, a case without precedent. Every novel by an important writer is a *nouveau roman* in the literal sense. Strictly speaking, none has predecessors or successors; every one is historically and aesthetically unique, tied to the instant of its creation, and—by virtue of its artistic uniqueness—different from every other product of the genre. If it identifies with a prototype, it is no longer a work of art. Thus, it develops from crisis to crisis, from revolution to revolution, from death to becoming. Like art in general, it changes its forms with unmistakable gaps, but with equally unmistakable signs of continuity. At moments when discontinuity dominates, as at the present moment, the breach seems to be irreparable.

The style of today's definitive novel is at once realistic and nonrealistic. The majority of the significant writers of the present—and among them most significantly Franz Kafka—represent immediate reality, in accordance with the legacy of surrealism, in such a manner that a reality which lies behind it is also revealed. This may be expressed in the form of allegories, parables, symbols, or metaphors; the essence of the structure which emerges is always divided into two spheres. No matter how true to life and rational, completely tangible and motivated the sensual details may, in the process, appear to be, the whole remains fantastic, irrational, enigmatic, and secret.

The writer does not, of course, as Robbe-Grillet maintains, find immediate reality ready-made. It is not yet available when he starts his work but only comes into existence with its help. The novel creates, so it is said, its own substratum when it is complete.[46] In place of abstractions, values, and concepts, it uses concrete objects whose es-

sence it sets forth and whose objectivity often remains the most lasting residuum of its effect. The nucleus of the objective world thus seems to lose its secrecy and to become tangible, but this is falsehood and deceit, for the sheer thing preserves its secret, just as the consciousness which gives meaning to the whole does. It is, moreover, also difficult to see why objects should lose their "romantic" subjectivity because of the emphasis upon their objectivity.[47] If they no longer reflect the "soul of the hero" or become the substratum of the author's moods, this is the result of the alienation of the subject from his environment and not of the fundamental surrender of the dogma that man is completely at one with the universe of things.

Even with this vital feeling of alienation, existentialism proves to be the ideological background to modern literature, just as since Sartre and Camus it has been to surrealism and the last adherents of expressionism. The distance between the psyche and things increases, and objects cease to be mirrors of moods and attitudes, emotions and frames of mind, because, for all their ubiquity, they have become distant, alien, and incomprehensible. This discord is connected with the end of romanticism only insofar as the concept of alienation loses the emotional romantic character—which it still had in Hegel's works—when realistic dialectical thought begins in the works of Marx, and it takes on the characteristics which it reveals, in part, in the works of the *nouveau roman*. It is true that already in Hegel the "unhappy consciousness comes into being" by means of the division between subjectivity and objectivity.[48] Alienation becomes a disgrace which can be cured by revolution only in the social world which Marx revealed. Or to speak theoretically, it becomes an intolerable contradiction—of the consciousness and the objective being—which has to be resolved by dialectical thought. It is a part of the self-deception of the writers of the *nouveau roman* that they believe they can complete this dialectic and eliminate the "unhappiness of the consciousness." They are just as unhappy and alienated from the world as the expressionists were before them and as the heirs to surrealism were after them, and they are—in spite of their empiricism—"without a world" in a way that the really great artists like van Gogh, Strindberg, Bartók, Stravinsky, Camus, and Kafka, who were adherents of expressionism and surrealism, never were, even if they do often make the fear of being without a world the central theme of their works. As promising as the program of the *nouveau roman* may be in this sense, the works of the movement contain little of what has been achieved and promised.

The *Nouveau Roman*

Like every new style, that of the *nouveau roman* differs from the older one by an allegedly enhanced realism. Its writers and heralds see in all earlier examples of the genre more or less arbitrary constructions which falsify reality—"fictions." In these, the so-called characters are artificially constructed entities of disconnected heterogeneous and un-integrated instincts, tendencies, and wills. The action is a series of conventional turns of events, complications, retardations, tensions, surprises, and solutions which are allegedly unexpected but which in reality have been done to death. The psychological motivation does not explain or justify anything, but merely simplifies and thus makes unrecognizable the attitudes which are often predicated upon innu-merable motives, and which are always complex and multifariously conditioned. The picture of the social environment which shows an obscure conglomerate of stimuli, efforts, hindrances, fulfillments, and frustrations is falsified since it becomes the scene of openly declared and completely simple points of view. The only reality on which we can rely, according to the writers of the *nouveau roman,* is formed by individual, fragmentary, disintegrated, self-sufficient perceptions—in antithesis to fictions, conventions, deceptions, and illusions. They are the apparently spontaneous observations and mechanical associations of the impartial narrator.

The elimination of the elements of the traditional novel—which was depicted in these statements as a series of attempts at escape—is es-sentially the result of the effort to escape from the general and the abstract and to stay within the limited, the definite, and the concrete. The narrower the circle and the smaller the extent of the observations, the more trustworthy does the picture of reality promise to be. And it is precisely in taking account of the triviality and the huge number of pictorial elements of this sort that people have talked of a psycho-logical *pointillisme.*[49] The statement, too, which could be taken as the motto of the whole movement, "Personne ne fait l'histoire, on ne la voit pas, pas plus qu'on ne voit l'herbe pousser," also points to a microscopic view as the basis of the *nouveau roman*'s depiction of existence. The eye practiced in art criticism will of course also "see the grass grow" and recognize the rudiments of action even in the works of the *nouveau roman,* no matter how disguised and distorted this may be.

The analysis of experience to which the theory of the *nouveau roman* subjects the perceptions of the narrator points to both essential, ob-jective components and conscious, subjective ones. Mere objectivism rests upon a self-deception of the same sort as direct immediate expres-

sion, completely transparent, purely subjectively colored language, and objectively unmotivated inflection. The *nouveau roman* simulates—quite unjustifiably—the possibility of a total objectivism and an external determinism, and is based upon a way of thinking in which the observer relies on nothing but his passively received perceptions, that is, on independent data which in reality do not exist. Even this obsession with the object belongs to the heritage of existentialism. Those favored by, and those who are the victims of, existentialism feel themselves surrounded by an alien and alienating, uncontrolled, objective world which somehow dominates them in a sinister fashion but which makes them responsible for all the decisions which have to be taken. The idea of such a "dehumanized world" is just as untenable a fiction as that of the "man without a world" in the sense of romantic subjectivism. Nothing, however, is more significant for the conceptual confusion of the *nouveau roman* than the fact that Robbe-Grillet, whose works are regarded as the paradigms of the objective representation of reality, free from lyricism and mood pictures, depicts his own point of view as a completely subjective one.[50] In fact both subjectivism and objectivism are as indissolubly linked in his definitive works as sensual perceptions and categories of consciousness in the critical theory of perception or as spontaneity and convention in artistic creation of every sort.

It has been remarked that the characters in the film *Last Year at Marienbad*, whose scenario was as we know written by Robbe-Grillet, give the petrified impression of statues and let themselves be moved around like chessmen, whereas the sculptures appear as though they were living characters. This observation serves as an example of the hallucination of being surrounded by unapproachable and, in some circumstances, threatening objects, which make us cry out like Natalie Sarraute, completely beside herself, "Les choses! Les choses!"[51]

The tendency of modern films to emphasize the link with objects and to treat the human element itself as an "object" has been observed by many people and interpreted as the origin of a new artistic principle. The fixation of the camera and its angle of vision and its fixed attachment to a single motif are obvious in them. But it would be just as precipitous and one-sided to see in this a sign of reconciliation with the world of objects as it would be to see it as an alienation from it. The attitude is the result of a complex relationship in which attraction and rejection are both equally expressed. A person feels lonely in the midst of alien things but has nothing else to cling to.

Now that the *nouveau roman* has got rid of all the elements of older novels, we have to take on the task of determining what the medium is which it uses, and of working out the criteria which the motifs used

for representation correspond to. With the exception of literature, whose medium, with certain relatively small deviations, is also the vehicle of normal extra-aesthetic understanding, new motifs gain admission into every form of art. They do this by adapting to certain principles of form, that is, to the particular sensual homogeneity, and they hold their own in it as long as they remain true to the form of the particular homogenization. In the film—in contrast to literature—everything has to assume a particular spatially and temporally mobile form, just as painting has to assume a purely visual structure or music one which is reduced to acoustic elements. Even literature is no exception to the general aesthetic rule, insofar as it talks in the same language but with a different dialect from everyday speech. What is artistically authentic has to be identified by showing that it expresses itself in the categories of *écriture,* an idiom which differs from everyday speech. Aesthetic problems in literature deal in part with questions of semantics, of the development of a change of meaning as the result of the substitution of one designation by another or as the result of different stages of linguistic reproduction, articulation, concealment, or suppression of the intended communication. The discovery that speech does not represent an unconditionally adequate expression of meaningful contents drew attention to the question, To what extent is it the source of autonomous and relevant aesthetic forms which differ from the rest of experience? On closer inspection, we were able to see that even words and syntactic formulas were not mere signs but also things, not only counters but also values, in short, that they not only mean something; they *are* something.

After the hero, action, psychology, society, author, and narrator had disappeared from the novel, people doubted whether it was able or authorized to communicate a trend-setting message. Claude Simon agreed with Robbe-Grillet's principle that the author of the *nouveau roman* "had nothing to say"—and his only binding commitment consisted of his relation to literature—in an interview which he gave about his own novel *Le palace.*[52] "It is completely impossible for me to say," he declared, "what my next book will be about. . . . I do not want to prove or demonstrate anything, merely translate my impressions into words, just as I experience them. This will produce a book while it forms itself" (un livre qui va se faire en faisant).[53] Natalie Sarraute stated most emphatically—in spite of her obvious sympathy with the political left—that the artist had to concern himself only with his perceptions and the sensually concrete picture of the world which is formed by them. His task did not consist in propagating a doctrine, an instruction, a prophecy, but in the replacement of the conventional media of expression by the expression of actual immediate experi-

ences.[54] Robbe-Grillet goes further along these lines when he says of Sartre's novels that they lead nowhere because the author knew where he intended them to go and because it was clear to him from the outset what he would say.

The representatives of the *nouveau roman* knew, just as the romantics had already known, not only that words are generally approximate but also that indeed they often actually lead us astray since they more or less neglect the individual quality of the objects to be depicted and do not let the intended aspect of their being come sufficiently clearly to the fore. However, it was not in the cards to derive an abstract literary formalism from the unsuitability of the literary expression. It was impossible to conceive an abstract literature in the sense of abstract painting, just because of the fact that every literary work of art contains, from the beginning, elements of discursive thought and the formation of logical concepts. The art of a Braque or a Mondrian could have no equivalent in literature even in, for example, the significance of decorative form in the lyric. Abstract literature in the Dadaist or the surrealist style, in the narrower sense, was far below the level of corresponding works of painting.

Just as unthinkable as a completely formless, unstructured, and anonymous representation of reality would be a work of art which contained no message, nothing about the ordering of existence, or no help in finding one's way through the labyrinth of life. The message may consist in doubting whether an unambiguous piece of advice can be followed, but it still remains a message. Even Michael Butor's novel *La modification* contains a message, even if it is one which says that we should abandon any attempt to follow it in the given circumstances. The author recognizes the unrealizability of the demand and confesses an unavoidable passivity. Only a real alteration of all the conditions of existence could bring about a change in the individual's life. But even a message of this sort, as disguised as it may be, is not a second-class message.

Whether someone is aware of such a direction or not, the writers of the *nouveau roman* do not set great store by the interhuman function, the humanistic, moral, and social value of their products. Those who, with Robbe-Grillet, agree that after the collapse of "divine order" art is confined to a "game," no matter whether the subject matter be love or revolution, words or deeds, see this game of art as differing from a game of cards or a form of sport merely in that it is not subject to any fixed rules, but is given over to the arbitrariness of the artist. These people will presumably remember Dostoevski's statement that after the collapse of religion, the end of belief in God and immortality, no moral law is valid any longer.

Robbe-Grillet analyzed the film *Last Year at Marienbad* as an example of many of the most significant characteristics of the *nouveau roman*.[55] First of all, the representation is identical with what is represented. The characters whom it is about only exist as long as the film lasts. They have no existence of any kind outside the work as it is projected. Their span of life corresponds to the running time of the projection. What, then, do these happenings we are witnessing represent? They must happen in someone's consciousness. But in whose consciousness? In that of the narrator, who is at the same time one of the film's protagonists? Or in his partner's, a woman behaving as though she were under the influence of hypnosis? Or are we dealing merely with the loose connection of moving pictures with one another? Would not the best answer be to depict the onlooker as being responsible for the action and to say that the happenings are a process taking place in his head? The work would not then be a representation or the evidence of a happening, but the hapening itself. Its immanence would be the actual criterion of its realism, since only so much reality would appear relevant as was expressly stated. Everything else would be as pointless as the well-known question in relation to Shakespeare's tragedy, How many children did Lady Macbeth have?

Reality which is immanent in the work and that which is beyond it are, however, not impenetrably separated from each other in art and, especially, in the film. Artistic effect is always conditioned by the dialectic of conscious and unconscious self-deception, total and interrupted illusion. Every concrete, objective art, that is, every one except music, architecture, and purely ornamental art, makes its effect by the illusion of reality. However, none of them maintains this illusion intact, that is, without letting it be seen that its picture of reality is mere "illusion." But even in becoming aware of the deception, we still move within the sphere of aesthetics and not in that of reality; thus, we think and feel undialectically and accept the simulations of art as an uninterrupted datum. Even if the receptive subject is warned that the apparent reflection is in reality nothing but a simulation, the signs of the warning are aesthetic in nature and not crumbs of reality which penetrate into art as a standard of what is authentic, even if such "natural sounds" are particularly frequent in the film. In this sense, it has rightly been pointed out that we learn—in a work like Godard's *Deux où trois choses*—apart from the fictional action—something about the private existence of one or another of the people taking part in the creation of the film. The communication is made with "filmic" media, for example, having the cameraman filmed as a private person by another cameraman.[56] The rule of immanence proves its worth when the given media of representation are not exceeded in any art form, and reality

can be immediately apprehended. In every form, however, the characteristics of the medium through which we apprehend reality remain perceptible.

The *nouveau roman* with its concept of simply "being there" in art and its rejection of the traditional factors of the "bourgeois novel" stands at the head of the avant-garde and permits us to gain an idea not only of the antinovel but also of antiart. If we want to define these, we must first designate them as a sort of practice in the reduction of criteria of what is authentically artistic to the lowest common multiple. However, negation in the *nouveau roman* in this way encounters another antithesis, namely, a positive which exists above all in the conservative and disciplined approach to language of, for example, Joyce and Beckett in contrast to the arbitrariness of many writers influenced by surrealism or existentialism.

The principles of the *nouveau roman* are extremely stimulating in spite of their limited ability to be carried out; the works themselves, however, satisfy at best those who support the movement from the beginning. However, they cannot fight with their predecessors about this any more than about taste. Their reply, for example, to the reproach that the *nouveau roman* is "boring" is, in all innocence, that its value consists precisely in wanting to express the boredom and futility of life instead of some artificially constructed "interesting" actions. They forget when they say this that, on the one hand, there is nothing new in such a plan since Flaubert and, on the other hand, boredom can only be represented artistically in an authentic and emphatic way in a nonboring manner. What is found boring is not the material but the way it is represented.

The Autogenesis of the Novel

One of the most significant changes the novel has undergone in its recent history consists in the metamorphosis of a narration of happenings which concerned the hero or a group of protagonists into the history of its own origins as a part of the autobiography of the author or as the depiction of the creativity which is his fate. The tendency toward autobiographical presentation by an artist which was finally restricted to the genesis of a single work had a long prehistory and developed, in the form of the *Bildungsroman* as it was written by Goethe, the romantics, Flaubert, Gottfried Keller, and Thomas Mann, into the form it takes in the works of Gide, Proust, Joyce, and many other modern writers.

It is a well-known and often remarked fact that the characters which the author sets in motion develop beyond him and go their own way,

often against the original intention of the author, toward a goal which often surprises him. The author who gives the impetus to a series of happenings may have no idea where the action he has started will lead—by following its own laws of gravitation. Once he has drawn the outlines of his characters and created the situations in which they find themselves, he can no longer do with them what he pleases.

If we are bent upon the creation of strange contexts, we can see in the autogenesis of the novel as an object of narration or in its genesis as the soil from which the life stories of its characters develop, a variety or prototype of the "scientific novel." Be that as it may, the autogenesis of the novel is, like the scientific novel, a by-product of the intellectualization which art has undergone and in the process of which it still finds itself. Art in its present form reflects this sedimentation. The novel, in particular, depicts—in the form of the history of its genesis—not only the characters as they are and the action as it takes place, but (much more) the mechanism through which the characters become what they seem to be and the events take the turn they do. Most of today's artists are completely conscious of their activity, their principles, their aims, and the values they attach to their work. Even if they are not aesthetes or even aestheticians, they are able to measure the aesthetic nature of their view of the world and the aesthetic quality of their works. The producer of authentic works of art also sees his own works, in the present circumstances, through the eyes of the beholder. In fulfilling this double function, he takes the decisive step in the history of literature, especially in that of the novel, on the way from a mode of expression which is still largely unreflective to a quasi-essayistic form.

If we look upon artistic expression merely as an excuse to say something which we do not wish to, or cannot, say directly, we can find attempts at this indirect designation—which merely outlines the object which is to be represented—everywhere in art. The essayistic element appears most frequently in the modern novel as the depiction of its own genesis, as it did for the first time in Gide's *Les faux-monnayeurs.* To what extent and in what sense the aesthetic element, as the factor which was actually planned and which is definitive for the value of the novel, is supplanted by this becomes clear in Gide's alleged statement that at the beginning he knew nothing but the title of his work.

Robert Musil's great novel *Der Mann ohne Eigenschaften* [*The Man without Qualities*] is also of a reflective-essayistic character; in it the description of the creative process is, it is true, completely missing, but in place of this every object and happening, every character and situation is looked at from different angles and judged from different points of view. However, no object is represented as totally under-

stood, in order to avoid the deception of its complete assimilation, thus, in accordance with the author's view, avoiding the diminution of its substance. A similar perspective, although a completely differently directed attitude, characterizes Proust's point of view and gave his art, too, an essayistic character. His *A la recherche du temps perdu* is at the same time one of the first novels whose content is essentially its own genesis. It is, however, Michael Butor who first expresses unambiguously what so many people felt and suggested before him, that it is in fact not the *romancier* who creates the novel but that, on the contrary, "c'est le roman qui se fait tout seul, et le romancier n'est que l'instrument de sa mise au monde—son accoucheur."[57] The novel is now "workshop and literature simultaneously," in the sense that Joyce's *Work in Progress* has been spoken of.[58]

Of course it is true that other works of art besides the novel contain their own genesis or motifs from it. Even Federico Fellini's film *8 1/2* and François Truffaut's *Les quatre cents coups* reveal autobiographical and self-analytical traits. Even the static forms of painting reveal a reflection of their genesis, or at least traces of it. In this sense the pop artist Robert Rauschenberg states that for him the process of painting is more important than the completed picture, which, as such, no longer interests him. And he adds that he is completely aware of the playful nature of this sort of activity. In fact, the game theory which we have already mentioned is just as close to pop art's view of art as that of the *nouveau roman*, so that it finds obvious examples in American "action painting" and in happenings. The experiments of John Cage belong in the same category of art, as do the improvisations of other avant-garde composers. They compose works which proclaim the principle of becoming, of doing, and of the involvement of artistic creativity in the process of life all the more openly because they not only organize the structures which are created according to this process, but praise the process rather than its result.

The desire of the artist to reflect himself in his work, to reveal his power as a creator, and to raise his genius—what God has granted him—above his work is not new, at least since Michelangelo, the late Renaissance, and mannerism. Since the romantic period, the process and the means of artistic creativity have become the actual source of inspiration. In modern literature—especially in the work of the symbolists Rimbaud, Mallarmé, and Valéry—the poetic attitude, the poet's sensibility, the struggle with his own material, and his design (with speech as the vehicle) and feelings (as the material of communication) become the special object of artistic style. It was from them that concern about the creation of the works—their prospering and their success—was transmitted to the novelist and the artist in general. Al-

ready in cubism and in abstract painting, we can see what Rauschenberg later stated, that the artist is more concerned with the way in which he creates than with the finished products of his efforts. He struggles for a method of production which is valid for him and would rather find the rule governing his own way of working than the criteria of an objectively valid quality. In this way every work becomes a sort of adventure, a leap into uncertainty, and what is not vouched for, the product and success, become things of fortune and chance, a prize and a reward which are constantly at hazard.

The presentation of the means by which the desired effect is achieved is particularly conspicuous in the film, especially in the work of directors like Godard and Bergman, or of authors like Cocteau and Robbe-Grillet. Obviously the work of these filmakers is accompanied all the time by a constant self-reflection, the consciousness of the possibilities and limits of their activity, and the play with the abolition and re-creation of "conscious self-deception." Essentially, it is a question here of the extension of the limits of the work of art, as a microcosm, which allows nothing which is beyond the work to appear in the artistic experience. This backward and forward movement between immanence and transcendence, between aesthetic distance and empirical immediacy is a symptom of the same feeling for life which was the basis of the surrealist juncture of realism and nonrealism, rationalism and irrationalism, nominalism and universalism. In the last resort, it appeared as a result of the ideology which expressed itself in the dialectic of "rule and be ruled," of individuality and community, of historicity and the claim to supertemporal validity. It led to the Hegelian "unhappy divided consciousness" of mankind, after the ego, which he had renounced, turned his self-consciousness into a thing—an objective object.[59]

The "inner monologue" as a form of self-alienation of the subject which has become a pure object is absolutely constitutive for the present-day novel. This is especially true of the *nouveau roman*, which only becomes what it is because of what Natalie Sarraute understands by "the attempt to take hold of perceptions in the condition of their creation." Its author is able to free himself from the artistic media of the older novel more completely in this form than in any other. The inner monologue consists of a flood of memories, impulses, and associations, which is not bound to either a continuous plot, a hero as the object and bearer of the psychic processes, or any chronology, no matter how ordered. Its total objective content resolves itself into a subjective stream of consciousness which is conditioned from within and which loses every grain of authenticity by its loosely ordered alienation. It furthers repressed instincts and hidden desires, disagree-

able and forbidden tendencies, needs whose satisfaction is mostly found in the unconscious. The concept of the inner monologue would, however, be too narrowly conceived if we were to restrict it to episodes like Molly Bloom's erotic fantasies in James Joyce's *Ulysses*. The whole of modern literature from Dostoevski's *Notes from the Underground*, Proust's great novel, Kafka's works, Camus's *L'étranger*, Sartre's *La nausée* to Samuel Beckett's novel trilogy consists of, or is full of, inner monologues. The earliest example of its use in Edouard Dujardin's *Les lauriers sont coupés* goes back to the end of the eighties of the nineteenth century, that is, to the beginning of the crisis the course of which conditions the history of the modern movement.

If we look closely, it appears that neither the objectivism nor the subjectivism of the philosophical outlook and feeling for life, nor the dialectic of the two, fully applies. The inner monologue is subjectively and objectively a nonsubstantial, disordered, heterogeneous continuum, an unrestrained pouring out of ideas and associations, a torrent of thoughts and words which flows not only without an interlocutor but without an actually positively identifiable speaker. The subject, uncontrolled, sunk in his own automatic associations, ranging freely in his unarticulated, unstructured, discontinuous process of thought, with half-conscious instinctual urges, unrestrained desires, and freely ranging fantasies, is no longer a firm substratum of the psychic processes. The speaker of the monologue resolves himself—torn from the stream of ideas—into the anonymous objectivity of unconscious or half-conscious psychic and linguistic structures and really becomes the "one" to which Heidegger believed he had reduced personality.

Proust and Joyce anticipate the form of the inner monologue with emphasis upon the unbroken confluence of arbitrary memories and mechanical associations. For them it is not the externalization of inner processes but the internalization of kaleidoscopic reality, caught in constant metamorphosis, which is determinative. Proust's long-winded telescoped sentences, his pages-long, unbroken sequences of pictures, and the statement that his works would most suitably be written in a single uninterrupted paragraph are, in spite of is heterogeneous material, just as characteristic of the structure of the unarticulated continuous inner monologue as the unpunctuated last forty pages of *Ulysses*.

The Legacy of Surrealism

Surrealism's remarkable products were in painting; compared with painting, literary works are insignificant. Nevertheless, it is writers who, in the last two generations of the avant-garde, are the most

qualified administrators of the surrealist legacy; they are representatives of the most recent artistic movement to come under the influence of surrealism, with Kafka and Beckett at their head. What is surrealist about them is their divided picture of the world, the makeup of their style from realism and nonrealism, worldliness and other-worldliness, the superficial and the enigmatic, experience and hallucination. The other decisive factor of surrealistic structures, montage of components, which seems to be indispensable in Joyce's and Proust's style, is completely missing in their works.

"Little of what is written about him counts: most of it is existentialism," maintains Adorno about Kafka.[60] But however little the voluminous literature about Kafka counts, the statements about his roots in existentialism, whatever our attitude may be, are important. They bear witness to the fact that the existentialist consciousness of life as the source of artistic creativity is far more important than its significance as a philosophical doctrine and, as example proves, lasts longer than this. The most existentialist aspect of Kafka's view of human existence is pessimism, hopelessness, and angst, the fearfulness of which is most unrestrainedly expressed in the conversation with Max Brod, which is so often quoted: "Our world," said Kafka, "is nothing but one of God's bad moods, a bad day." "Then," asked Brod, "there would be hope outside our world?" "A lot of hope, infinitely much hope, only not for us."[61] The existentialist character of the answer is not expressed so much in the vanity of a particular hope, but rather in the absurdity, senselessness, and futility of *all* hope. And this is the quintessence of all Kafka's works and sayings. What he wants to say is essentially confined to the fact that there is no salvation and happiness in the cards for human beings as they now are. They will never be conscious of the meaning and the point of their existence and will hardly ever find a possible path of appeal against the judgment which has been passed on them. This conception of the labyrinth in which they are trapped has ensured for Kafka an almost uncontested place in the eyes of the literary, if not the political, avant-garde ever since the discovery of his major works at the time of the Second World War—up till then they had been concealed.

Nobody besides Kafka was capable of expressing the feeling of angst, oppression, and panic which filled the surrounding world with the same force and suggestiveness that he did in his works. The expression of fear which he found became the criterion of what was artistically authentic and relevant, and the reassurance and glossing over of the existing danger became a sign of lack of sensibility and intellectual adequacy.[62] Art which does not make the angst which troubles people into its central theme now seems outdated and unable to give a proper

picture of the actual processes. Lukács's argument that the world only makes those fearful who look at it fearfully[63] is insufficient, in spite of Hegel's "whoever looks at the world in a reasonable fashion will be seen reasonably by the world!" The world is also responsible for the way people look at it. Hegel's and Lukács's composure is no less ideologically limited than Adorno's angst. Even Kafka expresses a quite specific ideology in spite of his apparently apolitical attitude. He belongs to the desperate ones who, for all their liberalism and nonconformity, do not quite believe in the Marxist prophecy and are not exactly enthusiastic about what its promises seem to hold for them.

The presupposition of the artistic expression of this ideology was the emergence of the testament of surrealism, which Kafka, like no one else, knew how to grasp and to fructify. Thus, he became a model for the whole avant-garde, which stood outside the *nouveau roman* movement—which they found all too dogmaticalty oriented, too restricted to the narrow point of view of its program, and fruitful only in its criticism of conventions.

Hopelessness and godforsakenness mean one and the same thing to Kafka, but they do not produce a feeling of empty irreligiosity in him, rather some religious "longing for comfort and redemption."[64] It is a sort of concession which he makes to the predominant nonrationalism, a sign that in spite of his agnosticism he remains a mystic who hopes to save himself—from the bankruptcy of reason—by faith as a desirable though inapproachable absolute. There are indications of Kafka's piety in his friends' reminiscences and in his own works. It is, however, difficult to make out whether the confused view people have of divine power corresponds in his view to no actual reality, or whether he admits the existence of such a power but considers its form so far beyond reason and so incomprehensible to rational thought that every statement about it seems to him from the beginning to be false and inadequate. The picture of heaven with choirs of angels and saints seems to him no less absurd than that of a Last Judgment in an attic.

The structure according to which Kafka represents today's completely organized and totally administered social existence is that of bureaucracy. It is neither a symbolic nor an allegorical nor a parabolic form, but one which is completely metaphorical, like that of a beehive. Both of these pictures say in an indirect, transferred way what the phenomena mean directly. Symbol, allegory, and parable designate a meaning which is hidden behind their external form and which has first to be discovered and revealed. They explain and teach what things mean without bothering about what they are. Even the metaphorical mode of expression which Kafka uses proves to be an indirect and unusual, though not exactly simple, presentation of facts. This indi-

rectness is in no sense the result of a hidden meaning, but, on the contrary, it avoids commentary by not attempting interpretation and explanation; it merely looks at things as they are. Kafka does not append any explanation or conclusion to his reports. His strange narratives, macabre adventure stories, and hallucinations are just as mysterious and unfathomable at the end as they were at the beginning—after all their twists, excursus, and philosophizings. His characters and their fates are, and remain, what they seem to be. They have no "deeper meaning." No interpretation could lessen their strangeness, no commentary reveal the laws which govern their actions.

Kafka's view of the world is immediately connected with his metaphorical mode of expression. Just as directness and indirectness are part of this, so his statements about people and conditions are to be understood to be both literal and farfetched. His metaphorical style is an indirect figurative speech which uses terms which are less usual and as surprising as possible rather than usual and well-known ones. However, in contrast to the symbol, allegory, or parable, it is direct speech, insofar as the author uses an out-of-the-way word, a speech which does not distort the original and fundamental meaning of the thing to be described and says no more than the designation it replaces and displaces. The motifs of Kafka's novels and stories are mere metaphors of solitude, alienation, and the unbridgeable gap which divides us from a satisfying meaning which will dispose of all uncertainty and doubt. The motifs are well known: the protracted trial which refuses to say where guilt lies, without prosecution or the attempt at a defense; the unapproachable castle with its innumerable offices, influential civil servants, silent porters, and closed doors; the son turned into an insect, despised and exploited by his family; an underground building with its yawning depths, emptiness, and silence. The assumption that we are dealing here with allegories[65] or symbols[66] is obvious since, like these, they stand in need of completion. They point to a nonexpressed meaning and, like symbols, retain in all circumstances the concrete nature of the individual case. But they lack—and this is the decisive difference between them and other figurative forms—the ability to relate to something universal and abstract.

The fate of Kafka's characters, of the bank official K., the surveyor in *Der Bau*, Georg Samsas or whoever it is, is always that of the single, unique, and noninterchangeable individual who has little to do with the human lot in general or with the superpersonal meaning of existence. In every case it is a question of a personal decision, a particular choice, a consciousness of guilt which is so enormous that any guilt which could be conceptually formulated would only lessen the degree

of responsibility and reduce the incommensurability of guilt and expiation.

The uniqueness of Kafka's art consists precisely in the fact that it distances itself, like all authentic art, from empiricism and theory, but that the "aesthetic distance" which it reveals cannot be exhausted with the catchword "typical," which means so much to Lukács, among others. It is better to stick to Goethe, who, it is true, sometimes talks of the value of typology and of the typical but whose distinction between symbol and allegory proves itself—precisely in the works of writers like Kafka—to be more fruitful than the distinction between the typical and the individually naturalistic. Kafka does not have a vague idea of an a priori abstract concept in his figurative forms of expression in order to seek a suitable image afterward—something with which Goethe reproaches the allegorist. Kafka always saw concept and image, phenomenon and metaphor as inseparable. His works from the first are based on a metaphorical conception in that they clothe individual instances which are represented with the greatest fidelity to nature in a hallucinatory, but never "profound," form. His style is essentially free of images; it is an objective, lucid, unornamented prose. Every one of them is, as Goethe says again, a single large trope, but it does not contain tropes.

In spite of the stereotypical nature of certain motifs and problems in Kafka's work—especially that of his constant feeling of guilt and of the insurmountable paralysis which prevents him from reaching his goal—he always sticks to the individual instance and the uniquely concrete form in which he represents the human lot. He never tries to go beyond this and construct a universal concept, an idea of the human being and of human existence. By refusing to name the unnameable eschatological things, existence in its complexity, with its insoluble contrasts and unfathomable motivations, the relation between being and consciousness, thing and person, instinct and reason, which are at the base of his art, he became the pioneer of modern literature in which absurdity, the unexpressed, and the indication of the unspeakable play so great a part.

For the whole of his life Kafka was an almost unknown and almost completely unread writer, whose works, with the exception of a few short narratives, remained unpublished. It was only after his death, actually after the forties, that he found a group of admirers and imitators. Yet it was only recently, that is, with the emergence of Samuel Beckett, who was still a long way behind him, that he found an actual successor and continuator. The historically developmental, and by no means qualitative, progress consisted in the fact that Kafka indicated what was actually inexpressible in the most articulate possible form,

whereas Beckett started out from the point that what was discursively unmentionable can only be communicated in some way by the regression of speech to stuttering, blabbering, and prattling. For Beckett the words which have become meaningless can to some extent become transparent by repetition, disintegration, and atomization, and the sense which is hidden behind them can be guessed at. But what he really revealed from the beginning was a world which had lost meaning, rather than a hidden meaning. He is still engaged in depicting people who try to make themselves understood by shouts, cries, mumbling, and whispering, but who remain, in defiance of everything, unapproachable and incomprehensible. His stories without events, his statements without listeners, his monologues which are spoken by no identifiable person take place in a medium devoid of time or place, somewhere and at sometime either before or at the beginning of the decline of the world. The *condition humaine* is, in his sense, the agony of humanity as it goes to its end. The existence which humanity has led since the loss of reason, of self-consciousness, and of the ability to express itself is a flickering up of the last vital spark as a herald of the end. As a conception of the situation in which we find ourselves, this may appear exaggerated, one-sided, and ideologically biased; nevertheless, in the form in which Beckett presents it, it does have an authentic and artistic relevance.

With his concept of human existence, Beckett does assume a remarkable position between original existentialism and critical post-existentialism which is in part politically committed and in part Marxist oriented. He persists in the hopelessness of the situation, the irrationality, and the contradiction of human consciousness, but finally has doubts even about the relevance of this schematic view of the world. Thus, it finally reaches an unconditional nothingness, the irrelevance of alternatives, in short, the absurd formulation of the absurd. If Lukács improperly simplifies the interpretation of Beckett's works when he says that they "reduce reality to a nightmare, if possible, in the vague consciousness of an idiot,"[67] Adorno, for his part, arbitrarily complicates it when he denies, probably justifiably, that the desperation of which Beckett is talking has to end in idiocy. However, he does not take into account the fact that the artistic expression does not have to be of the same kind, indeed cannot be of the same kind, as the circumstance which has to be expressed.[68] Lukács neglects the significance of the step which Beckett takes beyond existentialism; Adorno in contrast underestimates the attendant difficulty, on one hand, and overestimates the effort, which is in part vain, that the author makes to achieve this, on the other.

If, as we said above, Beckett stands in between existentialism and the world which subsequently evolves from this, what we are really saying above all is that he gains his significance precisely by the step he takes beyond existential fatalism, which he represents not as something which has been or can unconditionally be done, but as something to be done. The fulfillment of the task begins with the recognition that the existential category of mere existence leads from the outset to emptiness and nothingness and that existence forfeits its concrete being with the characteristics of timelessness and nonworldliness and loses itself in the abstract.

If existence really resolves into nothingness, then the assertion that a thing is either black or white would be too much, for this would establish the antinomy, and the disposition to living or continued existence would be removed. But things have to be divested of their one-sidedness, and this is the beginning of an insight into necessity: they must be determined as neither black nor white, but gray, gray-in-gray, that is, without quality, neutral, lifeless, destined only for a questionable reawakening:

> **Hamm:** The waves, how are the waves?

> **Clov:** The waves?
> *(He turns the telescope on the waves.)*
> Lead.

> **Hamm:** And the sun?

> **Clov** *(looking):* Zero.

> **Hamm:** But it should be sinking. Look again.

> **Clov** *(looking):* Damn the sun.

> **Hamm:** Is it night already then?

> **Clov** *(looking):* No.

> **Hamm:** Then what is it?

Clov *(looking):* Gray.
(Lowering the telescope, turning towards Hamm, louder.)
Gray!
(Pause. Still louder.)
GRRAY!
(Pause. He gets down, approaches Hamm from behind, whispers in his ear.)[69]

The leitmotiv of Beckett's works could be the statement "There's nothing to be done." They revolve around the renunciation of all action, around the loss of hope that something could change. Even *Godot* is an "endgame," a situation without a sequel. Nothing happens and nothing can happen which would not have already taken place. Beckett's ideology is completely ahistorical; human existence, as he sees it, is removed from time and the world. Yet he must have imagined it, caught as he is in the existential origin of his thought, as something independent of time, history, and society. However, we know that he actually viewed it as corresponding to historical time and its social conditions. Humanity stands at a crossroads where it means nothing particular any longer, neither for itself nor for those who observe it:

Hamm: We're not beginning to . . . to . . . mean something?

Clov: Mean something! You and I, mean something!
(Brief laugh.)
Ah that's a good one![70]

If nonsense could be expressed by nonsense, we would really have to accord his work the place it occupies in the eyes of the avant-garde. The essential criterion of the artistic is, however, precisely that content and form are not equivalent and exchangeable and that artistic mimesis is not simple imitation. Form is not only the bridge but also the chasm between the work of art and reality. The depraved condition of humanity, which Beckett is concerned with depicting, ought to be made comprehensible to us by means other than the stuttering and stammering of his clumsy and pitiable cripples if it is to make a deeper impression than that of just momentary shock. The inarticulate language in which he communicates his message, as alarming as the warning is, is partly as incomprehensible, partly just as boring as the *nouveau roman* seemed to be to most readers, something for which

the unaccustomed mode of expression was hardly responsible. Kafka is incomparably more original and unpredictable than Beckett, but he is nevertheless one of the most understandable and amusing writers of his time, even if he is one of the least simple.

The Absurd
The Concept of the Absurd

The most definitive and fruitful concept the present-day view of art owes to existentialism is that of the Absurd, which is at the same time the quintessence of the whole existentialist doctrine. It signifies essentially the fragility and incompleteness of being, the senselessness and lack of purpose in the whole of human existence. It is scarcely likely that we would agree with this philosophy of impotence, fear, and despair as a doctrine, however little we may share Marx's final optimism and however much we tend toward every historical prognostication whether in his sense or in the opposing one. Nevertheless, the significance of the existentialist state of mind as an expression of the crisis and as a stylistic factor of postwar art cannot be overestimated.

In spite of its decisive ideological significance, the effect of existentialism upon philosophy lasted for a far shorter time and left far fewer traces in it than in art and literature. In philosophical thought and in the literature of cultural criticism its decisive influence, which was far above that of other speculative tendencies, was restricted to France, but even there it lasted little more than a generation. In literature, on the other hand, it dominated the most important and most progressive movements from the First World War onward and set the standard for the avant-garde from Gide, Camus, Sartre, and Malraux up to Kafka, Joyce, and Beckett. The whole of modern literature of any importance is filled with existential pessimism and irrationalism, with the feeling of hopelessness and the absurdity of human existence. Current philosophy is dominated by a humanism which is hopeful in spite of all hopelessness, a critical rationalism, and a dialectical historicism, all of which lighten up the shadows of existentialism. This is in contrast to literature, in which everything which was not saturated with the senselessness of existence seemed pointless. Absurdity became the leitmotiv of authentic literary works, since the whole relationship of people to the world seemed absurd, as did the contradiction between their consciousness and their existence; but especially absurd was the fact that they were not identical with the things that surrounded them and that these remained inaccessible. Their inability to come to terms with the existence into which they had been "pitchforked" seemed absurd, together with the need of constantly making decisions and the im-

possibility of living up to them. For we are "condemned" when we have to make a choice, and yet there is none to be made. If we take a guide as a counselor, we merely place the responsibility for the decision on his shoulders. We have already *made the choice* when we seem to have *found* an adviser. There is no escape for existentialism from angst and fear, trespass and responsibility, alienation and loneliness, from the contradiction of being alone and in the world, the repellence felt for life and the "rush to death." Existentialism and surrealism intersect in the concept of the Absurd. The one signifies the nature of life which cannot be reduced to meaning, the other the incompatibility and the inseparability—in spite of their difference—of being and sense, rationalism and irrationalism realism and nonrealism. Both express in their own way the absurdity of the condition which arises from the contradictory conditions of the facts which have to be accepted. It is an "unhappy" condition because it cannot, immediately and completely, admit being into consciousness and cannot itself be absorbed in being.

Just like early surrealism around the time of the First World War, existentialism was the philosophical pioneer of new artistic efforts around the time of the Second. In both periods, art was nonrealistically and irrationally oriented, but while during the earlier period reality and action had something to say besides nonrealism and irrationality, in the later one irrationality had unlimited mastery over "existence."

However, after existentialism—which as Sartre and Malraux understood it was void of contradiction—made short shrift of the ghastly reality in its own nameless way, double-sided, dialectical surrealism reasserted after two decades its hold over psyches and the arts. Nondialectical, unresisting, totally negative absurdity now appeared to the eyes of a real artist as what it was, namely, pure nonsense. The idea of absurdity—as a heritage from existential philosophy—contributed most fruitfully to surrealism in the works of Kafka. For him, however, it was a question not of nonsense but of sense which was out of context and which did not necessarily distort the substratum which was subordinate to it, but rather showed the reverse side of the truth.

Real, rational, or true and unreal, irrational, or false appeared as what they are only when they were connected with one another. The Absurd acquired a "meaning" in the sense of Freud's "slips," which have to be rationalized in order to be properly understood. Kafka, however, remained difficult to understand, puzzling, obscure, and, according to his surrealist beginnings, ambivalent, paradoxical, and contradictory. In contrast to both the classical and the naturalist tradition, he found expression in broad associations, elliptical nomenclature, and erratic formal structures.

Postexistential surrealism no longer persists in the point of view of the *nouveau roman*, that is, in the view that the objects of art *are* and do not have a "meaning." For even if they do contradict one another and themselves, they do speak—they speak to us, and we are the ones who have the responsibility for interpreting what they say. This obligation does not, however, necessarily mean that the task can be accomplished, not only because of the complexity of the surrealist art of the present time, impregnated as it is by existentialism, but also because it often has no desire to be comprehensible. Every truly original and creative art contains some secret and thus a certain degree of incomprehensibility. The most modern works of art, however, want to remain incomprehensible, precisely on account of their originality and their creative quality.

Art is often essentially incomprehensible or hard to comprehend for two main reasons: first, because it is rationally impossible to reconstruct and is irreducible to discursive concepts; second, because the only possible way to receive, experience, and come to terms with it is an irrationally creative act of postexecution, an intensification of the inner conflicts and crises which were put to rights in the work of art and which must be set aside once again. It is a merely figurative, nonactual, and inexact description of artistic creation to describe it as a reflection of reality which is true to life and rejoices in reality. Every important art, no matter how realistic, is at the same time an affront to facts, an attack upon reality, a disavowal of the validity of its practicality, and has, in this way, a frightening and alienating effect. The meaning of every radically new, truly creative art consists in part in the fact that it renews the absurdity which is usually lost when the older unproblematic and traditional forms have been generally accepted.

The Absurd differs from the obscure not simply because it cannot be completely illuminated. Its peculiarity consists in the fact that it shuts its eyes to any possible rationalization; it can be interpreted but not explained. In this sense, every authentic work of art is absurd. Every one remains mysterious and veiled. Shakespeare no more knew whether the strange relationship between Hamlet and his mother originated in some sort of Oedipus complex than Beckett knew who Godot was. The all too simple answer, that if he had known it he would not have hidden it from us, does not appear in the least satisfactory, simply because the secret of art is not a question of sufficient knowledge. It starts with the unbridgeable distance between everything which is aesthetic and everything which is nonaesthetic, intensifies through the unmistakable style of every true artist, and culminates at the point at which every real work of art acquires the character of being something

impenetrable and irreplaceable. Thus, what is artistic is completely nonsensical. The incommensurability of which Goethe talks is only another word for this. The explanation of an artistic motif is in any case independent of whether the meaning ascribed to it accords with the artist's intention or whether he is conscious of it. The discrepancy between its psychological and phenomenological meaning does not condition in any way the absurdity of the subject. Yet its absurdity always points to a cleft between the subjectively psychological and the objectively phenomenological essence of the phenomenon under discussion.

The secret which is inherent in art expresses what is unattainable, what remains—in spite of all the hermeneutics—inexplicable and incomprehensible. It has nothing to do with what is hermetic or with cryptogenesis, which are its characteristics in times of crisis, of the intensified alienation of the avant-garde from the public, and of the ostentatious refusal by the artist to try to make himself understood in broad circles of the public. The secret is imposed upon art by the antiartistic nature of reality; what is hermetic is imposed upon himself by the artist as one alienated from society.

The *Homo Absurdus*

Contradiction is not absurd in itself, but the irresolubility of certain antinomies is. It is not the problems of a given situation which are insoluble but the problems inherent in the absurd human being. If we want to establish the beginning of the Absurd in literature, we have to ask about the conception of the type who is identical with neither the comic person nor the antihero. It is harder to determine the age of the *homo absurdus*. If we take the concept loosely, we can go back to Shakespeare. In any case, the whole of modern literature begins with his birth, with the coming into being of the idea of the contradictory, torn, and divided being and the analysis of a psychic split which does not come simply from a moral conflict. Antigone already hovers between duty and inclination, and the heroes of Corneille's tragedies are completely consumed in a struggle which is conditioned by this. In Shakespeare, however, it is the wavering of the hero, the inability to identify completely with one or another of his impulses, even to account for one's own identity—rather in the sense of "You are not yourself" in *Measure for Measure*—which becomes the origin of the conflict and the actual subject of the drama. However, even in Shakespeare psychological tendencies still appear separately, and the moral judgment of the characters about their own emotions is com-

pletely unequivocal, although they have to condemn themselves because they are unable to resist the one or the other.

The disintegration of the personality—in which the antagonisn of inclinations, of commitments, of loyalty to oneself and solidarity with others goes so far that the individual cannot come to terms with his own being and value and does not any longer know what to affirm and what to deny—only starts at the beginning of the last century. In this process it is a question of his being not merely a problem to himself, but also an insoluble puzzle, a question to which every answer is from the outset the wrong one. It is only the concomitant phenomena of the postrevolutionary period, romanticism, and the alienation of the individual from both society and himself in the period of mechanical production and the division of labor which created the necessary assumptions for the development of characters aware of their dual nature and—in this way—the literature of so-called problem natures.

In comparison with such natures, the tragic character is, it is true, hopeless but neither necessarily paradoxical nor alienated from himself. He hovers between duty and inclination, loyalty and love, or commitments of a similar sort, but he may accommodate to his tragic situation rather than vice versa. While in his tragic conflict and faced with the choice of alternatives, a way is opened up for him out of the chaos which surrounds him.

The psychological and moral contradictions in Shakespeare and his contemporaries are not just inconsistencies, symptoms of a stage of development which is preclassical. Nor are they signs of a view of art to which contradictory natures appear illogical, improbable, and irreconcilable with common sense. The characters of the Elizabethan drama create a grotesque and bizarre effect when placed alongside this classical view. This is not because we lay too much stress on their strangeness, but because they had not yet learned what the French classicists would soon learn, that is, how to depict characters which were unified and behaved logically, and because they set no store by the unity and unambiguity of a character.

The inconsequential, contradictory, and extravagant figures of romantic and postromantic literature in the nineteenth century represent, in contrast to the manneristic nonrealism and irrationalism of Shakespeare's time, a demonstrative, programmatically emphatic reaction against the rationalism and rigorism of classical psychology. Writers depicted, by preference, incalculable and fantastic natures, because the chaotic feeling and the incomplete state of temperaments seemed more real and interesting than characters which answer for their own nature. The complete dissolution of unity of character, which consists partly in the incoherence of psychic contents and partly in their continual

reevaluation and reinterpretation, only emerges in the struggle against romanticism and the interaction of romantic and antiromantic tendencies. In Stendhal's novels, the most obvious representatives of this phase of development, psychic attitudes change and move before our very eyes. Ever since, the relative instability and indefinability of characteristics have become the conditions of a valid psychology. Only character which is differentiated, heterogeneously composed, and kaleidoscopic now appears artistically interesting. The last stage of this romantic-antiromantic development is reached with the incalculability and the lack of integration of Dostoevski's characters. "You are not what you seem to be" is the slogan they bear. The most obvious, if perhaps all too handy, expression of the ego which has collapsed upon itself and which cannot be reduced to a unity is the doppelgänger. Dostoevski took over the notion of the doppelgänger together with many of the props for describing its character from the romantics. For all the complexity of his psychology, he makes use of the most stale remains of romanticism, of commonplace Byronism, the empty cult of prostitution, and the cliché of the golden heart under the rough exterior. In the process he discovers, without the help of others and long before Freud, the most important principle of modern psychology: the ambivalence of feelings and the doubtfulness of every excessive emotion which expresses itself in exaggerated, demonstrative forms. Not only are love and hate, pride and humility, conceit and self-abasement, sadism and masochism, the desire for what is lofty and noble and *nostalgie de la boue* combined in his works, not only are Myschkin and Rogoschin, Ivan Karamasov and Smerdjakow, Raskolnikov and Swirdrigailov various facets of one and the same principle, but every impulse, every feeling, every thought produces without fail its antithesis as soon as it appears.

Dostoevski's psychological novel represents the manifest continuation of the well-known Western development of the genre; it also represents the beginning of a new stage. It represents the paradigmatic turning away from the great nineteenth-century epic structure with its dramatic form, which crystallized around a few points of concentration and focused upon a culmination, as, for example, in *Madame Bovary*. It now turns to the picaresque structure with additive, loosely connected episodes which revolve around several culminating points, even if they are not entirely unconnected. Dostoevski anticipates one of the formal principles of expressionism with his abolition of unity and complete continuity in favor of a series of essential, but atomized, processes. In his works we also find that narrative, as the epic element par excellence, already recedes in favor of analysis, reflection, and speculation as factors of an "essayistic" nature. In his hands the novel

becomes a conglomeration of discussions, inner monologues which usually break off abruptly, which the narrator accompanies with commentaries which are sometimes more or less objective and sometimes personal confessions.

This method moves away from strict naturalism as a style, just as much as from the epic in the more narrow sense. As far as acuity of observation is concerned, it presents the most highly developed form of true-to-life mimesis. However, if we understand by naturalism the depiction of normal, usual, everyday situations, we have to see some sort of reaction against naturalism in the love of what is pathological, demonic, and visionary that surfaces in his work. "I love realism in art to excess," says Dostoevski, "realism which, so to speak, extends into the fantastic. . . . What can be more fantastic and unexpected to me than reality? Indeed, what can be more improbable than reality?" It would be hard to find a more exact and binding definition of the surrealistic attitude.

The *homo absurdus* is, reduced to the shortest form, the irretrievably lost "stranger," who, expelled by society, maintains his uncanny right to existence in literature ever since Camus's *L'étranger*. He is not merely a stranger to us, but also someone who is once and for all alienated, the rebel who fights against social conventions, who refuses to obey the rules which are generally tacitly accepted and simply will not play. This is where the insult lies for which he cannot be forgiven, and which the society of which he is part cannot forgive him if it is to continue to exist. The murder he commits could in some circumstances be forgiven him; the silent disregard for conventions which he exhibits, never.

Meursault, who was alienated from the social game, refuses to lie not only in that he is not prepared to tell an untruth, but also in that he never says more than the truth. But he does not do this because truth is sacred. He refuses to give the expected answer, in no sense only to stick to his own truth or to truth in general. He is prepared without more ado to mislead others, for example, the police or the representatives of authority, where his own identity, that is, not his honor or sincerity, is not in question.

Camus misunderstands Meursault's nature when he tries to heroicize him or to make him into a paragon of virtue; and though basically he is disinclined to do this, he does sometimes seem to try to do it. He knows that his "hero" is neither good nor bad, moral or immoral, but simply has to be regarded as "absurd."[71] His obstinacy has nothing to do with heroism. In his obduracy he is a negative hero wrapped up in himself, but more interesting, more complex, and more fruitful for artistic consideration than the most heroic sacrifice to the love of truth

could possibly be. His senseless and pointless opposition to the impositions of a world whose course he does not wish to alter or feel capable of altering, in which he merely feels lonely and uncomfortable, is *absurd,* and there is no other word for it. It is absurd that his existence is not compatible with it, and he feels that there are no alternatives of choice between the world and his own existence, of which apart from its strangeness he knows nothing and which has no answer to the questions it asks of him and the demands it makes upon him. His whole being is, in Sartre's sense, absurd as a result of the dualism between his consciousness and the reality around him or, in more usual existential terminology, as a result of his being "in the world" of his "being pitchforked" into an existence with endless goals and limited means.[72]

First of all, everything is absurd which is strange in principle, everything of which we see only the outside and of which we do not wish to see more. Thus, the world is absurd in which Meursault is condemned to speechlessness. As the creator of his mute reaction to the challenges of an intractable reality, Camus not only invents the *homo absurdus* but also is the first to discover the significance of the "inexpressible" for modern literature. In *Le mythe de Sisyphe* he expressly says, "Un homme est plus un homme par les choses qu'il tait que par les choses qu'il dit."[73] And although the technique of the "inner monologue" is not his invention, he is the one who first measures the value of this artistic medium and reveals how little the person who resigns himself without resistance to his associations, fantasies, and hallucinations really reveals about his unconscious. His monologuization alienates him further from us instead of bringing him closer. It has nothing to do with the instinct to communicate, nothing with self-confession and is a barrier rather than a support on the way to the perception of the individual nature of the person speaking the monologue. Mechanical associations and the uncritical and indiscriminate leaps from one idea to another are in any case more stereotypical than conscious and controlled linkages of thought and discursive thought processes. The subject of the inner monologue is, in spite of his freedom to move back and forth from one idea to another, more impoverished, monotonous, and unproductive than someone taking part in the most banal dialogue.

The Understanding of the Incomprehensible

The highpoint of absurdity is reached with Beckett's claim "to understand his incomprehensibility" and, as one of his enthusiastic disciples says, with the attempt to express the meaning of a work like

Endgame "through the medium of philosophy."[74] Yet, finally this is not so bad as it first sounds. Components of an artistic context cannot be chipped off from the coherent whole to which they belong without more ado, and the meaning of parts of a unified vision cannot simply be reconstructed in splendid isolation outside the work. Yet "even the limbs torn from the totality of a work do betray the author,"[75] and if we are ready to give up the dogma of the untouchable unity and totality of a work of art and also to see the works which are intact as parts of a total confession and scraps of an all-embracing philosophy, the partial incomprehensibility of the works will not conceal their artistic worth. This we have to do in times of social crisis and with an artist of the unusual complexity and limited articulation of a Beckett.

We may regard the threatened "end of the world," that is, the end of alleged "order" in which we live, in Beckett's way, as the most important and actual object of art yet at the same time doubt whether he is capable of making it immediately comprehensible. Just as "dead" figures have to be presented as though they were alive in order to create the effect of being dead, the end of the world cannot be depicted as an event which has already taken place and which is paralyzing humanity. No one in their right mind, unless it is one of Adorno's "totalitarians," "discounts the end of the world." In any case, the danger which faces us would not be any more discounted if it were not called "end of the world," just as Beckett's stuttering and stammering would be an essentially harmless crisis of artistic expression if it were not called the "end of art."

In theory the actual meaning of a concrete work of art can be grasped, and Beckett's alleged answer to the question of what he meant with *Godot*—the statement that he would have said it if he could—is the only possible one an artist can make to this sort of question. The realization of his incapability in this sense is not important nor is the courage with which he admits it, nor the incomprehensible title of his most representative work, nor the action in which nothing happens, nor the nature of the interpersonal relationships which only reveals the isolation and loneliness of individuals, nor the fact that time and place are undetermined. What is really noteworthy is the gripping power with which he presents futility, so that the work, in spite of the long prehistory of an artistic technique which turns almost everything into the negative, still manages to appear novel, unexpected, and exciting. Finally, everything appears—just as he wanted it to from the beginning—to be reduced to a zero point in meaning and being, and he seems to achieve what is the impossible, the comprehension and the explication of the incomprehensible, the interpretation of the vital manifestations of half-living beings.

Silence
The Crises of Language

The expression of the absurd is mainly linked to gaps in the development of continuous and closed linguistic form. Such interruptions of the flow of diction are not necessarily signs of absurdity; absurd ideas, however, are usually expressed in fragmented speech forms, in repressed or paralyzed forms of speech. The current crisis in art expresses itself most strikingly in the problematic of the media, and especially in the doubtfulness of the value of speech as a form of expression and communication, as the bearer of direct, intentional, and meaningful communication. The crisis of today's literature has its deepest origin in the crisis of language as the means of understanding, a means which during the classical period and the Enlightenment was the actual basis of culture and was still an unendangered vehicle of intellectual stimulation for the naturalists and the impressionists.

However, it has been discovered that, in spite of the availability of speech as the means of communication par excellence, considerable parts of experience not only remain uncommunicable but are even distorted and that language is by no means merely a medium in the sense of neutral communication, but that there also exists a dialectical relationship between language and linguistic content. Thus, the linguistic medium is one of the constituents of communicated contents, and linguistics has moved into a central position in the sciences of thought, of the formation of concepts, of the ways and limits of both the internalization and the communication of facts, as well as of what has been internalized. Alongside linguistics, especially semantics, interpretation and evaluation of the media play a role similar to semantics. They do this as a vehicle between impulses and their expression even in other nonliterary extraartistic spheres, especially in psychoanalysis and particularly in the relationship between the ego and the id, the conscious and the unconscious, the repressed libidinous instincts and their rationalizations and sublimations. For even the substitute symbols which replace the direct appellation of inadmissible tendencies and symptoms of illness which abreact against inadmissible instincts are quasi-linguistic signs which call for a semantic interpretation.

In general practice, language also fulfills a number of functions which are further differentiated in literature. The fundamental difference between their forms is denoted by the gap which divides them as mimesis, information, and communication from more autonomous statements which depend on themselves, the immanent and independent structures of creative fantasy. A part of these statements has its limits in historical relativity and the changing nature of the linguistic medium, another

part in the inexhaustibility of the phenomena of being in the external world and the unapproachability of broad regions of the world of feeling. Since the romantic period, this moment of independence or inadequacy was used as an excuse sometimes for unconditional surrender to language, sometimes for the complete rejection of it. People saw in it, from one point of view, just a complex of clichés; from the other, the original phenomenon and the seed of all literature. In doing so, people overlooked the fact that the fundamental avoidance of conventional forms leads to a rejection of all language and to the final failure of literature. Otherwise they saw that the reduction of literature to autonomous linguistic structures leads to an empty formalism; in other words, it prevents the total acceptance of the dialectical principle of linguistic communication which corresponds to the historical facts and allows the stasis of convention to exist side by side with living and creative language.

It is unthinkable that there were prelinguistic poetic experiences and impulses to expression. Language is the indispensable instrument of literature, even if literature did not simply emerge from the spirit of language. In any case, it represents not merely its vehicle but also its substratum and belongs not only to the reception but to the production of literary works. Their ability to be produced and to be received does not, however, depend upon their richness at a given moment. Periods of hypertrophy and atrophy constantly replace each other in the history of literature. After a phase of exuberance, there is usually one in which the linguistic medium disappears. The succinctness of speech and the economy of words can be regarded precisely as a reaction against verbosity and linguistic proficiency, the fluidity and the colorfulness of expression of the immediately preceding stage of development. The rhetoric, the tirades, and the huge number of images of classicism, romanticism, and symbolism, as well as the linguistic virtuosity of Proust, Joyce, Thomas Mann, and Robert Musil condition the puritanically simple, neutral, and restrained style of Camus and Kafka, though these are by no means monotonous and gray.

Every art, in T. S. Eliot's words, is "an attack upon the inarticulate" in the midst of an order of things of which part remains incapable of formulation and in need of articulation, and in the depiction of which gaps not only mark an inadequacy but also point to a secret something ineffably nobler and deeper—an absolute which is concealed in the chaos of inadequacy. Art as "an attack upon the inarticulate" is a part of the struggle against this chaotic element. We have therefore to interpret it first as a struggle with language as a means of distinguishing and naming things, and only after we have taken possession of language can we interpret it as a form of the struggle against the difficulties of, and for the goals of, existence.

In a world like the present, which seems to have lost its meaning, hope has been lost that human beings will understand each other. People feel themselves incapable of talking of their own misery and believe that this state can only be expressed in the form of absurdity, the inadequacy of word and meaning, like a new Tower of Babel, or by a lack of words, ostentatious rejection of language and every mimetically unequivocal communication.

The ability to articulate oneself, which is lessened, lost, or given up for lost, makes itself recognized in modern literature by a long series of linguistic inadequacies and nonconformist resistances to the use of language. The most common form of the impairment of artistically articulated and informative, mimetic, or purposeful language consists in the difficulty, complexity, and puzzling nature of expression. A difficulty of this sort emerges with every new style but grows less in the course of development of one and the same stylistic movement, since the stylistic innovation becomes a common convention. The difficulty may increase as art progresses from one style to another, in the sense of Wölfflin's examples of a difficulty of baroque, where the moving wheel in baroque paintings loses its spokes and thus becomes harder to recognize but at the same time acquires a new expressive quality. Lessened comprehensibility may result from the complexity of the thoughts and experiences which have to be expressed, but it can also be created artificially and be directed against the simplification of conventionalized attitudes. The ambivalence of attitudes, the ambiguity of statements, the breadth of associations are transitional forms—between the disclosure and the concealment of the meaning the artist pretends to wish to make clear. An in-between stage of another sort, which combines and separates expression and lack of expression, language and lack of language, apparently leads to its fundamental impairment and distortion, in contrast to the total inability to articulate or the voluntary renunciation of doing so. In pretending to speak, people just stammer and babble, or prattle and chatter. Senseless and pointless words or sentences are repeated, and one is as useless as the other. These linguistic "slips" conceal the lack of adequate forms of expression, and they make use of a regression to infantilism, that is, the lapse of language into the stage of childish helplessness in order to emphasize the fact that conventional modes of feeling and expression are nothing more than comfortable media of artistic practice.

Categories of Keeping Silent

Modern literature makes use—in the form of "silence"—of a well-known medium of artistic effect, though it has never before been used in the present sense and with the same intensity. It serves the alleged

purpose of surpassing positive statements but at the same time of negating the naively accepted omniscience of earlier writers. The function of silence in literature is complex and ambivalent. It leads to the formation of a concept which consists of many different categories and many stages. The renunciation of language or of its creative use in a form of art whose actual medium it is cannot simply be explained away. Reasons apparently differ from case to case, and different goals are pursued. The most obvious psychological and sociological explanation is that silence is a result of fear and disgust in the face of the apparent collapse of the social and individual order. It is a failure of words in the face of the terrible, a fear of calling it by its name, a sign of desperation which can only be pointed to by lack of speech. Falling silent is merely a symptom and not an expression of a state of mind, of an idea which Rimbaud, for example, was only able to communicate as long as he was writing, that is, "speaking." Thus, silence remains a negative, a defense, and a protest. The romantic theory of literature is also purely negative, for it persists in the programmatic rejection of the unavoidably mediated expression, despises convention and cliché, but neglects to explain what will become of literary language if the despised rules of the game are not replaced by new ones. The nature of silence is also negative on the level of the ineffability of the absolute and the inexpressibility of states which cannot be expressed from the outset. The concept of silence remained linked to the limit of what was inexpressible in the whole of older literature. This was true whether the ineffability was of something numinous, something inner which could not be expressed, or the ineffability of Goethe, something which was noble beyond all words. The concept changed in modern literature, first in the sense that for the modern writer the most trivial, simple, and everyday things seemed to be just as inexpressible, just as deeply wrapped in silence, as the most unapproachable secrets of existence, of human destiny, and of self-determination.

The function of silence also changes fundamentally in modern literature when the negative effect of something which is unsaid changes itself into a positive artistic medium. Silence used to mean in literature the mere suspension of the communicative and imitative role of language, and thus it remained a means of obstruction or a demonstration against the attempt to express things which were essentially inexpressible. In modern literature, however, it means not merely a coming to terms with the unavoidability of a lack—no matter what artistic value this may have—but it has become a medium of the effect which adds a new dimension to what can be expressed in language. The previously mentioned examples of silence were forms of the inability and refusal to come face to face with insurmountable difficulties. The

form of silence which has to be looked at more broadly belongs to the agencies of artistic organization and articulation. Speechlessness, as impotence, adds nothing to the artistic factors of an artifact. It is only as a substratum of a calculated function that it achieves a decisive aesthetic meaning and value. The smallest success of such a function is like the rests in a piece of music or the essentially neutral interruptions, pauses for breath, and breaks in the dialogue of a play or in the continuity of any artistic structure. A musical rest, which has the value of hearing notes fade away, is not matched in literature by any interruption of the linguistic expression for purely technical reasons. There is only an exactly calculated saving in the space required by language, an *ellipse* precisely calculated as to its effect. This always expresses more than a rest, especially if it represents more than a mere search for words or a lack of power which could be compensated for by words. The difference between rest and ellipse can best be translated in literature as the difference between silence and falling silent. It is only as *falling silent* that silence loses its empty negative quality and fulfills a completely positive artistic function.

Every linguistic expression—like every artistic form—operates with omissions. Not one of them represents a complete communication of the material which has to be and can be communicated. Its understanding includes, as Ortega y Gasset states, the comprehension of something secret and something stated. Silence in literature is only truly irreplaceable and only has meaning if it is falling silent, "negative speech," that is, if it is something stated indirectly. As a "higher" form of language, it is mere mystification which makes a virtue of keeping silent out of the plight of language.

If we take all this into account it is astonishing how much of all this is stated directly, for example, by Dostoevski, where other writers of the same caliber would leave the things unsaid or only to be read between the lines. Thus, he tells the reader in *The Idiot* that Myschkin actually loves Aglaja and is simply sorry for Nastasja Filippovna. He even states in a few words what could be the lesson of the whole work, namely, that sympathy is stronger, deeper, and more human than love. He conceals only one thing—that Rogoschin will finally murder Nastasja because he cannot possess her in any other way, since someone else possesses her while she is alive. The concealment of precisely this moment, however, is part of the magic of the secret which underlies the work.

Yet in some circumstances, not only the intentional concealment of essential moments in the state of affairs as depicted, but also the pure, enigmatic silence which has no need of ellipsis has an inner, substantial value instead of mere functional face value. Kafka opened a dizzying

view of the yawning maelstrom which is revealed by this. "The sirens," he writes in one of his parablelike short stories, "have an even more terrible weapon than their song, and that is their silence." They fell silent as Odysseus approached, "whether because they thought that this opponent could only be got at by silence or whether it was that the sight of the happiness in Odysseus's face who was thinking only of wax and chains, made them forget their song. Odysseus, however, so to speak did not hear their silence; he thought that they were singing and that only he was unable to hear it."[76] Art, too, may fall silent in the face of a listener armed in the same way and so communicate the unspeakable and the unhearable. Yet silence may from the beginning function as inaudible speech. The poet falls silent sometimes when we hear him talk and speaks even when we think that we hear nothing of what he is saying. Language and silence, sound and falling silent, are linked in constant interaction. Talking and singing make their effect through the transparence of what is unspeakable, concealed, and hidden, just as silence often only asserts itself in the presence of sound and word. It is only for someone who is desperate, like Beckett, that the falling silent of existence is the final unavoidable step. If everything is in vain, he says in *Molloy,* the only thing left for things is to create silence.

Criticism of Keeping Silent

The cult of silence and the mythologization of the unspeakable begins with Camus's paucity of words and the lack of ornamentation in Kafka's style. Not only the flowers of romantic style and the finesses of Flaubert's prose but also the symbolist cult of the *saint language* is avoided in order to pay homage to the *écriture blanche* and the "nadir of writing."[77] The tendency to budget linguistic supplies is by no means new. Earlier, in the Latin literature of the later republic and the early empire and again at the time of mannerism and in certain classical periods, there were works of unusual significance that owed their charm and their power to the strictness, succinctness, and precision of expression. The atrophy of language has, however, become a more general phenomenon in present-day literature than ever before, and sparseness of expression is most strict where there was formerly an unbridled extravagance of linguistic media, the most elaborate bombast, and the most insatiable plethora of images, similes, and metaphors. Yet this restraint does not necessarily imply a linguistic passivity or restraint. Many of the most extreme representatives of silence as an artistic medium, and among them Beckett, even prattle and pile up

words. In the process, it does not matter what they say and the unrestrained pouring out of words is just as sharp a protest against language, as an adequate means of expression, as silence is. The flood of words shows that in criticizing language we cannot stay silent and that the allegedly unspeakable is actually beyond the criteria of linguistic expression, that it is thus irrelevant what, or even if, anything is said.

The most apt description of the flood of words which competes with silence as vain talk and of the need to prattle on in avant-garde literature is to be found in Beckett himself. "Not to want to say," he writes, "not to know what you want to say, and never to stop saying, or hardly ever, that is the thing to keep in mind, even in the heat of composition."[78] As a commentary on the mode of writing he is here talking about, there is no doubt that the passage is important, and, as a diagnosis of the pathological state which conditions it, it is exact, but the artistic value of the detached style described in it is highly problematical. Announcements about paralysis in art (significant as these may be as symptoms of an illness and as authentic as their determination may be theoretically) have a barren effect if they are endlessly repeated. And the attempt to justify them, like the boredom of the *nouveau roman*, is fruitless. The urge to speak, like that to fall silent, is, in the absence of a meaning which is worth expressing and formulating, a symptom of the decay of the word whereby silence and prattle come to the same thing. The inadequacy of language, whether we use it or not, is evident in any case, and the attendant difficulty grows on one hand with the complexity of the contents of expression and on the other with the progressive internalization of the gap between word and thing, between the need for expression and the ability to express. The question of whether we should remain silent if we cannot say everything can only be answered separately in each case. However, what is beyond question is that stammering is further away from the extralinguistic facts, whatever form these may take, than the articulated word, inadequate as it may be.

The incompleteness of language signifies the defectiveness of the medium in which we have to express ourselves. However, the limits of its suitability are doubtful. It is a help and a hindrance, a means of expression and of alienation. But it is not exclusively any one of these. At the point where the word really fails, literature stops. Even the unspeakable makes discursive sense and has its being only in connection with something that can be expressed.

However, no matter how we evaluate talking and silence, fluidity or brokenness of linguistic expression, the fact that we fall silent or can only stammer where we previously expressed ourselves fluently

and articulately has deeply rooted and extensive individual and social causes. Organic inhibitions, whether physiological or psychological, appear all too sporadically to be considered as decisive motivations related to the history of thought. The whole social existence of mankind must appear doubtful in order to explain the dismay and the horror which belong to a loss of control over the ability to speak or which we feel when we are threatened with this loss. But the reality of the fear of the collapse of the world and the obvious appearance of its portents does not make silence a substitute for speech, or stammering a real surrogate for articulation. In the same way, the crisis of the ability to express ourselves, which we are not meeting for the first time in history, does not mean the end of art.

Language, like the colors of painting and the sounds of music, belongs to the constituents of artistic intention and is not merely their vehicle. In contrast to the media of painterly and musical expression, it represents a heterogeneous and highly problematic instrument because it only corresponds in part to the main demand of artistic usability, namely, that of promoting concreteness and vividness in the structures which are created with its aid, while on the other hand opposing their sensual immediacy and independence. It is true that language expresses itself in its own music, color, and melody, in the rhythm and flow of its components, and the combination of their elements in a very obvious manner. However, it involves at every turn more or less abstract conceptual factors and thus represents a much more complex categorical apparatus than all other artistic media, which as a result of the dialectic of their formation from moments of different origin are conditioned by many factors. A scientific literature is conceivable which did not have so heterogeneously composed a linguistic formulation, but not a literary one. A "postlinguistic" literature, like a prelinguistic one, is a monstrosity. Just as empty space in painting cannot be represented of itself and can only appear as the relationship between objects which fill space, so the indistinct and sensually untranslatable contents of consciousness only appear in literature as the boundary and antinomy of concretely sounding linguistic structures.

Silence is essentially a form of nonconformism, and as such it is a social and not an artistic gesture. It represents as, for example, in the works of Rimbaud, discontent and disgust in the face of the misery of existence, unless it is psychotically conditioned like Hölderlin's silence, the motivation for which had extraartistic causes. However, as long as the disturbance of articulate speech does not lead to a paralysis and we talk of the unavoidability of falling silent, we are still "talking," and we are still talking about the difficulty of speaking in

the categories of art. As a seduction to narcissistic withdrawal, the means of silence are always at hand in times of social and cultural crisis. However, we are protected to the end against actually falling silent by the gap between socialization and total alienation, between spiritual health and confusion.

Translator's note. The references given here are as accurate as possible. Unfortunately, the translator has not had access to the author's original notes and bibliography and some of the editions which were cited in the original were not available to him. In some cases it was not possible to identify the intended edition, in other cases the author cites from works without giving a reference in the notes, and in the case of some non-German works he has translated these citations into German. Every effort has been made to trace the original, but in those cases where this has not been possible the translator has had—perforce—to make a "new" version. In all cases, of course, the sense of the original has been preserved.

Full bibliographical information is given the first time a work is cited. Afterward the work appears in short-title form. However, in view of the large number of notes and the absence of a bibliography, subsequent references also bear in brackets the number of the original note so that reference may be made back to the full information.

Notes

Part One

1. Letter to Emile Bernard, 23 October 1905, in *Paul Cézanne correspondance*, ed. John Rewald (Paris, 1937), p. 276.

2. Marcel Proust, *A la recherche du temps perdu*, ed. Pierre Clarac and André Ferré (Bibliothèque de la Pléiade, vol. 3) (Paris, 1954), p. 986.

3. Otto E. Deutsch, ed. *Schubert, Zeugnisse seiner Zeitgenossen—Ausgewählte Erinnerungen* (Frankfurt am Main, 1964), pp. 208ff.

4. Robert Musil, *Der Mann ohne Eigenschaften* (Hamburg, 1952), pp. 114ff.

5. Paul Valéry, *Oeuvres*, ed. Jean Hytier, vol. 2 (Bibliothèque de la Pléiade) (Paris, 1957–60), p. 629.

6. Hermann Tietze, *Die Methode der Kunstgeschichte* (Leipzig, 1913), p. 42.

7. Benedetto Croce, "Zur Theorie und Kritik der bildenden Kunst," *Wiener Jahrbuch für Kunstgeschichte*, n.s. vol. 4 (18) (1926), p. 21.

8. Friedrich Nietzsche, *Werke*, ed. Karl Schlechta, vol. 1 (Munich, 1966), pp. 925ff.

9. Max Weber, "Über einige Kategorien der verstehenden Soziologie," *Logos* (Internationale Zeitschrift für Philosophie der Kultur), Tübingen, vol. 4 (1913), pp. 253ff.

10. Georg Simmel, *Die Probleme der Geschichtsphilosophie*, 2d ed. (Leipzig, 1905), pp. 19ff.

11. Georg Simmel, *Grundfragen der Soziologie* (Sammlung Göschen 101) (Berlin and Leipzig, 1917), pp. 22ff.

12. Cf. Arnold Hauser, *Sozialgeschichte der Kunst und Literatur* (Munich, 1972), pp. 226ff.

13. Cf. Arnold Hauser, *Der Manierismus* (Munich, 1964), pp. 114ff.

14. Talcott Parsons, *The Structure of Social Action*, 2d ed. (Glencoe, Ill., 1949).

15. Max J. Friedlander, *Von Kunst und Kennerschaft* (Oxford, 1946), passim.

16. Talcott Parsons, "Psychoanalysis and the Social Structure," *Psychoanalytic Quarterly*, Albany, N.Y., 19 (1950): 371ff.

17. Thomas S. Eliot, *Selected Essays* (London and New York, 1932), p. 22.

18. Karl Marx, *Grundrisse der Kritik der politischen Ökonomie (Rohentwurf 1857/8)* (Berlin, 1953), p. 111.

19. Emile Durkheim, Les règles de la méthode sociologique (Bibliothèque de la philosophie contemporaine) (Paris, 1919).

20. Emile Durkheim, *Le suicide; étude de sociologie* (Paris, 1897).

21. Paul Lacombe, *Introduction à l'histoire littéraire* (Paris, 1898), p. 29.

22. György Lukács, *Geschichte und Klassenbewusstsein, Studien über marxistische Dialektik* (Berlin, 1923), p. 63.

23. Lukács, *Geschichte und Klassenbewusstsein* [22], p. 73.

24. Karl Marx, *Das Kapital* (based on the 1st, 2d, and 4th eds., rev. Friedrich Engels, Hamburg, 1890/93/94) (Frankfurt am Main, 1967), vol. 1, p. 192.

25. Leopold von Ranke, "Politisches Gespräch," in *Sämmtliche Werke*, vols. 49/50 (Leipzig, 1887), pp. 322ff.

26. György Lukács, *Ästhetik*, vol. 1 (1) (Neuwied am Rhein, 1963), p. 228.

27. Proust, *A la recherche* [2], vol. 2, p. 420.

28. François Mauriac, *Aimer Balzac* (Paris, 1945), p. 110.

29. Lukács, *Ästhetik* [26], vol. 1 (1), p. 24.

30. Heinrich Wölfflin, *Die klassische Kunst*, 3d ed. (Munich, 1904), p. 249, and *Kunstgeschichtliche Begriffe* (Munich, 1943), p. xi.

31. Wilhelm Dilthey, "Die Funktion der Anthropologie in der Kultur des 16. und 17. Jahrhunderts," in *Gesammelte Schriften*, vol. 2 (Leipzig and Berlin, 1914), p. 458.

32. Friedrich Engels, letter to Bloch, 21 September 1890, and *Ludwig Feuerbach und der Ausgang der klassischen deutschen Philosophie* (Stuttgart, 1895).

33. Cf. Istvan Meszaros, *Marx's Theory of Alienation* (New York, 1970), pp. 191ff.

Part Two

1. Ferdinand Brunetière, *L'évolution des genres dans l'histoire de la littérature* (Paris, 1890).

2. Friedrich Ratzel, *Anthropogeographie*, 2d ed. (Stuttgart, 1899).

3. Theodor W. Adorno, *Versuch über Wagner* (Berlin, 1952).

4. Hippolyte A. Taine, *Philosophie de l'art dans les Pays-Bas* (Paris, 1869).

5. Max Weber, *Wirtschaft und Gesellschaft* (Tübingen, 1921–22), p. 609.

6. Karl Mannheim, "Das Problem der Generationen," in *Wissenssoziologie*, ed. K. H. Wolff (Berlin, 1964), p. 540.

7. José Ortega y Gasset, *El temo de nuestro tiempo, el ocaso de las revoluciones el sentido histórico de la teoria de Einstein* (Madrid, 1923).

8. Cf. Eduard Wechssler, "Generation als Jugendgemeinschaft," in *Geist und Gesellschaft,* vol. 1 (Festschrift, Kurt Breysig) (Breslau, 1927), pp. 66ff.

9. Wilhelm Pinder, *Das Problem der Generation in der Kunstgeschichte Europas* (Berlin, 1926), pp. 25ff.

10. Henri Pirenne, "Les périodes de l'histoire sociale du capitalisme," *Bulletins de l'Académie royale des sciences, des lettres, et des beaux-arts de Belgique* (Brussels, 1914).

11. Cf. Arnold Hauser, *Methoden moderner Kunstbetrachtung* (Munich, 1970), pp. 251ff.

12. Pinder, *Das Problem* [2, 9], pp. 14ff.

13. Pinder, *Das Problem* [2, 9], p. 30.

14. Pinder, *Das Problem* [2, 9], pp. 97ff.

15. Theodor W. Adorno, *Einleitung in die Musiksoziologie, zwölf theoretische Vorlesungen* (Frankfurt am Main, 1962), pp. 66ff.

16. Luigi G. Barzini, *The Italians* (New York, 1964).

17. Durkheim, *Suicide* [1, 20] (the author quotes here from the new ed. [Paris, 1960], pp. 435ff.).

18. Marc L. B. Bloch, *The Historian's Craft,* tr. Peter Putnam (Manchester, 1954), p. 34.

19. Durkheim, *Les règles* [1, 19], preface.

20. Lacombe, *Introduction* [1, 21], pp. 29ff.

21. Thomas S. Eliot, "Tradition and the Individual Talent," in *Selected Essays* [1, 17].

22. Walter Benjamin, "Das Kunstwerk im Zeitalter seiner technischen Reproduzierbarkeit," in *Schriften,* ed. Theodor W. Adorno and Gretel Adorno unter Mitwirkung von Friedrich Podzsus, vol. 1 (Frankfurt am Main, 1955), pp. 366ff.

23. Karl Mannheim, *Ideologie und Utopie* (Frankfurt am Main, 1952), p. 137.

24. *Grundlagen der marxistischen Philosophie (Osnovy marksistkoj filosifii dt.)* (Soviet textbook ed. Fedor V. Konstantinov) (Berlin, 1966), pp. 453ff.

25. Karl Marx and Friedrich Engels, *Die deutsche Ideologie* (Berlin, 1953), p. 26.

26. Letter from Engels to Conrad Smith, in Karl Marx and Friedrich Engels, *Werke,* vol. 37 (Berlin, 1967), pp. 205ff.

27. *Grundlagen der marxistischen Philosophie* [2, 24], p. 460.

28. Letter from Engels to W. Borgius (originally published by H. Starkenburg, who was originally thought to be the addressee, the letter was actually written to Borgius, but in earlier editions of the works will be found under Starkenburg), 25 January 1894, *Werke* [2, 26], vol. 39, pp. 205ff.

29. Friedrich Engels, *Herrn Eugen Dührings Umwälzung der Wissenschaft* ("Anti-Dühring"), *Werke* [2, 26], vol. 20, p. 239.

30. Letter from Engels to Joseph Bloch, 21–22 September 1890, in *Werke* [2, 26], vol. 37, pp. 462ff.

31. Friedrich Engels, *Ludwig Feuerbach*, in Karl Marx and Friedrich Engels, *Ausgewählte Schriften*, 4th ed., vol. 2 (Berlin, 1953), p. 370.

32. Karl Marx, *Zur Kritik der politischen Ökonomie*, 2d ed. (Berlin, 1951), p. 13.

33. Vere Gordon Childe, *History* (London, 1947) p. 75.

34. Ernst Troeltsch, *Der Historismus und seine Probleme* (Tübingen, 1922), p. 324.

35. Karl Marx, *Die Frühschriften*, ed. Siegfried Landshut (Stuttgart, 1953), p. 242.

36. Karl Marx, *Das Kapital* [1, 24], vol. 1, p. 193.

37. Karl Marx, *Der achzehnte Brumaire des Louis Napoléon*, in Ausgewählte Schriften [2, 31], vol. 1, p. 226.

38. Letter from Engels to Conrad Schmidt, 27 October 1890, in *Werke* [2, 26], vol. 37, pp. 488ff.

39. Engels, *Feuerbach* [2, 31], p. 373.

40. Marx, *Kritik* [2, 32], p. 269.

41. Lukács, *Geschichte und Klassenbewusstsein* [1, 22], p. 61.

42. Marx, *Kritik* [2, 32], p. 268.

43. George Orwell, *Critical Essays* (London, 1946), p. 114.

44. Cf. letter from Engels to Minna Kautsky, 26 November 1885, in *Werke* [2,26], vol. 36, pp. 392ff.

45. Pierre A. Caron de Beaumarchais, *Essai sur le genre dramatique* (London and Paris, 1912).

46. Thorstein Veblen's "conspicuous consumption" and "conspicuous leisure" in his *Theory of the Leisure Class* (New York, 1925).

47. Hauser, *Manierismus* [1, 13].

48. Engels, *Feuerbach* [2, 31], and cf. letter from Engels to Franz Mehring, 14 July 1893, in *Werke* [2, 26], vol. 39, pp. 96ff.

49. Theodor Geiger, "Kritische Bemerkungen zum Begriffe der Ideologie," in *Gegenwartsprobleme der Soziologie* (Alfred Vierkandt zum 80. Geburtstag), ed. Gottfried Eisermann (Potsdam, 1949).

50. Iosif Stalin, *Der Marxismus und die Fragen der Sprachwissenschaft* (Berlin, 1951).

51. Karl Mannheim, *Das Problem einer Soziologie des Wissens*, in *Archiv für Sozialwissenschaft und Sozialpolitik*, vol. 53 (1925) (Tübingen, 1925).

52. Cf. Adorno, *Einleitung in die Musiksoziologie* [2, 15] (Reinbek bei Hamburg, 1968), p. 215.

53. Marx and Engels, *Die deutsche Ideologie* [2, 25], pp. 44ff.

54. Cf. letter from Engels to Mehring, 14 July 1893 [2, 26].

55. Marx, *Der 18. Brumaire* [2, 37].

56. Marx, *Das Kapital* [1, 24], vol. 1, p. 88.

57. Lukács, *Geschichte und Klassenbewusstsein* [1, 22], p. 71.

58. Erich Fromm, "Die Entwicklung des Christusdogmas," in *Imago (Zeitschrift für anwendung der psychoanalyse auf die geisteswissenschaften)* (Leipzig and Vienna, 1930), p. 7.

59. Werner W. Jaeger, *Paideia, Die Formung des griechischen Menschen* (Berlin and Leipzig, 1934), p. 249.

60. Christopher St. J. Sprigg, *Illusion and Reality: A Study of the Sources of Poetry* (written under the pseudonym Christopher Caudwell) (London, 1946), pp. 256ff.

61. Moritz Noernes, *Urgeschichte der bildenden Kunst in Europa von den Anfängen bis um 500 vor Christi*, 3d ed., rev. and enlarged Oswald Menghin (Vienna, 1925), pp. 40 and 108.

62. Fritz Heichelheim, *Wirtschaftsgeschichte des Altertums, vom Paläolithikum bis zur Völkerwanderung der Germanen, Slaven, und Araber* (Leiden, 1938), pp. 82ff.

63. Vere Gordon Childe, *What Happened in History* (Harmondsworth, Middlesex [Penguin], 1942), pp. 79ff.

64. Max Pohlenz, *Die griechische Tragödie*, vol. 1 (Leipzig and Berlin, 1930), pp. 236 and 456.

65. Cf. Karl Mannheim, "Wissensoziologie," in *Handwörterbuch der Soziologie* (Stuttgart, 1931), p. 672.

66. Julius Kärst, *Geschichte des Hellenismus*, 2d ed. (Leipzig, 1926), pp. 166ff.

67. Bernhard Schweitzer, *Der bildende Künstler und der Begriff des Künstlerischen in der Antike* (Heidelberg, 1925), pp. 60 and 124ff.

68. Hauser, *Sozialgeschichte* [1, 12], pp. 143ff.

69. Fritz Brüggemann, "Der Kampf um die bürgerliche Welt- und Lebensanschauung in der deutschen Literatur des 18. Jahrhunderts," in *Deutsche Vierteljahrschrift für Literaturwissenschaft und Geistesgeschichte*, vol. 3 (1) (Tübingen, 1925).

70. Marx, *Der 18. Brumaire* [2, 37].

71. Eduard Hanslick, *Vom musikalisch-schönen; Ein Beitrag zur Revision der Ästhetik der Tonkunst* (Leipzig, 1854).

72. José Ortega y Gasset, *La deshumanización del arte, Ideas sobre la novela* (Madrid, 1925), p. 19.

73. Friedrich Schiller, *Briefe über die aesthetische Erziehung des Menschen* (*Sämmtliche Werke*, 4th ed.) (Munich, 1965–67), vol. 5, letter no. 22.

74. Desmond Morris, *The Biology of Art* (New York, 1962), p. 158 ("self-rewarding activity").

Part Three

1. Georg W. F. Hegel, *Enzyklopädie der philosophischen Wissenschaften im Grundrisse*, 2d ed. (Heidelberg, 1877), para. 389.

2. Theodor W. Adorno, "Zur Logik der Sozialwissenschaften," in *Kölner Zeitschrift für Soziologie und Sozialpsychologie*, vol. 14 (Cologne, 1962), p. 262.

3. Cf. Theodor W. Adorno, *Aspekte der Hegelschen Philosophie* (Berlin, 1957).

4. Engels, *Ludwig Feuerbach und der Ausgang* [2, 31], p. 361.

5. Cf. Robert Heiss, *Wesen und Formen der Dialektik* (Cologne, 1959), pp. 52ff.

6. Marx, *Grundrisse* [1, 18], p. 716.

7. Theodor Pinkus, ed., *Gespräche mit Georg Lukács, H. H. Holz, Leo Kofler, Wolfgang Abendroth* (Hamburg, 1967), p. 105.

8. Paul Frankl, "Der Beginn der Gotik und das allgemeine Problem des Stilbeginns," in *Festschrift Heinrich Wölfflin,* ed. Hugo Schmidt (Munich, 1924), p. 117.

9. Karl Marx, *Die Heilige Familie,* in *Die Frühschriften,* ed. Siegfried Landshut (Stuttgart, 1953), p. 317.

10. Ernst Bloch, *Subjekt-Objekt: Erläuterungen zu Hegel* (Berlin, 1952), p. 117.

11. Leo Rosen, *Joys of Yiddish* (n.p., 1970).

12. Marx, *Frühschriften* [3, 9], p. 239.

13. Marx and Engels, *Deutsche Ideologie* [2, 25], p. 27.

14. Helmut Ogiermann, *Materialistische Dialektik, ein Diskussionsbeitrag* (Sammlung Wissenschaft und Gegenwart) (Munich, 1958), p. 105.

15. Bloch, *Subjekt-Objekt* [3, 10], p. 99.

16. Georg W. F. Hegel, *Die Phänomenologie des Geistes,* ed. Johannes Hoffmeister, 6th ed. (Frankfurt am Main, 1952), p. 33.

17. Karl R. Popper, "Was ist Dialektik?" in *Logik der Sozialwissenschaften,* ed. Ernst Topitsch (Cologne, 1966), p. 265.

18. Marx, *Das Kapital* [1, 24], vol. 1, p. 192.

19. Cf. Karl Mannheim, "Historismus," in *Archiv für Sozialwissenschaft und Sozialpolitik,* vol. 52 (1) (Tübingen, 1924).

20. Georg W. F. Hegel, *Asthetik,* ed. Friedrich Bassenge (Berlin, 1955), p. 305.

21. Hegel, *Phänomenologie* [3, 16], p. 21.

22. Karl Marx, *Das Kapital* (Nachwort zur 2. Auflage) (Hamburg, 1890–94).

23. Cf. Friedrich von Nietzsche, *Götzendämmerung—Die "Vernunft" in der Philosophie,* in *Werke,* ed. Karl Schlechta, vol. 2 (Munich, 1954–56).

24. György Lukács, *Der junge Hegel: Über die Beziehungen von Dialektik und Ökonomie* (Zurich, 1948), pp. 128ff.

25. Marcel Proust, *Pastiches et mélanges,* Paris (*Nouvelle revue française* [Paris, 1921]), p. 267.

26. Wilhelm Dilthey, *Die Funktion der Anthropologie in der Kultur des 16. und 17. Jahrhunderts,* in *Schriften II* (Leipzig and Berlin, 1914), p. 458.

27. Pinkus, *Gespräche* [3, 7], p. 110.

28. Hegel, *Phänomenologie* [3, 16], p, 39.

29. Jean-Paul Sartre, *Critique de la raison dialectique précédé de question de méthode* (Paris, 1960), p. 131.

30. Sartre, *Critique* [3, 29], pp. 359 and 369.

31. Sartre, *Critique* [3, 29], pp. 165–377 passim.

32. Marx, *Das Kapital* [1, 24], vol. 3, p. 828.

33. Marx, *Die Frühschriften* [2, 35], p. 330.

34. Joseph Popper (Lynkaeus), *Die allgemeine Nahrpflicht als Lösung der sozialen Frage*, 2d ed., ed. Margit Ornstein (Vienna, 1923), p. 72.

35. Marx, *Das Kapital* [1, 24], preface to the first edition.

36. Ogiermann, *Materialistische Dialektik* [3, 14], p. 55.

37. Jean-Yves Calvez, *La pensée de Karl Marx*, éditions du seuil (Paris, 1956), pp. 411ff.

38. Marx, *Das Kapital* [1, 24].

39. Lukács, *Ästhetik* [1, 26], vol. 1 (1), p. 779.

40. Sartre, *Critique* [3, 29], p. 66.

41. Friedrich Engels, *Anteil der Arbeit an der Menschenwerdung der Affen*, in *Ausgewählte Schriften* [2, 31], vol. 2, pp. 72ff.

42. Marx, *Grundriss* [1, 18], pp. 13ff.

43. Eliot, *Selected Essays* [1, 17], pp. 20ff.

44. Jean-Marie Guyau, *L'art au point de vue sociologique*, 14th ed. (Paris, 1926), p. 41.

45. Konrad Fiedler, *Schriften über Kunst*, vol. 2 (Munich, 1913–14), p. 168.

46. Fiedler, *Schriften* [3, 45], vol. 2, p. 275.

47. Fiedler, *Schriften* [3, 45], vol. 2, pp. 168ff.

48. Fiedler, *Schriften* [3, 45], vol. 1, pp. 59ff., vol. 2, pp. 168ff.

49. Henri L. Bergson, *L'évolution créatrice* (Paris, 1907), p. 7.

50. Heinrich Woelfflin, *Kunstgeschichtliche Grundbegriffe; das Problem der Stilentwicklung in der neueren Kunst*, 7th ed. (Munich, 1927), p. 252.

51. Cf. Gottfried Semper, *Der Stil in den technischen und tektonischen Künsten oder Praktische Aesthetik: Ein Handbuch für Techniker, Künstler, und Kunstfreunde* (Frankfurt am Main [vol. 1] and Munich [vol. 2], 1863), and Alois Riegl, *Stilfragen: Grundlegungen zu einer Geschichte der Ornamentik* (Berlin, 1893).

52. Cf. Eugène Viollet-le-Duc, *Dictionnaire raisonné de l'architecture française du xiᵉ au xviᵉ siècle*, 10 vols. (Paris, 1854–68), and Ernst Gall, *Die gotische Baukunst in Frankreich und Deutschland* (Leipzig, 1925).

53. Walter Timmling, *Kunstgeschichte und Kunstwissenschaft*. mit einer Abhandluag Meinungen über Herkunft und Wesen der Gotik von Paul Frankl (Leipzig, 1923), p. 21.

54. Lukács, *Geschichte und Klassenbewusstsein* [1, 22], p. 217.

55. Cf. Hans Albert, "Der Mythus der totalen Vernunft," in *Der Positivismusstreit in der deutschen Soziologie*, 1969, p. 209.

56. Georges Gurvitch, *Dialectique et sociologie* (Nouvelle bibliotèque scientifique) (Paris, 1962), p. 239.

57. Karl Marx, *Deutsch-Französische Jahrbucher*, ed. Arnold Ruger and Karl Marx (Paris, 1844).

Part Four

1. Goethe, letter to Kanzler F. von Müller [not traced; author says 1822].

2. Marx, *Grundrisse* [1,18], p. 13.

3. Marx, *Grundrisse* [1,18], p. 13.

4. Marx, *Die Frühschriften* [2, 35], p. 357.

5. Benjamin, *Schriften* [2, 22], p. 40.

6. Benjamin, *Schriften* [2, 22], p. 41.

7. Martin Heidegger, *Der Vorsprung des Kunstwerkes* (Stuttgart, 1960), p. 82.

8. Heidegger, *Vorsprung* [4, 7], p. 85.

9. Hegel, *Ästhetik* [3, 20], p. 276.

10. Hegel, *Ästhetik* [3, 20], pp. 109ff.

11. Georg Simmel, *Soziologie, Untersuchungen über die Formen der Vergesellschaftung,* 2d ed. (Munich and Leipzig, 1922), p. 104.

12. Alphonse Silbermann, "Kunst," in *Soziologie,* ed. René König (Stuttgart, 1958), p. 157.

13. William Empson, *Some Versions of Pastoral* (London, 1935), p. 5.

14. Adorno, *Einleitung* [2, 15], p. 71.

15. Hippolyte A. Taine, *Nouveaux essais de critique et d'histoire* (Paris, 1865), pp. 104ff.

16. Cf. Wilhelm Dilthey, "Die Entstehung der Hermeneutik," in *Philosophische Abhandlungen,* dedicated to Christiph Sigwart on his seventieth birthday, 28 March 1900 (Tübingen, 1900), p. 202.

17. Joseph Aynard, *La bourgeoisie français, essai de psychologie* (Bibliothèque du musée social) (Paris, 1934), p. 350.

18. Simmel, *Soziologie* [4, 11], pp. 68ff.

19. Albert Thibaudet, *Le liseur de romans* (Paris, 1925), p. xi.

20. Karl Vossler, *Frankreichs kultur im spiegel seiner sptachentwicklung; geschichte der französischen schriftsprache von den anfängen bis zur gegenwart* (Heidelberg, 1921), p. 59.

21. Leo Steinberg, "Contemporary Art and the Plight of Its Public," in *The New Art,* ed. Gregory Battcock (New York, 1966), pp. 27ff.

22. Cf. Steinberg, "Contemporary Art" [4, 21].

23. Lukács, *Ästhetik* [1, 26], vol. 1 (1), pp. 629ff.

24. Benjamin, "Das Kunstwerk" [2, 22], pp. 366ff.

25. Cf. Adorno, *Einleitung* [2, 15], pp. 115ff.

26. Adorno, *Einleitung* [2, 15], p. 120.

27. Cf. Karl Mannheim, "Die Bedeutung der Konkurrenze im Gebiete des Geistigen," in *Verhandlungen des VI deutschen Soziologentages, 1928* (Zurich, 1929), pp. 35ff.

28. Charles A. Sainte-Beuve, *Portraits littéraires,* new ed., vol. 3 (Paris, 1864), p. 546.

29. Jakob Minor, ed., *Friedrich Schlegel 1794-1802; Seine prosaische Jugendschriften,* vol. 2 (Vienna, 1882), p. 143.

30. Frank R. Leavis, "Johnson as Critic," in *Anna Karenina and Other Essays* (London, 1967), pp. 198ff. and 216.

31. György Lukács, "Schriftsteller und Kritiker," in *Probleme des Realismus* (Berlin, 1955), reprinted in *Schriften zur Literatursoziologie* (Neuwied am Rhein, 1961), pp. 198ff.

32. Lukács, "Schriftsteller" [4, 31], pp. 198ff.

33. Henry James, in *New Review*, London, May 1891 (pp. not available).

34. Walter Benjamin, "Der Begriff der Kunstkritik in der deutschen Romantik," in *Schriften* [2, 22], vol. 2, pp. 420ff.

35. Wilhelm Dilthey, *Gesammelte Schriften*, vol. 7 (Leipzig and Berlin, 1927), p. 217.

36. Bertrand Russell, *Portraits from Memory* (London and New York, 1956), pp. 73ff.

37. Cf. Miguel de Unamuno y Jugo, *Vida de Don Quijote y Sancho* (Madrid, 1914).

38. Oscar Wilde, "The Critic as Artist," in *Selected Works*, ed. Richard Aldington (London and Toronto, 1946).

39. Albert Cassagne, *La théorie de l'art pour l'art en France chez les derniers romantiques et les premiers réalistes* (Paris, 1906), p. 325.

40. Cf. Stanley E. Hyman, *The Armed Vision: A Study in the Methods of Literary Criticism* (New York, 1948), p. 35.

41. Frank R. Leavis and Queenie D. Leavis, *Lectures in America* (London, 1969).

42. Cf. Adorno, *Einleitung* [2, 15], p. 53.

43. Henri Peyre, *Writers and Their Critics* (Ithaca, N.Y., 1944), p. 265.

44. John W. H. Atkins, *English Literary Criticism: 17th and 18th Centuries* (London, 1951).

45. Albert Thibaudet, *Gustave Flaubert* (Paris, 1963), p. 175.

46. Allen Tate, "The Hovering Fly," in *Sewanee Review*, 1943, reprinted in *The Man of Letters in the Modern World: Selected Essays, 1928–1955* (New York, 1955), pp. 146ff.

47. Cf. Erich Auerbach, *Literatursprache und Publikum in der lateinischen Spätantike und im Mittelalter* (Berne, 1958), part 4.

48. Cf. Julius Bab, *Das Theater im lichte der soziologie in den grundlinien dargestellt* (Leipzig, 1931).

49. André Malraux, *Les voix du silence* (Paris, 1951), pp. 11ff.

50. Paul Valéry, "Le problème des musées," in *Le Gaulois*, 4 April 1923, reprinted in *Oeuvres* [1, 5], vol. 2, pp. 1290ff.

51. Theodor W. Adorno, *Prismen; Kulturkritik und Gesellschaft* (Berlin, 1955), pp. 215ff.

52. Cf., for what follows, Peter Karstedt, *Studien zur Soziologie der Bibliothek*, 2d rev. and enlarged ed. (Wiesbaden, 1965).

53. Martin Wackernagel, *Der Lebensraum des Künstlers in der florentinischen Renaissance: Aufgaben und Auftraggeber, Werkstatt und Kunstmarkt* (Leipzig, 1938), pp. 289ff.

54. Rudolf und Margot Wittkower, *Born under Saturn, the Character and Conduct of Artists: A Documented History from Antiquity to the French Revolution* (London 1963), p. 20.

55. Cf. Hugh Trevor-Roper, *The Plunder of the Arts in the Seventeenth Century* (London, 1970).

56. Benjamin, *Schriften* [2, 22], vol. 1, pp. 366ff.

57. Cf. Mannheim, "Historismus" [3, 19], p. 35.

58. Wilhelm Dilthey, *Gesammelte Schriften*, vol. 5 (Leipzig and Berlin, 1924), p. 318.

59. Cf. Friedrich A. von Hayek, *The Counter-Revolution of Science: Studies on the Abuse of Reason* (Glencoe, Ill., 1952), p. 78.

60. Cf. Karl Mannheim, *Beiträge zur Theorie der Weltanschauungsinterpretation* (Vienna, 1923), p. 27.

61. Cf. Friedrich Nietzsche, *Die fröhliche Wissenschaft*, "Historia abscondita," with an afterword by Friedrich Baeumler (Leipzig, 1930).

62. Henri Bergson, *La pensée et le mouvant—essais et conférences* (Paris, 1934), pp. 23ff.

63. Eliot, *Selected Essays* [1,17], p. 15.

64. Adorno, *Einleitung* [2, 15], pp. 16ff.

65. Adorno, *Einleitung* [2, 15], p. 18.

66. Adorno, *Einleitung* [2, 15], p. 25.

67. Empson, *Some Versions of Pastoral* [4, 13], p. 15.

Part Five

1. Alfred Weber, "Die Not der geistigen Arbeiter," in *Schriften des Vereins für Socialpolitik* (Munich, 1920).

2. Henri Pirenne, "Le mouvement économique et social," in Gustave Glotz, ed., *Histoire général*, vol. 3, *Histoire du Moyen-Age* (Paris, 1933), p. 20.

3. Wilhelm Fränger, "Deutsche Vorlagen zu russischen Volksbilderbogen des 18. Jahrhunderts," in *Jahrbuch für historische Volkskunde*, vol. 2 (Berlin, 1926), p. 163.

4. Woelfflin, *Grundbegriffe* [3, 50], pp. 31ff.

5. Wilhelm Dilthey, *Einleitung in die Geisteswissenschaften*, *Gesammelte Schriften*, vol. 1 (Leipzig and Berlin, 1923), pp. 31ff.

6. Alois Riegl, *Volkskunst, Hausfleiss, und Hausindustrie* 1894 [further bibliographical information not available].

7. Cf. Hans Naumann, *Primitive Gemeinschaftskultur Beiträge zur Volkskunde und Mythologie* (Jena, 1921).

8. Robert Forrer, *Von alter und ältester Bauernkunst* (Esslingen, 1906), p. 6.

9. Cf. Eduard Wechssler, *Begriff und Wesen des Volkslieds* (Marburg an der Lahn, 1913), p. 13.

10. Heinrich Morf, "Das französische Volkslied," in *Aus Dichtung und Sprache der Romanen*, Reihe II (Strassburg, 1911), p. 90.

11. Wilhelm Tappert, *Wandernde Melodien* (Berlin, 1868), p. 38.

12. Gabriel Vicaire, *Etudes sur la poésie populaire légendes et traditions* (Paris, 1902), p. 80.

13. Cf. Henri Devenson, *Le livre des chansons; ou, Introduction à la connaissance de la chanson populaire française* (Neuchatel, 1946), pp. 26ff.

14. Emile Faguet, *Politiques et moralistes du dix-neuvième siècle*, vol. 1 (Paris, 1981), p. 167.

15. Letter from Achim von Arnim, quoted in Reinhold Steig, *Achim v. Arnim und die ihm nahe standen*, vol. 3, *Achim von Arnim und Jakob und Wilhelm Grimm* (Stuttgart, 1894–1913), p. 134.

16. Arthur Haberlandt, "Gedanken über Volkskunst," in *Die bildenden Künste*, vol. 2 (Vienna, 1919), p. 230, and Karl von Spiess, *Bauernkunst: ihre Art und ihr Sinn* (Vienna, 1925), p. 70.

17. John Meier, *Werden und Leben des Volksepos* (Halle, 1909), p. 13.

18. George D. Thomson, *Studies in Ancient Greek Society*, vol. 1 (London, 1949), pp. 527ff., and Albert B. Lord, *The Singer of Tales* (Cambridge, Mass., 1960), passim, and Milman Parry, *The Making of Homeric Verse* (Oxford, 1971), passim.

19. Hans Karlinger, *Deutsche Volkskunst* (Berlin, 1938), p. 9.

20. Rochus W. T. H. F. von Liliencron, *Die historischen Volkslieder der Deutschen vom 13. bis 16. Jahrhundert*, 5 vols. (Leipzig, 1865–69), vol. 1, p. xiii.

21. Alexandru Tzigara-Samurcas, *L'art du peuple romain—Aperçu historique—Catalogue de l'exposition de Genève*, 1925.

22. Spiess, *Bauernkunst* [5, 16], p. 282.

23. Naumann, *Primitive Gemeinschaftskultur* [5, 7], p. 6.

24. Malraux, *Les voix du silence* [4, 49], p. 512.

25. Hannah Arendt, "Society and Culture," in *Daedalus* (Proceedings of the American Academy of Arts and Sciences) (Boston, 1960), pp. 281ff.

26. Constant Lambert, *Music Ho!* (London, 1948) (Penguin Books), pp. 168ff.

27. Adorno, *Einleitung* [2, 15], p. 240.

28. Emile Faguet, *Propos de théâtre*, 2d ser. (Paris, 1905), p. 318.

29. Cf. Robert Mandrou, *De la culture populaire au xviie et xviiie siècles* (La bibliothèque bleue de Troyes) (Paris, 1964).

30. Francisque Sarcey, *Quarante ans de théatre*, vol. 1, *Feuilletons dramatiques* (Paris, 1900–1902), pp. 120, 122, 209ff.

31. Cf. Queenie D. Leavis, *Fiction and the Reading Public* (London, 1932).

32. Gustave Flaubert, *Correspondance*, vol. 2 (Paris, 1926–33), p. 378.

33. Simmel, *Soziologie* [4, 11], p. 51.

34. Dwight MacDonald, "A Theory of Mass Culture," in *Mass Culture: The Popular Arts in America*, ed. Bernard Rosenberg and David M. White (Glencoe, Ill., 1957), pp. 69ff.

35. Gilbert V. Seldes, *The Great Audience* (New York 1950).

36. José Ortega y Gasset, *La rebelión de las masas* (Madrid, 1930).

37. Benjamin, *Das Kunstwerk* [2, 22].

38. Stuart Chase, *Men and Machines* (New York, 1929), p. 25.

39. Georg Simmel, *Philosophische Kultur Gesammelte Essais von Georg Simmel* (Leipzig, 1911), p. 34.

40. Dwight MacDonald, "A Theory of Popular Culture," in *Politics*, vol. 1 (1) (New York, 1944), pp. 20ff.

41. Samuel T. Coleridge, *Biographia Litteraria*, ed. J. Shawcross (Oxford, 1907), section 3, note 1.

42. Marshall McLuhan, *Understanding Media* (New York, 1964), pp. 93ff.

43. Cf. Belá Balázs, *Der sichtbare Mensch* (Leipzig, 1924), and *Der Geist des Films* (Halle, 1930).

44. Benjamin, *Schriften* [2, 22], vol. 1, pp. 366ff.

45. Marshall McLuhan, *The Mechanical Bride: Folklore of Industrial Man* (New York, 1951), p. 21.

46. Ortega y Gasset, *La deshumanización del arte* [2, 72], p. 19.

47. McLuhan, *Understanding Media* [5, 42], pp. 12ff.

48. Jean-Paul Sartre, *Situations, II* (Paris, 1968), p. 191.

49. Bernard Diebold, "Film and Drama," in *Die Neue Rundschau*, vol. 43 (Berlin, 1932), p. 404.

50. Belá Balázs, "Zur Kunstphilosophie des Films," in *Theorie des Films: Ideologiekritik der Traumfabrik* (Frankfurt am Main, 1972), p. 160.

51. Cf. André Bazin, *What Is Cinema?* essays selected and translated by Hugh Gray (Berkeley, Calif., 1967–71), pp. 31ff.

52. Richard Poirier, "The Beatles," *Partisan Review*, Fall 1967, New York, pp. 526ff.

53. Cf., for the following, George Melly, *Revolt into Style: The Pop Arts in Britain* (London, 1970).

Part Six

1. Theodor W. Adorno, *Ästhetische Theorie*, vol. 2 of his *Gesammelte Schriften* (Frankfurt am Main, 1970), p. 475.

2. Cited in Hans Richter, *Dada—Kunst und anti Kunst* (Cologne, 1964), p. 23.

3. Bertolt Brecht, *Gesammelte Werke*, vol. 9 (Frankfurt am Main, 1967), p. 723.

4. Marianne Moore, *Selected Poems* (New York, 1935).

5. Charles P. Baudelaire, *Oeuvres* (Paris, 1951), p. 1195.

6. Gérard de Narval, *Promenades et Souvenirs* (Paris, 1931).

7. Benjamin, *Schriften* [2, 22], vol. 2, p. 174.

8. Virginia Woolf, *The Common Reader* (London, 1925).

9. György Lukács, *Die Zerstörung der Vernunft* (Berlin, 1954), pp. 389ff.

10. Cf. Wystan H. Auden, *The Age of Anxiety: A Baroque Eclogue* (New York, 1947).

11. Marcel Proust, "A propos de Baudelaire," in *Chroniques* (Paris, 1927), pp. 212ff.

12. Proust, *A la recherche* [1, 2], vol. 3, p. 920.

13. Francis Steegmüller, *Cocteau, a Biography* (Boston, 1970), p. 202.

14. Richter, *Dada* [6, 2], p. 33.

15. Werner Haftmann, *Malerei im zwanzigsten Jahrhundert* (Munich, 1965), p. 18.

16. György Lukács, "Grosse und Verfall des Expressionsimus," in *Essays über Realismus*, vol. 4 of his *Werke* (Neuwied am Rhein, 1971).

17. Ernst Bloch, *Erbschaft dieser Zeit* (Erweiterte Ausgabe) (Frankfurt am Main, 1962), pp. 269ff.

18. Roland Barthes, *Le degré zéro de l'écriture* (Editions du Seuil) (Paris, 1953).

19. Sartre, *Situations, I*, vol. 1, *Explication de "L'étranger"* (Paris, 1947).

20. Wilhelm Worringer, *Künstlerische Zeitfragen* (Munich, 1921).

21. Haftmann, *Malerei* [6, 15], p. 149.

22. Wilhelm Worringer, *Abstraktion und Einfuhlung; Ein Beitrag zur Stilpsychologie* (Neuwied am Rhein, 1907).

23. Cf. Malraux, *Les voix* [4, 49], pp. 589ff.

24. Cf. André Breton, *Le surréalisme et la peinture* (Paris, 1928).

25. André Breton, *Second manifeste du surréalisme* (Paris, 1930).

26. Lukács, *Essays über Realismus* [6, 16], pp. 109ff.

27. Bloch, *Erbschaft* [6, 17], pp. 243ff.

28. Ortega y Gasset, *La deshumanización del arte* [2, 72].

29. Cf. Heinz Werner, *Die Ursprünge der Metapher* (Leipzig, 1919).

30. Arnold Hauser, *Der Ursprung der modernen Kunst und Literatur* (originally published as *Der Manierismus*) (Munich, 1973), pp. 44ff.

31. Benjamin, *Schriften* [2, 22], vol. 2, p. 135.

32. Cf. Susan Sontag, *Against Interpretation and Other Essays* (New York, 1966).

33. Cf. Hauser, *Sozialgeschichte* [1, 12], vol. 2, p. 471.

34. Jean-Paul Sartre, *L'être et le néant, essai d'ontologie phénoménologique* (Paris, 1943).

35. Sigmund Freud, *Das Ich und das Es* and *Das Unbehagen in der Kultur*, in vol. 14 of his *Gesammelte Werke* (London, n.d.), pp. 237ff. and 421ff.

36. Theodor W. Adorno, *Philosophie der neuen Musik* (Frankfurt am Main, 1958), p. 35.

37. Adorno, *Philosophie der neuen Musik* [6, 36], p. 66.

38. Hegel, *Ästhetik* [3, 20], p. 57.

39. György Lukács, *Wider den missverstandenen Realismus* (Hamburg, 1958), p. 44.

40. Sontag, *Against Interpretation* [6, 32], and Lionel Trilling, *Sincerity and Authenticity* (Cambridge, Mass., 1972).

41. Alain Robbe-Grillet, *Pour un nouveau roman* (Editions de Minuit) (Paris, 1963), pp. 171ff.

42. Bloch, *Erbschaft* [6, 17], pp. 224ff.

43. Benjamin, *Schriften* [2, 22], vol. 2, p. 229.

44. Cf. Nathalie Sarraute, *L'ère de soupçon, essais sur le roman* (Paris, 1956), pp. 16ff.

45. Sarraute, *L'ère de soupçon* [6, 44], pp. 98ff.

46. Robbe-Grillet, *Pour un nouveau roman* [6, 41], p. 176.

47. Robbe-Grillet, *Pour un nouveau roman* [6, 41], pp. 23ff.

48. Hegel, *Phänomenologie* [3, 16] (B) IV, B.

49. John Weightman, *The Concept of the Avant-Garde: Explorations in Modernism* (London, 1973), p. 29.

50. Robbe-Grillet, *Pour un nouveau roman* [6, 41], pp. 148ff.

51. Nathalie Sarraute, *Tropismes* (Paris, 1939), p. 40, and cf. Weightman, *Concept of the Avant-Garde* [6, 49], p. 39.

52. Robbe-Grillet, *Pour un nouveau roman* [6, 41], p. 153.

53. Interview with Claude Simon, in *Les nouvelles littéraires,* no. 1743, 26 January 1961, Paris, p. 2.

54. Sarraute, *L'ère de soupçon* [6, 44], passim.

55. Robbe-Grillet, *Pour un nouveau roman* [6, 41], pp. 165ff.

56. Susan Sontag, *Styles of Radical Will* (New York, 1969), pp. 169ff.

57. Michel Butor, *Répertoire: Etudes et conférences* (Editions de Minuit) (Paris, 1960).

58. Bloch, *Erbschaft* [6, 17], p. 243.

59. Hegel, *Phänomenologie* [3, 16] (B), IV, B.

60. Adorno, *Prismen* [4, 51], p. 302.

61. Max Brod, *Franz Kafka, eine Biographie* (Prague, 1937), p. 95.

62. Theodor W. Adorno, "Das Altern in der neuen Musik," in *Dissonanzen; Musik in der verwalteten Welt* (Göttingen, 1956), pp. 102ff.

63. Lukács, *Wider den missverstandenen Realismus* [6, 39], p. 81.

64. Lukács, *Wider den missverstandenen Realismus* [6, 39], p. 46.

65. Lukács, *Wider den missverstandenen Realismus* [6, 39], p. 46.

66. Brod, *Kafka* [6, 61], p. 236.

67. Lukács, *Wider den missverstandenen Realismus* [6, 39], p. 31.

68. Theodor W. Adorno, *Noten zur Literatur,* vol. 2 (Berlin, 1958–61), p. 197.

69. Samuel Beckett, *Endgame* (New York, 1958), p. 31.

70. Beckett, *Endgame* [6, 69], pp. 32ff.

71. Albert Camus, *Le mythe de Sisyphe* (Nouvelle édition) (Paris, 1942).

72. Sartre, *Situations, I* [5, 48], p. 92.

73. Camus, *Le mythe de Sisyphe* [6, 71], p. 115.

74. Theodor W. Adorno, "Versuch das Endspiel zu verstehen," in *Noten zur Literatur* [6, 68], vol. 2, p. 190.

75. "Invenias etiam disjecti membra poetae," Horace, *Satires* 1 (4), line 62, in Horace *Satires, Epistles, Ars Poetica* (Loeb Classical Library) (London and New York, 1929), p. 53.

76. Franz Kafka, *Das Schweigen der Sirenen,* in *Gesammelte Schriften,* vol. 5 (Prague, 1936), pp. 97ff.

77. Barthes, *Le dégré zéro* [6, 18].

78. Samuel Beckett, *Molloy,* in *The Collected Works of Samuel Beckett* (New York, 1955), p. 36.